A History
of American Art

Reproduced on the cover: JASPER JOHNS. *Map* (detail). 1961.
Oil on canvas, 6'6" × 10'3½". Collection Mr. and Mrs. Robert C. Scull
(fractional gift to the Museum of Modern Art, New York).

A History of American Art

second edition

Daniel M. Mendelowitz
Stanford University

HOLT, RINEHART AND WINSTON, INC.

New York Chicago San Francisco Atlanta Dallas
Montreal Toronto London Sydney

*To the thousands of forgotten artists,
artisans, and craftsmen who have helped shape
the face of America*

Editor Dan W. Wheeler
Production editor Rita Gilbert
Manuscript editor Theresa Brakeley
Picture editor Joan Curtis
Designer Marlene Rothkin Vine

Library of Congress Catalog Card Number: 71–111303
ISBN: 0-03-089475-1 *Text*
ISBN: 03-081835-4 *Trade*
Copyright © 1960 by Holt, Rinehart and Winston, Inc.
Second edition 1970.
*All rights reserved. No part of the contents of this book
may be reproduced without the written permission of the publishers,
Holt, Rinehart and Winston, Inc., New York.*
Color photolithography: Les Imprimeries Réunies Lausanne S.A., Switzerland.
Composition and black-and-white photolithography: Les Presses Centrales Lausanne S.A., Switzerland.
Color printing: Lehigh Press, Pennsauken, N.J., U.S.A.
Black-and-white printing and binding: Capital City Press, Montpelier, Vt., U.S.A.
 9 138 98765

Preface

This is a history of the visual arts produced in the geographical area that now constitutes the United States. Such a book is difficult to title. *A History of United States Art* sounds awkward and logically might even be construed to exclude the arts of the colonial period. Thus, with apologies to our northern and southern neighbors, I use the title *A History of American Art,* knowing full well that the terms *America* and the *United States* are not synonymous.

During the past several decades, a period in which the United States has assumed a position of leadership in the world of art, the dynamic character of our contemporary visual expression has awakened a sympathetic and analytical interest in its historical antecedents. American architecture, painting, sculpture, prints, and our industrial and decorative arts and crafts now command the attention not only of art historians, collectors, and museums, but of students of cultural history in general. Courses in the history of American art have become a standard part of the college art history curriculum, and this awareness is shared by the public at large. The present book, in response to that burgeoning interest, has been designed to provide an introduction to the history of the visual arts in this country for all readers with a seriousness of purpose, whether they are formal academic students of art and cultural history or persons motivated solely by a desire to know more about a fascinating and vital tradition.

My particular aim has been to produce a broadly conceived, well-illustrated survey of the development of architecture, painting, sculpture, prints, the decorative arts and crafts, and photography from Pre-Columbian times to today. Though they tend to be neglected in most comparable publications, I have included the arts of the American Indian, because of their intrinsic merit, because the arts of primitive peoples

have played an increasingly important role in twentieth-century expression, and because they constitute an important element in our national heritage. For similar reasons I have also included a token survey of the decorative arts, for in our day the line between the fine and decorative arts becomes more and more tenuous. During the colonial period and the early nineteenth century, when the fine arts were still in a relatively formative state, American artisans and craftsmen produced furniture, silver, glass, textiles, and other household wares of genuine distinction.

Each author, in composing an art history, makes a conscious decision and places his primary stress on movements, on men, or on individual works of art. In my selection of the content and point of view for this volume, I have wanted to describe the most important stylistic movements primarily as they received expression in typical works by our more creative and influential artists; that is, I have hoped to characterize the shifting social-esthetic milieu through the works of the most significant personalities in the world of American art. Assuming this to be an introduction to the subject, and the reader to be less rather than more familiar with the material, I have tried to minimize ambiguity by discussing only works which are reproduced along with the text. Discussion has therefore been focused on the illustrations, from both an esthetic and a historical position—which is to consider art works as objects of beauty as well as manifestations of the cultural temper of our rapidly developing society. Insofar as possible, individual works have been presented within a biographical context. In this way, the role of the significant personalities as they influenced the various movements can be revealed, and, at the same time, the way in which personal expression has been shaped by the social forces dominating each period is made evident.

I should also mention that I have attempted to achieve a healthy balance between pictorial and textual elements, wanting to avoid either a picture book or a graphically impoverished essay. To provide sufficient space for illustrations of adequate size, I have sacrificed much relevant information. Thus, I have neither explored to its fullest the influence of artists upon one another, nor have I stressed the impact on the arts of the various schools of philosophic and social thought that play such a significant role in art history.

In content, as in methodology, limitations of space have forced many omissions. Certain popular and related arts are of particular interest to me, and it is with genuine regret that I forego including a consideration of caricature, book and magazine illustration, advertising, and more examples of typical houses, furniture, objets d'art, and related materials. The "popular" arts add a warmth and a human scale to the study of the "fine" arts.

Given the physical restrictions of a single-volume art historical survey, it may appear to some that an undue amount of space and number of colored plates have been devoted to the last three decades. My rationale is that so compelling are the arts of modern America that it is virtually impossible for contemporaries not to identify with the artistic production of their own time. By capitalizing on this excitement about the present, I hope to stimulate readers to explore the past more intensively.

Every day new publications appear, concentrating on the various artistic movements and on specialized aspects of American architecture, painting, sculpture, and the various decorative arts and crafts. A multitude of studies of major, and even of minor, architects, painters, sculptors, and craftsmen are published each year so that today there exists a rich body of reference resources for anyone concerned with studies in American art. Many of these are cited in the bibliography provided at the end of the text, and here is where, with assurance and profit, the interested reader may go to explore further the subject introduced by this general survey.

I wish to express my sincere thanks to the many individuals and institutions who have helped give form to this enterprise. First, I would like to cite Lewis Gannett, whose suggestion long ago that there was a need for a well-illustrated history of American art planted the initial seed for the first edition; then, my colleague Dr. Ray Faulkner, who nurtured the seed from an idea into a manuscript. The bibliography is my testimonial of indebtedness to the many students of American art whose patient research has unearthed the basic factual materials which make possible a survey such as this book attempts. I am equally indebted to the many artists, collectors, galleries, museums, historical societies, archives, and photographers that have provided illustrations and granted permission for their reproduction here. I especially want to thank Professors E. Maurice Bloch of the University of California at Los Angeles, David C. Huntington of the University of Michigan, and Jules D. Prown, Director, The Paul Mellon Center for British Art and British Studies, Yale University, for their thoughtful and constructive critiques of the first edition of this book. I am also most appreciative of the thorough, sympathetic, and constructive examination of the manuscript for the present, second edition made by Professors Francis S. Grubar of George Washington University and John Wilmerding, Jr., of Dartmouth College. The suggestions and comments of all these scholars of American art contributed much to the desired qualities of accuracy, substance, and readability. For errors of fact or omission, only I can be held responsible.

Many others, more than is perhaps feasible, should be mentioned and thanked. Among them I do want to single out Joseph Belloli, of the Stanford University Library, for his generous help with research. I wish also to thank my dear wife Mildred for her thoughtful assistance in the preparation of the manuscript and in the tedious job of reading proof. And last, I express my gratitude for the sustained patience and enthusiastic assistance I received from certain members of the staff at Holt, Rinehart and Winston: to Dan Wheeler, whose wise and guiding counsel was always forthcoming, Theresa Brakeley, for her expert and knowledgeable editing, Rita Gilbert, for her management of proof and production, both Mrs. Gilbert and Joan Curtis for their assistance in securing illustrations and permission to reproduce them, and Marlene Rothkin Vine for the handsome design and layout of this new edition of *A History of American Art.*

Stanford, California D.M.M.
April 1970

Contents

part I

The Arts
of the Indians

1

The Arctic, Eastern Woodlands, and Great Plains

Two great migrations populated the world of the Americas. The first commenced fifteen, thirty, or perhaps even forty thousand years ago, during the last Ice Age. At that time a bridge of land connected northeastern Asia and Alaska, which permitted small groups of nomadic hunters to enter northwest America. These hunters were following the animals who moved north and across the grassy land bridge to retain their natural habitat. The descendants of these original settlers formed the local native population when the second of the great migrations started about five hundred years ago. Most of the members of the second migration came from northern Europe, though in later years people came from all parts of the world. In an unbelievably short period the Europeans conquered the older inhabitants of the country and introduced the more elaborate social patterns of their homelands. This predominantly European way of living, modified, of course, by the demands of the new environment and the rapidly developing technology of the nineteenth century, created the brilliant and dynamic civilization which now covers the American continent.

Many histories of American art have omitted the Indians, the descendants of the first migrants. However, esthetic understandings have broadened immeasurably in the past few decades, and today the arts of the Indians have acquired a new significance. We now see universal relationships between the arts of all peoples. A stone pipe in the form of a human figure (Fig. 1), carved long before the first European landed in America, is closer to the contemporary spirit than was most of the sculpture done

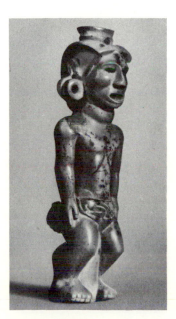

1. Anthropomorphous pipe, from Adena Mound, near Chillicothe, Ohio. c. 9th century B.C. – A.D. 500. Stone, height 8″. Ohio State Museum, Columbus.

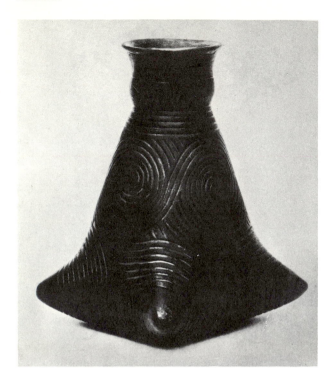

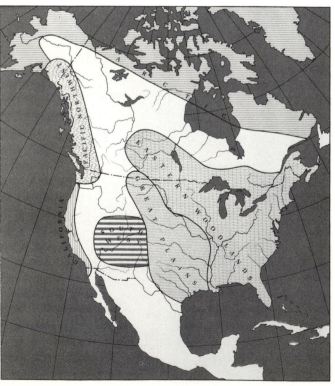

in the early years of the twentieth century. Current taste, too, leads us to prefer a ceramic water bottle from a prehistoric mound in Louisiana (Fig. 2) to the hand-painted vases left by our grandmothers. In addition, the systematic archeological explorations of our day have revealed a much higher level of Indian culture than had formerly been known. We now realize that in almost all areas of artistic activity—architecture, sculpture, painting, weaving, ceramics, and woodcarving, as well as a host of specialized native crafts—the Indians of North America achieved superlative results.

There are two conflicting theories concerning the origins of the American Indians and their culture. Both theories assume that man originated on a continent other than the Americas, because no remains of a true primitive man, such as the Java or the Peking man, have been found here. Both theories agree that man first entered the continent between fifteen and forty thousand years ago. The older theory assumes that the inhabitants of the Americas were of the proto-Mongoloid stock—that is, that the inhabitants of Asia and the American Indians came from common ancestral groups. These ancestors of the Indians are thought to have migrated to America while in an Old Stone Age level of culture and to have subsequently developed their elaborate ceremonial civilizations in isolation from the rest of the world. The other and newer theory is based on the premise of successive migrations of peoples of varying racial elements at different levels of development who brought with them varying patterns of culture. Today the second theory is receiving ever wider acceptance. These successive migrations are seen as part of a general diffusion of culture through the Asiatic-Oceanic-American orbit. Some of the late arrivals probably brought in highly developed ceremonial practices and crafts. It also seems possible that not all the migratory wanderers came via the Northwest; some probably came by boat from the South Pacific. New evidence suggests an interplay between Polynesian and certain American pre-Columbian cultures, since there is reason to believe that in prehistoric times there were movements in both directions across the Pacific.

When the European settlers arrived in North America, they found a thinly scattered population of native tribes of varying levels of development, even the most primitive of which performed admirably in some of the arts. In North America the areas of Indian culture were determined by the natural geographic and climatic divisions of the continent, and it is in relation to these areas that Indian art may be most meaningfully studied. A glance at a map (Fig. 3) reveals the six chief areas. Starting at the north and moving clockwise, we see the following broad divi-

sions: (1) Arctic, (2) Eastern Woodlands, (3) Great Plains, (4) Southwest, (5) California, (6) Pacific Northwest.

Each of these geographic areas had its particular climate, topography, fauna, and flora, as well as its unique native materials; and in each area peoples adapted the local materials to their particular requirements. Clay, wood, stone, bone, sinew, shell, fur, feather, grass, stem, bark, and a variety of other natural materials were fashioned with ingenuity and skill to serve the needs of these primitive men. Much of the pleasure we derive from the arts of the Indians comes from observing the brilliant invention and skill that characterized their manipulation of these native materials.

If we enjoy these objects that have come down to us from the Indians only as works of art, we overlook much of their significance. To be fully appreciated they should be seen as functionally designed, beautifully made objects with auxiliary religio-magical functions. We tend to look at a stone pipe or a mask (Fig. 6) as a piece of sculpture, but the Indian, while deeply conscious of the visual qualities of these objects, was probably most concerned with their utilitarian and ceremonial effectiveness. The Indian's esthetic sensitivity is revealed first by the perfection of craftsmanship for its own sake, second by an intensive refinement of shapes and surfaces, and third by the use of applied decorations. Thin-walled ceramic vessels of elegant shape and decoration (Fig. 2) and baskets with dozens of stitches to the inch are a tribute to that feeling for refinement for its own sake which we call artistry. At the same time, these beautiful objects functioned effectively in their utilitarian capacities. The tightly woven baskets are not only miracles of craftsmanship but can often hold water, and the elegantly chipped spearheads and polished stone clubs were deadly in the hunt or in warfare. The decorative motifs which enhance household and ceremonial objects also had both an esthetic and a utilitarian purpose. Carving an animal head on a hunting club was a magical act to ensure success in the chase. The decoration of a garment with the sun motif procured the sympathy and protection of a powerful deity.

The most elaborate and refined objects were made for ceremonial and burial purposes, since the most exacting skills were devoted to supplicating or placating the gods. Such masks, burial and effigy jars, figurines, and ceremonial pipes please us visually much as they did the original maker and user, but our appreciation is limited to the visual aspects. While we may be aware that the decorations were used for their protective powers, the magic eludes us emotionally. Though we recognize this function intellectually, we cannot feel it.

It is important to remember, then, that these objects of long ago were not created just to be looked at, and certainly not to be placed in a museum or hung on a wall. They were made in response to the requirements of daily life, much like contemporary automobiles or sacred vestments, and are as complex and subtle as the civilizations which created them. They served utilitarian functions, pleased the eye and mind, and propitiated the gods. We see them out of context and so tend to appreciate only one facet of a multifaceted creation.

The subsequent discussion is organized in relation to the chief geographic areas of the North American continent, concentrating on the most noteworthy achievements in each area. Starting in the north and moving east, south, and west, we parallel, to a degree, the movements of the early migratory tribes as they filtered down and across the continent, though not necessarily the chronology of the various migrations. The Eskimos and the tribes of the Pacific Northwest probably were among the last peoples of the first great migration to arrive in North America, the Eskimos moving east across the great Arctic wastes, the Indians of the Pacific Northwest moving south into the rich coastal areas.

THE ARCTIC

The treeless tundra that stretches for thousands of miles, from the northwestern tip of Alaska across the northern fringe of the continent to Greenland, is the home of the Eskimo. One of the most noteworthy traits of the Eskimos is their amazing ingenuity in adapting themselves to their environment—or, rather, in adapting their seemingly uninhabitable environment to their needs. The snow house, or igloo, represents only one way in which these self-reliant and inventive people have shaped a way of living from their inclement and snowy wastes. The snow house, which has caught the imagination of the world because it represents the triumph of practical imagination over the hostile forces of nature, is not the typical Eskimo dwelling, for less than a fourth of the people of the Arctic live in igloos. For the most part they live in houses of earth, raftered with slabs of stone or wood or with the bones of large animals. These dwellings usually consist of one large room, often semisubterranean, which is entered by a covered passageway. This arrangement provides both protection and warmth.

The Eskimos have proved themselves equally imaginative and skilled in devising their clothing, boots, household gear, and hunting and fishing equipment. From the feathers, fur, bones, shells, mosses, sticks, and stones which constitute the raw materials of their economy, they fashion the efficient and occasionally even beautiful objects that have enabled them to survive in what appears to the outsider to be an inhospitable world.

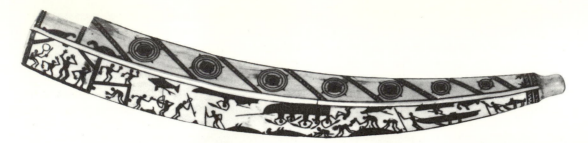

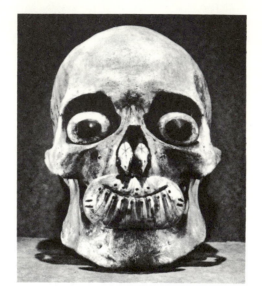

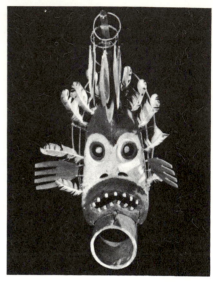

above : 4. Eskimo pipe stem. c. 1st century. Etched ivory, length 11″. Smithsonian Institution, Washington, D. C.

right : 5. Decorated skull, from Ipiutak site, Point Hope, Alaska. c. 2d–8th century. Bone with jet and ivory, 7 × 5 ½″. American Museum of Natural History, New York.

far right : 6. Eskimo mask from Alaska, representing Negakfok, the cold-weather spirit. Early 20th century. Painted wood with feathers, height 36 ½″. Museum of the American Indian, New York.

The oldest strata of Eskimo remains, from about the beginning of the Christian era, disclose beautifully carved objects of walrus ivory that reveal a fully developed artistic tradition. The surfaces of these objects are frequently engraved with vivid descriptive pictographs of hunting and fishing scenes or with abstract geometric patterns (Fig. 4). One of the most striking and memorable objects to be unearthed from a tomb in an ancient Ipiutak town is a decorated human skull (Fig. 5). The ivory eyes are inlaid with jet, the nostril cavities are filled with two delicately carved birds, and the mouth is covered with a curiously shaped and engraved ivory plaque. By sealing the orifices of the skull with precious materials and magic symbols, primitive man hoped to build a safeguard against the mystery of death and disintegration. Graves from this area also reveal beautiful linked chains, combs, long-handled back scratchers, and realistic seals. These objects were usually carved from bone or fine-grained, richly colored walrus ivory. Carved and inlaid wooden objects, pottery lamps, and clay cooking vessels have also been discovered at these ancient sites.

The masks which the Eskimos of northern Alaska fashioned from driftwood, bits of bone, feathers, and other curious odds and ends of materials are among the most charming and whimsical of Indian creations. A wooden dance mask representing Negakfok, the cold-weather spirit, who likes cold and storms, provides a vivid example of these imaginative creations (Fig. 6). Such masks were usually carved from light, thin oval or circular pieces of wood. The features were indicated by carving or by coloring, white, black, red, and blue being preferred. Appendages that dangle and sway like parts of a modern mobile may indicate the animal, bird, or fish attributes of the mythical, anthropomorphic creatures represented by the mask. The variety of materials and the rearranging of human, animal, and symbolic forms in unusual relationships occur in unexpected ways to form surprising and enigmatic combinations which often have a light, playful touch that is infrequent in the arts of primitive peoples. The ancient Eskimo skull and mask reveal certain qualities common to much Indian art: a delightful ability to manipulate environmental materials in an imaginative way, a high level of craftsmanship, a sense of humor, and the power to communicate the awe felt by primitive man when confronted with the mystery of life and death.

EASTERN WOODLANDS

Moving south and east, one comes to the most extensive area of Indian culture in North America. The Eastern Woodlands commence in the forests of northern Canada, sweep east and south, and cover the heavily wooded eastern half of the United States. The Indian tribes in the northern and northeastern parts of this vast region were the least developed. In the Ohio and Mississippi River valleys and along the Gulf of Mexico, higher levels of civilization existed, those of the Mound Builders, which included some of the most elaborate ancient cultures of North America. The most spectacular achievement of the Mound Builders was the construction of vast ceremonial and burial mounds of earth, frequently shaped in the forms of birds and animals (Fig. 7). They were also fine sculptors and potters and worked copper, mica, and many other materials.

A detailed study of the Eastern Woodlands reveals over eighty related cultural units, which flourished at different times in various sections of the area. The universal presence of chipped flint arrowheads indicates an archaic period of great antiquity, stretching back as far as 8000 B.C. At a later date more differentiated local cultures developed. Copper tools appeared in the Great Lakes area (artifacts of a culture called "Old Copper"), and extraordinarily fine tools of ground slate were produced in New England. An Asian type of pottery marked with textures made by a mallet wrapped with cord appeared in widely separated areas. There is still much difference of opinion as to the dates when these early cultures developed. Some authorities estimate that the Old Copper culture appeared as early as 4000 B.C., though it is usually placed between 1000 B.C. and A.D. 100.

Next came the early Mound Builders of the Ohio Valley. Again estimates as to the dates of the early Ohio mound-building cultures vary; some contemporary judgments based on the carbon 14 tests put them back almost to 1000 B.C. More conservative archeologists date the Adena and Hopewell cultures of Ohio, two of the most important early mound-building cultures, between 350 B.C. and A.D. 500. Later the Mound Builders moved south into the lower Mississippi Valley and along the coast of the Gulf of Mexico. The remains from this area have been dated between A.D. 900 and 1700, and this later phase of the Eastern Woodlands culture is frequently referred to as the "Temple Mound" period, since the mounds appear to have been substructures for ceremonial buildings. Beads and metal objects of European manufacture in some mounds indicate that the mound-building cultures were still flourishing when the first European settlers arrived.

Ceremonial Mounds

The elaborate ceremonial mounds, of varying heights and shapes, are found throughout the Eastern Woodlands from Canada south into Florida. The custom of building mounds may be of Mexican origin, for the construction of large earth platforms as bases for ceremonial structures was general practice in Mexico and Central America. Mound building was spread through many different tribes at many levels of culture, and the mounds appear to have been built for several different purposes. Three types were constructed—conical burial mounds, effigy mounds in the shapes of birds and animals, and pyramidal mounds which served as substructures for ceremonial buildings or the dwellings of chiefs. In general, the conical burial mounds and the effigy mounds are from earlier periods; the pyramidal mounds are later.

The effigy mounds were probably associated with burial practices and are shaped to resemble mammals,

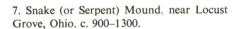

7. Snake (or Serpent) Mound, near Locust Grove, Ohio. c. 900–1300.

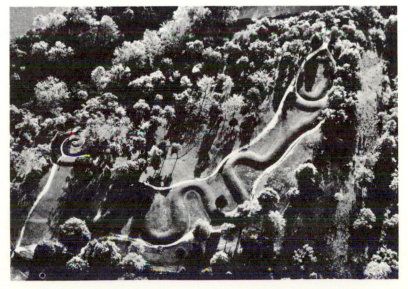

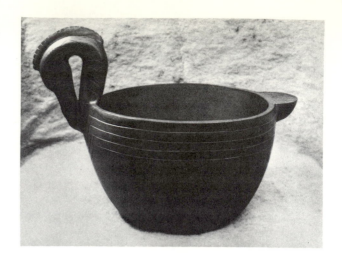

reptiles, birds, and other tribal totems. They frequently attain an impressive size. The Snake (or Serpent) Mound in Ohio (Fig. 7) is one of the most imposing, as is revealed by aerial photography. The carefully planned and laboriously built head, twisting body, and spiraled tail, which, following the curve, measure almost 1,400 feet, or a fifth of a mile in length, testify to the importance of the effigy in a remote and long-forgotten ceremonial activity.

Monk's Mound, the largest known of the pyramidal mounds, is the central unit of the Cahokia group near East St. Louis, Ill. This group consists of over forty-five large mounds and many smaller ones. Monk's Mound is over 1,000 feet long, over 700 feet wide, and almost 100 feet high and covers an area of about 16 acres. This makes it larger than the Great Pyramid of Cheops in Egypt, which covers about 13 acres. One of the largest earthworks in the world, Monk's Mound is composed of four terraces of diminishing height and size, placed one on top of the other, reminiscent of the platforms that formed the bases for the temples of the Mexican area. The sloping sides, now eroded by centuries of weathering, probably formed a ramp or stairway, which provided access to the top. Monk's Mound, like many of the later large, flat-topped mounds, appears to have served as a platform for a ceremonial structure or a residence of a priest or chief. Unlike some other temple sites, the Cahokia mounds have not revealed artifacts of special interest.

Stone

The working of stone was one of the most ancient arts of the Indian, and stone remained the material in which he created his most monumental work. The hunter who first crossed Bering Strait in search of reindeer and mastodon already knew how to shape the spearheads and stone axes that he used in warfare and the hunt. During thousands of subsequent years the art of making spear points and arrowheads of pressure-flaked flint was perfected, along with the art of shaping the ground-stone implements of the Neolithic Age—the beautifully shaped celts, axes, gouges, knives, weights, ceremonial pipes, bowls, mortars, and pestles necessary for a semisedentary life. Chipped and polished stone implements and ceremonial objects of a high level of technical excellence have been found distributed throughout North America.

A diorite bowl 12 inches high, from the late Temple Mound period in Alabama (Fig. 8), provides a superb example of the skill and taste with which the Indian

craftsman worked stone. Diorite is an igneous rock of unusual density and hardness. Cutting this smooth bowl, with its even thickness of wall, from a solid piece of diorite and allowing for the graceful projection of the bird's head, neck, and tail represents an amazing technical achievement; the Indian craftsman had no metal-cutting tools but had to shape the stone, smooth it, and polish it with either stone or bone tools and abrasives. The stone was first chiseled into the general required shape and next shaped by picking away smaller particles. The surface was then polished by abrasion with fine, hard, gritty materials, and the lines and details were incised by drilling with both solid and tubular drills rotated between the hands or with bowstrings. The engraved lines of this bowl have been skillfully placed to reinforce the circular shape and to create formalized patterns suggesting the feathers and anatomical forms of a duck.

The richest deposits of stone ceremonial objects have been taken from the burial mounds of Ohio—from the famous Adena Mound and from the important Hopewell mounds, near Lebanon, Ohio, which were named after the owner of the lands on which they were discovered. The tribes of the Hopewell culture constructed great effigy mounds in the shapes of birds and animals and buried their dead under elaborate funerary mounds. Both Adena and Hopewell appear to have been important centers of cultural diffusion, and their influence can be seen throughout the central Mississippi and Ohio valleys.

A unique stone pipe from the Adena Mound, near Chillicothe, is in the form of a standing human figure (Fig. 1) about 8 inches high. It has the large head, heavy limbs, and simplified anatomical forms with which the Indians achieved the sober monumentality so characteristic of their sculpture. A grave and somewhat ferocious grandeur emanates from the small figure. It exhibits such

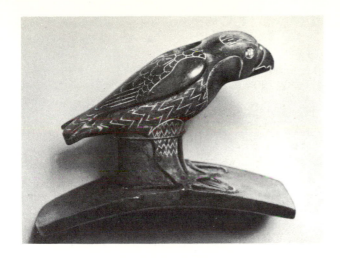

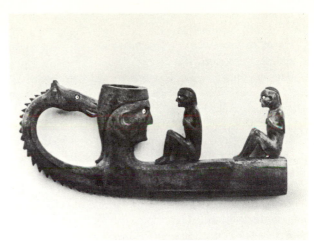

above : 9. Pipe representing hawk, from Tremper Mound, Ohio. c. 200 B.C.–A.D. 500. Ohio pipestone, 3 ⁷/₈ × 2 ⁹/₁₆″. Ohio State Museum, Columbus.

above right : 10. Pipe, from Miamisburg, Ohio. c. 200 B.C.–A.D. 500. Stone with shell insets, length 6 ¾″. Museum of the American Indian, New York.

below right : 11. Effigy pipe, from Pittsburg Landing, Tenn. 1200–1600. Red bauxite, height 10″. Smithsonian Institution, Washington, D.C. (on display at Shiloh National Military Park, Shiloh, Tenn.).

decidedly Mexican qualities as the ovoid mouth and eyes, the formalized muscles, and the flat, ribbonlike design of the loincloth, thus reinforcing the generally accepted premise that influences from the more advanced cultures of Mexico continuously moved north. An admirable skill and certainty are communicated both by the techniques with which the stone is finished and by the vigor with which the sculptural form has been conceived. Such an assured projection of the planes of the head and body accompanies only a highly developed sculptural sense.

The stone pipes from the Hopewell mounds, usually representing birds or animals, were carved with flint tools from grayish Ohio pipestone, which is capable of taking a high polish. The bowl of the pipe is in the head or back of the creature represented, and the mouthpiece is in the base of the pipe, which was held in the hands of the smoker. The hawk pipe (Fig. 9), from the famous Tremper Mound, is a fine example of the Hopewell style. While it is realistic in its essential concept, both the basic form and the incised feather patterns are formalized and simplified in a manner reminiscent of the monumental sculptured birds of ancient Egypt. The feet are particularly expressive of the ability to simplify a thoroughly understood anatomical form. A pipe from Miamisburg, Ohio, is unusual in the

strange variety of its forms (Fig. 10). A fantastic effect is created by the large human head, the bizarre long-necked animal, the worshiping seated figures, and the little, white shell eyes. This pipe surely represents a ceremonial rite.

Many handsome stone pipes featuring the human figure, often in a kneeling position, have been found in the temple mounds of later date from the lower Mississippi Valley. A characteristic pipe with a kneeling man (Fig. 11) treats the human figure with an easy naturalism and, like many of the pipes from the Temple Mound period, projects a sense of life and action.

Ceramics

The early European settlers found that almost all the Indians except those of California and the Pacific Northwest made pottery. None of it, however, was as beautiful as the ceramics from the prehistoric sites.

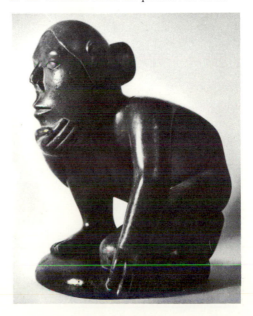

Pottery making is one of the first crafts to be developed as a people becomes sedentary in its living habits. The seasonal ripening of crops creates the necessity for storage containers, as does the more elaborate preparation of foods that characterizes a settled way of life. Where and how the ceramic arts first developed in America remains conjectural. The wide distribution of pottery marked with a cord pattern from sites dated as early as 1000 B.C. suggests that the ceramic arts may have been introduced from Asia, since similar cord-marked pottery was produced there at an early date.

The American Indian fashioned his pottery without the aid of the potter's wheel. The clay was built up by the coil method or pushed into shape from a lump. A number of early sites in the Eastern Woodlands area reveal pottery that appears to be patterned after simple stone vessels, as well as more sophisticated potteries marked by a wide variety of textures. These textural enrichments were achieved by punching, pinching, incising, and stamping, as well as by using the very ancient cord-marking techniques. A jar (Fig. 12) from Miller County, Ark., illustrates a rich surface of textures. The first impression of the jar is one of vigor and crudity, but more careful study reveals a sensitive feeling for relationships of shape and surface textures. The clay is used in a way that emphasizes massiveness and weight. The shapes are heavy, slightly angular, and almost awkward. The incised patterns appear to have been put on spontaneously, yet they not only emphasize the shapes, but also reinforce the effect of a fresh, unpremeditated creation. The horizontal engraved lines on the neck contrast effectively with the concentric swirls of texture on the body. Each swirl is

centered by a raised rough area to create an accent. Similar handsomely textured pottery, in which designs were pressed into the clay with wooden stamps, has been found in Georgia. Carbon 14 tests indicate that these richly textured ceramics were produced prior to A.D. 500.

The most beautiful wares of the Eastern Woodlands area come from the lower Mississippi Valley mounds of the late Temple Mound period, between A.D. 900 and 1700. The elegant ceramics from this period include the beautiful, polished brown wares (Fig. 2) from Ouachita Parish, La., which represent a very refined development of the early cord-marked patterns. The 5 ¾-inch-high water bottle pictured here is thin-walled and hard-fired. The handsome and subtle form is reinforced by a delicate pattern of logically placed rhythmic lines that emphasize the unique bottle shape in a most sensitive way. The surface texture has a handsome satiny sheen, and the color is pleasantly muted. A number of pieces of this polished brown ware have been discovered. They vary considerably in shape, but they all reveal the technical skill and refined taste that place this small bottle in the front rank of American ceramic achievements.

A beautiful frog jar modeled from green clay (Fig. 13) is typical of the ceramic effigy jars in reptile, bird, and animal forms from the mounds of the lower Mississippi Valley. Curiously, these effigy jars resemble ceramics from ancient Peru more than products of any neighboring peoples. The jars were made for use in burial ceremonials and may have established clan relationships. Despite the fact that they are modeled as thin-walled vessels capable of holding liquids, they are essentially religious sculptures. The frog jar reveals its maker's feeling for the plasticity

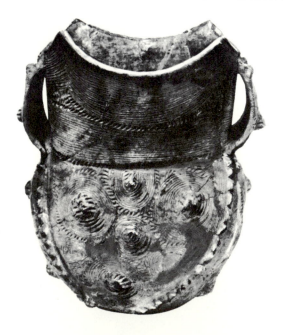

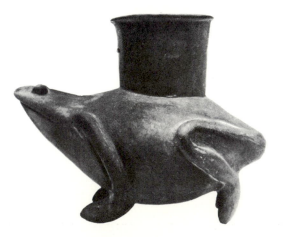

left : 12. Jar, from Miller County, Ark. Before A.D. 500. Clay, height 10 ¼″. Museum of the American Indian, New York.

above : 13. Jar representing frog, from Blytheville, Ark. 900–1700. Clay, height 7 ½″. Museum of the American Indian, New York.

of hand-shaped clay through the rhythmic unity of its generalized shapes and the monumental character of its forms.

Images of the dead constituted a sufficiently large part of the findings from the mounds of the lower Mississippi Valley to suggest that a death cult with elaborate burial ceremonies played an important part in the religious ritual in that area. Two effigy jars illustrate the vivid character of these ceramics. The front view of a seated, hunchbacked woman (Fig. 14) reveals the simple forms and heavy proportions that characterize Indian treatment of the human figure. The head is large; the body forms are massive, generalized, and rhythmically unified. Anatomical detail and exactness of proportion are subordinated to a sense of weight, monumentality, and sculptural unity. The expressive power of such primitive art frequently appears to result from the presence of highly formalized elements, together with naive and even crude expressions of deeply felt experience. Here one feels the direct communication of intense emotions and perceptions. The emaciated body is tellingly defined by the incised lines of the ribs; and the resigned, closed eyes, the thin arms, and the cross-legged, seated position all foretell death. A profile view reveals the hunched back, reminiscent of the Peruvian portrait vases, which frequently represented deformed and sick people.

A pottery jar representing a human head, from Mississippi County, Ark. (Fig. 15), is sufficiently individualized to suggest a portrait effigy. The forms are modeled with a fine feeling for the planes of the face and the underlying bone structure. The incised pattern of the scarification adds a vivid note.

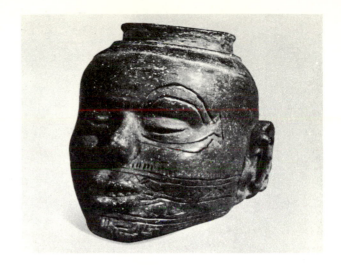

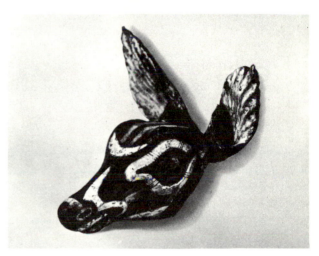

left : 14. Effigy jar, from Crittenden County, Ark. 900–1700. Clay, height 8½″. Museum of the American Indian, New York.

top : 15. Jar representing human head, from Mississippi County, Ark. 900–1700. Clay, height 6″. Museum of the American Indian, New York.

above : 16. Deer-head maskette with movable ears, from Key Marco, Fla. 15th century. Painted wood, length 10¾″. University Museum, Philadelphia.

Wood

Wood is one of primitive man's basic materials. Unfortunately, wood decays readily, and consequently the mounds and similar sources of prehistoric art have revealed few ancient wooden objects. A very fine deer head, which displays sensitive naturalism of a high order, comes from the swamps of Key Marco in southeastern Florida (Fig. 16). In this same area were found other fine natural-

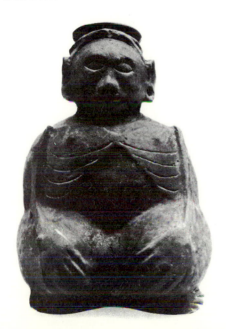

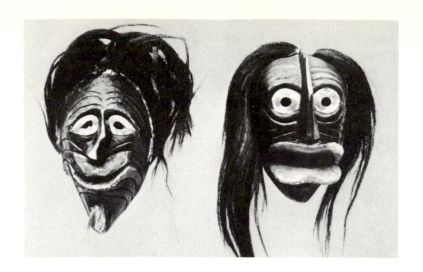

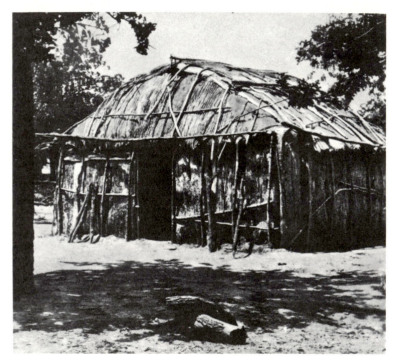

above : 17. Seneca masks, from Allegheny Reservation, New York. Late 19th–early 20th century. Painted wood with horsehair, height 10″. Museum of the American Indian, New York.

right : 18. Winnebago bark lodge, Wisconsin.

istic animal sculptures—pumas, wolves, alligators, and birds—as well as masks, statuettes, and utilitarian objects.

Perhaps the most entertaining wood carvings created by the Indians are the masks which represent various mythical beings. Some very effective ones were made by the Iroquois, Seneca, and related tribes from New York and New England. These vigorous masks (Fig. 17), mostly from the late nineteenth century, are like sculptured caricatures with bold features, deeply grooved wrinkles, and strongly contrasting eye and mouth patterns. They are usually painted, red and black being the most frequently used colors. Long masses of horsehair were attached to

the head. These masks are frequently boldly asymmetrical, with one eye or one side of the mouth going up and the other turned down or the nose twisted to one side. The result is both grotesque and humorous.

Wood was naturally the basic material from which the inhabitants of the Eastern Woodlands fashioned their ingenious and efficient shelters. A bark lodge of the Winnebago tribe of Wisconsin (Fig. 18) illustrates one of the simpler types of dwellings they constructed. The Indian living unit usually had one room for a family, although the family concept was more complex than our present one. Most sedentary groups created multiple-unit

dwellings, which were frequently of impressive dimensions. These were really clusters of single-family dwellings under one roof. The long house of the Iroquois, one example of such a structure, was an elaborated development of the bark lodge. Located in a protected area of the forest, the rectangular long house was often 80 or even 100 feet long. It had a simple pitched roof and was built over a structure of wooden poles, which provided a frame for the covering of bark. A passageway ran down the center of the interior. The side areas were divided by partitions into room-sized stalls, which were open to the center passageway. These were used for sleeping, eating, and storage. Fire pits were centrally located at regular intervals, and an opening in the roof above each fire pit allowed the smoke to escape. Raised benches along the walls provided space for sleeping and storing tools and utensils. The two ends of the long house were closed by bark doors or hangings of animal skins.

The early settlers of New England patterned many of their first dwellings after the bark lodges and long houses of the Indians, for such structures were easy to devise from the materials at hand and offered some degree of privacy and protection from the elements. It is significant that wood has remained America's first choice as a building material for dwellings.

Metal and Precious Materials

There is ample evidence that the art of working metals was introduced to North America from Asia at a very early date, possibly almost a thousand years before metallurgy was known in Central and South America. Archeological sites from the Great Lakes area, conservatively estimated to be as old as 1000 B.C., disclose tools of hammered copper sufficiently unique to have bestowed the name of "Old Copper" on the culture. Lances and knives were made with notched stems, and crescent-shaped knives, harpoon heads, and chisels appear to be replicas of similar metal objects from early cultures in Asia. The peoples of the Hopewell culture hammered nuggets of copper into thin sheets and cut them into bird, animal, human, and abstract shapes which were sewed on clothing and used as jewelry or as part of an elaborate headdress.

One such copper headdress ornament (Fig. 19), from the Citico Mound in Nashville, Tenn., is almost 12 inches high. It is handsomely designed with a pleasant variety of shapes. A subtle use of indented grooves and slightly rounded edges separates and emphasizes the various parts of the design and creates an illusion of volume and richness despite the flat surface.

The peoples of the Hopewell culture carried on extensive trading activities with distant tribes, obtaining rare raw materials such as grizzly bear teeth, pearls, sea shells, and mica from the remote coastal areas and the Gulf states. The elegant silhouettes of mica found in the Hopewell burial grounds have been shaped to emphasize the intrinsic beauty of the material. These artfully fabricated objects appear in a variety of strange motifs: headless human bodies, dismembered arms and legs, heads, hands (Fig. 20), eagle claws, duck bills, spear throwers and replicas of spearheads. The fragile and flaky mica was cut with elegant precision into flawless forms

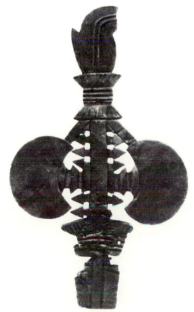

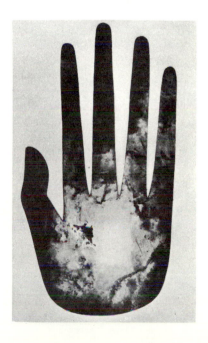

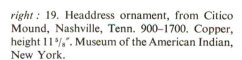

right : 19. Headdress ornament, from Citico Mound, Nashville, Tenn. 900–1700. Copper, height 11 5/8". Museum of the American Indian, New York.

far right : 20. Hand silhouette. 300 B.C.–A.D. 500. Mica, height 10". Field Museum of Natural History, Chicago.

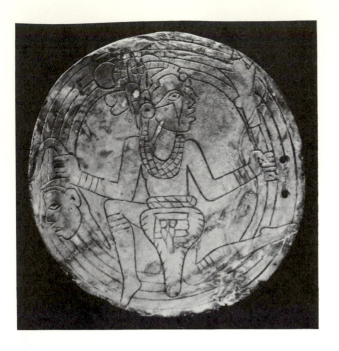

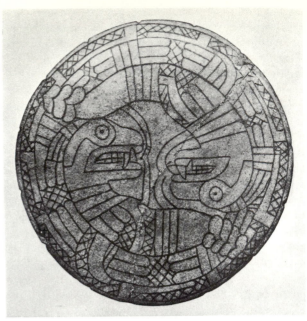

left : 21. Engraved gorget, from Sumner County, Tenn. 900–1700. Shell, diameter 3 ⁷/₈″. Museum of the American Indian, New York.

right : 22. Disk (paint palette?), from Mississippi. 900–1700. Brown sandstone, diameter 8 ½″, thickness 1″. Ohio State Museum, Columbus.

Pictorial Arts

The Mound Builders of the Eastern Woodlands left examples of pictorial art painted and engraved on the elaborate objects interred in the burial mounds. Particularly interesting are the engraved shell gorgets from the lower Mississippi Valley. These flattish disks were cut from the sides of conch shells, polished into smooth, flat shapes, and then engraved with human, bird, snake, and other motifs. One such shell gorget from Tennessee depicts a handsomely costumed warrior or priest with a knife in one hand and a victim's head in the other. Two small holes on one side of the gorget suggest that it was attached to part of some ceremonial costume (Fig. 21).

Similar but larger is an unusual flat, brown sandstone disk (Fig. 22) from Mississippi, about 8 ½ inches in diameter and 1 inch thick. This disk employs a Mexican motif—entwined rattlesnakes with feathered headdresses. The beautiful placement of the group of snakes in the circle, the clarity of the strongly organized border, and the contrasts of eyes, rattles, and fangs all attest to the intelligence of the designer and the maturity of the artistic tradition in which he worked.

Such visual realism as flourished in the ancient cave paintings of Spain and France seldom characterizes the arts of the Indians, whose pictorial conventions conform closely to the schematic pattern of most neolithic art. Representation was usually through symbols based on an idea about a form rather than on an analysis of its visual aspects. A few typical characteristics, such as the upright posture and two-leggedness of human beings, schematically rendered, satisfied the needs of the artist. Such formalism characterized much of the art of the American Indian, whose pictorial expression can best be understood if it is considered as a system of graphic symbols designed to convey ideas. As the illustrations show, these ideographic symbols could be used with great distinction of decorative effect and even with expressive power.

Leathercraft, Bead and Quill Work, and Bark Baskets

Though there is ample evidence that textiles were produced in the Eastern Woodlands in prehistoric times, no true textiles were being woven in this area when the European settlers arrived. Instead, the arts of dressing and shaping leather were well developed. Deer hide and other large animal skins were made into light, soft garments and into pouches, baby carriers, parfleches, bags, and other useful

objects. The skins of rabbits, squirrels, and other small animals were cut into narrow strips and woven into garments and blankets. Almost all leather goods were decorated with painted designs, feathers, shells, beads, and quills.

From very early times the Indians of the northern woodlands and plains decorated their skin garments and bags with a unique type of embroidery done with flattened porcupine quills. The quills were cut into short lengths, dyed, and sewed in place in bold geometric patterns. Porcupine quill embroidery has a shiny, smooth surface that contrasts very effectively with the soft mat surface of leather. Development of the skill necessary to achieve the even, fine surface texture of a Potawatomi shoulder bag (Fig. 23) demands infinite patience. These elaborate and involved designs, though executed without patterns, have been distributed over the bag with no signs of crowding or distortion. The craftsmen appear to have improvised on traditional motifs, for no two designs are identical, yet despite the spontaneous nature of the

procedure, no miscalculations mar the relationship between the designs and the surfaces to be decorated.

In the early nineteenth century glass beads were introduced by the Europeans and thereafter were used alone or in conjunction with porcupine quills. Beaded decorations were executed in the traditional geometric patterns or in floral, leaf, and curvilinear motifs derived from European textiles.

Baskets were woven by all the Indian tribes, but the baskets from the Eastern Woodlands do not compare with those from the Southwest and California (see Chap. 2). Closely allied to basketry and perhaps representing a craft halfway between woodcraft and basket-making, are the birch-bark boxes and baskets made by the Algonquians and other tribes from the northeast (Fig. 24). The bark was carefully cut to the proper shape and sewed with fine root fibers. The patterns were made by scraping away the top layers of white, revealing the dark brown bark underneath. Conventionalized animal designs were frequently used, but the somewhat curvilinear floral designs used here are typical of the historical period, when the influence of European textiles became evident in the crafts of this area.

THE GREAT PLAINS

The third area in North America with a unique and specialized culture is the high prairie country bounded on the east by the Mississippi and Missouri rivers and on the

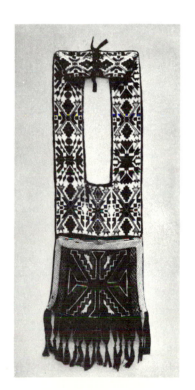

left : 23. Potawatomi shoulder bag. 19th century. Porcupine-quill embroidery, 33 × 7 ½". Museum of the American Indian, New York.

below : 24. Algonquian baskets, from Quebec. Late 19th–early 20th century. Birch bark, height of left 9". Museum of the American Indian, New York.

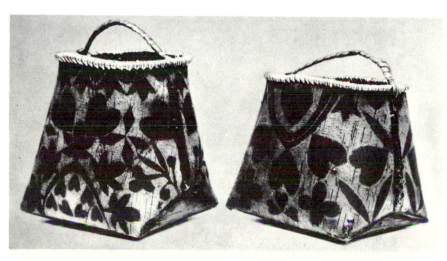

west by the Rocky Mountains, extending from the Dakotas and Montana south to Texas. This was the home of the tribes who contested the nineteenth-century settlement of the plains. A large body of literature describing the westward movement and the spirited defense of their homelands by the Indians has familiarized us with the life of these tribes, and we have come to think that the costumes, weapons, and living habits from this period are typical of Indian culture. Actually, the Plains Indian pattern of living with which we are familiar represents a violent distortion of an older and more civilized way of life, a distortion caused by contact with the Europeans. The introduction of the horse and the gun in the mid-seventeenth century and the later encroachments of white settlers on their territory motivated the Plains Indians to give up their semisedentary life, follow the buffalo, and engage in warlike pillaging of other tribes and of white settlers. They developed a nomadic existence and abandoned their settled communities to live in portable tepees. As these Indians left their communities, they also gave up the arts which characterize a sedentary pattern of living and developed a striking costume well adapted to horseback riding and fighting. The nomadic way of life, so readily associated in the public mind with the Indians

of this area, achieved its distinctive character during the early nineteenth century.

Before migratory habits disrupted the more sedentary life of the earlier period, a common type of dwelling in the Great Plains was the earth lodge. The appearance of a Mandan village of earth lodges has been recorded by the great painter of Indian life, George Catlin (Fig. 301). The simplest type of earth lodge was a partially excavated pit, the sides of which were reinforced by a palisade of logs and the top covered by a layer of sod on a framework of branches and twigs. Communities of these earth lodges were placed in a naturally protected cave, or artificial fortifications or ditches were constructed to protect the village. This simple earth lodge was elaborated by some tribes into circular structures of considerable dimensions. The walls were then constructed of heavy wooden posts. Sometimes the posts, rafters, and beams were fitted together by skillful joinery; in other cases the posts were held in place with woven cords. These earth lodges were entered by a covered entrance way and were often semi-subterranean because of the excavation of the floor. The largest structures of this type would accommodate as many as a hundred persons and frequently measured 50 feet in diameter. Many variations of this basic structure still exist; the hogan used by the Navaho Indians of today is a simple one-family version of it. Some Plains tribes, such as the Wichita, built very neat domed huts covered with straw thatch. Certain tribes in the south lived in circular or rectangular semisubterranean huts covered with grass. Others, in Utah, lived almost without protection from the elements or from marauders in poorly constructed brush shelters.

The tepee, or wigwam (Fig. 25), so often pictured as the typical Indian dwelling, was originally used by most tribes only as a temporary shelter during the seasonal hunting and food-gathering expeditions. More permanent abodes were constructed for use during most of the year. When the Indians of the Great Plains gave up their settled communities to follow the buffalo and deer, the tepee became the standard dwelling, since it was easily transported. The tepee was a cone, usually of skins, supported on a frame of from three to sixteen or more poles. Some tepees reached a height of more than 30 feet and required as many as twenty buffalo skins to cover them, whereas others were barely as tall as a man. The tepee is the prototype of the contemporary tent—a portable shelter, hard to surpass for sheer efficiency, in which a wooden skeleton supports a skin covering almost as in an organic form.

Tepees were decorated with a variety of designs, ranging from conventionalized geometric symbols to naturalistic depictions of birds and animals. They contributed a colorful and picturesque element to the Plains

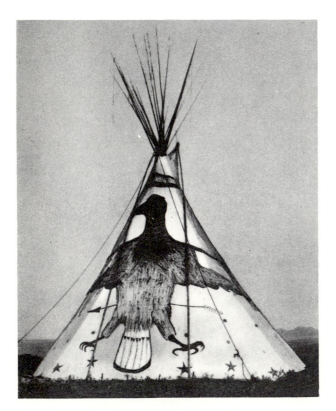

25. Decorated Crow tepee of the Great Plains.

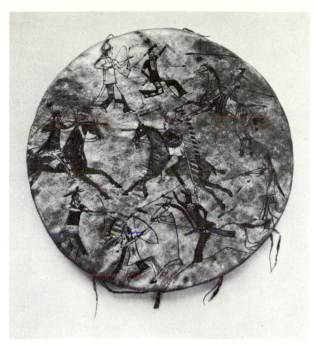

26. Sioux dance shield, from South Dakota. Mid-19th century. Painted hide, diameter 22 1/4". Museum of the American Indian, New York.

and their fringed and flowing costumes all increased the effect of ferocity as they galloped across the prairies.

Contact with the Europeans stimulated an interesting development of painting in the late eighteenth century among the Plains Indians. All through the area painting appeared on wearing apparel, tepees, and shields. Two styles developed. One, practiced by the women, utilized abstract and decorative motifs of a traditional type. The men, on the other hand, apparently stimulated by the European tradition of representational art, employed a realistic style and usually pictured some military exploit or hunting scene. The Sioux dance shield (Fig. 26) illustrates this realistic style in a battle scene distinguished by elegance of line and liveliness of pattern. The figures and horses are drawn with surprising accuracy, for realistic representation was foreign to the Indian, and these artists were completely untrained in the European style of drawing. This composition is full of movement, expressed by the skillful organization of the scattered figures around the central figure of the chief. Despite the absence of formal perspective and foreshortening, the forms are realized with force, and the general vitality of the delineation contributes to the total sense of exciting action. Such painted skins, recounting the stories of exploits and victories, provided a permanent record of prowess for all members of the tribe to see and remember.

landscape during the strenuous years of settlement and left a more vivid impression on the national memory than any other type of Indian dwelling.

Much of the artistry of the Plains Indians went into the making and decorating of their colorful costumes, as well as of their dwellings. Feathers, embroidery, beads, bits of glittering metal, shell, and other decorative elements were used on their clothes, on the bridles and harnesses of their horses, and on their hunting and battle equipment. As the horse became more and more a part of daily life, the Indians dressed to increase the effectiveness of their movements on horseback. The great feather headdresses, the bundles of quivering feathers attached to their bridles,

The arts of the Eastern Woodlands and the Great Plains tribes had achieved their most impressive developments long before the Europeans reached America. When the first settlers arrived, there was little to indicate the high level of accomplishment which subsequent archeological research has revealed. As the settlers moved across the continent, they discovered a vigorous artistic culture in the Southwest, but archeological evidence shows that this, too, was the feeble afterglow of a brilliant earlier period. It was not until the end of the eighteenth century that contact with the Pacific Northwest brought to light a flourishing culture in which the arts were at their zenith.

2

The Southwest, California, and Pacific Northwest

THE SOUTHWEST

The oldest traces of man in America are in the Southwest, centering in the canyon-eroded, high plateau near the convergence of Arizona, New Mexico, Utah, and Colorado. Stone spear points discovered in caves with the bones of extinct animals indicate that man lived and hunted here ten or even fifteen thousand years ago. The ancient way of life in this area changed very slowly. About the beginning of the Christian era there appeared polished stone implements which, along with woven baskets and, later, rude pottery, indicate a more sedentary way of life. The baskets woven by A.D. 500 were so notable that the culture has been termed "Basket Maker." In addition to this activity, the Basket Makers built settled communities, made decorated pottery, raised turkeys, beans, and corn, and wore ornaments of turquoise. Following the Basket Makers, about A.D. 700, the direct ancestors of the Pueblo Indians appeared, apparently from Mexico, for they introduced a number of Mexican traits into the prevailing way of life, although certain aspects of their culture suggest that it was derived from that of the southeastern Woodlands area.

Architecture

The most impressive development of domestic architecture achieved by the Indians in the United States is found in the cliff dwellings and pueblos of the Southwest. At the beginning of the Christian era, the inhabitants of the high plateau and desert areas, the previously mentioned Basket Makers, lived in caves modified by simple additions to make them more secure. About A.D. 700 a new culture group, physically distinguished by round heads rather than the long, narrow heads of the original inhabitants, introduced the more systematic construction of shelters. This cliff-dwelling, pueblo-building culture, called Anasazi, reached its height between the eleventh and fourteenth centuries of our era. Its most impressive architectural achievements take two forms: the great multiple dwellings built in the immense shallow caves which pit the canyon walls of this area and the pueblos in the plains beside the rivers.

Mesa Verde, in the southwestern corner of Colorado, contains the most extensive cliff dwellings. One side of Mesa Verde ("green mesa"), standing 1,000 feet above the great highland plateau, rises to a height of over 8,500 feet.

The other side of the mesa slopes away in narrow gorges, in which there are innumerable shallow caves, many bearing evidence of prehistoric habitation. There are a considerable number of communities in Mesa Verde, the Cliff Palace (Fig. 27) and Spruce Tree House being the most notable.

Few architectural monuments in the world have a more impressive site than does the Cliff Palace at Mesa Verde, and not many builders have so sympathetically integrated their architecture with the site and with their living pattern. Such a broad shelf of land standing securely above the plateau could be easily defended from intruders attacking from below, and a sheltering half-dome of rock gave complete protection from enemies above as well as from the extremes of Colorado weather. In this naturally protected, shallow cave these early Americans built an imposing structure. The site measures 425 feet in length and 80 feet in depth, and its greatest height is almost equal to its depth. In this huge cavern a complex of over two hundred rooms was constructed. The site was, of course, as irregular as nature often is. Participating happily in nature's laws and freedom from straight lines, the builders adapted their shelter with an innate sense of fitness.

They built with the materials at hand. The walls were of stones dressed to a generally rectangular shape and fitted together with clay mortar. Floors and ceilings were of heavy beams covered first with branches and twigs and then with packed clay to seal the surfaces. We do not know the exact date of this structure, but most of it appears to have been built in the twelfth century. There are, however, evidences of earlier and cruder constructions, which suggest that the same site served earlier generations. Lower stories at the front lead to a multistoried section at the rear in a series of irregular, steplike terraces, which echo in man-made forms the topography of the local landscape. Communal dwellings of this kind were continually modified in terms of changing needs; chambers that were older, lower, and therefore less desirable as living space were walled off or used for storage. Entrances to the many chambers were through hatches in the roofs; wooden ladders provided for passage from story to story. Pulling up the ladders and closing the hatches transformed this apartment house into a fortress.

The Cliff Palace is a great complex of living quarters, storage space, and the all-important sacred kivas, subterranean rooms used for religious ceremonies. The dramatic setting, the irregular terraces, the solid walls with only occasional small window openings, the rectangular and cylindrical towers, and the circular kivas make a memorable architectural mass, primitive and crude, indeed, yet monumentally grand.

Perhaps the most beautiful of the ancient cliff dwellings are the ruins in the Canyon de Chelly National Monument, Ariz. (Fig. 28). The sheer, pale mass of the cliff provides a dramatic background for the geometric patterns of the Casa Blanca (White House). The sense of scale is overwhelming, partly because the total relationship of dwellings to cliff can be seen at a glance. No

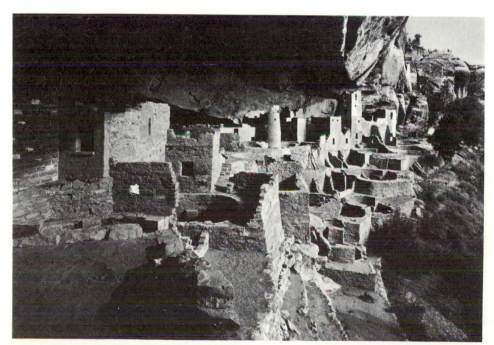

27. Cliff Palace, Mesa Verde, Colorado. c. 12th century.

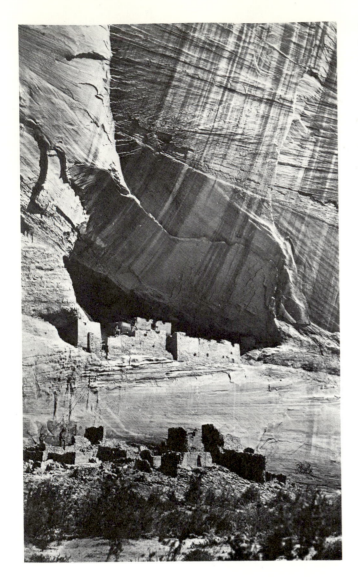

other ruin conveys so forcefully the way primitive man adjusts to and improvises on nature. Here is functional architecture, literally growing from its carefully chosen site and taking form according to the precarious lives of its builders.

Characteristic features of both the cliff dwellings and the pueblos are the great semisubterranean ceremonial chambers, which are evident in Figures 27 and 30. A partially restored one, the Great Kiva (Fig. 29) of Chetro Ketl, Chaco Canyon National Monument, N.M., gives some idea of their original appearance. The kivas were covered by a flat roof made with huge beams that supported a ceiling of smaller poles and twigs plastered with adobe. The kiva was entered from a hatch which led to the antechamber and thence through to the main chamber. A low ledge ran around the wall of the circular main chamber, providing seating space. In the center were fire pits and an altarlike platform. The regular rectangular recesses in the main wall probably held ceremonial objects. A circular hole in the roof allowed air to enter and served as a chimney for the smoke from the fires. As can be seen from the seated figures, the Great Kiva at Chetro Ketl must have been well over 50 feet in diameter. Some kivas of the fourteenth century were decorated with elaborate frescoes picturing ritual symbols. Unfortunately, the adobe plaster walls have disintegrated, leaving only fragments of the original mural decorations. Certain rock-chamber temples in Mexico, notably Malinalco, are similar to kivas.

While some tribes of the Southwest sought the protection of inaccessible cliff caves, others built their fortified communities on the plains close to the source of their food. The Spaniards called these communities "pueblos," meaning villages.

above: 28. Casa Blanca (White House), Canyon de Chelly National Monument, Arizona. 11th–14th century. (Photograph by TIMOTHY H. O'SULLIVAN, 1873. George Eastman House, Rochester, N.Y.).

right: 29. Great Kiva (restored), Chetro Ketl, Chaco Canyon National Monument, New Mexico. 11th–14th century.

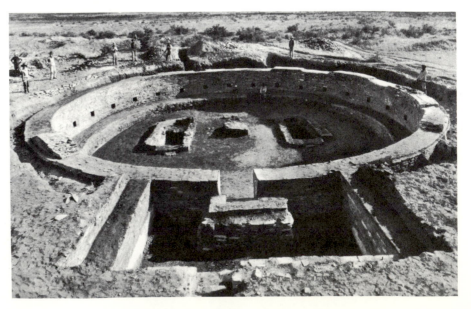

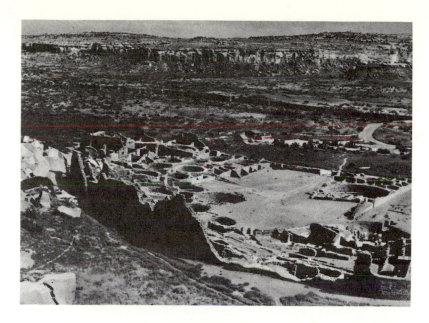

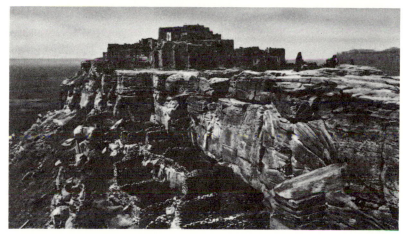

The ruins of Pueblo Bonito (Fig. 30), one of twelve communities in the Chaco Canyon, N.M., indicate the extensive nature of these prehistoric apartment houses. The pueblo is a great, walled, semi-circular, or D-shaped, complex. The exterior walls reached a height of 40 feet on the curved side; the straight side, which faced the open floor of the canyon, was made up of one-story rooms. The encircling wall was built without a break, except for a narrow entrance in front, which was blocked by a boulder that permitted only one person to enter the compound at a time. In the interior of this enclosure was a huge court occupied by about twenty kivas. At the back the living quarters and storage areas rose tier upon tier to a height of four or five stories. Pueblo Bonito, over 650 feet at its greatest length and over 300 feet wide, contained more than six hundred chambers.

A devastating drought of a quarter-century's duration occurred in this area at the end of the thirteenth century. At this time the cliff dwellers abandoned their inaccessible caverns and joined the pueblo dwellers who lived nearer the sources of water. The abandoned cliff dwellings were never used again but were held in awe by successive generations as the abodes of ancestral spirits. Though there was a general decline in the culture of this area after the fourteenth century, a number of the pueblos have been inhabited continuously up to the present time.

The most dramatic of these ancient, still occupied pueblos are Acoma, N.M., and Walpi, Ariz. (Fig. 31). Each of these villages occupies a promontory atop a steep mesa and is approached by a tortuous path up the cliff. Valley pueblos, such as Zuni and Taos (Fig. 32), are more typical of today. The latter are multistoried and made

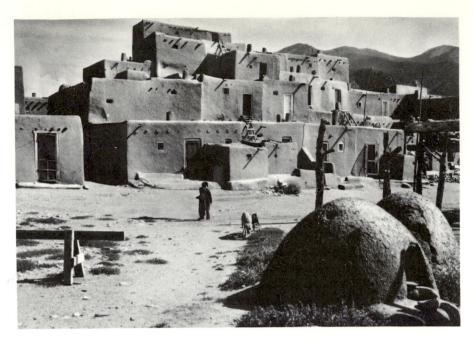

32. Pueblo of Taos, near Taos, N.M. 16th century.

of rich tan adobe brick finished with a smooth coat of adobe plaster. Great projecting poles provide the horizontal supports. Each story is recessed behind the one below it to form terraces which lead to the various apartments. Ladders provide passage from story to story.

At times these ancient structures charm the eye and fire the imagination. The undulating, smooth walls, punctuated by the ends of poles and beams, and the wavering horizontals of roofs and terraces, accented by chimney pots of Spanish type, catch the changing light with dramatic clarity. With the irregular rectangles of the varying sized rooms, the crude log ladders leading from story to story, and the round beehive ovens, the buildings create an almost magic illusion of an austere yet picturesque ancient way of life. At other times all illusion disappears. The harsh light of noon reveals the conflict between the Stone Age Indian culture and the modern world—shabby doors, windows, screens, electric wires, metal pails, tubs, and mechanical devices catch the eye and introduce a jarring note. The pueblo of today, standing beside the highway in the clear desert air, exists as an architectural anachronism, partly prehistoric monument, partly contemporary slum.

Ceramics

The beautiful pinkish tan clay of the Southwest encouraged the development of an unusually high level of ceramic arts in both prehistoric and modern times. The Southwest is unique in that it exhibits an abundance of early pottery

and deposits from subsequent periods, thus making it possible to follow the evolution of ceramic techniques in the area. There is some evidence that the first step from basketry to pottery occurred when the Basket Makers daubed their baskets with clay to make them waterproof. Certainly baskets preceded pottery, and some of the pots from this area, made between A.D. 500 and 1000, simulate the texture of the woven basket as a decorative device (Fig. 33).

Toward the end of this same period, smooth, rather chalky pottery appeared in an exuberant variety of forms. Between the ninth and twelfth centuries, these informal and vivacious ceramics were produced in great quantities. Unlike the later and more refined wares, they were unstandardized in form and decoration (Fig. 34). Bold patterns of stripes, interlocking scrolls, stepped designs, concentric meanders, checkerboards, fine parallel lines, and combinations of dots were freely painted in black over a white, or occasionally a red, slip. The geometric and frequently angular character of these patterns suggests a textile or basket-weaving origin; many of the motifs appear to have originated as nature symbols. The same gay and lively attitude that characterizes the patterns pervades the forms; mugs, bowls, "Roman lamps," and fanciful shapes frequently suggesting humorous animals and birds give evidence of a merry and sensitive people whose creative spirit had not been stultified by formulas.

In the following century technical perfection appears to have been stressed. A large 15-inch olla, or water jar, from before the thirteenth century, suggests that at the

height of the culture the taste shifted toward formal perfection and increased elegance of form and decoration (Fig. 35). The beautiful fullness of form of this vessel is skillfully reinforced by the boldly conceived, precisely executed pattern that encircles it. The rhythmic movements of the great diagonal black-and-white zigzag patterns are striking. Diamond-shaped lozenges filled with small checkerboard shapes provide an effective contrast. Fine sets of parallel lines create a gray tone, thus adding subtlety and refinement to the already richly varied textures and tones of this water jar. The skill necessary to paint freehand these parallel lines on the rounded shape of the vessel gives ample testimony to the technical discipline of the potter. The surface is polished, and the luster, too, contributes to the general elegance.

In the mountainous southwest corner of New Mexico a particularly charming ceramic style, called Mimbres after the Mimbres Valley in which it appeared, developed between the tenth and twelfth centuries. This was a localized offshoot of a more widespread, pit-dwelling culture of a generally low level of development termed "Mogollon." Large quantities of Mimbres pottery, chiefly bowls, were buried with the dead, and at the time of burial each bowl was "killed" by having a hole knocked in the bottom (Fig. 36). Mimbres pottery was technically fine, light in weight, and decorated with freely painted black designs on a white base. An unparalleled variety of

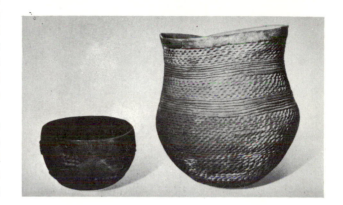

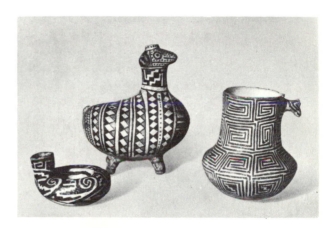

above right : 33. Bowl and jar, from Apache County, Arizona. 500–1000. Clay, height of jar 13 ½". Museum of the American Indian, New York.

right : 34. Pottery forms ("Roman lamp," bird-shaped jar, jar with animal-head handle), from Socorro County, New Mexico. 9th–11th century. Clay, height of center jar 9". Museum of the American Indian, New York.

below left : 35. Black-on-white olla (water jar), found near Grants, N.M. c. 1000–1200. Clay, height 15". School of American Research, Santa Fe, N.M. (Indian Arts Fund Collection).

below right : 36. Mimbres bowl with grasshopper design, from New Mexico. 10th–12th century. Clay, diameter 11 ⅛". Buffalo Museum of Science, Buffalo, N.Y.

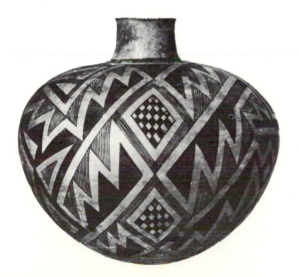

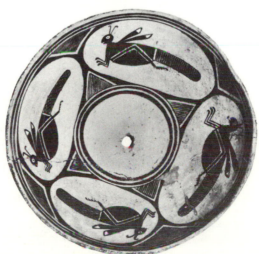

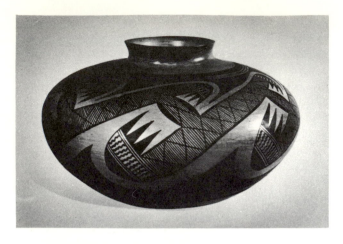

left : 37. Hopi jar, from Arizona. 20th century. Clay, height 9 ¼". Museum of the American Indian, New York.

center : 38. Hopi kachina (spirit) dolls, from Arizona. 20th century. Painted wood, feathers, fibers, and other materials; height of doll at left 16 ¾". Museum of the American Indian, New York.

below left : 39. Navaho squash-blossom necklace. c. 1890. Silver, length 23". Collection the author.

motifs were used to decorate these bowls. Birds, insects, reptiles, animals, people, and mythological creatures predominate, but geometric designs, bandings, hatchings, and various abstract patterns were also used. The Mimbres potters revealed exceptional powers of invention in the patterns on their bowls. In one site where over seven hundred pieces were excavated, no two were alike.

The general decline in the cultural level of the Southwest after the fourteenth century was reflected in the coarsening of the later ceramics, but the techniques were not forgotten. A jar (Fig. 37) 20 inches in diameter, by a twentieth-century Hopi potter, reveals the same disciplined taste and high level of craftsmanship that distinguished the finest prehistoric wares.

Wood and Metal

Though clay is the medium most frequently used in the arid Southwest, the Hopi Indians still carve charming kachina dolls from the soft wood of the cottonwood trees. Kachina dolls, made in the images of masked ceremonial dancers (Fig. 38), are created as playthings for children, serving to teach them the various kachina spirits. Kachina is a term denoting spirits—the spirit of the dead, of rain, of local springs, and of many other natural phenomena. Masked Indian dancers represent the kachinas on ceremonial occasions; in fact, the belief is that the wearing of the kachina mask transfigures the human dancer into a supernatural being. Fabrics, feathers, furs, and other materials are often used to enrich the kachina doll costumes.

In the nineteenth century the Navaho Indians of New Mexico and Arizona developed the craft of making cast- and wrought-silver jewelry of an original and distinguished character. The techniques for working metal were acquired from Spanish Mexico, along with the dies used to decorate the silver. The Navaho craftsmen adapted these dies, originally employed for leather tooling, to the techniques of working metal and used them, along with the traditional turquoise, to enrich their bracelets, rings, buttons, beads, buckles, necklaces, bridles, halters, and stirrups. A squash-blossom necklace (Fig. 39) reveals the original and distinguished character of Navaho jewelry.

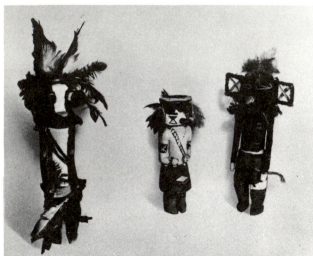

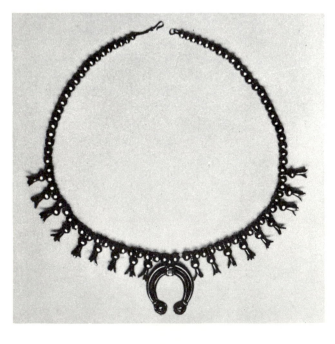

Basketry and the Textile Arts

It is difficult to determine the antecedents of the textile arts in North America. The mounds of the Eastern Woodlands and other prehistoric remains reveal evidences of well-developed textile arts. Like wood, however, textiles disintegrate in the damp earth, and it is only in the dry caves of the arid Southwest that sufficient quantities of prehistoric weavings have been found to provide any substantial picture of the development of this art in North America.

The Basket Makers of the Southwest were dependent upon the gathering of wild seeds, acorns, nuts, and roots, and this necessitated light, easily transported containers. The baskets from as early as A.D. 500 are highly developed in technique and tremendously varied in size and shape, ranging from great storage baskets in which a man could hide, to gemlike little ones for holding precious small seeds. Some of the baskets are so tightly woven that they are waterproof. They were filled with water, which was brought to the boiling point by immersing heated stones, and could thus be used for cooking.

The ingenuity and skill with which the basket weaver of the Southwest developed his craft is illustrated by a cradle basket (Fig. 40) from the cliff dwellers of Moki Canyon, Utah, produced between the eleventh and fourteenth centuries. The form of the object has been determined by its function—to carry a baby on its mother's back. The manner in which the twined technique has been adapted to create the complex shape of a cradle basket reveals an impressive command of the craft. The structural ribs have been spread on the outside and brought together in the crotch with consummate skill. Despite the complicated shape, the decoration is applied with clarity and logic to produce a handsome, animated functional object.

By the eighth century of our era cotton had been introducd to the pueblo peoples from Mexico, and this material and the contact with the highly developed textile tradition of the Mexicans stimulated an impressive flowering of the already well developed weaving tradition. Through the successive centuries appeared textiles of an ever-increasing variety of weaves, distinguished by both technical and decorative excellence. Elaborate damasks employing contrasting colored threads were woven, as well as lacelike textiles with openwork patterns. An example of cotton openwork in an intricate fret-and-diamond-patterned mesh from fourteenth-century New Mexico attests to the sophistication of the textile arts at that time (Fig. 41).

The Spaniards' introduction of sheep and goats and the standing loom in the sixteenth century stimulated the

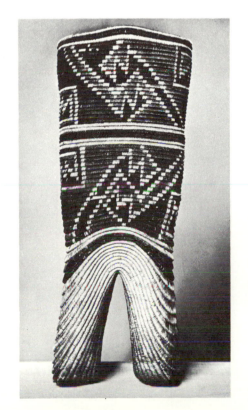

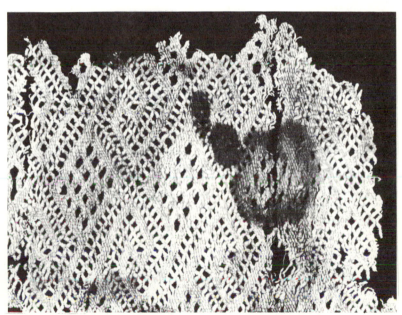

left : 40. Cradle basket, from Moki Canyon, Utah. 11th-14th century. Twined basketry, height 19 ¹/₂″. University Museum, Philadelphia.

above : 41. Fragment of weft-warp openwork textile, from Grant, N.M. 14th century. Cotton. Peabody Museum, Harvard University, Cambridge, Mass.

production of woven woolen blankets (Fig. 42), saddle blankets, and, in modern times, Indian rugs, particularly among the nomadic Navaho tribes, who are the principal sheep owners of the Southwest. The typical blankets and rugs are decorated with abstract or formalized motifs. Although the designs are traditional, each weaver modifies and combines them according to individual preference so that an element of originality always exists and prevents the exact repetition of any pattern. Rugs and blankets were originally executed in natural wool colors—black, gray, brown, and white—accented by a few bright vegetable-dye colors. In the early twentieth century the introduction of brilliant aniline dyes cheapened the color schemes. Since 1940 the quantity of weaving done in the Southwest has dropped, but some that has been produced under the guidance of the Indian Arts and Crafts Board of the Department of the Interior is distinguished by a fine sense of design and by subtle vegetable-dye colors.

Pictorial Arts

Curious symbols have been found pecked, painted, or incised on boulders and rocky walls of canyons in most parts of the continent, notably in the Southwest. Frequently the symbols are geometric—triangles, zigzags, meanders, circles, dots, and parallel lines. Sometimes strange, wavering, almost formless motifs have been painfully engraved into the hard surface of the rock. The incised or pecked-out patterns are often reinforced with color. Symbolic motifs which can be easily identified also appear in these cryptic murals. Human figures, animals, and silhouettes of hands and feet are grouped in such a way as to suggest that some ancient ceremonial rite is being pictured. Some of the best-preserved and largest rock engravings measuring many yards across have been found pecked into canyon walls in Utah (Fig. 43). The random variety of the patterns, the curious scrambling of

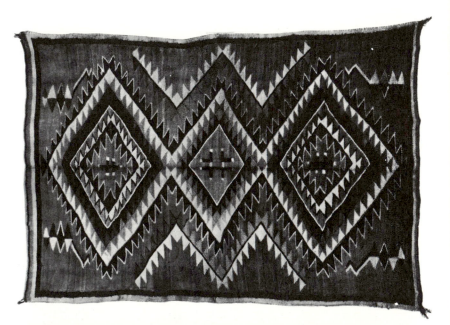

above : 42. Navaho woven blanket, from New Mexico. 19th–20th century. Wool, length 4′ 2 ½″. Museum of the American Indian, New York.

right : 43. Pictographs, Tickaboo, Glen Canyon, Utah. c. 1100.

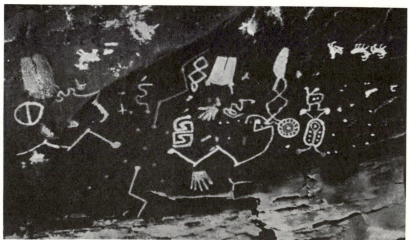

figures, mountain goats, and hands, and the many enigmatic, unidentifiable motifs lead one to imagine some infinitely patient and whimsical Paul Klee at work.

The Southwest remains one of the few areas in which the Indians have maintained a living tradition of pictorial expression into the twentieth century. A sand painting (Fig. 44) depicting the Night Chant ceremony shows four figures in black, blue, yellow, and white, the colors of the four points of the compass. The elongated, highly formalized symbols are typical of this elaborate ritualistic art, one of the few modern forms of expression that reveal the magical background of much Indian art.

Sand painting as practiced by the Navaho tribes of the Southwest is an old and unique art. Colored rocks were crushed to make the delicately colored sands used by the medicine men for the magic ceremonial pictures, which were supposed to banish the offending spirit from the body of a sick person. The various motifs are symbolic; each line, form, and color has its particular meaning. The medicine man worked from memory, laying out the various colored patterns in their proper places with amazing certainty and skill. If a sand painting failed to effect a cure, the medicine man destroyed it and continued to make new sand paintings until the patient recovered or died. When a patient was cured, the sand painting was destroyed to ensure his continued health.

In the late 1920s and early thirties a vigorous school of easel painting, stimulated by the Indian Arts and Crafts Board, started among the Plains tribes of Southwest Oklahoma and the Navahos, Apaches, and Pueblo tribes of New Mexico and Arizona. The paintings were usually done on paper in watercolor, though a few artists also did oils. The subjects were drawn from Indian life and depicted religious ceremonies, dances, genre subjects, and animals. *Apache Fire Dance* (Fig. 45) by Al Momaday, a Kiowa Indian, illustrates the somewhat flat, decorative style of drawing and the vigorous rhythmic sense of movement that characterizes this contemporary school of Indian painters. Though the school languished subsequently, the sixties witnessed a vigorous revival, which extended far beyond the Southwest.

CALIFORNIA

Little is known of the prehistory of the rather backward Indians from the southwestern corner of the United States—the strip of California between the Sierra Nevada Mountains and the Pacific Ocean—and from the islands off the southern coast. Despite their low level of culture, these Indians produced what are perhaps the finest woven baskets in the world, and they also created out of soapstone charming fish and animals and handsome bowls and

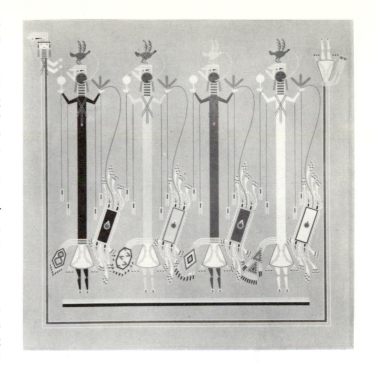

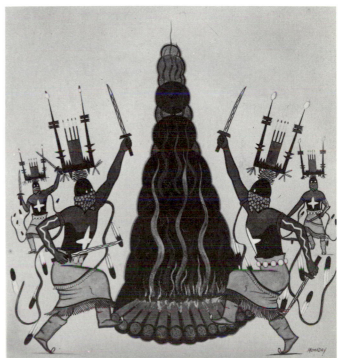

top : 44. The four "first dancers" of the Navaho Night Chant Ceremony. 20th century. Sand painting, 8′ square. Museum of Navaho Ceremonial Art, Santa Fe, N. M.

above : 45. AL MOMADAY. *Apache Fire Dance*. 20th century. Watercolor, 20 × 21″. Philbrook Art Center, Tulsa, Okla.

right : 46. Pomo storage basket, from California. 19th century (?). Coiled basketry. Museum of the American Indian, New York.

below right : 47. Wappo gift basket, from Napa County, Calif. 19th century (?). Coiled basketry with feathers and abalone shell. M. H. de Young Memorial Museum, San Francisco.

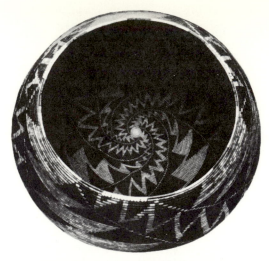

right : 46. Pomo storage basket, from California. 19th century (?). Coiled basketry. Museum of the American Indian, New York.

below right : 47. Wappo gift basket, from Napa County, Calif. 19th century (?). Coiled basketry with feathers and abalone shell. M. H. de Young Memorial Museum, San Francisco.

containers. The Chumash tribes from the Santa Barbara area, one of the more highly developed California tribes, also created intriguing pictographs and cave paintings in the eroded canyons of the inaccessible coastal mountains.

Basketry

The gentle California Indians lived upon fish, shellfish, acorns, seeds, and roots. Their habitations were extremely sketchy, and when the Spaniards discovered them, they exhibited no special achievements except for their great skill in weaving baskets.

Most notable among the basket weavers of California were the Pomo tribes, who made baskets of incredible fineness. In some one can count sixty stitches to the inch. A great variety of shapes were produced and decorated with designs that usually moved diagonally across the surface. The characteristic stepped patterns which develop naturally from the weaving process can be seen in a beautiful Pomo storage basket (Fig. 46). Many of the patterns have identifying names, such as fish teeth, earthworm, arrowhead, or clouds, which may or may not be related to the origin of the motif. The various natural-colored materials (barks, roots, grasses, and other fibers) employed for the patterns were reinforced with dyes to provide a greater range of tones. Black, brown, and red were used most frequently, and they contrast effectively with the pale straw-colored backgrounds.

Shell, feathers, and other precious materials were used for the splendid ceremonial baskets. A coiled gift basket (Fig. 47) from the Wappo Indians of northern California is richly decorated with colored feathers arranged in a pleasant but simple design supplemented by abalone shell pendants. The feathers from many species of birds were collected ior their bright colors and saved to make this laborious art possible. Featherwork of a similar type was practiced in the Southwest, in Central and South America, and among the South Sea Islanders. Elegant baskets of this kind were frequently made as wedding gifts.

The introduction of glass beads by the Europeans provided a new medium for decorating gift baskets. A Pomo example (Pl. 1, p. 55) covered with blue and red beads is one of the finest baskets in existence. Not small for a gift

basket, this 4-by-12-inch basket has the usual woven-grass base, to which the small glass beads have been added by interweaving. The formal placement of the paired red triangles provides an effective but restrained contrast to the almost iridescent blue-tan background.

Sculptured Stone, Pictographs, and Cave Paintings

The California Indians also left a group of small stone pipes, bowls, and similar ceremonial objects designed to resemble whales, sharks, other kinds of fish, animals, and insects. These charming sculptured forms were carved in full plastic shapes from steatite, a kind of soapstone, and were enlivened with details of shell circlets. Three whale

pipes (Fig. 48) from Los Angeles County are typical in their naturalism and informal grace. The shell circlets create a sense of scale, provide a decorative touch, and contribute animation and even humor. An unusual and very effective sculpture from this culture is a bowl in the form of a tarantulalike monster (Fig. 49), a little over 10 inches long, which is larger than most of the sculpture from southern California. These steatite sculptures were carefully polished to produce a handsome sheen.

A number of caves or shallow shelters with painted pictographs were discovered in the coastal mountains around Santa Barbara in the late nineteenth century, but only in the mid-twentieth century were these sites studied. Mostly located on protected walls and ceilings, these pictographs by the Chumash tribes were painted on natural yellow sandstone or on smoke-blackened walls in red, white, or black, with lesser amounts of yellow, orange, and green. The motifs used are formalized animal, insect, reptile, and human symbols, often difficult to identify, as well as stars, suns, spirals, crosses, and other semigeometric forms (Fig. 50). A copy of a cave painting such as we have here, no matter how carefully done, cannot convey the rough vigor and large scale of the original.

THE PACIFIC NORTHWEST

The last area to be considered, the Pacific Northwest, is the home of one of the richest Indian cultures. Here a narrow strip of land is cut off from the rest of the continent by high mountains on one side and ocean on the other. This thousand-mile strip, which runs south from southern Alaska to the Columbia River, is a mountainous coast dotted with thousands of islands. The area abounds in fish, game, and berries and is heavily wooded. From these great coastal forests came, first and foremost, the cedar but also the spruce, pine, cypress, fir, hemlock, yew, maple, and alder from which the Indians of this area created most of their tangible culture, for wood remained the material most frequently used for both practical and beautiful objects. With an unerring sense of their craft, these master carvers could shape a 70-foot totem pole or make a tiny rattle from wood and achieve an equally fine sense of form and decoration.

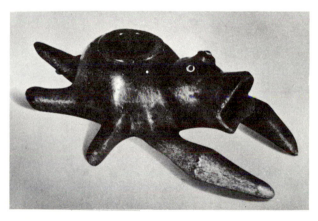

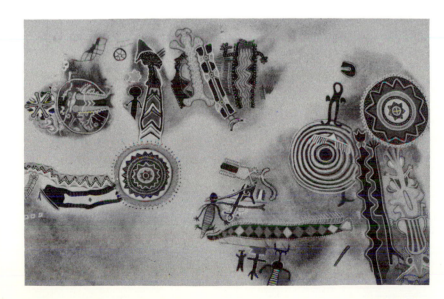

top : 48. Whale pipes, from Los Angeles County, Calif. Historic Period (1600–1900). Steatite with shell, length of center pipe 6 ¼". Museum of the American Indian, New York.

above : 49. Spider monster, from Los Angeles County, Calif. Historic Period (1600–1900). Steatite, length 10 ¼". Museum of the American Indian, New York.

left : 50. Chumash rock painting (facsimile), Santa Barbara area, Calif. c. 1500–1900.

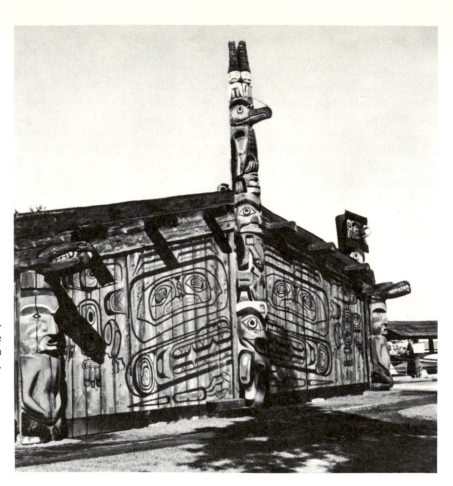

51. Composite community house (Nootka corner posts, Haida totem pole at center, and Salish carved planks on front), Thunderbird Park, Victoria, B.C.

The arts of the Northwest show puzzling similarities to those of many far-removed areas but are quite unralated to the other Indian arts of North America. South Sea Island traits are frequent, and an affinity to the arts of the early Chinese, as well as to those of the Mayans and Olmecs of Central America, has been noted. There is no evidence on which to base a chronology for the prehistoric developments in this area, for little archeological exploration has been conducted here. When Captain Cook visited it in 1778, he found a thriving culture in which the arts flourished. Some students believe that the introduction of European cutting tools stimulated the native arts, which consequently came to their fullest development in the nineteenth century. Others believe that the culture was at its height when Captain Cook paid his famous visit. Cook noted that the Indians used metal tools of their own manufacture with great effectiveness, and the objects he and others of his time collected in this region are in no way inferior to later products.

The chief tribal names in this region, starting at the mouth of the Columbia River and going north, are Salish, Nootka, Kwakiutl, Haida, Tsimshian, and Tlingit, the last four tribes producing the most splendid objects. Though minor differences distinguish the arts of one tribe from another, the similarities are greater than the differences, and for our general purposes the entire area can be considered as one culture.

Both the objects used in daily life, such as fishhooks, oars, ladles, cooking vessels, and storage boxes, and the objects for ceremonial purposes are decorated with the characteristic carved and painted patterns that make the arts of this region rich and fascinating. The largest and most elaborately decorated objects are the totem poles. Equally impressive are the many ceremonial artifacts that were made for the elaborate rituals which formed such a vital part of the life of these peoples.

Totem Poles

The unique product of the Northwest is the totem pole, a tall cedar column carved and painted with typical symbols. Totem poles vary in height from a few to 70 feet. The poles were used in various ways; some were attached to the front of the house, at times straddling the entrance,

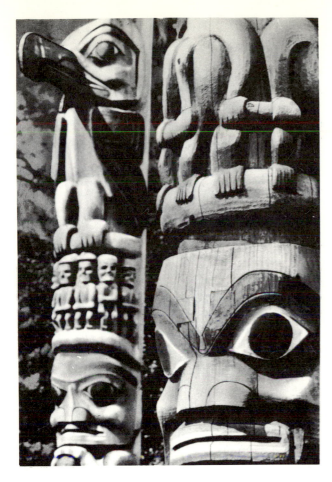

and indicated the totem, clan affiliations, and social status of the family living in the house. Some were erected in front of a house to commemorate the dead, and some shorter and heavier posts, called "house posts," were placed in the interior of the house to help support the roof. Lastly, there were also mortuary columns which actually held the body or ashes of the deceased.

A house front (Fig. 51) in Thunderbird Park, Victoria, British Columbia, was made by taking a number of parts from different houses, including a totem pole and two side posts, and assembling them in one building for display purposes. Houses of similar design provided shelter for most of the tribes in this area. Usually of cedar planks and frequently 40 or 50 feet long, these rectangular structures, with their moderately pitched roofs, resemble houses of European derivation in their external appearance, except for the addition of totem poles and painted decorations.

The fecundity of imagination displayed by the sculptors who carve the totem poles appears endless, for no two are alike. Formalized though these symbols may be, this is no art of formula, for each artist modified and combined the totemic symbols in a personal way. This is well illustrated in a pair of totem poles (Fig. 52) also from Thunderbird Park. Here one can see the typical anthropomorphic character of the symbols used in carving the poles, symbols in which details from birds, animals, fish, and other creatures are combined with human characteristics. As in the heraldic crests of Europe, these complex motifs were designed to establish symbolic relationships rather than to represent actual appearances. Complex though the poles may be in their intertwining forms, an innate sense of design enabled the sculptor to achieve variety and avoid confusion by establishing focal points that avoid an undue diffusion of interest. The most striking forms, such as the great staring heads at the bottom, create major centers of interest. Quieter intervening areas in which the carving is more complex, detailed, and shallow, such as in the rows of small standing figures, provide for visual change through variations of scale. The three-dimensional relief created by the projecting and receding carved surfaces is augmented by the addition of reds, blues, blacks, whites, and other colors, so that a counterpoint of color and pattern enriches the sculptural ensemble. The varied symbols, one above the other, usually culminate in a commanding figure at the top, a fitting climax to the dynamic composition of mounting forms. No uncertain shape or weak pattern mars the entire structure. The totem pole remains the most imposing example of the style of the Pacific Northwest, unselfconscious, intuitive, and sure, growing from the living habits, beliefs, and traditions of a people who were dedicated to an ancient way of life.

The decorative characteristics of the art so brilliantly developed in the totem poles can be summarized as follows: In general, the motifs are drawn from the birds, animals, and fish of the area and include, of course, the human form. Raven, hawk, eagle, owl, bear, beaver, wolf, seal, otter, salmon, octopus, shark, and whale are the most common totem symbols, for totemism is the motivating force behind the decorative arts of the Northwest. Totemism is the belief in the animal ancestors of the groups of people that made up a family or clan. It is this ancestral relationship that determines the social affiliations, degrees of kinship, marriage relationships, and ceremonial rituals of each individual. Totemism therefore determines the insignia, crests, and decorations that will be used to identify and enrich an individual's belongings. As new clan relationships are acquired through intermarriage and conquest, the totem is enriched by secondary

motifs which indicate these new additions. The basic crests are raven, eagle, bear, and wolf, but there are countless subclan motifs, extending even to starfish, the moon, and the rainbow. This is the basis for the involved combinations of fish, bird, mammal, and human form in a typical totem pole.

The Indians of the Northwest considered all living things to be spirit manifestations. Human characteristics were bestowed upon the various mammals, birds, and sea creatures, which both in mythology and everyday life were endowed with supernatural powers. The totem animals were the guardians of the family and clan. Dances, ceremonials, the display of totemic devices, and certain taboos propitiated the spirits of the guardian animals and procured their protection. The motifs used in the totemic decorations represent natural forms abstracted, simplified, formalized, and then combined into interlacing curvilinear shapes, usually arranged bisymmetrically, or perhaps one should say bilaterally. These rich and involved arrangements were made even more effective by the free use of strong contrasts of tone and color to reinforce the distinction between the various levels of relief carving.

The vigorous stylizations of anatomical form and the characteristically bold patterns are handsomely displayed in a Haida house post (Fig. 53). The carved figures on this post have a typical combination of human and animal attributes; the eyes and brows of the top head appear human, but the nostrils and protruding tongue suggest the bear symbol. This probably indicates that the figure represents a mythological creature or bear spirit. The staring eyes, the strange anatomical dislocations, and the placing of heads at both the top and bottom of the pole transform this 11 ½-foot post into a vivid sculptured form.

Ceremonial and Household Arts—The Potlatch

The large scale of much of the art of the Northwest and the striking designs are in keeping with the spirit of the most typical institution, the potlatch, a ceremonial feast given by an important chief to display his wealth and power. It lasted for several days, and in the course of the celebration the host gave to his guests vast quantities of his most valued possessions—slaves, canoes, blankets, clothing, and household articles. The guests were obligated to accept the gifts, and custom demanded that they return the favors with gifts of even greater value. If this could not be done, the recipients were disgraced, to such a point that some individuals who were unable to compete effectively committed suicide from shame. Thus, there existed a kind of compulsory parade aimed at self-glorification through the display of wealth and largesse and, as a corollary, the humiliation of rivals. The tremendous quantities of goods exchanged in the course of the potlatch and the fact that the richness and elaboration of the ceremonial objects gave evidence of a host's influence provided a strong stimulus to artistic production.

In addition to the potlatch, there were religious ceremonies in the winter months during which special dances and elaborate performances took place under the direction of the medicine man to illustrate or commemorate events from the complex mythology. Rich costumes and masks designed to represent the supernatural forces of the spirit world were worn by the participants in these ceremonies.

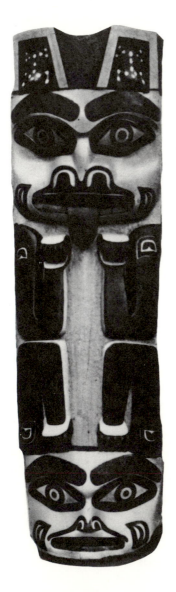

left : 53. Haida house post, from Alaska. Carved and painted wood, height 11′ 6 ½″. Museum of the American Indian, New York.

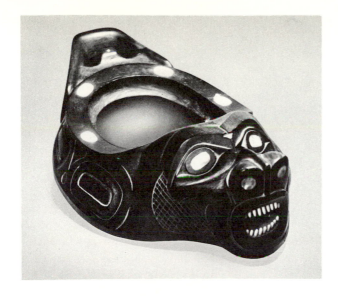

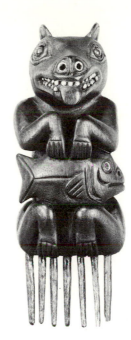

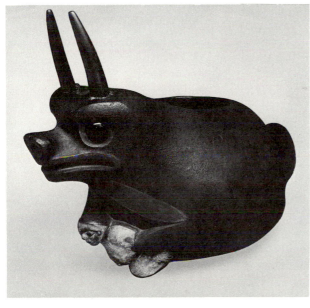

above left : 54. Bowl representing seal, Pacific Northwest. c. 1900. Wood with mother-of-pearl, 3 ½ × 16 ″. Stanford Museum, Stanford, Calif.

left : 55. Bowl representing horned animal, Pacific Northwest. Painted wood with glass eyes, height 28 ½″. M. H. de Young Memorial Museum, San Francisco.

above : 56. Tlingit comb representing bear with salmon, from Alaska. Mid-19th–20th century. Wood with shell insets, height 6″. American Museum of Natural History, New York.

Wood Carving and Painting

A great variety of wooden objects, produced for the pot-latch, for hunting and fishing expeditions, or for household purposes, exude the surging vitality so characteristic of the arts of this area. Two bowls reveal the typical blends of utility, magic, and display. An oil dish (Fig. 54) with the head of a seal, enriched with crosshatched patterns, engraved lines, and mother-of-pearl eyes, nostrils, and teeth, is both a container and a vivid and refined sculptured form. In addition, it ensured its owner success in his hunt for the all-important seal. In the second bowl pictured (Fig. 55) an enigmatic horned creature holds an

infant in his front paws. The rounded forms are vigorously realized by means of a slight degree of abstraction and simplification. The glass eyes add a vivid contrast in texture. The directness and strength of the forms in this bowl contribute an illusion of realism that is unusual in the highly conventionalized art of the Northwest Indians.

A charming little wooden comb (Fig. 56) from the Tlingit tribes of Alaska displays the same vigorous sense of form that distinguishes the monumental sculptures. A bear, seated on its haunches, holds a chubby fish in its paws. The forms are effortlessly related by the alternation of vertical, horizontal, and curved movements. Nostrils, teeth, and eyes of shell provide lively contrasts with the dark wood. The gay, almost humorous quality of this lively sculptured comb is delightful.

The Indians of the Northwest Coast produced a great number of masks representing various spirits—human, animal, and mythological—for use in the dances and rituals of the winter ceremonies.

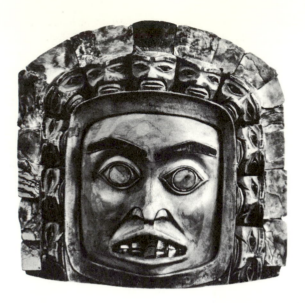

left : 57. Tsimshian headdress, from British Columbia. Wood with abalone shell. Provincial Museum, Victoria, B.C.

below : 58. Tlingit partition screen, from the house of Chief Shakes, Shakes Island, Wrangell, Alaska. Before 1840. Carved and painted planks, 15 × 9′. Denver Art Museum.

An unusually handsome mask-headdress (Fig. 57) is made up of a large human face framed by eleven small faces. The squarish shape of the large head is rhythmically emphasized by the surrounding concentric planes of similar shape, and the varied facets of the encircling border contribute an illusion of depth to the essentially flat surface of the mask. Skillful variations of the relief carving and firm definition of the features intensify the effect of a fully developed three-dimensional form. The headdress is enriched with color and inlaid with abalone shell. The glittering, staring eyes and the bared teeth reinforce the almost hypnotic effect of the large head and create a mask of magic potency.

In the art of the Northwest each animal is characterized by certain typical symbols. The beaver, for example, is identified by its hachured tail and large incisor teeth (Fig. 63), the bear by its large nostrils and protruding tongue (Figs. 53, 56), the eagle by its hooked beak (Fig. 51), and the killer whale by its large dorsal fin. These highly conventionalized symbols, modified according to the area to be decorated, are arranged in such complex, interwoven patterns that it is difficult to separate and identify all the various elements of the design. The deliberate scrambling of totemic motifs often appears intentionally mystifying; forms are conventionalized beyond identification. Thus the art appears to be designed for an elite of chieftains and medicine men who seek to impress the uninitiated. Probably only the artist who created a design could identify all the symbols with certainty.

Other characteristic aspects of the style are the frequent use of a squatting human figure, with the arms and legs extended frog fashion, and a curious custom of placing eyes or human faces at the joints of the arms and legs of human, animal, and bird forms. These conventions can be seen in a carved and painted Tlingit partition screen (Fig. 58) from the House of Chief Shakes (or Shaiks), Wrangell, Alaska. This great bear is seated frog fashion with extended arms and legs. Heads are placed at all the joints, as well as in the eyes and nostrils; full figures decorate the ears; and eyes appear in the ankles, chest, and abdomen. The hole between the bear's legs served as a door. This splendid screen is painted red and blackish brown.

Much of the painting on wood was carried out in a local type of true oil painting. With the ingenuity that

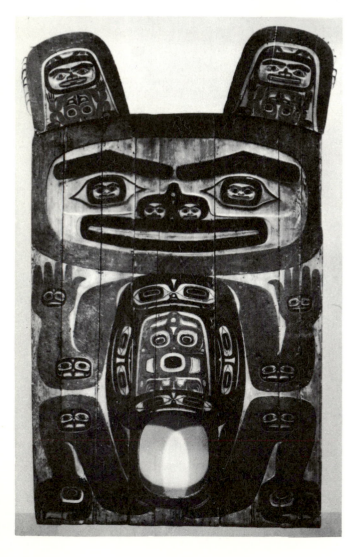

characterizes so much of their art, the Indians squeezed oil from salmon eggs, and colors were applied in this oily base on the hand-hewn cedar logs.

Stone, Metal, and Ivory

The Indians of the Northwest Coast, most noted for their virtuosity in wood carving, were also expert sculptors in stone and worked effectively in metal, bone, ivory, shell, and other materials. Stone sculptures by the Indians of the Northwest were collected by Captain Cook during the eighteenth century. The introduction of an abundance of metal-cutting tools by European traders stimulated a unique development among the Haida tribes of the Queen Charlotte Islands in the nineteenth century, the carving of handsome, ornamental black slate ceremonial objects and totemic devices. Many of these objects provide amusing surprises; for example, human or animal forms spring up when the lids of vessels are removed, and other movable parts reveal an unexpected sense of humor. These slate sculptures are frequently enriched with mother-of-pearl, shell, and ivory inlays.

A remarkable level of skill was developed in carving this evenly textured, black carboniferous shale, and some of the striking designs acquire an added dignity because of the inherent character of the slate. A typically elaborate bas-relief group (Fig. 59) combines human figures with animals, birds, and other characteristic motifs. The alternation of large and small shapes and of smooth and patterned areas and the clear articulation of the various planes produced a unified bas-relief distinguished by a fine sculptural sense.

The Bear Mother (Fig. 60) was carved in the late nineteenth century by a Haida Indian named Skaouskeay. This

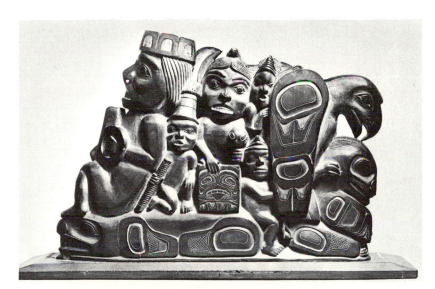

left: 59. Haida bas-relief sculpture, from Queen Charlotte Islands, B.C. 19th century. Black slate, height 8 ½″. Stanford Museum, Stanford, Calif.

below: 60. SKAOUSKEAY. *The Bear Mother.* c. 1883. Slate, length 5 ½″. Smithsonian Institution, Washington, D.C.

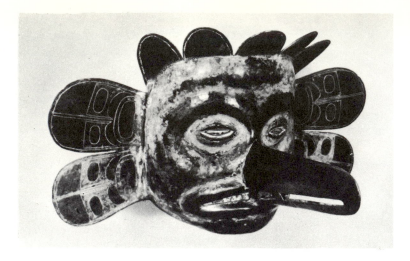

sculpture is based on a local legend, the story of a woman who married the bear king. Her child was born in the image of man but with the instincts of the bear, and the human mother is shown grimacing with pain at the violence of the suckling infant at her breast. The forms are naturalistic, and the composition is illustrative and expressive. In this respect the carving is unusual and represents the intrusion of European artistic concepts, with the consequent departure from the traditional symbolism and formalism. There is almost no slate carving done today, because of a general disintegration of traditional culture in the area.

An effigy pipe bowl carved from walrus ivory in the form of a squatting man provides a superb example of the ability of the Northwest carver to impose a powerful form upon a small object (Pl. 2, p. 56). The forms of this

figure, only 2 ½ inches high, are projected with amazing strength and incisiveness. The warm, deep tone of the ivory is heightened by the glittering bluish abalone-shell inlay, and the contrasts of color contribute considerably to the power of this tiny sculpture.

The Indians of the Pacific Northwest also worked copper, steel, and other metals with great effectiveness. Native copper, hammered into thin sheets, was shaped into masks or made into rattles and other ceremonial objects. A copper mosquito mask of Tlingit origin (Fig. 61) provides an unusually vivid visualization of mosquito characteristics. Steel obtained from wrecked ships was utilized to make fine fighting knives, which show remarkable skill in working this most intractable of materials.

Textiles and Leatherwork

The large fringed blankets made by the Chilkat branch of the Tlingit tribes are an interesting textile development from the Northwest. On important occasions the leading members of a clan used these handsome blankets as capes to display the family crests. The designs, usually symmetrical, are typical of the area—boldly patterned in contrasting tones and colors with intricately intertwined symbolic motifs. In the blanket shown here (Fig. 62) a strong animal form is enhanced with spots and human heads, and the background is filled with striking, enigmatic symbols, including eyes and large heads. The designs for the blankets were prepared by the men, who painted them on boards, but the actual weaving was carried out by the women who wove these large blankets with their fingers in a simple tapestry technique without the aid of a loom. A surprisingly fine texture was achieved by this primitive technique. A strand of cedar bark formed the core of the thread, and this core was covered with the hair of the mountain goat and then dyed in a variety of colors. The color scheme is usually black, white, green, and yellow. Skirts, kilts, and leggings were also woven in this manner.

Painted buckskins are another product of the northwestern tribes. The supple white buckskin was decorated and then made into dance shirts and other articles of ceremonial apparel. A handsome painted buckskin with a striking beaver motif (Fig. 63) has been enriched by the curious addition of eyes and faces, which add to the decorative effectiveness of the whole. The brilliant pattern, made up of basically rectangular shapes with typically rounded corners, has been executed in fluid lines of great elegance and distinction.

A characteristic feature of northwestern Indian art, seen in both the Chilkat blanket and the painted buckskin, is the bilateral representation of natural forms—that is,

the tendency to split forms into halves laid open to show both sides. Animals are depicted with the profiles of the two halves placed facing each other to make a full mask; birds are united along the back with the two profiles facing away from each other. Frequently both internal organs and external anatomical details are represented at the same time, the spine, stomach, or intestines making a pattern, along with claws, eyes, ears, and so on. Elements from the underside and top are also transposed freely, apparently at the whim of the artist. The beaver motif used on the painted buckskin, identified by the two large incisor teeth and the hachured tail, combines a face in full front view and the underside of the body. There is a face on the beaver's chest, at the base of the tail, and eyes are placed at the joints of limbs.

63. Beaver motif, Pacific Northwest. Painted white buckskin, 40 ⁹/₄ × 21 ⁹/₈″. Portland Art Museum, Portland, Ore.

As yet we have no clue to the origin of the tribes of the Northwest, and the antecedents for their art pose a number of problems. Many of the elements appear to be derived from the South Sea Islands and Asia. The great houses of wood with the central totemic posts strongly resemble those of the Maoris of New Zealand and of the Bataks of Sumatra. Totemic posts with intertwined figures of animals and men are found in New Zealand, New Ireland, and New Guinea. Heads or masks surmounting one another were also used in early China and among the Mayans of Central America. The principle of bilateral representation, the use of squatting figures with arms and legs spread frog fashion, and the use of eyes or human faces in the joints of the arms and legs can also be found in ancient China, Polynesia, and the cultures of Central America.

Fortunately for us, the arts of the Northwest Indians flourished throughout the nineteenth and into the early twentieth century. This enabled museums and collectors to make precious acquisitions before this original and vital culture disappeared and the magnificent wooden sculptures returned to humus in the rain-sodden forests.

part II

The Arts of
the Colonial Period

3

Architecture and the Household Arts: Seventeenth Century

The second of the great migrations which peopled the continent of North America started with a trickle of European explorers and adventurers early in the sixteenth century. They were joined by an increasingly steady stream of settlers from Europe during the seventeenth and eighteenth centuries, and in the following hundred years this stream swelled to a torrent of peoples from all parts of the world seeking political, economic, and religious freedom. By the end of the nineteenth century the Indians had been conquered and the continent was the home of men of varying races, national backgrounds, cultural traits, beliefs, and ambitions, who created the dynamic and splendid culture of which we are the heirs. Except for the few isolated situations in which the Spanish and Indians merged, the settlers from Europe found the Indian culture unsuited to their needs. They methodically dispossessed the Indians of their lands and rejected the Indian pattern of living, retaining only tobacco, a few foodstuffs, and a very few building practices.

The Spaniards arrived in the last half of the sixteenth century and built their first settlements in Florida and the Southwest. At the end of the sixteenth and during the seventeenth and eighteenth centuries, the French fur traders established trading posts and isolated communities along the St. Lawrence River in Canada, through the Great Lakes district, and down the Mississippi River to New Orleans. In the seventeenth century the Dutch settled in New York, the Swedes in New Jersey and Delaware, the Germans in Pennsylvania, and the English up and down the Atlantic seaboard. Negro slaves and the aboriginal Indians added to the cultural complexity, as did the rapid diffusion of the French Huguenots throughout the colonies.

Man lives by habit except when circumstances force him to do otherwise, and habit directed the colonist to attempt to re-create familiar patterns of living. Each of the national groups that settled America, as soon as the barest foothold had been established in the new land, tried to duplicate its former way of life. The settlers began to build houses and churches and to make furniture and household utensils. A bit later they attempted to paint pictures as much like those they had left behind as was possible. However, except for isolated rural pockets, English cultural patterns rapidly became predominant along the Atlantic seaboard. Because of the Navigation Acts, Great Britain was the principal source of imports. Clothes, cloth, household goods, tools, and, most important, books from England gradually determined the way

left: 64. Reconstructed cottage of 1630. Pioneers' Village, Salem, Mass.

opposite: 65. Parts of the framing of a New England half-timber structure.

of life. German, French, Swedish, and other European influences served primarily to add a fillip of local color in certain areas.

EUROPEAN INFLUENCES ON ARCHITECTURE

The first concern of the European settlers after they arrived in America was to provide themselves with shelters. They did this with whatever materials were at hand, according to whatever methods of construction they could remember, devise, or observe. The earliest shelters in all frontier situations were similar: caves were dug in hillsides; tentlike structures were made of tree branches and covered with sailcloth; or stakes were driven into the ground to form palisades, which were enclosed with bark or with wattles, rushes, or supple branches woven into mats and plastered with mud, and then roofed with sod or grass thatch.

The first steps toward more permanent shelters were the "cottages" built by the settlers at Plymouth, Salem, and Jamestown within a year of their arrival—simple frame houses imitating the crudest huts of shepherds and peat burners in England. The colonists brought the axe, adze, and similar tools with them, making it possible to hew the framing timbers, which were then covered with broad boards laid flush. A reconstruction of such an early cottage from the Pioneers' Village in Salem, Mass., (Fig. 64) provides us with a picture of these simple shelters. As rapidly as was feasible, the first rude shelters were replaced by more substantial dwellings patterned

after the simplest and most familiar types of houses in the homeland. In order to understand the colonial architecture of America, we must examine the building tradition that the settlers had known in Europe.

Though educated men and gentry came in fair numbers to America throughout the colonial period, most of the settlers knew little of what we generally consider the significant arts of sixteenth- and seventeenth-century Europe, for these were the arts of a small elite. By the seventeenth century the monarchies and aristocracies throughout Europe had adopted the elegant Renaissance and, later, Mannerist and Baroque modes of Italy to build and decorate their palaces and churches. These styles —formal, splendid, and dependent largely on the use of carefully cut stone—were dominant in the courts of France and Spain and were becoming established in the aristocratic circles of England, Holland, and even Germany when the first settlers from Europe were landing in North America. However, few of the settlers would have dreamed of attempting to build in such learned and pretentious ways during the initial years of colonization. Instead, they drew on the familiar, medieval building conventions of their homelands, not as developed for the construction of the great medieval cathedrals and fortress-like castles, but as they were employed in the tidy homes that lined the streets and squares of small villages.

Medieval construction in northern Europe tended to be of two fundamental types: all-wood log and half-timbered. The first, native to the heavily forested areas of northeastern Europe—Scandinavia, eastern Germany, and Russia—used carefully fitted, unframed log walls and

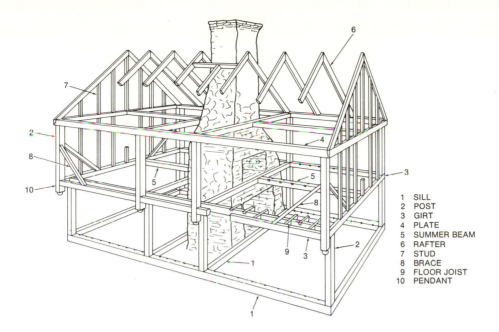

1	SILL
2	POST
3	GIRT
4	PLATE
5	SUMMER BEAM
6	RAFTER
7	STUD
8	BRACE
9	FLOOR JOIST
10	PENDANT

was the precursor of the log cabin which, in the late eighteenth and early nineteenth centuries, became a common frontier shelter. The other type of construction, half-timber, was common to most of the peoples that settled America, and it formed the basis for most of the early building practices in America.

Half-timber construction was based on the use of heavy wooden sills, vertical posts, horizontal beams, and diagonal cross braces for the exterior walls, interior partitions, and roof braces of a building. The terms "half-timber" and "heavy-timber construction" are almost interchangeable, although "half-timber" is more frequently used to describe heavy timber construction in which the structural beams are exposed. The structural members used in heavy-timber or half-timber construction, as well as the names of the chief parts, can be seen in Figure 65. This heavy-timber structure, pegged and notched at the joints, constituted the skeleton of the building. The spaces between the supporting posts and beams were filled with wattle, stone, brick, plaster, earth, rubble, or any other satisfactory material. The exteriors were finished in a number of ways. At first both the heavy-timber frame and the material used to fill the intervening spaces were left exposed, creating the characteristic interesting pattern of wooden beams in contrast with brick, stone, or plaster. However, in order to make the building waterproof, various kinds of surface sheathing were eventually added. A coat of hard plaster covered the entire structure or left only the structural beams exposed; or a coating of horizontal boards called "clapboards" or a surface covering of tiles or brick sheathed

the entire surface and protected it. A great chimney formed the heart of the building. The high-pitched roof was covered with thatch, sod, tiles, or, in areas where timber was abundant, shingles. The first builders in America turned to this tradition for their models.

In America, particularly in New England, the heavy structural timbers were usually of oak, an exceptionally sturdy wood. They were fitted together by various types of mortise-and-tenon joints, which were in turn strengthened by a wooden pin, known as a "treenail," which ran through the entire joint. The carefully fitted mortise-and-tenon joints, hand-cut with augers, chisels, and mallets, are wonderfully skilled pieces of carpentry. The clapboards were usually about 5 inches wide and 4 to 6 feet long. Cut from oak, cedar, or pine, they were wedge-shaped and placed to overlap. The shingles were hand-split and heavy, varying from about 14 inches to 3 feet in length.

Typical half-timbered construction, as it was used in the villages of England, France, Germany, and elsewhere, was not a formalized system of architecture but was an elastic mode of building influenced by local tastes and materials and subject to infinite minor variations. The informal and variable nature of this building tradition made it well-suited to the needs of the early settlers, and within a few years after settlement each community boasted a number of substantially built houses patterned after the familiar models of the homeland.

No unsheathed half-timbered houses of the seventeenth century have survived to the present time; however, two eighteenth-century models will serve to visualize this

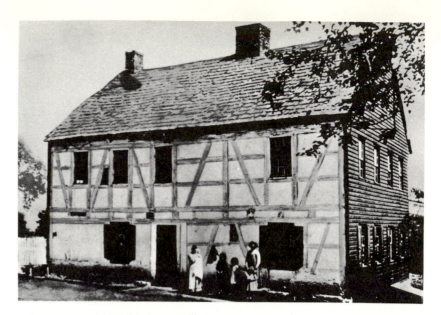

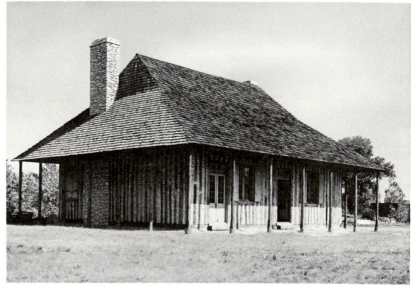

above: 66. Moravian Meetinghouse, Berks County, Pa. 1743–45.

right: 67. Cahokia Courthouse, Cahokia, Ill. 1737 (rebuilt 1939).

elementary kind of construction. The façade of the Moravian Meetinghouse (Fig. 66), built by the German settlers in Berks County, Pa., between 1743 and 1745, shows the exposed supporting skeleton of timbers with the areas between the timbers filled with whitewashed plaster. Typical English heavy-timber construction did not employ as much diagonal bracing as can be seen here, partly because the clapboard siding so frequently used tended to reinforce the structural supports. The second example (Fig. 67) is a reconstruction of one of the oldest houses in the Midwest, the Cahokia Courthouse, Cahokia, Ill., originally built as a dwelling by a French settler about 1737. A stone foundation supported horizontal timbers that served as a sill into which were fitted vertical posts spaced a few inches apart. Doors and windows were framed by the vertical and horizontal timbers, and the spaces between the wooden posts were filled with crude rubble and hard clay plaster. Since the early settlers had an abundance of wood, the practice of sheathing the half-timbered structure with wooden clapboards rapidly became standard practice among the English colonists, for the boards provided both additional insulation against the bitter winter weather and kept rain from washing out the fill. To our good fortune, a number of these seventeenth-century clapboard-covered houses have been preserved in New England.

NEW ENGLAND COLONIAL BUILDING

The wooden-sheathed, heavy-timber-framed mode of construction that became characteristic of seventeenth-century New England cannot reasonably be classified by any of the traditional style names used in identifying European architecture; therefore it is best described by the term "colonial." The more formal, decorated structures of the eighteenth century, even though they, too, were built during the colonial period, are best termed "colonial Georgian" (see Chapter 4). Both styles left a permanent imprint on house design in America.

An examination of three houses, commencing with one of the simplest one-room plans and continuing to more complex structures, reveals the basic plans employed during these early years. The Paul Revere House in Boston (Fig. 68) is thought to have been built in 1676. The restored façade we see today typifies a very simple New England colonial house. It is essentially a rectangle of two stories, topped by a high-pitched shingle roof and a great chimney. The framing timbers have been sheathed with typical clapboards. The second story overhangs the ground floor, providing more space on the second floor and simplifying the waterproofing of the wall areas. The structural timbers of the second story and the eaves are carved into bulbous pendants, introducing an interesting decorative accent with a decidedly medieval flavor. The eaves of the high-pitched gables extend only slightly beyond the walls, producing a compact and unified profile. Shuttered casement windows (hinged windows that swing open), small because glass was scarce and expensive, are glazed with little diamond-shaped panes. Doors are of heavy planks equipped with large wrought-iron locks and hinges.

The interior details indicate that the house originally had a one-room plan, but subsequently a kitchen was added in back and a chamber was added above the kitchen. The typical one-room floor plan can be seen in Figure 69. The exterior door opened into a small vestibule, which contained a steep staircase crowded against the great chimney. This vestibule led directly into the main room, which served as living room, dining room, and kitchen. The fireplace occupied almost all of one side of the "hall," as this main room was called. The staircase in the vestibule led to a second-story bedroom, which was under the sloping eaves of a story-and-a-half house or occupied the full height of a two-story structure.

The two-room plan was essentially a doubled one-room plan, except for the fact that a single vestibule provided access to both of the downstairs rooms, one of which was called a "parlor" (Fig. 70). The staircase led to two upstairs sleeping rooms, called the "hall chamber" and the "parlor chamber," depending on which room

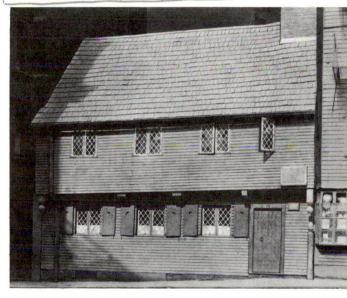

68. Paul Revere House, Boston, Mass. 1676.

69–71. Typical New England colonial houses.

left: 69. One-room plan.

below: 70. Two-room plan.

left: 71. Lean-to plan.

below: 72. Whitman House, Farmington, Conn. 1664.

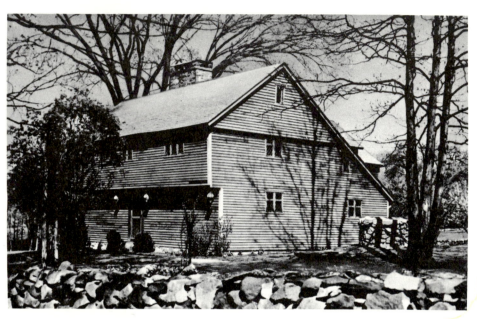

they surmounted. All the fireplaces in such a house opened directly off the great central chimney, which formed the warming core of the house. The two-room plan, it is evident, would constitute a four-room house today.

The most familiar expansion of this basic plan in the seventeenth century was the addition of a one-story lean-to at the back of the house (Fig. 71). The roof of the lean-to frequently had a less sharp pitch than the original roof. The additional space was usually used as a kitchen, and the cooking was done in a fireplace added to the back of the central chimney mass. When not all the space in the lean-to was needed for cooking purposes, part of the expanded area might be partitioned off into extra bedroom space. The garret of the lean-to provided closet space for the upstairs bedrooms or additional sleeping quarters. The two-room plan plus the lean-to became standard in the later seventeenth century and was called an "original lean-to" to differentiate it from the added-on lean-to. In constructing an original lean-to, the builder

employed continuous rafters to cover the two-room width of the rear half of the house. This produced a house with a two-story façade and a one-story rear, the standard salt-box type of colonial house. The Whitman House (Fig. 72) in Farmington, Conn., is a fine example of the salt-box type, with its two-story façade and long slanting roof that descends to a one-story level in the rear.

As more space was needed and the patterns of everyday life became more elaborate, house plans became increasingly complex. The addition of large gables lighted by small windows to the already steep-pitched roofs provided large attic rooms. Gambreled roofs—those with a double pitch, a short upper slope of low pitch and a long lower slope of steep pitch—also increased the usable attic space. Other additions were made as necessity demanded, and by the end of the century houses of impressive dimensions graced many of the cities.

The John Ward House of Salem, Mass., started in 1684, represents such an expanded structure, with two

cross gables and a rear lean-to (Fig. 73). The Ward House now serves as a colonial museum on the grounds of the Essex Institute. Originally built on a one-room plan, with a tall windowed gable to enlarge and light the attic, it was later extended to include a hall, a hall-bedroom topped by a second cross gable, and a lean-to in the rear. The overhanging second story and the introduction of cross gables on the front side added much bedroom and storage space. No one building speaks more eloquently than the John Ward House of the honesty and energy that characterized the colonial tradition of building. The aggressive rectangular bulk of the building, the great jutting triangles of the gables, the sharp, fresh textures of sheathing and shingles, and the weighty, exposed structural timbers are concrete architectural expressions of the intelligence, energy, and dauntless optimism that enabled these settlers to conquer and make habitable the formidable wilderness in less than a century. The rhythmic sequence of the forms as they expand from the ground up and the sensitive relationship of the windows to one another and to the wall surface give evidence that a vigorous native tradition had rapidly developed from the building habits brought from Europe.

While the free-standing dwelling represented an ultimate ideal, row houses (houses with sides attached to one another) were also built all through the colonies at an early date, both for economy and for mutual protection. Though there was an abundance of stone available for building purposes in New England, and bricks were soon manufactured, the general scarcity of lime made stone and brick construction expensive and therefore much less common than wood. Lime made from oyster shells was needed for the construction of fireplaces and chimneys, because the wooden chimneys of early years were serious fire hazards. Toward the end of the century the number of brick houses increased rapidly, particularly in cities, where the danger of fire was great. Brick construction will be discussed in connection with Maryland and Virginia, where excellent examples of seventeenth-century brick structures are still standing.

Interiors

The same forthright vigor and honesty that distinguished the exterior of the New England colonial house also characterized the interior. The hall, the central all-purpose room, was where food was prepared, meals were served, and the family spent most indoor hours. The visual and work center of the hall was the great fireplace, as can be seen in the Eleazer Arnold House (Fig. 74), built in 1687 in Lincoln, R.I. As in most seventeenth-century interiors, the ceiling is low, barely permitting a tall man to stand

erect. The ample fireplace, which almost fills one end of the room, is an exceptionally large one, over 10 feet wide, 5 feet high, and almost 4 feet deep. Though the manteltree, or lintel, that spanned colonial New England fireplaces was occasionally of stone, it was most frequently of oak, like the 12-foot beam used here. The fireplace in the Arnold House is made of fieldstone, shaped and laid in irregular courses. Above the mantel the heavy beams

below: 73. John Ward House, Salem, Mass. 1684.

bottom: 74. Hall, Eleazer Arnold House, Lincoln, R.I. 1687.

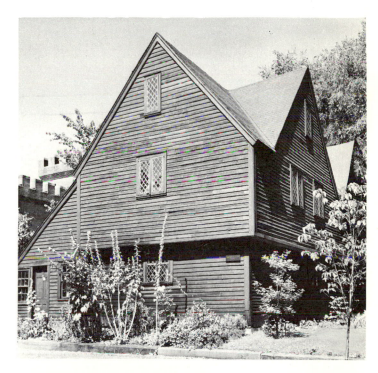

75. Interior, from the Thomas Hart House, Ipswich, Mass. 1640–70. Metropolitan Museum of Art, New York.

and structural timbers provide dramatic evidence of the massive construction. Stretching across the room above the lintel is the chimney girt, into which is dovetailed the summer beam, an element that bridges the middle of the room to provide an intermediate support for the floor joists of the second story. The floor boards are wide oak planks, sanded smooth and laid over a heavy subfloor, which gives protection against cold air rising from the unheated basement. Exposed timbers frame the doors and windows, and the intervening areas are plastered. More elegant interiors sometimes had a wainscoting of carefully finished pine boards.

The character of a more substantial New England house of the late seventeenth century can be judged by an interior from the Thomas Hart House (Fig. 75), built in the mid-sixteenth century in Ipswich, Mass., and later remodeled. Here, too, the low-ceilinged room is dominated by the structural timbers overhead. Well-laid courses of brick form the hearth and fireplace, and a cast-iron fireback protects the bricks from the heat and reflects warmth into the room. The fireplace wall of the hall, as was frequently the case, has been surfaced with a wainscoting of vertical pine boards, beveled at the edges to provide a craftsmanlike refinement of finish to the room, as do the chamfered edges of the summer beam. The side wall clearly shows the exposed structural beam that provides the support for what is overhead. The beautifully laid floor planks; the clear, sharp patterns of dark beams against smooth, white plaster; the simple but well-made furniture, with its sturdy proportions and vigorously turned decorations—all convey the sense of thrifty, well-ordered living that characterized New England. The

elaborate court cupboard, the gleaming pewter, brass, and ceramic bric-à-brac, the rug on the floor, as well as the rich fireback and the handsome Turkish rug on the table, might well have been found in the homes of many successful colonial merchants or professional men at the end of the century. Though direct trade was by law confined to the mother country, England was less insular in the last half of the seventeenth century and reflected the opulence of Continental court styles in her arts and household wares. These splendid wares were imported in quantities to grace the homes of the prosperous colonists.

While the development of domestic architecture was the most noteworthy achievement of the New England colonial settler, other types of buildings were erected by the same general methods of construction used for homes. The Puritan meetinghouse was purposely kept plain, because the elaborate Gothic structures of England were anathema to the Puritans, who thought that sculptured saints, shadowy vaults, and lofty spires distracted the eye and mind from God. It was not until the following century that the graceful elaborations of the Georgian style, which we think of as typical of New England churches, were tolerated by the Puritans. In England the dissenters had used any house or hall that would accommodate them, and at an early date the settlers of New England proceeded to build large, plain rooms which would suffice for both religious and community assembly (Fig. 76). These meetinghouses (the word "church" was avoided as smacking of popery) were usually square in plan (the term "four-square" is still with us) and were furnished with a simple pulpit and hard benches. The plain, square

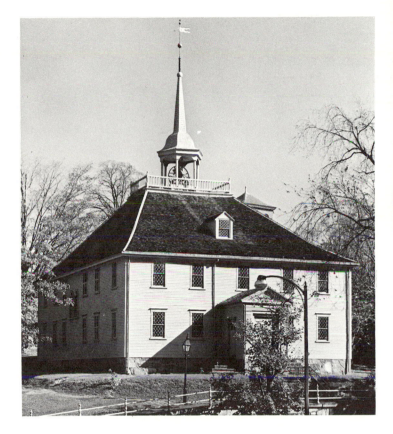

left: 76. Old Ship Meetinghouse, Hingham, Mass. 1681 (modifed 1730, 1775; restored 1930).

above: 77. Interior roof construction, Old Ship Meetinghouse, Hingham, Mass. 1681.

structure was usually surmounted by a hipped or pyramidal roof, topped by a square platform carrying a belfry.

The Old Ship Meetinghouse in Hingham, Mass., though amplified with two porches and some classical details in the eighteenth century, is the only seventeenth-century New England church to retain most of its original form. The interior is particularly impressive, for it reveals the finest system of great beams, rafters, diagonal braces, and pendants to come down to us from those early years (Fig. 77).

Schools, town halls, the first colleges, stores, mills, taverns, and trading posts were also built in the little New England communities, but except for a few reconstructions none of these still stands.

The log cabin has often been erroneously considered the standard early type of dwelling, but it did not achieve its wide popularity among Anglo-Saxon settlers until well into the eighteenth century. The Swedes who moved into the Delaware Valley in the mid-seventeenth century brought from their motherland a superb tradition of wood crafts. Their early dwellings and fortifications were made of round logs, notched to fit together at the corners, with protruding ends. At a very early date the Swedish settlers also used a superior form of log construction in which hand-hewn rectangular logs with dovetailed corners were fitted together so carefully that they remained waterproof even without the usual clay chinking. Long after the log cabin had been introduced into Delaware by the Swedes and into Pennsylvania by the Germans, it became a standard frontier dwelling. It was particularly popular with Scotch-Irish immigrants, who arrived in great numbers during the eighteenth century and settled in many of the inland frontier areas where timber was abundant.

Curiously enough, the early English settlers did not employ hewn-log construction for their residences, though they were familiar with it, as is revealed by their early blockhouses and fortifications. Though no blockhouses have been preserved from the seventeenth century, Fort

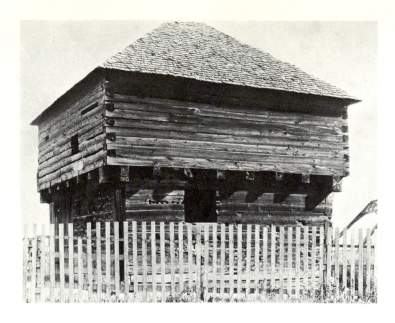

78. Fort Halifax, Winslow, Maine. 1754. Hewn-log construction.

Halifax (Fig. 78), built in Winslow, Maine, in 1754, illustrates the typical hewn-log construction and rectangular design of the earliest fortifications. The most distinctive features of these blockhouses are the heavy construction, the height, the bold overhang, the absence of windows, and the presence of an occasional loophole to permit the firing of guns. The few examples of these early fortifications that still stand serve as a grim reminder of the dangers of frontier existence. Blockhouses were ordered built in all the early communities to provide protection for the townspeople in case of attack by the French or the Indians.

SOUTHERN COLONIAL BUILDING

Jamestown, located on an island in the James River in the heart of tidewater Virginia, was the first city in England's great colonial empire of the South, which stretched for 500 miles along the Atlantic coast from Delaware Bay to the Savannah River. About one hundred colonists established Jamestown in 1607 and sheltered themselves in "flimsy cabins and holes within the ground." Despite the initial hardships that decimated their ranks, by 1615 Jamestown boasted two fair rows of houses of framed timber, each of two stories and an upper garret, and three substantial storehouses.

The colonists who settled in Virginia, Maryland, the Carolinas, and elsewhere in the South had no quarrel with the Church of England nor with the king, and, for the most part, their society reflected the aristocratic ideals and aspirations of England. In contrast to New England there were few towns or villages. This great agricultural empire was made up of large plantations, isolated yet connected with one another and with England by continuous waterways. Because of its social and economic structure and the larger proportion of aristocratic colonists, the South retained the more elegant traditions of Europe. Certainly the commodious mansions built before the end of the seventeenth century in Virginia and Maryland reflect the increasingly Renaissance flavor of Tudor court architecture, unlike the architecture of New England which remained essentially medieval during the same period.

The settlers of New England came mainly from the southeastern counties of England, where wood was relatively plentiful; those of the South more frequently came from areas where brick construction was traditional. Brickmakers were among the first artisans to settle Jamestown, and an abundance of fine clay and oyster shells, from which lime could be made, encouraged the construction of brick buildings.

The plans of the first one- and two-room, story-and-a-half and two-story houses built in Virginia and Maryland, whether of brick or wood, resemble those of New England, with one frequent exception. The chimney, which even in the one-room plan of New England was centrally located and entirely enclosed by the house, in the South was often incorporated into the end wall or projected from it. In the one-room plan the stairway to the second story stood in one corner of the room. The typical two-room plan of the South had two chimneys, one at each end of the building, rather than the central chimney with back-to-back fireplaces.

The Adam Thoroughgood House (Fig. 79) in Norfolk, Va., provides a handsome example of the two-room southern brick house, with its copious chimneys, superb

79. Adam Thoroughgood House, Norfolk, Va. 1636–40.

brickwork, and gently arched headers above the casement windows.

At rather an early date in southern houses the staircase which led to the second story was placed in the center of the building, between the two rooms, on the side opposite the entrance. This stairway soon occupied a separate room, and the central section housing the stairway was elaborated into an entrance hall which projected in front of the building. Behind this were a central hall and a stairwell which projected from the back, making a cruciform plan.

This plan is found in one of the most elaborate and impressive brick structures of seventeenth-century Virginia, Bacon's Castle (Figs. 80, 81), in Surry County, built about 1655. It is the earliest of the Virginia cross-plan houses still standing. Two large rooms, a hall and a parlor, run the length of the ground floor. A porch extending in front and a stair tower in the rear make the transept, or crossarm, of the cruciform plan. The second floor has two large chambers, and the garret encloses three additional bedrooms. Two chimneys extend from the wall at each end of the building and serve the four main rooms of the house.

Each end wall is shaped at the top to terminate in impressive gables, the rectangular steps of which alternate with curves to form a bold crested silhouette. Standing a few inches free of these gables are triple chimney stacks set diagonally and joined only at the top. These stacks rise

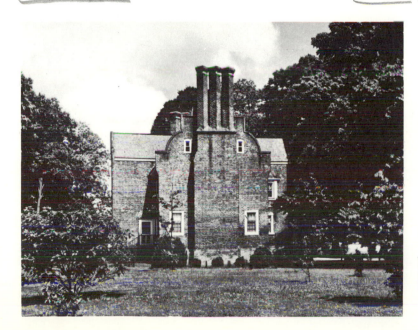

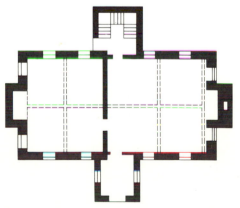

left: 80. Bacon's Castle, Surry County, Va. 1655. (旧 N)

above: 81. Plan of Bacon's Castle (southern cruciform plan).

51

from a capacious lower chimney, 4 feet deep and 10 feet wide. The English bond brickwork is skillfully done, and the elaboration of moldings at the tops of the gables and chimneys and around the windows is well conceived and executed. Bacon's Castle is patterned after the great Jacobean country houses of England, in which such essentially Baroque elements as the crested gables were combined with Renaissance and even Gothic details, such as the great triple chimney stacks. This ambitious exterior speaks for the aristocratic temperament of the Virginian, who fashioned his home after the manor houses of the English gentry.

The finest church to be built in America in the seventeenth century also stands in Virginia. The date of construction for the Old Brick Church, or Newport Parish Church (Fig. 82), of Smithfield, Isle of Wight County, is the subject of controversy. An inscribed brick in one wall has a worn numeral that could be a 3 or an 8. Modern study of the evidence places the date at 1632. The building was the handsomest duplication in America of the late medieval parish churches of England. The walls, over 2 feet thick, were skillfully laid in Flemish

82. Old Brick Church (St. Luke's or Newport Parish Church), Smithfield, Isle of Wight County, Va. 1632.

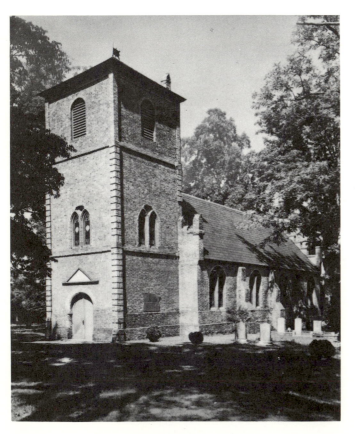

bond—a method of laying brick in which the lengths and widths of the brick alternate in a single course. A tower 20 feet square rises three stories to a belfry. The pointed-arched windows with simple brick tracery, the sturdy pinnacled buttresses, the high-pitched roof, and the stepped rear gable prove that the memory of Gothic churches was still alive and that the colonial builder was capable of handling these remembered forms with invention and vigor.

DUTCH COLONIAL BUILDING

The Dutch West India Company was established in 1621 to found the colony of New Amsterdam. By 1626 a fort had been built and thirty bark-covered huts had been constructed. Within a short time thereafter, permanent homes, a church, an inn, and other necessary buildings were under construction. Though the Dutch ruled this area for less than fifty years, and though the city of New Amsterdam was noted for its cosmopolitan flavor, the architecture of southern New York, Long Island, and northern New Jersey retained Dutch elements for almost two hundred years. By the middle of the seventeenth century, New Amsterdam was in many ways a replica of Holland's Amsterdam, with gently curving streets and canals lined with buildings whose quaintly gabled façades faced the main arteries of the city. A great fire in 1776 wiped out most of the original Dutch city, but its appearance was recorded in a few old prints. One of the most informative of the early prints (Fig. 83) shows the character of the dignified five-story State House, as well as the more usual two-and-a-half-story and three-and-a-half-story row houses on either side of it.

The most striking architectural features of Dutch architecture were the stepped gables, facing the street, which rose through a series of right angles to end in a chimney or rectangular crest. Framing and construction were of the heavy-timbered type similar to that of New England. The windows, symmetrically placed on the front, had small panes, and the larger windows were divided into two parts by a heavy transom. The headers for the windows were often gently arched, and the space between the arch and the rectangular window frame might be ornamented with brightly colored tiles. Though houses were built of wood and stone, brick was the favorite material here, as in the homeland, and the gay effect of the colored bricks and tiles was frequently commented on by travelers, who contrasted the Dutch love of color with the drab sobriety of the villages of New England. Ordinary red bricks of fine quality were made, but monotony was avoided by the use of glazed bricks in pinks, yellows, oranges, and dark tones, which ran to deep

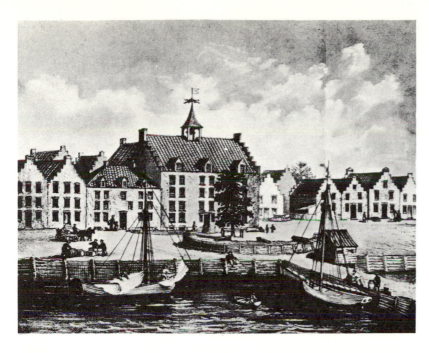

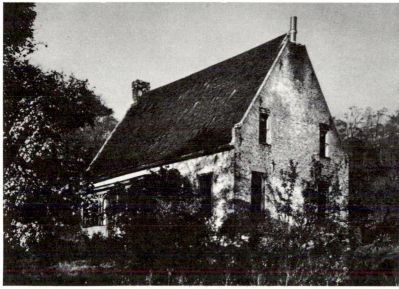

purples and blue-blacks. These shiny, colored bricks were laid in a variety of bonds enlivened with diamond, herringbone, and other ornamental patterns. The warm-hued tiles preferred for roofing also added color and texture. Travelers also noted the light, brightly painted interiors. The charm of the scrupulously clean Dutch rooms was augmented by ceramics and pictures from Holland.

Though the stepped gable was popular, it was not universal. In many rural areas the high-pitched, straight-edged gable was preferred. The De Bries House, East

Greenbush, N.Y. (Fig. 84), is a fine example from the early seventeenth century, and, like many rural houses, it has its entrance on the long side. Among its character-istic features are the steep roof, the "elbows" at the lower corners of the end gables, and the bricks set at right angles to the sloping sides of the gable, producing a more weathertight surface than the stepped gable.

During the seventeenth and eighteenth centuries, there appeared in certain rural districts of Long Island, southern New York, and northern New Jersey a type of house that departed radically from the tall, gabled structures of

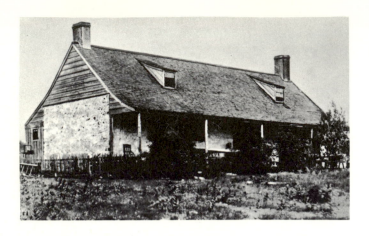

New Amsterdam. The antecedents for this way of building appear to have been taken to Holland from Flanders by the Walloon and Flemish settlers who sought refuge during the Spanish occupation of Flanders early in the seventeenth century. Finding Holland crowded, these refugees continued their flight overseas to the New Netherlands, and since many were peasants, they settled in the rural areas. They introduced a type of house design common to northwestern France and Belgium. Usually a story-and-a-half, these houses are simple in plan, containing two or three rooms in a straight line, with narrow bedrooms in back opening off the main rooms. Shingle, clapboard siding, or fieldstone were the materials used most frequently on exteriors, and many houses combined them. The most distinctive feature of these dwellings was the roof, which extended 2 or 3 feet beyond the wall in both front and back to create a graceful overhang with a gentle curve.

The Hendrickson-Winant House (Fig. 85) at Rossville, Staten Island, despite later additions, provides an example of this kind of structure. The dormers and the farther section of the building were added in the eighteenth century, at which time the overhang was extended and supporting posts added.

In the eighteenth century this Flemish type of house, modified by the addition of gambrel roofs to create more space under the eaves and the enlargement of the front overhang to an entrance porch, produced a type of American house, called "Dutch colonial," which persisted into the twentieth century.

SPANISH ARCHITECTURE

The Spaniards were the first European settlers and builders in America. The philosophy on which they built their empire is revealed by the sequence in which they constructed the buildings that marked their entry into a new country. First came the presidio, or fort; then the mission church; and last, the pueblo or village. The Spaniards came to conquer land and seek treasure for the king of Spain; to conquer souls for the church was also an ardent aim; to build villages, till the land, or found a new way of life was farther from their purpose, although in time those activities followed as an inevitable corollary to the primary aims.

Spain and France fought for Florida in the sixteenth century, and Spain won. The Spaniards began settling in Florida, and by the middle of the seventeenth century they had established a chain of about forty missions, of which no sign remains. The outstanding monument to Spanish rule in Florida is the great Castillo de San Marco (Fig. 86) in St. Augustine. Commenced in 1672 and constructed over a period of more than seventy-five years, the Castillo de San Marco is the most impressive surviving example in the United States of the type of fortress that

top: 85. Hendrickson-Winant House, Rossville, Staten Island, N. Y. 17th century.

right: 86. Castillo de San Marco St. Augustine, Fla. 1672–1750.

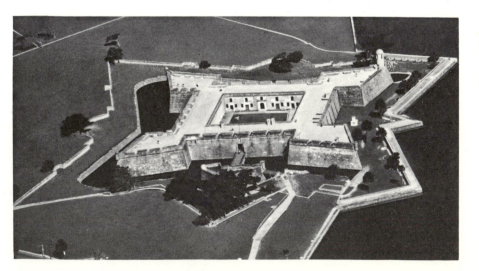

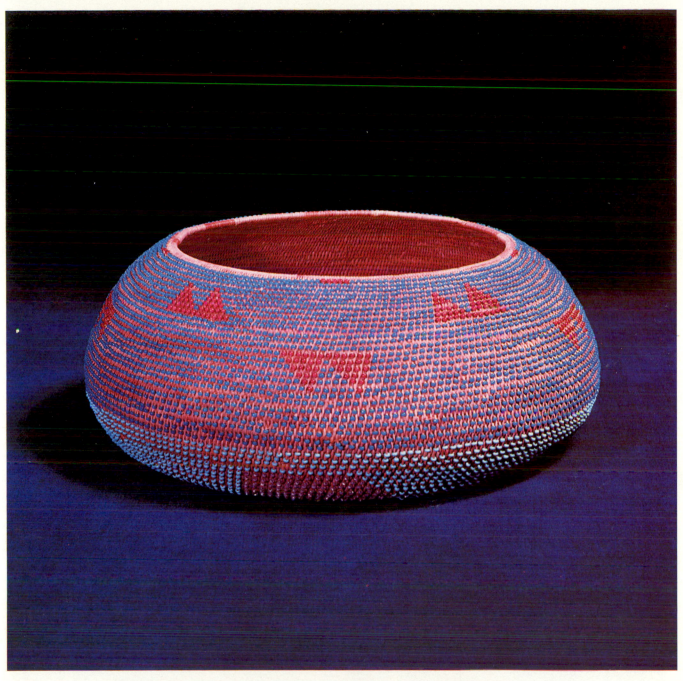

Plate 1. Pomo gift basket, from California. c. 1900. Woven grass with glass beads, 3 ¾ × 12″.
Museum of the American Indian, New York.

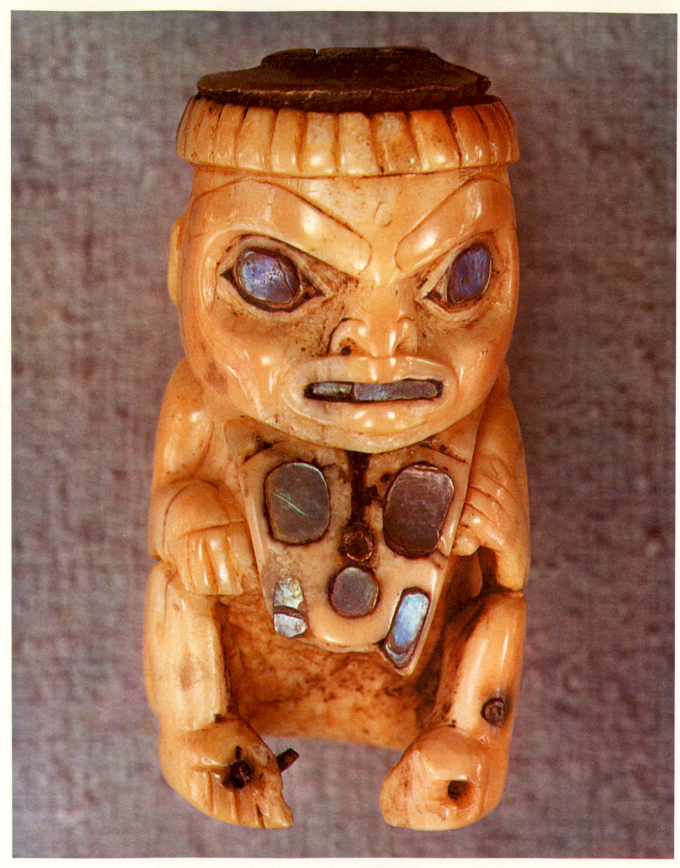

Plate 2. Tlingit effigy pipe bowl, from Klukwan, Alaska. 1825–50.
Walrus ivory with haliotis shell, height 2 ½″. Museum of the American Indian, New York.

87. Palace of the Governors, Santa Fe, N.M. 1610–14.

appeared in Europe in the late Middle Ages with the advent of gunpowder. Built of great blocks of gray-white coquina limestone, the fortress has an inner court, about 100 feet square, surrounded by heavy walls. In these walls are chambers with heavy vaulted ceilings, housing chapel, officers' quarters, arsenals, and cells. The entire fortification was surrounded by a great outer wall 25 feet high and 12 feet thick at the base, which sloped to a width of 3 feet at the top. A huge platform 40 feet wide faced the river, and this area was surrounded by a heavy parapet pierced for sixty-four guns. Except for this great bastion, a church, and a few houses of questionable authenticity, nothing remains in Florida from the Spanish builders except a tradition that remained dormant many years until its revival in the twentieth century.

New Mexico was the first part of the Southwest to be settled. Earlier expeditions from Mexico into New Mexico had come to nothing, but in 1609 Santa Fe was established as the administrative center of New Mexico, and the following year work was started on the Palace of the Governors (Fig. 87). Completed in 1614, the building still stands—the oldest non-Indian structure in the United States. Typical of a presidio, this great rectangular enclosure, 400 by 800 feet long, once housed barracks, chapel, offices, storage facilities, and a prison. The most important building in the compound was the Governor's Palace proper, a long, low structure facing the open plaza, fronted by a covered porch. Indians provided the labor, and many traditional Indian building techniques were retained in constructing these buildings. Though the Indians employed adobe bricks, a European

improvement in the form of a box was used to mold the wet clay into uniformly sized and shaped bricks. The covered porch supported by wooden posts was also a Spanish feature, as were the enclosed patio and the wooden-framed doors and windows. This manner of combining native materials and building practices with elements from the European tradition characterized Spanish building practices all through the New World; consequently, the buildings erected under Spanish guidance seem less foreign, more in harmony with the original Indian culture of the area, than do those built by the English, Dutch, and French settlers.

Nowhere is this harmony among the traditional native style of architecture, the terrain, and the buildings of the Spanish settlers more evident than in New Mexico. Even today, as one travels through the little villages, the peculiar rightness and charm of the low, rectangular houses plastered with tannish orange adobe are inescapable. The small buildings, punctuated occasionally by the solemn bulk of a church, appear very little amid the endless vistas of mountain and mesa under the vast canopy of sky. The forms become part of the earth, as related visually to their surroundings as the adobe is materially.

The mission churches, built during the seventeenth century, abandoned and then rebuilt during a period of intensive recolonization in the eighteenth century, are the major architectural achievements of the Spaniards in this area. In all Spanish colonies the church stands as the chief symbol of Spanish idealism, just as the private dwelling appears to express the aims, hopes, and ideals of the colonists of the Atlantic coast.

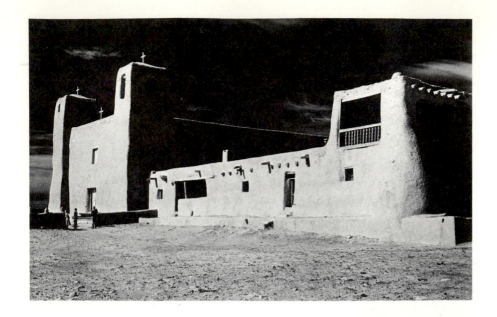

88. San Esteban Rey, Acoma Pueblo, New Mexico. c. 1642.

The great church of San Esteban Rey at Acoma (Fig. 88) is probably the most impressive of the mission churches of New Mexico. It is estimated that the church was completed in 1642 after years of construction. The simple, massive towers, with their heavy, wavering, buttresslike forms, frame the bare façade, which is unbroken except for the entrance door and a window that lights the choir loft. The thick walls of adobe are narrower at the top than at the base, giving a weighty pyramidal character to the structure, and there are a minimum of windows, doors, and decorative enhancements. On the north side is the long, low *convento*, with its enclosed patio, living rooms, workrooms, storerooms, and the picturesque balcony with irregular railings and curious corbeled capitals on the columns. Impressive because of the sober monumentality of its forms, the handicrafted honesty of its surfaces and materials, and its magnificent location atop the mesa, San Esteban Rey stands as a tribute to the merging of two great building traditions.

The mission churches represent a last, faint, provincial echo of Spanish church design, the monastic complex of buildings with its splendid Baroque decorations being modified and interpreted in terms of Indian craftsmen, local materials, and the simple life of the mission settlements.

Though it appears to have been built toward the end of the eighteenth century, the Ranchos de Taos Church (Fig. 89) belongs stylistically to the seventeenth century. Not so large as San Esteban Rey nor so remarkable in plan, nevertheless the mission church at Taos is the most frequently pictured of the New Mexico churches because of its rare charm. Two sturdy bell towers topped by

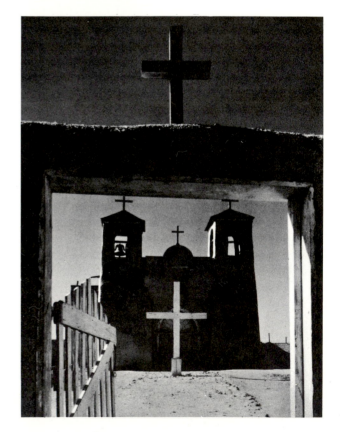

above: 89. Mission St. Francis of Assisi, Ranchos de Taos, N.M. 1772.

opposite: 90. Interior, Mission St. Francis of Assisi, Ranchos de Taos, N.M.

simple crosses flank the entrance, which is enhanced by simple wooden doors and a decorated tympanum surmounted by a semicircular crest and a third cross. The forms of the buttresses, the central area, and the bell towers enfold one another with a rich sculptural unity, and the almost unbroken masses produce a handsome architectural composition of unique distinction. The interior (Fig. 90) is of touching simplicity. The elaborately shaped corbels which support the heavy beams of the ceiling, the candidly crude braces, and the simply constructed pews and altar railings were all the handiwork of local craftsmen under the direction of their priests. A few sacred statues and paintings were brought from Mexico, but the Indians carved and painted most of their own images, and these simple, even crude, figures, seen in the dim light against the whitewashed walls, convey the faith of these people with unusual directness and force.

FURNITURE

Though most American seventeenth-century furniture and household wares, like the architecture, were based on medieval folk practices, the more elaborate pieces from the end of the century reflect the English court styles. Consequently, the chief stylistic developments of the mother country might well be noted here. The English court styles between 1608 and 1688 are generally described by the term "Jacobean," and the Jacobean period divides into two parts. In the first half, from 1603 to 1659, Renaissance elements constituted the new look in architecture, furniture, and the household arts. Between 1660

and 1688, after the Cromwellian Commonwealth, Baroque features from France and Flanders became increasingly frequent. The William and Mary style, a more fully developed Baroque style, flourished from 1688 until well into the eighteenth century. In America William and Mary stylistic characteristics first appeared in the silverware of the last decade of the seventeenth century, and not until the turn of the century did furniture reflect this newer style.

Furniture was scarce in seventeenth-century America, and the repertory was limited. Stools, benches, small tables, chests, and chest-and-drawer combinations were the pieces in most frequent use. A trestle board (a wide board which rested on light-braced sawhorses and could be dismantled and stored in a small space) served as a dining table. Side chairs, used much less frequently than stools, were reserved for old or distinguished persons. Settles (benches with high backs) were placed in front of the fireplace or flanking the hearth, for their high backs held in the heat and kept out drafts. Small trundle beds on rockers provided protection for the babies. Beds hardly constituted pieces of furniture; a wooden frame supporting cross slats or ropes held a straw or feather mattress. At a later date hangings were suspended from the ceiling or from a frame extended from the corner posts of the bed to provide increased protection from drafts, thereby creating the four-poster bed.

Little seventeenth-century furniture still remains, other than from the English settlers. Most of that is from Massachusetts and Connecticut and was made by anonymous craftsmen in the last quarter of the century. Like

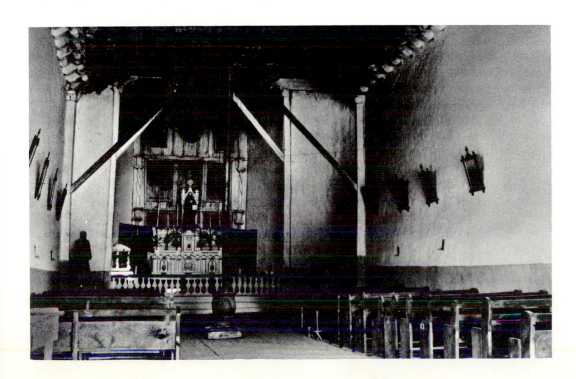

the architecture, it was based on a simple medieval tradition in which sturdy utilitarian considerations were foremost. Square-framed construction was employed, with vertical supports connecting horizontal parts, reinforced by vertical and horizontal stretchers. Much of the furniture was devoid of ornamentation, but in even the simplest pieces the headboards, arms, legs, and stretchers were shaped to increase the grace of the whole. Toward the end of the century increased affluence brought grander homes and more elaborately designed furniture based on the more sophisticated Jacobean style, which had been adopted by the English court and upper middle class by mid-century.

Turning was the most common decorative treatment in the seventeenth century. Turning is achieved by the application of cutting tools to a surface that is rotated on a lathe. The most characteristic seventeenth-century turning is simple "bun" turning, such as can be seen topping the posts in Figure 91, or the sausage type made by repeating the bun profile. Late in the century, when the more pretentious court styles were introduced into America, elaborate designs were used—spiral turnings, baluster types (Fig. 93), melon type (cupboard, Fig. 96), disk-and-spool (Fig. 97), and many others. Turning was applied to legs, posts, feet, spindles, stretchers, and rungs, and turned spindles were split and applied as surface decorations on the more elaborate cupboards and chests. In addition to turned decorations, cabinetmakers decorated flat surfaces with shallow carvings of typical medieval folk motifs, including formalized leaves, flowers, rosettes, and geometric patterns. The carved patterns were frequently reinforced by color or textural enrichments.

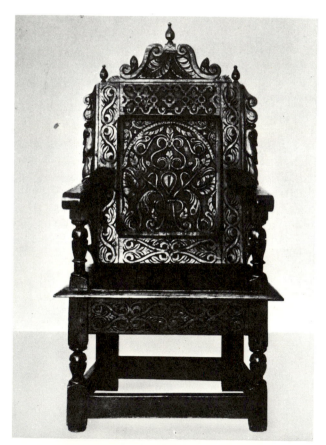

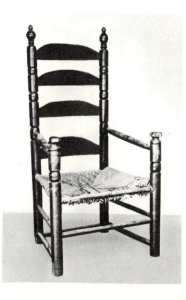

above left: 91. "Carver" armchair. Mid-17th century. Maple and oak. Philadelphia Museum of Art (Charles F. Williams Collection).

left: 92. Slat-back armchair. 1675–1700. Maple. Metropolitan Museum of Art, New York (gift of Mrs. Russell Sage, 1909).

above: 93. THOMAS DENNIS (?). Wainscot armchair. 1660–75. Oak. Essex Institute, Salem, Mass.

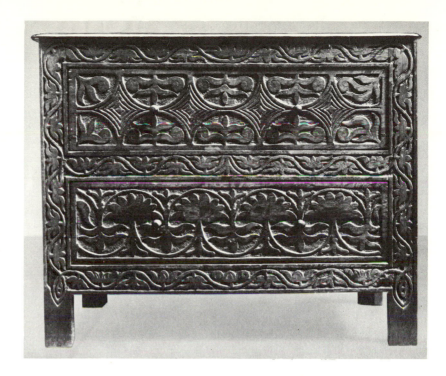

94. Hartford chest, from Connecticut. c. 1625. Oak and pine. Metropolitan Museum of Art, New York (Rogers Fund, 1908).

Chairs with straight posts, stick backs, simple stick stretchers, and rush seats were common in all parts of Europe, and most of the chairs made in seventeenth-century America were of this type. When elaboration was desired, the vertical supports were enhanced with simple turnings, and the back slats and arms were tapered and carefully shaped. Such chairs constituted unpretentious but pleasing pieces of furniture that were in harmony with the plain colonial interiors. A "Carver" chair (Fig. 91), named after Governor Carver of Plymouth, is a fine example of such straightforward design. Small bun finials top the vertical posts, and turned spools and a double bar in the backrest lighten the forms and provide a touch of grace to this serviceable piece of furniture.

Similar in construction but more elaborate are the "Elder Brewster" armchairs, in which the spaces between the horizontal structural members are filled with slender vertical spindles. A third closely related type was the slat-back chair, in which carefully shaped, graduated, flat, horizontal slats provided the back supports (Fig. 92). In less sophisticated areas slat-back chairs remained popular well into the nineteenth century.

The wainscot chair, a type that appeared less frequently in seventeenth-century America, was derived from the more elaborate English court styles. One handsome example (Fig. 93) has been attributed to Thomas Dennis of Ipswich, Mass., one of the few seventeenth-century "joyners" whose name has been preserved. Though richly ornamented, the structural framework remains sharply

defined in this solid oak chair. The carved back and the front rail have been decorated with a somewhat naïve interpretation of such Renaissance ornamental motifs as scrolls, leaves, caryatidlike figures, finials, and a crest. The shaped arms terminated by scrolls and the baluster turnings of the front posts foreshadow the more complex, lighter, three-dimensional ornamentation which became increasingly popular in succeeding generations.

Late in the seventeenth century the Baroque elements that had been introduced into English furniture and silver with the restoration of the Stuarts in 1660 began to appear in American furniture. These Baroque tendencies came to their initial fruition in the taller, more graceful, and more richly ornamented William and Mary styles at the end of the century. These stylistic changes will be discussed in Chapter 5.

Chests and storage boxes were among the most useful pieces of furniture in the colonial household, since they provided space for the household valuables. The chests from Massachusetts seem to be patterned after the more elaborate English chests or court cupboards (Fig. 96). Connecticut chests tended to imitate the more simple, humble folk wares, and some interesting local versions appeared. The various types of Connecticut chests are named after the localities where they were produced; thus Hartford chests were produced around Hartford, and Hadley chests around Hadley, to mention two familiar types. On a chest (Fig. 94) from Hartford County, Conn., the front is completely covered by bands carved in flat,

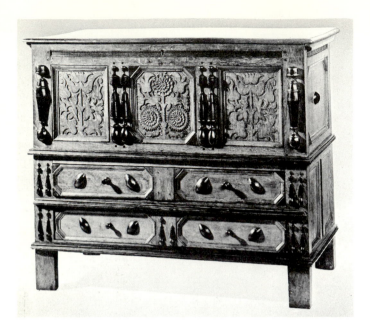

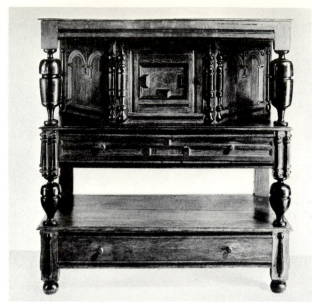

left: 95. PETER BLIN (?). Chest over drawers. 1670–1710. Oak and pine, 39¾ × 47½″. Yale University Art Gallery, New Haven, Conn. (Mabel Brady Garvan Collection).

right: 96. Court cupboard. 17th century. Oak. Henry Francis du Pont Winterthur Museum, Winterthur, Del.

shallow relief. The formalized leaf, flower, and tendril patterns based on the popular tulip motif are placed logically to enrich the drawer fronts and the frame. This clean craftsmanship and decorative patterning contribute an unpretentious charm, which often appeals to modern tastes more than do the heavily ornamented aristocratic styles. Though here the background in the carved section is separated from the front plane by a texture, the carved pattern was usually emphasized by staining or painting the background a contrasting color.

A somewhat more elaborate chest from around Weathersfield, Conn., is less purely a product of folk tradition and begins to reflect the Renaissance character of Tudor court styles (Fig. 95). While the tulip and sunflower patterns carved in shallow relief in the panels of the top half are of folk origin, the semilozenge-shaped framed panels, the architectonic design, and the use of more three-dimensional moldings, applied split spindles, and turtleback drawer pulls, all reveal the tendency toward fuller three-dimensional decoration and greater formality and elaboration so characteristic of the Renaissance period.

The most imposing pieces of furniture produced in Massachusetts were court cupboards, closely patterned after the splendid examples used in England (Fig. 96). This fine court cupboard of oak is decorated with split spindles, geometric and arched inset panels, rounded moldings, and, most conspicuously, the heavy melon turnings used as supports on the front. These motifs all derive indirectly from Renaissance conventions. Similar cupboards can be seen in the interior of the Hart House (Fig. 75). As a departure from the boxlike solidity of earlier chests, open spaces have been left for the display of plates, pottery, and other valuables. These chests and cupboards were the precursors of the splendid chests, double chests, and highboys that were among the most notable achievements of the eighteenth-century American designers.

An interesting type of chest from this period was the Bible box. This small boxlike chest with a hinged, slanting top, sometimes placed on long legs, was designed to hold the Bible and important papers. The ancestor of the desk, the Bible box, too, was destined for a stellar role in the following century, when it developed into the magnificent secretary or secretary-bookcase.

Space was at a premium in the seventeenth century, for the crowded multipurpose rooms had to serve a great variety of family needs. Necessity coupled with Yankee ingenuity produced such interesting combination pieces of furniture as a chair with a back which folded down to make a table; the hutch tables of the day performed a third service by including storage space in a chest incorporated in the base of the chair part. Gate-legged tables in a variety of forms, as well as butterfly tables (small drop-leaf tables whose leaves were supported by a swinging bracket shaped like the wing of a butterfly) also represented popular space-saving devices. A gate-

right: 97. Gate-legged table, from Connecticut. Late 17th century. Walnut. Philadelphia Museum of Art (Charles F. Williams Collection).

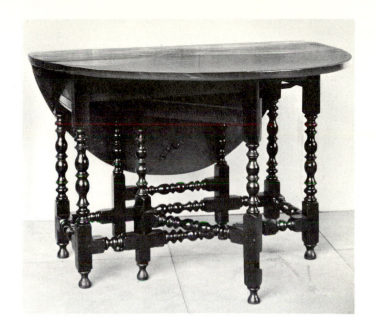

legged table from the end of the century (Fig. 97) fore-shadows the William and Mary style of the turn of the century in its rich multiplicity of turnings.

A variety of hard and soft woods was available to the colonial craftsman. Oak, birch, maple, and hickory were used when strength was the primary consideration. Pine was frequently employed when wide boards were needed or when ease of working was an important factor. A number of woods were frequently combined in one piece of furniture, oak or maple being used for the framing members while pine provided the paneling or the planking for chair seats or table tops. At the end of the century walnut became popular. Its fine grain was suitable for the more elaborate turnings and carvings that were used in the furniture made for the rapidly expanding class of business-men, planters, and traders. The wood was either left raw or finished with wax or oil; it gradually acquired depth of color and polish through simple friction and natural darkening.

HOUSEHOLD ARTS

Although the exigencies of settlement demanded the major energies of the people, within a surprisingly few years energetic craftsmen were busily producing the wares associated with civilized living. Potters were making dishes and containers, brick and tile makers were at work, glaziers were making bottles and window glass, silver-smiths, ironmongers, tinsmiths, and weavers—all were attempting to supply the needs of the colonists and aug-ment the limited flow of goods from Europe. Unfortunate-ly, little except for metalwares survived the hard usage of colonial life. It is only in recent years that the excavations at Jamestown, Va., have provided enough household artifacts to give us a picture of the other household arts in the seventeenth century.

Jamestown served as the capital of Virginia for almost a hundred years. After a century of prominence it entered a long period of decline, precipitated by the removal of the capital to Williamsburg in 1700. By the middle of the nineteenth century the site of Jamestown had become farmland, but in 1934 the area was made a national park,

thus permitting the extensive excavations that have enabled us to become familiar with the way of life that once flourished there.

Ceramics

The simplest and most abundant pottery uncovered at Jamestown, the essentially utilitarian glazed redware, is like that from seventeenth-century New England. This early redware was made from local glacial clays of the same type as were used in the manufacture of bricks and tiles. Pots, bowls, mugs, and pitchers were thrown on the potter's wheel, and their shapes were sturdy and full. Red lead or litharge was mixed with sand or ground glass to provide a brilliant, shiny glaze, and pleasant variations of the glaze were obtained by the addition of manganese, copper filings, cobalt, and other materials. A photograph of ceramic wares (Fig. 98) from Jamestown, which were

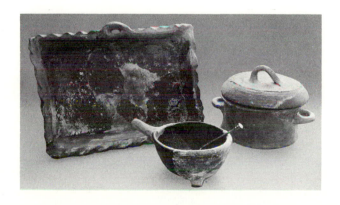

right: 98. Baking and cooking vessels, from Jamestown, Va., probably made in North Devon, England. 17th century. Grit-tempered earthenware. Colonial National Historical Park, Yorktown, Va.

probably from England but could have been from the hands of a local potter, reveals something of the variety of earthenware dishes that were used for baking, cooking, and the table.

The potters of Jamestown, like those of New England, employed various simple devices to decorate their wares. Some ceramics were decorated with liquid slip made of white or pipe clays. This thin mixture of light-colored clay was trailed across the body of the darker base in thin lines to make zigzags, scrolls, dots, wavy lines, and other familiar patterns. Engraved parallel straight or wavy lines were also made on the body of a vessel, before it was glazed, by holding a sharp stick against the side while it was being turned on the wheel. An interesting ceramic find at Jamestown is English sgraffito ware, very similar in character to the sgraffito ware produced by the German settlers of Pennsylvania (Fig. 156), even to the use of the tulip motif, which was the favorite of the German craftsmen. Sgraffito ware was decorated by cutting through the covering slip with a pointed instrument and exposing the dark-red pottery base.

Silver and Metalwares

The accumulation of household silver presented a convenient way to store savings in the days before banks, stocks, and bonds. Consequently, there was a great demand for the services of the silversmith in the thriving colonies. The elaboration of social life in the late seventeenth century, the popularity of tea, coffee, and chocolate, and the general refinement of eating habits contributed to the demand for silver utensils for the home. Church ritual also demanded silver ceremonial plates. A number of silversmiths migrated from England, and while silverware was produced in Jamestown and other colonial cities, first Boston and then New York became the chief centers for the manufacturing of silver objects in the eighteenth century.

Much of the remaining seventeenth-century silver seems more elaborate than the furniture. There are a number of reasons for this. First, simpler pieces would be considered less valuable than the elaborate ones and so would be melted down and remade by later generations. Second, silver was both a repository for wealth and a symbol of social prestige, so that elaboration was inevitable. Last, the first silversmiths working here had been trained abroad and so were conversant with the elaborate designs desired by the aristocracy and wealthy mercantile classes of Europe. Even so, colonial taste being conservative, much of the silver was devoid of excessive ornament and depended for its beauty on fine proportions and excellent workmanship.

Most of the silver was rolled into sheets and hammered into shape, a method of production which creates a rich surface sheen. The pieces which were cast in molds or shaped over revolving wooden forms were also hammered and worked over until a fine surface was obtained, providing pleasure to both hand and eye. The more ornate pieces of silver were decorated by engraving (or "chasing," as it is frequently termed) and embossing or by casting sculptural forms which were then soldered to the body of the vessel. The most popular designs used for engraving were owners' initials, family crests, floral and foliate motifs, birds, animals, and human forms drawn from medieval and Renaissance sources and from Chinese ceramics and textiles. The more sculptural decorations stemmed primarily from Baroque modes. These consisted of the heavier turned forms used on the stems of cups, flutings, gadroonings, and swelling cartouches, as well as the cast enrichments mentioned above. Drinking vessels—such as the various types of cups, tankards, beakers, tumblers, and punch bowls—and candlesticks are the chief

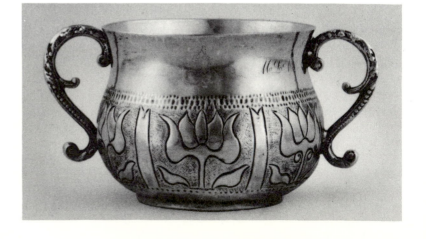

99. JOHN HULL and ROBERT SANDERSON. Caudle cup. 1652. Silver, height 3 ³/₁₆″. Museum of Fine Arts, Boston (The Philip Leffingwell Spalding Collection).

surviving wares. Forms tended to be low and rounded with full-bellied profiles.

The earliest Bostonian silversmiths of whose work we have records were John Hull (1624–83) and his partner, Robert Sanderson (1608–93). A caudle cup (Fig. 99) from the workshop of Hull and Sanderson is dated 1652. The chubby, full shape of this wine cup is enriched by a simply textured, engraved band of tulips and leaves and by the animated curves of the cast handles. The effect is gay and unpretentious. Jeremiah Dummer (1645–1718), an apprentice to Hull and Sanderson, was one of Boston's most productive silversmiths. A pair of his candlesticks are distinguished by his fine craftsmanship and the strength and simplicity of his design (Fig. 100). The tall, fluted columns are broken by a raised band slightly above the center, creating a pleasing division of spaces. The squares at the top and bottom of the column, which repeat the shape of the base, have been modulated by a simple foliate pattern to avoid monotony. The New England preference for a pure and severe form enriched with rather sparse decoration is here given a masterful treatment.

There is no finer example of the richly decorated silver produced in Boston about the turn of the century than a sugar box (Fig. 101) by John Coney (1655–1722), one of the most versatile silversmiths in the city at the time. This particular piece is engraved with the legend "Gift of Grandmother Norton to Ann Quincy." It was in the designing of such gifts that the colonial silversmith displayed his skill and ingenuity. A full repertoire of decorative effects was used here. Full-swelling, elliptical medallions separated by flutings topped by leaf and bud shapes decorate the body of this bowl, and the same motif is repeated on a smaller scale around the edge of the domed cover. Effectively developed acanthus leaves in striking contrast to a heavily textured ground enliven the center of the cover. The handle and feet have been cast in Baroque forms, a cut-out pattern enriches the latch, and the elegantly shaped moldings around the edge of the cover complete the decoration of this splendid piece.

New York silver from the end of the century shows the Dutch predilection for elaborate decorations. Engraved and embossed fruits, flowers, leaves, birds, and figural elements were used freely, along with heavier cast forms of acanthus leaves, curved handles, and rounded moldings.

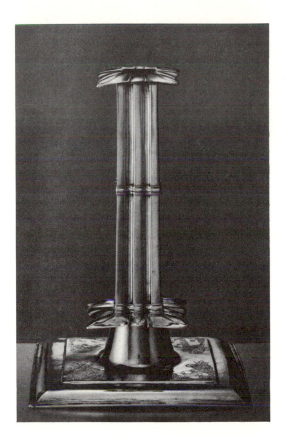

100. JEREMIAH DUMMER. Candlestick. Before 1686. Silver, height 10⅞". Yale University Art Gallery, New Haven, Conn. (Mabel Brady Garvan Collection, gift of Francis P. Garvan, 1897).

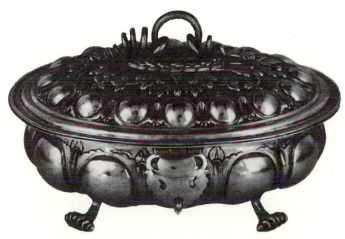

right: 101. JOHN CONEY. Sugar box. c. 1690. Silver, height 4⅞". Museum of Fine Arts, Boston (gift of Mrs. J. R. Churchill).

below: 102. GERIT ONKLEBAG. Covered caudle cup. Late 17th–early 18th century. Silver, height 5¾″. Yale University Art Gallery, New Haven, Conn. (Mabel Brady Garvan Collection, gift of Francis P. Garvan, 1897).

right: 103. Hinges with cock's-head design. Mid-17th century. Wrought iron, length 7″. Metropolitan Museum of Art, New York (Rogers Fund, 1937).

below right: 104. Weather vane. 1673. Metal, height 4′3½″. Concord Free Library, Concord, Mass.

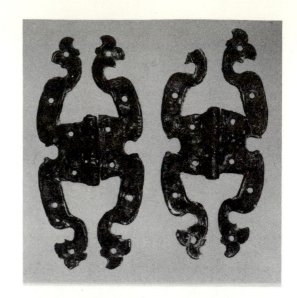

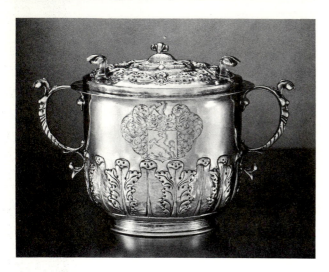

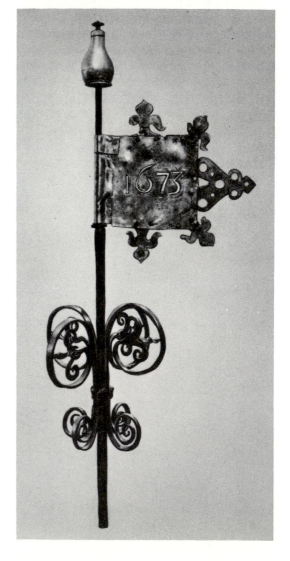

A covered caudle cup for drinking mulled wine (Fig. 102) by Gerit Onkelbag (1670–1732) is a splendid example of such richly decorated silver. The three knobs that adorn the lid and terminate in conventionalized acanthus leaves served as feet when the lid was used as a dish.

The blacksmith, too, played a most important role in the colonial economy, for cast- and wrought-iron hardware and implements were in constant demand. The fireplace was the heart of the colonial home, and the blacksmith produced tongs, shovels, warming pans, cast-iron firebacks, kettles, pots, skewers, and ladles, as well as all kinds of knives, forks, and spoons. A pair of hinges (Fig. 103) in a cock's-head design are worth attention. They reveal the colonial ironmonger's delight in enriching the utilitarian necessities with ingenious and entertaining decorative touches. Such modest effects as the pierced, split, and shaped ends of the hinges provided charming enhancements to the rude and strenuous surface of colonial existence.

No more pleasing example of the gracious touches that appeared with increasing frequency in the course of the seventeenth century can be found than the graceful weather vane (Fig. 104), dated 1673, that topped the First Church in Concord, Mass. Recalling the heraldic devices of Europe, the iron standard, enhanced by four wrought-iron decorative arabesques, is topped by a gilded banner

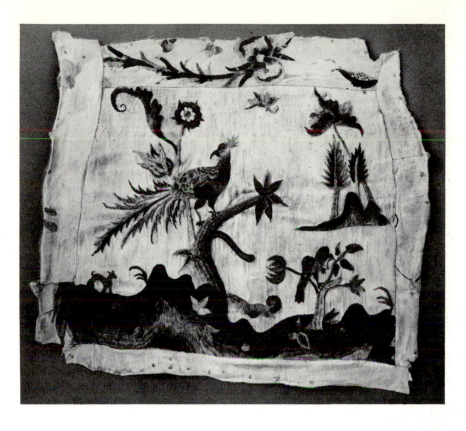

105. ANNE BRADSTREET. Chair seat. 17th century. Colored wool embroidery on cotton and linen twill, 3'8" × 4'6". Museum of Fine Arts, Boston (gift of Samuel Bradstreet).

enriched with fleurs-de-lis, the date of erection, and a gay pierced arrowhead. A shining finial crowns the entire work.

Textiles

In the colonial period most textiles were produced at home. Spinning yarn and weaving cloth were important parts of the housewife's responsibilities, and she and her family made cotton, linen, and woolen materials for clothing and all other household purposes. A knowledge of the various weaving processes, as well as of the many kinds of decorative stitches, formed an essential part of feminine education in both the Old and the New World, and this heritage was perpetuated by the daughters and granddaughters of the first settlers well into later centuries. Every homestead was a textile factory; children helped with the carding and spinning, and when the men of the house were unable to pursue their regular duties, they also took a turn at the loom.

Though the production of workaday textiles was burdensome, the colonial woman found time to indulge in her love of fancywork. As traveling journeymen and factories took over the task of producing the fabrics necessary for clothes and household linens, more time was available for weaving the elaborate bedspreads and

for embroidering chair covers, bed curtains, and the samplers which were the pride of the housewife.

The most popular early decorative needlework was done in crewel embroidery, which was used to decorate spreads, hangings for four-poster beds, chair covers, purses, and dresses. Crewel is a loosely twisted wool yarn, and it was used in bright colors to embroider on a cotton or linen twill base. A seventeenth-century chair seat (Fig. 105) from Boston employs the typical birds, flowers, and landscape motifs. The fanciful designs were frequently taken from the Chinese embroideries that were being introduced into Europe, but they were freely adapted according to the tastes of the embroiderer. A great variety of stitches was used in crewel embroidery. The stem stitch, a large stitch on the surface with a shorter one in back, was popular, and small French knots frequently formed the centers of flowers.

Another form of stitchery from colonial times is the sampler. In the early seventeenth century the sampler was a long strip of cloth containing a collection of stitches adapted to various decorative needs and reproducing popular decorative motifs. Thus, it served as a source book of decorative stitching. The housewife referred to the sampler when she needed direction or assistance or inspiration. By the end of the seventeenth century the sampler tended to be less a set of examples and more a vehicle for

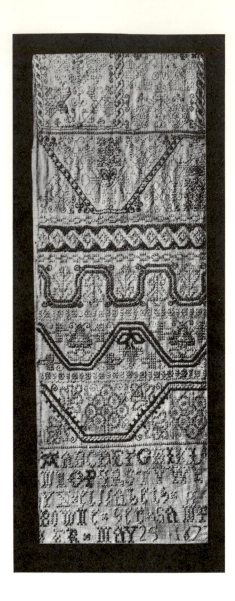

displaying embroidery skill. Verses and texts, alternating with borders, numbers, floral patterns, and other popular motifs, were carried out largely in cross-stitch, but samplers frequently included drawn work and other types of embroidery. A sampler (Fig. 106) dated 1677 belongs to the earlier tradition; it presents a variety of stitches and patterns rather than a composition around a maxim.

Initial ventures into drawing, painting, and the related arts also appeared in America during the seventeenth century. These tentative beginnings are most meaningful when seen in relation to the subsequent developments of the eighteenth century and will, therefore, be discussed in Chapter 5.

The seventeenth century in America was a period of gestation. Throughout the colonies the seeds of Europe's many rich cultures were sown. Some fell on fertile soil while others withered in the wilderness. Men came and died by thousands, suffered, struggled against the cold, the wilderness, the Indians, and one another, but by the end of the century a fruitful way of life had been established. From Florida in the South to the northernmost reaches of New England, from the great Mississippi Valley to the plateau of New Mexico, people were building homes, churches, and arsenals, shaping silver and iron, making furniture, glass, ceramics, and textiles. These first vigorous shoots of American culture grew from old memories and patterns of living modified by the raw materials, climate, and rigors of the new world. In the following century these vital shoots brought forth their first blossoms, and a unique way of life began to flower.

left: 106. Sampler. 1677. Embroidery, 19 × 9″. Philadelphia Museum of Art.

4

Architecture and Interiors: 1700–1776

The progressive character of American life was evident early in the eighteenth century. Whereas the seventeenth-century population had come largely from England, eighteenth-century immigrants came in increasing numbers from other parts of Europe. A restless energy infused the population. The mixture of various nationalities and religions served as a catalyzer in the raw formative environment, stimulating a rapid social, economic, intellectual, and artistic development.

The general culture of the eighteenth century in both England and America, unlike that of the seventeenth century, was increasingly urban. London set a common standard in matters of dress, literature, art, architecture, and home furnishings. Even Benjamin Franklin, with his genuine belief in the validity of colonial life, advised his wife to follow the latest London fashions in home furnishing and decoration. The finest products of London were imported and were intermingled with domestic wares. A Philadelphian in 1765, comparing goods produced in the colonies with those of England, declared that the household goods manufactured in Philadelphia were as cheap and as well made as those purchased in London. In surveying the churches, houses, furniture, and crafts of eighteenth-century America, one cannot help

but be impressed by their amplitude, richness, and technical excellence. Experts today frequently cannot differentiate between colonial and continental products.

The English majority was, of course, but one element in colonial America. German communities in Pennsylvania continued their folk-art traditions. The French were moving into the limitless backwoods areas and building communities in the Mississippi Valley and around the Great Lakes. Their activity as traders and trappers was not conducive to a settled way of life, but New Orleans and the plantations and the few cities of the lower Mississippi Valley had a strong French flavor. The Spaniards continued building missions and settling in Texas, New Mexico, Arizona, and California. However, the German, French, and Spanish traditions did not become an important factor in the mainstream of American culture until the nineteenth century.

Most eighteenth-century buildings constructed with no particular pretensions follow the patterns established in the preceding period. However, the more splendid structures built between 1700 and 1776 on the eastern seaboard were patterned after the Georgian style of the same period in England. The term "colonial Georgian" best describes the architecture of the first three quarters

of the eighteenth century in America. This term differentiates American architecture of the eighteenth from that of the seventeenth century and American Georgian from English Georgian, while acknowledging the relationship between these periods and styles.

The Georgian style of England, named after the three Georges who ruled England during most of the eighteenth century, was a very restrained, one might say domesticated, version of the palatial High Renaissance and Baroque styles of Continental Europe. The High Renaissance style was characterized by symmetry; a logical proportioning of parts, often on a mathematical basis; a horizontal emphasis, as opposed to the verticality of the Gothic style; and the formal use of many of the decorative and structural features of ancient Roman architecture. The Baroque, which first appeared in seventeenth-century Italy, featured a rich and profuse use of Renaissance motifs to produce more elaborate and dramatic effects than were consonant with Renaissance decorum. The Georgian style of England appeared largely in great city and country houses constructed for the aristocracy and the wealthy mercantile families, but these structures were relatively modest as compared to their Continental prototypes. This quality of the Georgian style has two explanations. First, English taste in the arts had always been characterized by a certain degree of restraint. Second, by the eighteenth century the Baroque style had lost its initial impetus, even on the Continent, and a return to High Renaissance principles and practice, particularly as they had been formulated in the work and writings of Palladio, one of the most important Italian High Renaissance architects, again characterized much architectural design. By mid-century, when grand effects were desired by Englishmen of wealth and social prestige, Palladian reserve and formality were preferred to Baroque exuberance. This movement is best described as mid-eighteenth-century neo-Palladianism.

The first English architect on whom the formal High Renaissance style of Italy made a substantial impact was Inigo Jones (1573–1652), who introduced the manner of Palladio to England in a number of grand buildings. A book published in London in 1727 on the designs of Inigo Jones had a strong influence on Colonial designers. The most important architect to introduce Baroque elements into Georgian practice was Sir Christopher Wren (1632–1723), whose greatest achievement was St. Paul's Cathedral in London. Wren designed more than fifty smaller churches for London after the Great Fire of 1666, as well as palaces. He also designed a number of smaller but commodious residences for the expanding middle class, and the impact of his work was strongly felt in America, particularly in the first half of the century.

The English architect James Gibbs (1682–1754) also wielded considerable influence through his treatise *A Book of Architecture*, which appeared in London in 1728. The revived interest in Palladian design and a stricter classicism produced a number of publications in London about the middle of the eighteenth century, and these were brought to the colonies and studied by the amateur gentlemen-designers who served as architects for the principal colonial structures. This more formal Palladian trend was reflected in America in the quarter-century preceding the Revolutionary War, when the most fully developed colonial Georgian-style mansions were built.

Equal in importance to the books about and by the great architects were the many carpenters' handbooks which were published in England for the instruction of carpenters and builders who had not the cultivated background of the amateur gentlemen-designers. Such a book was the popular *The City and Country Builder's and Workman's Treasury of Designs*, by Batty Langley, which was published in London in 1740. This and similar handbooks were widely circulated in the colonies, and they provided designs and structural details which enabled untutored builders to translate current theories of architectural design into actual practice. Fireplaces, mantels, doorways, porticoes, steeples, and entire façades were derived from such sources.

The houses, churches, and public buildings built in America in the Georgian style follow their English prototypes but are smaller and employ even fewer decorations. As stated before, symmetry and a carefully proportioned relationship of parts were basic to Georgian design: doors were centered, and windows and doors were equidistant. The small casement windows of the seventeenth century, glazed with little diamond-shaped panes, were replaced by larger, double-hung sash windows with bigger panes of glass. Windows frequently diminished in size with successive stories. To provide the classic horizontal emphasis, roofs were lower than in the preceding period and high-pitched gables were eliminated. Horizontality was further stressed by a string course on the exterior which marked the separate stories, and by projecting the basement a few inches beyond the main mass of the building, thereby creating a water table and a stable base for the superstructure. Decoration appeared principally in the embellishment of entrances, window areas, under the eaves, and at the corners of buildings, and in the case of public buildings, on the spire. On the interior, the overmantel, door, window, and stairwell received the greatest attention. Between 1750 and 1776 more elaborate porticoes capped by imposing pediments, arched and triangular pediments above windows, pilasters and columns extending the full height of the façade, and the use

of balustrades to top the roof line all contributed to a more imposing effect. Even at its most impressive, however, the colonial Georgian, like the Georgian of the mother country, remained a comfortable style, in which warmth, restraint, and a somewhat informal liveliness and lightness of touch counterbalanced any tendency toward an unduly pompous formality.

DOMESTIC ARCHITECTURE

The Eastern Seaboard

Among the most impressive architectural achievements in the colonial Georgian style were the residences built by the mercantile princes of the North and the great landholders of the South. Three examples from this period are, in chronological sequence, Westover (Fig. 107), the home of William Byrd, of Charles City County, Va., built about 1730–34; the Vassal (Longfellow) House (Fig. 108), built by John Vassal but famous as the home of Longfellow in Cambridge, Mass., 1759; and Mt. Pleasant (Fig. 109), Philadelphia, built about 1761. Westover, the seat of an immense Virginia estate, is the most extensive of the mansions; Mt. Pleasant is the richest and most urbane; and the Vassal House comes closest to the traditional idea of the colonial house. Westover, like most southern mansions, is brick; Mt. Pleasant is brick, stone, and plaster, for stone remained popular in Philadelphia though brick was the preferred material; and the Vassal House is typically New England in its use of wood.

The main mass of all three structures is symmetrical, though the smaller secondary additions on Mt. Pleasant and Westover depart from the lines of the main body of the building. Each building rests on a foundation which encloses a full basement; the main entrance leads to a central hall and stairway, on either side of which are the various rooms. Large chimneys flank the sides of the main mass of the building to care for the fireplaces, which originally provided the only source of heat. Colonial houses very frequently had four rooms to each floor, each room occupying one corner of the house. The windows, large as compared to those of the preceding century, admitted a plentiful supply of light and air, so that the interiors were bright, fresh, and serene, a quality commented on by Continental visitors accustomed to the cramped, dingy houses of the crowded European cities.

The first of the three houses to be built, and the largest, was Westover (Fig. 107). William Byrd was born to wealth and position, and a great mansion like Westover formed the proper setting for the elaborate social activities of a southern gentleman. Westover has two almost identical façades. The one which faces inland to the north, pictured here, is approached by an impressive composition of entrance gates and an extensive forecourt. The southern façade crowns a gradual rise of ground from the James River. The central building, of two stories, is topped by a high, hipped roof punctuated with the third-story dormer windows. Four tall chimneys accent the end walls of the main structure. On each side of the main building are two smaller dependencies, now attached to the central

"home of W. Byrd"

107. Westover, Charles City County, Va. c. 1730–34.

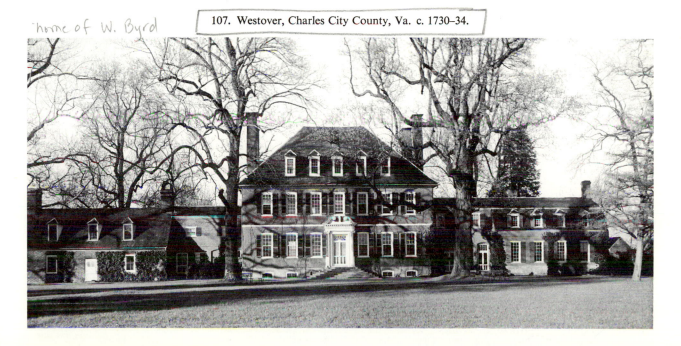

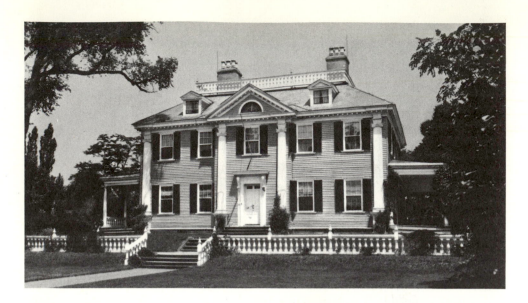

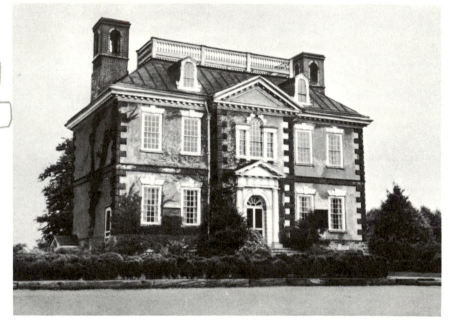

above : 108. Vassal (Longfellow) House, Cambridge, Mass. 1759.

right: 109. Mt. Pleasant, Philadelphia. c. 1761.

building but originally separate, one having been used as a kitchen, the other as a library.

A comparison of Westover with either Mt. Pleasant or the Vassal House reveals the difference between colonial Georgian design in the first half of the century and later. The architectural decorations most characteristic of Georgian style are here confined to the entranceway, where a richly designed scroll pediment rests on composite pilasters. The patrician stateliness of Westover is achieved primarily through its excellent proportions, the clear articulation of parts established by the contrast of white stone and red brick, and the fine detailing of the cornice and windows. The high, hipped roof, tall chimneys, and narrow dormers also contribute to its commanding presence. The designer of Westover is unknown, but its firm distinction has led certain students to attribute it to Richard Taliaferro, a prominent landowner in Virginia, who designed a number of handsome mansions.

Both the Vassal House (Fig. 108) and Mt. Pleasant (Fig. 109) display the fully developed style of the third quarter of the century. In both the chief architectural feature is the main entrance. In each case the entrance mass projects in front of the rest of the façade, thereby providing an effect of importance and adding to the three-dimensional

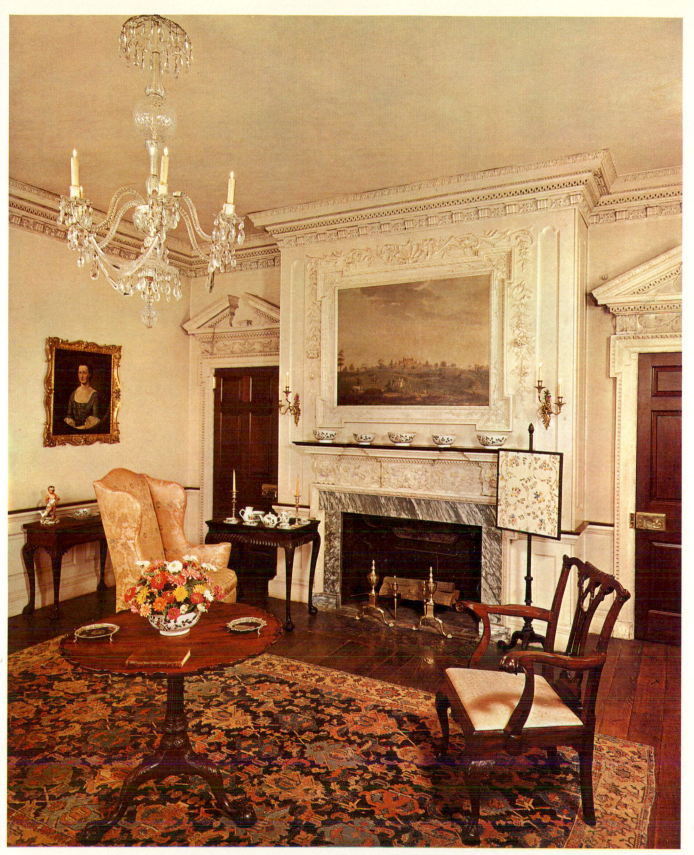

Plate 3. Parlor, from the Blackwell House, Philadelphia. c. 1764.
Henry Francis du Pont Winterthur Museum, Winterthur, Del.

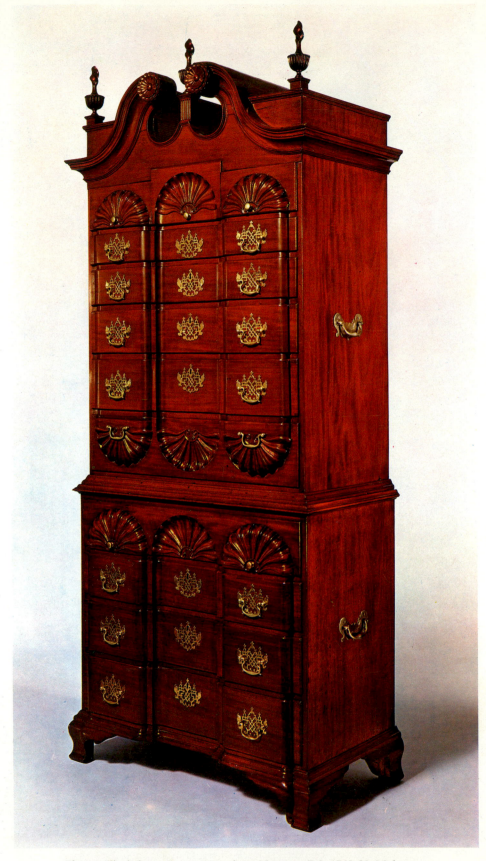

Plate 4. Block-front double chest, from Newport, R.I. 1765–80. Mahogany.
Henry Francis du Pont Winterthur Museum, Winterthur, Del.

movement of the façade. Columns and a triangular pediment, among the chief decorative devices of both the Renaissance and Baroque styles, contribute an imposing dignity to each of the entranceways. In the Vassal House, pilasters (attached columns) run the full two stories of the house and are topped by a bold pediment. The same pedimental motif is repeated in the small dormer windows on each side, and pilasters identical to those used at the entrance dignify the corners of the building. The dentil molding made up of small rectangular blocks, so characteristic of the fully developed Georgian style, enriches the cornice under the eaves and the pediments of both houses. The low hip roof of each is topped by a strong balustrade and massive chimneys.

As one approaches the Vassal House, one is aware of its dignity in relation to its surroundings. The house is on a slight eminence. A balustraded fence and a sequence of steps lead up to the main entrance. Dark shutters create a pleasant accent that strengthens the window pattern. The typical horizontal siding provides an interesting texture and contributes to the unpretentious feeling of the house. The effect is serene, orderly, charming, and comfortable. Such a home could not have been built until a prosperous and stable way of life had been established.

By Revolutionary times Philadelphia, rather than Boston, had become the foremost metropolis of the new country, and the brilliance of Philadelphia's social life was reflected by its handsome homes and furniture. Mt. Pleasant was one of the great mansions of eighteenth-century Philadelphia, in fact, of eighteenth-century America. Though similar in plan and façade decoration to the Vassal House, the grandeur and substance of the building is produced by the richly formed character of its ornamentation, which has the weight and sculptural quality of stone, though the construction was, for the most part, executed in rather crudely cut rubble masonry covered with stucco. The entrance is traditional; a rather deeply inset doorway is topped by the elliptical fanlight, which became a characteristic feature of the last half of the century, as compared to the rectangular transom used earlier. The door is framed by attached columns, above which is a frieze of triglyphs and metopes topped by a pedimental triangle. The second story features a Palladian window group, an architectural device much valued by the Georgian designers, in which the arched central window is flanked by side lights, each framed by attached columns. Surmounting the whole is the pediment. Contrasting stone quoins mark the corners with a strong pattern, and keystones accent the windows. The dormer windows are arched, and the chimneys are enriched with arched openings. The vigorous scale of the building and the decorative scheme, a certain authoritative sureness in the handling of parts, and the suggestion of gracious affluence without ostentation all mark the maturity of the colonial Georgian tradition.

A view of some of the other houses built during this period may help to exemplify the variety in domestic architecture at this time. Stratford Hall (Fig. 110), built in Westmoreland County, Va., about 1725, was the center of a 16,000-acre plantation. Its plan, a clear and bold H, was undoubtedly suggested by the palatial homes of eighteenth-century England. A handsome flight of stairs, which narrows as it approaches the doorway, carries one's eyes to the main entrance. Here, an ingenious use of brick to create an effect of pilasters and pediment provides a focal accent and adds a touch of gracious

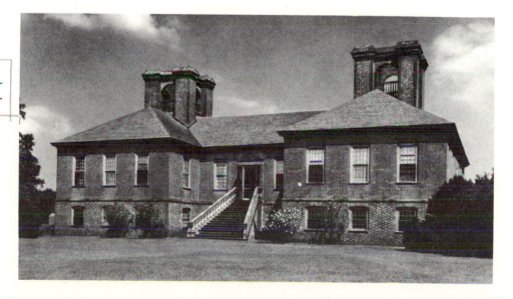

110. Stratford Hall, Westmoreland County, Va. c. 1725.

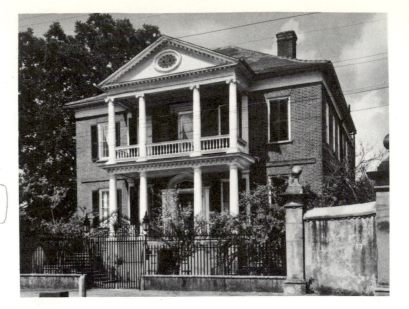

right : 111. Miles Brewton House, Charleston, S.C. 1769.

below : 112. WILLIAM SPRATT. Samuel Cowles House, Farmington, Conn. 1780.

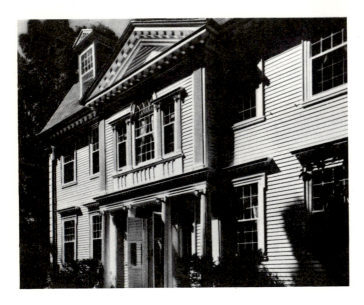

and most important early paneled room constructed in the colonies.

The free-standing portico, a feature much favored by neo-Palladian designers, appeared in increasing numbers in the public buildings erected after the middle of the century and in the South, particularly, it was frequently used to grace the façades of great mansions. Charleston, S.C., boasted a number of handsome mansions, and the Miles Brewton House (Fig. 111), 1769, was one of Charleston's finest. A double, or two-story, portico of stone, with the Tuscan order on the ground floor and the Ionic on the second story, dignifies the entrance. As was often the case in that warm, humid climate, the house is raised above a high basement to provide for freer ventilation. A double stairway, a popular Baroque device, leads to the entranceway which is framed with double pilasters and surmounted by an arched fanlight above the door. A balustrade enclosing the second-story porch, a pediment with a great oxeye window, and the dentil molding are additional characteristic features.

The lovely Cowles Houses (Fig. 112), in Farmington, Conn., built a few years after the Revolutionary War by the master-builder William Spratt, reveals a late New England interpretation of the Georgian style. Resourcefulness and imagination modify the traditional Georgian details to suit wooden construction. The animated moldings that frame the windows and the small-scale complexities of cornices, fluted columns, and pilasters convey an omnipresent sense of boards in harmony with the narrow clapboard sheathing. The increased lightness of scale carries a premonition of the Classical Revival style, which began to replace the Georgian at the close of the century.

urbanity which softens the general austerity of the building. The symmetrical arrangement of all the parts, the monumental arched chimneys, the strong three-dimensional relationship of the masses, and the fine craftsmanship exude a forceful air of vigor and self-confidence. As in most buildings from the first quarter of the century, there is a minimal use of the Renaissance and Baroque architectural decorations that were used with such effectiveness at a later date.

The interior is of a splendor that belies the severe exterior. Its great hall (Fig. 117), imposing in scale and formally symmetrical, with dignified but richly developed pilasters, panels, and cornices, was probably the largest

Pennsylvania

In the early eighteenth century many German settlers immigrated to Pennsylvania and set up their prosperous communities in the interior valleys. Their word for "German," "Deutsch," has frequently been corrupted to "Dutch"; consequently these peoples are usually referred to as "Pennsylvania Dutch." The German settlers brought their crafts and modes of building with them and faithfully preserved many of their traditional practices in the communities they built in the new homeland. From one of these early communities survives the oldest known example of half-timber in America, the Moravian Meetinghouse (Fig. 66).

The German settlers established a number of religious communities, among which the most notable still remaining is the Cloisters, near Ephrata, Pa., where the medieval-style buildings are constructed of heavy logs faced with poplar clapboard on the outside and plastered within. The Pennsylvania Germans frequently turned to the abundant stone resources of the area for their building material. The Sisters' House of the Moravian Seminary (Fig. 113), built in 1773, has heavy stone walls and a characteristic steep roof punctuated by stories of dormer windows. The exterior air of weighty solemnity also characterizes the interior, where heavy beams, unadorned walls, trestle tables, and simple benches create an atmosphere of cloistered dignity.

The Mississippi Valley

The French settlers of the Mississippi Valley also built in a way stylistically far removed from the Georgian of the eastern seaboard. They combined elements from the medieval building traditions of France with features taken from the architecture that the Spaniards had evolved in the West Indies and in the humid ports of Central America. The Courthouse in Cahokia, Ill., mentioned earlier (Fig. 67), was built in the first half of the century by a French settler and later became a county courthouse and jail. The house had four rooms and a spacious attic. Its unique feature was a gallery surrounding the house, over which extended the double-pitched roof. Each end of the building boasted a heavy stone fireplace. Buildings of this type established the prototype for the plantation dwellings of a later period.

Very few structures built by the French in the Mississippi Valley survived to modern times, but the conventions the French established remained a most important element in the design of the plantation mansions of later years. Among these were a raised ground floor and a gallery that surrounded the entire house. These features provided protection from the almost unbearable heat and humidity of the long summer. Parlange (Fig. 114), in Pointe Coupee Parish, La., built about 1750, is one of the few classic examples of an eighteenth-century French plantation mansion to come down to our day. The ground-story

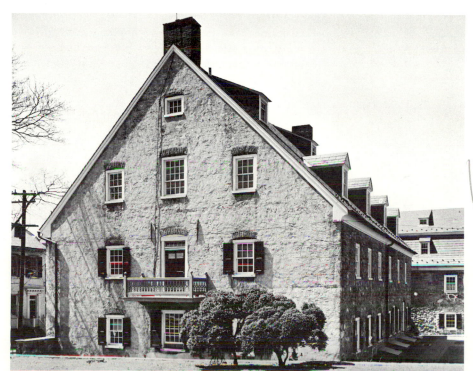

German

113. Moravian Seminary, Bethlehem, Pa. 1773.

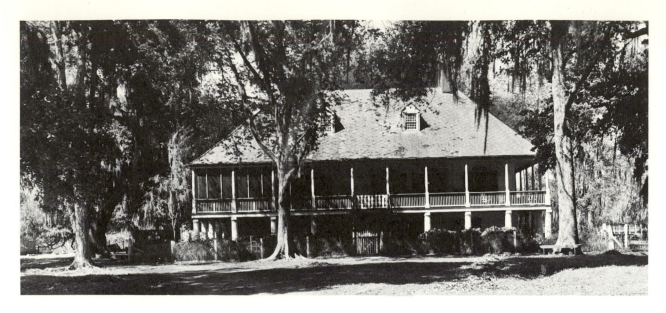

walls and the columns supporting the second-story gallery are of brick. The upper stories are of cypress timbers, with a combination of clay and moss filling the chinks between the timbers. In accord with the fully developed form of the plantation house, the great gallery of Parlange extends around all sides of the house. The wooden posts of the second-story gallery support the high, overhanging hipped roof, which is covered with heavy cypress shakes. Access to the second story is provided by a broad flight of outdoor stairs in front, and French doors surmounted by decorative transoms permit passage from the gallery to the inner rooms. The basic arrangement of plantation houses remained unchanged until the Civil War.

COLONIAL GEORGIAN INTERIORS

Though the exteriors of the fine colonial Georgian mansions are imposing, the interiors reflect to an even greater degree the newly found wealth and elegance of the prospering eighteenth-century eastern seaboard. Three rooms that represent steps in the evolution of the colonial Georgian interior serve to illustrate the style. The first (Fig. 115), an interior from the Wentworth-Gardner House in Portsmouth, N.H., built in 1671 and paneled in 1710, shows the transitional stage between the informal seventeenth-century room and the early eighteenth-century style. The exposed ceiling beams and the low ceiling are retentions from the seventeenth-century. As

above: 114. Parlange, Pointe Coupee Parish, La. c. 1750.

right: 115. Interior, from the Samuel Wentworth House, Portsmouth, N.H. 1671 (paneled 1710). Metropolitan Museum of Art, New York.

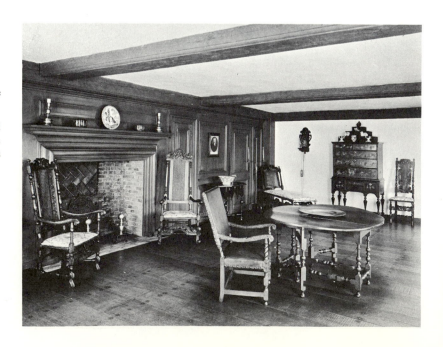

was frequently the case, only the fireplace wall was paneled, and this paneling follows the style of the late seventeenth century country homes of England. In place of the narrow, vertical boards used here in the preceding century, regularly spaced, wide rectangular panels divide the wall, each panel in turn being divided slightly below the center to create a dado below and larger panels above. To provide an element of sculptural enrichment to the wall the panels are framed with the rounded projecting moldings known as "bolection moldings." In the larger eighteenth-century houses the kitchen had become a separate room, in the North usually in an ell attached to the rear of the house, in the South frequently in a separate building. Thus the hall or parlor fireplace, no longer needed for cooking, was made smaller, and, whenever possible, it was placed in the center of the wall. The fullest and most complex moldings in the room frame the fireplace, giving it importance and building up to a mantel on which silver, ceramics, and other objects of value could be displayed. The dark paneling and white plaster provide a handsome setting for the William and Mary style furniture of the early eighteenth century.

The second example, the Marlboro Room (Fig. 116), made up from what had been the woodwork of two rooms in Patuxent Manor, a Maryland plantation house completed in 1744, reveals the character of the more developed colonial Georgian interior. More than a quarter-century later than the Wentworth House, and in keeping with the aristocratic life of the South, the room is large and high-ceilinged, and the structural beams and framing timbers are hidden behind plaster and paneling. The tall, double-hung sash windows reach almost to the ceiling. The fireplace and windows of the end wall are symmetrically composed. Beautifully finished paneling, divided as usual into a dado below and tall, well-proportioned panels above, is disposed around the room with formal regularity, and the greater size and increased complexity of the panels above the fireplace presage the handsome overmantels of the fully developed style of the fifties and sixties. The room provides a setting of quiet elegance and refinement for rich furniture, shining crystal, brass, and handsome textiles.

In the two decades before the Revolutionary War the colonial Georgian interior reached its full development. Some of the most splendid interiors from this period graced the mansions in the flourishing city of Philadelphia. In the third interior, the formal and elegant parlor of the Blackwell House (Pl. 3, p. 73), the end wall of the parlor is the chief focus for the decorative scheme. The central mass of the fireplace and overmantel, projecting into the room, is flanked by two great doors, capped by richly sculptured broken pediments. The form of the overmantel, like so much detailing in the interiors of this period, came from an English carpenters' handbook, in this case Abraham Swan's *Collection of Designs in Architecture*, published in 1757. The design features a number of Baroque enrichments, amplified by the exquisite carving which was the signal achievement of a number of master craftsmen working in America. Equally impressive is the delicate decoration of the cornice that provides a transition from the walls to the plain ceiling. As was frequently the case at this time, the upper walls are of smooth, painted plaster, while paneled wainscoting occupies the lower part. A rich ivory color contrasts with the blue-gray marble of the fireplace and the dark floors, doors, and details.

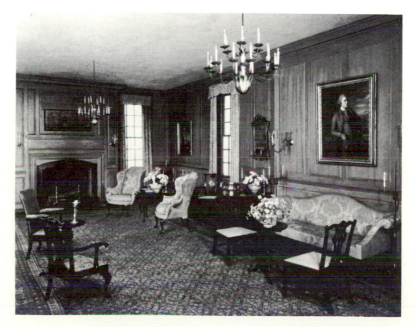

116. Marlboro Room, from Patuxent Manor, Maryland. 1744. Henry Francis du Pont Winterthur Museum, Winterthur, Del.

Patterned papers frequently covered the plaster walls, and ceilings were sometimes embellished with molded plaster decorations. The total effect of the fully developed colonial Georgian interior, one of opulence counterbalanced by refinement, also characterized the furniture of this period. Taken together, the interiors and the furniture probably constitute America's greatest contribution to the decorative arts.

One more interior, from early in the period, not only rounds out the picture of the affluent pattern of southern colonial life but also reveals another contrast between the early colonial Georgian interior in its most splendid form and the fully developed style represented by the Blackwell parlor. The grand but severe exterior of Stratford has already been illustrated (Fig. 110). Its great hall, equally dignified, provides a striking contrast because of its splendid decorations (Fig. 117). Tall pilasters surmounted by beautifully carved capitals flank the doors, the windows, and the tall, narrow wall panels. A full entablature and finely modeled moldings top the stately paneled walls. The high ceiling, with its pitched sides, amplifies the scale of the room. Lacking the rich elaboration of detail of the Blackwell parlor, the great hall at Stratford reveals the more reserved taste of the first half of the century.

The colonial Georgian mansions were, indeed, impressive achievements. Their spacious and sensible elegance has made colonial Georgian America's most popular revival style. Following close on the heels of the sturdy seventeenth-century homes, these houses give concrete and tangible evidence of the remarkable economic and cultural growth of the colonies, a growth that made it possible and necessary to shake off the restraints of a colonial status and achieve the stature of an independent country.

PUBLIC ARCHITECTURE

The flourishing colonial communities boasted a number of churches, schools, colleges, and government buildings which, like the houses, interpreted the Georgian mode with various degrees of provincial simplification and understanding. A few of the public buildings constructed before the Revolutionary War are still standing today, seldom, of course, without having suffered some changes, renovations, and remodeling, but often still retaining much of their original character.

Most of the stylistic characteristics of public buildings were similar to those of private houses, but even more frequently than with private dwellings the designs were taken from English architectural publications. Buildings were symmetrically oriented around the main entryway, which was made the focal center of the design. The use of the free-standing portico to provide an appropriately dignified and authoritative approach appeared first on public buildings, although later it was also frequent on private residences, particularly in the South. Most of the motifs used to enrich and dramatize the important areas are already familiar—round arches; free-standing or attached columns; curved, broken, triangular, and scrolled pediments; as well as brackets, wreaths, balustrades, and various types of ornamental moldings. Steeples, used infrequently on private residences, often provided a symbol of official dignity.

Williamsburg

Williamsburg, Va., provides an excellent starting point for a study of the public architecture of the colonial Georgian period. Virginia was the largest, wealthiest, and

117. Interior, Stratford Hall, Westmoreland County, Va. c. 1725.

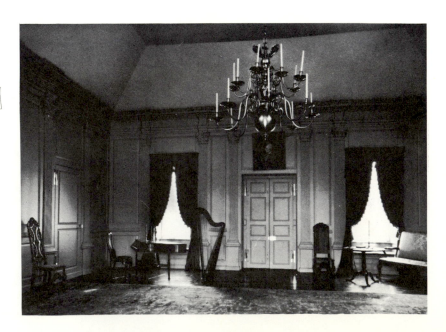

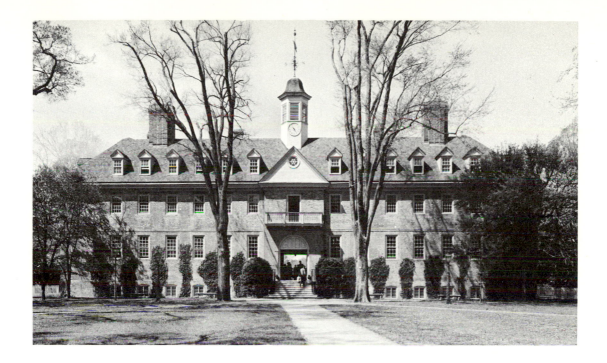

above : 118. Wren Building, College of William and Mary, Williamsburg, Va. 1695–98 (restored 1928–31 and 1967–68).

most populous colony in eighteenth-century America, and her architecture reflects this affluence.

The construction of the College of William and Mary, in what was then known as Middle Plantation, started even before Williamsburg became the capital. When completed in 1702, "The College," as it was called, was probably the largest building in the colonies. There is reason to believe that Sir Christopher Wren participated in preparing the plans for the college, as well as for subsequent government buildings.

In 1699 the capital of Virginia was moved to Williamsburg, named after King William III, and plans for the city as well as designs for the principal buildings were prepared in England. Williamsburg was carefully laid out according to precepts of eighteenth-century planning, with streets and rectangular blocks oriented in relation to wide major avenues, impressive vistas, and minor reciprocal accents. The main avenue, the major axis for the city, was Duke of Gloucester Street, 99 feet wide, nearly a mile long, which terminated in the College of William and Mary at one end and the Capitol at the other. The splendid Governor's Palace was situated at the end of the Palace Green, which constituted the chief minor axis and was located about in the middle of, and at right angles to, Duke of Gloucester Street. These three principal buildings of Williamsburg were first erected between 1695 and 1720, and though fire, rebuilding, later additions, and subsequent neglect have left little of the original structures intact, it is still possible to observe the basic character of the ori-

ginals because of the care with which the city has been reconstructed.

In 1780 the capital of Virginia was transferred to Richmond. Williamsburg declined in importance, and its buildings fell prey to fires and neglect. However, with the support of John D. Rockefeller, Jr., the restoration of Williamsburg as a complete eighteenth-century colonial capital was undertaken in 1927. Since then more than three hundred buildings have been restored with scrupulous care for authenticity, making Williamsburg the most vivid "museum piece" in America today and thereby providing an excellent opportunity to observe the genesis of the Georgian style.

The College of William and Mary (Fig. 118), the Capitol building (Fig. 119), and the Governor's Palace (Fig. 120), as well as many other buildings in Williamsburg, owe their effectiveness to the powerful massing of large forms rather than to lavish decoration. In this respect they reveal the influence of Sir Christopher Wren, who caught the essential spirit of Baroque design in his rich relationship of three-dimensional masses, while minor designers tended to depend on surface ornament.

The College of William and Mary was the first public structure to be built in the colonial Georgian style. Though it is frequently called the "Wren Building" because of

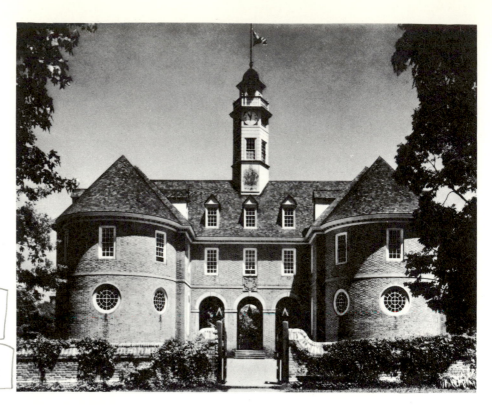

right : 119. Capitol, Williamsburg, Va. Rebuilt 1751–53 (completely restored 1928).

below : 120. Governor's Palace, Williamsburg, Va. 1706–20; wing 1749–51 (restored 1930).

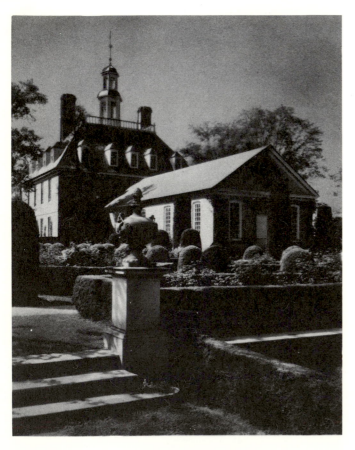

the possibility that Wren had a hand in its plans, its present design is credited to Governor Alexander Spotswood, who added the central pavilion when the college was rebuilt between 1708 and 1716 after being damaged by fire in 1705. Subsequent fires, rebuildings, and remodeling created many changes, but with its final restoration between 1928 and 1931 the college was reconstructed in its second form. Designed in a **U** shape, with two wings running at right angles to the main façade (Fig. 118), the Wren Building presents a forceful illustration of the strong and simple character of early colonial Georgian design. The façade is formal and symmetrical, with its central axis marked by a narrow, projecting pavilion; a high, rather sharp pediment; an arched entrance crowned by a balustraded balcony; and a simple steeple. The hipped roof has narrow dormers, and the windows, which diminish in size with the ascending stories, are evenly spaced. A string course, a projecting water table which tops the basement, and a rather bold, wooden-bracketed cornice stress the horizontal. A round window accents the pediment, which is higher in proportion than the classically correct pediment used later in the century.

The construction of both the Capitol building and the Governor's Palace, most probably designed by Governor Spotswood, who, like many cultivated gentlemen of his day, was an amateur architect, was supervised by Henry Cary, who acted as master-builder, or overseer. The plan

of the Capitol building, with its two wings connected by an arcaded passageway on the ground floor, represented an original, lucid, and convenient solution to the need created by the Commonwealth's bicameral legislature. Its two great semicircular wings buttress a deeply recessed entranceway (Fig. 119). The entrance is pierced on both sides, so that a sense of deep space and of three-dimensional forms moving in space contributes to the vigor of the building. The sparse ornamentation, rounded arches, round and rectangular windows, triangular dormers, and hexagonal steeple all work together to create an effect of energetic and commanding dignity befitting the capital of a young and flourishing colony. As originally built in the first decade of the century, the Capitol had no facilities for heating; fireplaces and chimneys were added in 1723. The building was destroyed by fire in 1747, and rebuilt between 1751 and 1753. By the nineteenth century deterioration and fire had demolished it completely, so that nothing but the foundations remained when restoration was undertaken in 1928.

Construction of the main body of the Governor's Palace started about 1706 and continued until 1720. A ballroom wing designed by Richard Taliaferro, one of Virginia's most talented gentlemen-designers, was added on the north side between 1749 and 1751; it projects forcefully from the main body of the building (Fig. 120). Except for the sumptuously decorated ballroom addition, the Palace exterior was also kept simple, though a balcony accenting the south entrance, a balustrade capping the roof, and pilastered chimneys create a somewhat more animated and elegant effect than that of the two buildings previously discussed. The principal interiors were embellished with handsomely wrought fine woods, marbles, and other precious materials. The ornamentation of the interiors in the ballroom wing was particularly splendid, as befitted both its social role and later date. Like so many buildings at Williamsburg, most of the original structure was destroyed by fire, but old prints, records, and the building's foundations have made it possible to restore the Palace to its original state. On the south side a curving brick wall and a crested wrought-iron gateway provide an imposing approach. The splendid gardens, planned like most Baroque gardens in spheres, cubes, and other geometric shapes and designed to be seen in perspective, create a handsome setting for this remarkable building.

Bruton Parish Church (Fig. 121) also deserves mention. Originally built between 1711 and 1715, it conforms to the simple, vigorous style characteristic of Williamsburg.

Bruton Church was one of the first churches in the colonies designed on a cruciform plan. In the latter half of the century an octagonal wooden spire was added to surmount the square tower on the west wall.

The types of steeples and cupolas that top the major buildings at Williamsburg merit special attention. First developed by Sir Christopher Wren and later popularized by William Gibbs, such constructions represent a Baroque development of the medieval Gothic spire. Though most of the steeples at Williamsburg commence with a hexagonal base, those of a later date usually rise from a rectangular base and then step through a sequence of octagonal and circular drums to terminate in a dome or spire. In typical structures, each story is smaller, more open, and usually more ornamented than the one below it. In the eighteenth century steeples marked most public buildings; later they came to be the special earmark of American churches.

Boston

The first Town House in Boston, a great seventeenth-century gabled wooden structure of medieval flavor, was lost by fire. The second Town House, or Old State House (Fig. 122), built in 1728, is one of the earliest government

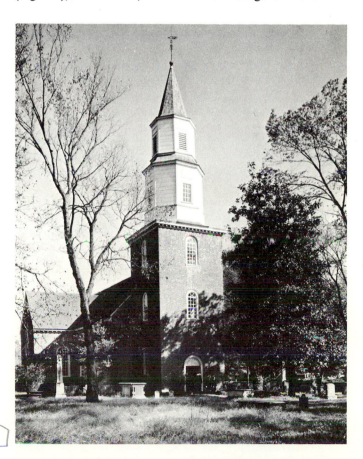

right: 121. Bruton Parish Church, Williamsburg, Va. 1711–15.

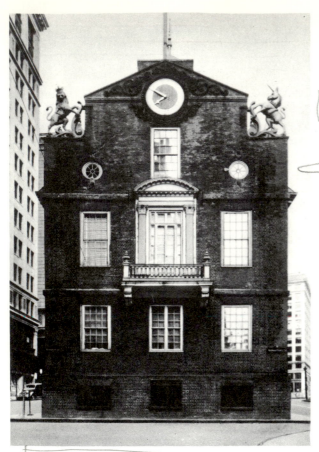

122. Old State House, Boston. 1728.

in Boston is the work of an ambitious designer, rather than a skillful one, anxious to build a state house for the leading city of the colonial empire in the latest and most splendid mode of London. The borrowing was enthusiastic, rather than informed, the beginning of a long and frequently unsuccessful attempt to use the elaborate forms of European architecture without understanding the underlying principles of architectural design.

Peter Harrison

A few of the many cultivated gentlemen who served as architects in eighteenth-century America have already been mentioned. Through their services, and those of the master-builders and the superbly trained woodcarvers and carpenters, the colonial Georgian mode was brought into being. The most famous of the gentlemen-architects, Peter Harrison (1716–63), was a merchant in the thriving city of Newport, R.I., of all New England cities second only in importance to Boston. Peter Harrison's mercantile interests took him frequently to London, where he had opportunities to see the newest fashions. His interest in architecture encouraged him to collect a library on the subject, to which he applied himself assiduously when called upon to design an important building. That Harrison and other American designers of this period drew upon English sources for direction and inspiration in no sense discredits them. Each stylish innovation from England was eagerly followed to the degree permitted by the limitations of local craftsmen and of materials, for the colonial settler at that time had no national identity independent of the motherland. Insofar as a building was an exact copy of its prototype, it reflected the knowledge and cultivated taste of its designer and his patron.

Harrison's first major architectural effort, the Redwood Library (Fig. 123), which he designed for Abraham Redwood, is of particular significance, because it was the first building in America to employ a free-standing portico, complete with Tuscan columns, an entablature with triglyphs and metopes, and a low-angled pediment of classical proportions. The façade of the building appears to have been derived primarily from an English publication on the architecture of Palladio. Today the small scale of the building seems inappropriate to its monumental design, and the use of rusticated wood to simulate stone seems false. However, the design reflects the mid-century taste for academic propriety in preference to the freer manner suggested by the earlier work of Sir Christopher Wren.

The impact of the library on colonial taste was such that Harrison was immediately requested to design a new King's Chapel for Boston and subsequently Christ Church

buildings still in existence in New England. After various vicissitudes of neglect and restoration, the exterior stands now very much as it appears in a late eighteenth-century engraving. Its rather flat façade is reminiscent of the seventeenth-century English Renaissance, both in its use of red brick trimmed in white stone and in the undisciplined, even clumsy, way in which motifs are combined. The balustraded central window, flanked by Corinthian pilasters and capped by a curved pediment, breaks through the brick string course that separates the stories and carries the eye up to the clock framed by sculptured stone wreaths and swags. The crested gable terminating the design is flanked by sculptured heraldic figures, which enliven the silhouette.

The effect is vigorous, though awkward, for the window above the arched pediment crowds the center of the composition, and the circular windows on each side are too small to fill the remaining area adequately. Unlike the principal buildings at Williamsburg, in which disciplined simplicity, fine proportions, and boldly disposed three-dimensional masses prevailed, the Old State House

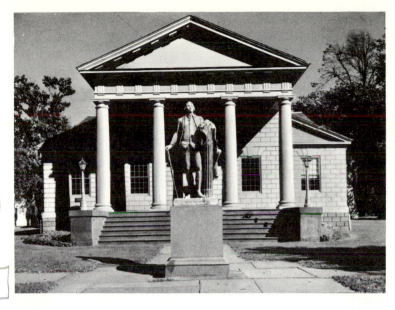

1st free ng standng portico (handwritten annotation)

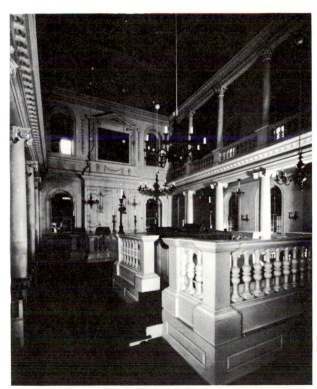

synagogue is unpretentious on the outside, but its interior is richly decorated and ingenious in its successful provision for the requirements of a Sephardic Jewish congregation. Above the handsome Ionic columns which support the gallery is an order of beautifully carved Corinthian columns. An ornate pulpit is surrounded by a heavy balustrade, and another elaborate balustrade taken from a design by Gibbs encloses the upstairs gallery. All the devices of the joiners' and carvers' art were lifted out of the latest books from England to create what, for the day, was a brilliant display of decorative virtuosity.

Harrison's old Brick Market (Fig. 125), Newport, built in 1761, is a dignified design also in the manner of

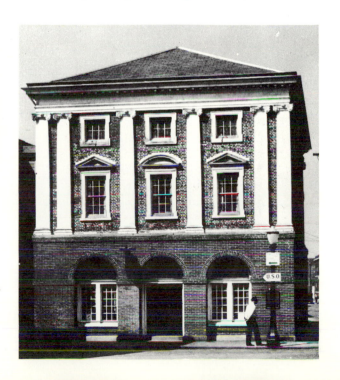

in Cambridge. Both of these churches are distinguished by particularly spacious and handsome interiors.

It is the interior which also distinguishes the synagogue that Harrison designed for congregation Jeshuat Israel (Fig. 124). Built in Newport between 1759 and 1763, the synagogue was based on Inigo Jones' design for a galleried two-story hall in Whitehall Palace, London. The

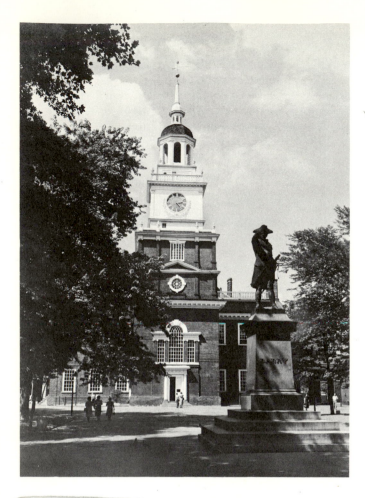

Inigo Jones. The model for the Brick Market was the great gallery at Somerset House in London, but Harrison adjusted the design to meet the demands of brick construction, omitting the heavy rustication of the ground story, with its roughened surface and sunken joints. Harrison's design of arcades (originally open), surmounted by windows with alternating triangular and arched pediments, flanked by a two-story order of pilasters doubled at the corners, was one of the most formal and academically correct to appear in the colonies. Such a triumph of neo-Palladian propriety, though it revealed an admirable striving for knowledge and taste, also reflected a trend toward academic formalism that was poorly suited to the burgeoning energy of colonial life. Fortunately this tendency did not prevail in colonial architectural practice. The absence of both imposing examples and established authority in matters of taste, the preference for wood and brick instead of stone, and, above all, the general independence and ingenuity of the settlers encouraged the modification of tradition in terms of local tastes and needs.

In 1731 the Provincial Assembly of Pennsylvania began the construction of a state house in Philadelphia. A number of talented men contributed their labors to the building, which was not completed until 1753, but faulty engineering made the great tower unsafe. It was removed a few years later, and the building stood without a tower until well into the nineteenth century, when it was reconstructed according to the original design. Renamed

above: 126. Independence Hall, Philadelphia. Begun 1731.

right: 127. Hollis Hall, Harvard University, Cambridge, Mass. 1762–63.

Independence Hall after the Revolution, this handsome building (Fig. 126), which witnessed both the adoption of the Declaration of Independence and the framing of the Constitution, has one of the finest towers in the fully developed colonial Georgian style in America. The south façade is the most satisfying. The simple, white-trimmed windows carry the eye along to the entrance and to the strong Palladian window which focuses the composition. Designed in the manner of Sir Christopher Wren's church steeples, but certainly not copied from any one of them, the tower has as its base a strong rectangular brick mass; then rectangular wooden forms give way to octagonal and domed shapes. The tower is enriched with traditional architectural decorations, used here with ingenious and sensitive variations of size and scale. White-framed openings of diverse sizes and shapes stand out against the red brick and reinforce the upward movement through their vertical alignment. Higher, the clock face and bell tower continue the rhythm. As the eye moves on up, the differing widths of the cornices animate the surfaces. Evolving ever upward from the solid and weighty brick base to the open arches of the cupola, the tower flows from stable base to lofty spire in an unbroken progression.

College halls remain among the few eighteenth-century buildings to come down to us relatively unchanged. Hollis Hall (Fig. 127) at Harvard, built in 1762–63, is very similar to contemporary halls at Princeton, Dartmouth, and Brown, all of which established the prototypes for college buildings in America. Hollis Hall is four stories high, with a hipped roof, many chimneys, and a central pavilion topped by a pediment. Here the Georgian mode is interpreted with New England restraint. Three modestly accented entrance doors on the front façade and a panel of tall, thin windows in the center of the pavilion relieve the regularity and prevent the bare and forthright design from becoming monotonous.

RELIGIOUS ARCHITECTURE

In America the church never became the dominating symbol of authority it had been in Europe and was in Latin America. Church and state were separate, and the church stood as only one of the focal centers of community life. This attitude found expression in the size and character of church architecture. Small communities frequently had a simple, one-room church building which could be distinguished from a private dwelling only by the bell tower. The Puritans and other dissenting groups built austere meetinghouses devoid of ornament. On the other hand, the wealthier Anglican congregations of the metropolitan areas built grand and highly ornamented edifices, designed to compete in size and elegance with the churches being erected in England.

Trinity Church, Newport, R.I., built in 1725–26 by Richard Munday (?–1739), Newport's most talented designer-builder in the first half of the century, is a fine early example of a somewhat provincial but ambitious church (Fig. 128). A two-story wooden building dominated by a high commanding spire, it helped establish the prototype for the wooden churches which later became so typical of the New England setting. The design is very similar to that of Old North, an earlier Anglican church of Boston. A rectangular structure with a high pitched roof and two stories of arched windows constitute the main body of the building, which is fronted by a square tower. The high and richly developed steeple was added in 1741, and the church was lengthened by two bays in 1762. Much of the design of Trinity Church, like that of Old

128. RICHARD MUNDAY. Trinity Church, Newport, R.I. 1725–26.

left : 129. RICHARD MUNDAY. Interior, Trinity Church, Newport, R.I. 1725–26.

North in Boston, was derived from Christopher Wren's London churches, particularly St. James', Piccadilly.

The galleried interior (Fig. 129), with its superimposed order of square pillars and its groined vaults projecting from the fronts of the galleries into the nave, has a spacious unity that speaks well for Munday's architectural sense. Comparison with Christ Church, Philadelphia, provides an interesting contrast between the somewhat more Spartan simplicity of the earlier structures and the more opulent flavor of the fully developed Georgian as it evolved in metropolitan Philadelphia at a slightly later date.

Of all the colonial churches Christ Church (Fig. 130), in Philadelphia, designed by Dr. John Kearsley, a physician from England, is one of the largest, most vigorously conceived in terms of the disposition of the main masses, and certainly the most ornate. Patterned after contem-

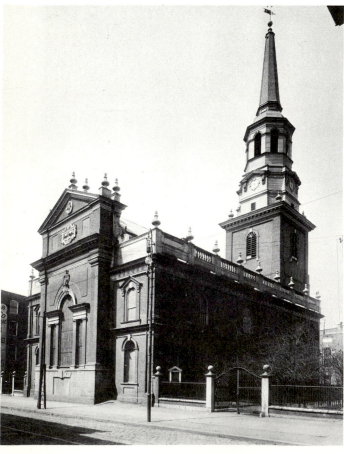

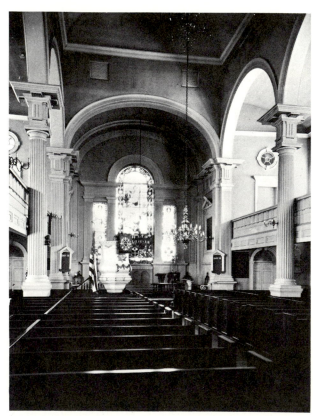

left : 130. JOHN KEARSLEY. Christ Church, Philadelphia. 1727–54.

above : 131. JOHN KEARSLEY. Interior, Christ Church, Philadelphia. 1727–54.

porary English structures, its 28-foot-square tower has brick-faced stone walls 4 feet thick, which support a smaller tower and an octagonal wooden spire rising to a height of 196 feet. The main mass of the church is heavily decorated in the fully developed Georgian style, with the chancel wall creating a particularly splendid effect. The great Palladian window which lights the chancel is topped by a carved keystone and a heavy projecting molding. Large spiral scrolls flank the crowning pediment, which is surmounted by flaming, bulbous urns. A heavy balustrade and similar flaming urns crown the eaves.

The interior (Fig. 131) is one of the few in America with a truly Baroque disposition of parts. Seated in the spacious nave one senses the flow of space into the two-storied side aisles and the deeply recessed chancel. Two great columns with bold and original capitals support the elliptically vaulted ceiling. The vigorous composition comes to a focus in the Palladian window behind the altar. Though some of the details may be gauche, there is a splendor about the total conception that makes the interior of Christ Church unequaled in eighteenth-century America.

There is a possibility that Peter Harrison designed St. Michael's (Fig. 132), in Charleston. The impressive two-story Doric portico was the first of such dimensions to be built in the colonies. The 185-foot tower is unusually solid and simple in its continuous movement from a square base through diminishing octagonal drums to its graceful spire. The sides, with their well-proportioned arched windows and two-story pilasters, are handled with the same monumentality and dignity that characterize the façade and tower. St. Michael's Church, like the other great colonial Georgian churches, reflects an exuberant and healthy community which expressed its pride through fine buildings.

By the time of the Revolution architectural design in America had traversed the long road from the seventeenth century mode of construction—vigorous, sturdy, but essentially unrefined and lacking in most decorative attributes—to the spacious, richly ornamented houses, churches, and public buildings of the colonial Georgian style. Much of the elegance that the colonial builder attempted was awkward and self-conscious, and many of the stylistic devices were used with little understanding, but such is the nature of growth. As America's physical resources and needs grew, its intellectual and artistic

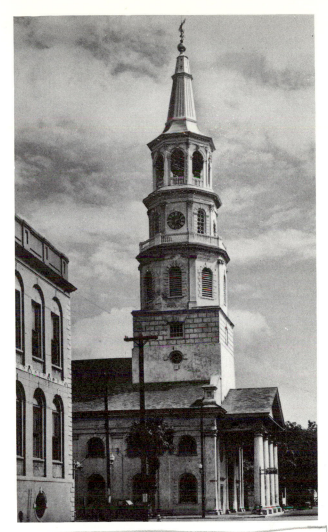

132. PETER HARRISON (?). St. Michael's Church, Charleston, S.C. 1752–61.

aspirations also expanded. Just as France, England, and Germany in earlier periods drew on the authoritative Italian sources, so American designers in this period turned to the mother country, England, for inspiration, information, and direction. The concept of an indigenous art or of a native style was far beyond the aspirations of the colonies, who thought of themselves as outposts of the great homeland whose cultural ideals they shared. Artistic and cultural independence came, as would be expected, with maturity, and maturity only commenced after the link with the motherland was severed.

5

The Household Arts: 1700–1776

Furniture

The eighteenth century witnessed a flowering of all the arts in England. The growth of the colonial empire, the development of trade, and the acquisition of great wealth stimulated an elaborate social life, which assumed its material form in splendid palaces and fine country homes furnished in a sumptuous and refined manner. Consequently, this was the great age of furniture design, and a succession of brilliant styles found expression during the last half of the century in the work of individual designers whose names are still household words—Chippendale, Sheraton, Hepplewhite, and the Adam brothers.

In America the household arts reflected the elegance and sophistication of the motherland, partly because the colonies mirrored English style, but also because, like England, they were in a flourishing state of expansion. While the modes of London were faithfully followed, the colonial craftsmen did not restrict themselves to what was done in that style center. Certain pieces of furniture developed here in a unique way, becoming characteristically colonial—the Windsor chair, the block-front chest, the double chest, and the case-top desk, or secretary. The sequence of styles first in England and then in America

was (1) William and Mary; (2) Queen Anne; (3) Georgian, which received its richest formulation in the hands of the English designer, Thomas Chippendale; and (4) the Classic Revival. The Classic Revival styles, which began to appear in England soon after the middle of the century, did not arrive in America until after the Revolution and therefore will be discussed in a later chapter.

William and Mary (1700–25)

The style in force at the turn of the century was named William and Mary after the English rulers. Reflecting Continental Baroque influences, particularly Dutch and Flemish, William and Mary furniture is higher, lighter, and much more richly ornamented than were the seventeenth-century styles. A William and Mary armchair (Fig. 133), probably from Boston, where many chairs like this were produced, reveals some characteristics of the style. Though the structure remains essentially rectangular, curvilinear elements appear in the arms, the raked back, the foot, and the carved enrichments. The high, narrow back with a central panel is, like the seat, upholstered in leather. The style employed Baroque features for further enhancement—the crested back, elaborately varied

turnings, often in vase, trumpet, or baluster shapes, and, in this particular example, the type of foot called "paintbrush," "Portuguese," or "Spanish." The William and Mary furniture in the Wentworth living room (Fig. 115) reveals additional characteristics of the style, including the wealth of turnings. The chair to the right of the fireplace shows an elaborately carved crested back, a carved arched-front stretcher, and the caned back combined with a cushioned seat that was sometimes used instead of leather. This period witnessed the development of the handsome case furniture which later became the particular province of the American cabinetmakers. A splendid example of such casework is the highboy (a tall chest on high legs) standing against the plaster wall. It has trumpet-shaped turnings on the legs, an elaborately shaped skirt, and the rich, Oriental-flavored surface patterns, which were executed either in inlaid woods or Chinese-style lacquer. Walnut became the most desired wood at this time and was finished with a high polish.

Queen Anne (1725–55)

The Rococo style, the dominant aristocratic mode in France in the first half of the century, rapidly replaced the Baroque William and Mary in England and then in America. In the Queen Anne period, the characteristic rectangularity of the William and Mary style gave way to a curvilinear emphasis, which established a rhythmic unity throughout the various parts of a piece of furniture. The single element that contributed most to this graceful unity was the consistent use of the elongated S curve, keynote of Rococo styling. The cabriole leg, the most obvious curvilinear feature of the style, was designed with a double S curve, which moved gracefully from the heavier knee to the slender ankle and then curved in reverse and swelled to a broader slipper or, especially in mid-century, to the popular claw-and-ball foot. A variety of pieces of furniture—tables, desks, framed mirrors, and even grandfather clocks—were created in the Queen Anne mode, but the style received its most complete fulfillment in the side chair (Fig. 134) and armchair.

By the middle of the century Philadelphia and Newport produced the finest furniture in the colonies. In the fully developed Queen Anne chairs from those cities the cabriole legs; the horseshoe-shaped seat, wider at the

left : 133. William and Mary armchair, probably from Boston. 18th century. Maple with leather. Henry Francis du Pont Winterthur Museum, Winterthur, Del.

right : 134. Queen Anne side chair, from Philadelphia. 1725–50. Walnut. Metropolitan Museum of Art, New York (Rogers Fund, 1925).

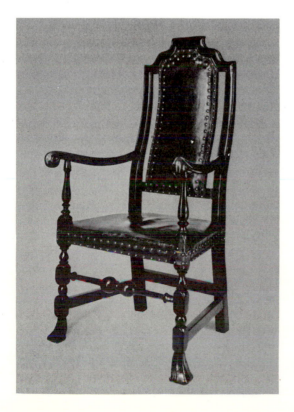

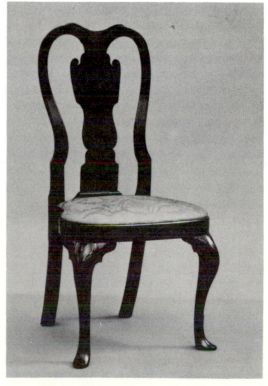

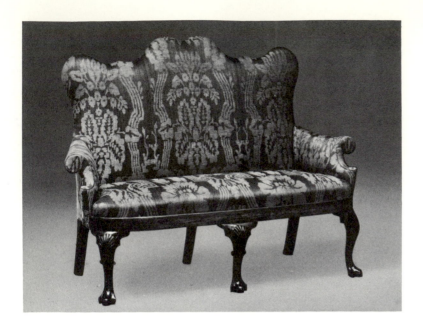

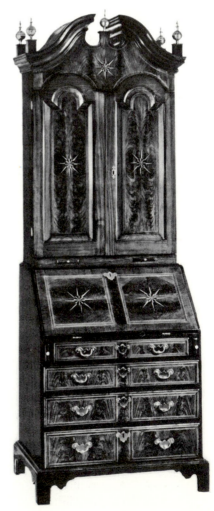

left : 135. Sofa, from Stenton, Germantown, Pa. Early 18th century. Metropolitan Museum of Art, New York (Rogers Fund, 1925).

below : 136. Queen Anne secretary-bookcase. 1720–30. Walnut inlaid with satinwood and rosewood. Museum of Fine Arts, Boston (M. and M. Karolik Collection).

front and narrower at the back; the vase-shaped back splat with its graceful curves; and the continuous line running from the curved back through the raked back legs—all combined to create a unified and rhythmic piece of furniture with both simplicity and elegance. Although certain Philadelphia cabinetmakers used quite elaborate carving, the colonial cabinetmaker generally relied for his effects on grace, lightness, fine proportions, and elegance of line, rather than on rich decorations.

The upholstered wing chair first appeared during the William and Mary period. With the Queen Anne style the taste for comfort and luxury expanded, and the upholstered double settee and the sofa were introduced. In a sofa from Philadelphia (Fig. 135) it can be seen that the high back, with its ogee-curved profile, has a somewhat William and Mary flavor, while the set-back armrest, the general lightness of proportion, and the fluid continuity of the piece is typical of the fully developed Queen Anne style. Frequently such settees and sofas have six or even eight legs strengthened by stretchers.

The Queen Anne period in America witnessed the development of certain typically American forms of case furniture. Boston was particularly noted for the secretary (a slant-topped desk topped by a two-door bookcase), whereas Philadelphia was famed for her handsome highboys and double chests. A secretary-bookcase from Boston (Fig. 136) displays most of the characteristics of these products of the cabinetmaker's art, though this particular secretary has straight bracket legs rather than the small cabriole legs most frequently used. Typically tall and narrow, this piece is of walnut with inlaid stars of

right : 137. BENJAMIN RANDOLPH (?). Side chair, from Phila-
delphia. 1760–90. Mahogany. Henry Francis du Pont Winter-
thur Museum, Winterthur, Del.

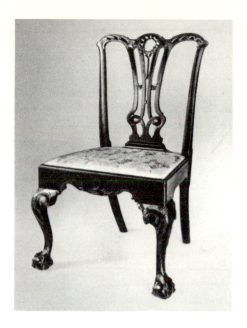

rosewood and satinwood. Such stars remained popular
in Connecticut long after they had disappeared in more
fashionable centers. Typical of case furniture in the Queen
Anne and subsequent Chippendale styles was the use of
imposing architectural forms, the most conspicuous being
the towering broken pediment accented with vertical
finials. The most splendid examples of case furniture ap-
peared in the third quarter of the century (Pl. 4, p. 74).

The elaborate social life of the eighteenth century
necessitated a great variety of tables. Tray tables, card
tables, piecrust tables, drop-leaf tables, dressing tables,
and side tables all were in use, and many, such as the
drop-leaf tables, had ingenious mechanisms that per-
mitted them to be folded or collapsed and stored in a
small space. A beautiful Queen Anne tea table can be
seen to the left of the fireplace in the Blackwell parlor
(Pl. 3, p. 73). Its slender forms provide an interesting con-
trast to the heavier lines of the fully developed Georgian
style seen to the left of the wing chair.

In general, walnut remained the preferred wood for
Queen Anne furniture, but in the Connecticut Valley and
other rural areas cherry and maple were frequently used,
and in Philadelphia and Newport mahogany became
increasingly popular at the end of the period.

Georgian Style—the Chippendale Influence

The three Georges ruled England from 1714 through most
of the century. During the first half of the century the
Georgian style developed from the relatively simple
Queen Anne to a rich, highly ornamented mode. The late
Georgian pieces of the mid-century continued to employ
the curvilinear construction that characterized the earlier
Queen Anne style. Their chief differentiating character-
istics were a tendency toward greater magnificence, with
florid decorations replacing the simpler lines and lighter
proportions of the earlier style, and the taste for mahogany,
which replaced the earlier preference for walnut. In
England the fully developed Georgian mode received its
most handsome expression in the work of Thomas
Chippendale, whose unique gift was to create designs of
great beauty in which the various Chinese, Gothic, and
French elements of the Rococo style were used in a
manner acceptable to the English taste. In case furniture,
particularly, these rather fanciful elements were often
combined with the previously mentioned architectural
forms. During the two decades preceding the Revolution-
ary War the furniture designs published by Thomas

Chippendale became the principal source of inspiration
to the cabinetmakers of Colonial America.

Chippendale-style furniture, though evolved from the
earlier Queen Anne style, has certain distinctive differences.
Heavier, larger in size, and more florid in decoration, it has
at the same time certain whimsical aspects. Naturalistic
carved leaves, flowers, shells, and even figure groups are
incorporated into the decorations, and though the chief
forms tend to be massive, very fine-scale carvings and
playfully convoluted small curves break the profiles of
skirts, finials, and other parts. Large and heavy as they are,
the pieces convey a sense of movement and animation.

Chippendale's influence on chair design is particularly
marked. The chair in Figure 137, compared with a typical
Queen Anne design (Fig. 134), reveals the way in which
Chippendale modified the earlier models. In general, the
Chippendale chairs are larger, more imposing, and more
elaborately carved. Instead of the continuous flowing
curves of the earlier style, straight lines and curves play
against each other to provide an animated variety of line
movements. The front and sides of the seat are straight,
rather than curved, and the rounded back has been re-
placed by a somewhat rectangular back with elevated cor-
ners. The back splat has been pierced and elaborated into
ribbonlike, interlacing forms designed with the graceful,
flattened curves typical of the Rococo. The vigorously
formed cabriole legs, heavier than in the typical Queen
Anne chair, terminate in the popular claw-and-ball foot.
Judiciously placed carving enriches the surfaces and con-
trasts effectively with the smooth, beautifully propor-
tioned, undecorated area.

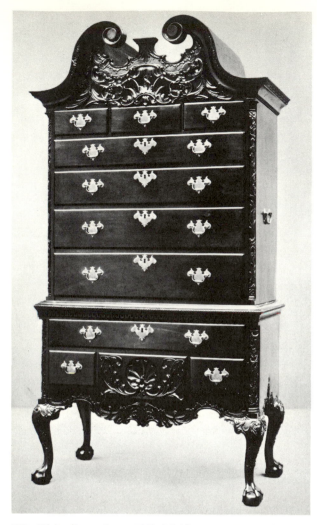

138. High chest, from Philadelphia. 1760–80. Mahogany, height 7′ 5 ¼″. Metropolitan Museum of Art, New York (Kennedy Fund, 1918).

duct compares favorably with the best from Europe is that of cabinetmaking. No finer examples of the American cabinetmaker's art can be found than the great highboys or high chests produced in Philadelphia. An excellent illustration of this uniquely American form can be seen in Figure 138. Measuring well over 7 feet from top to bottom and almost 4 feet in width, this chest could have looked oppressively bulky, even top-heavy, but for the skill with which the parts are related and the taste with which the ornamentation is distributed. Basically this design consists of two rectangular chests resting on cabriole legs and topped by a scroll pediment. The lower section, considerably shorter than the upper, acts as a subordinate, horizontal base. The cabriole legs, a sturdy yet resilient support for the weight above, move up from the floor with energetic rhythm. This movement continues in the curved contours of the apron, with its flowing lines of carved leaves, stems, and central shell, and then up the sides to culminate in the great pedimental scrolls, which resolve the wavelike motion initiated by the legs. The surface carving provides a most effective unifying agent, reinforcing and supporting the rhythms of the major masses. On the legs, the finely carved decoration animates the form and intensifies the movement so that one is hardly aware of their weight. This rhythm carries across the front and up the sides by means of the delicately carved corners to the fanciful flow of French Rococo motifs which reach their fullest development in the dynamic interplay of leaves and related motifs held in place by the powerful enclosing scrolls of the pediment. Other elements in the design serve to further reinforce the upward movement in a most subtle way. The drawers in each section become progressively shallower from bottom to top. Even the handsome brass drawer pulls tend to take the eye continuously upward. In this piece one can see the union between the reasonable and the fanciful so aptly described by Talbot Hamlin when he wrote, "Over this bedrock of rationalism played the fantasy of the rococo imagination, as though to express the unconscious feeling of a world which was losing its old standards with amazing rapidity."

The double chest, or chest-on-chest, appeared in England early in the century and then went out of fashion. In America it remained an important piece of furniture all through the century. While the double chests from Philadelphia were famous for the splendor and elaboration of their carvings, many from other areas achieved distinction through their fine proportions and general restraint.

The most noteworthy local development of chests was the block front, which was used on chests of drawers, desks, and secretaries. The block front appears to have originated between 1760 and 1780 with the famous New-

American Chippendale reached its height in Philadelphia, where weight, richness of decoration, and fine craftsmanship were combined with restraint and an impeccable sense of proportion. A number of Philadelphia's finest cabinetmakers are known. The chair illustrated (Fig. 137) is attributed to one of these men, Benjamin Randolph (active 1760–90).

In many of Chippendale's later chairs the Chinese feeling was emphasized. Straight channeled legs were used and rectangularity was stressed in a way that foreshadowed the Classic Revival. A graceful interpretation of the ladder back frequently accompanied the use of straight legs.

Most of the arts of colonial America, impressive though they are, retain a provincial flavor. One field in which this is not the case and in which the colonial pro-

port cabinetmakers John Goddard (1723–85) and his nephews, John (1732–1809) and Edmund (1736–1811) Townsend. In the block-front chests, the front of the rectangular mass was alternately protruding and recessed, the middle block being set back. An impressive block-front double chest from Newport (Pl. 4) features nine shells, carved in the usual manner so that the shells on the projecting side panels form a convex ornament, while those in the center panels are concave. Admirably restrained, this splendid chest-on-chest has curved bracket feet and a simple broken pediment with boxed sides.

During the eighteenth century many other pieces of furniture underwent elaboration. Table forms responded to the Rococo impulse in a variety of ways. A piecrust table with claw-and-ball feet, a richly carved pedestal, tripod cabriole legs, and an elaborately scalloped rim can be seen in the front left of the Blackwell parlor (Pl. 3). The bed emerged from its canopied obscurity to become a handsome object with reeded corner posts and carved cabriole legs. The simple wall clock became the grandfather clock, an important piece of furniture, housed in a tall case. Mirrors were framed with complex moldings and crests, and some of the mirror frames became veritable extravagances of Rococo carving. Elaborately carved, gilded, and painted, they were used as important decorative accents over mantels or on bare walls.

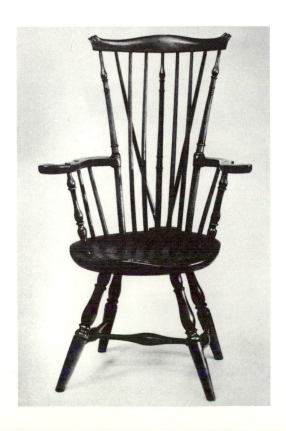

The Georgian age has been called the "age of mahogany," and in both England and America this firm, fine-grained wood was preferred to any other for good furniture. Contact with Cuba and with Central and South America ensured an abundant supply. Mahogany was particularly admired for its soft, warm color, which gradually darkened to a rich tone. In the eighteenth century it was usually polished with red-tinted beeswax to produce a lustrous, satiny surface. The preference for mahogany lasted well into the nineteenth century.

Windsor Chairs

Though the wealthy followed the fashions of London in their parlors, the folk traditions of the motherland were retained in many situations, and furniture was made in the older, simply carpentered handicraft manner. The Windsor chair, of English origin, remained popular among all classes throughout the colonies. Of relatively simple construction, practical, and graceful, it developed its most refined form in America and came to be considered a characteristically colonial piece of furniture. Windsor chairs varied greatly in shape and size, according to their use. Among the types produced were the high comb-backed, with the center spindles extended at the back to support a shaped headrest; the braced high comb-backed (Fig. 139); the low-backed; double settees; high chairs for small children; and a great variety of other forms. As it developed here, the original thick, crude, stoolseat was given a saddle shape. The legs, turned in slender baluster forms, were joined and strengthened by turned stretchers. A back of slender spindles, housed in the seat, was held in place either by a hooped top rail returned and also housed in the seat or by a horizontal rail extended into arms.

Like so many utilitarian objects developed in America to answer functional requirements, the Windsor chair achieved a lean elegance, a combination of lightness and strength, that contrasts interestingly with the ponderous design of European equivalents. All its parts were pared down to the minimum weight compatible with strength and were shaped primarily by function. The only decoration found on the Windsor chairs is machine turning, used with craftsmanlike consideration and good judgment. The thick seats of Windsor chairs were usually made of pine. Beech, hickory, birch, and ash were used in the bent parts, and maple, ash, beech, oak, and birch were all employed for turned parts. Windsor chairs and settees were frequently painted, dark green being a popular color,

left : 139. Braced comb-back Windsor chair. c. 1760. Maple, oak, and pine. Museum of Fine Arts, Boston.

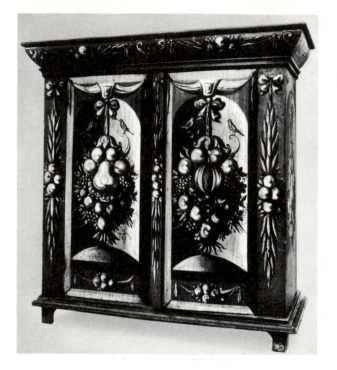

and lines and bands of gilt and bright color were used for added liveliness. Tables and stools of equal simplicity and light grace were also frequent.

Dutch and Pennsylvania Dutch Furniture

Some of the German, Dutch, and Scandinavian groups in rural New York, New Jersey, and Pennsylvania retained the folk idiom of their native lands and produced colorful, sturdy, and unpretentious furniture. Though the construction of such furniture was simple, the craftmanship was excellent, and frequently the decorations were gay and charming. Of the various national groups that settled in the colonies, the Dutch of New York and the Germans of Pennsylvania left the most vigorous heritage.

A great wardrobe, or "Kas," (Fig. 140) from eighteenth-century New York shows the Dutch tradition both in its heavy rectangular construction and in its gay decoration. It has a vigorous and fresh handling of such traditional Baroque decorative elements as painted garlands of flowers and festoons of fruits, vines, leaves, and ribbons, which are handsomely massed against a strong background shaped and shaded to suggest a niche.

The liveliest development of the North European peasant tradition occurred among the German settlers of Pennsylvania. The German immigrants who settled in eastern Pennsylvania continued to create furniture and household objects in the traditions of their homeland

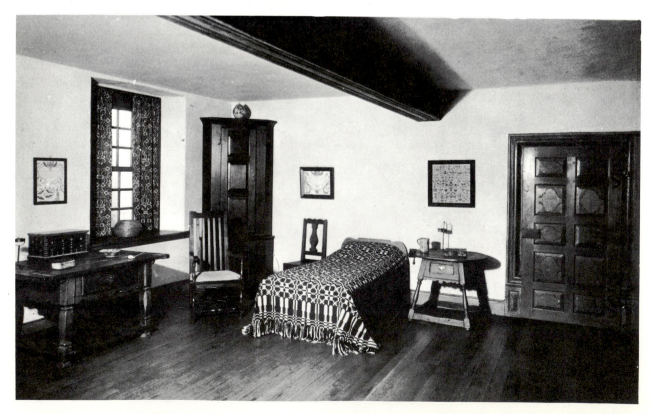

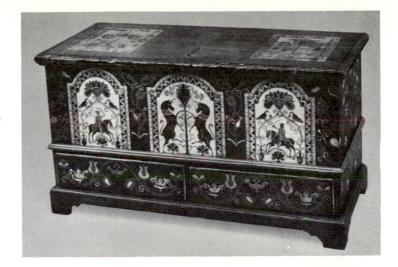

142. Bridal chest, from Pennsylvania. 18th century. Painted pine and poplar. Metropolitan Museum of Art, New York (Rogers Fund, 1923).

with little change until almost the end of the nineteenth century. A mid-eighteenth-century room from Millbach, in Lebanon County, reveals the character of the interiors and the furnishings (Fig. 141). The low-ceilinged room, with its plain plaster walls, is uncluttered and uncrowded. Simple turnings and contours sawed in scalloped or wavelike patterns animate the furniture profiles. Rather flat moldings and such carpentered devices as simple beveled panels are used to relieve the plain surfaces. Geometrically patterned woven coverlets and curtains, and a variety of heavy, vigorously decorated ceramic and painted tin wares provide spots of color in the room.

Bridal chests are perhaps the most charming and richly ornamented pieces of furniture produced by the Pennsylvania Germans. The chest shown here (Fig. 142) has two large drawers decorated with the very popular tulip motif, as well as with handsome brass pulls. The upper section of the chest has three niches on the front, the center one featuring two dancing unicorns (symbols of virginity), and the narrower side ones painted with horsemen, birds, vases, spirals, flowers, and a number of geometric ornaments. The colors are as gay and bright as the patterns. The naïve idiom of the entire piece has great appeal to contemporary tastes.

DECORATIVE ARTS

All the decorative arts contributed to the gracious charm of the Georgian household. Ceramics, glass, textiles, silverware, pewter, wrought iron, brass, and copperware were greatly desired both because they provided convenience in the home and because the variety of their forms and colors and the luster of their surfaces added to the visual enrichment of the interiors. Though fine wares

were imported from Europe in ever-increasing quantities, demand outstripped supply, and ambitious settlers commenced to manufacture these various commodities. The first American glazed china was produced prior to the Revolution, and glassware, silver, pewter, pottery, and even brass fittings, far superior in design and craftsmanship to the utilitarian wares of the seventeenth century, appeared here early in the eighteenth century.

Silver and Metalware

Eighteenth-century American silver can best be described under the same style names as the furniture. In general, American silversmiths responded more rapidly to the style changes in England than did the cabinetmakers. The Baroque tendencies that came to fruition in the William and Mary style, already visible in the silver of the last decade of the seventeenth century, continued in the early eighteenth century. Forms tended to be low, profiles were full and rounded, and important pieces were heavily ornamented (Fig. 101). Applied cast ornament; chasing and repoussé work in elaborate foliate, floral, and other patterns; gadrooning; fluting; and forms derived from the turnings on furniture—all these appeared in the decorative repertoire of William and Mary silver.

During the second quarter of the century, when the Queen Anne mode was dominant, silver tended to be taller and more slender. Serpentine curves were frequent, gracing profiles, handles, small cabriole feet, and decorative details. In general, the Queen Anne period witnessed a reaction against Baroque redundancy, and simple surfaces with decoration concentrated at a few strategic areas became popular. As in furniture design, the second quarter-century also saw the adaptation of Oriental

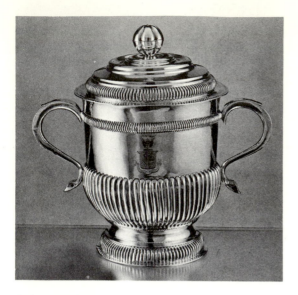

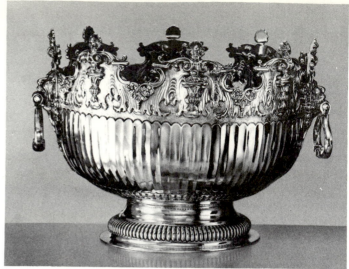

designs to silver. Handles, spouts, and entire pieces were shaped to resemble Chinese porcelains, and occasional bowls were designed with exquisite simplicity to resemble rice bowls.

The Rococo mode that flourished in England was encouraged in America by the arrival of a number of French Huguenots, and in the third quarter of the century handsome Rococo pieces were made in all the major cities. The silver of Boston and New York was still characterized by a certain restraint, but some pieces from Philadelphia reflected the florid tastes of London (Fig. 149). The full-blown Rococo expressed itself in the elaboration of the typical playful reverse curves beloved by Rococo designers. Shells, foliate and floral devices, ruffled forms, and complex cabochons (convex raised surfaces filled with rich embossed patterns) contributed to the elegance and sophistication characteristic of the style.

The refinements of eighteenth-century social life stimulated the development of many forms of silver. Teapots (tea was a recent Oriental import), as well as services for coffee and chocolate, and the accompanying creamers, sugar bowls, and trays constituted striking examples of the silversmith's art. More common pieces included cups, porringers, bowls, tankards, mugs, knives, forks, and spoons. Each major city had its famous silversmiths. A number of them were virtuoso performers whose work has never been surpassed and whose names are revered by all collectors of fine silver.

Three pieces of silver from early in the century display the characteristics of the William and Mary style. Edward Winslow (1669–1753), one of Boston's finest silversmiths, designed a covered cup with a typically low, swelling form amplified by vigorously curved handles (Fig. 143). Convex moldings, gadrooning, and related patterns en-

left : 143. EDWARD WINSLOW. Two-handled, covered cup. c. 1715. Silver, height 11″. Yale University Art Gallery, New Haven, Conn. (Mabel Brady Garvan Collection, gift of Francis P. Garvan, 1897).

right : 144. JOHN CONEY. Monteith. c. 1700. Silver, height 8 ½″. Yale University Art Gallery, New Haven, Conn. (Mabel Brady Garvan Collection, gift of Francis P. Garvan, 1897).

hance the body and the lid, which is topped by the flourish of a bud finial.

The second example, one of the grandest pieces of early eighteenth-century silver, is by John Coney (1656–1722), another of Boston's great, whose work has already been discussed in Chapter 3 (Fig. 101). His impressive monteith (Fig. 144), a large punch bowl with scalloped rim from which glasses were hung for cooling, provides a most spectacular display of Baroque decorative devices. A strongly molded base enriched with gadrooning is surmounted by the ample form of the bowl, which is treated with very shallow fluting. Above is a complex border, rich in its leafy patterns, volutes, bold curves, and full-bodied decorations, topped by fanciful cherubs' heads. Though the ornamentation is heavy, the expanse of shallow fluting provides relief, so that the total effect is not oppressive.

The third piece, a silver snuffer stand (Fig. 145) by Cornelius Kierstede (1675–1757), shows the elaboration of form and decoration that characterized the more pretentious pieces wrought by the Dutch silversmiths of New York. A succession of bold shapes with heavily wrought engraved and applied ornamentation makes this elaborately decorated stand appear much larger than its 8 ¼ inches. The Dutch influence also made itself felt in the preference for festoons of fruits and flowers and the use of much embossing and engraving.

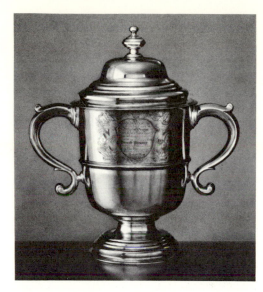

The preference of the Queen Anne period for a fine form unencumbered with ornament is shown in a two-handled covered cup (Fig. 146) by Jacob Hurd (1702–58), of Boston. The splendid handles, which are beautifully related in both scale and shape to the covered top and the base, provide the principal ornament. The delicate engraved inscription framed with Rococo motifs adds interest but in no way detracts from the simple form.

Paul Revere, Sr. (1702–54), was another Boston silversmith who produced distinguished examples of the Queen Anne style. His famous son, who created fine silver in the Classic Revival manner, will be discussed in Chapter 9.

Three examples of Rococo illustrate the character of the fully developed style. Simeon Soumain (1687–1750), a Huguenot, of New York, created a silver salver (Fig. 147) in which cabriole legs and fluted edges employ the reversed curves of the Rococo style to contribute an element of grace, animation, and even frivolity to a simple design. An unusually handsome tea set (Fig. 148) made by Peter

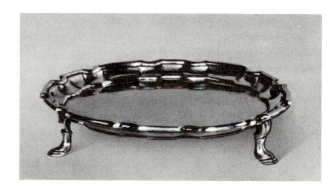

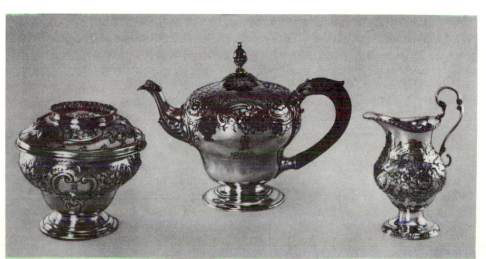

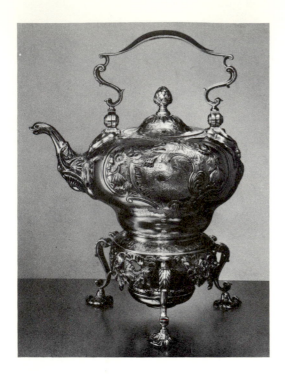

above : 149. JOSEPH RICHARDSON. Teakettle and stand. 18th century. Silver. Yale University Art Gallery, New Haven, Conn. (Mabel Brady Garvan Collection).

below : 150. Candlesticks. 1720–50. Iron. Art Institute of Chicago (Dr. and Mrs. Dudley Phelps Sanford Collection).

below right : 151. Fireback, "The Highlander," from New York. 1767. Cast iron, 39 ½ × 21 ⅛". Metropolitan Museum of Art, New York (Rogers Fund, 1916).

de Riemer (active 1763–96) for Philip Schuyler Van Rensselaer is reputed to be the first silver service to have been made in New York. Its embossed cartouches and garlands of leaves and flowers have the grace of form and delicacy of surface that typify Rococo in its most refined and elegant manifestations.

A silver teakettle and stand by Joseph Richardson (1711–84) provides a nontypical example of the extreme elaboration that occasionally appeared in Philadelphia (Fig. 149). Reflecting the mid-century splendor of London service, this teakettle and stand employs the full gamut of Rococo devices. Elaborate repoussé cartouches, framed with involved reverse curves and filled with foliate, floral, and ruffled decorations, almost obscure the form of the body. Emerging from a ruffled and pierced profusion of curves, the stand has Rococo legs which repeat the curves of the handle. Such extremes of Rococo decoration inevitably brought reaction. The neoclassic style which followed turned back to simple forms and smooth surfaces.

The majority of the colonists could not afford to own silver services and used the more humble pewter ware. Less stylish than silver, pewter objects tended to be made in the same forms over a long period, forms modeled after early eighteenth-century silver objects. A wide variety of articles, including almost all standard kitchen and table items, were made of pewter.

The importance of the blacksmith in early American life has already been mentioned. Many iron objects were made for the stove and fireplace, but they appeared and were used in other parts of the house. Waffle and wafer irons, gridirons, lamps, trivets, tongs, shovels, andirons, candlesticks, stove plates, stoves, and firebacks for fire-

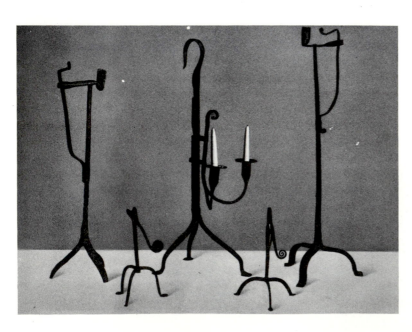

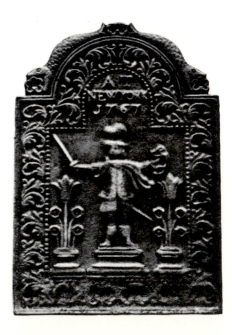

places were all produced in the colonial blacksmith shop and iron foundry. A group of iron candlesticks from the eighteenth century (Fig. 150) reveals the varied forms and ingenious devices as well as the decorative touches that contributed a note of grace to simple utilitarian objects. The large central candlestick can either stand or be hung from a wall bracket, and its notched standard provides for lowering or raising the candles.

Eighteenth-century firebacks, made of heavy iron to throw more heat into the room, were usually cast in elaborate designs, contributing, along with the andirons, a decorative note to the fireplace. "The Highlander" (Fig. 151), combining human, fish, floral, and leaf motifs in a bisymmetric arrangement, is more elaborate and somewhat more formal in design than most American firebacks. Another attempt to increase the effectiveness of the fireplace was the five- or six-plate jamb stove, a series of heavy enclosing iron plates extending into the room. From these extended hearths Benjamin Franklin developed the Franklin stove, the front of which was decorated with a sun and an inscription reading "ALTER IDEM" (Fig. 152).

The elaborate exteriors of the Georgian houses also provided excellent opportunities for the ironmonger to display his skill and artistry. Knobs, latches, handles, key plates, bolts, and locks were given graceful enhancement whenever a surface or contour permitted. The impressive gates, stair railings, and fences that framed the entrances to the more imposing homes and estates were ornamented with the full vocabulary of wrought-iron effects, as well as with cast-iron leaves, rosettes, and classical motifs. Foot scrapers were cast into fanciful animal and plant

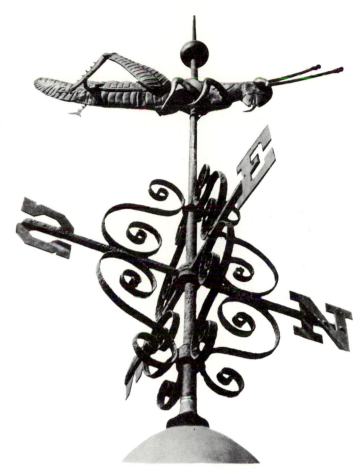

left : 152. BENJAMIN FRANKLIN. Oldest known Franklin stove. c. 1755–70. Iron, height 32″. Mercer Museum, Doylestown, Pa.

above : 153. SHEM DROWNE. Grasshopper weather vane. 1742. Hammered copper with green glass eyes. Faneuil Hall, Boston.

forms, as well as into geometric and architectural patterns, and weather vanes were ornamented with cutouts of birds, animals, fish, owner's initials, the dates when a house was built, and other relevant or whimsical motifs. Such weather vanes were frequently many feet across and created an elaborate and intriguing silhouette against the sky. The most famous weather vane in America is probably the great copper one (Fig. 153) which has topped Faneuil Hall, in Dock Square, Boston, for more than two centuries. The giant grasshopper with green glass eyes was hammered from one sheet of copper by Shem Drowne in 1742. Less famous, but perhaps more amusing, is one in which Shem

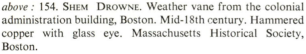

above : 154. SHEM DROWNE. Weather vane from the colonial administration building, Boston. Mid-18th century. Hammered copper with glass eye. Massachusetts Historical Society, Boston.

above right : 155. Pennsylvania Dutch shaving dish. 1769. Slip-decorated earthenware, diameter 8 $^{13}/_{16}$". Metropolitan Museum of Art, New York (Rogers Fund, 1953).

center right : 156. GEORGE HUBENER. Plate, from Montgomery County, Pa. 1775–98. Red earthenware with sgraffito decoration, diameter 12". Metropolitan Museum of Art, New York (gift of Mrs. Robert W. de Forest, 1934).

below right : 157. Plate, from Pennsylvania. 1790. Glazed earthenware with painted and sgraffito decoration, diameter 11 ¾". Metropolitan Museum of Art, New York (gift of Mrs. Robert W. de Forest, 1933).

Drowne transmuted a ferocious Indian into a charming decoration (Fig. 154).

Ceramics

The lead-glazed redware described in Chapter 3 continued to be the standard household pottery through most of the eighteenth century. Almost every town had its potters who provided redware vessels for the table, for cooking, and for storing food. Slip-decorated pottery was made by most early settlers; the vigor and variety of that

produced by the Pennsylvania Dutch makes it one of America's most charming ceramic wares. Pennsylvania pottery, like that produced in the English-speaking colonies, was either thrown on a wheel or made in molds. Two main types of decoration were employed: slip-painted (Fig. 155) and sgraffito (Fig. 156). In the first, patterns were painted on the cream-colored slip with various combinations of clay and color glazes. In sgraffito decoration, as described in Chapter 3, the design was incised in the slip to expose the dark red color of the pottery beneath. Sometimes both kinds of decoration were used on one piece (Fig. 157). To decorate the pottery, the cream-colored glaze was enlivened with a number of other colors; dark red, brown, green, and olive yellow were all used occasionally, although most of the potters limited their color schemes to a few bright colors, red, green, and white being the most popular. In the final firing the glaze melted and filled the engraved areas; consequently the sgraffitoware presented an almost smooth surface. Slip-decorated pottery and sgraffitoware remained very much folk arts, carried on during slack seasons by farmers and other types of workmen who made the pottery almost as a lucrative hobby. The patterns and techniques continued unchanged over many generations.

Platters, pie plates, jars and crocks, and cooking bowls were made in the greatest quantities, but a wide variety of other pieces have also been found. Many unusual shapes were made for particular individuals or for special occasions. The unique slip-decorated shaving dish (Fig. 155) is a particularly amusing example of such a specialized piece. The motifs used to decorate Pennsylvania pottery are similar to those on the painted furniture from this area. Flowers, particularly the tulip, leaves, fruits, birds, animals, human figures, initials, writing, and many groupings of lines, dots, and simple geometric motifs were all popular. As is so frequently the case in folk art, the same motifs were used many times, but each potter modified them to suit his own tastes.

Another handsome type of ceramic ware produced in the colonies was the gray or gray-brown stoneware used primarily as containers and for storage purposes. Pitchers, jugs, butter crocks, mugs, and pickle jars of fine simple shapes were made in this ware from the mid-eighteenth century up to modern times. Stoneware is a hard and dense type of pottery produced by firing at a high temperature and glazing with salt. It has a finely pitted surface texture similar to that of an orange peel. The gray and tan stoneware was frequently decorated with cobalt-blue patterns, either freely painted on the surface or run into shallow incised designs before the entire piece was glazed. The most frequent motifs were floral sprigs, birds, or patriotic motifs. The Morgan potteries at

Cheesequake, N.J., were famous for the fine quality of their stoneware. In the early years New Englanders, lacking a suitable clay, had to import their stoneware from England or from the other colonies. At a later date the proper clay was imported from New York, New Jersey, and Pennsylvania, and the pottery works of New England produced fine stoneware (Fig. 158).

Fine porcelain tablewares were, for all practical purposes, beyond the capabilities of the colonial potter. However, at the time of the Revolution a rather refined white earthenware (Fig. 159) designed in a modified Rococo form for the table was being manufactured in

top : 158. Jug with eagle and olive branches, from Hartford, Conn. 18th century. Glazed stoneware incised in blue, height 15″. Brooklyn Museum (gift of Arthur W. Clement).

above : 159. GOUSSE BONNIN and GEORGE ANTHONY MORRIS. Sauce boat, from Philadelphia. 18th century. White earthenware with blue underglaze, $4 \times 7^{9}/_{8} \times 3^{1}/_{2}″$. Brooklyn Museum.

Philadelphia. This ware, decorated with an underglazed blue pattern of Oriental inspiration, was styled after, and produced in competition with, the English porcelain and Oriental import china that graced the homes of the wealthy.

Glassmaking started in America during the seventeenth century without much success. In the eighteenth century three glass manufacturers, all of German origin, succeeded in creating both window glass and fine table and household glasswares for the colonists. Caspar Wistar (1696–1752) established his glass works at Wistarberg, West Jersey, in 1739. "Baron" Henry Stiegel (1729–85) located his factory at Manheim, Pa., between 1760 and 1765. John Frederick Amelung (active 1785–94), emigrated to Maryland and opened his glass works in New Bremen, Md., about 1785.

Caspar Wistar is reputed to be the first man in America to manufacture flint glass, though no existing glass pieces can be attributed to him with certainty. Flint glass, now made with sand, was originally made with ground flint or flint pebbles and was pure, lustrous, and of great beauty. Although his factory was set up primarily to make window glass and bottles, Wistar also made flint table glass in clear white and in a variety of colors. The so-called "Wistar-style glass" is fine in craftsmanship, simple but refined in shape; its interesting decorative effects were achieved by super-imposing waves, spirals, scallops, and similar shapes of colored glass on a plain or contrasting colored base. Wistar's considerable influence on nineteenth-century glass is discussed later.

Stiegel was a German entrepreneur who went to Philadelphia in 1750 and embarked upon a series of ambitious business enterprises, one of which was a glass factory. He manufactured flasks, bottles, fine tableware, cologne bottles, goblets, tumblers, sugar bowls, creamers, and other pieces. His glass was produced in many colors, but a very rich, deep blue is the color most frequently associated with his name. Stiegel glass displays a variety of kinds of decoration. Engraving and enameling were both used extensively, and many variations of color and tone were produced by manipulating the molten glass in the blowing process.

below left : 160. Bottle of Stiegel type. 18th century. Amethyst glass. Metropolitan Museum of Art, New York (gift of F. W. Hunter, 1913).

below center : 161. Bottle. 18th century. Blue glass with enameled decoration, height 5 ½″. Metropolitan Museum of Art, New York (gift of F. W. Hunter, 1913).

below right : 162. JOHN FREDERICK AMELUNG. Covered goblet, from New Bremen, Md. 1788. Clear glass engraved. Metropolitan Museum of Art, New York (Rogers Fund, 1928).

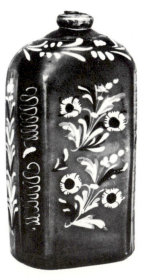

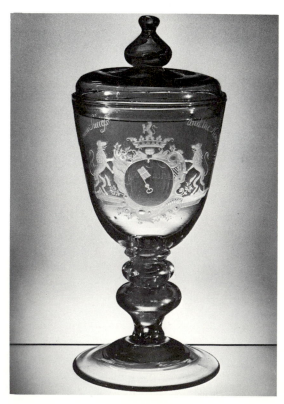

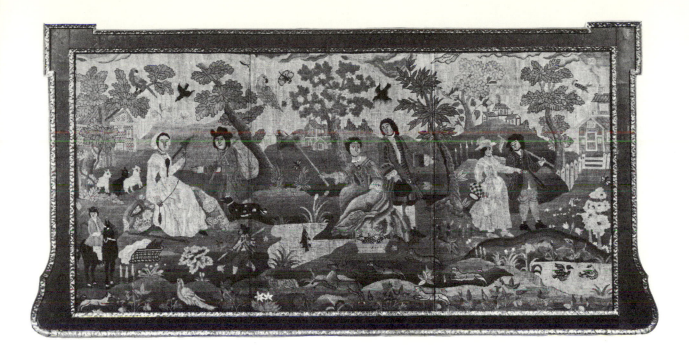

above : 163. *The Fishing Lady on Boston Common.* 18th century. Petit point, 20 ½ × 43 ¼″. Museum of Fine Arts, Boston (Seth K. Sweetser Fund).

Two bottles from this period will serve to illustrate the sophistication of form and decoration of eigtheenth-century colonial glass. The amethyst bottle (Fig. 160), a pure example of the glass blower's art, derives its decorative values from its fine shape and from variations in the thickness of the glass. The bottle of deep-blue glass (Fig. 161) is decorated with freely applied enameled patterns in bright colors. Either of these pieces of glass might have been produced by Stiegel, and they undoubtedly reflect his influence, but they cannot be positively attributed to his factories.

Only Amelung has left glass that can be identified as his without question. Though his arrival in America postdated the Revolutionary War, his glass is more related to pre-Revolutionary styles than to typical American nineteenth-century developments. A covered goblet dating from 1788 (Fig. 162) reveals the handsome, full form that characterized his wares, as well as the delicate copper-wheel engraving whereby he inscribed and decorated his finer pieces. Unfortunately, despite the technical and stylistic excellence of his glass, Amelung, too, went into bankruptcy before the end of the century.

Textiles

The colonial housewife continued to spin yarn and to weave the sturdy textiles necessary for clothing and household linens throughout the eighteenth century. As the journeymen weavers relieved her of the more burdensome tasks, and as importations became more numerous, she spent more time embroidering, weaving fancy bedspreads, and making the appliqué and patchwork quilts and coverlets which displayed her love of fancywork.

Fine needlework and embroidery constituted an important part of a young lady's education in colonial Boston, and the ultimate exercise in her craft was the needlepoint picture. A favorite subject for such pictures was a pastoral scene with a woman seated on a rock fishing in a small pond. It became the vogue to use the buildings and activities of the Boston Common as a background for such pictures. About a dozen of these elaborate needlepoint pictures (Fig. 163) are extant today, and they have the common title of *The Fishing Lady on Boston Common.* Their decorative charm is enriched by quaint humor and exquisite craftsmanship.

No home craft was more universally popular than the weaving of decorative covers for the imposing bedsteads in which the colonial housewife took so much pride. Eighteenth-century bedspreads were usually woven in geometric patterns, since the hand looms of that period would not accommodate the more elaborate conventionalized floral and pictorial designs popular in the nineteenth century. A detail of a bedspread (Fig. 164) from New Hampshire, woven in the eighteenth century, shows the remarkable effects the colonial weaver could achieve within the limitations of simple geometric figures.

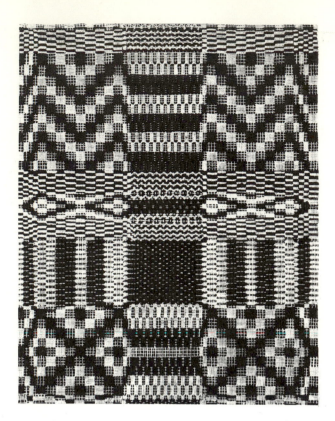

left : 164. Coverlet, from New Hampshire. c. 1779. Linen and indigo-blue wool, c. 7 × 6′. Private collection.

Chevrons, stripes, and squares combine here in a fascinating variety of sizes and shapes to achieve many different textures. The colors of this spread are those most frequently used, natural linen color and indigo blue. The effect is modest but certainly not dull. Cotton, linen, and wool were the fibers most commonly found in such spreads, the cotton and linen usually providing the foundation woof threads and colorful wools forming the warp. Many of the dyes used to color the threads were made from native flowers, barks, and berries. Indigo provided the blue, sumac the favored orange-red. Popular patterns were known by names, many of which have a quaint charm; "Checkers, Stripes, and Squares," "Sunrise," "Maid of Orleans," and "Nine Snowballs with Pine Tree Border" were all familiar repertory pieces to former generations.

Samplers remained popular in the eighteenth century, but they ceased to be a collection of stitches and became displays of embroidering prowess. Mottoes, texts, human figures, birds, beasts, flowers, and fruits were combined with ingenuity, and the finished products were framed for use as wall decorations.

The architecture and household arts of the Georgian age are highlights in the history of American art. During this period the high roofs, the towering gables, and the bulbous pendants of an earlier period gave way to graciously decorated symmetrical façades; low, dark, and crowded halls were transformed into high-ceilinged, spacious rooms; great hand-hewn beams disappeared behind handsome wainscot paneling; and the heavy oak lintel above the fireplace was replaced by an elegant pedimented architectural composition. The Bible box became a secretary, and from the sturdy, boxlike seventeenth-century chest sprang the great 7-foot highboy, with cabriole legs, carved apron, and towering pediments filled with rococo shells, leaves, and flowers.

By the time of the Revolution, America was well on its way toward competing with Europe in the elegance of its way of life and its arts. But the age of elegance in Europe was drawing to a close. The American Revolution was not an isolated event but part of a great social change that was occurring all over the civilized world. This change eventually broke the power of the great monarchies of Europe, unseated the aristocrats, and brought to an end a whole complex of social institutions. The arts and crafts which were the chief expressions of those aristocratic institutions shared the same fate. France and then all the countries of Europe were caught in a maelstrom of successive disturbances, political, economic, and social. The arts reflected these disturbances through a series of shifting styles initiated with increasing rapidity all through the nineteenth century. Architects and designers revived earlier styles in a search for forms that would function socially and esthetically in response to two fundamental social changes: the political transformation of society inherent in modern democracy and the technological changes attendant on the emerging industrial revolution.

Now we look back upon the rich beauty of Georgian art as the flowering of an older way of life transplanted to American shores, and we see the conflicting currents of nineteenth-century taste as the confused expression of a period of gestation. The search for new forms to embody the forces of the new society continues today, but something of the integrity of the colonial Georgian tradition remains part of our heritage, giving promise of another period of distinguished achievement in architecture, in the industrial and household arts, and in the handicrafts.

6

Painting, Sculpture, and Printmaking in Colonial America

Unless men revert to a brute level of existence, the home and its basic equipment are necessities. But for man conquering the intractable wilderness the fine arts have less immediacy. The hardships of colonial life left little time or energy for painting pictures or carving statues, and the Puritan antagonism toward the arts as expressions of courtly extravagance and vanity did not provide an atmosphere conducive to artistic production. It comes therefore as something of a surprise to find artists working in America almost from the moment the continent was discovered.

The early explorers brought with them artists who played the same role as that of a photographer on a modern expedition of exploration, making records of new places, strange people, beasts, and plants. Among the conquistadors who accompanied Cortes were men who could make sketches of what they saw. During the sixteenth century in North America, French, English, and Dutch adventurers also made drawings and water-colors which were taken back to Europe to inform the Europeans of the new continent. Often technically naïve and sometimes distinguished more by imagination than by accuracy, these early records did much to direct the interest and ambitions of Europeans toward the newly discovered lands. They provided the basis for the engravings used to illustrate the European publications about the new continent and played a part in the whole expanding tradition of realism and scientific observation as a basis for art.

Between 1577 and 1590 John White, an English artist, was sent by Sir Walter Raleigh to accompany three expeditions to what was later Virginia to make a permanent pictorial record of the fauna, the flora, and the customs of the natives. His delightfully descriptive watercolor drawings have, by a miracle, been preserved and are now in the British Museum. *Indian Village of Secoton* (Fig. 165) is as informative as only a pictorial record can be. White's drawings of animals, plants, individual Indians, and Indian living habits were probably the finest early pictures of the new land.

Although the men who made the first sketches of America were in no sense artists of great distinction, they helped to establish a concept in the New World that had been long accepted in the Old—that the activities of the artist were not eccentricities but were the normal pursuits of civilized man.

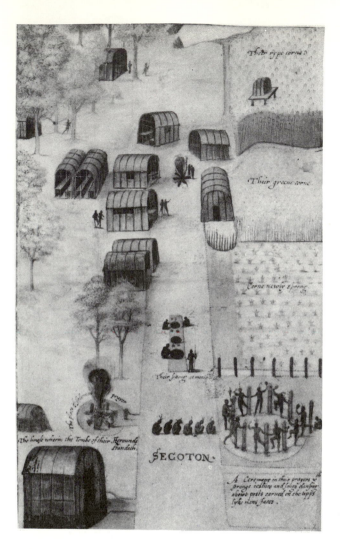

left: 165. JOHN WHITE. *Indian Village of Secoton.* 1577–90. Watercolor, 12 ¾ × 7 ¾". British Museum, London.

The Limners: The English Tradition

Little is known of the men who painted the earliest portraits in the colonies, but there are numerous references in the literature, letters, and documents of the day to the activities of "limners," as portrait painters were then called. Because the names of most of the limners are unknown, they are identified by the personages they painted. From Boston come the best-known: the John Freake limner, the limner of the Gibbs children, and the limner of the Mason children.

The three Gibbs children, Margaret, Henry, and Robert, were all painted in the same manner by what was undoubtedly the same artist. The two handsome portraits of members of the Freake family, *John Freake* and *Mrs. Elizabeth Freake and Baby Mary* (Fig. 166), are also similar in manner. It seems most likely that the Gibbs limner and the Freake limner are one and the same. In all these portraits the poses reveal a full three-quarter face, with the figure standing or stiffly posed as Elizabeth Freake is seated, with no body movements, and with little foreshortening in the arms or body. The backgrounds are dark and unbroken, except for a suggestion of a piece of furniture or a drapery, or, as in the portraits of the Gibbs children, bold tile patterns which establish the plane of the floor. The faces are similar in all the paintings, with almond-shaped eyes, a swelling fullness of cheek, and a small chin. The modeling of the form is slight, with only enough contrast of light and dark to make the details of the face and body convincing. Though Baby Mary has an almost doll-like stiffness and lack of expression, a grave, reverent, and poetic feeling for the wistful charm of the mother is projected with surprising force. The details of costume, ribbons, bows, lace, and embroidery reveal a sensitive artist at work, an artist who delights in refinements of shape and decorative convolutions of line, even though he is not a facile practitioner of figure painting as it was produced in the courts of Europe. The limner who painted *Mrs. Elizabeth Freake and Baby Mary*, though limited in conventional skills as compared to the European masters of his day, was able to project into his work both a grave respect for his sitters and refined feelings for pattern and color.

A portrait of Anne Pollard (Fig. 167) reveals a very different talent. In the early eighteenth century an unknown limner painted her after she had passed her hundredth year. According to tradition, Anne Pollard, at the age of ten, was the first of Governor Winthrop's party to set foot on American soil. She had witnessed

SEVENTEENTH-CENTURY PAINTING

In the seventeenth century artists came to America in increasing numbers, not only as illustrators accompanying parties of exploration, but as travelers and settlers. None of them was thoroughly trained or gave evidence of great talent, but they catered to the artistic needs of the colonizers, humble though these might be. They painted signs, decorated carriages, documents, and public properties with appropriate insignia, and painted likenesses. Many of the portrait painters appear to have moved from town to town to paint important personages and their families, probably carrying on most of this activity in winter, when cold weather made it impossible to work outdoors.

Few seventeenth-century portraits have come down to us except from New England and the New Netherlands, and thus a discussion of seventeenth-century painting is confined to the areas around Boston and New York.

the development of Boston from what had been a bushy swamp, had borne twelve children, and had outlived all of her generation. The sense of character and age is conveyed with direct force. Her sober and pious expression is established by strongly modeled forms executed with firmness and energy. The dark and light patterns animate the space of the composition with sufficient conviction so that awkwardnesses of drawing are overcome by the vigorously painted face, hands, and costume. The limner who painted Anne Pollard may well have been acquainted with the work of some of the Dutch painters of his day, since the dark background and the sculptural modeling of the forms appear closer to the Dutch tradition of portraiture than to the English Tudor manner.

To the limited degree that the work of the seventeenth-century limners was rooted in a tradition, it was based on a style of painting that had flourished in England through the Tudor period, coming to its full development during the reign of Queen Elizabeth. This style, which lingered on in the rural areas of England and was still practiced by innumerable country painters in their painstaking portraits of country squires and their families, was essentially flat and linear. In these paintings the sitter is painted in a full flow of light, with only enough shadow modeling the edges of the forms to establish a sense of solidity. The sitter is usually seated full face to the front or in a three-quarter view, and the figure fills most of the area of the picture. There is little action in the pose and a minimum of background accessories. Details of costume are carefully and elaborately delineated, but no

ideal of courtly elegance or sentiment softens the uncompromising observation of features and expressions. Colors tend to be pale and clear, the artist attempting only to render what he saw before him.

By the end of the seventeenth century, in the court circles of England, this linear and detailed style of painting had been replaced by the suave and highly refined Baroque tradition of painting practiced by Van Dyck and the artists who followed him. In this later style broad masses of light and shadow reveal and envelop the sitter, who is placed in deep space. Poses are casual and graceful; elaborate landscape and architectural settings, as well as details of furniture and draperies, create an atmosphere of elegance. An all-pervasive color harmony relates the sitter, the background, and the details into a harmonious whole. Lastly, the application of the paint is dexterous and painterly, with skillful brush work and interesting variations of the density of the paint contributing an expressive play to the painted surface.

Few of the painters working in seventeenth-century America revealed a familiarity with this tradition of

left: 166. *Mrs. Elizabeth Freake and Baby Mary*. c. 1674. Oil on canvas, 42 ½ × 36 ¾". Worcester Art Museum, Worcester, Mass. (gift of Mr. and Mrs. Albert W. Rice).

above: 167. *Anne Pollard*. 1721. Oil on canvas, 24 × 28 ¾". Massachusetts Historical Society, Boston.

168. Thomas Smith. *Maria Catherine Smith.* c. 1690. Oil on canvas, 27 × 25″. Worcester Art Museum, Worcester, Mass. (on loan from American Antiquarian Society).

The Dutch Tradition

A portrait of the artist's wife by Gerret Duyckinck (Fig. 169) reveals the nature of the Dutch tradition from which the painters of New Amsterdam drew their sustenance. Evert Duyckinck, father of Gerret, came to New Amsterdam from Holland in 1638 and practiced the crafts of limner, painter, glazier, and glass manufacturer. His painting activities covered a wide variety of assignments, from signs, to coats of arms on fire buckets and coaches, to portraits. Gerret (c. 1660–c. 1710) continued with his father's various activities. The portrait of the artist's wife reveals the more plastic, three-dimensional nature of the Dutch tradition in New Amsterdam, as contrasted to the linear character of the limners in New England. The circular movement of the shoulders in space, the relationship between the hands, the turn of the head, and the swirl of the draperies all indicate an awareness of volume and space. The modeling of the head and hands also suggests a systematic use of light, shadow, and reflected light that denotes a working knowledge of the space and form concepts of the mature seventeenth-century tradition in Holland. As in most portraits of Dutch burghers, the characterization is sober and factual. The artist had no desire to glorify or idealize his sitter but rather placed his emphasis on an honest presentation of appearances. Technical inadequacies, more apparent when an artist is attempting to work in the mature Baroque manner than in the naïve and linear style of the typical limner, kept Duyckinck from fully realizing his ambition. The foreshortening of the far eye is awkward, the hands are stiff, and the arm resting on the table is poorly related to the rest of the figure.

Inventories of the homes of the Dutch settlers indicate that they had a more developed taste for paintings than the English. A wide variety of paintings were imported, but like the English, the local Dutch restricted their patronage to the commissioning of portraits. Hendrick Couturier (died 1684), who moved to New Amsterdam from Holland in 1661, was recorded as a painter in the Leyden guild of painters. This documentation probably proves him the first professional painter to practice portraiture in America. He obtained his burgher's rights in New Amsterdam by painting a portrait of Governor Peter Stuyvesant. Though it cannot be identified with absolute certainty as the portrait painted by Hendrick Couturier, the portrait of Governor Stuyvesant (Fig. 170) is by a trained artist familiar with the tradition of Dutch portraiture. The drawing is accurate, the compositional arrangement of the figure in the oval canvas is easy, the value relationships are bold and certain, and the paint is applied dexterously and without pedantic fussing. Cou-

court painting, and, had they been competent to practice it, their clients probably would not have been sympathetic to a style which to them might symbolize an ideal of display, affectation, and sybaritic indulgence that was in conflict with their Puritan ideals. One seventeenth-century painter, however, has left a few portraits which appear to have been influenced by this fully developed Baroque tradition. Captain Thomas Smith (active 1680–90), sailor and painter by profession, came to America from Bermuda, obtained a few portrait commissions, and also left a portrait of himself and one of his daughter.

Though no great skill is reflected in the portrait of Maria Catherine Smith (Fig. 168), Smith employed a number of devices that suggest a degree of familiarity with the tradition of the English court painters. The background is not a solid dark but has a movement of tone so that one sees the figure as light against a dark background on the right side and as dark against a light background on the left. The costume and hair are painted with the rich, swirling movements and the freely applied brush strokes of the Baroque style, and there is a feeling of movement in the flowing draperies of the costume. There is also a suggestion of voluptuousness and physical beauty in the full features and the low neckline that is more akin to the worldly attitudes of the Restoration court than to the Puritan morality of the colonies.

turier moved from New Amsterdam after a few years and became a trader and public official in a small Dutch settlement on the Delaware River; consequently his career as an artist was short-lived.

Not all the painting produced for the Dutch settlers aimed at the full-blown Baroque tradition. In the Hudson River Valley between Albany and New Amsterdam a group of forceful, naïve portraits of Dutch planters, burghers, and their wives and daughters was produced in the late seventeenth and early eighteenth centuries. The painters of these portraits, unlike those of New Amsterdam, showed little interest in space and form but painted with clearly defined patterns which are broad in conception, certain in execution, and often achieved a vigorous defini-tion of character approaching caricature. In relative isolation, these painters appear to have developed a self-trained, native school out of an artisan tradition of decorative craftsmanship deeply rooted in the Dutch folk culture. *Girl with the Red Shoes* (Fig. 171), as the popular

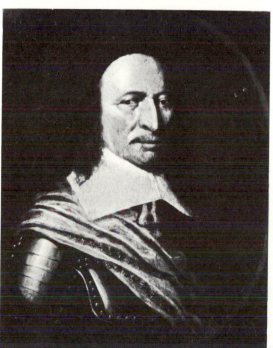

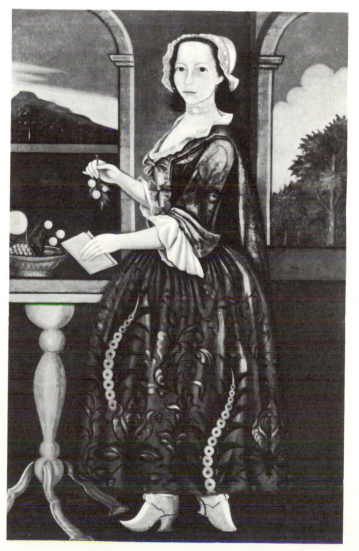

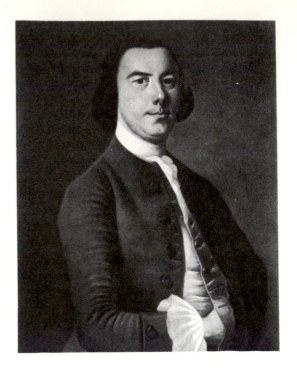

portrait of Magdalena Gansvoort is usually called, is a most charming work of the early eighteenth century. The color is clear and fresh, and the shapes are animated and composed with an innate feeling for harmonious relationships of line and pattern. The unknown author of the work accepted the Baroque tradition of a richly costumed figure standing before a background of handsome architectural and landscape forms and translated this into the local idiom of flat patterns. The result is highly decorative—sprightly, fresh, and vivacious—reflecting the unpretentious but confident taste of this folk mode.

EIGHTEENTH-CENTURY PAINTING

The seventeenth century witnessed America's first attempts at painting; the eighteenth century began to show promise of an American school. By the time of the Revolution a number of both foreign and native-born artists were at work in the principal colonial cities. Certain characteristics—a general simplicity of effect, a preference for fact over flights of fancy, and an earnest naïveté rather than lofty style—mark the most persuasive painting done in America during the years immediately preceding the Revolution, giving it a common flavor sufficiently distinct to constitute an American school.

These distinctive characteristics did not result from any conscious sentiment on the part of the artists. Rather, they were the inevitable result of the isolated colonial situation, the limited facilities that existed here for training artists, the absence of major works of art which could serve as a guide to aspiring students of painting, and the essentially Puritan background of New England.

This absence of expert practitioners, schools, and works of art had both a positive and a negative aspect. The negative aspects are obvious: many artists failed to mature from lack of both patronage and esthetic stimulus. However, isolation also had its positive values. Copley, the most important painter of the colonial age, reveals the strength developed by isolation. His clear and objective vision of human character and his strong tactile sense might never have emerged had he spent his learning years mastering the facile conventions of the eighteenth-century academies of Europe. The artist's vision of life established during his formative years was not limited by tradition and established formulas, so that while he frequently saw more naïvely, he occasionally saw more clearly, or at least saw aspects of reality that might have been obscured by the conventions of European painting.

Imported Talents

Enough wealth had been accumulated by the eighteenth-century colonial planters, merchants, and professional men to attract the attention of ambitious or restless painters from Europe who had not achieved sufficient success there to satisfy them. No one of them was a major artist, and many of them were hardly more than amateurs, but they did bring some skill and knowledge with them which they passed on to the local practitioners, thereby making it possible for such artists as Feke and Copley to develop without leaving the shores of America.

Most of the painters who arrived here before mid-century attempted, no matter how inadequately, to employ Baroque concepts of portraiture, with handsome settings, full chiaroscuro, rich color, and painterly execution. Later arrivals tended to affect the Rococo mannerisms currently popular in fashionable European circles. Of the many who arrived here in the first half of the century only a few need be singled out; most painted only a few portraits and then left the country or moved on to another vocation. Among the remembered ones are Henrietta Johnston (died 1728/29), who introduced pastels to Charleston in the first decade of the century; Justus Kuhn (died 1717), who did naïve but ambitious portraits in Annapolis; and John Watson (1685–1768), who painted in Perth Amboy, N.J., and New York.

Jeremiah Theüs (1719–74), a Swiss, left a more substantial heritage. He arrived in Charleston, S.C., in

1739, and spent the remaining thirty-five years of his life doing somewhat decorative portraits (Fig. 172) of the people of that area. These portraits are not notable either as character studies or as incisive likenesses, but they are vigorously, if somewhat crudely, painted. Unlike the earlier limners, Theüs employed the strongly massed lights and shadows, the richer colors, and the bold brush work of the fully developed Baroque court style. He helped popularize the gaily colored portrait that was fashionable in eighteenth-century Europe and contributed greatly to interior *décor*.

In mid-century Charles Bridges (active 1735–40) came to Virginia and spent some time painting planters and their families before he returned to England. Bridges handled the portrait formula of the eighteenth century with more refinement and assurance than Theüs. His portrait of Maria Taylor Byrd (Fig. 173), the attribution of which is sometimes questioned, is firm in drawing, easy in movement, and has a poised elegance that suggests an artist of taste as well as skill.

Peter Pelham (died 1751) is also worthy of mention. He was an English engraver, settled in Boston, who made mezzotint engravings and taught drawing. His marriage to Copley's widowed mother made him Copley's stepfather.

The painter who had the greatest influence on the emerging American school in the first half of the eighteenth century was John Smibert (1688–1751). Smibert was born in Scotland and trained in Italy. He became Boston's leading portrait artist in those formative years.

The most complex and ambitious painting of Smibert's that has come down to us is the large group portrait,

Dean Berkeley and His Entourage (The Bermuda Group), so called because both Smibert and Bishop Berkeley were in Newport, R.I., en route to Bermuda when the painting was executed (Fig. 174). The composition, involved and carefully considered, indicates a rather thorough knowledge of the compositional concepts of the early eighteenth

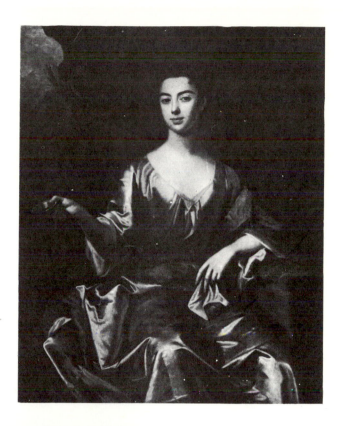

above: 173. CHARLES BRIDGES (?). *Maria Taylor Byrd.* c. 1735. Oil on canvas, 4′ ½″ × 3′ 6″. Metropolitan Museum of Art, New York (Fletcher Fund, 1925).

left: 174. JOHN SMIBERT. *Dean Berkeley and His Entourage (The Bermuda Group).* 1729. Oil on canvas, 5′ 10 ¾″ × 7′ 10 ½″. Yale University Art Gallery, New Haven, Conn.

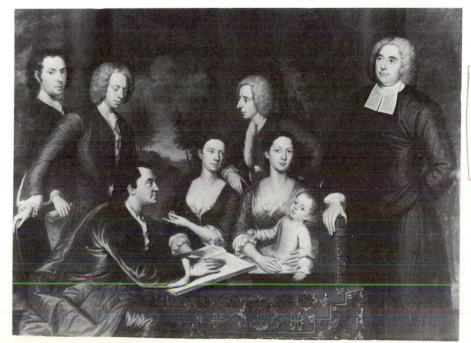

century. The figures on each side establish dignified vertical lines, which are repeated in the shadowy colonnade in the background. The table top provides a stabilizing horizontal base for the central triangular group that constitutes the main mass of the picture. The eye enters the space of the painting through the flowing line of draperies on the lower left and moves up and back into the main pyramidal mass of the seated figures to the standing figures in the rear right. The gestures of hands, the directions of eye movements, and the rhythmic folds of draperies establish an arabesque of lines to animate the space of the picture. Well-rendered surface textures, rich color, and the effective dark and light pattern all attest to Smibert's competence. His limitations are also evident. Though the likenesses have a degree of differentiation, they do not communicate a strong sense of character; an air of artifice dominates the gestures, rather than an interplay of personalities. The application of paint is monotonous, careful finish substituting for spirited execution. It is a painstakingly planned and thoughtful piece of work, not a great group portrait but certainly the most complex and competent painting produced in America up to that time.

The trip to Bermuda was never completed, and Smibert returned to Massachusetts and settled in Boston, where he was influential as a portrait painter, and his copies

175. GUSTAVUS HESSELIUS. *Lapowinsa.* 1735. Oil on canvas, 33 × 25″. Historical Society of Pennsylvania, Philadelphia.

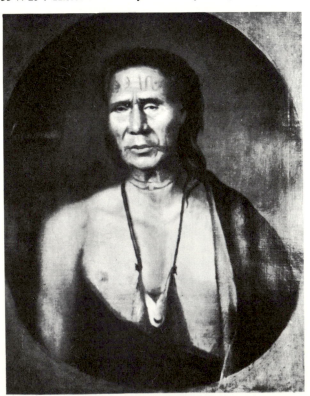

of the Italian masters introduced Bostonians to the works of certain Renaissance painters.

Gustavus Hesselius (1682–1775), a Swede, played a similar, though less influential, role in Philadelphia. In America he practiced portraiture and also painted some classical allegories and other grand subjects. As time passed, his style, like that of Smibert, became less elaborate and courtly and more concerned with the realities of life in America. His portrait *Lapowinsa* (Fig. 175), one of the earliest paintings of an Indian subject, is distinguished by its searching truthfulness. No Baroque glorification of the savage chieftain appears here. Instead, the furrowed questioning face reveals the artist's interest in human beings, not as symbols of elegance or power but, rather, as individuals. This concern with the individual as a unique personality rather than as a representative of a social group became one of the chief characteristics of the American school of portraiture. Hesselius also attempted elaborate mythological allegories and a *Last Supper*, which probably constitute the first attempt in America to enlarge the scope of painting beyond factual statement. Later in the century John Hesselius (1728–78), the son of Gustavus, followed his father's career as a portrait painter in Philadelphia.

The Rococo

In the middle of the century an echo of the Rococo style, which was the dominant mode in the courts of France and England, was imported into America. Joseph Blackburn (c. 1700–c. 65) and John Wollaston (active 1750–67) were the two men who played the most important role in introducing certain Rococo graces and affectations into the sober current practice. Joseph Blackburn arrived in Boston in 1753 and painted in the colonies for twenty years. John Wollaston arrived in New York in 1749. He spent almost two decades in America and painted in most of the principal cities of the central and southern states.

In *The Winslow Family* (Fig. 176) Blackburn displays his facility in rendering the satiny surfaces of textiles and attempts to endow his sitters with an airy grace reminiscent of French court portraits. Wollaston painted with heavier brush strokes and larger, simpler masses of color (Fig. 177).

A comparison of Blackburn's *Winslow Family* with Smibert's *Dean Berkeley and His Entourage* reveals the change of emphasis that accompanied the Rococo. Many devices were used to achieve the air of elegance that was the ideal of the Rococo painter. Poses were more animated, at times becoming frankly artificial and whimsical, as can be seen in the little girl holding a skirt full of fruit. Much emphasis was put on the sheen of fine materials

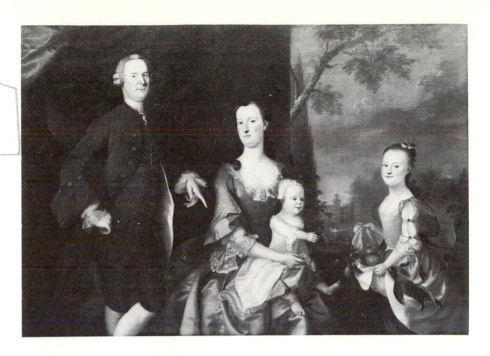

right : 176. JOSEPH BLACKBURN. *The Winslow Family.* 1755. Oil on canvas, 4′ 6 ½ ″ × 6′ 7 ½″. Museum of Fine Arts, Boston (Abraham Shuman Fund).

below left : 177. JOHN WOLLASTON. *Mrs. Samuel Gouverneur.* c. 1750. Oil on canvas, 4′ 1 ¹⁵/₁₆″ × 3′ 4 ⅛″. Henry Francis du Pont Winterthur Museum, Winterthur, Del.

below right : 178. JOHN HESSELIUS. *Portrait of Charles Calvert.* 1761. Oil on canvas, 4′ 2 ¼″ × 3′ 4 ¼″. Baltimore Museum of Art (gift of Alfred R. and Henry G. Riggs in memory of Gen. Lawrason Riggs).

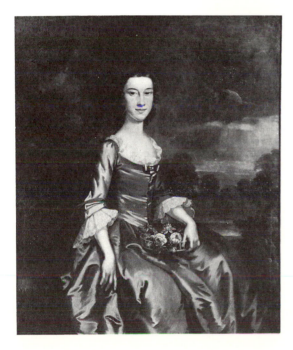

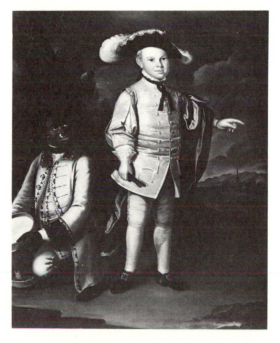

and on the undulations of ribbons, laces, and fluttering draperies. Such stabilizing compositional elements as the horizontal table top that plays such an important role in the Bermuda group were eliminated in Rococo portraits. Instead of stressing elements that contributed to compositional monumentality, the Rococo painter emphasized sinuous line movements to produce grace and movement. Colors tended to be lighter; pale rose, turquoise blues, and clear yellows replaced the strong reds, blues, and golds of the Baroque.

The influence of Wollaston on native American painters can be observed in the work of John Hesselius (1728–88). His *Portrait of Charles Calvert,* shown with his black slave (Fig. 178), projects an image of aristocratic elegance consonant with southern ideals. Richness of costume is stressed along with informality of pose and animation of

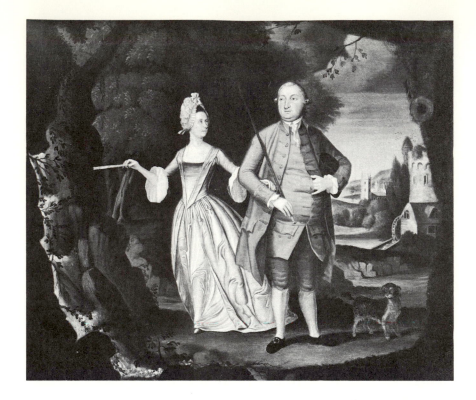

179. WILLIAM WILLIAMS. *Husband and Wife in a Landscape*. 1775. Oil on canvas, 33 ³/₁₆ × 39 ¹/₈″. Henry Francis du Pont Winterthur Museum, Winterthur, Del.

gesture. The stable symmetry that characterized many earlier figure groups here gives way to a more dynamic asymmetrical arrangement.

William Williams (c. 1710–90) and John Durand (died c. 1820) also reflect the influence of the Rococo in the central colonies in the mid-eighteenth century. Williams followed the Rococo conventions when he painted his *Husband and Wife in a Landscape* (Fig. 179). The handsomely dressed couple are pictured strolling in the parklike setting of their estate. The foreground is framed by a waterfall and a leafy bower. Though the forms are delineated too sharply to create the mood of misty reverie typical of the Rococo outdoor portrait, and though the faces are too specific to convey the Rococo ideal, it is clear that Williams' intention was to portray his subjects in the courtly manner of Gainsborough. John Durand, of Huguenot extraction, was, like most untrained painters, unable to envelop his sitters in the airy spaciousness so essential to the Rococo mood, but his gracious gestures, smiling faces, and splendid costumes indicate his ideal.

Blackburn's influence in New England, particularly around Boston, was comparable to that of Wollaston around Philadelphia. Blackburn went to Boston just when young Copley was first learning to paint and provided the young man with an initial stimulus out of all proportion to his own power as an artist.

Native Painters

The paintings by native artists from the early part of the eighteenth century echo those of the men who came from Europe, as may be seen in the work of Joseph Badger (1708–65), one of the portrait painters of Boston after the death of Smibert. The deficiencies of these untrained but ambitious painters are apparent in Badger's portraits and in those painted by William Johnston (1732–77) in Connecticut in the middle of the century. Johnston could neither foreshorten anatomy nor draw hands fluently. The uniformly sharp edges of his forms destroy the sense of space, and the flat areas of color create an airless vacuum. Yet despite these limitations, a rather vivid sense of personality and appearance is conveyed. His severe, sparse works provide a transition from the generally undistinguished portraits of the early limners to subsequent works by esthetically sodhisticated folk artists such as Winthrop Chandler and Ralph Earl, who will be discussed later.

Another young Boston painter whose work has character and energy despite its technical limitations was John Greenwood (1727–92). Greenwood left some portraits and engravings, but the most original and interesting of his works is his satirical genre painting, *Sea Captains Carousing in Surinam* (Fig. 180), a delightful piece of picaresque realism quite unlike the staid and proper

pictures that have come down to us from colonial times. It is undoubtedly the first American genre painting.

From the many colonial painters three artists emerge to leave a distinguished heritage: Robert Feke, Winthrop Chandler, and, most important, John Singleton Copley.

Robert Feke

The most fully realized talent to appear in America during the first half of the eighteenth century was that of

Robert Feke (1705–52/67). This enigmatic figure, of whom little is known, produced his paintings in a limited period between 1741 and 1750, working largely in the cities of Boston, Newport, and Philadelphia. Because of the assurance and taste with which he handled the Baroque ideals of dignity and elegance, his paintings seem to summarize the aims of his time. One of his earliest works, *Isaac Royall and Family* (Fig. 181) is very similar to Smibert's *Dean Berkeley and His Entourage* in conception and was undoubtedly influenced by it. Feke's lack

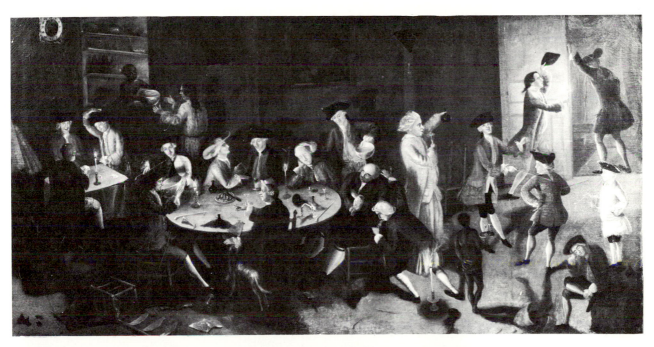

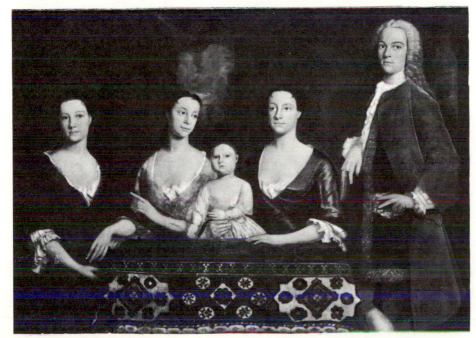

above: 180. JOHN GREENWOOD. *Sea Captains Carousing in Surinam.* 1757–58. Oil on bedticking, 3' 1 ¾" × 6' 3 ¼". City Art Museum, St. Louis.

left: 181. ROBERT FEKE. *Isaac Royall and Family.* 1741. Oil on canvas, 4' 6⅝" × 6' 5 ¾". Harvard University Law School Collection, Cambridge, Mass.

117

of experience is evident. The faces are not strongly differentiated, and the grouping lacks both variety and a sense of interaction among the five sitters. The body of the baby is stiff and unconvincing in anatomy and proportion. However, despite its awkward areas, the painting has the air of poetry and grace that always distinguishes Feke's work. Each sitter he painted seems to be endowed with the artist's personal concept of gracious dignity. Each painting radiates a serene and elevated mood. An innate painter's sense kept his pigments from being dead. The brush work is expressive, the paint flickers, and surfaces appear luminous. The colors are richly and harmoniously related. Somehow this artist, painting in America far from the schools of Italy and handicapped by a lack of knowledge and training, still could imbue everything he did with a dignified taste and an impeccable painterly sense that were lacking in many a student of the European academies.

The late *Self-portrait* (Fig. 182) most fully reveals Feke's sensitivity as an artist. The intelligent face is made vivid and alive by a detailed treatment of the illuminated area, while the quiet simplification of the shadow plane provides relief and keeps the total effect from being factual and hard. The broad simplifications of form in

the costume and in the hand and the subtle diagonal movement created by the edge of the canvas on which the artist is at work indicate Feke's maturity of taste. As in all his portraits, the composition, though rhythmic, is stable, and the line movements are simple. The easy and broad application of paint reveals surprising skill. This portrait is masterly in its restrained elegance and its power to suggest character, form, and space through airy and unlabored brush work.

Winthrop Chandler

The style of Winthrop Chandler of Connecticut (1747–90) relates more to the manner of the early limners than to the late Baroque tradition attempted by Smibert, Feke, and others. However, the intense reality of the likenesses he has left us, the authenticity of setting, and the impeccable sense of composition distinguish these richly developed works from those of the limners. One of his best portraits is of his sister-in-law, *Mrs. Samuel Chandler* (Fig. 183). Though her elegant costume is elaborately described and the book-lined recess behind her is framed in unnecessarily convoluted draperies, her resolute face, penetrating glance, and folded hands dominate the painting and project a vivid characterization. Costume details and background, though observed and described with the precision one would expect from a fact-respecting New Englander, in no way distract from the sitter.

All through the nineteenth century a body of folk art, as distinguished from more technically sophisticated painting, contributed a vivid flavor to American culture. Seldom, however, did this folk tradition yield such vivid and authentic works as those of Chandler. His portraits provide a transition from the work of the limners to that indigenous school of painting which developed in Connecticut during the first years of the Republic and reached its culmination in the art of Ralph Earl (see Chap. 10).

John Singleton Copley

In the years between 1760 and 1774 John Singleton Copley (1738–1815) created the most eloquent record left to us of colonial life. Copley was born in Boston and grew up in the household of his artist stepfather, Peter Pelham, surrounded by prints and paintings, an unusual atmosphere for an eighteenth-century Boston boy. This environment and his inborn strength as a draftsman undoubtedly helped him to discover his vocation. Before

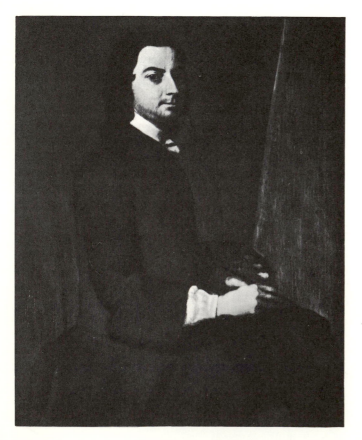

left : 182. ROBERT FEKE. *Self-portrait.* 1749–50. Oil on canvas, 40 × 32″. Rhode Island Historical Society, Providence.

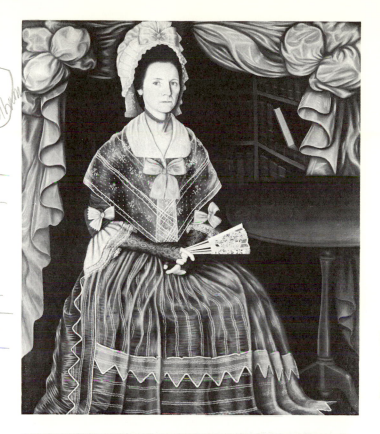

he saw Blackburn's paintings, Copley had studied Smibert's portraits and copies and prints from the works of the old masters and had absorbed certain skills from the work of Badger and Feke as well. Blackburn's example taught him how to make his color alive and his surface textures flash. In certain of the works painted just after being introduced to Blackburn's style he imitated the elegant artifice of the Rococo. As he matured, he moved away from the mannered aspects of the Rococo and retained only those elements which suited his particular temperament. These were the use of vigorous rhythms, the strong sense of surface texture, and the eighteenth-century French practice of portraying a subject in the setting of daily life.

By 1765 Copley had attained material and artistic success in colonial Boston, but he also dreamed of an international reputation, indeed of rivaling the European masters. To measure the degree of his ability and promise, the 27-year-old artist, in a rare instance of his painting not on commission but out of pure professional interest, sent a portrait of his half-brother, Henry Pelham, popularly titled *Boy with the Squirrel* (Fig. 184), to London to be exhibited. It was shown at the Society of Artists and was noticed by both Benjamin West, a newly arrived young American painter from Philadelphia, and the great Joshua Reynolds. Reynolds at first assumed the portrait to be the work of Joseph Wright of Derby, a fresh talent whose art, he thought, showed a "surprising degree of merit." It may have been their common provinciality—Copley from the American colonies and Wright from the British Midlands—that caused the two artists to partake of a similarity in vision and style and appear unspoiled and original to the London audience. Among the letters written to Copley congratulating him upon the successful reception of the painting was one from West in which he conveyed both his own and Reynolds' enthusiasm for the work as well as opinions about Copley's limitations. Both men considered the painting somewhat hard, detailed, and consequently wanting in atmosphere. Reynolds suggested Copley study in Europe, providing he could do it soon enough to profit from the experience. If the late Baroque tradition is taken as an ideal, the criticism is justified, but the realism of Copley's style reveals strength as well as weakness. This portrait displays the characteristics of

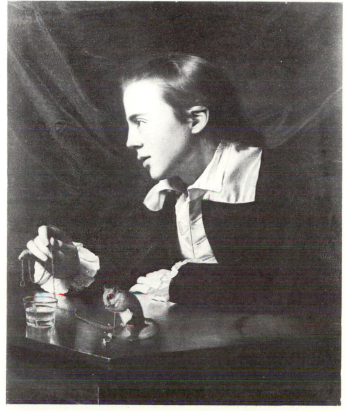

Copley's mature manner. The sitter is posed in a natural way, carrying on a normal activity in a familiar setting, and all the parts of the painting work together to communicate the character of the subject and the mood of the moment. Copley seldom, if ever, painted only a head. He usually included much of the body, and the attitudes of the body, the arms, and particularly the hands play an important role in providing a secondary source of insight into the temperament of the sitter. In every portrait by Copley the hands and what they are doing bear study. In *Boy with the Squirrel* the graceful hands, hesitating in their play, act in unison with the abstracted and thoughtful pose of the head to establish the sense of a gentle and contemplative personality. The surface textures are triumphs of still-life rendering; the glass, chain, linen, hair—all are recorded with an unerring eye and amazing technical skill.

From a compositional standpoint also Copley's mature style is embodied in this painting. The eye moves in at the bottom from a close frontal plane and carries back through diagonals into the main form, which, placed in the mid-distance, turns rhythmically in space. The background closes the space and repeats the rhythms established below with gentle linear and tonal movements. The dark-and-light scheme is typically simple. The head is the chief center of interest, brilliantly lighted against the dark background, while hands, linen, and flashes of shiny material provide secondary lights. The color is clear, without being too sharp, and the range of hues is greater than that used by most American painters of that day. The entire painting is conceived and executed with astonishing consistency and technical brilliance, and the level of maturity is doubly impressive when one remembers the scant opportunities for observation and training that existed in contemporary Boston.

However, though *Boy with the Squirrel* foreshadows Copley's mature style, it does not show his full power. The characterization is satisfying, but not forceful; the very youth of the sitter mitigates against a powerful presentation of character. In *Mrs. Thomas Boylston* (Pl. 5, p. 155) Copley displays his powers at their peak. The skill and subtlety of the linear, tonal, and spatial elements of the composition strike the observer immediately. The graceful interplay of rhythmic lines in the skirt, arms, body, and background draperies; the skillful increase in the contrasts around the focal points of the painting, which come to a crescendo of lights and darks about the head; the forceful way in which the placement of the head dominates the entire painting, while the hands become secondary accents despite the glitter of satin and the flourish of linen kerchief—all these factors are handled with amazing assurance and control. Each surface is painted with consummate skill, so that an authoritative tactile quality is established throughout. The color is rich and fine. The gold of the chair, the warm brown of the shimmering skirt, the rosy tone of the distant wall, repeated in the shadows of the flesh and in the frame of the chair, form a handsome contrast to the gray column and the cool shadowed whites. The bronzy-green back drape provides a foil for both the bluish grays and dominant warm tones.

Above and beyond Copley the craftsman, with his skill, knowledge, and control, stands Copley the artist, with his ability to perceive the character of the sitter and make it come alive. This ultimate ability is the source of Copley's greatness. Mrs. Boylston looks out of the painting and past us with quiet self-assurance and determination—kindly, patient, but with that core of firmness which must have been necessary for coping efficiently with the problems of colonial life. The face appears slightly isolated, not compositionally but in spirit, from the elegance of the clothes, the furniture, and the sumptuous background, which undoubtedly were props designed to please her sons, who had become wealthy Boston merchants.

Copley spent the last half of his life in England. In London he continued to paint portraits but enlarged his repertoire to include the enormous historical genre paintings which constituted the chief basis of his fame abroad. Benjamin West, by then well established in London, had already set a precedent for the creation of imposing canvases based on current historical events. The topical and dramatic nature of such paintings by West and Copley in a sense presaged the romantic trend that would become a dominant force within four decades. Copley's first important painting in this category, done three years after his arrival in England, was *Watson and the Shark* (Fig. 185), illustrating an incident in Havana harbor. Somewhat more awkward and bumptious in composition than his later and more conventionally skillful historical canvases, *Watson and the Shark* remains most impressive as a first attempt at complex organization of many figures in violent action. This canvas and the huge historical works which followed, particularly his spectacular *Death of Major Pierson*, contributed greatly to his fame in England and had an important influence on historical painting in America during the early years of the Republic.

Copley was one of the many American artists to go abroad for study during the last of the eighteenth century. Almost every artist felt the need to take advantage of the superior facilities for training that existed on the Continent, and an extended period of study abroad came to be considered a necessity. Benjamin West had commenced this exodus of art students to Europe in 1760. Matthew Pratt, Charles Willson Peale, and later, Copley, Gilbert

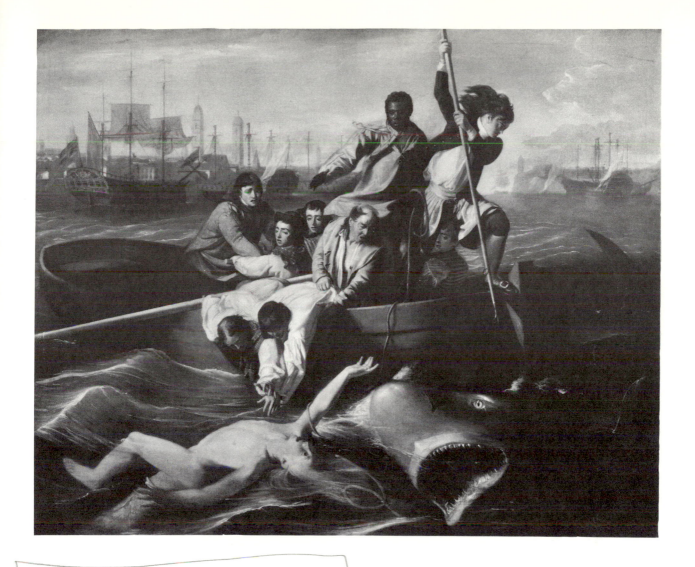

above: 185. JOHN SINGLETON COPLEY. *Watson and the Shark*. 1778. Oil on canvas, 6′ × 7′ 6¼″. Museum of Fine Arts, Boston (gift of Mrs. George Von Lengerke Meyer).

Stuart, Ralph Earl, John Trumbull, and all the other major painters of the following period continued it. They succeeded in advancing the standard of American painting so that the best compared favorably with the general level of practice in Europe. This increase in technical excellence and refinement of taste was not accomplished without exacting a price. Something of the archaic strength of Copley's greatest works disappeared from American painting and did not reappear until almost the middle of the following century, when such artists as Thomas Cole painted the American landscape and George Caleb Bingham the folkways with the same assurance that Copley displayed in portraying his sitters.

PRINTS

The mezzotints and engravings which constituted the popular pictorial arts in the eighteenth century were imported from England at an early date. Such prints, particularly the mezzotint copies of English portraits, played an important role in the development of young American artists, being the chief source for the study of the European masters. As was previously noted, Copley derived some of his earliest portrait arrangements from the imported mezzotints in his stepfather's shop. Original prints were produced here well before the middle of the eighteenth century. Portraits of notables, maps, views of cities, harbors, and public buildings, as well as depictions of such topical events as battles provided both information and pictures suitable for framing. John Foster (1648–81), whose gravestone will be illustrated later, is credited with

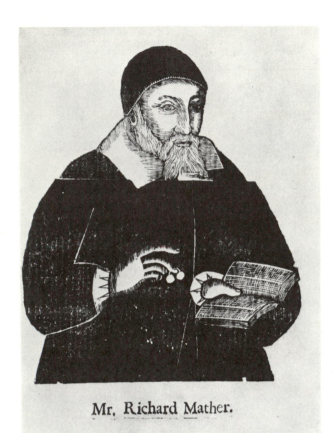

Mr. Richard Mather.

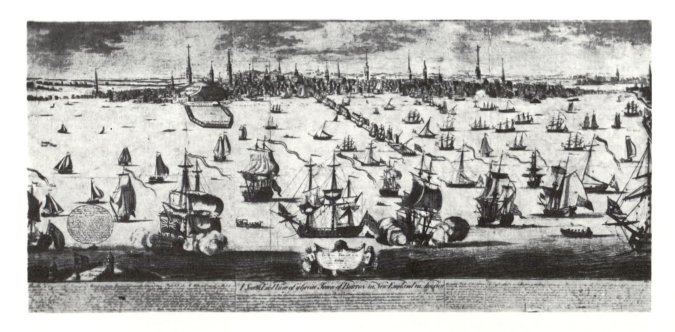

left: 186. JOHN FOSTER. *Portrait of Richard Mather.* c. 1670.
Woodcut, 6 × 5″. Massachusetts Historical Society, Boston.

above: 187. PETER PELHAM. *Cotton Mather.* 1727. Mezzotint,
11 ⁷/₈ × 9 ³/₄″. International Business Machines Collection,
New York.

below: 188. WILLIAM BURGIS. *View of Boston.* 1722. Engraving,
20 ³/₄ × 51 ¼″. New York Historical Society, New York.

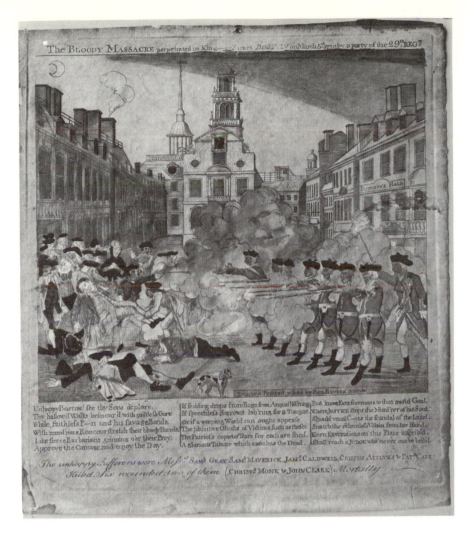

189. PAUL REVERE. *The Bloody Massacre*. 1770. Engraving, 7 ⅝ × 8 ⅝". Metropolitan Museum of Art, New York (gift of Mrs. Russell Sage, 1910).

having produced the first print to be made in the colonies, a woodcut *Portrait of Richard Mather* (Fig. 186) from about 1670.

Peter Pelham (1697–1751), mentioned earlier as an Englishman trained in the art of mezzotint, executed a very creditable portrait of Cotton Mather (Fig. 187) which is generally considered to be the earliest mezzotint printed in the colonies. Mezzotint portraits were the most widely circulated prints of the late eighteenth century and the early decades of the nineteenth.

Prints of cities, colleges, harbors, and other points of interest had a wide appeal. William Burgis (active 1716–31) engraved a lively view of Boston harbor in the first quarter of the eighteenth century (Fig. 188). Though intended as a statement of fact, the scattering of boats in the foreground and the profile of the skyline in back create a scene that is as visually entertaining as it is informative.

The struggle for independence and the Revolutionary War stimulated a considerable production of topical engravings. Some of the most vivid were the caricatures and political cartoons used to illustrate the handbills printed and circulated during the tempestuous conflicts which rocked colonial life. The appearance of caricatures, political cartoons, and topical sketches coincided with the development of American journalism, and they have remained vivid and important elements of our national life. An early example of the journalistic print based on a contemporary episode is Paul Revere's *The Bloody Massacre* (Fig. 189), which he copied from a larger and better engraving by Peter Pelham. Though its crudities are evident, the print manages to communicate both facts and feelings, and it established a precedent for recording the passing scene in a popular pictorial style. With the expansion of journalism in the nineteenth century, the various types of illustration constituted an increasingly original and lively body of pictorial material.

Amos Doolittle (1754–1832), a silversmith like Paul Revere, frequently turned his hand to engraving maps,

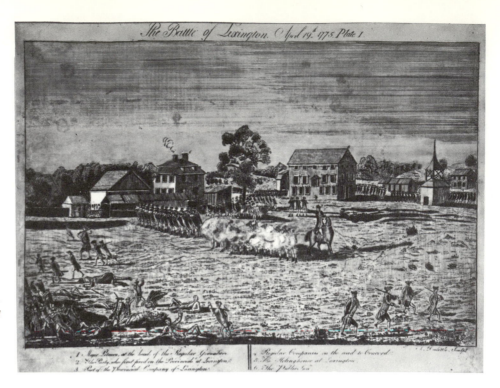

190. AMOS DOOLITTLE. *The Battle of Lexington, April 19th, 1775.* 1775. Engraving, 13 × 17 ½". Collection Mr. and Mrs. J. William Middendorf II, New York.

bookplates, illustrations for books, and a wide variety of other prints. Doolittle showed considerable technical skill in the series of four prints on the Battle of Lexington that he made from sketches by the painter Ralph Earl. The first of the four prints, *The Battle of Lexington, April 19th, 1775* (Fig. 190), illustrates the initial encounter when the British troops quickly dispersed the colonial militia, which had gathered on Lexington Common because of the warnings spread the previous night by Paul Revere and others. Like the engravings of the Boston Massacre, these prints caused intense feelings when published, for they showed Americans being fired upon by the well-armed and trained redcoats.

Though, on the whole, colonial prints were neither conceived nor executed on a distinguished level, they contributed to the creation of a popular, independent, and indigenous colonial culture and so served to stimulate the growing national consciousness. The printmaking tradition established during these early years became a significant force in the nineteenth century.

SCULPTURE

Monumental sculpture was not produced in America until after the Revolution, when the desire to commemorate great men, great deeds, and important events created a need for permanent and imposing memorials. However, from very early times wood and stone were carved to

enhance buildings, ships, and pieces of furniture and to make signs, gravestones, weather vanes, and toys. Out of these simple crafts developed a rich and original tradition that came to fruition in the nineteenth century both in folk art and in more formal and learned guise.

Gravestones provided the stonecutter with his most frequent sculptural commissions. Seventeenth-century gravestones were usually ornamented with motifs symbolizing the vanity of life, the inevitability of death, and the glory of salvation. Skeletons with scythes, skulls, and hourglasses are the most frequently encountered, for the Puritan consciousness tended to dwell on death, but fig leaves, vine leaves, peacocks, and the sun, moon, and stars were also used to symbolize the forces of life. The more austere symbols dominate the stone, but usually a graceful border of leaves implies that the deceased had achieved a state of grace by laboring in the Lord's vineyard. These few leaves and twining tendrils also provide a touch of decorative grace and reveal that our Puritan forefathers had some feeling for the redeeming role of beauty in this harsh world.

An unusually rich carved gravestone (Fig. 191) marked the burial place of John Foster, Bostonian painter, engraver, and printer. He probably designed his own gravestone and left its execution to a stonecutter of less imagination. A globe of the world supports the candle which symbolizes Mr. Foster's brief period on this earth. A skeletal Death prepares to snuff out the candle, and

Father Time, holding an hourglass, is unable to stop Death's hand. Above all shines the sun, a symbol of God, benign, timeless, and omnipotent. The arched, rather handsomely shaped stone, with its vigorous but crude relief and its elegant lettering, reveals a paradox of ambition, imagination, and inadequate technical skills, a paradox that grew inevitably out of the attempt to transport a rich Old World tradition to distant shores still lacking the craftsmanship necessary to give full expression to it.

In the eighteenth century the dour skull-and-hourglass motif was frequently replaced or accompanied by an attempt at a bas-relief portrait. Crude though these grave portraits are, they evoke a sense of sober urgency born of the desire to perpetuate an image of the deceased to outlast time and man and to provide a landmark for a soul on some far distant Judgment Day.

Almost every eighteenth-century coastal town had a wood carver who made handsome figureheads and the other carvings that enhanced the ships of that day, as well as the Ionic and Corinthian capitals, fluted columns, wreaths, swags, garlands, crests, and other heraldic symbols that decorated the splendid interiors and exteriors of Georgian mansions and public buildings. Simeon Skillin (1716–78), a famed wood carver of Boston, was such a master craftsman. To his hand has been attributed the wooden figure of *Mercury* (Fig. 192) which is supposed to have stood before the Boston Post Office during the eighteenth century. This winged messenger has little of

the grace of a classical symbol but rather resembles some sturdy New England boy decked out in a few borrowed classical properties.

In the days before shops were distinguished by a special type of architecture, an identifying figure above or before the door was common. In England the use of such figures was traditional, and this custom was continued in America, where public buildings, inns, and taverns, as well as shops were marked by their special insignia and figures. Though sometimes classical, like Skillin's *Mercury*, the figures were more often picturesque and occasionally amusing. A stocky mariner using a quadrant might mark the shop of the seller of nautical instruments, a cluster

left : 191. Gravestone of John Foster, Boston. 1681.

above : 192. SIMEON SKILLIN THE ELDER (?). *Mercury.* 1750. Wood, height 42″. Bostonian Society, Old State House, Boston.

During the first two centuries of colonial existence the painting and sculpture of America began to assume the attributes that were to characterize its maturity. Sculpture did not develop as early or as fully as painting, but much of the wood carving of the eighteenth century has an unpretentious charm that foreshadows the character of sculpture in the next century. Painting achieved a level of technical competence sufficient to reflect the fashionable currents of Europe, passing from the detailed and linear fashion of English Tudor to the more robust atmospheric character of the Dutch and English Baroque and then to the animation and decorative charm of the Rococo. But American painting was not identical with that of Europe; it did not attain the power, eloquence, and sophistication of its European models. Instead, it reflected the life of the colonial settlers, of an energetic, thoughtful, middle-class society that was sober, realistic, idealistic, and earnest. The art that appeared in America during these years was an art in which sensibility was balanced by reason, scientific objectivity by idealism, and a broad humanism by practicality. These attitudes received their most forceful expression in the work of Copley, who combined the objective approach of the scientist with the ardor of the artist.

Architecture, sculpture, furniture, and the crafts were infused by this same practical humanism. A Copley painting, a Georgian house, and a fine block-front chest are all of a piece in spirit. Each art borrowed elements from a rich old tradition but selected only what could be meaningfully assimilated in the colonial environment. Each achieved a sturdy beauty primarily through a harmonious relationship of necessary parts rather than through elaboration and enrichment. The Revolution interrupted the development of America's cultural life. The turmoil and economic disruption of years of war in a young nation left little time or energy for the arts. In the decade following the Revolution, the country gathered its forces and renewed its energies, and the turn of the century witnessed a new florescence of our national culture.

of grapes that of a wine merchant. These shop signs were painted in bold colors; the painting of sculptural forms remains one of the fundamental characteristics of folk sculpture. A 30-inch-high felon (Fig. 193) identified the Kent County Jail, in East Greenwich, R.I., during the last half of the eighteenth century. The carving is broad, almost crude, the texture of the tool marks revealing the activity of the carver with freshness and force. The face of the handcuffed wretch, with its great pleading eyes and tight lips, communicates in a direct and expressive way the tension under which the sad prisoner is laboring. Such a figure stood as an awesome warning to the lawbreaker, a perpetual reminder of the wisdom of righteous ways.

part III

The Young Republic: 1776–1865

7

Architecture: The Federal Style and the Greek Revival

The Revolution ended America's colonial status and the dominance of the colonial Georgian style of architecture. There was little building in America for more than a decade after the Revolution, and when large-scale construction recommenced, it took the form of the classic revival. The new mode revealed itself in a shift toward greater formality and a new reverence for Roman and Greek precedent.

The neo-Palladianism of the mid-eighteenth century has already been noted in the discussion of colonial Georgian architecture (see Chap. 4). This represented the first countermovement from the Baroque toward classic tradition, a movement which culminated in the nineteenth century. Nineteenth-century architecture, essentially progressive in terms of structural method and plan, repeatedly cloaked itself in earlier styles. The first to be revived were those of ancient Rome and Greece, later to be followed by a revival of Gothic, Renaissance, Romanesque, Baroque, and various other architectural modes, all as part of a romantic attempt to reconcile a genuine admiration for the achievements of the past with contemporary needs. The use of a Roman or Greek façade to ennoble a building through association with the past, like the later use of a Gothic church interior to achieve a devotional atmosphere, was motivated primarily by sentiment and thus was closer in attitude to the newly developing Romanticism than to the Renaissance tradition of rational classicism. For this reason the nineteenth-century classic revival is often termed "Romantic classicism," contradictory as these terms may seem.

In the early years of the classic revival, neoclassicism (the new classicism), as the movement is also called, was oriented toward Rome, rather than Greece, although the enthusiasm for all classical antiquity was greatly quickened. This more Roman-oriented phase occurred in America between 1785 and 1810, the years during which the Federal government and its institutions became established, and therefore the style of this period in America is often termed the "Federal style." After 1810 ancient Greece became the focal point of intellectual and artistic inspiration; thus this later phase of Romantic classicism has been called the Greek Revival.

The reexamination of classic tradition in Europe and America was related to a number of esthetic, archeological, and political factors. By mid-eighteenth century the potentialities of the aristocratic Baroque and Rococo styles had been exhausted, and change was stimulated to a considerable extent by the exciting new archeological

discoveries that were being made. Since 1711 there had been excavations at Herculaneum. Systematic excavation was commenced at Pompeii in 1763, and the revelations concerning the dramatically buried city turned many minds toward Rome. Robert Adam, a Scottish architect, published a study and drawings of the palace of Diocletian in Spalato (Split, Yugoslavia) in 1764, and subsequently Adam and his brother used much of the architectural idiom of late Roman decorative detail in their very influential architectural designs in England. About mid-century Johann Winckelmann formulated his theories describing the development of Greek art and created his idealization of classic antiquity, in which rational discipline and a sensuous love of beauty were combined. Greece entered further into the orbit of antiquarian concern when James Stuart and Nicholas Revett published their *Antiquities of Athens* in 1762. Clearly an interest in classic antiquity was in the air, but archeological enthusiasms alone did not fully explain the revived interest in classicism.

This was a time of political unrest, a time when the conflict among an increasingly powerful bourgeois class, an extravagant and irresponsible aristocracy, and an autocratic church was coming to a head in many countries and particularly in France. The excavations of ancient sites, coinciding with the political events, reinforced the reawakened interest in the republican institutions of Greece and Rome, as well as in the rational philosophies of

classical times. By association, almost by analogy, as it were, first the Roman style, particularly the columnar Roman style of Pompeii, and later the Greek became the official styles of republicanism and of the nineteenth-century republics.

In the Federal style of America the practice was to duplicate major architectural forms, structural devices, and decorative details taken either directly from Roman buildings or from French or English classic revival designs. However, not all inspiration either in Europe or America came directly from Rome. Frequently architects (and it was during this period that the professional architect first appeared in America) employed domes, vaults, arches, porticos, columns, pediments, and other elements of Roman building practice from the formulations of Palladio, for the eighteenth-century neo-Palladianism still lingered as an influential element in classic revival practice, particularly in England and conservative New England.

After the turn of the century Greek ideals came to the fore, first in Philadelphia, in the work of Latrobe, then in Washington, and gradually spreading through the central states into New York, New England, and the South. By the third decade of the century the Greek Revival was at its height; its influence permeated the newly developing areas west of the Allegheny Mountains, and it flourished in the prosperous lower Mississippi Valley. In the most derivative manifestations of the Greek

Revival, the Greek temple provided the pattern for architectural propriety, particularly the Doric or Ionic temple with a pedimented portico. On the other hand, much of the building of this period was so far from a servile imitation of ancient Greek architecture that even some of its most serious students question the validity of the term "Greek Revival." Though authentic Greek effects were much desired, indigenous interpretations were varied and widespread. What might be described as the Greek spirit frequently prevailed through simple, functional plans, a straightforward use of fine materials, integrity of structure, and bits of elegant classic detail, all monumentally composed.

By 1840 the classic impulse had passed its climax, but the thrust toward an original, clean idiom distinguished by simplicity and structural integrity had left its imprint on American architecture. Before mid-century the Gothic Revival, to be followed by a succession of other revivals, was well under way.

As soon as the Revolutionary War was over and the reconstruction of the exhausted nation had begun, America faced the problems of forging the new political institutions required by its status as an independent power. As state governments and, in time, a Federal government were brought into being, and as the necessary administrative agencies, bureaus, and commissions were formed, a pressing need developed for buildings to house them. The triumphant and energetic nation wanted its government buildings to serve also as monuments to the pride, vigor, and independent status of the new democracy and to embody its ideals of freedom in concrete form. Some of the notable public buildings constructed during these years offer an introduction to the Federal style.

At the request of the governor of Virginia in 1785, Thomas Jefferson, who was traveling in France, drew up plans for a state capitol based on the Maison Carrée, an old Roman temple in Nîmes. Completed in 1789, the Capitol in Richmond (Fig. 194) was the first of a long succession of buildings to abandon eighteenth-century models and to follow the inspiration of ancient Rome. In 1795 the architect Charles Bulfinch (1763–1844) laid the cornerstone for a new capitol building in Boston (Fig. 195), which, completed by 1802, provided a handsome and monumental setting for the lawmakers of Massachusetts. A great dome, a colonnaded portico, and arched arcades and windows proclaimed the glory of the young state. Here inspiration came less from Rome than from current English practice combined with elements of the late colonial Georgian style. Other states followed suit, and the spaciousness of the new capitol buildings and the rivalry as to the size of the domes and the length of the colonnades bore witness to the ambition and energy of the growing nation.

City halls of equally impressive design and scale were built in continuously increasing numbers after the turn of the century. In 1803 Joseph Mangin, a French architect,

opposite : 194. THOMAS JEFFERSON and CHARLES-LOUIS CLÉRISSEAU. State Capitol, Richmond, Va. 1789.

right : 195. CHARLES BULFINCH. State House, Boston. 1795–1802.

working with John McComb, began the construction of a city hall for New York (Fig. 196). In its formal elegance it reflected the French background of the designer, as well as the desire of the young metropolis for a municipal hall as impressive as any of the great palaces or public buildings of the sister republic France.

WASHINGTON, D.C., AND THE CAPITOL

As the concept of a powerful Federal government evolved in the last decade of the eighteenth century, plans for the capital city of the nation and its new buildings took form. Under the general direction of George Washington and, later, Thomas Jefferson, a swampy site beside the Potomac River was selected, and the French military engineer Major Pierre Charles L'Enfant (1754–1825) was commissioned to lay out the plans for the national capital.

L'Enfant's conception was a magnificent one (see endpapers), and only in the mid-twentieth century has the city of Washington, D.C., outgrown its original spacious plan. L'Enfant envisioned a series of broad avenues radiating from the Capitol, the White House, and other focal centers. This radial pattern was laid over a more typically American gridiron arrangement of parallel streets and rectangular blocks running north and south. As the modern city took form, the daring and breadth of L'Enfant's conception became evident. He had achieved the almost impossible feat of combining Versailles and the practical American city, providing both glorious views through the avenues and efficiency. His pattern of streets created the picturesque and irregular block shapes and building sites that characterized the charming older cities of Europe and at the same time introduced the regularity of arrangement that made American cities

efficient and orderly. In addition, the points at which the broad avenues converged on one another formed open squares or circles suitable as sites for monumental sculptural groups, while the intersections of the radial avenues with the parallel streets created open triangles of grass or park. L'Enfant's hope that at least half of the area of the city would be devoted to spacious streets, avenues, and parks has been maintained, despite the repeated assaults of real-estate speculators and shortsighted engineers and builders.

The story of the national Capitol reveals the problems that were faced by the young Republic in attempting to translate grand aspirations into concrete achievements. The design selected as the winner in a competition for the building was by Dr. William Thornton (1759–1828), an English gentleman born in the West Indies and by profession a physician rather than an architect.

Thornton's plan called for a central structure of essentially late Georgian character but including a lower dome than the present one, flanked on each side by balancing wings. This basic concept has been retained, despite subsequent additions and changes. The cornerstone for the original Capitol was laid in 1793 by President Washington. This building (Fig. 197) stood until 1814, when the two wings were gutted by a fire started by the British troops during the War of 1812.

After the fire the building was reconstructed under the direction of Benjamin Latrobe and, later, Charles Bulfinch. Latrobe had been invited to act as architect of the Capitol in 1803, before the fire, and, to a great extent, the monumental appearance of the reconstructed building was due to his guidance and influence. He redesigned the portico on the eastern façade, added the domed roof and the cupolas that topped each of the wings (Fig. 198), and also

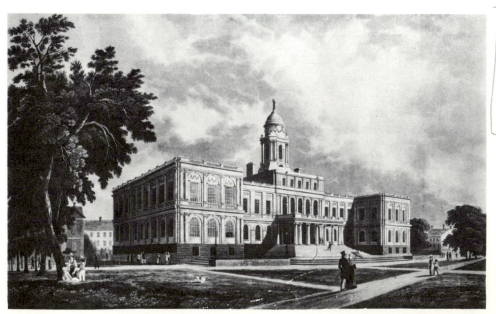

196. Joseph Mangin and John McComb. City Hall, New York. 1803–12. Color aquatint by W. G. Wall and I. Hill, 1826. Museum of the City of New York (J. Clarence Davies Collection).

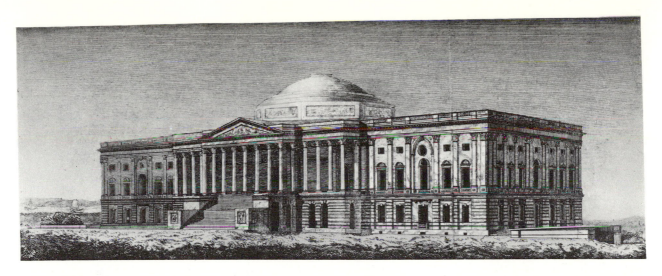

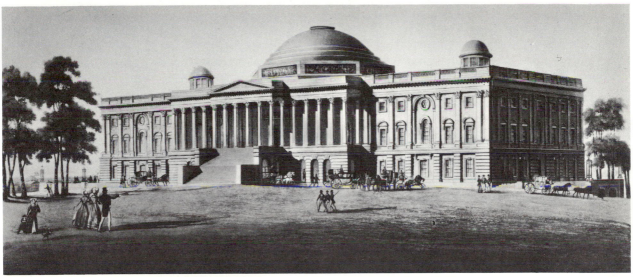

remodeled the major interior chambers. Perhaps Latrobe's most popular innovations, though hardly his most significant, were the capitals of columns for the Senate wing, featuring ears of corn, tobacco, and other native plants that he designed in an effort to create an indigenous classical column (Fig. 199). Much to Latrobe's chagrin, the so-called "corncob capital" received more attention than many of his major architectural concepts.

above : 200. THOMAS USTICK WALTER. U.S. Capitol, Washington, D.C., with present dome and wings. 1865.

Bulfinch did not contribute materially to the new structure, but he did perform the estimable service of coordinating many diverse design elements and reconciling conflicting personalities, as well as adding the colonnade on the west front.

By mid-century the nation had outgrown its Capitol, and in 1851 Thomas Ustick Walter (1804–87) was commissioned to enlarge the building. He designed the present dome, which rises to a height of 268 feet, and planned the two flanking wings (Fig. 200). These two additions were completed by 1865. The new wings are of white Massachusetts marble, while the older central portion is of Virginia sandstone painted white. Prophetically enough, the great dome utilized cast iron, a major engineering achievement for that period. The grand structure, conceived by a number of America's best nineteenth-century architects and executed over a period of almost seventy years, embodies the architectural aim of the young nation—to create a significant monument which would express its cultural aspirations and political independence. To achieve this the United States, in accordance with the fashion of the day, had employed the architectural forms of ancient Rome, the forms through which the imperial Capitol had proclaimed its power and grandeur.

Classic revival architecture can best be discussed in terms of four geographic areas—New England, the central states, New York, and the South—though the newly opened Midwest also felt its impact, particularly in the Greek Revival phase. New England, centering particularly around Boston, provides a logical introduction to the style, for this area adhered most closely to the eighteenth-century American and English traditions. Charles Bulfinch, Samuel McIntire, and Asher Benjamin were the most influential New England architects. The second geographic area centers around Washington and Philadelphia. Both the Federal style and the Greek Revival flourished here. Thomas Jefferson and Benjamin Latrobe were the dominant figures, followed by Latrobe's two pupils, Robert Mills and William Strickland. The area around New York City seems to have been less dominated by individual personalities, but distinguished designs were produced by Mangin and McComb, who designed the previously mentioned City Hall, the firm of Town and Davis, and Minard Lafever. Architecturally, Charleston was the most distinguished city in the South, but in the extensive coastal areas bordering the Atlantic and the Gulf of Mexico and, during the early years of the nineteenth century, in the lower Mississippi Valley, the Greek Revival style appeared in some unique and interesting local forms.

NEW ENGLAND

Boston and the New England area remained conservative in architectural tastes. Many elements of the colonial Georgian mode remained in fashion, and the elements of classic tradition that did appear were via English precedent, particularly as they had been developed by the Adam brothers, England's most influential early classic revival designers. Robert Adam had studied the late Roman style as it appeared in imperial palaces and sumptuous villas and had adapted many elements from these sources to his architectural designs. The most conspicuous aspects of the Adam brothers' style were the attenuated proportions of columns, pilasters, and related architectural forms and the use of small-scale decorative details such as swags, urns, rosettes, and classical moldings. Along with the use of these refinements came an interest in composing with varied masses, so that oval, circular, semicircular, and octagonal rooms were integrated with the more traditional rectangular forms to provide visual variety to both exteriors and interiors. Elaborate molded stucco ceilings of fine scale enhanced the most exquisite interiors and contributed an effect of great elegance. In New England the tendency to restrict decoration to a few limited areas and to contrast ornamented areas with extensive plain surfaces created a distinctive effect of simple elegance. The delicate scale of the Adam style also suited the colonial tendency to reduce the weight of architectural details for construction in wood from the proportions developed in Europe for forms conceived in stone.

Domestic Architecture

As soon after the Revolution as shipping and business were reestablished and prosperity returned, the merchants, bankers, and shipbuilders again began to build handsome houses along the main streets of such coastal cities as Salem, Providence, and Newport. The houses built in the last decade of the eighteenth century and the first decade of the nineteenth, though discreet in detail and style, were larger than those of the earlier eighteenth century. The more imposing structures were three stories in height, with flat or low hipped roofs hidden by cornices and balustrades. Frequently the traditional colonial plan of four rooms to a floor arranged around a central hall and staircase continued to prevail, but in the grander mansions variations of plan to provide for comfort, privacy, and ease of management began to appear. Rooms were varied in size according to their function; circular, oval, and octagonal shapes were employed when an effect of particular elegance was desired, and subsidiary stairs, passageways, and service facilities contributed to a more gracious way of life.

Some of the most subtle and refined interpretations of the Federal-style houses of New England appeared in the work of certain master builders and wood carvers around Salem, Mass., of whom the most famous is Samuel McIntire (1757–1811). McIntire's early designs retained much of the Georgian idiom. The Gardner-White-Pingree House in Salem (Fig. 201), built in 1810, is a particularly fine example of his late work. Comparison of the Gardner-

201. SAMUEL MCINTIRE. Gardner-White-Pingree House, Salem, Mass. 1810.

White-Pingree House with those built before the Revolution makes evident the differences between the houses of the two periods. By the turn of the century the pitch of the gable and roof area was reduced, and the roof was hidden behind the balustrade to create an effect of contained rectangularity of form throughout the entire structure. The façade is seen as a simple rectangular unit, with the separate stories marked off by white stone divisions and the white balustrade and the white architraves above the windows relating all the parts of the building. The façade is smooth, and the details of moldings, trim, and entrance porch are kept flat, projecting from the building as little as possible. All the forms are slender—the columns delicate, the moldings thin, and the fanlight over the door and the side lights designed with geometrically precise, delicate divisions. Essentially a craftsman, McIntire achieved distinction by a fine sense of porportion and disciplined restraint in the use of ornament. Much of his most beautiful detail is found in the interiors of his houses and will be discussed in the section on interior design.

Despite the elegance of the Pingree House, the effect is one of restraint rather than of grandeur. Such splendor as appears is of a proper and dignified kind, the expression of a conservative and secure propertied class whose inclination to cultivate its taste and live elegantly was counterbalanced by its sense of decorum and social responsibility.

One of the most splendid mansions of New England is Gore Place in Waltham, Mass. (Fig. 202), built for the Federalist governor Christopher Gore. The elegance and restraint of the design suggests that either Bulfinch or a French architect may have planned it, but there is no documentary evidence to support either thesis. A gracefully curved central block, with rectangular abutments containing semicircular and oval rooms on both floors, is flanked by extended wings which terminate in small projecting pavilions topped by light pedimented gables. Judiciously placed tall windows, semicircular windows and fanlights, and slightly pilasterlike recessions on the end pavilions constitute the chief elements of the design. The subtle relationship of the curved and rectangular masses, the beautiful proportions of all the parts, the purity and delicacy of the trim, and the slender chimneys create one of the most subtle and distinguished examples of the Federal style.

Charles Bulfinch

The particular blend of the colonial Georgian tradition and the English Adam style which flourished in New England at the turn of the century received its most mature and refined expression in the work of Charles Bulfinch. Bulfinch came from a socially prominent family and received the advantages of a formal education and a trip abroad, which provided an eighteenth-century gentleman's exposure to the arts. The handsome Old Meetinghouse Church at Lancaster, Mass. (Fig. 203), and the superb capitol for the state of Massachusetts (Fig. 195) reveal the more monumental aspects of his work.

The genius of Bulfinch first became evident in the originality and taste with which he combined the elements of the Adam style and the older colonial Georgian mode in his early works. This is illustrated with particular effectiveness in the State House. The design for the building combined vigor, statleiness, and refinement without the infringement of any one of these qualities on the others. The tall, slender arches and columns, the recessed Palladian windows of the second story, and the delicate proportions of trim and moldings throughout create an effect of great elegance, but they do not detract from the

202. South façade, Gore Place, Waltham, Mass. 1805.

strength of the massive structure. Even the great soaring dome seems almost weightless, yet it adds a touch of majesty to the building.

Later Bulfinch stressed the simpler and more severe aspects of classic-revival design; the church at Lancaster is one of his masterpieces. At first one's attention is captivated by the elegant details—the slender height of the pilasters and arched openings of the porch and the crisp pattern of the fanlike forms between the rectangular front of the church and the vertical bell tower. The clear, crisp carving of the swags, moldings, and columns and the sparkle of white against dark brick also catch the eye immediately. More thoughtful examination reveals an unexpected strength that results from the forthright statement given to the relationship of the various parts of the building. The porch, entrance hall, bell tower, and main auditorium are all cleanly articulated, but vigorous and continuous movements relate each part to the next. Rectangles, triangles, squares, and circles play against one another energetically, and one unconsciously feels these strong forms while appreciating the exquisite details.

Also notable were the row and town houses Bulfinch designed for fashionable Bostonians. From the elegance of English neoclassicism and the lean simplicity of the New England building tradition Bulfinch, more than any other architect of his day, formulated a style particularly suited to the moment of poised quiet at the turn of the century, the interlude before the older tradition of eighteenth-century elegance gave way to the dynamic tempo of the nineteenth century.

Alexander Parris

Among the important second-generation classic-revival architects working in New England, Alexander Parris (died 1852) should be singled out for mention. His early work remained close to the manner of Bulfinch, but after 1815 he showed an increasing preference for the weighty and severe manner of the Greek Revival. A fine and characteristic example of the way in which he translated the traditional colonial Georgian church into the idiom of the Greek Revival can be seen in the Unitarian Church in Quincy, Mass. (Fig. 204). An austere, monumental portico and an unadorned pediment carry the eye to a series of massive blocks and a colonnaded drum topped by a simple dome. Cornices are reduced to a few clearly defined planes. The great blocks of Massachusetts granite

above : 203. CHARLES BULFINCH. Old Meetinghouse Church, Lancaster, Mass. 1816.

right : 204. ALEXANDER PARRIS. Unitarian Church, Quincy, Mass. 1828.

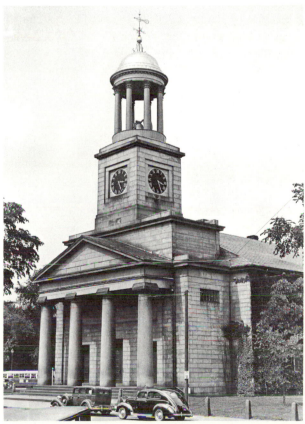

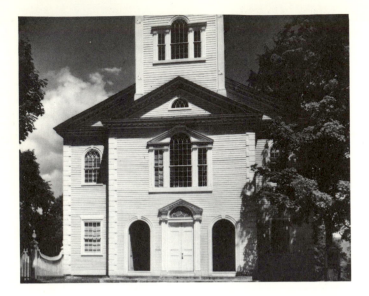

left : 205. LAVIUS FILLMORE. First Congregational Church, Bennington, Vt. 1806.

from which the building is constructed, used with distinction in many Greek Revival buildings, contribute to the dignified sobriety of the edifice.

Parris, like Latrobe, Strickland, and many other architects of this period, was interested in working on large engineering projects, such utilitarian structures as warehouses and the new types of commercial buildings demanded by the expanding economy. These essentially functional structures were designed with a monumental reserve and severe simplicity in keeping with Greek Revival ideals, even though they reveal few of the decorative elements of the style.

Asher Benjamin

The story of the development of building practices in America in the nineteenth century is not complete without some mention of the influence of the books on architectural design from which many a modest builder took his plans. Such a book was Asher Benjamin's *The Country Builder's Assistant*, published in 1797, the first of his many successful publications. Asher Benjamin (1773–1845) was a Massachusetts carpenter, cautious about abandoning the traditional ways of building, yet willing to introduce the newer neoclassic styles when he felt that builders and the public were ready to accept them. All over the rapidly expanding country, carpenters, builders, and customers alike turned to his publications for direction and inspiration. Although Benjamin was not a powerful or very original architect, his designs have charm, and they helped raise the general standard of taste.

The First Congregational Church (Fig. 205) in Bennington, Vt., built in 1806 by a carpenter-builder, Lavius

Fillmore, and featuring a number of early Federal-style details, is taken from a plate in Benjamin's *The Country Builder's Assistant*. Certain modifications were made, but the general design stays close to Benjamin's plan. It is another example of the sensitive development of wooden construction that occurred in America in the nineteenth century. Benjamin frequently took his inspiration from designs conceived for masonry construction, but the scale and weight of all the parts and the open, light character of the structure appear logical for wood. The two arched doors flanking the main entrance are framed by two receding moldings, with the joint in the moldings capped by a light keystone block, revealing a refreshing sensitivity to the style potentialities of wooden construction.

In grace, gaiety, and unpretentious charm, this façade is not unique; similar buildings appeared all across the land during the nineteenth century, thanks in large part to the designs of Asher Benjamin. The details of door, windows, eaves, pedimented gables, and bell tower were copied exactly or with slight modifications hundreds of times. From New England to California, narrow rustic siding became one of the standard materials for covering homes, schools, churches, and business buildings. Benjamin's later publications provided equally fresh interpretations of the Greek Revival mode. Through his books, the New England architectural idiom was widely adopted.

THE CENTRAL STATES
Thomas Jefferson and the Federal Style

The first, and certainly a chief, exponent in America of the new way of building was Thomas Jefferson (1743–1826). Jefferson was the product of an eighteenth-century classical education and the colonial environment. The result was a cultivated gentleman—a scholar interested in government, philosophy, the arts, and the newly developing sciences—who was also a practical man of action deeply involved in affairs of state. His esteem for the arts is indicated by his epitaph; in it he did not mention having served twice as President of the United States but pointed with pride to having founded the University of Virginia, where he planned the buildings to serve as an architectural lesson for builders.

Even before his travels abroad, Jefferson was dissatisfied with traditional colonial architecture. He found even the architecture of Williamsburg a sorry mess and bemoaned the "barbarious ornament" and the lack of

symmetry and nobility. Too intent in his search for the noble grandeur of the ancient styles to feel the charm of the colonial Georgian, he based his earliest architectural venture, the original design for his home, Monticello (Fig. 206), on Palladian models. Between 1793 and 1809, after his return from France, Jefferson undertook the remodeling of Monticello, drawing upon current French neoclassic practice as well as upon ancient Roman sources of inspiration.

Monticello is a pleasing combination of restrained magnificence and dignity with the informality of a country mansion. The projecting colonnaded porch and the low central dome reveal the Roman inspiration, whereas such features as the octagonal projections at the sides show an independent and inventive designer who could retain the dignity and nobility of his models, while departing freely from precedent and established plans. Jefferson's inventive and practical turn of mind also found an outlet in many interior details. Here he developed and utilized double doors which worked simultaneously, dumb-waiters, cleverly concealed staircases, and many other novel and useful features.

The Federal style received its first formulation in Monticello. The most evident feature was the projecting portico on the principal façade, colonnaded, capped by a triangular pediment, establishing a one-story effect. The careful proportioning of the classic orders, the maintenance of a rigid bisymmetric arrangement, the use of crowning balustrades, a continuous all-encompassing entablature, the elimination of all evidence of the high-pitched roof and gables of early times, and the use of domes on circular or octagonal drums are all characteristics of the Federal style apparent in Monticello.

In the Capitol at Richmond (Fig.194), designed with the aid of the French architect Charles-Louis Clérisseau, all architectural elements are subordinated to that most characteristic feature, the imposing portico which formed the façade. Ionic columns were substituted for the Corinthian columns of the Maison Carrée. In this first public building to be patterned directly after an ancient temple Jefferson again showed himself to be no mere copyist. Recognizing the need for a practical building, as well as for a symbol of government, he incorporated two stories of windows into the main body of the building to light the interior. The monumental temple façade, with its free-standing columns surmounted by a pediment, rapidly became the symbol of architectural propriety.

The chief source of Jefferson's pride was the University of Virginia. This institution not only embodied his ideal of state-supported education but also served as a text on the Roman style. The chief building, the central library (Fig. 207), was inspired by the Pantheon in Rome, though it is an adaptation; the pedimented lower story of windows, the plain second-story windows, the entablature that runs continuously around the building, as well as the taller proportions of the whole, are Jefferson, not the

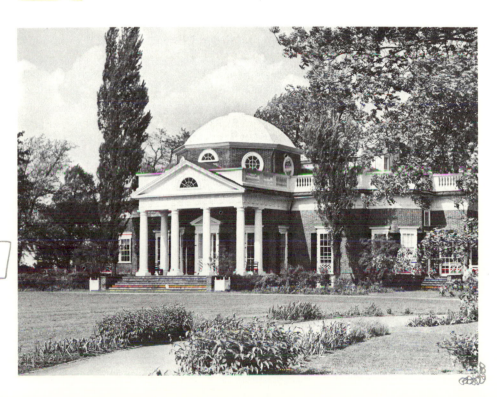

206. THOMAS JEFFERSON. Monticello, near Charlottesville, Va. 1770–1809.

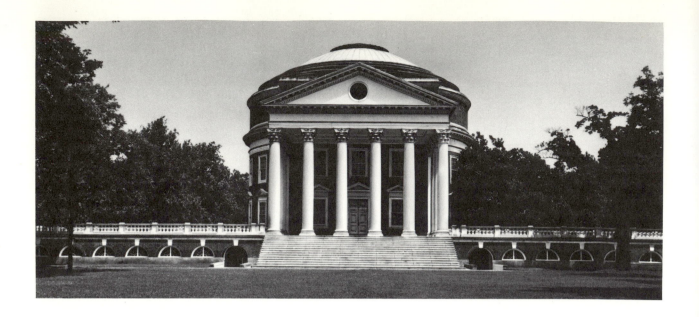

Pantheon. The series of professors' houses symmetrically arranged behind the library represents Jefferson's idea of the finest examples of the various classic orders; one building, for instance, employs the Doric order as used in the Baths of Diocletian; another copies the Ionic order of the Theater of Marcellus. Each building features one of the orders as used in a specific ancient prototype.

Equally important to Jefferson were the orderly and logical relationship of the various buildings to one another and the harmony of buildings, gardens, and site. The symmetrical arrangement did not inhibit or restrict the plan. The variety in the sizes of the buildings and garden areas, the charm of the vistas, the sensible provisions for access to and from the various buildings, and the use of red brick with white stone trim all attest to the ingenuity with which Jefferson reconciled his classical tastes with American building practices and the practical demands of an American university.

Jefferson's benign influence colored many phases of life in America during the post-Revolutionary period. Of prime importance was the influence he exerted by sponsoring certain architects of whose training and taste he approved. Through his favor Benjamin Latrobe, in particular, received many commissions, both Federal and private, and Robert Mills and William Strickland prospered.

Benjamin Latrobe

Benjamin Latrobe (1764–1820) has been mentioned already in relation to the United States Capitol. His contributions there are now difficult to separate from what went before and has been added since, but the quality of his thinking and his work and the subsequent influence of his pupils make him the most important classic-revival architect in America. Born in England, trained as an engineer in Germany, and subsequently apprenticed to an English architect of considerable stature, he was the first professional architect to practice in America.

Latrobe came to America while still a young man, and by 1800 he had settled in Philadelphia and received his first major commission, the Bank of Pennsylvania, unfortunately no longer in existence. Here he revealed his originality and his distinguished taste. The exterior, which had a Greek portico at each end, was beautifully proportioned and of striking simplicity, and the interior displayed his unusual capacity to design a functionally efficient contemporary building. He utilized masonry vaulting to span a domed main chamber, which was flanked by vaulted side chambers on two stories. The beauty of the building made a great impression on Philadelphia, and its originality encouraged other designers to solve problems without slavish reference to historical precedent.

While he could admire with enthusiasm the "immense size, the bold plan, and arrangements of the buildings of the Romans," he found "their decorations and details absurd beyond tolerance from the reign of Severus downward." Latrobe built effectively in the Roman manner and through his work helped formulate the Federal style, but his great love was Greek architecture, and more than any other individual he helped launch the Greek Revival. "My principles of good taste are rigid in Grecian architecture," he said, but his practice and understandings

were less rigid than his taste. He found that "the forms and the distribution of the Roman and Greek buildings which remain are in general inapplicable to the objects and uses of our public buildings." Modern churches, government buildings, and legislative assemblies demanded plans that were very different from those used in ancient times, and certainly the severe winters of the eastern seaboard necessitated a more protective architecture than the bland Mediterranean climate. Latrobe's greatness lay in his ability to provide plans to serve the needs of the aggressive young democracy and the evolving industrial age, to build the many specialized kinds of structures demanded by the new society, and yet to reconcile his solutions for these practical problems with his love for classic, and particularly Greek, architecture.

Though Latrobe is remembered as the chief protagonist of the classic revival in America, his own taste was more catholic than his influence. When he prepared the original plans for his great cathedral in Baltimore (Fig. 208), he submitted a Gothic design along with the Roman one that was accepted. Two or three other ventures into the Gothic manner indicate that, like most nineteenth-century architects, he sought through selective eclecticism to achieve a style which would serve the multifaceted diversity of that dynamic age. The Baltimore Cathedral was the first great classic-revival church to be built in America. Employing the elements of the Roman style, Latrobe as usual adapted the ancient forms to the tastes and needs of his own day and created an original and commanding church building. Of particular distinction is the interior (Fig. 209), where half-domed and barrel vaults lead the eye to the great central dome in a composition of spacious grandeur. To emphasize the beauty of the internal spatial volumes the decoration has been kept to a minimum, thereby creating a truly classic feeling of restraint.

opposite : 207. THOMAS JEFFERSON. Rotunda, University of Virginia, Charlottesville, Va. 1822–26.

right : 208. BENJAMIN H. LATROBE. Baltimore Cathedral, Baltimore, Md. Dedicated 1821.

below : 209. BENJAMIN H. LATROBE. Interior, Baltimore Cathedral, Baltimore, Md.

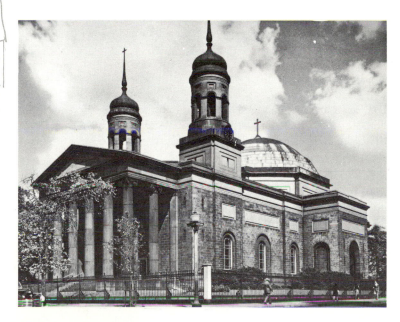

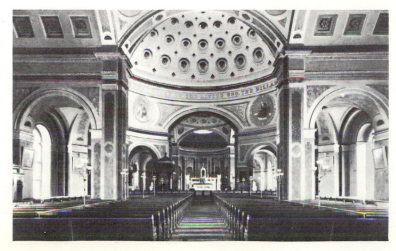

141

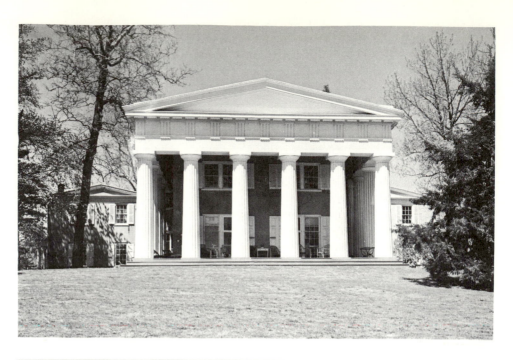

above : 210. Andalusia, home of Nicholas Biddle, Andalusia, Pa. 1833.

right : 211. WILLIAM STRICK-LAND (and BENJAMIN H. LATROBE ?). Second Bank of the United States, Philadelphia. 1824.

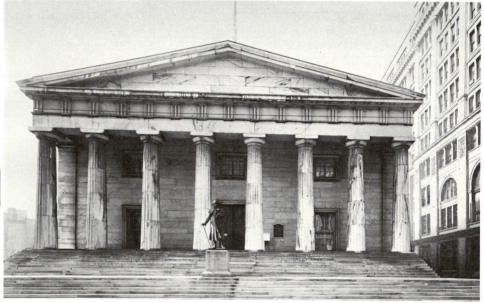

The Greek Revival in the Central States

The Greek Revival movement came to its height in the decades between 1820 and 1850, and its most brilliant examples first appeared in the Washington-Philadelphia area. The Doric order suddenly became the most popular of the classic orders, because its severe character suggested a Spartan austerity pleasing to the Victorian idealist, while both the Ionic and Corinthian styles suggested Oriental sensuousness. No more imposing illustration of the over-

whelming enthusiasm with which the Doric portico was adapted can be found than in Andalusia (Fig. 210), the Pennsylvania home remodeled in classic dress for Nicholas Biddle in 1833.

The Doric prostyle that forms the main façade of the building is an unadorned replica of the entrance to a Doric temple, even to the stepped stylobate, or platform, that supports the great columns. A monumental portico dominates the building, overwhelming the two-story body of the residence. Pedimental triangles also top the side

wings. Since marble was the material preferred by the ancient Greeks, the portico, constructed of wood, was given a thin coat of stucco ruled with lines to suggest masonry construction. The brilliant white recalls the mistaken nineteenth-century concept of a pure, colorless, ancient classic world.

A comparison of Monticello (Fig. 206) with Andalusia reveals some of the essential differences between the earlier Federal style and the Greek Revival in its most imitative manifestations. First, the prostyle portico dominates the Greek Revival façade. The similar portico in a Federal-style building is not so overwhelming, not so heavy in its proportions, and not likely to be in the pure Doric style. An elegant balustrade dominates the roof line of the Federal-style structure, and sometimes a dome is used, whereas the severity of the Greek Revival skyline is unrelieved except for the great pedimental gables. Last, as can be seen in Monticello, the Federal style is urbane and gracious, and though there is restraint and logic in the disposition of parts, the style is distinguished by a certain decorative splendor. The Greek Revival, on the other hand, severe and unadorned, suggests the remote calm of antiquity, rather than the animation of the nineteenth-century world.

Two of the principal architects of the Greek Revival to practice in the Philadelphia–Washington area, William Strickland and Robert Mills, were trained by Latrobe. William Strickland (1787–1864), like his master, could design in the Gothic, Baroque, and Greek Revival styles, but the Greek Revival was his favorite. There has been considerable controversy over whether Strickland or Latrobe himself designed the Second Bank of the United States (Fig. 211) in Philadelphia, built in 1824. Latrobe is frequently credited with the original conception and Strickland with the final design of the building. Almost more than any other building, it established the Greek portico as a symbol of financial stability. In its day it was considered one of the most distinguished structures of the nineteenth century. James Fenimore Cooper said that of a hundred similar magnificent structures erected in Europe, not one could be found in which "simplicity, exquisite proportion, and materials unite to produce so fine a whole." Even today one is intimidated by this monumental façade, with its broad flight of stairs, its great Doric columns, its rigid symmetry, and the complete absence of ornament. Certainly there is nothing about the façade to reveal the commercial purposes to which this templelike structure was dedicated.

Strickland did not always adhere to ancient models; in fact, many of his most impressive buildings, such as his lively Merchants Exchange in Philadelphia or his imposing State Capitol in Nashville, Tenn. (Fig. 212),

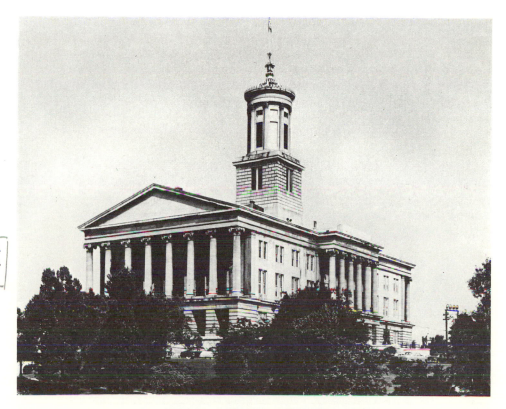

212. WILLIAM STRICKLAND. State Capitol, Nashville, Tenn. 1845–55.

reveal a very free combination of Greek Revival elements that achieves a spirited effect. In the Tennessee State Capitol the prostyle porticos at each end, rather than resting on the usual stylobate, are raised high above the eye level on a series of heavy piers, thus producing an air of great authority. A colonnaded section surmounted by the continuous entablature breaks the monotony of the sides, and the entire structure is capped by a circular tower inspired by the ancient choragic monument to Lysicrates in Athens.

Such unorthodox combinations became increasingly frequent in the 1830s and forties. Having first paid its respects to the classic spirit through direct imitation, the Republic proceeded to devise its own symbols of authority that reflected its youthful energy and exuberance.

Robert Mills (1781–1855) is most frequently remembered for the disciplined, dignified, and severe buildings he designed for the Federal government, including the imposing Treasury Department building (Fig. 213). The main entrance is marked by a broad stairway and a columned and pedimented portico. The basement story was kept subordinate to the main body of the building, which was fused into a single visual unit by the use of regularly spaced pilasters extending, like the portico, the full height of the building. An entablature and a simple, weighty continuous balustrade crowned the structure. Light-gray granite, the preferred material of the day, was used. This and other similar buildings by Mills established the prototype for government administrative structures all across the country. They reveal him as an original designer who could reconcile the complex requirements of modern administrative buildings with the architectonic integrity and dignity, which, rather than archeological exactitude, was the principal contribution of the Greek Revival to American architecture.

While Washington and Philadelphia were leading centers of the Greek Revival, Ohio, Kentucky, Missouri, Tennessee, and other new states played the role of provincial outposts for the style. An examination of the areas settled between 1800 and 1840 reveals city after city with Greek names; Athens, Sparta, and Troy were frequent, and each Athens, Sparta, and Troy boasted schools, city halls, churches, banks, and mansions that were elegant and Grecian—in front, at least. If finances did not permit the entire façade to be designed as a prostyle portico, then at least the entranceway was framed by a pair of Doric columns, an entablature with triglyphs and metopes, and a pediment. If stone and brick were not available, wood and stucco sufficed, and many a master carpenter built his columns and walls of wooden boards fitted together so skillfully that even the most discerning eye could not distinguish the individual boards. America longed fervently to achieve the classic dignity and nobility befitting the concept of democracy. In the adaptation of Greek tradition to nineteenth-century America, much architecture of an elemental simplicity, more Greek in spirit than in fact but frequently brightened by beautiful, modified classic detail, came from the hands of untutored builders who were more sensitive to the aspirations of their day than to the disciplines of the past.

213. ROBERT MILLS. Treasury Department Building, Washington, D.C. 1838–69.

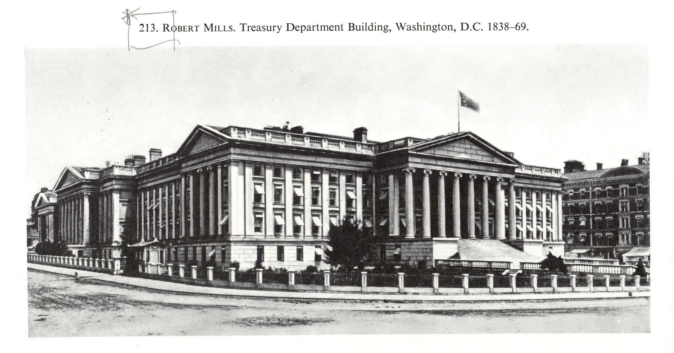

NEW YORK

The New York area abandoned the eighteenth-century models more readily than New England and, like Philadelphia and Washington, seemed more receptive to French influences. The elegant City Hall (Fig. 196), already mentioned, reveals its French origin both in the bold and clear relationships of its main masses and in the formality of such details as the suave groupings of pilasters, swags, and balustrades on the second story. The interior rotunda is particularly imposing in its spaciousness and in the magnificent sweep of its curved stairways.

The architects of the New York area began to explore the possibilities of other styles of building while the Greek Revival was in full swing. The first examples of Gothic Revival structures appeared in New York almost contemporary with the Greek Revival buildings.

Minard Lafever (1798–1854) worked in the Greek, Gothic, and even Egyptian styles. His Old Whalers Church (Fig. 214) at Sag Harbor, New York, built in 1844, is an amazing building, displaying an unusually ingenious integration of such divergent elements as Egyptian architectural forms, Greek Revival detail, and wooden construction. The influence of Lafever extended beyond that of his work, since he also published builders' handbooks containing exquisite details that range from Pompeiian to Gothic.

The frantic searching through the architectural vocabulary of the ages had begun. Architects were looking for styles that would fit the varying needs of a period of increasing complexity and allow for new engineering and structural methods. For the following hundred years elements from every historical style would be tested, and not always with the success that Minard Lafever achieved in his Egyptian church. The age of eclecticism was well under way.

THE SOUTH

The landed gentry of the South continued to live in a lordly manner in the years after the Revolution and built accordingly, so that handsome examples of the classic revival also appeared there. Latrobe himself worked in New Orleans; Robert Mills designed a number of buildings in his native city of Charleston and in Baltimore; Savannah and other southern cities boasted homes, churches, and public buildings of distinction in the Federal style. With the extension of the southern agricultural world through the purchase of the Louisiana Territory and the acquisition of Florida, the plantation system expanded, and the great cotton and sugar empires of the far South developed. There were few cities, and the

plantation seat became an almost feudal center, where the mansion of the owner was surrounded by servants' quarters, shops, warehouses, and other buildings. Black slaves, skilled in the building crafts, enabled southern landholders to build with an unprecedented splendor. The façades of great mansions lined the shores of the Mississippi, as well as other major waterways of the old South.

These vast plantation mansions, with their great colonnaded porticos, varied tremendously in design. Some are rambling and irregular, like Belle Grove (Fig. 215), near White Castle, La., and show a development of plans and details so free that at times the houses appear to have grown merely according to the caprice and whim of the builder or owner. Belle Grove had seventy-five rooms. The florid exuberance of such mansions expressed the ambitions of their owners, who aimed at a degree of opulence equal to that of the late Roman emperors.

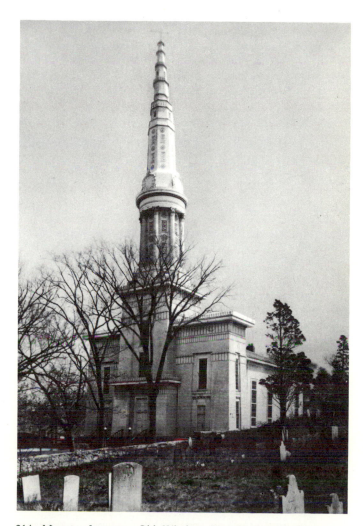

214. MINARD LAFEVER. Old Whalers Church, Sag Harbor, N.Y. 1844.

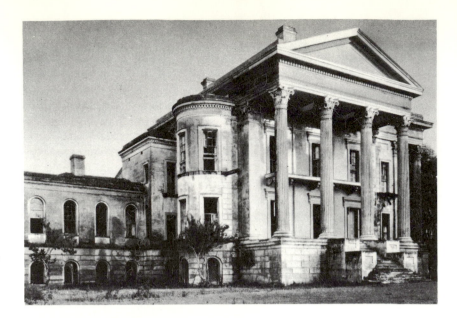

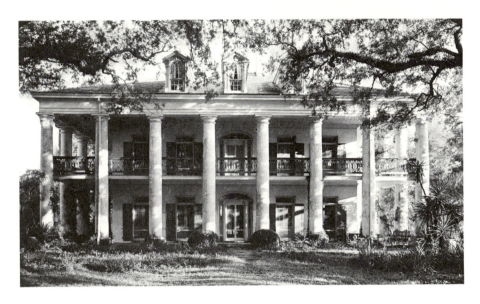

right : 215. Belle Grove, near White Castle, La. 1857.

below : 216. Oak Alley, near La Vacherie, La. 1836.

In some of the southern mansions a more authentic indigenous element characterizes the design. Oak Alley (Fig. 216) near La Vacherie, La., utilized a plan originally developed by the French settlers. A two-story gallery around the house provided shade and protection from the heat. The large and high-ceilinged rooms inside were cool and shadowy. Great two-story columns, often made of plaster on a brick core, supported the roof. The Greek Revival taste for impressive simplicity and regularity was satisfied here, but there is no outright copying of Greek stylistic details. Instead, an original and quite unique building was developed in response to the special demands of southern plantation life.

The Greek Revival reached the peak of its popularity in the northern and central states in the 1830s, after which time it was gradually replaced by an enthusiasm for the Gothic style, but it remained dominant in the South until the Civil War. Then, with the collapse of the southern economy, the great plantation mansions were neglected and gradually fell into disrepair or ruin. In the first decades after the Civil War there was little building activity in the South, and by the time it was resumed, the Greek Revival was dead. Today the great porticos and pediments of these old mansions constitute some of America's most romantic remains as they stand desolate amidst a litter of crumbling plaster and broken laths.

8

Architecture:
The Romantic Revival

The nineteenth century believed in progress; it did not doubt that political democracy, science, technology, and social idealism could enable man, individually and collectively, to realize more fully his physical and spiritual capacities. Nineteenth-century optimism concerning the future was accompanied by a reawakened interest in the past, in archeology, history, and religion, and a faith that lessons learned from the past would provide a guide for the present and the future. A period of expanding intellectual and social horizons, this age witnessed an equally dynamic economic growth. The industrial revolution and the rising democracies were creating a multitude of new institutions and economic activities, and architects were challenged to devise special forms to house banks, schools, factories, railway stations, department stores, and a myriad of previously nonexistent types of buildings.

Equally zealous was the search for styles that would express the humanitarian ideals and deep sentiments that guided the period. The enthusiasm for the styles of Greece and Rome discussed in the preceding chapter was the first of a long series of revivals, each of which was an attempt to reconcile a genuine admiration for the achievements of the past with current needs. But at the same moment that the designer looked to the past for inspiration, techno-

logical change was revolutionizing the techniques and materials of building, and architects, particularly in America, readily adopted structural iron, plate glass, the iron nail, and a host of other innovations. Thus continuous change permeated the very fabric of the structures which appeared externally to be copies of the past, but it was not until the end of the century that the full significance of technological change was to be realized and given conscious esthetic expression.

Every art movement carries within itself the seeds of its dissolution. Because the urgencies of artistic expression grow from the entire range of potential human experience, each movement, by its arbitrary limitation of expression, eventually sets up a current of opposition. The artistic expression based on classical ideals had focused on the rational, the controlled, and the balanced. The deep springs of human emotion—mystical, inspirational, subconscious rather than conscious, often irrational—which had been held in check by the classicists were gathering force in the nineteenth century. Gradually at first, and then in a torrential outburst, these forces began to break through the rigorous disciplines of the academies and the conventions of public taste to become dominant in nineteenth-century artistic expression.

The movement that gave expression through all the arts to the deepest feelings of the nineteenth century has been termed "Romanticism." Romanticism embodied those artistic tendencies which are opposed to classicism—the dominance of emotion over reason, reliance on personal taste and intuition rather than on tradition, an emphasis on content rather than on form, and reference to a rich body of literary and historical associations rather than a concern with purely formal and esthetic elements.

Even while Greece and Rome dominated the world of style, the champions of the Gothic manner began to appear, first in England and to a lesser extent in France, then in America. As noted before, the classic revival carried within it elements of Romanticism. The use of a Greek temple as a façade to ennoble a building, to achieve grandeur by association, as it were, was essentially a sentimental and romantic concept. After a final essay in the Greek manner the Romantic architect turned to other earlier styles, first, with ardent enthusiasm to the revival of the Gothic, and almost simultaneously to the Romanesque, the Renaissance, the Baroque, the Rococo, and even the styles of the Orient.

After 1820, whether architects worked in the Gothic manner or in one of the other current modes, the styles were used in accordance with the ideals of the early Victorian age, the period between 1820 and 1850. A particular style was chosen to suit a specific situation. Designs were conceived in the grand manner and focused on inspiring concepts to achieve sublime and elevated modes of feeling. After some initial and relatively untutored trials, in which lack of information, particularly in regard to Gothic practice, often resulted in charming but far from authentic buildings, the early Victorian architect sought for purity of style, as the neoclassic designers had done. At the same time the difference between institutional and utilitarian architecture increased, and utilitarian included the modest house. While historic precedent seemed essential for churches, colleges, libraries, government structures, and perhaps mansions, such practical considerations as efficiency of plan and economy of construction became paramount in the design of industrial, commercial, and domestic architecture.

THE GOTHIC REVIVAL

The Gothic Revival, a return to the style of the Middle Ages, had appeared in England almost contemporarily with the advent of the Adam style. Even earlier, in the later furniture of Chippendale, Gothic motifs had been featured in the quest for novelty, change, and a fresh stimulus. In the middle of the eighteenth century elements from the medieval style of building were appearing in England in a few country mansions such as Strawberry Hill, the country home built for the Romantic novelist Horace Walpole. In the nineteenth century a number of English architects turned with ardor to the Gothic. The most notable, Augustus W. N. Pugin, published extensive studies of medieval Gothic structures and designed churches and such famous buildings as the Houses of Parliament in the Gothic Revival style.

America was not slow to follow. In 1829 young Alexander Davis, who was to become one of the chief practitioners of the Gothic Revival style in America, sketched the buildings he saw about him on the streets of New York. He included in his notebook two structures with Gothic details. One was a synagogue with a Gothic tower above a Greek façade, the other a Masonic Hall featuring such Gothic details as pointed arches, tracery above the windows, and crenelated towers topped by medieval pinnacles. Gothic buildings had already been constructed elsewhere in America, even by architects who were champions of the Greek Revival. As mentioned earlier, no less a classicist than Latrobe had occasionally designed in the Gothic manner.

The architectural vocabulary of the Gothic Revival differed sharply from that of classicism. The symmetry so essential to the classic style gave way to a taste for irregularity; formality was replaced by informality; restraint in the use of decoration yielded to exuberance. The horizontal moldings and low roof lines essential for creating an air of classic calm were supplanted by a vertical emphasis. Round arches, domes, barrel vaults, and classic columns and pilasters gave way to pointed arches, clustered columns, ribbed vaulting, and buttresses. The entire repertory of medieval architectural forms was used to satisfy the growing desire for a mood of romantic sentiment. Charming spires, towers, turrets, and pinnacles helped to create an uneven, aspiring skyline; crenelated battlements and projecting machicolations suggested the romantic environment of knights in armor and of fair maidens in dark castles on remote moors. Bargeboards, the details of tracery in windows, and the flattened Tudor arch recalled the cozy rusticity of Elizabethan England.

In churches particularly, and to a lesser degree in homes, libraries, and public buildings, the high, narrow rooms, the tall windows with their traceries and stained glass, and the buttresses and spires all contributed to a mood of religious exaltation, of the self immersed in a greater whole, of communion with an infinite good—a mood that quickened the Victorian sensibilities, reinforced humanitarian convictions, and confirmed the belief that "God's in his heaven: All's right with the world."

As a reaction against the sprawling growth of cities and a landscape increasingly scarred by the blight of indus-

trialization came a taste for the rural, for the suburb, for nature. Country houses and gardens free from the geometry of formal design became a frequent part of the English landscape, and the popularity of a picturesque bit of ruined medieval architecture in a rustic English wooded garden indicated a preference for something other than the symmetries of the classic mode—a desire for a melancholy, atmospheric note. Americans quickly observed that the picturesque irregularity of the medieval styles, of towers, turrets, and pinnacles, irregular stone surfaces, and wood painted in dull colors fitted unobtrusively into the landscape, where the flickering light and shadows of foliage, falling on the broken surfaces, created a harmonious intermingling of the man-made and the natural.

The taste for visual picturesqueness and irregularity also coincided with a growing impetus for more freedom in laying out the floor plans. The classical rules of rigid symmetry had long restricted the development of efficient plans, and designers readily took advantage of the freedom offered by the new mode to introduce novel and ingenious arrangements of interiors. These internal changes produced greater variety in exterior appearances. Houses and public buildings lost the uniformity of the earlier periods, and a conscious striving for individuality and uniqueness became the order of the day.

Andrew Jackson Downing

The most influential spokesman for the Romantic approach to architecture in early nineteenth-century America was Andrew Jackson Downing (1815–52). Downing was a writer, arbiter of taste, architect, and landscape designer whose books championed the new modes—the rustic, the informal, and particularly the medieval styles, Gothic, Romanesque, and Tuscan. In his writings he frowned on the pompous formality of the Greek mode in architecture and deplored the geometric rigidity of the eighteenth-century formal gardens. He presented sound, if sentimental, arguments for the honest use of simple building materials, maintaining that stone should be used in such a way as to bring out its natural beauty and that wood should be treated as wood. The style of a building, he argued, should be related to its site, and he poked fun at battlemented castles in the midst of suburban meadows. He even championed the selection of building styles in terms of the personality of the owner, implying that a castle could make a mouse of a meek man.

Of particular significance to the evolving industrial democracy was Downing's interest in the middle-class house, as opposed to the general architectural concern with monumental building. Downing's publications supplied a number of plans for modest wooden dwellings, often of vertical board and batten, characterized by open and informal plans, wide bracketed eaves, and ample porches. These houses were frequently enhanced by decorative details derived from earlier historical styles modified for carpentered wooden construction, but these echoes of the past hardly did more than lend a piquant note to his essentially progressive designs. Probably more than any other individual Downing helped to bring to an end the reign of the Greek temple. He believed that the ideal dwelling was the product of a creative adaptation of elements selected from the various architectural styles of the past, combined and modified according to the personality, needs, and tastes of the owner, and constructed soberly and with fine craftsmanship.

Believing in the salutary effect of natural surroundings on sity dwellers, Downing championed the acquisition of great parks for our modern cities. It was largely through his agitation and vision that the plan for Central Park in New York City was first conceived and was later brought into being by Downing's pupil Calvert Vaux (1824–95) and Frederick Law Olmsted, Sr.

Frederick Law Olmsted, Sr.

No discussion of the influence of Downing can be complete without a consideration of Frederick Law Olmsted, Sr. (1822–1903). In the last half of the century Olmsted planned a number of America's great parks—Fairmount Park in Philadelphia, Central Park in New York (Fig. 217), Prospect Park in Brooklyn, Golden Gate Park in San Francisco, to name a few of the best-known. These parks

217. Central Park, New York.

represented the first attempt to relieve the mechanical rectangularity and the growing congestion of the rapidly developing metropolitan communities by setting apart large areas of essentially rural landscape within the cities, "refined and softened by art," as Downing said. Unlike the gardens of the eighteenth century, in which a geometric pattern was imposed on nature, frequently to provide a grand vista of an important architectural monument, Olmsted's parks were planned as three-dimensional compositions, employing the principles of picturesque naturalism. Gently curving walks and roads, irregularly shaped pools of water, natural outcrops of rock, and graceful stretches of lawn alternating with informal groups of trees and shrubs were laid out in relation to the contours of the terrain.

During the last half of the century Olmsted was also active in community planning. In this he was influenced by the same general considerations that entered into his designs for public parks, stressing informal plans that followed the natural character of the landscape. He was also imaginative in his approach to traffic problems, working to separate traffic lanes from living areas. Some of his plans for suburban communities have not as yet been greatly improved upon.

Alexander Jackson Davis

Andrew Jackson Downing suffered an untimely death, but he had already bestowed the approval of his patronage on Alexander Jackson Davis (1803–92), who was probably the most successful builder of Gothic-style houses in nineteenth-century America. Davis listed the following as the styles in which he could produce suburban dwellings: "American Log Cabin, Farm House, English Cottage, Collegiate Gothic, Manor House, French suburban, Swiss cottage, Lombard Italian, Tuscan from Pliny's villa at Ostia, Ancient Etruscan, Suburban Greek, Oriental Greek, Oriental, Moorish, and Castellated." But his modern renown rests largely on his handsome mansions in the Gothic manner. Davis seemed particularly adept at selling great baronial castles to persons with newly acquired wealth, and the most extravagant of these were veritable mazes of rooms, halls, and staircases topped by a forest of towers, turrets, balconies, chimneys, and gables.

His achievements went beyond mere size and complexity, however. Davis had a genuine ability to adapt the Gothic manner to the needs and tastes of his day and create a visually appealing, informal building. These talents can be seen to advantage in the Rotch residence (Fig. 218), built in New Bedford, Mass., in 1845. Using elements from the English Tudor style, but by no means restricting himself to this idiom, Davis created a charming house. The eaves of the steep roof are decorated with bargeboards, pendants, and finials, combined to suit his fancy but beautifully related in size and shape to the area in which they are located. The lacy trellises that support the porches, topped by pretty brackets enclosing quatrefoils, have little historic precedent but contribute unerringly to the creation of a light, open veranda. The low Tudor arch of the ground-floor window is combined with other windows of rectangular shape or framed by high, pointed arches; yet each window shape is so logical for its position that the total effect appears harmonious. The Rotch home presents an arbitrary combination of elements of the Gothic style, a practice frowned on by the devotees of authenticity, but the effect of the whole is fresh, vivacious, and pretty. It is easy to understand the attraction of the style for a public long restricted to the propriety of the classic revival.

James Renwick, Jr.

James Renwick, Jr. (1818–95), was another early nineteenth-century architect who did much to popularize the Gothic, and, in addition, he designed the first important government building in the Romanesque style. He was famous as the designer of both Grace Church and St. Patrick's Cathedral in New York (Fig. 219), the latter one of the first French Gothic structures to appear in America. His most original conception was the massive Smithsonian Institution (Fig. 220) in Washington, D.C., built between 1846 and 1855. This structure of dark-red sandstone is more Romanesque than Gothic, for its round arches, clearly marked stories, and blind arcaded galleries were

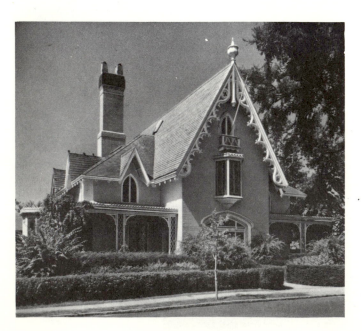

left: 218. ALEXANDER JACKSON DAVIS. Rotch Residence, New Bedford, Mass. 1845.

features that characterized medieval building practice before the true Gothic developed. The 500-foot-long maze of towers, turrets, gables, and chimneys is distinguished by the inventive capacities of the designer, rather than by authenticity. The crisp vigor of the detail, the dramatic effect of the crenelated roof lines, and the forbidding machicolations and towers reflect the tastes of a strong and energetic personality searching in the early Middle Ages, as Henry Richardson was to do a generation later, for a style appropriate to the expanding and energetic young America. Renwick's dark and dramatic achievement is particularly impressive when seen against the background of white-columned architectural propriety that characterized nineteenth-century Washington.

Richard Upjohn

Perhaps the best-known Gothic Revival edifice in the United States, and one of the finest, is Trinity Church (Fig. 221), New York, which today nestles amidst the skyscrapers at the foot of Wall Street and Broadway. Richard Upjohn (1802–78) was probably the most distinguished practitioner of the Gothic Revival style in nineteenth-century America, and Trinity Church is undoubtedly his masterpiece. Upjohn came to the United States from England in 1829, and, though originally trained as a cabinetmaker, he went to work after his arrival here as a draftsman, teaching and working for various architects. His first architectural assignments were Gothic villas which he designed with sufficient distinction so that he was called in to repair the sagging roof of the old Trinity Church of New York. Upjohn took advantage of the opportunity inherent in the situation and prepared such a persuasive design for a new church that the idea

below: 219. JAMES RENWICK, JR. St. Patrick's Cathedral, New York. 1850–79.

bottom: 220. JAMES RENWICK, JR. Smithsonian Institution, Washington, D.C. 1846–55.

151

of repairing the old church was abandoned. His new church was completed by 1849, and its merit was soon recognized. No less a critic than Downing declared it as superior to the other churches of its day as a Raphael Madonna was superior to a painted sign.

Today it is difficult, because of the neighboring skyscrapers, to see the building from a sufficient distance to appreciate the relationships of the main masses, but the unobstructed length of Wall Street still provides a superb view of the façade and of the towering spire that is the dominant feature of the building. The direct and unified movement of this great tower, the powerful way in which all the details are held within one continuous upward sweep, and the uninterrupted receding scale of the arches, windows, buttresses, pinnacles, and finials reveal Upjohn's power as a designer. His background as a craftsman stood him in good stead, for he planned and supervised the ornamental details in person. The clear, crisp stone cutting and wood carving pay tribute to his early training as a cabinetmaker and contribute a masculine and incisive flavor to the detail. Though the great office buildings surrounding Trinity Church may soar far above it, they do not overwhelm it visually or spiritually.

Upjohn was deeply respectful of English Gothic tradition and concerned with both the original spirit and, when possible, authenticity of detail, but he was not indifferent to the demands of his time or to the traditions and practices peculiar to America. Some of his most pleasing and original designs were for the modest churches desired by small communities and built in accordance with the carpentered Gothic tradition initiated by Downing and subsequently widely adopted and developed by other designers and builders. Such a structure is St. Luke's Church, in Clermont, N. Y. (Fig. 222). The body of the church is of vertical board and batten, a not uncommon bit of American building vernacular. The decorative detail on the eaves, belfry, and porch has the particular charm and flavor that resulted from translating the flowing lines of stone tracery into the rectangular pattern of wooden "stick" construction, thus creating a unique native version of Gothic Revival.

In house design Upjohn proved himself equally imaginative. Kingscote, an elaborate seaside home in

above: 221. RICHARD UPJOHN. Trinity Church, New York. Completed 1849.

right: 222. RICHARD UPJOHN. St. Luke's Church, Clermont, N.Y. 1857.

left : 223. JOHN HAVILAND. Eastern State Penitentiary, Philadelphia. 1829. Engraving by Fenner, Sears & Co., from a drawing by C. BURTON. New York Historical Society, New York.

below : 224. J. H. DAKIN. State Capitol, Baton Rouge, La. 1847–50.

Newport, R.I., reveals both in its exterior and interior (Fig. 248) his ability to adapt Gothic motifs to residential needs and to invent a vocabulary of architectural effects that would reconcile the taste for medievalism with the living patterns of nineteenth-century America.

Prisons were still medieval dungeons in most parts of the world—great thick-walled, windowless, foul caverns, where human beings were confined under inhuman conditions. John Haviland (1792–1852), another Englishman who came to America to find an outlet for his abilities, specialized in the design of penal institutions. His buildings were sufficiently original and satisfactory to attract study from the major European capitals. He preferred the Gothic style for his prisons, although he executed designs in other styles also, among them handsome Greek Revival structures and, most notably, an Egyptian exterior for the Tombs in New York. His design for the Eastern State Penitentiary (Fig. 223) in Philadelphia, built in 1829, presents an unusually imposing exterior, in which massive crenelated towers and austere surfaces of unbroken wall suggest some unassailable medieval fortress, a suggestion appropriate enough for its function. The Penitentiary also reflected a new concept of prison design in its plan. Cell blocks were arranged along corridors which radiated from a central point of observation, and each prisoner had his own bit of solitary garden as well as cell. The development of such revolutionary answers to an age-old problem represented a genuine optimism about society, a belief that human conditions could be bettered by new designs, plans, and arrangements. This deep optimism stimulated the changes in house plans, the development of kitchen equipment, the improvement of agricultural tools, and the thousand and one inventions that altered the character of nineteenth-century America.

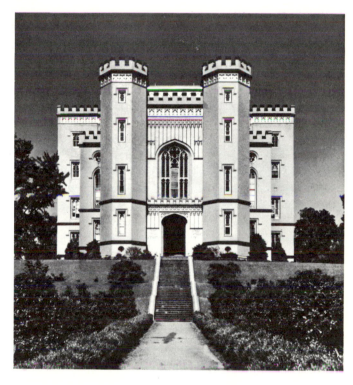

While the charm of naïveté often proved a substitute for authenticity of detail, Gothic Revival, like the other revivals of the period, could at times suggest pretense and sham. The old State Capitol at Baton Rouge, La., destroyed by fire during the Civil War and rebuilt in the 1880s (Fig. 224), represents an unfortunate attempt to adapt the Gothic mode to the world of civil administration. Remaining formally symmetrical, its sharp edges and thin detailing destroy the sense of weight and architectonic unity that gives Gothic both its grandeur and its picturesque character. The feeling of a pretentious

stage setting that characterizes this structure also mars much other architecture of the last half of the century, particularly as designers and builders, primarily concerned with plans, new structural materials, and the economics of building, ransacked the storehouse of past styles to find ready-made effects that would satisfy public tastes.

THE TUSCAN VILLA

In 1835 the firm of Town & Davis designed what it called a Tuscan villa, in New Rochelle, N.Y. It is not surprising that, as painters, writers, and sculptors rediscovered Italy, architects also would be attracted to the charming villas scattered through Tuscany, which were designed with Renaissance motifs used in a casual way, rather than according to the precepts of such architectural purists as Palladio. The informal floor plans and profiles, the bold contrasts of irregular rectangular masses, the warm-colored stone or stucco walls, and the broad, extending cornices appealed to the eye. The unformulated and essentially picturesque combinations of arches, columns, pediments, balustrades, and urns which characterized the style provided a new source of pictorial delight for the romantic designer, nostalgic for a warmer and sunnier place than the chill, gray world of northern Europe.

The Morse-Libby House (Fig. 225) in Portland, Maine, by Henry Austin (1804–91), presents a mid-century interpretation of the Tuscan villa as a grand mansion. Its richly bracketed cornices, curved and triangular pediments, Ionic columns, pilasters, balustrades, and textured quoins reflect a growing taste for the High Renaissance, or even Baroque, phases of the villa style.

In the metropolitan centers after mid-century the style was adopted with increasing frequency for handsome residences and business buildings. In designing business blocks or row houses, some of the more picturesque aspects of the style were sacrificed to conform to the regularity demanded by city streets.

Significantly, the Morse-Libby House is dated 1859, for it was during the fifties that the tastes which were to distinguish the post-Civil War years began to assert themselves. The Morse-Libby House foreshadows the trend toward a purposeful combination of diverse stylistic elements, richly textured surfaces, and marked irregularities of contour which represented the High Victorian ideal in the subsequent period, when the equalitarian goals of the Jacksonian age were increasingly subjected to the influences of the entrepreneur in politics and business. This trend, initiated during the fifties, came to its peak after the Civil War, when a heady exuberance replaced restraint, and elaboration provided the means for displaying newly acquired wealth and power. In the High

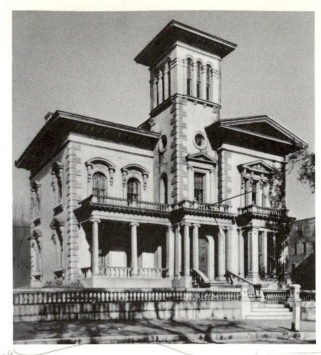

225. HENRY AUSTIN. Morse-Libby House, Portland, Maine. 1859.

Victorian style energy and invention worked hand in hand with a kind of brash originality and power to produce an architecture in which stylistic purity was freely sacrificed to display.

DIVERGENT CURRENTS

Not all nineteenth-century American architecture was based on the revival of historical styles, classic or romantic. The story of architecture in America went beyond the dominant culture, with its imposing monuments and grand mansions. Religious mystics who sought to escape a worldly corruption of the spirit, simple working people, and the scattered settlers from other than English-speaking countries also contributed to the fascinating complexity of American building practice. These groups, indifferent to the sequence of revivals, built their essentially utilitarian structures by modifying the traditions of their homelands in terms of new patterns of living.

Shaker Architecture

Far removed from the pomp, power, and display of the thriving business communities were the Shakers, a dissident offshoot of the Quakers, who came from England in the last half of the eighteenth century and, after a few desultory attempts to settle elsewhere. established the

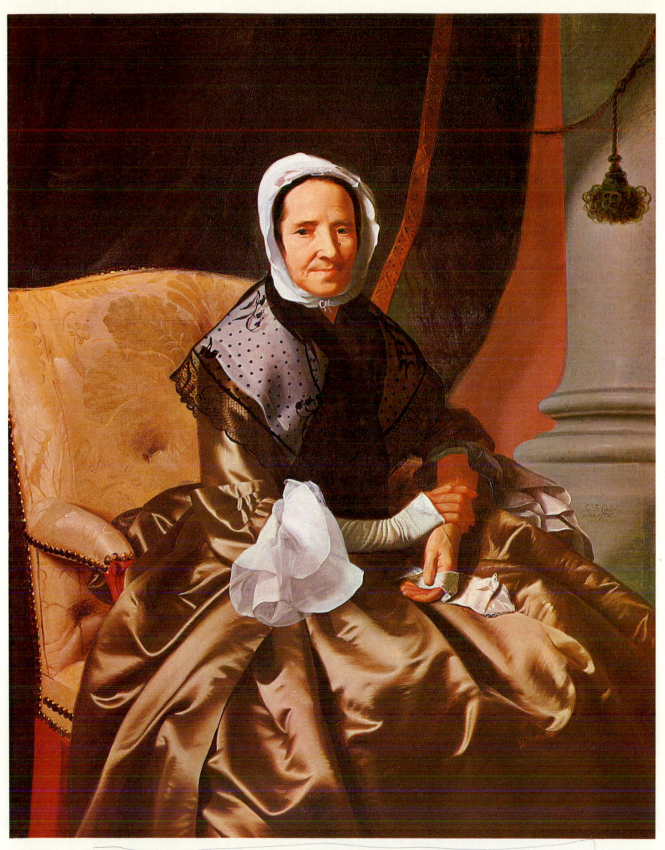

Plate 5. JOHN SINGLETON COPLEY. *Mrs. Thomas Boylston.* 1766. Oil on canvas, 4′ 1″ × 3′ 2″.
Collection Harvard University, Cambridge, Mass. (bequest of Ward Nicholas Boylston, 1828).

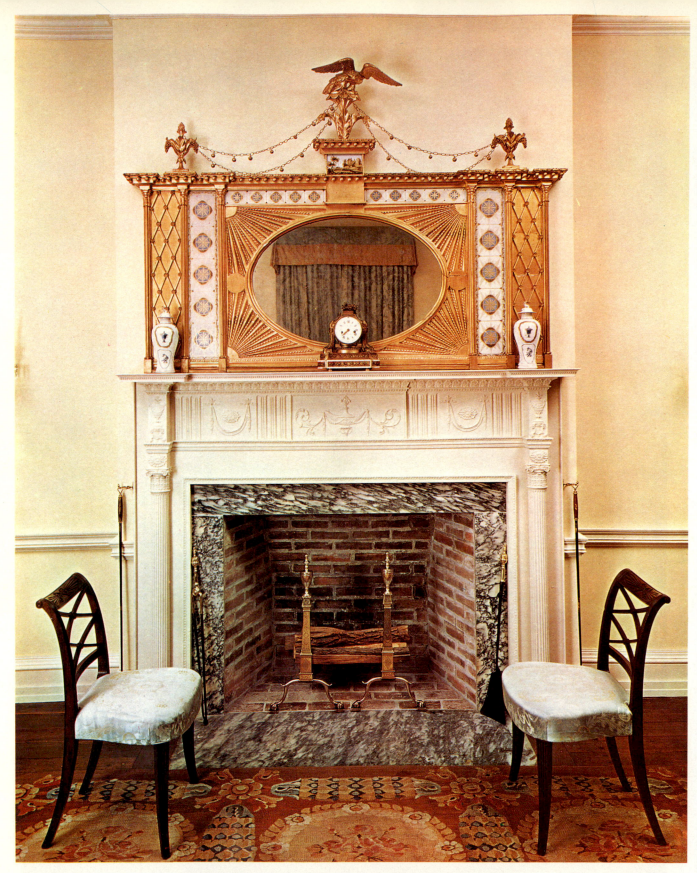

Plate 6. Duncan Phyfe Room, composite from New York. c. 1807.
Henry Francis du Pont Winterthur Museum, Winterthur, Del.

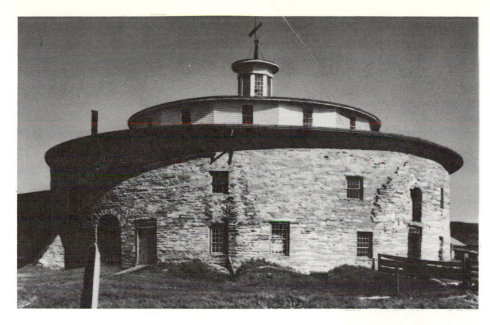

left: 226. Circular stone barn, Shaker colony, Hancock, Mass. 1826.

below: 227. Interior, Shaker stone barn, Hancock, Mass.

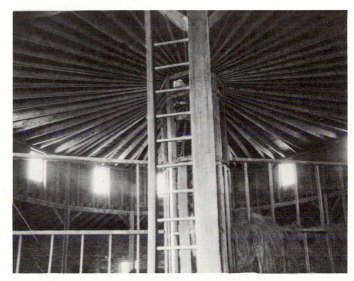

community of New Lebanon, N.Y. New Lebanon remained the chief center of Shaker life until the twentieth century, but in the early nineteenth century a number of other communities were established in New England, upstate New York, Pennsylvania, and farther west. Each of these settlements was almost self-sufficient, but all held certain attitudes in common. The convictions that "true Gospel simplicity ... naturally leads to plainness in all things" and that "anything may, with strict propriety, be called perfect which perfectly answers the purpose for which it was designed" created a homogeneity in the wares produced in all the Shaker communities.

Using the simple materials at hand, the Shakers retained the basic forms of eighteenth-century architecture and furniture but modified them freely when they could thereby be made more efficient. Because the Shakers lived mainly in multistoried communal dwellings and housed the community cattle in tremendous barns, their architecture is impressive in scale. It is also notable for integrity of construction and for the ingenuity displayed in building to suit their needs. The great circular stone barn (Fig. 226) at Hancock, Mass., with its twelve-sided wooden superstructure topped by a hexagonal cupola, shows how far the Shaker builders could depart from conventional practice for greater utility. This barn, built on a sloping site, permitted the driver of a hay wagon to enter, unload directly into the copious loft, and leave with a minimum of waste motion. The hay could then be pitched down to the stock as needed. The interior (Fig. 227), with its complex of joints radiating from the center, reveals the Shaker ingenuity in its use of structural beams. On the exterior the direct use of vigorously textured materials, the simplicity of the forms, and the sharp clarity of doors, windows, and eaves reflect the same honesty of design and craftsmanship that distinguished the Shaker interiors and furniture, which will be discussed in Chapter 9.

The Cottage

The nineteenth century, though romantic, was also a very practical age. Its problems grew from its attempts to reconcile sentimental enthusiasms, humanitarian ideals, and technological developments. Accompanying the expansion of industry and the fantastic growth of the

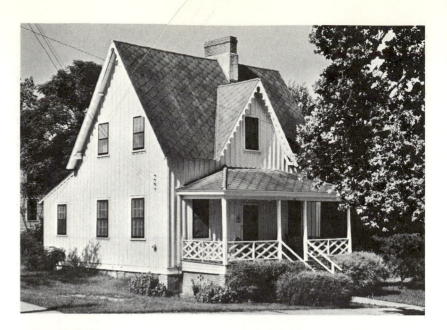

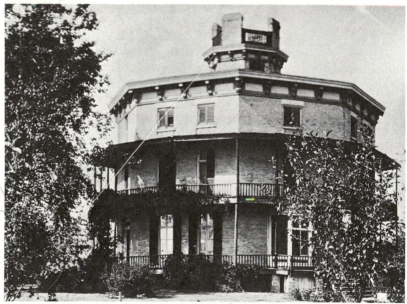

above : 228. Millworker's house, Granite-
ville, S.C. 1846.

right : 229. Octagon House, Watertown,
Wisc. 1854.

cities came urgent need for housing. Planners laid out
ideal communities, real-estate promoters made fortunes
from building housing that was far from ideal, and
somewhere between these two groups evolved the various
typical American cottages. While the row houses of the
urban working class degenerated into airless and dark
flats, the small-town, rural, or suburban cottages, standing
free on their own lots and open to light and air, remained,
on the whole, superior to their equivalents anywhere else
in the world. Downing's concern with house design has
already been mentioned, and simplified versions of his
ideas were widely disseminated. A mill-town house

(Fig. 228), built in Graniteville, S.C., in the 1840s, typifies
the small-town or country dwellings constructed of wood
on a brick or, later, a concrete foundation. The plan was
simple and practical. The front door opened directly
into a parlor or into a hallway flanked by a parlor and a
dining room and kitchen. As in the older colonial houses
and the fashionable Gothic mansions of the day, a high-
pitched gabled roof sheltered the second-story bedrooms.
A front porch provided protection from the weather and
a place for enjoying the outdoors. The shed roof in back
covered whatever could not be comfortably included
under the main roof. These modest cottages were fre-

quently enhanced by stylish decoration; in the Graniteville house a modest jigsaw cutout trimmed the eaves in a faint echo of the splendid bargeboards which might decorate the mansion of the mill owner.

Not everyone concerned with developing a pleasant and comfortable home for the average man thought in such conventional terms. Americans had always shown an inventive turn of mind and a preoccupation with practical matters, and, as might be expected, these talents were applied to improving home design. Inventions to lighten housework, to improve ventilation, heating, plumbing, and lighting appeared in quantities during these years. Books of house plans assisted builders to design comfortable and efficient homes. About mid-century, Orson S. Fowler wrote *A Home for All* and presented the octagonal house as his solution to the problem of logical house design whether on the scale of a mansion or of a modest dwelling. The octagonal house (Fig. 229) contained no dark corners or long hallways and provided the maximum amount of enclosed living space with the minimum of construction. The book went into a seventh printing, and octagonal houses appeared with some frequency in America, the first of a number of radical housing concepts to appear here.

One of the most important developments in building practice before the Civil War was balloon framing, which contributed to economical and efficient construction. Balloon framing was used in Chicago in 1833, and for many years it was termed "Chicago construction." In balloon-frame construction, thin 2-by-4-inch vertical studs and plates ran the entire height of the building and were held together by nails, providing a light and sturdy frame which could be sheathed with wooden siding or some other suitable material. Balloon framing, a product of the industrial age, was made possible by improved lumbering methods and by the development of machinery for manufacturing nails, which rapidly came to cost only a few cents a pound. The use of this rapid, light construction soon became widespread, contributing greatly to the development of indigenous housing, and has since remained standard in America.

The French—New Orleans

The initial architectural ventures of the French settlers of the lower Mississippi Valley and of the Spaniards in the South and the Southwest have already been discussed. During the last years of the eighteenth century and in the first half of the nineteenth, there were further developments of these two traditions, far removed in spirit from the fashions of the North and East.

Except for a very few buildings, such as the Cahokia Courthouse and the plantation houses previously mentioned, little evidence remains of the long French domination of the Mississippi River Valley except in the city of New Orleans. Remaining French through the middle of the eighteenth century, New Orleans fell into the hands of Spain in 1764 and then briefly reverted to France until 1803, when it was ceded to the United States. During the period of Spanish occupancy fires obliterated most of the old city except for the section around the main square. Most of what is now called the "Old City" was built in the nineteenth century.

The Cabildo (Fig. 230), or Old City Hall, built during the period of Spanish domination, retains much of the formal dignity that distinguished Baroque monumental

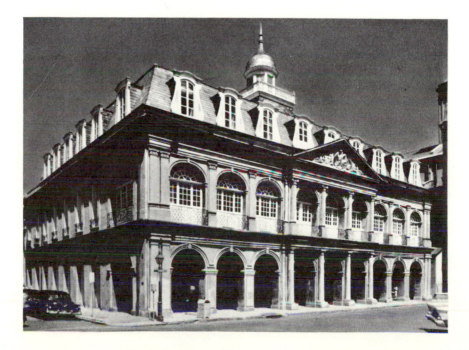

230. Cabildo, New Orleans, La. 1795.

architecture. Its French mansard roof was added at a later date, but as a whole the Cabildo reveals a feeling for the logical proportioning of parts, a strong emphasis on structure, and delicacy of detail. The increased lightening of the parts from the massive arcades of the ground floor to the delicate dormer windows of the mansard-roofed third story; the bold way in which the pedimental triangle, attached columns, and dome establish the central axis of the building; and the delicacy of the decorative details —all speak for the rich tradition of building inherited from the two mother countries.

The homes (Fig. 231) in the surrounding area may be of more significance to the evolving American tradition than the imposing municipal buildings. Less European and more Creole, these houses combined French, Spanish, and local elements in a unique and lively indigenous style. In the nineteenth century two- and three-story houses became frequent. Broad balconies, sheltered in the eighteenth century by high-pitched roofs and in the nineteenth by low-pitched ones, extended over the full width of the sidewalk and provided both access to the outdoors and a shaded walk. Windows were shuttered, and the balconies, held up by colonnades in the eighteenth century, were supported in the nineteenth century by

ornamental iron grilles. Originally made of delicate hand-wrought iron, these ornamental grilles were supplanted by elaborate cast-iron trellises and railings in the last half of the nineteenth century. Much of the finest wrought and cast iron from New Orleans was the handiwork of highly skilled Negro craftsmen.

The plans of these houses are as interesting as the façades. The typical plan featured a large room on the front with windows facing the street. This room was entered from a side hall or driveway, which also provided passage to a courtyard in back. The courtyard served as an area for family activity. It also offered a space in which servants could carry out tasks not suited to the indoors and a passageway from the kitchens, service rooms, and slaves' quarters which opened off the court. This plan, common to Latin countries, in which rooms are arranged around an open court, gives a distinctive character to New Orleans houses.

The Spanish Styles

In the mid-eighteenth century the Spanish colonial world entered an era of unparalleled prosperity due to the discovery of tremendous deposits of gold and silver in Mexico. The communities of the Southwest shared in this outburst of energy and experienced a period of expansion and building. New churches were put up in an area extending from eastern Texas to California. Two fine examples of these churches are still standing—San José and San Miguel de Aguayo Mission, in San Antonio, Tex., and San Xavier del Bac (Fig. 232), in Tucson, Ariz.

Built between 1784 and 1797, after the final phase of the Spanish Baroque style, the Churrigueresque, had found colorful expression in a series of extravagant churches in Mexico, San Xavier del Bac represents a remote provincial echo of the Mexican style. Yet that style had such a wealth of flamboyant ornament that even a remote provincial echo of it remains impressively rich. As in most of the Mexican churches of this type, two relatively simple side areas of the front façade carry bell towers which frame a richly ornamented central panel of Baroque decorative motives. Scrolls, volutes, pilasters, crests, leaves, flowers, and the shell, the particular symbol of the Franciscan order, are all executed in a soft, dark brick color that contrasts effectively with the light-colored surfaces around them. San Xavier del Bac probably boasts the most richly decorated façade in North America and presents an exciting contrast to the general restraint that characterizes our colonial heritage.

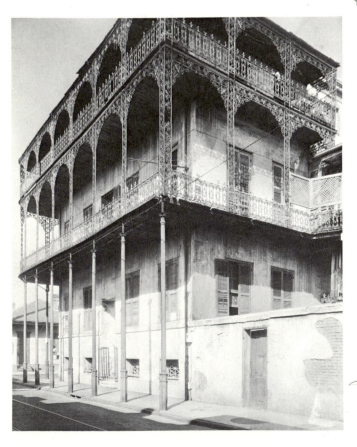

left: 231. Le Prete Mansion, New Orleans, La. 19th century.

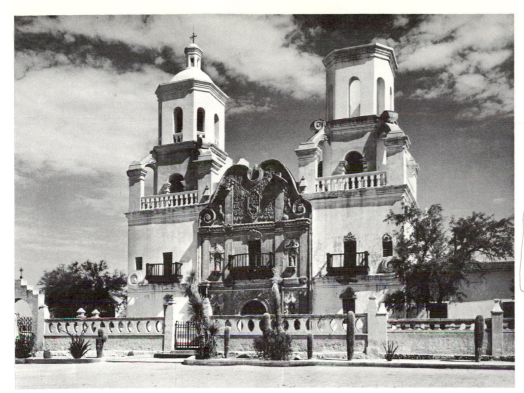

left : 232. San Xavier del Bac, Tucson, Ariz. 1784–97.

below : 233. Interior, San Xavier del Bac, Tucson, Ariz.

San Xavier is equally splendid inside. The interior (Fig. 233), covered by five low domes made of brick, with a high dome resting on an octagonal drum at the crossing of the transept and the nave, is elaborately ornamented with carved stone, molded plaster, gilded woodwork, and painting. An immense richly gilded and polychromed retable (the elaborate background for the altar) occupies the entire end wall of the apse, and each of the transepts has a profusion of decoration.

The California missions, built between 1769 and 1823, the last mission churches to be established, are probably the most familiar examples of Spanish colonial architecture in North America. Stylistically they stand half way between the simple structures of New Mexico and the elaborate churches of Texas and Arizona. Like other mission churches, the California mission church was the center of a group of buildings enclosed by walls and usually grouped around one or more open patios. The church, the most imposing unit of the complex, usually formed one side, or a part of one side, of the main patio. Close to the church, and usually attached to it, were auxiliary buildings which held living rooms, a kitchen, cells, offices for the keeping of records, and quarters for travelers. Opening off the enclosed patio and fronted by covered arcades were other buildings: dormitories for the unmarried Indian neophytes, shops for all the craft

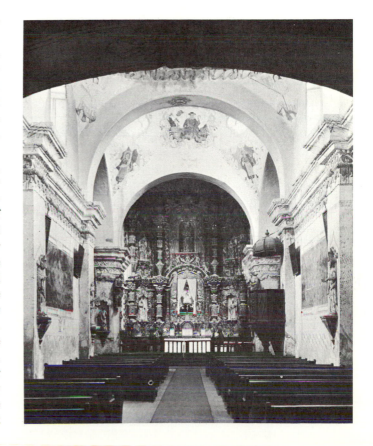

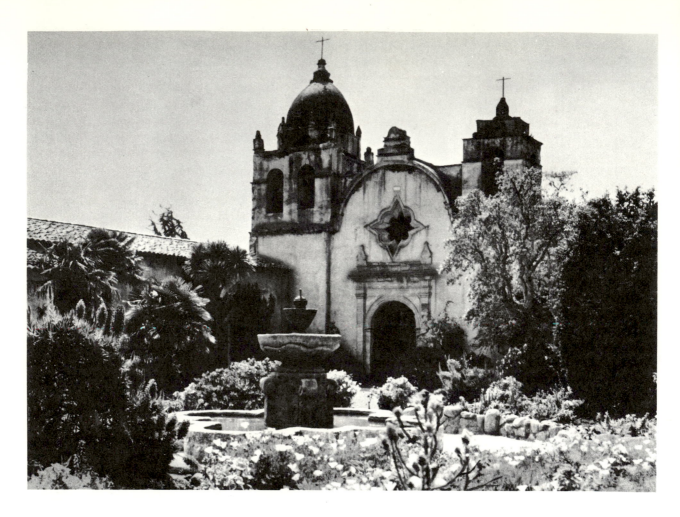

activities carried on within the mission, and rooms for storing food and the products made and used by the mission community. Within easy reach were such subsidiary buildings as barns, corrals, and a tannery. A short distance away lay the Indian community, called the *rancheria,* which was usually an assemblage of crudely constructed huts.

San Carlos Borromeo (Fig. 234) at Carmel was the administrative center for the California missions, and in 1793 Father Lasuen began to construct a new mission church worthy of its position. Since building in stone represented the ultimate aspiration of the mission founders, a mason was brought in to instruct the Indian workers. An unusual wooden tunnel-vaulted ceiling supported by three transverse stone ribs provided an impressive interior to match the elaborate façade. In order to withstand the outward thrust of the vaulted ceiling, unusually heavy walls and thick reinforcing buttresses were used.

The façade of the Carmel mission is vigorous in its use of provincial Baroque forms. A tall bell tower on the south has two openings on the front and one on the south side. Finials crown its four corners, and, above, an octagonal drum decorated with eight finials carries the eye to the tall dome surmounted by a slender iron cross. A small tower with only one arched opening and a modest crest marks the north corner. The main portal, impressive in size, is framed by weighty pilasters and moldings. Above the door, a bold star-and-quatrefoil window and a strong arched pediment capped by a weighty finial terminate the composition. The combination of sturdy forms, the contrasts between decorated areas and broad expanses of smooth wall, and the harmonious tones of cream-colored stone and darker stucco make the Carmel mission the most impressive monument left by the Spaniards in California. Neglected along with the other missions in the last part of the nineteenth century, San Carlos Borromeo has fortunately been restored with great care, so that it appears now very much as it did in the early nineteenth century.

Municipal and residential architecture in Spanish colonial California reflected the general pattern that

characterized the mission churches. Adobe walls enclosed rectangular rooms which opened onto covered arcades. These arcades, formed by continuing the slanting roof beyond the outer walls of the building, were supported either by wooden posts or adobe piers. When there were many rooms, buildings were arranged around a rectangular open patio. The adobe walls were given a heavy coat of whitewash, sometimes tinted with colored pigment, and the roof was covered with red tiles or, if tiles were not available, with heavy wooden shingles.

In southern California the one-story adobe ranch house was most common. The typical ranch house ranged from a few rooms, with or without an arcade, to a commo-

dious structure with a dozen or more rooms opening onto spacious arcades that framed an orderly patio (Fig. 235). The patios, with flowering plants and paved walks, potted flowers, and sometimes a fountain, formed the heart of these houses in the same way that the great hearth served as the focal center of the colonial New England home.

Farther north, after the 1830s, the two-story adobe appeared. Fine examples of the two-story adobe house are sufficiently numerous in Monterey to give it the name of "Monterey-style." A long veranda usually extends across the façade of the building, supporting a second-story balcony. In the famous Larkin House (Fig. 236),

opposite : 234. San Carlos Borromeo Mission Church, Carmel, Calif. 1793.

right : 235. Veranda, De la Guerra House, Santa Barbara, Calif. 1819–26.

below : 236. Thomas Larkin House, Monterey, Calif. 1834.

residence of the first American consul to Alta California and probably the prototype for the Monterey-style house, the veranda and balcony extend across the front and down the two sides of the house. The verandas are supported on slender wooden posts which continue through second-story supports to the roof. A simple but graceful railing encloses the balcony. Though the walls of the ground floor in the Larkin House are 3 feet thick and those of the second story are 2 feet thick, the effect is graceful and light, because the slim posts of the verandas and balconies and the graceful low slope of the pitched hip roof create an open and airy feeling. The plan of the typical Monterey-style colonial house was simple. The ground floor housed the living, dining, and service rooms and the kitchen. The stairway to the second floor was outside, at one end of the veranda, and led to the balcony, which provided access to the bedrooms. The rambling one-story ranch house planned around an open court and the two-story Monterey-style house, with its extended verandas, established the prototypes for what would become the popular twentieth-century California ranch-style architecture.

In the seventy-five years between the Revolutionary War and the Civil War, the United States emerged from colonial dependency to become a full-fledged sovereign nation. During these years the American builder abandoned the colonial Georgian style of building and, borrowing from earlier styles, tried to fashion a dignified garb for national and state capitols, as well as for many other buildings. A particularly charming combination of Georgian and classic-revival elements appeared in the Federal style of New England. After 1830 there was a rapid succession of revivals, led by the Greek Revival and then the Gothic. This experimentation with various modes of the past continued with unabated vigor in the years following the Civil War. Another quarter of a century had to pass before the new style of the emerging industrial age defined itself with any degree of assurance and clarity.

The architecture of the French and Spanish settlers and of certain dissident religious groups in our midst constituted separate and independent elements of our architectural heritage. Not until the twentieth century would their unique flavor be incorporated into our rich architectural tradition.

<div align="center">

9

</div>

Interiors
and the Household Arts

CLASSIC-REVIVAL INTERIORS

Comparison of a room in the Derby House (Fig. 237) in
Salem, Mass., one of Samuel McIntire's masterpieces,
with an equally splendid Georgian interior (Pl. 3, p. 73)
makes the changes that characterized the Federal style very
apparent. The most striking differences appear in the
increased rectangularity of forms, in the diminished
weight of ornamental details, and in the absence of
Baroque motifs. The scale of the decorations is more
delicate; moldings are lighter, door jambs and mantel
and window details project only slightly into the room,
and the carving is in very shallow relief. The extensive
wall paneling so characteristic of the earlier period is
eliminated, so that the walls are smooth and unadorned
except for the chair rail running around the room at the
level of the window sills. The rich pedimental decorations
have disappeared, along with the elaborate sculptured
brackets, the complex moldings, and the broken Baroque
curves. Quiet horizontal and dignified vertical lines
dominate the room. The ceilings in the more splendid

right : 237. SAMUEL MCINTIRE. Room from the Derby House,
Salem, Mass. 1799. Pennsylvania Museum of Art, Philadelphia.

cilings

homes of the Federal style are decorated with delicate molded stucco patterns, which tend to be centered single designs rather than continuous allover patterns. The rich, full-bodied colors of the Georgian interior have given way to pale tones, with white predominating. The furniture, which will be discussed more fully later, is rectangular in structure, light in scale, with extreme refinement of detail. Rooms remain lofty and large, with tall and imposing doors and windows. Door jambs frequently are topped by a broad carved panel to give an illusion of increased height. The decorative motifs used in the interior, like those on the exteriors, seem to have been inspired by antiquity, particularly as it was interpreted by Robert Adam.

McIntire's talents were essentially those of a craftsman and decorator, rather than those of an architect; consequently, the refinement and charm of his work are most apparent in such interior details as the exquisitely carved woodwork seen in the mantel and above the doors in the Derby House interior. These areas are enhanced by cameolike swags, urns, fine flutings, and moldings, and

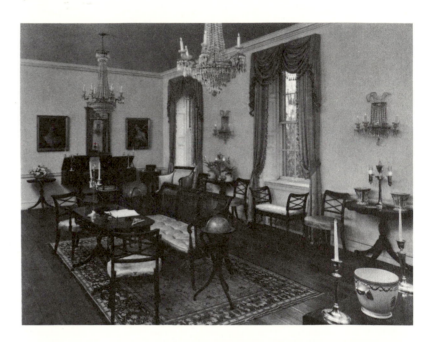

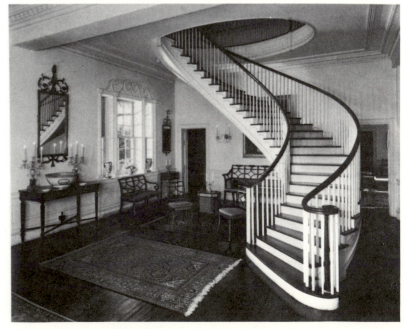

above : 238. Duncan Phyfe Room, composite from New York City. c. 1807. Henry Francis du Pont Winterthur Museum, Winterthur, Del.

right : 239. Montmorenci Stair Hall, from Shocco Springs, near Warrenton, N.C. 1822. Henry Francis du Pont Winterthur Museum, Winterthur, Del.

the dainty stucco ceiling ornament contributes greatly to the elegance of the room. The house features a great oval drawing room on the garden side. Whenever possible, rooms in the Federal period were symmetrical, with, as previously noted, oval, semicircular, and octagonal ends, niches, and bays providing stately variations of room shape when an effect of unusual distinction was desired.

Interiors of the Federal style were much alike throughout the states, but minor regional differences are evident. Restraint characterized New England, a Continental splendor predominated in New York and the central states, and an air of aristocratic elegance distinguished the beautiful mansions in the South. A comparison of McIntire's New England interior, the Duncan Phyfe Room (Fig. 238), based on a New York room of about 1807, and the stairhall from Montmorenci (Fig. 239), a famous mansion near Warrenton, N.C., reveals minor differences in emphasis. The basic framework of the Duncan Phyfe Room, named after the maker of its fine furniture, is similar to that observed in the Derby House. The room is large and high-ceilinged. The walls are plastered and without extensive paneling. The only moldings are the mop boards, chair rail, and cornice moldings. The paneling of the doors and window casements is rectangular, regular, and projects only slightly from the wall, and the tall windows reach almost to the ceiling.

The more elaborate arrangement of the draperies, the symmetrical design of the cut-glass ceiling chandeliers, and the Regency flavor of the furniture all contribute an urbane air. A view of the fireplace in the room (Pl. 6, p. 156) reveals with particular clarity both the typical motifs and the exquisite delicacy of detail that were the keynotes of the Federal style. The mirror above the mantel is one of the masterly confections produced in New York state; its gilded wood, decorated by "candy-twist sunbursts," slender colonnettes, and flowered latticework, is topped by leafy urns and a gilded chain with pendant balls. The entire composition, in turn, is surmounted by that most popular patriotic motif, the eagle. Pale yellow walls, white woodwork, and the cool blue-green marble facing of the fireplace supply the clear colors preferred during this period.

One entered Montmorenci from a two-story, columned veranda and looked across the spacious entrance hall to the back hall, out of which the stairway rose in an elliptical curve. The splendid sweep of the stairway reinforces the ample volume of the hall and the grace of the molded stucco ornamentation over the window and in the cornice moldings. The handsome mirrors, the Oriental porcelains, and fine rugs were imported to satisfy the distinguished tastes of the owners. The airy elegance of the Montmorenci stairhall suggests that the older patterns of life still prevailed in the South.

Empire-style Interiors

Created at the behest of Napoleon to provide the proper setting for his imperial dreams, the Empire style in the decorative arts parallels Greek Revival architecture in many ways. Foreshadowed by the Directoire style of 1790 in France and the very similar Regency style, which flourished in England from 1800 to 1830, the Empire style, with its more imposing, weighty, and antiquarian air, gradually replaced the delicate and refined earlier classic-revival manner. The new mode reached its most ostentatious expression in France between 1810 and 1830. Even though American designers relied more upon the less pompous English Regency designs for inspiration than upon French sources, it is customary to classify American styles in interior design, furniture, and the decorative arts between 1810 and 1830 as Empire.

The Red Room in the White House (Pl. 7, p. 173), which was originally designed and furnished in the fully developed Empire style and has recently been redone with careful exactitude, reveals the imposing character of the style in a room of exceptional magnitude. The most obvious characteristics are the impressive scale, the increased weight of all framing members, and the severe simplicity of the moldings. Though the Red Room has kept a paneled dado, surmounted by a stenciled gilt pattern of Pompeiian flavor which is repeated below the cornice, in many Empire rooms even the chair rail was eliminated to create the unbroken expanse of wall that would best display the rich furnishings.

Moldings framing the doors and windows were broad and flat, suggesting the stone-framed portals of antiquity, and the number of moldings was reduced in an attempt to recapture the grand austerity of masonry construction. Caryatids such as those which flank the fireplace and support the mantel in the Red Room were used both as architectural details and as parts of furniture, and anthemia, urn shapes, Greek-key patterns, cameolike medallions, and other motifs of classic or ancient derivation were used to accent or relieve the heavy surfaces. The large scale of the interiors required massive and monumental furniture, which assumed an increasingly architectural flavor as classical columns and ancient composite animal and human forms (sphinxes, phoenixes, claw feet, and eagles' heads) were incorporated into the already ponderous pieces. Numerous small objects—mirrors, wall sconces, oil lamps, candelabras, urns, pitchers, vases, elaborate clocks, and other *objets d'art*—contributed to the decorative scheme and enriched the room. Colored marble, gleaming varnished mahogany, and shining brass added splendid textures and color effects. Both gilt and color were applied to carved surfaces, lamp shades, and even

the marble tops of tables. Metallic embroidery shone in the curtains, metal fringe glittered on the valances, and gilded plaster enriched picture frames and mirrors. Full-bodied, rich colors replaced the light, pale colors of the previous years. Though it is elaborate, the Red Room still has both symmetry and regularity, and, despite the profusion of detail, order predominates. The exuberant patterns and the crowded and redundant flavor of the High Victorian style observable in individual objects do not prevail in the ensemble.

Classic-revival Furniture

The classic revival, like the preceding Georgian age, produced one of the great periods of furniture design. Such designers as the Adam brothers, Hepplewhite, and Sheraton in England and Duncan Phyfe in America established certain basic furniture styles of such vigor that they persisted well into the twentieth century. An important factor was the publication by the Adam brothers, Hepplewhite, and Sheraton, in that sequence between 1760 and 1800, of books of designs that were widely used by a host of superb cabinetmakers both in England and America. At a slightly later date the French Empire mode made its impact. In taste and practice America lagged behind England and the Continent; modes that began to appear in England about 1760 did not appear in America until after the Revolution. Except for the Empire and some of the corresponding English Regency-derived styles, American classic-revival furniture is usually identified by the name of the originator of the design. The following dates indicate the periods when the influence of the best-known designers was dominant here:

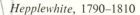

Hepplewhite, 1790–1810
Sheraton, 1800–10 (paradoxically, pieces derived from late Sheraton designs (1810–20) are usually identified as Regency or Empire, rather than as Sheraton.)
Empire, 1810–30 (Duncan Phyfe produced such authoritative furniture in certain late Sheraton, Regency, and Empire designs that his name has also become a style name.)

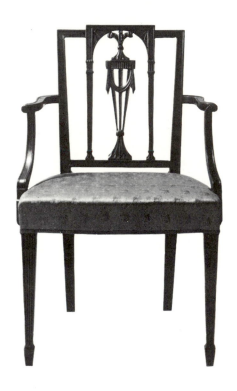

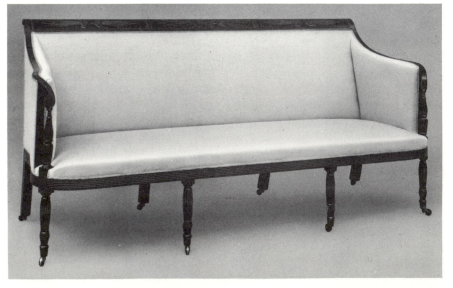

above : 240. Sheraton-style armchair, from New York. 1790–1800. Mahogany. Museum of Fine Arts, Boston (M. and M. Karolik Collection).

left : 241. DUNCAN PHYFE. Sheraton-style sofa. 1805. Metropolitan Museum of Art, New York (gift of Mrs. Harry H. Binkard, 1941).

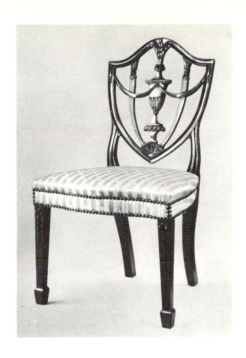

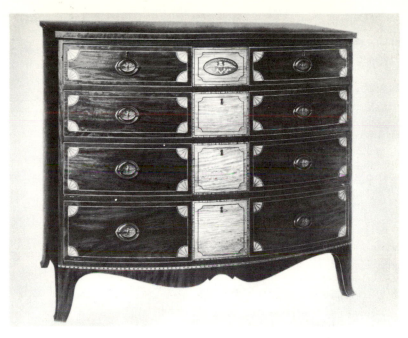

left : 242. Hepplewhite-style chair, from Salem, Mass. 1790–99. Ash, birch, and pine. Metropolitan Museum of Art, New York (Lee Fund, 1937).

right : 243. Hepplewhite-style chest of drawers, from New York. 1796–1803. Satinwood and mahogany. Private Collection.

Federal-style Furniture

The furniture produced in America in the period between the Revolutionary War and 1810, inspired most directly by the designs of Hepplewhite and the early designs of Sheraton, is much lighter in weight than the preceding Georgian. A Sheraton-style chair (Fig. 240) of the turn of the century illustrates the characteristics of the period. Parts tend to be slender, at times even spindly, and the decorative enhancements are few and delicate in scale, thereby contributing to an effect of great refinement and elegance. Rectangular contours are most characteristic, with vertical supports and horizontal lines dominant, although curvilinear elements are retained in certain areas. The manner in which curved lines are combined with straight can be seen in the graceful armrests and ends of a Sheraton-style sofa (Fig. 241) from around 1805, as well as in the shield-shaped back and shaped seat of a Hepplewhite-style chair (Fig. 242) from the end of the eighteenth century. Restraint and a touch of formality replace the vigor of Georgian furniture. Diminutive inlay patterns, marquetry, and painted decorations augment the fine-scale carving which was preferred to the heavy sculptured decorations of the earlier style. Reeding and simple turnings reappear. These elements contribute to. the smooth continuity of line that was desired by the classic-revival designers. Classical decorative motifs prevail; carved urns and swags can be seen on the Hepplewhite-style chair, although Hepplewhite and, to a lesser degree, Sheraton also used other designs—the three-feathered crest of the Prince of Wales, wheat, ribbons, and formal garlands of leaves and flowers. In America patriotic motifs were popular.

A chest of drawers (Fig. 243) in the Hepplewhite manner, made between 1796 and 1803, effectively demonstrates the combination of straight lines and fluid, simple curves that gives the Hepplewhite designs their particular charm. The essentially rectangular profile of the chest is relieved by the swelling front and the curve of the blocked legs, which flow gracefully into the apron. This mahogany chest also shows the use of satinwood inlays, the delicate scale of the detail, and the fondness for patriotic emblems which characterized the period here. The American eagle decorates the top drawer, and the brass pulls are enriched with an eagle motif. The furniture in the Derby House, the Duncan Phyfe Room, and Montmorenci displays the slender grace and formal elegance so characteristic of the style. Of particular beauty are the chairs, settees, and tables in the Montmorenci hall, which are attributed to John Seymour of Boston and his son Thomas. The work of these two men is unmatched for its delicacy of form and exquisite inlay.

below: 244. DUNCAN PHYFE. Lyre-back side chair. 1805–15. Mahogany. Henry Francis du Pont Winterthur Museum, Winterthur, Del.

bottom: 245. DUNCAN PHYFE WORKSHOP (?) Empire-style sofa. c. 1815. Metropolitan Museum of Art, New York (gift of Mrs. Bayard Verplanck, 1940).

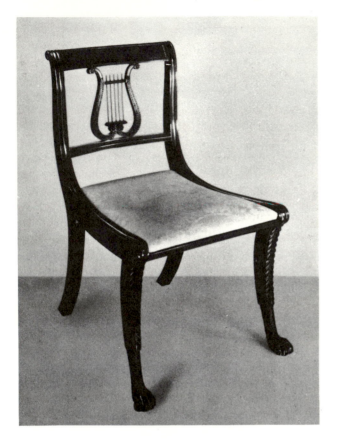

Empire Furniture

In the second and third decades of the century fashionable American furniture designers adopted elements of the Empire style in response to a general wave of enthusiasm for the new fashion. While certain designers such as Duncan Phyfe showed remarkable taste in handling elements of the Empire style, lesser talents lost the grace of the early classic revival and gave way to a Greco-Egyptian solidity and a mistaken archeological exactitude. Roman, Greek, and Egyptian chairs, tables, and benches were copied or adapted to nineteenth-century needs. For those articles which had no precedent in the ancient world, archeological enthusiasm devised substitutes; bookcases were designed to suggest temple façades, couches were made like Roman beds, and console tables were inspired by ancient altars. At its best the Empire style is distinguished by continuity of line and a massive simplicity. Its least attractive aspects display pretentious combinations of shiny wood, graining, gilding, metal mounts and marble, grotesque decorations involving human, animal, bird, and related forms, and ponderous, often awkward shapes.

Duncan Phyfe

Duncan Phyfe (1768–1854), America's most distinguished cabinetmaker, worked in a sequence of classic-revival styles. His best-known work was based on the English Regency style, often as interpreted by Sheraton, but he also adapted the Empire mode to American tastes with such success that his name is almost synonymous with the American Empire style. Duncan Phyfe arrived in New

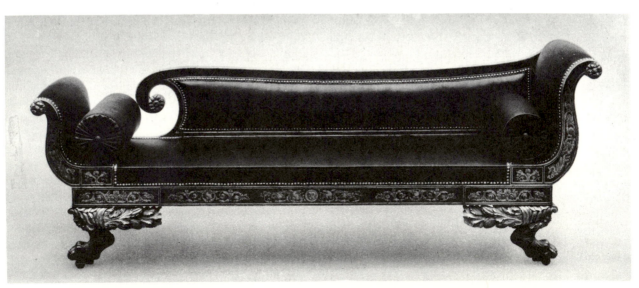

York City from Albany about 1795 and from that time until his death produced furniture of exquisite workmanship and design. A fine example of his early furniture is the Sheraton-style sofa (Fig. 241), in which the subtly used straight lines, curves, and delicate flutings produce an effect of rare elegance.

During his first thirty years in New York City Phyfe produced a tremendous quantity of furniture based on Sheraton designs and French Directoire models, which he interpreted with unsurpassed beauty and refinement. The furniture in the Duncan Phyfe Room (Fig. 238) provides exquisite examples of this, his most popular manner. The pieces combine lightness of scale and grace of form and movement with surprising comfort and strength. Some of his favorite motifs are exemplified in the pedestal-based table with splayed tripod legs enhanced with fine-scale carved acanthus patterns. Typical also are the chair backs, low and gently curved, with slender diagonal cross braces.

Another characteristic Duncan Phyfe piece is the lyre-back chair (Fig. 244), with its typical incurved front legs joining the side rails and the backposts in one flowing movement. A sofa in the Empire style (Fig. 245), attributed to Phyfe's workshop, provides an interesting contrast with the early Sheraton-style sofa. The proportions are heavier throughout the later work, most noticeably in the framing and the legs. Straight lines and gentle curves characterize the earlier model, whereas the Empire sofa is dominated by the long, sweeping curve of the back and the active reversed curves at the sides. Gilded ornamentation, bold metal mounts, and claw feet, combined with bits of naturalistic carving, replace the simple reeding, turning, and delicate carving of the earlier style. Stunning as a design, this awesome piece of furniture seems far

beyond the mundane uses of a household. After 1830 the heavier and more ostentatious aspects of the Empire mode marred much of Phyfe's production. His early work was done in mahogany, but in later years he also used much rosewood.

The character of late Empire furniture, particularly as it developed in cosmopolitan New York, is well exemplified in a center table from the third decade of the century (Fig. 246). Made of mahogany grained to imitate rosewood, it exhibits typical late Empire details in the smooth column-supports, heavy platform base, and leaf-bracketed paw-feet. Also typical are the stenciled gilt decorations, which in America were frequently substituted for the ormolu mounts so popular in France.

Not all the furniture manufactured in the Empire style was designed for grand mansions. A chair (Fig. 247) from about 1822 shows the character of Empire design translated into a more modest vein. The broad, flat back rail and central splat retain the formality and weight of the grander pieces, but the smooth unornamented surfaces contribute an effect of dignified simplicity. This is augmented by the continuous flow of line that moves from the back supports down through the side rail into the front

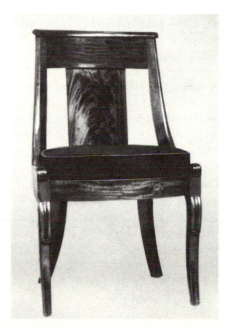

left : 246. Late Empire table, from New York. 1830s. Mahogany. Cooper-Hewitt Museum, Smithsonian Institution, New York.

above : 247. Empire-style chair. c. 1822. Mahogany. Metropolitan Museum of Art, New York (Rogers Fund, 1926).

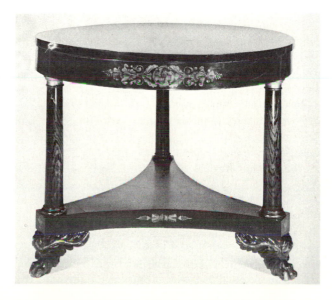

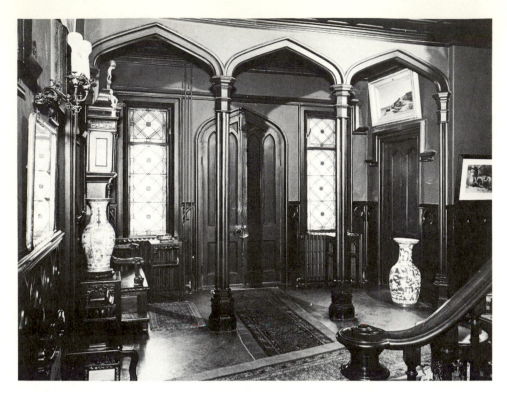

248. RICHARD UPJOHN. Entry hall, Kingscote, Newport, R.I. 1839.

legs to create a remarkably unified design. Stripped of its load of pompous ornament, Empire furniture often had a sober elegance and distinction.

A further glance at the Red Room of the White House (Pl. 7) will round out the picture of Empire-style furniture. Much of the striking furniture in this room is attributed to Charles Honoré Lannuier, a French emigré cabinetmaker who worked in New York between 1805 and 1819 and specialized in high-style furniture. Many Empire devices can be seen here: metal mounts and gilded enrichments, winged figures serving as caryatids, clawed animal feet, and stenciled gilt decorations. The sofa reveals the long flowing lines ending in a scroll, as well as the typical outcurved legs so characteristic of Empire design. Striking though the *décor* of the room may be, the mingling of naturalistic and conventionalized motifs, the sometimes awkward combinations of form, and the tendency toward display all foreshadow the decline of taste evident in furniture after the middle of the century.

THE GOTHIC REVIVAL

By 1850 interior and furniture design also reflected the increased popularity of the Gothic, Tuscan, and other styles. Gothic architectural details similar to those used on the exteriors of the buildings appeared in interiors. Wooden paneling reappeared on the walls of living rooms,

libraries, and dining rooms, frequently ornamented with linen-fold carving or with trefoils, quatrefoils, pointed arches, and other Gothic motifs. Windows became tall and narrow and were filled with colored glass and traceries. The curious mid-nineteenth-century translation of Gothic detail into an elaborate wooden pattern of brackets, vaults, and pendants reached its most astonishing development in the elaborate steamboats which served as pleasure palaces on the rivers of America in the decade before the Civil War.

The entry hall at Kingscote (Fig. 248), Upjohn's previously mentioned Gothic Revival mansion in Newport, R.I., reveals the change in mood. A general vertical emphasis is created by the narrow windows. Wooden paneling and moldings divide the wall into numerous parts. Geometrically patterned colored glass replaces the clear, large-paned windows of the classic revival. A cozy darkness predominates, suggesting a cloistered study or some dimly lit small chapel.

The Gothic Revival had less influence on furniture design than on architecture. Because there had been almost no household furniture used in the Middle Ages, there was little authentic Gothic furniture to copy, except for altars and choir stalls. Linen-fold patterns, pointed arches, trefoils, and quatrefoils were grafted onto standard furniture shapes when Gothic effects were desired. Crockets and finials often surmounted such pieces to provide the

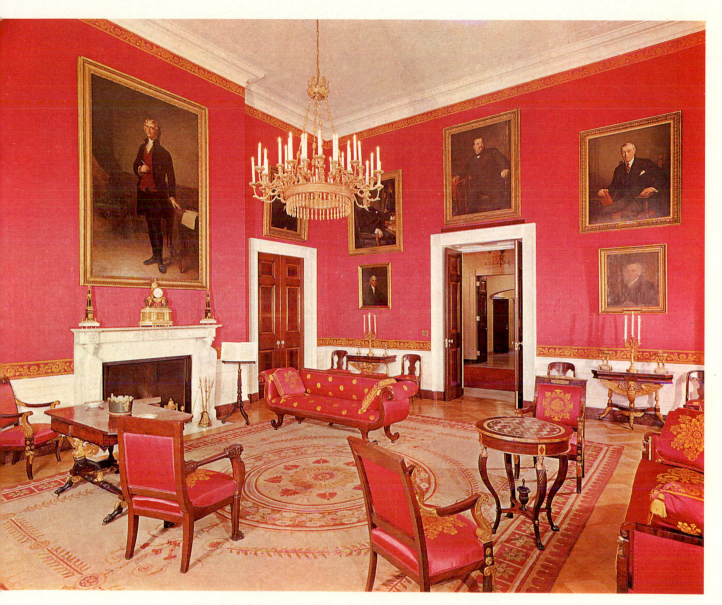

Plate 7. Red Room, the White House, Washington, D.C. c. 1814.

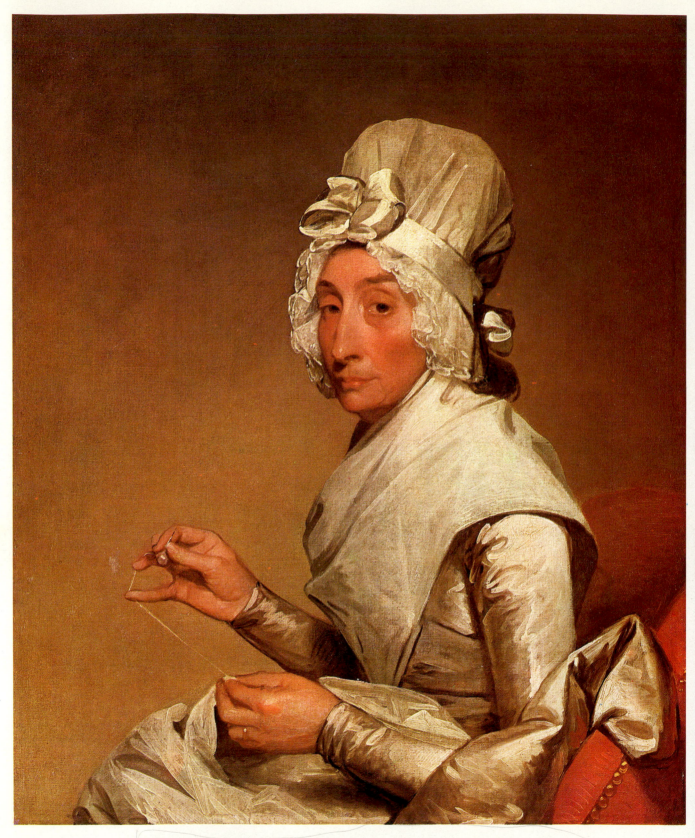

Plate 8. GILBERT STUART. *Mrs. Richard Yates.* c. 1793. Oil on canvas, 30 ¼ × 25″.
National Gallery of Art, Washington, D.C. (Andrew Mellon Collection).

proper aspiring line. A chair from mid-century (Fig. 249), with a high, narrow profile, is topped by typical detail derived from medieval Gothic tracery. The disk turning so freely used on the legs and backposts, while hardly Gothic, derives from the medieval handicraft tradition of the guild system. This is significant, for the chief impact of the Gothic Revival on furniture design was indirect; it was largely the interest in the Middle Ages that stimulated Charles Eastlake and William Morris to attempt to combat machine developments through their revival of medieval handicraft practices later in the century.

THE ROCOCO REVIVAL

While the Gothic Revival and the Tuscan villa styles were popular for the designing of exteriors of buildings, the dominant mode after the Empire style in interior and furniture design was the French Rococo, that aristocratic mode which received its most exquisite development in France during the reign of Louis XV. The Milligan Parlor (Fig. 250), from Saratoga, N.Y., provides an unusually pure example of the Victorian Rococo which, though it reached its peak in the fifties and sixties, enjoyed a much longer period of popularity. In keeping with the spirit of the Rococo, curvilinear rhythms dominate the room. Graceful, flowing lines appear in the rugs, draperies, ceiling, and fireplace, as well as in the furniture, mirrors, pictures, and bric-a-brac. Reinforcing the curved lines to produce the desired effect of elegance is the sheen of smooth textures—satin, damask, gilt, varnished woods, polished marble, porcelain, and crystal. Brocades and embroideries further enrich the shining surfaces. Though the Milligan Parlor has plain walls, in many homes walls were covered with ornamental papers or rich damasks.

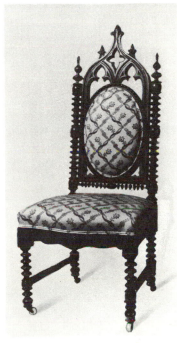

above : 249. Gothic Revival chair. c. 1850. Collection Laura Hofstadter, Stanford, Calif.

right : 250. Milligan Parlor, from Saratoga, N.Y. Mid-19th century. Brooklyn Museum.

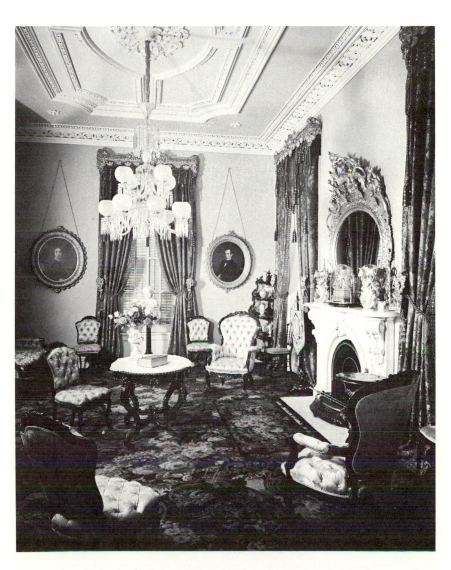

Color was as omnipresent as pattern. An author of the day advised on the color scheme for a drawing room: "The color of a drawing room should be more gay than grave, hence the predominating colors should be rather light and delicate with a considerable proportion of gilding." In practice this turned into a preference for bright, even sharp, colors. Rose, blue, green, and gold competed with the rich colors of the highly finished woods, with cream, white, and multicolored marble, and with the gilt of mirror frames, picture frames, and bric-à-brac. Rococo motifs dominate the Milligan Parlor, but most designers did not confine themselves to one style. Even here the molded stucco ceiling appears to be of Baroque inspiration. Whatever the source of inspiration, the final effect is Victorian in essence—fussy and nervous rather than in the airy spirit of the original Rococo. The eighteenth-century Rococo interior had appeared spacious, even when an effect of intimacy and informality was desired. The Victorian interior always appeared crowded, no matter what its size, because too many forms and patterns were introduced into the room.

The Milligan Parlor provides good examples of Victorian Rococo furniture. In contrast to the eighteenth-century French Rococo, which tended to be low and compact in contour, the Victorian furniture (particularly the chairs) displayed the general tendency toward a high, narrow profile. The frames for upholstered pieces were thin, the legs long and narrow, and the backs of chairs heightened through the desire to create an impressive effect. The cabriole leg, the distinguishing mark of eighteenth-century Rococo, here appears stringier and inadequate, lacking the variations in width that gave the originals a feeling of organic strength. Also, the excessive ornamental carvings seem applied, instead of being an outgrowth of the sinuous movements of the forms on which they appear. Tables, chests, and dressers frequently were topped with gray or white marble. Mahogany continued in favor, but rosewood, walnut, and oak began to share its popularity. The woods were finished with a high polish and shiny varnishes. Satins, damasks, and horsehair cloth were valued for their high sheen. An elaborately framed mirror like that over the mantel in the Milligan room usually provided the culminating note of splendor in an interior.

John Belter

The most popular American cabinetmaker to work in the Rococo Revival manner was John Belter (1804–63). Belter's workshop in New York provided furniture for the finest homes of the fifties and sixties and established the patterns for much later Victorian Rococo furniture.

A table from his workshop (Fig. 251), like so much of Belter's furniture, is of superb craftsmanship, but careful examination reveals it to be a tour de force rather than a richly synthesized design. The legs appear almost too slender in profile, since the open strapped effect, though admirable as an example of intricate craftsmanship, weakens the visual impact of the forms. The carved ornament is too large and tends to overwhelm the main lines of movement. Finally, much of the ornamental detail of oak leaves, roses, and clusters of grapes is too naturalistic to become an organic part of the design.

The decline in taste that characterized furniture design in the decades before the Civil War was the result of a number of factors. A most important one was the development of complicated mechanical lathes for shaping wood and jig saws for cutting patterns in it. These tools encouraged elaborate decorations, and furniture makers reveled in substitutes for the older and more expensive handicrafts. Accompanying this development of new manufacturing techniques came a shift in social leadership. A new elite, born of the unprecedented opportunities that accompanied the economic and geographic expansion of the age, began to dominate both the settled eastern communities and the frontiers of the West. Social and economic power went to the cunning and the strong. The cultured gentlefolk of the eighteenth century and their standards of taste were lost in a flood of change. Handicraft production for a small clientele with cultivated tastes gave way to machine production for large numbers of unsophisticated people who preferred pretentious elaboration to refinement of detail and proportion. Taste characterized the finest designs of the earlier period; ingenuity, the best of the ensuing age. Many years were to pass before elegance and fine craftsmanship would again typify distinguished furniture.

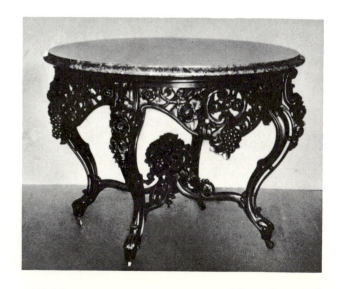

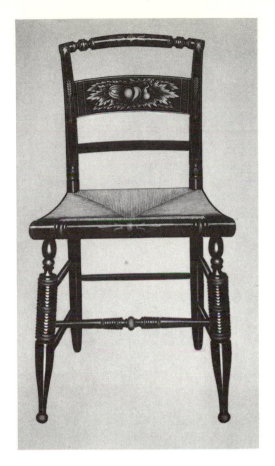

DIVERGENT TRENDS

A native development of considerable charm is seen in the side chairs made by a number of companies but most notably by Hitchcock, Alford & Company of Riverton, Conn., and therefore usually called "Hitchcock chairs." These were inexpensive factory-made chairs based on Sheraton designs, with machine turnings and joinery replacing the more subtle molded shapes and the carved ornaments of the chairs made by fine cabinetmakers. The typical Hitchcock chair (Fig. 252) was painted black and ornamented with bands, striping, and stenciled floral and geometric decorations applied in gilt, bronze, and color. Hitchcock chairs and the popular Boston rockers, in which a high back was topped by a broad, flat splat and the legs were set into rockers, were designed for mass production. The parts, made separately, were easy to assemble; the machine turnings and stenciled decorations could be applied by inexperienced workmen.

While the furniture and household wares designed for the dominant aristocracy of wealth each day became more elaborate and cumbersome, the Pennsylvania Germans continued to make their gaily decorated household furnishings, and certain dissident religious groups and Utopian communities developed their own simple and functional furniture and household equipment. The furniture, both free-standing and built-in, that graced the Shaker interiors (Fig. 253) is most noteworthy. For the

opposite : 251. JOHN BELTER. Table. Mid-19th century. Rosewood. Museum of the City of New York.

above : 252. Hitchcock chair. 1830–40. Painted wood with rush seat. Private collection.

right : 253. Shaker Dwelling Room, from Enfield, N.H. c. 1840. Henry Francis du Pont Winterthur Museum, Winterthur, Del.

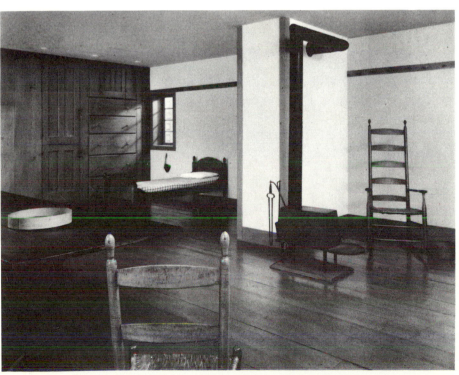

most part the Shakers retained simple eighteenth-century forms. That which had been tried and proved serviceable was duplicated with little change. Simple trestle tables, ladder-back chairs, and various types of chests constituted the chief items of manufacture. The Shakers retained many traditional pieces of furniture, but much ingenuity went into increasing the comfort and efficiency of these familiar household items. Comfort and cheerfulness were not frowned on, though luxury was.

The rocking chair, which was supposedly a Shaker invention, was actually a modification of the older splat-backed chair designed for increased comfort. Like all Shaker furniture, the rocker in this room reveals its structure in a straightforward manner; a glance shows how it was put together. Its charm is the result of the sensible and orderly relationship of the necessary parts, the quietly modulated shapes of spindles, splats, and rockers, and the fine and unhurried craftsmanship.

The Shakers were not averse to a gracious form although they decried elaboration for its own sake. "Put your hands to work and your hearts to God"—from this basic philosophy came the direct shapes that functioned so well, the beauty that was synonymous with utility, the conviction that superfluous ornament was conducive only to vanity. Nowhere are the results more clearly revealed than in the corner of the room, where efficiency is evident in every beautifully crafted detail. The orderly, built-in wall chest and closet, the wide, flat mop board, pegged coat rack, and simple bed create an air of sensible serenity. The sparse, honest, clean shape of the stove, like so much of Shaker manufacture, foreshadows the direct clarity of twentieth-century functional design. Its simplicity contrasts strongly with the misplaced decoration that disfigured most early mass-produced cast iron.

Almost no furniture of American manufacture has come down to us from the French settlers. The trappers and traders rarely established a sufficiently settled mode of life to necessitate much in the way of household furnishings, and the plantation owners imported furniture for their handsome houses from Europe. The Spanish also imported many of their fine wares from Mexico and Spain, but in the mission communities the Indian neophytes were trained in all the crafts necessary for civilized living—potting, blacksmithing, stonecutting, carpentering, cabinetmaking. The furniture made in the mission communities, like Renaissance furniture, was simple, sturdy, and of rectangular construction. If it were decorated, the decorations were carved in shallow, flat-relief patterns that recalled the ornamented silver of Renaissance Spain. Thus the more elaborate furniture in this style is sometimes termed "plateresque," from *plata*, the Spanish word for silver. The chief importance of the furniture made in the mission communities was that its simple, rectangular form and boardlike members established the prototype, or at least provided the name, for the craftsman-style furniture termed "mission" of the early twentieth century.

THE HOUSEHOLD ARTS
Silver

The making of fine silver remained in the hands of individual workmen through most of the nineteenth century, and the high standard of craftsmanship that distinguished the earlier silver was maintained, despite changing tastes. The shift from Baroque and Rococo designs to the classic-revival manner was clearly reflected in both the shapes of individual pieces and the typical decorative motifs. A sugar bowl and creamer (Fig. 254) by Paul Revere reveal many characteristics common to the furniture and architecture of the Federal style. The individual pieces are taller and more slender than theretofore, and some parts, such as the handle of the creamer, are very attenuated. Chaste forms and restrained curves were preferred to the complex Rococo shapes. The urn of classic antiquity became a source of continued inspiration. Urn shapes and the lines of Greek vases were adapted to coffeepots, teapots, creamers, and sugar bowls, and small urns were used as finials on the domed covers for tureens, teapots, and coffeepots. Urn-shaped vessels frequently had square bases. The straight sides, the fine scale of the engraved designs, and the logical placement of the bands of decoration also reveal the rational tone of classicism, as opposed to the whimsical Rococo.

Paul Revere (1735–1818), famous as a patriot, was one of America's finest silversmiths. He commenced his career when he took over his father's shop at the age of nineteen. His ability as a silversmith was equaled by his versatility and ambition, for he was also one of the first manufacturers of brass in America and was active politically.

While New England taste in silver tended to remain conservative, New York and Philadelphia enjoyed a vigorous expression of the later classic-revival tendencies. A teapot (Fig. 255) made by William Heyer, one of many fine silversmiths who worked in New York in the first half of the nineteenth century, reflects the turn toward heavier proportions and bolder curves. The oval base resting on ball feet, the full forms of the bowl and lid, and the weighty finial all suggest that the turn-of-the-century simplicity was giving way to formality and artifice.

A sugar bowl (Fig. 256) made in Philadelphia illustrates the adoption of more florid forms during the third or fourth decade of the century. The decorations on the

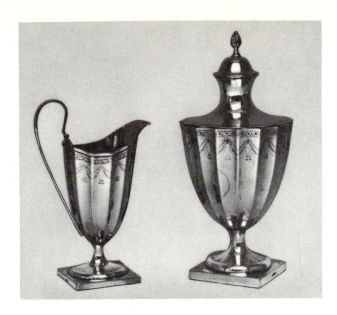

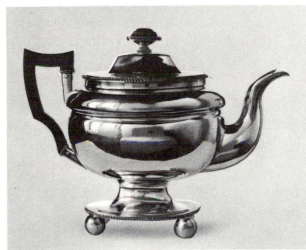

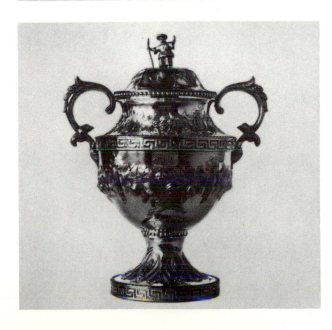

basic urn shape strike a pretentious, even pompous, note. Such traditional Empire motifs as the Greek key and the conventionalized acanthus leaves are combined with stylistically unsuitable details—for example, the naturalistic garlands of fruit and flowers which encircle the body of the bowl and the shepherd which tops the cover. Though a high level of technical skill is evident, this striving for effect by combining a multitude of decorative devices suggests that in silver also the great eighteenth-century tradition of restraint gave way to a desire for ostentatious elaboration.

Ceramics

Although fine porcelain had been produced in Philadelphia as early as the 1830s, the sustained production of such wares seemed beyond the capacity of American manufacturers. The wealthy imported porcelain to furnish and decorate their homes, and native ceramics reflected the tastes of the growing mass markets, rather than the high styles which characterized American fine furniture and silver articles.

Lead-glazed redware, slip-decorated pottery, and the sturdy gray and brown stonewares continued to be the staple output of most American nineteenth-century potters. One of the largest centers of pottery manufacture was Bennington, Vt., where a fine deposit of clay encouraged the production of many popular decorative ceramics, notably the Rockingham and Parian types of ware, both eventually fabricated in various centers.

Rockingham wares were all-purpose nineteenth-century ceramics made from a fine, cream-colored clay which, in its plastic state, could be easily and quickly pressed into molds. It could thus be fashioned by modern factory methods, thereby eliminating the laborious use of the potter's wheel. Pottery manufactured in molds was thin, light, and attractive. All types of table and kitchen wares, as well as finely modeled ornamental pieces in both low and high relief were manufactured in quantity. Rockingham wares were glazed with a mottled, shiny glaze, which varied from dark, almost blackish, brown, to light cream and tan tones, giving a tortoise-shell effect.

top : 254. PAUL REVERE. Creamer and sugar bowl. 1770–1810. Silver, height of bowl 9 ¼". Metropolitan Museum of Art, New York (bequest of A. T. Clearwater, 1933).

center : 255. WILLIAM HEYER. Teapot. 1798–1827. Silver, height 8 ¾". Metropolitan Museum of Art, New York (bequest of A. T. Clearwater, 1933).

left : 256. ROBERT and WILLIAM WILSON. Sugar bowl, from Philadelphia. 1825–46. Metropolitan Museum of Art, New York (bequest of A. T. Clearwater, 1933).

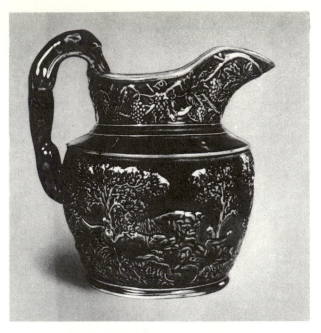

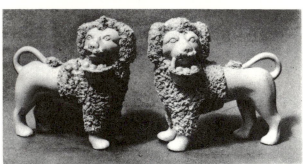

Among the favorite items were the hound-handled pitchers (Fig. 257). The pitcher shown here combines the characteristic hound handle, a bas-relief hunting scene, and the typical grape and grapeleaf motif. The pitcher is sturdy, and its mélange of naturalistic decorative designs reflects the popular tastes of the time.

Parian ware was one of the most noteworthy developments in decorative ceramics at Bennington. An unglazed porcelain named for its lovely surface texture which suggests Parian marble, this type of ware originated in England. It was usually white or cream-colored, but vases, pitchers, and figurines were also produced in blue, buff, and green. A pair of amusing poodle dogs (Fig. 258) have a combination of sentimental charm, humor, and decorative effectiveness. The clever way in which the textures are delineated—smooth surfaces, crinkled fur, and woven basket—exploits the beautiful mat surface of the clay.

top : 257. Hound-handled pitcher, American Pottery Company, Jersey City, N.J. 1840–45. Rockingham glazed earthenware, height 10 ¼". Brooklyn Museum.

left : 258. Poodles. Mid-19th century. Unglazed white Parian ware, height 8 ½". Metropolitan Museum of Art, New York (gift of Dr. Charles W. Green, 1948).

below left : 259. South Jersey type of pitcher. Early 19th century. Blown glass with threading and lily-pad overlay. Yale University Art Gallery, New Haven, Conn. (Mabel Brady Garvan Collection).

below right : 260. Stiegel-type sugar bowl, S. Sheppard & Company, Zanesville, Ohio. 1815–45. Expanded mold-formed green glass. Yale University Art Gallery, New Haven, Conn. (Mabel Brady Garvan Collection).

Glass

Two basic types of glass appeared in America in the early nineteenth century. One, which derived its decorative values from effects that grow naturally out of the blowing process, has been termed "South Jersey-type glass." The other, in which patterns imprinted on the molten glass by a mold are expanded in blowing, is termed "Stiegel-type glass." After the demise in the late eighteenth century of Caspar Wistar's New Jersey factory, his employees settled throughout New Jersey, New York, and New England. These men maintained the South Jersey tradition of allowing individual workmen to make hand-blown pieces from the tag ends of molten glass prepared for manufacturing windows and bottles. Such pieces, made at the blower's pleasure, vary greatly in shape. The typical decorative effects can be seen in an early nineteenth-century pitcher (Fig. 259). The generally sturdy proportions, the lily pad decorations superimposed in a heavy swirl of glass over the body of the pitcher, the crimped, applied foot, and the threaded neck are common to the pitchers, bowls, and bottles produced in these factories.

"Baron" Stiegel's factory had been set up to manufacture bottles and fine glassware for the table and for decorative purposes. With this in mind, Stiegel imported workmen trained in the fine glass factories of England. When his enterprises dissolved, many of his former workmen went west to Pittsburgh and Ohio. A green, swirled sugar bowl (Fig. 260) reveals the complexity and refinement of form and color found in the Stiegel type mold-formed glass. Such glass was shaped while molten in a mold incised with ribbings, flutings, and diamond-shaped patterns. The glass was then expanded by blowing, and subsequent twisting, turning, and other manipulations produced the desired shapes and surface textures.

The most distinctive development in American glass-making came about 1820, with the invention of the full-sized, three-piece mold, which enabled American manufacturers to meet the competition of European cut glass at a much lower price. Hot glass was blown into a mold in which designs were engraved. As the mold was closed, air pressure forced the glass into the patterns and shape of the mold (Fig. 261). The patterns on blown-mold glass are not so sharply defined as those on the pressed glass which came later, but because both the inner and outer surfaces of the glass are faceted, blown-mold glass reflects the light with great sparkle and brilliance. Blown-mold glass was occasionaly fashioned with two- or four-piece molds, but the three-piece molds were most common.

In the late 1820s machines were invented for pressing glass into molds by means of mechanical power. The resultant designs are sharp-edged and clear, as distinguished from the softer and more fluid patterns of the blown-mold process. The most popular pressed glass in the first half of the century was the distinctive "lacy" glass (Fig. 262), which at first imitated hand-cut glass but rapidly acquired a character of its own, with fine textures replacing the clearly defined patterns of wheel-cut glass.

Many American companies produced pressed glass, lacy and otherwise, the most famous being the Boston and Sandwich Glass Company of Sandwich, Mass., which made fine glass from 1825 to 1888. The fame of this

left: 261. Pitcher. 1810–50. Blown-mold glass from three-piece mold, height 4 ½". Metropolitan Museum of Art, New York (Rogers Fund, 1910).

above: 262. Compote. 19th century. Pressed lacy glass, diameter 8 ½". Metropolitan Museum of Art, New York (gift of Mrs. Charles W. Green, 1951).

company is such that all nineteenth-century pressed glass has often been called "Sandwich glass," irrespective of its place of origin.

Textiles

The early years of the Republic witnessed the full flowering of hand weaving, but in the 1780s the automatic loom was patented in England, and the machine-powered automatic loom followed soon after. The first Jacquard loom was set up in Philadelphia in 1826, and the day of machine weaving in America had begun.

Hand weaving persisted side by side with the new industrial developments for a time, but the machine rapidly replaced the home weaver except in a few very poor and isolated communities such as those in the mountains of Kentucky and Tennessee, where weaving remained traditional into the early twentieth century.

A linen double-cloth coverlet (Fig. 263) was handwoven in the first half of the nineteenth century. Geometric patterns of this type, characteristic of the eighteenth century, continued to be popular in the frontier communities. This pattern, called "Nine Snowballs with Pine Tree Border," is vigorous, crisp, and clear, with its

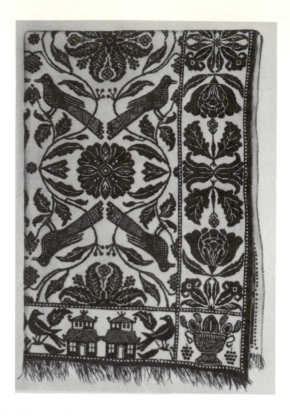

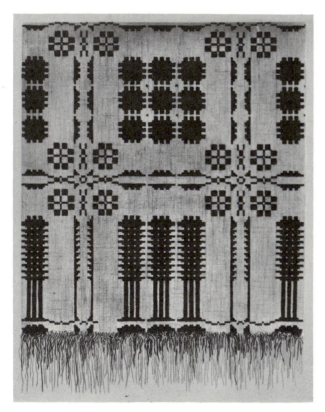

263. Double-cloth coverlet, from Indiana. Early 19th century. Linen, 8′ × 8′8″. Private collection.

straight lines and rectangular shapes deriving naturally from the weaving process. There is a pleasing variety in the sizes and shapes, so that, though the effect is direct and uncomplicated, it is neither dull nor lacking in interest. The pattern shows blue against white on one side and white against blue on the other because of the double weaving, a technique that flourished in the early years of the century. The spread shown here is all linen, but usually in double cloth colored wool was combined with white cotton or linen. With the introduction of the Jacquard looms the simple geometric patterns dropped from popularity. A detail from a woven coverlet (Fig. 264) of the mid-nineteenth century reveals the complicated leaf, flower, and bird patterns in flowing lines and interlacing rhythms that became popular in Jacquard weaves.

As hand weaving disappeared, the housewives of America poured their enthusiasm for needlework into the making of elaborate appliqué and pieced quilts. An appliqué quilt (Fig. 265) from Virginia combines a number of characteristic motifs in a charming manner. An American eagle and stars form a medallion of patriotic emblems in the center. Above are the initials of the maker and below the date of completion. A striking border of oak leaves frames the more delicate central motifs. The quilting stitches outline a lovely leaf and star pattern, and the small-scale patterns of the appliquéd calico contribute to the total effect. In some quilts extra cotton was stuffed

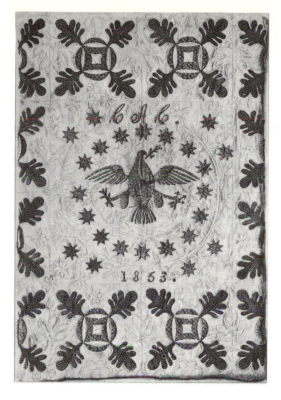

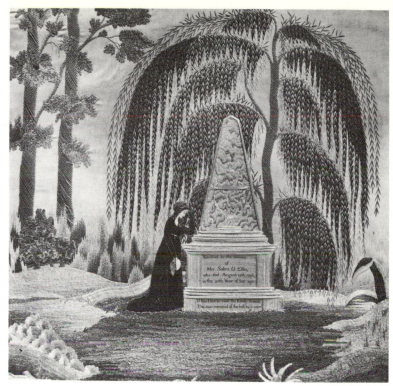

opposite above : 264. Jacquard-weave coverlet (detail) from Crawfordsville, Ind. c. 1850. Blue wool and unbleached cotton, full size 7' 9" × 5' 4". Private collection.

above left : 265. Appliqué quilt, from Virginia. 1853. Cotton, 6' 7" × 7'. Private collection.

above right : 266. Mourning picture. 1808. Embroidery, 20 ½ × 21 ½". Museum of Art, Rhode Island School of Design, Providence.

into the more important areas to build them up in relief, thereby creating textiles of unusual sculptural richness.

Candlewick bedspreads were also popular. To make the candlewick patterns, threads were worked over a roll to form looped knots, which were left uncut or cut, depending on the texture desired.

Pride of stitchery was great among nineteenth-century housewives, and though most of them found an adequate outlet for their skills in embroidering pillows, furniture covers, and samplers, a few ambitious individuals devoted their talents to elaborate needlework pictures. Mourning pictures enshrining the memory of loved ones were among the favorite subjects. A mourning picture (Fig. 266) from the first decade of the nineteenth century, embroidered on silk in colored yarn, displays an astonishing variety of stitches, a nice sense of design, and an unusual ability to express genuine sentiment in what to our day appears to be a medium somewhat unsuited to such sober purposes.

In the period following the Declaration of Independence, interiors, furniture, silver, and other fashionable articles designed for the home reflected the influence of the classic revival. Between 1790 and 1810 this influence expressed itself in a preference for straight lines, light, clean surfaces, fine-scaled details, and an orderly and logical disposition of parts. Such typical classic motifs as swags, urns, and garlands replaced the whimsical and fanciful Rococo forms, and slender and attenuated parts were preferred to the heavier proportions of the Georgian style. Starting about 1810 there was a turn to massive, even pompous, effects. Broad, flat moldings, the use of imposing architectural details on furniture and *objets d'art,* and bold, sweeping reverse curves were typical of the grandiose, ornamental elements that characterized the Empire style.

The Empire style was followed by a succession of revivals, but by mid-century the disintegration of the older handicraft tradition was becoming apparent. Furniture design and the traditional crafts showed the effects of industrialization. The beauty of line and graceful proportions which had distinguished fine furniture at the turn of the century gave way to endless elaboration. Much of the new purchasing public came from social elements with little background in the arts, and textiles, glass, ceramics, and metalware were frequently elaborated to the point of vulgarity.

10

The London School, Portraiture, and Historical Painting

The Revolutionary War ended the period in American painting when the untrained or partially trained artist was typical. Thereafter an increasing number of artists revealed an intimate knowledge of the mature tradition of painting in Europe. Hands trained in the established academies and minds refined by contact with great works of art took over the leadership. London became the center where most young American artists chose to study in the later years of the eighteenth century and the early part of the nineteenth, and "the London school" is the term that most conveniently describes the many painters who studied there and then returned to pursue their careers at home. One of these Americans, Benjamin West, never returned home, but it was his success and fame, more than any other factor, that made London the lodestar. No single individual contributed more to the increased technical and esthetic sophistication of American artists in the early years of the Republic than Benjamin West.

THE LONDON SCHOOL

Benjamin West

Benjamin West (1738–1820) was born in Philadelphia and in his youth applied himself energetically to the develop-

ment of his talents, modeling himself after the older painters in the Philadelphia area. His youthful efforts were sufficiently successful that when he was just twenty-one, assisted financially by a benign patron, he was able to go abroad for study. West went to Rome, the first American painter to do so, where he studied for three years. En route home, he stopped in London for a brief stay, never to return to America. He not only became historical painter to King George III but was President of the Royal Academy for nearly thirty years.

Despite the fact that West is an American painter only by the fact of birth, his influence on the emerging American school was tremendous. Copley, Charles Willson Peale, John Trumbull, Gilbert Stuart, Ralph Earl, Washington Allston, Samuel Morse, and many less significant painters in the early years of the Republic, drawn to England by West's reputation, were befriended, helped, and given artistic direction by their eminent compatriot. It was through West's influence that, first, the classic-revival manner, particularly as it was employed in grand historical paintings, and, later, the more Romantic treatment of historical and literary themes became part of the American heritage.

When Benjamin West arrived in Italy, the classic revival was in the air. Neoclassic painting had a number of

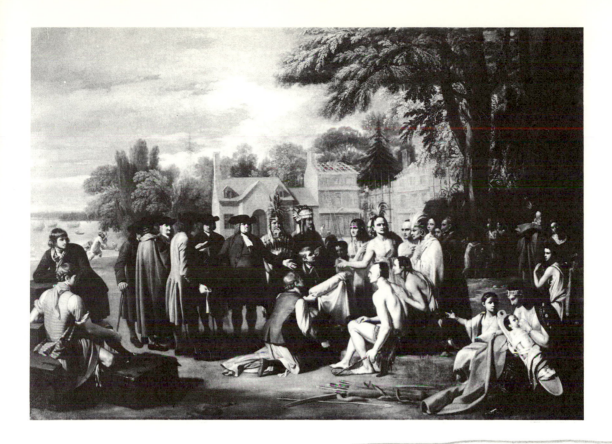

above : 267. BENJAMIN WEST. *Penn's Treaty with the Indians.* 1771. Oil on canvas, 6′ 3 ½″ × 9′ ¾″. Pennsylvania Academy of the Fine Arts, Philadelphia.

specific precepts, most of which were closely related to the characteristics of classic-revival architecture and household arts. Since the classicists held rationalism as an ideal, they proceeded in a rational way to create a style which would summarize and combine the finest from the past. The sculptural forms of Greece and Rome; the lucid and considered compositional devices of the High Renaissance, particularly of Raphael and the Venetians; and, later, Poussin provided the principal stylistic sources. Themes were drawn from history, both classical and contemporary, were of a didactic nature, and usually emphasized some heroic act. Compositions were stable; strong vertical, horizontal, and pyramidal elements were introduced to replace the sinuous curves of the Rococo. Line and form were given precedence over color. Painterly elements, like spontaneity of execution and variety of brush work, were abandoned for an enamel-like smoothness of surface.

The precepts of this school were not clearly defined at the time West arrived in Rome, but were being formulated. His paintings were among the first to embody them, preceding even those of the great French painter David, and when he arrived in London, in 1763, as a disciple of the new school, his success was immediate. He proclaimed his American heritage by including subjects from the history of the New World as well as of the Old. Both his original and subsequently influential *Death of Wolfe* and his *Penn's Treaty with the Indians* (Fig. 267) describe incidents from American history with monumental dignity and force. Size often indicates something of an artist's estimate of the importance of a painting, and *Penn's Treaty with the Indians*, over 6 by 9 feet, is one of West's largest canvases. It is particularly worth examination both as one of his most successful major works and as an example of the rational compositional concepts of the neoclassic painters.

In each of the two lower corners of the canvas a triangular group of figures carries the eye to the central group of actors. This group of principal characters forms a semicircle in the middle space of the painting, open in front and surrounding the kneeling figure displaying cloth to the Indian chief. Penn himself stands behind the kneeling figure, and both the gestures of his spreading hands and the subtle spacing of the figures around him make his figure one of the principal focal points of the composition. The background establishes the setting for the action and provides stabilizing vertical and horizontal lines. The

drawing throughout the painting is skilled and proper, textures are well simulated, the color is bright and clear, and the somewhat histrionic gestures ensure narrative clarity. Though the compositional arrangements and the groupings of the figures were traditional, West made innovations of his own. Costumes and background were drawn from life, and the choice of subject matter was unique. In its day the painting stood as a marvel of dignified and grand narrative realism.

In his later paintings West moved to a more Romantic manner, endowing his works with symbolic and literary overtones and intensifying the dramatic and atmospheric elements. His portrait of the inventor Robert Fulton (Fig. 268) heralds the portraiture of the oncoming Romantic school in the moody and contemplative pose of the inventor, whose pale face and dark eyes stand out in theatrical brilliance against the shadowy and ominous background. West's skill remains evident in the precise delineation of contours and the enamel-like smoothness of the surface. There are no ambiguities of form or space, no awkwardnesses of drawing. On the other hand, control and technical skill seem almost to inhibit the free expression of perceptions and feelings, to stiffen gestures, and to confine the eye. One is left feeling that the painter's vision could record only the outward appearances, that West could not go beneath the smooth surface to discover the character of the sitter.

Time has not dealt kindly with West. Today many of his paintings seem cold and overfinished, contrived rather than deeply felt, but his influence upon the subsequent development of painting in America, particularly upon historical painting, cannot be dismissed. Fortunately, his influence upon portraiture was minimal. The great English portrait tradition, with its brilliantly summarized forms, its dexterous, direct brush work, and its fresh color, seduced most of the young Americans, and it was this painterly tradition that was popularized in America by such skilled practitioners as Gilbert Stuart. However, before this sophisticated tradition was introduced by Stuart, other directions in portraiture were explored by the more homespun Charles Willson Peale.

PORTRAIT PAINTING

Charles Willson Peale and the Peale Family

One of the first Americans to study with West in London, and perhaps the first to return and set up shop at home, was Charles Willson Peale (1741–1827). The son of a poor Maryland school teacher, Peale set out for London in 1767. Though he spent time in West's studio and admired his impressive historical canvases, the esthetic doctrines

268. BENJAMIN WEST. *Robert Fulton*. 1806. Oil on canvas, c. 36 × 28″. New York State Historical Association, Cooperstown, N.Y.

of classicism were remote from his concerns. Equally remote from his tastes and abilities was the facile and brilliant style of such great British portrait painters as Reynolds, Gainsborough, and Romney. Instead, he showed a preference for miniatures and for a meticulously rendered realism. After two years in London Peale returned to Annapolis, worked briefly in Baltimore, then moved to Philadelphia, where he spent the rest of his life.

The story of Peale's career is essentially that of an intelligent, optimistic extrovert, full of energy and enthusiasm, who could translate his enthusiasms into concrete accomplishments. Peale's temperament seemed particularly in harmony with the evolving American culture, and his achievements form an important chapter in the annals of American art. Not only did he paint some very original genre scenes and most of the important personages of his day (his portraits of Washington and the prints he made from them were considered by many of his contemporaries to be superior to all others), but he saw active army duty during the Revolution, was the author of many inventions, organized the first museum in the United States, and fathered a large family. He stimulated his brother James to join him in his painting endeavors, and his sons, named after the great European masters, also painted and organized museums. In all, three generations of Peales contributed their talents to the artistic development of America.

Though miniatures and conventional portraits constituted the bulk of Charles Willson Peale's production, his most original and interesting works are those in which the full-length portrait figure is part of a larger composition. This development probably represents to some degree an adaptation of West's grand manner to the prosaic American temper. *The Staircase Group* (Fig. 269), the masterpiece of his earlier style, depicts his two sons, Titian Ramsay descending and Raphaelle mounting a staircase. The painting was planned to create a convincing deception, in fact was originally titled as such, and, to reinforce the simulation of an actual scene, it was first exhibited framed in a doorway with an actual stair projecting into the room at the base of the painting. The clear, precise depiction of details, the carefully rendered surface textures, the remarkable realism of the likenesses and gestures, and the skillful light and shadow create a most impressive illusion of reality. Executed for the "Columbianum Exhibition" of 1795, the first major exhibition of painting held in America, the life-sized painting was conceived to demonstrate for younger artists what a painter with thirty years of experience could do. Its success as *trompe l'œil* was proved when Washington himself, no stranger to the Peale family, on confronting the painting was reputed to have taken off his hat and bowed to it.

Peale's self-portrait in his museum (Fig. 270), painted when he was eighty-one, shows the artist lifting a curtain

left: 269. CHARLES WILLSON PEALE. *The Staircase Group.* c. 1795. Oil on canvas, 7′ 5″ × 3′ 3 ½″. Philadelphia Museum of Art (George W. Elkins Collection).

right: 270. CHARLES WILLSON PEALE. *The Artist in His Museum.* 1822. Oil on canvas, 8′ 7 ½″ × 6′ 8″. Pennsylvania Academy of the Fine Arts, Philadelphia.

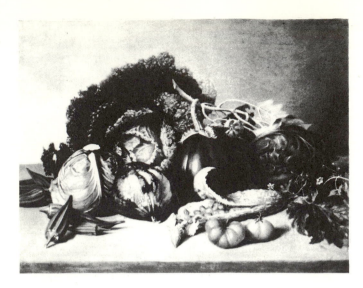

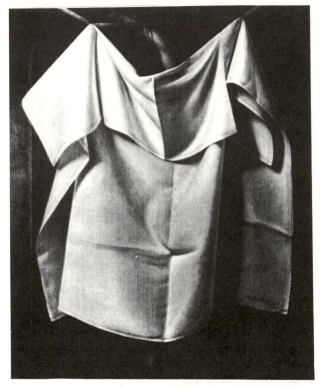

left: 271. JAMES PEALE. *Balsam Apple and Vegetables*. 1820s (?). Oil on canvas, 20 ¼ × 26 ½". Metropolitan Museum of Art, New York (Maria De Witt Jessup Fund, 1939).

below: 272. RAPHAELLE PEALE. *After the Bath*. 1823. Oil on canvas, 29 × 24". Nelson–Atkins Gallery, Kansas City, Mo. (Nelson Fund).

to display one of the great achievements of his life, the Peale Museum. In the foreground are the symbols of his accomplishments—the stuffed turkey and taxidermists' tools, the great bones of the mastodon, and the artist's palette, suggesting respectively the craftsman, the scientist, and the artist. Beyond the raised curtain can be seen the cases of stuffed birds and animals, surmounted by portraits of the great men of the American Revolution painted by the artist and his sons. The artist welcomes the spectator with a calm and inviting glance and gesture. The tone of the painting is one of quiet pride, the satisfaction of a sensible man in the considerable results of his life-time of effort. Influenced by the more painterly and atmospheric style of his much-traveled son Rembrandt, who had been exposed to both West's later style and the mature artistic traditions of France, *The Artist in His Museum* is painted in a broader manner than his earlier *Staircase Group*. The rich and full-bodied color glows, shadows are transparent and luminous, and details are kept subordinate to a richly developed sense of form. Both *The Artist in His Museum* and the handsome *Lamplight Portrait* of his brother James, painted in the same year, show that even in his last years Peale was still capable of change and growth.

The influence of Charles Willson Peale extended far beyond his immediate accomplishments. His energetic devotion to the cause of the arts helped make Philadelphia a leading center of the intellectual and artistic life of the country. Under the stimulus of his example and training, a number of members of his immediate family became painters. His brother, James Peale (1749–1831), painted miniatures and portraits in a style similar to that of Charles Willson, but James' most distinguished works were still lifes, of which *Balsam Apple and Vegetables* (Fig. 271)

is typical. The skillful rendering of the colors and surface textures of familiar objects creates a work of quiet charm.

Raphaelle Peale (1774–1825) showed a particular aptitude for still life and has been called the "father of still-life painting in America." While many of his works are similar to those of his uncle, James, a few of his still lifes are distinguished by striking illusionism, wit, and great originality. *After the Bath* (Fig. 272) is one of his freshest and most entertaining pictures. It is probably the best-known still-life painting in America, both because of the unconventional subject and because of the startling effectiveness with which it is painted. A towel hangs on a line in front of a painting of a girl, presumably nude, drying her hair. Not only does this provide an unusual and brilliant *trompe l'œil*, but it also constitutes an amusing conceit that suggests the gentle, whimsical personality of Charles Peale's talented, but not too successful son.

Another son, Rembrandt Peale (1778–1860), became a portraitist of considerable consequence. His handsome painting of *Thomas Jefferson* (Fig. 273) displays his

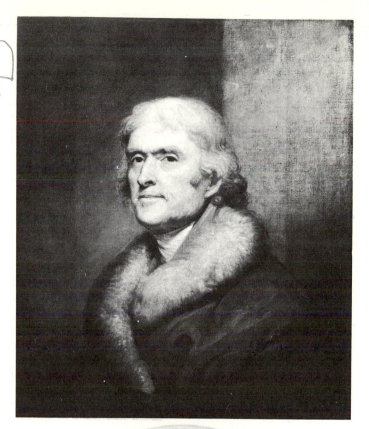

right : 273. REMBRANDT PEALE. *Thomas Jefferson.* 1805. Oil on canvas, 29 × 24″. New York Historical Society, New York.

below : 274. GILBERT STUART. *Athenaeum Portrait of George Washington.* 1796. Oil on canvas, 39 ½ × 34 ½″. Museum of Fine Arts, Boston (on loan from the Boston Athenaeum).

particular forte. The pose is quiet and the background simple, the movement of the fur collar and the turn of the head revealing the thoughtful but active man. Vibrant shadows and luminous surfaces suggest that Rembrandt Peale was aware of the emotive style of the master after whom he was named. The sensitive brush strokes that seem to describe the movement of the artist's eye over the sitter and the quiet harmony of tone create an atmosphere of poetic sentiment that is absent from the father's stalwart prose. The portrait is gentler, and the perceptions, no less acute than those of the older Peale, are presented with more grace and charm. Rembrandt Peale presaged the imminent tide of Romanticism.

Gilbert Stuart

Probably no painter has left a more indelible impression on American life than Gilbert Stuart (1755–1828). Stuart not only created the visual image of George Washington that has been imprinted on the national mind ever since, but he also painted almost every other important American during the formative years following the Revolutionary War. His first portraits, executed in Newport during his teens, caught the attention of a Scottish migrant painter who took him to Edinburgh to study. Stuart eventually spent twelve years in London, studying with West and observing the English masters and developing his own mature style. There he achieved success and honors, but his extravagant mode of living and the consequent debts finally forced him to flee. After a period in Dublin, Ireland, he returned to America, where he spent the remainder of his years in productive activity.

Gilbert Stuart painted Washington three times from life and made many copies of these originals, but the image that remains most vivid in the national memory is the unfinished version in the Boston Museum of Fine Arts, the *Athenaeum Portrait* (Fig. 274). Here is no mere record of a man's appearance; instead, Stuart created a symbol of a great leader—dignified, contemplative, and assured. This portrait reveals the artist's particular ability to see beneath the gesture and expression of the moment to the basic physical structure and the fundamental character of the sitter. The form is built solidly by means of the most subtle modeling. The paint is applied with a direct certainty to reveal the sculpture of the skull, the strong jaw, the clear, thoughtful eye, and the firm mouth.

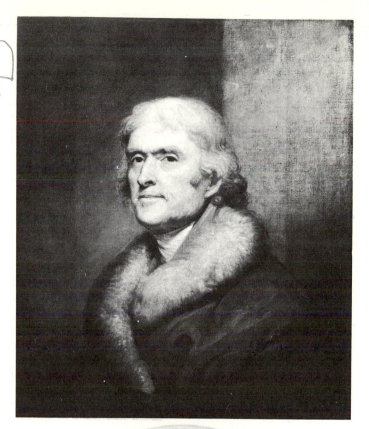

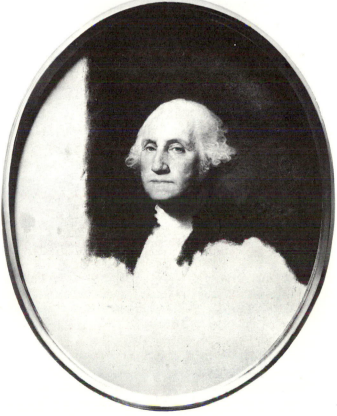

The virtuosity of the brush work leaves a fresh and unlabored crispness of surface that almost denies the monumental nature of the form it describes. Most of Stuart's portraits, like this one, are without any supplementary devices. The head stands out, immobile, against an airy background. The form is revealed by the quiet flow of light over the features, creating a timeless and significant symbol of a personality. Stuart had observed the work of Reynolds, Gainsborough, and others, and it had contributed to this direct, unadorned, yet decorative style. The suave golden color harmonies and the luminous textures recall the English masters; yet this was no shallow imitation of their skillful style but, rather, a timely flowering of a great talent.

Stuart was at his best with a sitter who combined patrician distinction with a certain vigor of personality. His *Mrs. Richard Yates* (Pl. 8, p. 174) is a masterpiece of subtle understanding, sharp observation, skillful brush work, and harmonious tone. The light flows across the surfaces, revealing forms and textures with lucidity and elegance. The effortless depiction of the gesture of the hands, the sudden turn of the head, and the contained, knowing, and patient expression of the face are achievements of a master. The brilliance of execution that characterized Stuart's style, the painterly, shining flesh tones, and the beautifully harmonized color are particularly evident here. A rosy warmth suffuses and harmonizes all the color; the shadow areas in the figure tie into the background, making the cool lights of the costume shine like luminous pearls. The pillow in the lower left, the face, and the hands provide brighter color accents. The total effect is discreet, tasteful, and sophisticated, a far cry from the hard brightness by means of which earlier painters, even Copley, projected vivacity and life into their work.

Stuart's influence on subsequent painters was great. John Trumbull, Thomas Sully, John Neagle, and a host of others observed him at work or studied his paintings, and their portraits reflect his brilliant manner with varying degrees of success.

Ralph Earl

In many somewhat isolated areas of the country the awkward strength of the colonial style still persisted. Ralph Earl (1751–1801) is the most impressive example of a post-Revolutionary artist whose work gained in strength and power because of its indigenous and naïve character. Earl was born in an isolated rural area of western Connecticut and executed his earliest work with little or no training. He fought in the Revolution and then sailed for England, where he spent six years. Though he studied with West, his style always retained some of the awkward and

monumental gravity that characterized it before his period abroad. On his return to America he settled in western Connecticut, where he spent the remainder of his life painting the local gentry, frequently in the setting of their homes, fields, and village streets. His presence contributed to the maintenance of a naïve folk style of portrait painting that almost constituted a Connecticut school.

Earl's portrait of *Roger Sherman* (Pl. 9, opposite), painted before his sojourn in England, reveals the power of his severe style. Except for the light hands and face, the painting is somber and dark, brown, black, and dark red being the predominant colors. The forms, delineated with a direct austerity, create from the black-stockinged legs of the sitter and the black-painted legs of the Windsor chair a pyramidal base, which then builds up through the thighs, hands, arms, and body to the strongly structured, dominating face. No graceful supplementary forms, no flickers of deftly painted textiles, no flashing brush strokes relieve the angular grandeur of the sitter, whose movements were, as John Adams noted, "stiffness and awkwardness itself." Earl's bare but certain notations of form suggest an intense, even ardent, artistic personality, restrained by the rural New England Puritan tradition but still able to give expression to that graceless but forthright and courageous way of life.

Portraiture and Romanticism

Though nineteenth-century portrait painters were primarily interested in the facts of appearance, they, too, were affected by the rise of Romanticism. Even Benjamin West, as revealed in his portrait of Robert Fulton, had become concerned with the realm of highly wrought emotions and exciting visions that were the particular province of the Romantic. The Romantic mood asserted itself in portraiture in a way particularly compatible with the American temperament, for the Romanticism that flourished in America was not the most extreme or imaginative form. Rather, it was a kind of pragmatic Romanticism, its head occasionally in the clouds, but its feet usually firmly set in reality.

That the portrait painting of the day reflected the Romantic attitude was inevitable; the warmth of sentiment and the deep humanitarian impulses of the movement were central to the human concerns of the portrait painter. The artist could achieve an exact and literal likeness and, at the same time, by gesture and expression, and even more by the use of color and tone, could suggest such Romantic attributes as a deep capacity for emotion, inner tumult, dreams, visions, compassion, and heroism. But the Romantic tendencies were kept firmly in leash; the dominant desire was for a fine likeness.

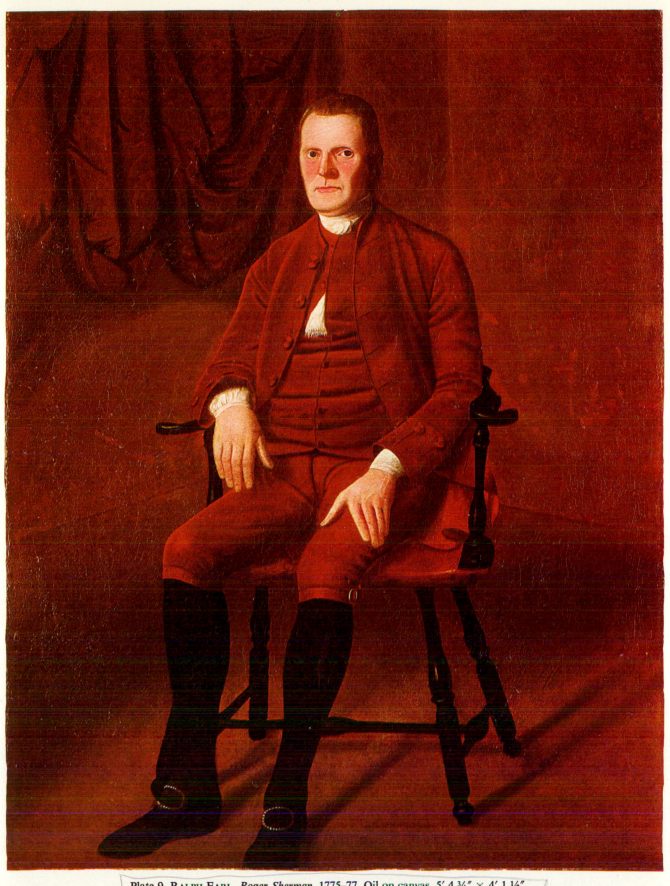

Plate 9. RALPH EARL. *Roger Sherman*. 1775–77. Oil on canvas, 5′ 4 ¾″ × 4′ 1 ½″.
Yale University Art Gallery, New Haven, Conn.

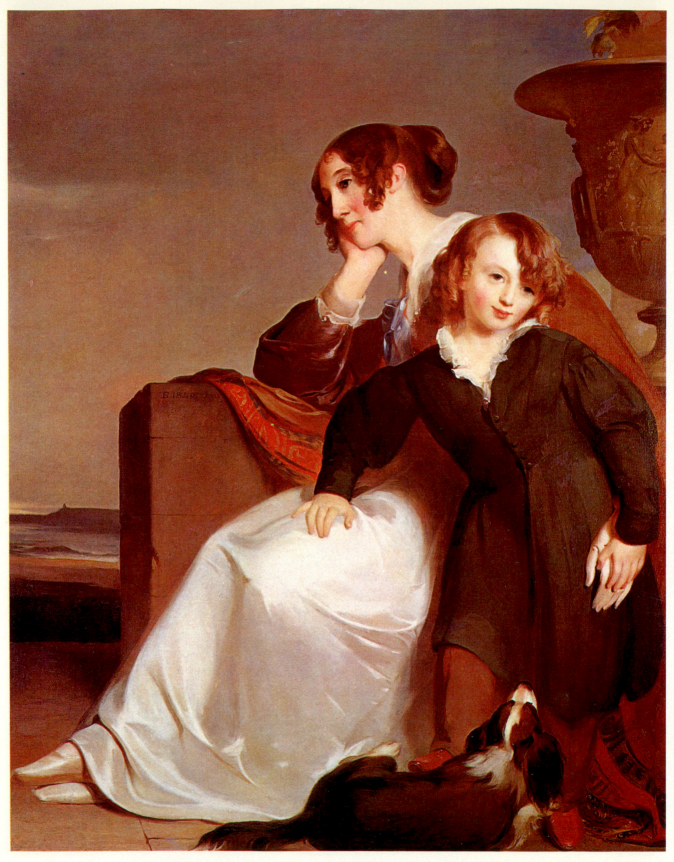

Plate 10. THOMAS SULLY. *Mother and Son*. 1840. Oil on canvas, 4′ 9″ × 3′ 9 ³/₈″. Metropolitan Museum of Art, New York
(bequest of Francis T. S. Darley, 1914).

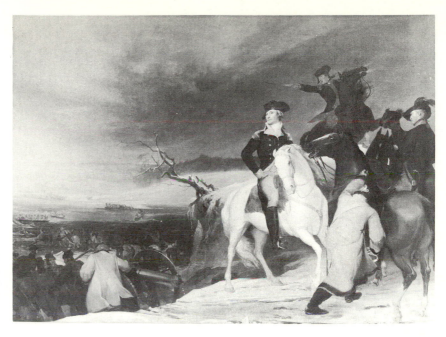

275. THOMAS SULLY. *Washington at the Delaware*. 1819. Oil on canvas, 12′ 2 ½″ × 17′ 3″. Museum of Fine Arts, Boston (gift of the owners of the museum).

Thomas Sully

Thomas Sully (1783–1872) was the leading portrait painter in Philadelphia and the central states during the third and fourth decades of the century. A student of Gilbert Stuart and later, in England, an admirer of the facile brilliance of Sir Thomas Lawrence, Sully was immensely popular. His portraits of celebrities were in sufficient demand that one of the printmakers of the day made a stipple engraving of his *Portrait of Andrew Jackson* (see Fig. 336). Though the active brush work of the painting is lost in the print, the Byronic pose and sweeping movements whereby Sully projected a romantic aura are clearly evident. If in his later years solidity of form and a sense of character were often sacrificed to flashing execution, he has left a number of convincing portraits in which his facility contributed to grace and charm without detracting from a satisfying likeness.

His *Mother and Son* (Pl. 10, opposite), a portrait of his daughter, Mrs. William Darley and her son, provides a telling example of his ability to achieve a romantic portrait of mood. The sheer elegance of tone—flashing lights, rich darks, and melting grays—would be difficult to surpass. The curve of the child's body forms a graceful opposition to the mounting movement of the main compositional mass. Starting at the feet of the seated figure, the forms build up to the urn on the upper right, creating a rhythmic flow of broad masses which accord with the Romantic love of grace, animation, and a sense of resolved conflict. The facial expressions are pensive and thoughtful, with a hint of a sad, sweet smile, the gentle melancholy of popular poetic sentiment. Even the pose of the mother, reminiscent of Dürer's *Melancolia*, evokes romantic associations with the past. The idealized features suggest elegance and breeding. The brush work is broad and facile.

Color plays an important role in establishing the mood of poetic reverie. Fresh pink and white flesh tones shine out against the opalescent sky. The luminous white skirt shimmers against the roseate tan urn, wall, and earth. A touch of soft red drapery and a few rich browns provide contrast. The color, like the form, is sweet, without any sharp, strong, or full-bodied hues to disturb the gracious harmony. This masterpiece of decorative Romantic painting is so skillfully executed and charming that one hardly notices the absence of an incisive depiction of character.

While Sully's fame rests largely upon his facility as a Romantic portrait painter, his *Washington at the Delaware* (Fig. 275), painted more than thirty years before the better-known version of the same subject by Emanuel Leutze, deserves more attention than it generally receives. The handsomely conceived tonal pattern, culminating in the focal figure of Washington on horseback, concurs magnificently with the wave of movement that, starting in the lower left, rises to a crest in the form of Washington and the mounted rider behind him. The action is projected without effort; the handsome forms of men and animals are depicted with fluency and force. The ease with which all the elements of the painting are composed in a continuous movement of line, color, and tone reveals an ability to control and orchestrate all the parts of a complex narrative painting that no American painter of Sully's day, except perhaps Trumbull, ever surpassed.

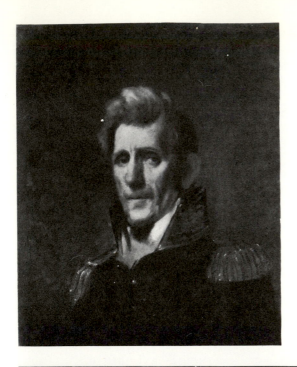

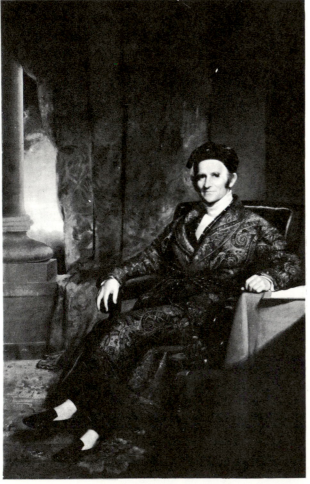

Samuel Waldo (1783–1861) painted *Andrew Jackson* (Fig. 276) in the Romantic manner, but without the heroics of the Byronic gesture. Instead, the deeply emotive device of the transparent shadow is explored. The soft brush strokes barely define the surfaces, and the warm background seems vibrant, like some deep, sonorous musical note. A reverent sentiment pervades this sober portrait, and yet the Andrew Jackson that looks out at us is no sentimental conception; a masculine character of surprising strength emerges from the canvas. After long years as a professional portrait painter in New York, Waldo lost some of the evocative subtlety that marked his early work, but his portraits were always painted with sensitive honesty and strength.

Portrait painting was a flourishing art in the early nineteenth century but not all of the successful practitioners can be discussed here. John Wesley Jarvis (1780–1840) and John Neagle (1796–1865) were among the many who produced competent and even distinguished works. Henry Inman (1801–46) and, later, Charles Loring Elliott (1812–68) painted fine portraits in New York City. Some men of the day produced good likenesses only out of the necessity to earn a living, for their ambitions were cast in a more heroic mold, and they considered portrait painting a prosaic task. Three of these men, John Trumbull, John Vanderlyn, and Samuel F. B. Morse, who aspired to create great historical canvases and inspiring allegories, will be discussed later.

Mid-century Realism

By mid-century a more factual style of portraiture replaced the earlier Romantic manner. A sensible middle-class respect for fact, abetted by the newly discovered daguerreotype process of photography, led the public to prefer a hard, detailed realism to the painterly flourishes and the sentimental idealism of the earlier style. Painting portraits became a business in which hard-headed, skillful practitioners flourished.

Most typically a child of the new era of Jacksonian democracy was Chester Harding (1792–1866), farmhand, woodsman, saloon keeper, and peddler, who, though he had hardly seen a painting before the age of twenty, became sufficiently successful as a portrait painter to have

above: 276. SAMUEL WALDO. *Andrew Jackson.* 1817. Oil on canvas, 25 ¾ × 21". Metropolitan Museum of Art, New York (Rogers Fund, 1906).

left: 277. CHESTER HARDING. *Amos Lawrence.* c. 1845. Oil on canvas, 7' ⁵/₈" × 4' 6". National Gallery of Art, Washington, D.C. (gift of the children of the Rt. Rev. William Lawrence).

278. GEORGE P. A. HEALY. *President James Buchanan*. 1859. Oil on canvas, 5′ 2″ × 3′ 11″. National Portrait Gallery, Smithsonian Institution, Washington, D.C. (gift of Andrew Mellon).

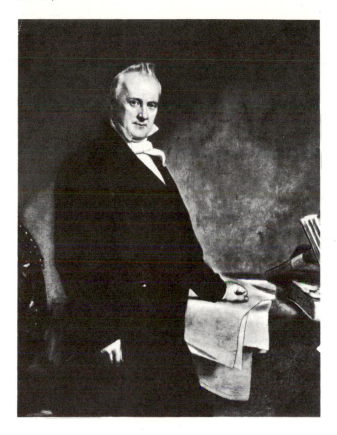

taken away eighty sitters, it is said, from Gilbert Stuart in a six-month period.

In the course of his long and profitable career in the Boston area, Harding painted innumerable portraits of America's great and celebrated. His handsome portrait of a New England philanthropist, *Amos Lawrence* (Fig. 277), reveals his particular forte. Amos is seated in a comfortable chair, dressed in a handsome Paisley dressing gown. The atmosphere is relaxed and intimate. The background may suggest regal splendor, but this is the only concession to imagination or sentiment. The rest is clearly observed and brilliantly stated fact. The fine features of the face, the lively eyes staring out from beneath the bushy brows, the various surface textures—velvet, wool, wood, damask, and skin—the forms of the body, and the spaces in the room are all described with startling fidelity. This portrait is the work of an intelligent, skilled man who saw clearly and objectively. No deep lyric feeling, subtlety of mood, or psychological insight distinguishes the work. It is a positive and energetic reflection of a positive and energetic age.

George P. A. Healy (1813–94) made his home in the new metropolis of Chicago, though his successful career kept him continuously on the move both here and abroad. Healy's life was a nineteenth-century American story of rags to riches. Born of a poor Boston family, his rise to success was meteoric. At eighteen his portraits of Boston's celebrities had brought him renown. Before he was twenty, he was studying with Antoine Gros in Paris, and in the course of his life he painted over six hundred of the famous personages of Europe and America. From Gros Healy learned the importance of varying the weight of the oil paint; American painters tended to work in a thin manner that left a monotonous surface. By changing the paint from a thick impasto of great carrying power in the lights to thin, transparent darks, Healy achieved the brilliance of tone that is one of the most notable elements in nineteenth-century academic painting. The effctiveness of his light-and-dark contrasts distinguishes his handsome portrait of *President James Buchanan* (Fig. 278). Healy was probably at his best in communicating the physical energy and dynamic personalities of the vigorous and successful men who dominated his age.

HISTORICAL PAINTING

A number of young painters, inspired by West's success and by the great canvases of the Renaissance and Baroque masters, returned to America from Europe fired with the ambition to paint important historical works. All about them a great nation was developing. New states and young cities were springing up; great city halls and greater state capitols were being built, and artists looked forward to another Renaissance, during which they would be entrusted with the glorious task of painting their noblest visions on the walls of public buildings. The new buildings exposed their expanses of bare wall, and the artists had their dreams, but it seemed difficult to reconcile the artists' ambitions with the facts of American life.

John Trumbull

John Trumbull (1756–1843) was the youngest son of Jonathan Trumbull, governor of Connecticut during the Revolution. Intellectually precocious, he was sent at an early age to Harvard, where his tutor called his father's attention to the boy's "natural genius and disposition for limning," a talent which his father found not particularly useful. After graduation Trumbull returned home and there painted a group of portraits which reveals both his abilities and his lack of training. In 1780, after serving as an officer in the Continental Army, the temperamental Trumbull resigned his commission and set out to study

with West in London. He remained there until 1889, once returning to America and twice visiting the Continent during that time. In England Trumbull was much impressed with the great historical paintings which had brought acclaim to West and Copley, and in France he admired the small, luminous canvases prepared by Rubens as studies for his large paintings. While in England Trumbull conceived of a grand project: to depict a series of scenes from American history. During the next decade he painted eight small, dramatic compositions as studies for projected murals. These studies remain his most impressive works, and it is primarily as the painter of the American Revolution that we know him today.

After this first extended stay in Europe Trumbull returned to America to document his project with portraits, landscape settings, and other factual materials, since he wanted to produce both great works of art and an authentic record. An excellent example of his portraiture from this, his best period as a portrait painter, is his *Alexander Hamilton* (Fig. 279), painted about 1792.

To appreciate Trumbull's full gifts one must see his earliest studies. Though in many ways indebted to West's *Death of General Wolfe*, his *Battle of Bunker's Hill* (Fig. 280) reveals his ability to organize a tremendous number of figures into a unified composition and at the same time to establish the complex currents of action and the different individual personalities in a clear and forceful way. The scene pictures the moment when the Americans had expended their ammunition, allowing the British troops to master the field. In this crisis General Warren was killed by a musket ball through the head. The main group of figures shows General Warren dying, supported by a kneeling soldier, who, at the same time, wards off the bayonet of a British grenadier. Colonel Small is shown grasping a musket and stopping the fatal blow, while directly behind him Colonel Pitcairn, mortally wounded, is shown falling into the arms of his son. The impact of Rubens' fluid and powerful narrative style is all pervasive. A continuous diagonal line sweeps up from the lower

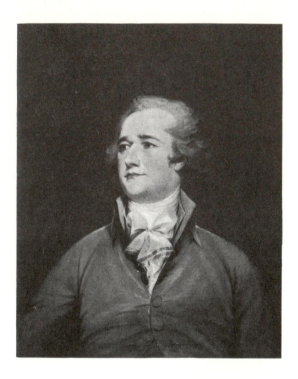

above : 279. JOHN TRUMBULL. *Alexander Hamilton.* c. 1792. Oil on canvas, 30 1/4 × 24 1/8″. National Gallery of Art, Washington, D.C. (gift of the Avalon Foundation, 1952).

right : 280. JOHN TRUMBULL. *Battle of Bunker's Hill.* 1786. Oil on canvas, 25 × 14″. Yale University Art Gallery, New Haven, Conn.

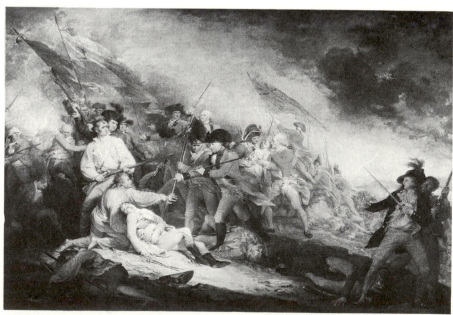

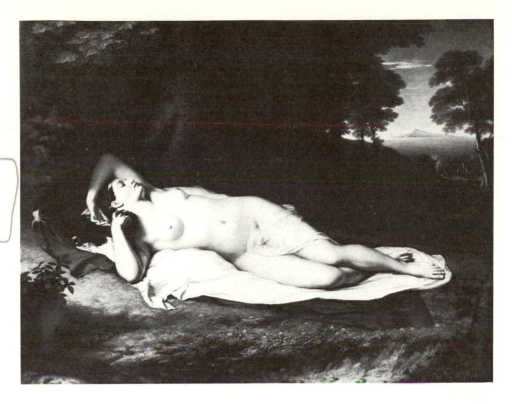

281. JOHN VANDERLYN. *Ariadne Asleep on the Island of Naxos*. 1814. Oil on canvas, 5′ 9″ × 7′ 4″. Pennsylvania Academy of the Fine Arts, Philadelphia.

right, carrying the eye through successive waves of movement to this central group of figures, which is boldly projected in a full burst of light. A countermovement is set up by the figure of Lieutenant Grosvenor and the other figures in the lower right, and this countermovement is sustained by the ominous line of the upraised sword and the bayonet which is about to be plunged into the supine body of General Warren. As in all great dramatic painting, the narrative creates the composition, and the composition, in turn, brings the narrative to life. The broadly conceived tonal pattern is beautifully realized; from its fluid depths the forms emerge into light and sink back into darkness. There is an amazingly varied use of pigment, from heavy impasto to thin washes of transparent paint.

In 1817 Congress commissioned Trumbull to paint a group of his Revolutionary subjects as mural decorations for the rotunda of the new Capitol in Washington. These murals remain handsome and impressive paintings, although Trumbull was unable to transfer the full fire and plasticity of his smaller sketches into the larger works. The wonder is that over the many years of inactivity Trumbull's talents had not atrophied from disuse.

The late years of Trumbull's life witnessed a sad decline in his fortunes. He was made head of the American Academy of Fine Arts in New York, and through mismanagement and poor judgment he contributed to the financial ruin of the institution. Instead of providing much-needed

leadership to the young painters of his day, he became a bitter and tyrannical old man.

John Vanderlyn

Another American artist who, like John Trumbull, never realized his full potential, was John Vanderlyn (1775–1852). Vanderlyn spent five years in Paris, where he had been sent to study by Aaron Burr, who had great faith in his talent. In France he absorbed the precise drawing, the firm modeling, and clear color of the neoclassic school, but unfortunately he also became imbued with the idea that only didactic historical canvases or classical allegories were worthy of a great artist's talents. After his initial period of study abroad, Vanderlyn returned to America, spent a discouraging period at home, and on the receipt of another stipend from an American admirer, he returned to Europe for three more years of study, this time in Rome. It was during this last stay in Europe that he painted his best-known work, *Ariadne Asleep on the Island of Naxos* (Fig. 281).

This large and brilliantly painted nude represents Vanderlyn at the height of his powers. The idealized figure, beautifully composed in relation to the spacious background, is like a quiet reflection of the great Venetian masters. Clear, lucid, and controlled, Vanderlyn's *Ariadne* is probably the finest example of the classic idealized nude

above: 282. JOHN VANDERLYN. *Panorama: Palace and Gardens of Versailles*. c. 1820. Oil on canvas, 12 × 165′. Metropolitan Museum of Art, New York (gift of the Senate House Association, Kingston, N.Y., 1952).

below: 283. SAMUEL F. B. MORSE. *The Old House of Representatives*. 1823. Oil on canvas, 7′ 2 ½″ × 10′ 10 ¾″. Corcoran Gallery of Art, Washington, D.C.

in America, but the very nature of its subject matter reveals how far Vanderlyn's sojourn in Paris and Rome had taken him from a realistic appraisal of American attitudes.

In an attempt to achieve the stature that his career in Europe had promised, Vanderlyn conceived the idea of painting a great panoramic view of Versailles, based on sketches he had brought back from France. Panoramic views of famous places, like the great historical canvases of the day, were popular showpieces and, when successful, were well patronized by the public and brought in substantial revenues. Vanderlyn's *Panorama: Palace and Gardens of Versailles* (Fig. 282) was housed in a great circular building financed by his advisers and specially built for the display of his works near City Hall, New York. The enterprise, constituting New York's first museum, was a failure artistically and financially, another setback to add to Vanderlyn's disappointments.

Not until he was in his sixties did the great opportunity for which he had waited all his life come through. In 1838 he was commissioned to paint a *Landing of Columbus* for the Capitol in Washington. The commission came too late. Vanderlyn was unable to complete the project. Though he went to France to carry out the work, most of it had to be executed by his assistants. The circumstances of American life had defeated Vanderlyn. There was neither the tradition nor the institutional patronage here to ensure the commissions which were part of the official pomp of Europe. Equally important, America still had few collections of paintings and sculpture which could nourish the artist, when, lacking commissions, he might need to sustain his faith in the validity of his dreams by communing with the glorious examples of the past.

Samuel F. B. Morse

Samuel F. B. Morse (1791–1872) also dreamed of a Renaissance in America. His ambition, he wrote his father, was "to rival the genius of a Raphael, a Michelangelo, or a Titian." Morse was a forceful and effective realist. His scenes in Italy and his large genre paintings, such as *The Old House of Representatives* (Fig. 283), are surprisingly original in conception, rich in color, and sensitive in observation. *The Old House of Representatives* combines a grandiose design with startling accuracy of detail. Forcefully realized and dramatic without being melodramatic, it was a real achievement for an age of romantic sentiment and theatrical posturings.

Morse also painted a number of fine portraits; some of his later ones in the romantic manner achieve genuine distinction. He also painted some impressive landscapes. One of his most important contributions to the arts was his aid in organizing the National Academy of Design in New York City. As its first president, Morse helped it to become a strong and progressive institution managed primarily by and for artists. It provided a school for the study of the fine arts and an annual exhibition wherein painters could display their works. Its success hastened the demise of the American Academy of Fine Arts, still under Trumbull's faltering leadership. After his invention of the telegraph, Morse gave up his artistic career.

11

Painting:
Allegory, Landscape, Genre, Still Life, and Folk Art

ROMANTIC ALLEGORY

The Romanticism of the first half of the nineteenth century received its most intense expression in themes concerned with highly wrought emotions, exciting visions, inner tumult, compassion, and heroism. The paintings which most effectively reflected this temper tended to be allegorical, Biblical, or legendary episodes chosen to fill the viewer's breast with sublime and uplifting emotions. Even Benjamin West, the exponent of the neoclassic, attempted to escape the shackles of rationalism in his later works by essaying themes with symbolic, mystical, and visionary overtones; and Trumbull, Rembrandt Peale, and, later, Thomas Cole followed suit.

As mid-century approached, an increased concern with science, technology, and social problems turned men's minds away from dreams toward the world about them. In America in particular, when the heightened emotional tone persisted, it found its subject matter in the grandeur of the wilderness or the adventure of frontier life. A comparison of Washington Allston's *Dead Man Restored to Life by Touching the Bones of the Prophet Elisha* (Fig. 284) and George Caleb Bingham's *Verdict of the People* (Fig. 305) vividly demonstrates the age's

discovery of inspiration in fact, rather than fancy, and its fascination with the present, rather than the past.

Washington Allston

America's foremost exponent of the intense Romanticism of the early nineteenth century was Washington Allston (1779–1843). Born in South Carolina, Allston was educated at Harvard, spent two years in London while the Romantic movement was at its height, and then visited Paris and Rome. His tour of the Continent introduced him to the Venetian masters, and he was greatly impressed with their use of color and tone to create a pervasive mood or atmosphere, addressed, to quote his own words, "... not to the senses merely, as some have supposed, but through them to that region (if I may so speak) of the imagination which is supposed to be under the exclusive domination of music." Allston introduced the Romantic movement into America through both the highly emotionalized visionary painting of his early years and his later poetic landscapes, which reconciled his romantic mood with the increasing realism of the mid-century.

The Dead Man Restored to Life by Touching the Bones of the Prophet Elisha (Fig. 284) illustrates an Old Testament

story concerning Elisha, who, endowed during his life with prophetic and mystical powers, retained them after death. A group of Israelite mourners accompanying a corpse to the cemetary in which Elisha was buried saw a group of enemy marauders approaching. The mourners hastily concealed the body in Elisha's tomb, and when the body accidentally touched the bones of Elisha, the dead man, restored to life, stood upon his feet. The analogy between the powers of Elisha and Christ is both obvious and significant. The renewed religious orthodoxy of the nineteenth century, though frequently appealing to the mystical powers of faith, sought at the same time to bolster faith by historical analogies; in fact, the use of such analogies was part of the apparatus of Romanticism in all areas of expression.

Allston depicts the episode in an atmosphere of mystery and drama. The disbelief, wonder, and astonishment expressed through faces and gestures is augmented by a theatrical quality of illumination that recalls various Resurrections—Raphael's, Titian's, and others. The great Michelangelesque bodies and the pyramidal groupings of form also reveal Allston's debt to the masters of the late Renaissance. Though to some degree the execution is labored and the color turgid and heavy, Allston is successful in communicating an atmosphere of grandeur.

The large allegorical and religious compositions which sapped much of Allston's energies (his great *Belshazzar's Feast* was never completed) are not his most satisfying works. His later dreams became gentler and more lyrical. *Moonlit Landscape* (Fig. 285) is a small and very lovely landscape in which the tone is one of peaceful reverie; the human spirit expands in the spacious quietude of nature. The rather formal aspect of the composition suggests that, like many painters of his day, Allston also studied such seventeenth-century French masters as Poussin and Claude Lorrain. Undoubtedly Allston, more than any other artist of his day, took American painting from a narrow concern with fact into the realm of the imagination and introduced into the creation of a poetic mood a subtlety of color and tone that had previously been unknown.

LANDSCAPE

The nineteenth century was the great age of landscape painting, and for American artists the scenery of their own country was of particular significance. An increasing awareness of their unique national character, intensified by the growing nationalism of the major nineteenth-century European countries, fostered the desire to establish a uniquely American culture. Novelists, poets, and essayists, celebrating the virtues of American life, took

top: 284. WASHINGTON ALLSTON. *The Dead Man Restored to Life by Touching the Bones of the Prophet Elisha.* 1811–13. Oil on canvas, 13 × 11′. Pennsylvania Academy of the Fine Arts, Philadelphia.

above: 285. WASHINGTON ALLSTON. *Moonlit Landscape.* 1819. Oil on canvas, 24 × 35″. Museum of Fine Arts, Boston (gift of Dr. W.S. Bigelow).

left : 286. THOMAS DOUGHTY. *Landscape : House on a Cliff above a Pool.* 19th century. Oil on canvas, 18 ¾ × 25 ½". Pennsylvania Academy of the Fine Arts, Philadelphia.

opposite : 287. THOMAS COLE. *The Oxbow.* 1836. Oil on canvas, 4' 3 ½" × 6' 4". Metropolitan Museum of Art, New York (gift of Mrs. Russell Sage, 1908).

delight in describing the scenery. The native landscape also provided a motif particularly suited to an indigenous school of painting. There had been no conscious "American" school of painters previous to the group of landscapists who worked in New York, New England, and western Pennsylvania after 1825, but as this group, later to be termed by critics the "Hudson River school," became conscious of their common interests, they proudly proclaimed their American identity. By the 1850s the increased importation of paintings from Europe began to offer serious economic competition, and this further stimulated the champions of native versus imported culture.

Certainly America presented the landscape painter with subjects of seemingly endless variety. Mountains, lakes, rivers, deserts, and oceans were here for those challenged by space and grandeur. Woods, ravines, inlets, fields, and brooks provided more intimate and gentle aspects of nature. There were the cities, villages, farms, and frontier for those who preferred to include man. For many, the landscape of America symbolized the nation's greatness and its potential for human happiness. There was room for all in the limitless expanses of the virgin continent, and the variety of opportunity was as great as the variety of climate and topography.

The landscape was not only a patriotic symbol but also served as a vehicle for expressing the deep religious and romantic feelings of the age. For those who could no longer believe in a religion of miracles and myths, the sublimity of nature symbolized the benign power of the Almighty. Allston's landscapes had encouraged American painters to use the depiction of nature to express the full range of their imagination and feelings. Certainly this ability to infuse the real and familiar scene with majesty and drama constituted the particular strength of the Hudson River painters and those who later followed in their footsteps.

The Hudson River School

It was not ideological conviction that turned Thomas Doughty (1793–1856) to landscape painting but a penchant for painting and a love of the outdoors and of sports such as hunting and fishing. Most American nineteenth-century painters tried their hands at landscape, but Doughty was the first to devote himself exclusively to it, and he enjoyed considerable success, particularly in his early years. Though he neither considered himself a member of a school nor concentrated on Hudson River scenery, he is often considered the father of the school, because his example and success encouraged the others to follow his example.

A contemporary catalogue of his works divides them into three categories; "from nature," "from recollection," and "imaginary compositions." *Landscape : House on a Cliff above a Pool* (Fig. 286) is obviously from nature. Though not completely typical, since it lacks the panoramic spaciousness and misty distances of much of his work, it is one of his most beautiful paintings. Direct observation of nature has provided an authenticity of form often absent from his remembered scenes, in which trees, water, and distant mountains executed according to a formula lack an incisive character. However, *House on*

a Cliff above a Pool has many elements common to his works: trees, a pool of water, the solitude of nature disturbed only by a pair of fishermen, and a poetic tone.

Thomas Cole

Thomas Cole (1801–48) was born in England, but when he was a small child, his family came to the United States and settled on the frontier of Ohio. He commenced his professional life as a wandering self-taught artist, and his early pictures depicted the wild scenes of the frontier. These early landscapes reveal the mood of solemn wonder that the vastness of the wilderness aroused in the young man. The popularity of his youthful works enabled him to go abroad for three years of study and to travel in England and Italy. On his return he settled near the village of Catskill and commenced to paint the Hudson River Valley and the neighboring mountains. During his frequent sketching trips, he made notes that could be composed in his studio when winter made travel difficult. Working at home, he let his imagination play over what he had seen, and he depicted the mighty wilderness in its most dramatic and awesome moods. Though some of his pictures recall the works of Salvator Rosa, the landscape he painted was the lonely back country of America, not picturesque Italy. *The Oxbow* (Fig. 287) reveals Cole in a factual mood, depicting the pleasant cultivated valley of the Connecticut River. Despite the accumulation of

detail there is a strong sense of space and scale. The soft veil of rain-washed light in the middle distance, the rich pattern of cloud shadows, and the energetic angle of the twisted oak in the foreground keep the painting from being a mere inventory of landscape forms. In paintings such as *The Oxbow* Cole showed himself able to reconcile his own taste for drama and sentiment with his clients' more prosaic preferences.

Landscape with Tree Trunks (Pl. 11, p. 209) is in Cole's more generalized and richly painted style. Dramatic elements dominate. While still awesome in scope, the panoramic space gives way to a more turbulent atmosphere; the dead tree is more skeletal, the sweep of storm more threatening. The broader brush work and richer paint textures may reflect the influence of the French Barbizon masters. The color, more vivid than in *The Oxbow*, also contributes emotional intensity.

Cole's travels in Europe had quickened both his patriotic sentiments and his strong moral and religious propensities. In Europe he saw, to use his own words, "both the ruined towers that tell of outrage, and the gorgeous temples that speak of ostentation," and he found America, by contrast, "to be the abode of virtue." He returned from Europe deeply impressed with the great sweep of history and the fugitive nature of man's achievements. He saw the great architectural monuments of Europe as a setting for the endless pageant of civilization and the ancient ruins as God's judgment on iniquitous

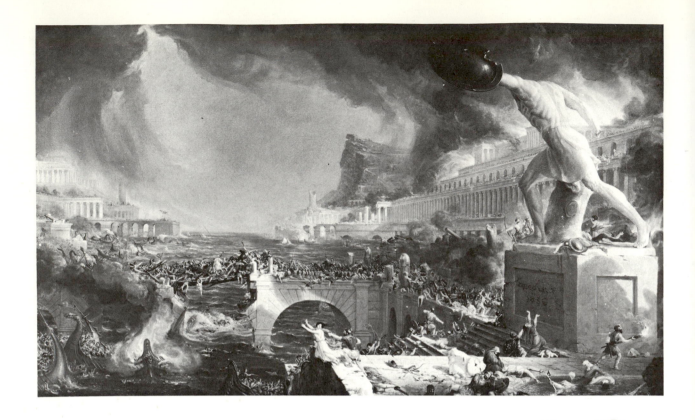

above: 288. THOMAS COLE. *The Course of Empire: Destruction.* Series completed 1836. Oil on canvas, 3′ 2 ½″ × 5′ 2 ½″. New York Historical Society, New York.

nations that had abandoned Him. This vision of the past inspired a series of allegorical paintings picturing the theme of man's destiny and the passage of time. These comprised the major productions of his later years. Each series, the most notable of which were *The Course of Empire* and *The Voyage of Life*, was composed of a sequence of canvases, each depicting one episode in a continuous theme. These paintings clearly reveal the literary habits of mind that dominated the visual arts at the time. History, archeology, and science were providing new tools for exploring the past. Man faced the mystery of his destiny and questioned the meaning of life. Rhetorical and didactic as they may seem today, such illustrative paintings were deeply meaningful in the early nineteenth century, for they visualized both new-found knowledge and the deep questionings that perplexed the age. Engravings made from the *Voyage of Life* series were widely circulated and provided the basis for much of Cole's popularity.

One of the most effective of these compositions is *Destruction* from *The Course of Empire* series (Fig. 288). The view of architectural history that constitutes the theme is paralleled by the perspective in deep space into which the composition is cast. The accumulation of knowledge that went into its making is translated into concrete form

in hundreds of details, architectural and otherwise, that contribute to its fascinating complexity. Sun and shadow, turbulent sea, and cloudy sky form the background for an awesome spectacle of chaotic turmoil, collapsing monuments, and hordes of frantic people. An effective indication of scale is given by the great headless statue in the foreground. The apocalyptic vision projected here had a lesson for a young and moral America!

Though Cole might logically be considered the leader of the Hudson River school of landscape painting, other artists added to the renown of the group. Asher B. Durand (1796–1886) began his professional career as an engraver. The plates he engraved from Trumbull's *Declaration of Independence,* Vanderlyn's *Ariadne,* and the landscapes of Cole and others had brought him considerable success before he started painting in oils. Much of Trumbull's, Vanderlyn's, and Cole's fame resulted from the wide circulation enjoyed by the engravings of their works.

No painting by Durand better reveals the sentimental reverence with which he observed nature than his charming

Kindred Spirits (Fig. 289), which was painted in memory of Thomas Cole the year after his death. Cole is represented with his friend, the poet William Cullen Bryant, standing on a ledge of rock, in silent communion with the grandeur of the Catskills. It is a testimonial to the tender and romantic spirit which frequently motivated the Hudson River painters.

As befitted an engraver, Durand painted in a meticulous and detailed style. In his later works he preferred a more intimate scale than Cole and saw nature less as an awesome force than as a beneficent setting for human activity. Sometimes the human factor is only implied, as in his *Catskill Stream* (Fig. 290). Here no human figure obtrudes itself, but the poetic spirit of the artist contemplating the scene is felt, and it infuses the woodland with a wealth of human sentiment. Durand's long discipline as an engraver appears in his penchant for detail and his craftsmanlike exactitude of execution as well as in the fine sense of tone by which he has suggested the dim and diffused light of the woods.

Two divergent tendencies in landscape painting became apparent in the 1850s, both of which had roots in the practices of the Hudson River school. One was a continued predilection for the grandiose, panoramic effects seen in much of the work of Cole; the other moved toward an increasingly intimate and unpretentious naturalism, which stressed the poetic mood of varying kinds of light on quiet stretches of woodland, water, or familiar, inhabited countryside.

Probably the most successful artist to continue painting landscapes in the grand manner in the fifties and sixties was Frederick E. Church (1826–1900). Born in

above : 289. ASHER B. DURAND. *Kindred Spirits.* 1849. Oil on canvas, 46 × 36″. New York Public Library (Astor, Lenox, and Tilden Foundations).

below : 290. ASHER B. DURAND. *A Catskill Stream.* 1867. Oil on canvas, 15 ¼ × 24 ³/₁₆″. Brooklyn Museum (gift of Mr. W.W. Phelps, 1933).

Connecticut, Church became a friend and pupil of Cole's and was deeply imbued with Cole's love of a spectacular sweep of awesome landscape, particularly when seen under unusual and dramatic atmospheric conditions. He had an innate aptitude for landscape, and even his early works show a remarkable ability to combine sharp detail with panoramic breadth and still retain a unity of effect. *Niagara Falls* (Fig. 291) reveals this talent with particular clarity. The magnificent sweep of cascading water is composed with spacious simplicity, the magnitude of the foreground contrasting most effectively with the minute distances. The sky, reinforcing the solemn mood, reveals the artist's facility for handling outdoor light and color.

More than any other painter, Church reveals the change of emphasis occurring in the second generation of Hudson River painters. The Romantic idealism that motivated Cole and Durand gave way to a factual verisimilitude more precise than before, even though the facts with which Church was concerned were such intangibles as atmosphere and light. The birth of photography, coming as a challenge to the painter, probably promoted the taste for actuality. One of the marvels of Church's talent was his ability to convey a sense of the spacious majesty of nature, despite the meticulous finish and detail with which his enormous canvases were executed.

After the late fifties Church traveled extensively and with facile brush, sensitive eye, and reverent spirit recorded the wonders of the tropics, the Arctic, the Near East, and Europe. The grandeur of his paintings of remote and previously inaccessible parts of the world caused one

above: 291. FREDERICK E. CHURCH. *Niagara Falls.* 1857. Oil on canvas, 3′ 6″ × 7′ 5″. Corcoran Gallery of Art, Washington, D.C.

right: 292. JOHN FREDERICK KENSETT. *Paradise Rock, Newport.* c. 1865. Oil on canvas, 18¼ × 30½″. Newark Museum, N.J.

opposite above: 293. GEORGE H. DURRIE. *Winter Landscape: Gathering Wood.* 1859. Oil on canvas, 28 × 35¼″. Museum of Fine Arts, Boston (M. and M. Karolik Collection).

206

critic to exclaim, "This is art's noblest, truest function; not to imitate nature but to rival it."

The skillful rendition of panoramic landscapes viewed under dramatic weather conditions continued to find spectacular expression in the canvases of Albert Bierstadt and others in the last half of the century. These men will be discussed later.

John Frederick Kensett (1816–72), like Durand, became a painter after serving an apprenticeship as an engraver. From study in England, Kensett was strongly influenced by the English landscape painters, particularly Constable. His early works, in which heavily wooded scenes were frequently composed to create a tunnel of space through tree trunks and dark masses of foliage, were rendered in gloomy color with a thick impasto of oily paint applied in agitated brush strokes. This somewhat turbulent manner gradually gave way to the style of his mature years. In these later works, in harmony with the dominant temper of the mid-century, he endowed a friendly nature with delicate poetry. His most distinguished paintings are those in which a tranquil and slightly melancholy mood is imparted to a scene through a quiet sequence of horizontal lines that move through subtle gradations of texture, tone, and color into the far distance. *Paradise Rock, Newport* (Fig. 292) illustrates this vein most effectively. The luminous tone of this painting works with the dominant horizontals in establishing the peace of a quiet stretch of marsh land on a gray day. The particular quality of diffused light has been most sensitively observed; the gray sky illuminates the top planes of the landscape

and brings out the sharply etched details of patterns and textures against the prevailing tone. Kensett is at his best in his paintings of water; a still stretch of river, a tranquil bay, or a moody expanse of marshland. His concern with the particular qualities of light established him as one of the first and most expert of the nineteenth-century luminists, that group of mid-century artists whose special concern was the study of outdoor illumination, particularly the modulations of twilight and dawn or the diffused and misty light of the seashore.

Many less notable painters contributed to the prestige of the Hudson River school. Among them Henry Inman (1801–46), noted in Chapter 10 as a portraitist, and Jasper Cropsey (1823–1900) should certainly be mentioned.

The artistic success and renown of the Hudson River school of New York tended to overshadow the achievements of landscape painters elsewhere. In Boston Alvan Fisher (1792–1863) and in Philadelphia Thomas Birch (1779–1851), better known as a printmaker (Fig. 334), painted pleasantly, if without distinction. Almost every small town had its local artist, many of whom, popular in their own day, have been almost forgotten. Such a man was George H. Durrie (1820–62), born in Connecticut, who tried portrait painting and then shifted to landscapes. He painted in both the New York and the New Haven areas. Many of his paintings were reproduced as prints by Currier & Ives and thus achieved extensive circulation. *Winter Landscape: Gathering Wood* (Fig. 293) reveals the elements that made for his popularity. Durrie was not

294. FRANCIS GUY. *A Winter Scene in Brooklyn.* c. 1817–20. Oil on canvas, 4′ 10 ⁵/₈″ × 6′ 3″. Brooklyn Museum (gift of the Brooklyn Institute, 1897).

an artist of subtle perception, nor were his technical methods far beyond those of popular illustration, but he operated effectively within the limited scope of his ambitions. His unerring sense of the gray tone and color of winter, of the scraggly texture of bare branches and snowy brush, made his winter scenes particularly appealing to rural Americans, for whom winter, with its enforced quiet and inactivity, was a period of contemplation and delight in nature.

Topographical Cityscapes and Marine Paintings

Maps, topographical views, and the painting of cities, harbors, fortifications, and gentlemen's estates had preceded landscape painting in America, and such paintings continued to be popular. A number of the artists who specialized in these subjects came from England in the last decades of the eighteenth century. Among them were William Birch (1755–1834) and his son Thomas, mentioned above, who settled in Philadelphia, where they practiced painting and engraving. Thomas Birch specialized in naval battles and marine views, traveling extensively for subjects. As the century progressed and the landscape tended to be painted as visual spectacle rather than as fact, the life of the city, the harbor, and the sea also became objects of esthetic contemplation.

Robert Salmon (died 1840), also of English origin, painted Boston harbor in a clear, factual style that contributed much to the popularity of this genre.

Francis Guy (1760–1820) came from England between 1790 and 1800. Though he painted country estates, harbor scenes, and views of cities, and, when he felt so inclined, could turn in a conventional and gentlemanly performance, his preference was for a more colorful genre. His street scenes of Brooklyn, N.Y., and of Baltimore constitute by far the most lively visual commentary on the folkways of America's young cities that has come down to us. *A Winter Scene in Brooklyn* (Fig. 294) inevitably reminds one of Bruegel; there is the same affectionate delight in the antics of men and animals, the same sharp eye for the pattern of buildings and the gleam of white snow against gray skies, the same ability to create a unified composition out of an infinite number of details. Guy's skill and imagination in organizing this entertaining pattern is worthy of our attention. The flow of movement projected by the imaginatively composed figures is as continuous and varied as the life of the community itself. The skillful alternation of lights and darks offers constant contrast, and snowy surfaces provide a quiet relief from the complex textures of the buildings and trees.

Guy had a capacity to assimilate each fact and create an animated pattern imbued with wit and charm. He also has the distinction of having held what was probably the first

Plate 11. THOMAS COLE. *Landscape with Tree Trunks.* c. 1827–28. Oil on canvas, 26 1/4 × 32 1/8″. Museum of Art, Rhode Island School of Design, Providence.

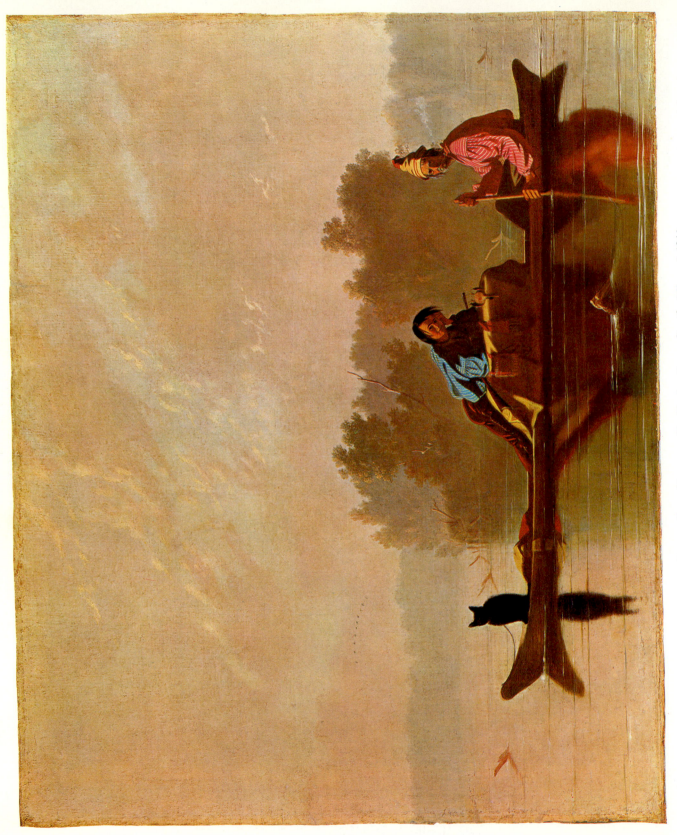

Plate 12. George Caleb Bingham. *Fur Traders Descending the Missouri.* 1844.
Oil on canvas, 29 × 36 ½". Metropolitan Museum of Art, New York (Morris K. Jesup Fund, 1933).

one-man exhibition of landscapes in America. The show was held the year of his death, 1820, in New York.

Fitz Hugh Lane (1804–65) was born in Gloucester, Mass., a shipping and fishing center of New England and a community to which the movement of tides and the caprices of weather were a matter of daily concern. He moved to Boston, where he was trained and worked as a lithographer, but later returned to Gloucester to produce fine prints and to paint both landscape and marine subjects, particularly harbors. *Ships in Ice off Ten Pound Island, Gloucester* (Fig. 295) reveals the elegance of his crisp, clear drawing, as well as the subtle tonality and convincing sense of scale that distinguish his painting. His training as a lithographer had its effect in the precision of detail and the play of small black accents against pale and delicate grays. Unlike earlier painters of similar subjects, his concern was not so much with the facts —though the paintings reveal an amazing ability to adhere to the realistic aspects of his subjects—as with the mood of the weather, the color of the light, the pale distances, and the cold dreamlike clarity of the winter day at sea. This sensitivity to atmospheric effects and the spacious expanse of ice and sky suggest a refined and poetic temperament expressing itself through a discipline in which exact observation and controlled relationships of dark and light contribute to the heightened emotional tone that was the goal of a number of mid-century luminists.

below: 295. FITZ HUGH LANE. *Ships in Ice off Ten Pound Island, Gloucester*. 1850–60. Oil on canvas, 12 × 19 ¾". Museum of Fine Arts, Boston (M. and M. Karolik Collection).

GENRE PAINTING

Genre painting concerns itself with depicting everyday life, and, as the artist descended into the city streets, he inevitably focused on man, his activities, and his habits. Genre painting flourished in America all through the nineteenth century. That produced between 1830 and the Civil War displayed an engaging warmth and gentle humor, whether the subject was city life, the quaint ways of countryfolk, or the adventure of the frontiersman.

William Sidney Mount

A painter whose modest aims have frequently resulted in an underestimation of his abilities is William Sidney Mount (1807–68). Mount was a Long Island farm boy, one of three brothers, all of whom were practicing artists. After a period of apprenticeship to his brother and a stint at the National Academy of Design, he started his professional life as a painter of portraits and religious subjects in New York. Illness forced him to return to the country, and there he discovered his bent for portraying the life of the farm and countryfolk. Mount settled at Stony Brook, Long Island, and spent the rest of his life painting anecdotes of his rural surroundings.

Bargaining for a Horse (Fig. 296) reveals his particular talent—an ability to create a story from the quiet interplay of personalities and to invest the simplest subject with warmth and humor. The scene is composed with admirable skill. Against the well-observed and carefully designed pattern of picturesque farm buildings, fences, and distant

above : 296. WILLIAM SIDNEY MOUNT. *Bargaining for a Horse*. 1835. Oil on canvas, 24 × 30″. New York Historical Society, New York.

right : 297. WILLIAM SIDNEY MOUNT. *The Long Story*. 1837. Oil on canvas, 17 × 22″. Corcoran Gallery of Art, Washington, D.C.

trees, stand the bargaining figures. The patient stance of the saddled horse serves as a foil to the subtle contest of wits between the two whittling men, the younger and more aggressive trying to break down the older man's quiet stubbornness. The weathered shingles, split and rotting wood, and straw-covered ground are described with the same affection and understanding as the baggy garments of the men and the sleek, shining-coat of the horse. Equally well observed is the outdoor light—clear, cool, with sharp-edged shadows in which reflected lights cast a golden warmth into even the darkest tones.

In his day Mount was frequently criticized for expending his talents on rustic anecdotes, rather than applying them to lofty themes. Fortunately, he paid little attention to his critics and continued to paint his charming tales and bucolic scenes. *The Long Story* (Fig. 297), though not staged in the out-of-doors, also reflects the flavor and tempo of rural life and again reveals Mount's skill at narrative painting, his sense of character, telling gesture, and authenticity of detail. Despite his limited professional training, Mount was not a naïve painter. The stable pyramidal composition and the rich feeling for the

chiaroscuro of indoor lighting indicate that he had observed the masterpieces of the Dutch genre painters and learned from them.

Mount's significance is easily undervalued because of the unpretentious nature of his subjects. Content to depict the environment in which he lived with honesty, skill, and humor, he did much to turn the tide of painting away from history, literature, and the tedious, didactic tendencies of the day. Though his appraisal of reality was on a light, narrative level, it was reality and his own experience that concerned him. The first major genre painter in America, he remains one of the best.

Richard Caton Woodville

One of the most talented of the young nineteenth-century genre painters was Richard Caton Woodville (1825–56), whose early death kept him from realizing his full promise. Woodville was born and spent his youth in Baltimore. The Gilmor and Edmondson collection of Dutch genre painting which he saw there, combined with his own temperamental fondness for depicting the humor of character and situation, directed him toward the painting of picturesque narratives. Consequently he departed for Düsseldorf, the particular center at the time for the study of anecdotal painting. Except for two short visits home, Woodville spent the rest of his short life abroad, producing a small number of paintings that reveal his unusual gift for the incisive depiction of personality and place.

Politics in an Oyster House (Fig. 298) is an excellent example of his skill at vigorous narrative and at creating a convincing illusion of realistic form and texture. The rendering of surface textures, the particular earmark of the Düsseldorf school, is not overstressed here, as it frequently was in the hands of lesser men. Woodville's primary concern was to describe the character of people and places in interaction with one another. He was one of those fortunate artists whose ambitions coincide with their talents. His compositions appear completely unpremeditated, yet examination of *Politics in an Oyster House* reveals a thoughtful organization of the pictorial elements. Typical of his compositions is the limited space within which the figures are composed. The tone builds up from grayer values around the edges of the canvas to more brilliant contrasts of dark and light around the focal areas, creating a handsome and logical pattern. The way in which the shining white pitcher focuses attention on the gesturing hand is masterly. The faces, in effective relationship with the hands, bodies, and clothes, give evidence of a vivid appreciation of personality, just as the accessories reveal a quiet delight in the expressive character of inanimate things.

Each area of the painting has its element of interest. No part is dull, and yet the taste of the artist allows no part to become overly elaborated, and no objects appear to have been introduced merely to display the painter's virtuosity. The entire painting suggests a modest artist of intelligence, capable of viewing the world with affection and good humor, delighted with the color and flavor of everyday life. Master of the immediate and the specific, Woodville, like Mount, provided a refreshing antidote to symbolism and didacticism.

John Quidor and David Gilmor Blythe

Not all the painted anecdotes glorifying folkways were as restrained as those of Woodville and Mount. John Quidor (1801–81) and David Gilmor Blythe (1815–65) both painted with commendable zest and energy. One might expect their humor and skepticism to have made them immensely popular, for Americans of the period had already displayed a distaste for grand sentiments and pretentious philosophies, but both men lived in obscurity.

John Quidor spent most of his life in New York City. He appears to have been an eccentric dreamer and to have derived his livelihood from painting fire buckets, fire

298. RICHARD CATON WOODVILLE. *Politics in an Oyster House.* 1848. Oil on canvas, 16 × 13″. Walters Art Gallery, Baltimore.

299. JOHN QUIDOR. *The Return of Rip Van Winkle.* 1829. Oil on canvas, 3′ 3 ¾″ × 4′ 1 ¾″. National Gallery of Art, Washington D.C. (Andrew Mellon Collection).

300. DAVID GILMOR BLYTHE. *Art versus Law.* Before 1860. Oil on canvas, 24 × 20″. Brooklyn Museum (Dick S. Ramsey Fund, 1940).

engines, insignia, and banners. The subject matter for his imaginative and often fantastic paintings was taken largely from the whimsical stories of Washington Irving. The only artistic recognition he received during his lifetime was an exhibition at the National Academy of Design of a series of paintings that illustrated Irving's legends of early New York. Sadly enough, these paintings never found a purchaser, and Quidor gradually faded from notice. The vivid and fantastic grotesquerie of his imagination is well illustrated in *The Return of Rip Van Winkle* (Fig. 299). The technique employed is a painterly one, not the dry and precise style of the engraver or the popular illustrator of the day. Developed by underpainting and glazing, the forms swell up out of a luminous, golden, all-enveloping chiaroscuro. The paint, applied freely and zestfully, infuses the spaces and forms with a Baroque animation. The figures move with a diabolic energy far beyond the gentle legends that inspired them.

David Gilmor Blythe was born on the Ohio frontier and was active in and around Pittsburgh, Pa. He was both self-taught as an artist and self-reliant. Trained as a wood carver, he painted, carpentered, and wrote verses to make a living. Blythe painted Pittsburgh's traders, coal miners, and solid citizens with the vigor and gusto of a born caricaturist, and he was not above laughing at himself, as in *Art versus Law* (Fig. 300). In this trenchant commentary on his own life as an artist we see the essence

of his style. He had an innate feeling for the expressive gesture, as well as the ability to make a character or situation come alive through a few broad strokes of the brush. The architectural setting for his witty commentaries is as vital as the figures which move within them. Since Blythe appears unconcerned with subtle painterly qualities, one is apt to overlook the crisp certainty of his brush work, the forceful and clearly organized range of values, and the solid impasto by which he built up his lights in contrast to his transparent and limpid shadows.

The Frontier

The frontier was ever present in the consciousness of nineteenth-century America. It was inevitable that the taste for genre, as well as for the romantic and exotic, would stimulate painters to record the continuous movement into fresh territories. The life of the Indians, the bitter conflict between Indians and settlers, daily life in the raw new communities, even the strange birds, animals, and plants of the vast unstudied continent provided subject matter of infinite novelty.

George Catlin

Many artists went west to paint the life of the Indians. None left a more authentic and lively record of them than George Catlin (1796–1872). Catlin saw his first Indians when a delegation of chiefs visited Philadelphia en route to Washington. The dignity of their bearing made a deep impression on the young man, and in his own mind he

determined his future. "The history and customs of such a people," he wrote, "preserved by pictorial illustrations, are themes worthy of the lifetime of one man, and nothing short of the loss of my life shall prevent me from visiting their country, and of becoming their historian."

In 1832 Catlin set out from St. Louis to spend eight years living among the Indians of the Great Plains. During this period, in hundreds of drawings and paintings, he recorded the customs and habits of the various tribes. *A Bird's-eye View of the Mandan Village* (Fig. 301) is a fine study of Indian life, painted 1,800 miles above St. Louis in the area of the present state of North Dakota. Catlin also sketched numberless portraits of Indian chiefs and other individuals who impressed him. His portrait *One Horn (Ha-won-je-ta), a Dakota (Sioux) Chief* (Fig. 302) illustrates his facility in portraying his proud and colorful subjects.

Catlin worked rapidly, and his style is sketchy and free, tending to be more graphic than painterly. The paint is applied directly in a thin wash, and the color is bright, descriptive, but without subtlety. His particular ability lay in his capacity to establish a vivid sense of character and costume by a kind of pictorial shorthand very much his own. Equally admirable was his ability to describe

left : 301. GEORGE CATLIN. *A Bird's-eye View of the Mandan Village.* 1832. Oil on canvas, 19 1/2 × 27 5/8". Smithsonian Institution, Washington, D.C.

right : 302. GEORGE CATLIN. *One Horn (Ha-won-je-ta), a Dakota (Sioux) Chief.* 1832. Oil on canvas, c. 28 × 23". Chicago Natural History Museum.

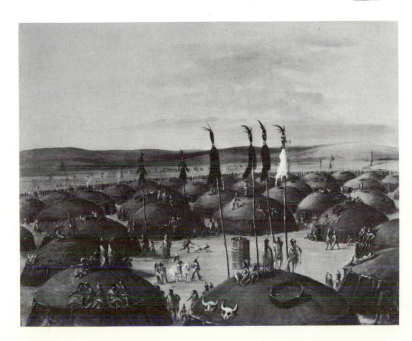

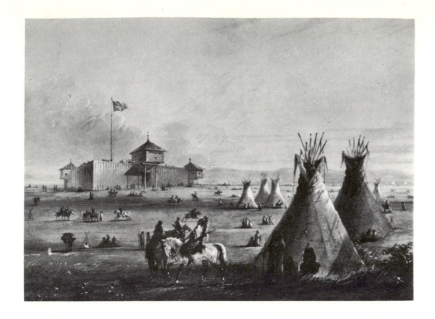

left : 303. ALFRED JACOB MILLER. *Laramie's Fort.* 1858–60 (from a sketch of 1837). Watercolor, 8 ½ × 11 ¾". Walters Art Gallery, Baltimore.

opposite : 304. GEORGE CALEB BINGHAM. *Shooting for the Beef.* 1850. Oil on canvas, 2' 11 ½" × 4' 1 ½". Brooklyn Museum (Dick S. Ramsay Fund, 1940).

complex tribal maneuvers or the tactics used in hunting buffalo without oppressing the onlooker with a tedious accumulation of detail.

Another artist who explored the Far West and painted and drew the first outposts of the frontier was Alfred Jacob Miller (1810–74). Miller was born in Baltimore and studied with Sully. While painting portraits in New Orleans, he was persuaded to join an expedition being organized to explore the Rockies in 1837. During this expedition Miller produced his most notable works. These included both landscapes and studies of the life of the Indians and the early white settlers. Perhaps his most interesting works are the sketches which picture the conquest of the wilderness. His watercolor of the early outpost at Fort Laramie, surrounded by an Indian encampment (Fig. 303) reveals his fresh and lively style. The vivid and picturesque character of frontier life is presented without the melodramatic tone that marred much late nineteenth-century painting of the Far West.

Among the other mid-century painters of Indian life and the Far West were Seth Eastman (1808–75), Charles Bodmar (1809–93), John Mix Stanley (1814–72), and Charles Wimar (1824–62).

George Caleb Bingham

Most artists who journeyed to the frontier saw it in terms of picturesque anecdotes, but it remained for a son of the frontier, George Caleb Bingham, to portray it with dignity, as a way of life. Bingham (1811–79) was born in Virginia, but his family moved to Missouri when he was eight. Left to support his family by the death of his father when he was fifteen, Bingham worked as a farm hand and as an apprentice to a cabinetmaker until a chance meeting with a traveling portrait painter, perhaps Chester Harding, spurred his ambition to be a painter. He subsequently executed a number of rather primitive portraits and, in 1838, realizing the need for training left for Philadelphia, where he studied for three months before returning home to continue with his career. Later he returned to the east a number of times, on his first return remaining for four years, during which he had ample opportunities to study the various American masters, among them probably the genre painter, Mount, as well as engravings and copies of the High Renaissance and Baroque masters. His ultimate achievements indicate that he had an astonishing capacity to absorb a knowledge of drawing and composition, for it was during these years of training that he developed his distinctive style, with its firm drawing and its carefully structured compositions, in which the formal groupings of figures reflect the compositional principles of Raphael, the Venetian masters, and probably Poussin. Most impressive was his capacity to project the Western genre into this monumental mold without sacrificing the indigenous flavor of his subject matter.

Bingham's masterpieces were painted in the dozen years following his return to Missouri in 1844. In 1856 he went to Paris, then to Düsseldorf for a period of study, but on his return political activities absorbed much of his energy and his painting suffered. It was soon after his return to Missouri following his four years of study in the east that he painted what is probably his best-known

work, *Fur Traders Descending the Missouri* (Pl. 12, p. 210). Here he showed his ability to select a subject both singular and typical, a subject as commonplace in his day as the activities of a garage mechanic are in ours. The painting conveys the tone of life on the frontier, even though it depicts that life in a quiet, contemplative moment, rather than in strenuous action.

The composition is remarkably direct and effective. The brilliant forms of the rowing trader, the relaxed, smiling boy, and the tame fox stand out with sparkling clarity against the calm horizontals of the water and the spacious background of misty trees and the sunny, moisture-laden sky. The reflections in the water, by providing a transitional value, relate the bright colors and bold contrasts of the figures in the boat to the tints of the background. The exotic accent of the seated fox, mirrored in the water, provides a dramatic and isolated vertical that acts as a foil for the dominant horizontals and helps to carry the eye left to convey the quiet downstream movement of the boat.

The color is equally noteworthy. The brilliant turquoise and vermilion of the men's clothes and the inky darkness of the fox sing out against the tawny sky and the green-gold tone of the water. The drawing of the figures is incisive and sure, the paint is applied easily yet unobtrusively, and the forms are solid, yet not ponderous. This ability to infuse the observed and described fact with sentiment and to invent an artistic structure to communicate the poetry of the commonplace situation constitutes the particular strength of Bingham. Nowhere is this power more apparent than in his *Fur Traders Descending the Missouri*.

Shooting for the Beef (Fig. 304) reveals Bingham's mastery of another type of genre. Here the late afternoon light sheds its glow over the sky, warmly illuminates the foreground figures, and throws across the earth great transparent shadows that define the sequence of planes which move back into the canvas and provide the framework for the action. The low point of vision, skillfully reinforced by the bright shapes of the watching dogs, causes the frontiersmen to loom up manly and strong, and the triangular grouping of the secondary figures inevitably focuses attention on the principal actor, the man taking aim at the distant target. The verticals of the figures and trees playing against the horizontal lines of the shadows, the vigorously sculptured forms, and the convincing attitudes of the men and the animals all work together to communicate to the viewer in grand, heroic terms the tense mood of the moment just preceding the decisive shot.

Bingham was an ardent believer in the democratic processes, and he understood the conflict and excitement, the elation and despair, of election time as one who had himself participated in the strenuous campaigns of Whigs

versus Democrats. *Verdict of the People* (Fig. 305) is one of the two great compositions he devoted to the election theme, a highly significant subject, since the moments of political assembly translated the drama of American democracy into a visual spectacle. In these two paintings, more than in any of his other works, we see Bingham's power as a master of cogent narration. The astonishing facility with which he grouped great numbers of gesticulating, highly individualized figures into a lucidly organized composition with both monumentality and action, both grandeur and narrative fluency, is doubly impressive in view of the relative isolation in which he developed his artistic talent.

In *Verdict of the People* one's eye moves into the painting via the dejected figure of the loser in the foreground. The eye mounts through a series of skillfully articulated diagonal lines that builds into a grand pyramidal grouping of figures. On the left the eye follows the line of the barrow back into the picture through the body of the Negro, up through a group of secondary figures, to the triumphant orator, who, framed by the majestic columns and recessed portico, forms the apex of the pyramid. From the same foreground figure the other side of the pyramid mounts through the centrally located seated man, carries through the charming and wry note of the long-nosed cast shadow, to the same dominant figure of the speaker. On the far right a balancing cluster of men takes the eye aloft and then turns one's attention back toward the center through the upraised arm of the smiling celebrant. The movement into the depth of the canvas is controlled with equal facility. There is not an ambiguous space nor an unrealized figure to confuse one in the entire picture. The lively color and the brilliant alternations of tone contribute to the vigor of the total effect. The painting is the positive and energetic statement of a healthy extrovert who delights in describing the hardy processes of democracy and who wholeheartedly believes in the "verdict of the people." More than any other single individual Bingham gave artistic form to the spirit of the Western frontier.

below : 305. GEORGE CALEB BINGHAM. *Verdict of the People.* 1855. Oil on canvas, 3′ 10″ × 5′ 5″. Boatmen's National Bank of St. Louis.

John James Audubon

Not all the artists who traveled into the wilderness were looking for the melodrama of Indian warfare, the color of frontier life, or the vast sweep of the western landscape. Another aspect of American life that proved exciting to a small group of artists was the infinite number of birds, animals, and plants that inhabited the bounteous country.

John James Audubon (1785–1851) is by far the best-known and most important of these artist-naturalists. Born in Haiti, Audubon was educated in France, where he received some instruction in drawing. After his arrival in America and subsequent marriage, he settled on the Kentucky frontier to make a living as a merchant. However, his love of the wilderness proved to be too much for his business career, which he finally forsook to follow his great passion, studying and drawing America's birds.

After completing an initial series of watercolors, Audubon conceived of the idea of publishing a comprehensive portfolio of his bird studies. He found little support for his idea in Philadelphia, the chief publishing center in America. Convinced of the merit of his project, he set sail for England, where his enthusiasm and perseverance bore fruit, and within ten years he achieved the astonishing feat of bringing this great publication to completion. The labors involved were endless, but *The Birds of America, from Original Drawings, with 435 Plates Showing 1,065 Figures* was brought out in four double-elephant folio volumes between 1827 and 1838, and the five volumes of accompanying text, the *Ornithological Biography*, were completed in 1839. The original studies for the work were executed in watercolor, and the engravings, mostly by Robert Havell, Jr., from which the plates were printed, retained the decorative quality and the informative exactness of the originals to a remarkable degree.

The Birds of America is one of the great scientific and artistic achievements of the century. Almost every plate has its own particular charm. *Carolina Parroquet* (Fig. 306) is one of the many which display his unusual talents—a rare sense of design combined with an ability to provide a full cataloguing of the birds' identifying characteristics. In all the plates the birds are pictured in their natural habitat, with branches, leaves, flowers, grasses, rocks, and waves disposed over the pages with an infallible decorative taste. These forms are kept sufficiently flat so that they carry as simple patterns, yet within the flat organization the details of forms and textures are developed through clearly defined lines and silhouettes. The subtle yet lively colors are distributed with an unerring eye for the total ensemble; still, they retain their factual validity. By developing the forms to something less than their full volume and by minimizing the envelope of air, Audubon avoided any possible ambiguity as to shape or marking and emphasized the over-all pattern.

Audubon's oils are less well known than his illustrations, but their full-bodied realism makes it apparent that in the plates for his great book he accepted the challenge of scientific illustration and from its limitations conceived and developed an original graphic style.

STILL LIFE

The still-life painter is the genre painter of the inanimate. While the genre painter portrays the everyday life of people, the still-life painter concerns himself with the world of everyday things. The nineteenth-century Romantic, becoming increasingly less concerned with the exotic, the wild, the remote, and the unfamiliar, gradually turned

right : 306. JOHN JAMES AUDUBON. *Carolina Parroquet,* original for Plate 26 of *The Birds of America.* 1827–38. Watercolor, 29 ½ × 21 ¼″. New York Historical Society, New York.

his attention to the poetry of the familiar and was able to weave a spell of sentiment about the most commonplace objects.

A catalogue of the "Columbianum Exhibition" of 1795 lists a number of still lifes, including examples by Copley, William Birch, and James Peale. The many still-life painters in the Peale family did much to establish a school of painting patterned after traditional seventeenth-century Dutch and Flemish models.

The *Poor Artist's Cupboard* (Fig. 307) is a charming still life of an original nature. The artist, Charles Bird King (1785–1862), is best known as a minor portraitist and painter of Indians. In *Poor Artist's Cupboard* he foreshadows the *trompe l'œil* of the latter half of the century. The unique charm of this still life results from the many avenues through which it appeals to our senses and our sentiments. First and foremost, one is aware of an intense and magical illusion of reality. The various surface textures are rendered so that they can almost be felt; the smooth glass, shiny seashell, old leather, and crusty bread are all painted to appeal to our tactile sense. Also contributing to the effectiveness of this painting is the animated pattern created by the various shapes, colors, and textures—the light paper shining out against dark book bindings; the sheen of glass, shell, and metal against the dull, worn surface of red leather; the brightly illuminated lower left-hand corner contrasting with the shadowy upper recesses of the cupboard. Though the pattern is complicated, the composition moves with gusto. The forms build up in vigorous diagonals, through the various books, the shell, a roll of paper, and a curled print, to the sheriff's notice of sale that terminates the composition. The total effect is one of unusual vivacity.

Still another source of interest is the story inherent in the subject matter. King's ironic humor is evident in the sequence of book titles: *Lives of Painters, Pleasures of Hope, Advantages of Poverty.* These, in juxtaposition with the sheriff's sale sign tell their bitter-sweet story without any other props, though the theme is reiterated by the glass of water and the loaf of dry bread. All these commonplace objects also have the seeming magic of discarded and long-forgotten things which convey a sense of the past and the passing of time. King's *Poor Artist's Cupboard* and a very similar composition, *The Vanity of an Artist's Dream*, in the Fogg Art Museum, Cambridge, Mass., are among the great still-life paintings of the early nineteenth century.

FOLK ART

All through the nineteenth century a multitude of untrained men and women in all walks of life painted more for pleasure than for profit. To the degree that they followed any conventions or traditions, they followed those of folk painting, far removed from the lessons of the academies and from both Romantic and classical concepts and devices. In this folk tradition, forms were clearly defined, but as flat, decorative designs rather than as three-dimensional entities. Compositions were conceived in terms of a flat picture plane, rather than spatially. The traditional academic conventions for achieving depth, particularly the use of perspective and foreshortening, were largely ignored. Details of pattern and texture were carefully observed and as carefully described. Because these nonprofessional painters were frequently artists of sensitivity, they often revealed a singular capacity not only to convey their perceptions with clarity and a fine decorative sense but also to communicate their emotions with enviable directness and force. Their forms, motifs, and textures assault our eyes more immediately than they would had they been embedded in familiar conventions.

Folk artists are seldom inventive about what they paint. Landscapes, still lifes, illustrations of Biblical texts, genre studies, and, of course, portraits were the most popular subjects. *The Herbert Children* (Fig. 308) is signed by L. Sachs and dated 1857. It is evident that the artist was not completely naïve. Some training is revealed by his systematic use of light, shade, and, most important,

307. CHARLES BIRD KING. *Poor Artist's Cupboard.* 1812. Oil on canvas, 29 ⁵/₈ × 27 ³/₄". Corcoran Gallery of Art, Washington, D.C.

reflected light to build form. Traditions in the posing of children have been carefully observed; the children are seated in front of a partially drawn curtain which reveals a charming bit of landscape with flowering shrubs, a lake with sailboats on it, and a sky with floating clouds. The children are playing with their toys, and one child rests her hand on the shoulder of the other. Reynolds and his followers might have been charmed with the subject, if not the execution.

Here the similarity to fashionable portraiture ends. The composition is almost formally bisymmetric, the swirls of skirts balancing one another, as do the patterns of sofa and flowering shrubs. There is no interest in such intangibles as air or space, but the surface facts fascinate the artist. Each fold of cloth is carefully described. Each anatomical detail—the hollow below the temples, the serious, questioning eyes, the compressed lips—is depicted with scrupulous honesty. The leaves on the rose bushes have been seen one at a time, and the patterns of the sofa have been described as the artist knows they are, rather than as he sees them, and through his eyes we share his fresh enthusiasm and unjaundiced vision. His fact becomes our fancy.

In 1836 Joseph H. Davis painted a watercolor of James and Sarah Tuttle (Fig. 309) which reveals to an unusual degree the peculiar strengths of the naïve artist.

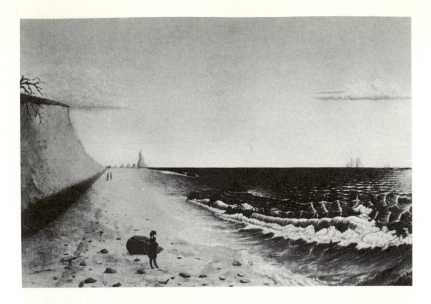

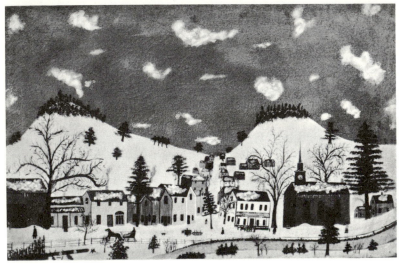

Unlike L. Sachs, Joseph Davis was probably without any formal training. The faces, details of costume, and furniture give ample evidence of the artist's painstaking observation. The couple sit in dignity, reading the Bible in their parlor. The picture on the wall, the pattern of the rug, the grain of the table, the cat, the fruit, and the hat are all noted with due seriousness. The symmetrical arrangement of the seated figures is both a formal compositional device and a subtle statement of human relationship. Such a painting provides a refreshing and delightful insight into the manner in which an artistic intelligence reacts intuitively to the familiar world. Training might have enabled Joseph H. Davis to depict forms with more illusion of depth, weight, air, light, and shadow. But training would probably not have enabled

him to recreate the mood of Mr. and Mrs. Tuttle in their parlor either more vividly or more charmingly.

The body of anonymous portraiture produced throughout the nineteenth century transmits the impression that there existed among the people deep reservoirs of sentiment and creativity sufficient to sustain a rich and continuous development of the arts in America.

The landscape had a particular appeal to the untrained folk painter. Though it was part of his immediate environment, and thus familiar, it was also an accredited subject for professionals, worthy of display in art galleries and national exhibitions. In addition, it provided an outlet for both the aspiring painter's fascination with detail and his lofty sentiments. *Meditation by the Sea* (Fig. 310) may have been suggested by a Kensett, for the unknown artist,

like Kensett, seems inspired by a limitless expanse of sky, sea, and shore. True to folk-art practice, the details are not lost in an all-encompassing sweep of vision but, bit by bit, are clearly delineated. The small figure in the foreground, staring thoughtfully at the foamy breakers and glittering waves, provides an effective symbol of man's insignificance in the face of nature's overwhelming grandeur. Clouds, an ambling couple, rocks, and distant sailboats may be softened by the atmospheric envelope, but an unblurred horizon suggesting the limitless sea is depicted as the most constant fact in the painting, realistic space meaning less to the artist than symbolic space.

If some folk artists were moved to paint the vastness of nature, the animation of daily life suited many with less lofty ambitions. The artist who painted *American Landscape* (Fig. 311) reveals his naïveté both by the style of his work and by the disarming signature, L. Whitney Pt. ("Pt." signifying either "painter" or "Pinxit," that is "Painted"). The gay pattern of houses, a church, and a barn stretches across the front of the canvas, and houses mount the steep hill behind. Clouds fleck the sky, and bare trees and evergreens provide dark accents. Tiny figures and other details furnish a sense of scale and contribute life to the scene. No element of technical skill blocks this folk artist's direct expression of his delight in a familiar scene.

Still life has always been popular with the folk artist, for it involves fewer challenges than other subjects. Every home, no matter how humble, can provide models, and there are few of the problems that beset the landscape and portrait painter. In this period when the folk arts flourished, still lifes were turned out by painters from all walks of life—the sign or house painter with visions beyond the routine of his job, young ladies in seminaries, the housewife desirous of beautifying her home, and countless others. In answer to their needs, sets of stencils of fruit and flower forms were manufactured to aid and guide the young or untrained painter. These stencil, or "theorem," paintings, in the hands of a person of taste, often yielded charming decorations that show a fine sense of color and a discriminating use of media.

The nineteenth century witnessed a revival of religious fervor, which was reflected in the religious paintings of folk artists. Three examples will give some idea of these direct and moving expressions of faith. A watercolor, dated about 1800, representing the Crucifixion (Fig. 312) is from one of the Pennsylvania German communities. The drawing is highly formalized. Christ on the Cross, the two thieves, and the Roman soldiers are part of a design which includes conventionalized flowers, geometric patterns, and Biblical texts executed in *Fraktur*, the art of illuminated writing elaborated with pen-drawn decorations. The formalized and calligraphic nature of this Crucifixion in no way negates its expressive power; rather, to a degree because of this nature, it remains a testimonial to the sincere faith of the pious country folk.

The second illustration of religious folk art is a *retablo* from New Mexico. The *retablos* were religious images painted or carved on a flat surface by the Indians of New Mexico for use in a home shrine or in church. A *retablo* representing the Virgin Mary with the Holy Ghost (Fig. 313) is based on the traditions of Latin American religious painting, but it achieves additional interest through its provincial Indian flavor. The forms are represented as flat patterns without perspective or foreshortening. The vigorous, rhythmic lines and direct, simple shapes

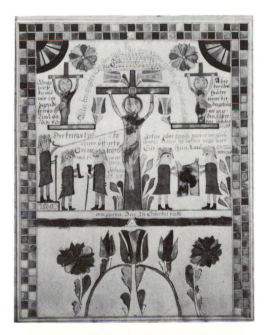

create an image of dignity and grace. The compassionate Virgin, seated on a throne and radiating light, is depicted with the unquestioning assurance of primitive people and children, who allow no problems of representation to interfere with their image making.

The third popular religious painting, *The Peaceable Kingdom* (Fig. 314), by Edward Hicks (1780–1849), provides a charming note on which to end this discussion of painting in America between the Revolutionary War and the Civil War. The life span of this naïve sign painter from Bucks County, Pa., extended over most of the period. Hicks was a Quaker, and his paintings were an expression of his convictions, his deep faith, love of peace, and literal belief in the word of the Bible. His most popular subject was drawn from the prophecy in Isaiah XI: 6 of a day when "the wolf shall dwell with the lamb and the leopard shall lie down with the kid," and he painted it more than a hundred times, usually depicting an assembly of animals, carnivorous and herbivorous, resting together with children and cherubim in an idyllic landscape setting. Hicks frequently set in the background a secondary group of figures to reinforce the basic theme. William Penn signing his peace treaty with the Indians was his favorite secondary motif, since it represented both an American and a Quaker contribution toward the happy state prophesied in Isaiah. He gave his paintings as gifts to his neighbors, acquaintances, and relatives to indoctrinate his fellowmen in the ways of peace.

Hicks painted in the manner of most untrained folk artists. The forms are kept flat and the contours are clearly defined. The animals present a charming combination of ideas and visual impressions. The glittering eyes of the cat family, the gay spots of the leopard, the placid ruminating oxen, the enfolded sleeping lamb are all translated into simple but vivid patterns, and the compositions are often embellished with lettered Biblical texts.

In his own day Hicks was not thought of as an artist. It is unlikely that he or any of the humble neighbors whose homes were graced by his pictures would have described him by so pretentious a term. Had they known that in a hundred years his paintings would be the prized possessions of museums and connoisseurs, they, and he himself, would with true modesty have probably attributed the success of his pictures to the source of his inspiration, the Holy Bible, rather than to the artistry of Hicks. Like thousands of other Americans who painted from conviction rather than for profit, he felt impelled by some inner need to give form to his beliefs. He did this like the conscientious sign painter that he was—carefully, with craftsmanlike precision, using soberly defined forms and neatly applied pigments. Part of this simple and uncritical attitude stemmed from his childlike ability to draw on a deep reserve of images from remembered Biblical illustrations and folk patterns. With these he created his direct statements of faith.

Today, having come through a long and arduous education designed to develop sophistication of technique and taste, we recognize the power of the naïve image born of conviction. Having almost lost the ability to symbolize our beliefs without self-consciousness, we have come to value direct self-expression more than technical virtuosity, sincerity more than facility, taste more than formula. These are the appealing qualities that we find in the unique pictorial forms by which Hicks and other artists embodied their faith.

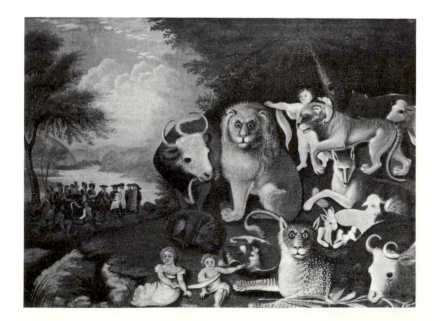

left : 314. EDWARD HICKS. *The Peaceable Kingdom.* c. 1848. Oil on canvas, 17 1/2 × 23 5/8″. Brooklyn Museum (Dick S. Ramsay Fund, 1940).

opposite : 315. JEAN-ANTOINE HOUDON. *George Washington.* 1788 (installed 1796). Marble, height 6′ 2″ (without base). State Capitol, Richmond, Va.

12

Sculpture, Prints, Photography, and Art Patronage

An American school of sculptors, as distinct from the native folk carving tradition, came into existence in the interval between the Revolutionary War and the Civil War. This development was largely a result of the surge of patriotic sentiment that followed the successful struggle for independence. A desire for commemorative portraits made itself felt almost immediately after the Revolution, with figures of George Washington, the most revered of the revolutionary heroes, most in demand. Since there seemed to be no native artists of sufficient prestige to undertake monumental sculptures, the first major commissions went to Europeans.

The state of Virginia, with a new capitol building in Richmond, was the first to desire a full-length figure of Washington. At the suggestion of Jefferson, Jean-Antoine Houdon, who had portrayed the major prophets and protagonists of the French Revolution, was offered the commission. Houdon visited the United States to make studies of Washington, and in 1796 the completed marble statue was delivered and installed in the rotunda of the State Capitol, where it still can be seen. It has remained a source of inspiration and dissent for successive generations, for though the head and torso were found to be grand and properly imposing, the legs were frequently criticized as being spindly (Fig. 315).

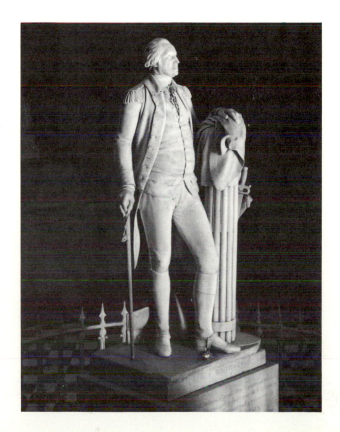

An ambitious Italian sculptor with both republican sympathies and grandiose ideas, Giuseppe Ceracchi, visited Philadelphia between 1791 and 1794 with the idea of creating a 100-foot patriotic allegory to liberty. He made masks of Washington and other important political personages but was forced to abandon his grand project because its overwhelming scale and elaborate symbolism seemed not to appeal to the pragmatic American temperament. However, the mask Ceracchi made of Washington served one worthy purpose: it provided a likeness for the use of Antonio Canova, the brilliant Italian neoclassic sculptor, who received the next major commission in America. In 1810 North Carolina entrusted Canova with the execution of a Washington for its new capitol building. The ill-fated statue, unveiled in 1821 and greatly admired, was destroyed by fire ten years later.

That no local sculptors were judged worthy of monumental commissions comes as no surprise. The local school of wood carvers, though their output was simple and charming, were neither technically nor esthetically prepared to attempt such ambitious projects, and no other native school of sculptors existed. It is therefore worthy of note that in one short decade after the destruction of Canova's *Washington* three American sculptors, Horatio Greenough, Thomas Crawford, and Hiram Powers, were well established in Italy and were engaged upon large and lucrative commissions, so rapidly had a few American sculptors achieved fame and prestige. In the 1850s dozens of American sculptors were studying in Florence and Rome and were sending back to America a steady flood of portraits and idealized allegorical and mythological figures patterned after those of Canova and the other classic-revival sculptors. The same fever for the culture of ancient Greece that had produced a rash of white, porticoed buildings in every American city also demanded white marble figures, since that was considered the form in which the artistic genius of Greece had received its fullest expression.

The florescence of American sculpture in the two decades from 1830 to 1850 was astonishing. The most concrete evidence of the value placed on sculpture in this period is given by the prices the sculptors received for their work. Canova received over $11,000 for his North Carolina statue of Washington, an impressive sum when one realizes that the annual expenditure of the state was then about $90,000. Hiram Powers, the most successful of the Yankee sculptors working in Italy, sold six replicas of the sensational *Greek Slave* (Fig. 326) for prices averaging about $4,000 each. By mid-century the demand for classical figures and allegories was exceeded by the market for portraits, and these, too, brought impressive prices. Curiously enough, the popularity of

sculptured portraits was in part the result of the newly established parklike cemeteries, where sepulchral white marble likenesses ensured a kind of classic immortality.

The successful sculptors preferred to live in Italy only partly because of the inspiring treasures and the opportunity for study that existed there. Wealthy Americans were more approachable and more in the mood to purchase works of art and commission portraits in the art-laden climate of Italy. Even more important, skilled Italian marble workers were available at a fraction of the cost of workmen at home, and these men could translate a crude clay sketch into a shiny, finished product with a surface perfection which glossed over weaknesses of structure or conception. The substantial monetary award available to sculptors undoubtedly enticed many energetic and ambitious American boys to choose sculpture as a career. It may also explain why much sculpture produced in this period is less interesting than the painting. The work of the neoclassic sculptors who sought success in Italy will be discussed later in this chapter.

FOLK CARVING

A rich body of folk carving developed during the early years of the Republic. With the expansion of American shipbuilding after the Revolution there came an increased demand for the products of the skilled workers in wood. The wood carver tended to think of himself as a workman and so was content to remain anonymous. In this respect he was unlike the ambitious sculptor of the day, who thought of himself as an artist and demanded both fame and fortune. Time has reversed the judgment. Today we seek the names of the men who made the charming and unpretentious carvings that graced the ships, shops, and homes of the early days of our Republic, while we tend to forget the creators of the fashionable nymphs and goddesses. Fortunately, the fame of some of the master carvers was widespread enough to have been remembered beyond the immediate locality where they worked.

Three sons of the older Simeon Skillin, presumed author of the *Mercury* (Fig. 192), continued to practice his craft, and from their shop in Boston they sent forth countless fine carvings to decorate Boston's ships, homes, gardens, and public buildings. For the figureheads they carved they drew on varied sources, mythological and historical as well as purely fanciful. They carved gods, goddesses, and shepherds for mantels and gardens, and Corinthian capitals and yards of classic moldings for the new public buildings. Simeon Skillin the Younger (1756–1806), following in the footsteps of his father, was one of the ablest wood carvers of his day. His head of Apollo (Fig. 316) is one of a pair of matched polychrome wood

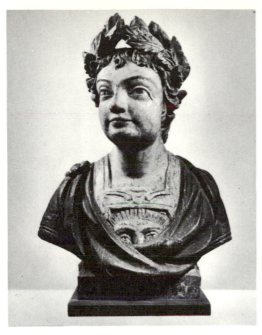

figures. The carving is boldly executed; all the forms are fully developed and clearly articulated. While Skillin shared the current enthusiasm for classical subjects and the classic manner, he was not overwhelmed by it. Ancient precedent did not obliterate all traces of personality from the head, which has enough individuality of feature and expression to suggest that it might have been done from a sitter. The draperies, costume, hair, and acanthus wreath have the vigorous rhythm that enlivened the figureheads for which Skillin was famed. The polychrome decoration that distinguishes folk carving from the "fine arts" sculpture of the period is also clear and lively.

Figureheads and Signs

Since shipping was one of the first industries to develop after the Revolution, it is not surprising that the carving of figureheads was one of our major crafts. Placed at the front of the ship under the bowsprit, the figurehead was the symbol of the vessel. It served no practical purpose but was regarded with almost superstitious reverence by crew and owner alike, signifying pride in the beauty and sturdy strength of the ship. The most characteristic figureheads were full-length figures, often female. The subjects, usually related to the name of the ship, included historical figures, mythological and allegorical beings, portraits of the owners, and characters from legend, literature, and romance. Animals, sea serpents, dolphins, and mermaids were also used. The early figureheads stood almost erect, because the rounded hulls of the earlier vessels seemed to demand vertical figures. As the ships became sleeker and narrower, the figureheads leaned forward until on the clippers they were almost horizontal. The figures were usually carved from white pine, frequently from one solid block of wood, and were painted and gilded. Most of the men who carved figureheads had no training beyond that of an apprentice to a master carver. At the end of the nineteenth century the use of the figurehead disappeared. As steam replaced sail, the colorful carved forms of the earlier days gave way to more discreet symbols.

Isaac Fowle (1818–53) carved some of the finest figureheads to come out of Boston, where he and his son were active for over sixty years. The boldly sculptured figurehead of a woman with billowy skirts (Fig. 317)

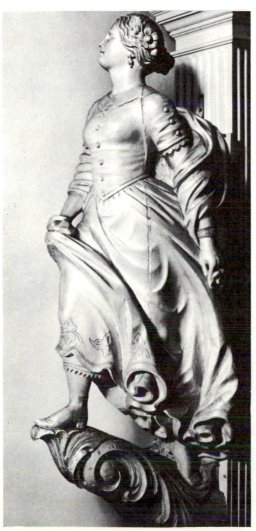

above: 316. SIMEON SKILLIN, JR. *Apollo.* c. 1800. Carved and painted wood, height 24″. New York State Historical Association, Cooperstown, N.Y.

left: 317. ISAAC FOWLE. Figurehead. c. 1830. Carved wood painted ivory color, height 6′ 2″. Bostonian Society, Old State House, Boston.

served as the sign which identified his shop. The body of the woman is solidly realized beneath the sweeping draperies. The vigorous rhythm which gives this figurehead its striking movement is established by repeating the long arc of the bow of a boat in the two massive folds of skirt and in the upward lift of the head. This figure has none of the sharp-edged stiffness that marred the products of inferior shops of the day; the sculptural form is realized with richness in the volumes of both the figure and the costume.

Another outlet for the talents of the wood carver was the wooden figures placed at shop doors to identify the establishment and attract attention. These gaily colored and often amusing figures constitute an appealing part of our visual folklore. *Captain Jinks* (Fig. 318) stood in front of a cigar store in Newark, N.J., for more than fifty years. The remarkable feeling of movement in the stationary figure is the achievement of a very capable and observant artist. A rhythmic line sweeps up from the beautifully simplified legs through the rigid body and

The Little Navigator (Fig. 320), from about 1835, probably marked a ship chandler's supply shop in New Bedford, Mass. The vigor of such a piece of sculpture results from the balance between the humorous aspects of the figure and the innate sculptural sense revealed by the consistent relationships of the chunky forms.

Religious Carving, New Mexico

America produced little religious sculpture. Protestant opinion, which dominated American religious life in most parts of the country, considered religious sculpture to be identical with idolatrous images. Even the Catholic community through most of the country reflected this attitude, importing from Europe most of the little sculpture it employed. However, the Spanish-speaking Southwest did not share this aversion to the carved and painted image. There, where Catholic ritual and Indian traditions had worked together to produce the mission church, the two heritages combined also to create a unique body of folk sculpture. Church services and processions played a significant part in the lives of the Indian converts, who, still not far removed from their primitive religions, needed images to symbolize their adopted faith. Under the guidance of Spanish priests the Indians were trained to copy the models set before them, to carve with metal tools, and to finish the carved wood figures with gesso, gilt, and paint. As time passed, the Indian carvers evolved their own simplified but expressive repertory of symbolic forms. The carved figures produced by the villagers of New Mexico were called *bultos*, signifying three-dimensional images. The particular power of these images lies in the directness with which they communicate the deep religious beliefs of the simple men who produced them.

Father Jesus (Fig. 321) reveals both the ancestry of the *bultos* and the direct impact they make upon the senses. The influence of the traditional polychromed sculpture of the Counter-Reformation is very evident—the figure is colored, clothed, and has real hair. But the astonishing illusionism of the European models has given way to bold simplifications of form and pattern that communicate only the essence of a situation. One is most conscious of the great sad eyes, the emaciated cheeks, and the streaming blood. Such a figure provides a symbol of Christ's suffering reduced to the most elemental and readily comprehensible terms, with no element of technical virtuosity to distract from the direct expression of religious feeling. *Father Jesus* is probably from the last half of the century, but it exemplifies the tradition that reached its height between 1820 and 1840, years which are considered the "classic period" of New Mexican folk art because of the superb quality of the carvings and paintings then produced.

folded arms to the erect head and creates an attitude in which movement and repose are skillfully related. The exaggerations of anatomical form—the long, thin legs, puffed-out chest, columnlike neck, and egg-shaped head with aquiline nose and sweeping mustaches—express a light and ironic attitude toward military formality which is refreshing in an age that tended to be cloying in its propriety and sentimentality.

The most frequent figure to identify the tobacconist's shop was the wooden Indian, for tobacco was the best-known gift of the red man to our civilization. Though isolated figures of Indians appeared before 1800, the type became popular only with the advent of cigar smoking after 1840. By mid-century two to three hundred of these figures were manufactured yearly by firms in New York, Chicago, and elsewhere. The figures were usually hewn from white pine and were patterned after old prints and colored lithographs or were modeled from live Indians. The Indian chief (Fig. 319) was the most popular form, but squaws and other types were occasionally produced.

THE NATIVE SCHOOL OF SCULPTURE
William Rush

It is difficult to draw a line of distinction between the folk carver and the sculptor. Certainly the sculptor seems to be more aware of the formal qualities of composition and the monumental aspects of form that have characterized the great sculptural tradition. William Rush (1756–1833), more than any other individual, seems to be a transitional figure between the folk carver who practiced his craft without self-consciousness and the artist concerned with the formal problems of sculpture. Rush has frequently been called America's first sculptor, though mention should be made of Patience Wright (1725–86), who, at an earlier date, modeled life-sized figures in colored wax here and in England, where she died. Perhaps it would be more accurate to say that Rush was the first man in America to whom the practice of sculpture was a major professional concern. Born in Philadelphia, the son of a ship carver, Rush grew up with the wood carver's tools in his hands, and wood was the material of much of his life's work. His output falls into three categories: ship carvings, allegorical figures, and portraits, which are usually busts but include a few full-length figures, notably the famous portrait of George Washington. The ship carvings by Rush were, in the opinion of his day, the finest produced in America, if not in the world. This was a genuine tribute in an age when ship carving was a living art with a highly critical audience. Among his most notable allegorical sculptures are the handsome wooden figures of *Comedy* and *Tragedy* which enhanced the old Chestnut Street Theater in Philadelphia.

Rush's life-sized figure of Washington (Fig. 322), seen here in the form of a bronze cast, reveals both his skill as a wood carver and his power as a monumental sculptor. Rush had always been concerned with the inadequacies of wood for permanent sculpture. In order to minimize the tendency of wood to shrink, check, and split, Rush states that he made it "hollow, so that air circulates through the inside ... for it is not more than three inches on an average in thickness, is perfectly seasoned and saturated with oil." The figure is posed so that a vigorous **S** curve unifies it and reaches fulfillment in the beautifully poised, lifted head. The opposing movement established by the hand resting on the left hip and continued through the extended right thigh and leg provides a strong counterbalancing stress. Rush was ingenious in the way he reconciled the taste for classical attire in sculpture with his own penchant for realism. Washington is dressed in the costume of his day, amplified by sweeping draperies that fall across the hips and thighs. This device, probably inspired by the thin and unsculptural legs that for many

marred Houdon's *Washington*, unifies the lower part of the figure by making one massive form of the separate legs and adds a note of official dignity to the figure.

Though wood was Rush's favored material, he handled other media with success. His portrait bust of the Marquis de Lafayette (Fig. 323) is sharply observed and forcefully realized. No sentimental idealizations of form blunt the sculptor's clear vision. The firm jaw and strong mouth, the quizzical and inquiring expression of the lifted eyebrows, and the half-closed lids create living portraiture without any dependence on the clichés of classic formula. Rush combined the requisites of a great sculptor in his sense of formal and monumental qualities, his feeling for the sculptor's materials, his ability to handle details of pattern and texture with grace, and his sensitivity to human values of character and personality. That some of

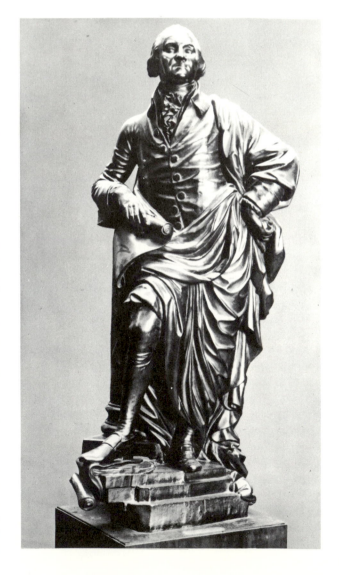

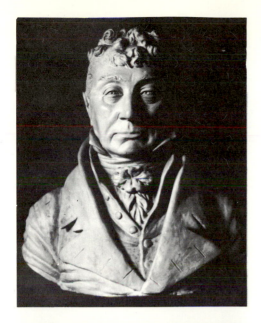

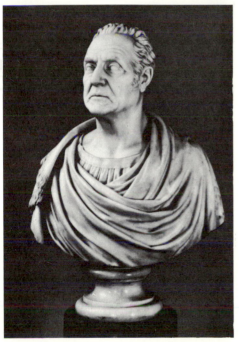

his great potential remained unrealized was the inevitable result of the limitations of his milieu.

John Frazee (1790–1852), another native-born sculptor, bridged the gap from artisan to artist by commencing his career with the popular frontier pastime of whittling. When he was twenty, he apprenticed himself as a stonecutter and subsequently acquired his initial training by carving tombstones. When the successful conclusion of the War of 1812 brought a spell of prosperity, he established a business to produce a variety of ornamental items, including sculpture and carved stone, wood, and cast metal decorations. His sources for learning were meager, consisting of a few plaster casts and even fewer carved stone figures by the Italian stone cutters who had been imported to adorn the new public buildings. Frazee revealed an unusual capacity to learn, and in 1825 he executed a bust of John Wells for St. Paul's Chapel in New York City, the first marble bust to be made in America by a native-born sculptor. The successful completion of this project brought him a commission to execute seven portrait busts for the Boston Athenaeum. This was an important assignment for that time, and the fact that it was awarded to a person of Frazee's limited background indicates the respect in which his achievements were held. The saccharine influence of the classic ideal which was to infect his late work had not as yet impaired the talent for trenchant realism revealed in his portrait of Col. Thomas H. Perkins (Fig. 324), one of the most forceful of this group of seven heads.

The career of Hezekiah Augur of Connecticut (1791–1858) also illustrates the transition from craftsman to artist in the early years of the nineteenth century. A carpenter's son, he showed a natural aptitude with wood and carpenters' tools and rapidly became an expert cabinetmaker and wood carver. Encouraged by others and inspired by some plaster casts of classical subjects, he began to do portraits and figures in marble. His efforts, like those of many relatively unsophisticated sculptors, are naïve in some respects, but they are expressive and reveal a native sculptural sense. His most famous work, *Jephthah's Daughter*, was probably the first classically idealized figure group to be produced in marble in America.

No classical aspirations vitiated the vigorous portraits of John H. I. Browere (1792–1834). Much controversy existed in Browere's day as to whether the portrait busts he made from casts taken from the living subjects were works of art or merely mechanical records of the appearances of his sitters. Browere, to create a gallery of busts of American heroes, traveled from city to city to make casts of the faces of heroes of the Revolution and the War of

opposite : 322. WILLIAM RUSH. *George Washington.* 1814. Bronze, height 6′ 10″. Pennsylvania Academy of the Fine Arts, Philadelphia.

top : 323. WILLIAM RUSH. *Marquis de Lafayette.* 1824. Terra cotta, height 24 ½″. Pennsylvania Academy of the Fine Arts, Philadelphia.

above : 324. JOHN FRAZEE. *Col. Thomas Handasyd Perkins.* 1834. Marble, height 31″. Boston Athenaeum.

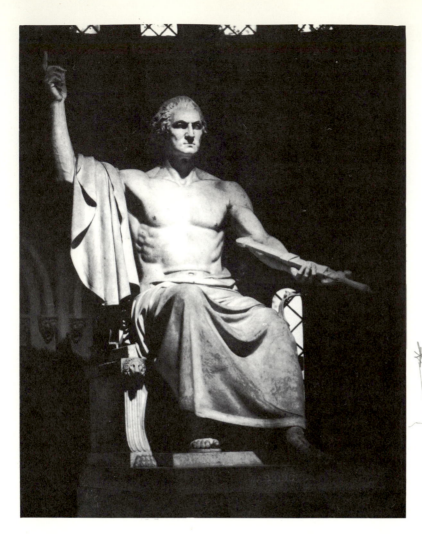

325. HORATIO GREENOUGH. *George Washington.* 1832–40. Marble, height 11′ 4″. National Collection of Fine Arts, Smithsonian Institution, Washington, D.C.

1812, of presidents, vice-presidents, and other notables. Between the years of 1825 and 1834 he assembled an impressive number of portraits of America's great. Well posed and finished, they contributed to the country's evolving tradition of realism.

THE ITALIAN SCHOOL

Local sculptors were not sufficiently recognized during the first years of the century to be entrusted with the sculptural decorations needed to complete the new capitol buildings. Though Latrobe greatly admired the figureheads by Rush, declaring that no one in Europe could equal them and that they "seemed rather to draw the ship after them than to be impelled by the vessel," he did not direct any of the available sculptural commissions to Rush. Jefferson was determined to have well-trained men from Europe decorate the new government buildings. In 1806

Giuseppe Franzoni (1786–1819) and Giovanni Andrei (1770–1824) were brought from Italy to work on the House of Representatives, the first of a succession of competent, if uninspired, Italian sculptors to be employed first in Washington and then in other cities of America. It was their influence, the extensive collections of Greek and Roman sculptures in Italian museums, the fame of Canova and of the Danish neoclassic sculptor Bertel Thorwaldsen that made Italy the mecca for the aspiring young sculptors of the next few decades.

Horatio Greenough

No nineteenth-century sculptor has received more posthumous praise than Horatio Greenough (1805–52), but it is more as an esthetic philosopher than as an artist that he has received his recognition in modern times. Greenough was born in Boston and was encouraged to

become a sculptor by Washington Allston. As a youth he made copies of the casts in the Boston Athenaeum, later attended Harvard, and at the age of nineteen set out for Italy. His first years in Rome marked a period of intense study and growth. He returned home in a few years because of illness and soon after executed his first important portrait, a bust of President Adams. Greenough's first portraits were sufficiently successful so that in 1832, only one year after the disastrous fire in Raleigh had destroyed Canova's *Washington*, he was commissioned to do a monumental statue of Washington for the rotunda of the United States Capitol. This was the first major commission to be awarded an American sculptor.

Greenough returned to Italy to carry out his assignment and labored on the great figure for nine years. His *George Washington* (Fig. 325) was conceived in Olympian terms, like a Zeus seated erect on a marble throne, with a drapery thrown over one raised arm and covering the lower half of his figure, and the other arm grasping a spearlike scepter. The head was modeled after the famous portrait of Washington by Houdon, and the design as a whole was inspired by Canova's lost work. In 1841 the colossal marble mass, weighing 20 tons, was shipped across the Atlantic on a Navy sloop and with much expense was installed in the rotunda. Innumerable difficulties attended the installation; the underpinnings were said to be inadequate, and the lighting was poor. Greenough protested, and Congress moved the figure to the east front of the Capitol, where it stood under a makeshift and temporary shelter, for the most part unprotected, until half a century later, when it was moved to its present quarters in the Smithsonian Institution. The public reaction to the great statue was little better. The nude torso shocked the conventional, while the capital wits poked fun at the partially robed figure, one remarking that "Washington was too prudent, and careful of his health, to expose himself thus in a climate as uncertain as ours. . . ." Today we are conscious of the scale of Greenough's vision. No American of his time had conceived of a national symbol of such heroic proportions or thought in such monumental terms. The stately gesture and commanding pose represented a sculptural conception which in power and dignity went far beyond the topical and illustrational effects typical of the period.

Despite the importance of Greenough's *Washington*, his total achievement as a sculptor is less impressive than his contribution to American esthetic thought. Greenough commented significantly on the art of his day. He protested against the repressive influence of the antique and encouraged originality of conception and expression. Fifty years ahead of his time, he defined a theory of functionalism. Observing the beauty of a ship at sea he remarked: "What Academy of Design, what research of connoisseurship, what imitation of the Greeks produced this marvel of construction? . . . God's world has a distinct formula for every function . . . we shall seek in vain to borrow shape; we must make the shapes. . . ." A final summation of his philosophy appeared in his "Stonecutter's Creed":

Three proofs do I find in man that he was made only a little lower than the angels—Beauty—Action—Character.
By Beauty I mean the promise of function.
By Action I mean the presence of function.
By Character I mean the record of function.

Hiram Powers

While Greenough typified the artist-philosopher exploring the world of ideas, Hiram Powers' (1807–73) career represented the ultimate in the practice of sculpture as a business. Energetic, practical, ambitious, shrewd, and ingenious, Powers constituted a paradox, the Yankee businessman-artist. Born in Woodstock, Vt., he moved to Ohio as a youth. He started his career modeling figures in a wax museum in Cincinnati and at the age of thirty set out for Italy via Washington, D.C., where he executed a portrait of Andrew Jackson which remained one of the finest achievements of his career. In 1837 Powers arrived in Florence; there he spent most of his subsequent years. One of the first sculptors of his day to settle in Italy, his career there represented the ultimate triumph for an ambitious young sculptor. Born and brought up in humble circumstances, he achieved eminence among the aristocrats of lineage and finance. Skeptical of all that was not immediately useful, he had little interest in the deep philosophic concerns of a man like Greenough. The ultimate mysteries of life and creation were not mysteries to him—one lived to be successful; one created to sell. The typical patrons of his day, the business tycoons, understood him and felt comfortable in his presence. He charmed them and asked enormous prices for his work. They admired a forceful salesman, accepted his own evaluation of his worth, and willingly paid him the impressive prices he demanded. Powers spent most of his life in Europe, preferring it to America largely because he could hire an efficient staff of workmen much more cheaply than at home.

Powers' most famous single work was *The Greek Slave* (Fig. 326). The success of this work was a tribute to his shrewd awareness of his age and its tastes. The subject, based on the reputed traffic in Greek girls captured by the Turks in the Greco-Turkish war, had an overwhelming appeal, since it played on so many facets of public sensibility. The Greco-Turkish war, still vivid in

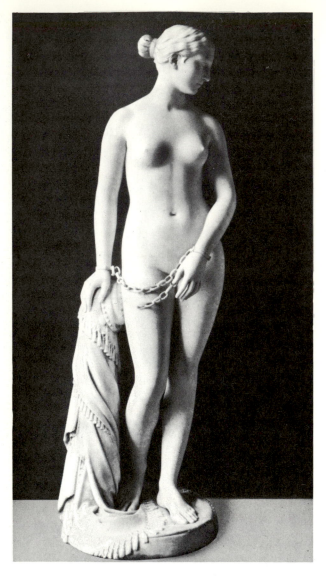

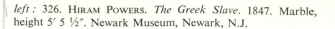

left : 326. HIRAM POWERS. *The Greek Slave.* 1847. Marble, height 5′ 5 ½″. Newark Museum, Newark, N.J.

posed not in body but in spirit, and that he had portrayed "what trust there could still be in a Divine Providence for a future state of existence, with utter despair for the present...." Powers had the wisdom to have the statue approved by a body of clergymen, and when the statue was singled out for honors at the Great Crystal Palace Exhibition in London in 1851, his triumph was complete. Hailed as a rival of the *Venus de Milo*, the statue sold in a half dozen full-size replicas, as well as in hundreds of miniature copies, while an exhibition of the original in New York netted over $25,000 in admissions. A number of its admirers claimed that Powers surpassed the ancients, since his *Greek Slave* had all the attributes of the ancient goddesses plus a Christian soul that rendered her nudity chaste and respectable.

Thomas Crawford

Another favored American was Thomas Crawford (1813–57). Crawford was born in New York City and at the age of fourteen was apprenticed to a wood carver. A few years later he went to work for Frazee, cutting tombstones, and there he learned the rudiments of stone carving and sculptural techniques. In 1835 he departed for a period of study in Rome.

Crawford was the first American sculptor to settle in Rome, and he was the leader of the American artistic group there, much as Powers was in Florence. During his lifetime he received the most flattering adulation. This was owed partly to his own modest charm, partly to his ambitious wife's activities, but mostly to the temper of the time, which seemed ripe for a national genius in sculpture. America felt sufficiently mature to dispense with the imported talents of the Canovas and the Houdons, and Crawford was hailed as the artist who "would enable America to be rescued from dependence on European artists, and to rejoice in a Phidias of her own." Crawford's recognition was more than verbal. He received many commissions for portraits and figure pieces, and the height of success came when he was asked to execute several major sculptures for the Capitol Building in Washington—a pedimental group called *The Progress of American Civilization*, and a pair of bronze doors for the Senate wing, and, most notably, a monumental figure to crown the great new dome. For this lofty site he designed an *Armed Freedom* (Fig. 327), which was installed with much fanfare in 1863. Certainly no statue in the United States enjoys a more elaborate pedestal nor a more impor-

people's minds, stood as a symbol of Christianity versus the world of disbelief and darkness—this in an age in which a revived religious fervor was challenged by an increasing worldliness and by the advance of science. In addition, the entire problem of slavery was a political and moral issue of the greatest timeliness. The classical attributes of *The Greek Slave* also ensured its popularity, for it was modeled on the goddesses of Greece and Rome, the Aphrodites and Venuses whose antiquity permitted them to be viewed as symbols of pure beauty rather than as pagan goddesses of love.

Powers exploited the nudity of the figure to the maximum. Aware that the fascination of the nude human body could be reconciled with the prudery of the age by clothing it in morality, he declared that his Greek slave girl was ex-

right : 327. THOMAS CRAWFORD. *Armed Freedom*. Installed 1863. Bronze, height 19′ 6″. U. S. Capitol, Washington, D.C.

tant location, but the fact remains that the figure, with all its elaborate detail, is almost impossible to see properly on its lofty perch.

Neither the extravagant eulogies nor the grand commissions which Crawford received during his lifetime represent an accurate estimate of his talents. His modest abilities appear to best advantage in such of his less pretentious works as *Babes in the Wood* (Fig. 328). Here his love of anecdote, his delight in sentimental idealizations of form, and his skillful working of stone to simulate the texture of skin, hair, and fabric can be enjoyed thoroughly, since the group was made as a conversation piece to be viewed at close range and subjected to minute inspection. Crawford moved more effectively in the world of fairy-tale sentiment than in the realm of national symbols, despite the contemporary opinion to the contrary.

William Story (1819–95), Randolph Rogers (1825–92), Harriet Hosmer (1830–1908), and a host of lesser known American artists working in Italy also contributed to the flood of white marble figures. One American sculptor who resisted the promise of fame and fortune in Italy found it at home. Erastus Dow Palmer (1817–1904) stayed in his native city of Albany, N.Y., and through persistence and talent transformed himself from a carpenter who cut cameos as a pastime into one of the most successful sculptors of his day. His *White Captive* (Fig. 329), a life-sized nude of a maiden captured by Indians, undoubtedly inspired by the *Greek Slave*, shows a knowledge of anatomy and has a vigor of sculptural form that is missing from the more famous figure by Powers. Palmer did a

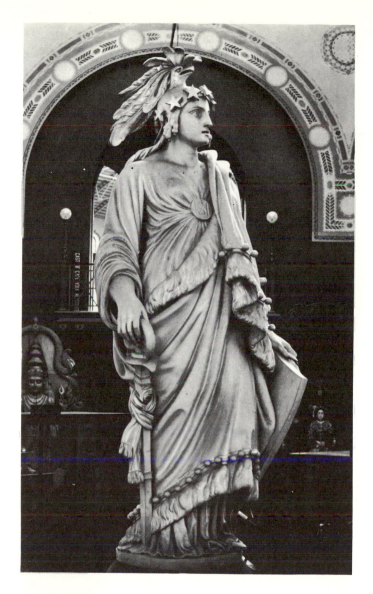

right : 327. THOMAS CRAWFORD. *Armed Freedom*. Installed 1863. Bronze, height 19′ 6″. U. S. Capitol, Washington, D.C.

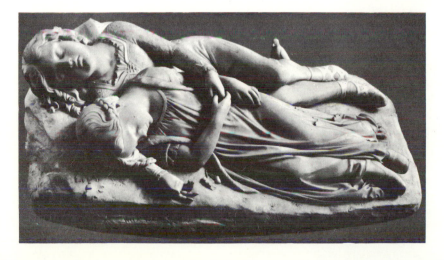

left : 328. THOMAS CRAWFORD. *Babes in the Wood*. 1851. Marble, length 4′½″. Metropolitan Museum of Art, New York (gift of the Hon. Hamilton Fish, 1894).

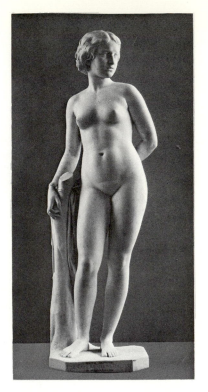

flourishing business in portrait busts but perhaps was best known in his day for his religious bas-reliefs.

Clark Mills (1810–83) also stayed home and successfully completed two great equestrian statues, despite the fact that he could refer only to engravings for help with the difficult anatomical problems posed by a figure mounted on horseback.

By mid-century the Greek Revival movement was dying. Henry Kirke Brown (1814–86) spent a short period of time in Italy but was one of the first to maintain that study abroad was not necessary. On his return to America he opened a studio in New York City, where he experimented with casting bronze. His bronze equestrian statue of Washington in Union Square, New York (Fig. 330), is his most famous work. One of a number of bronze equestrian statues erected in the fifties, it suggests that the great sculptural traditions of Rome and the Renaissance were usurping the neo-Greek, and that realism was replacing classic idealism. Even Crawford himself declared that "the darkness of allegory must give way to common sense." One of the critics of the day put it well when he remarked with tongue in cheek, "Purity has had her day; it's time she retired, and made room for nightmares and nastiness."

William Rimmer

Though clients and sculptural commissions were plentiful in the first half of the nineteenth century, not all sculptors enjoyed success and affluence. Recognition of William Rimmer (1816–79) has grown through the years, but during his lifetime no rich assignments came his way, and his great talents remained unrecognized except by an intimate circle of friends. Born in Liverpool, England, he was brought to Boston as a child. His talent for drawing, painting, and modeling appeared at an early age, but poverty and the need to make a living kept him from practicing the arts professionally. He engaged in various occupations to finance his studies as a physician and later practiced medicine in the poor village of Brockton, near Boston. There a community of stoneworkers reawakened his youthful desire to become a sculptor. In 1855 he began to work in granite, and he gradually became more and more involved in the arts. He taught drawing and anatomy at a number of institutions, most notably at

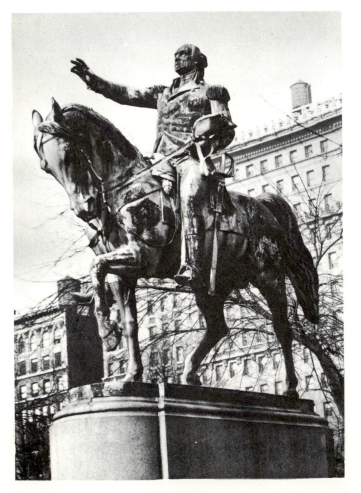

above : 329. ERASTUS DOW PALMER. *The White Captive.* 1859. Marble, height 5′ 6″. Metropolitan Museum of Art, New York (gift of the Hon. Hamilton Fish, 1894).

left : 330. HENRY KIRKE BROWN. *George Washington.* 1850s. Bronze, height 13′ 6″ (without base). Union Square, New York.

left : 331. WILLIAM RIMMER. *Despair*. c. 1830. Gypsum, height 10 ¹/₁₆″. Museum of Fine Arts, Boston (gift of Mrs. Henry Simonds).

below : 332. WILLIAM RIMMER. *Falling Gladiator*. 1860. Bronze, height 5′ 2 ¾″. Metropolitan Museum of Art, New York (Rimmer Memorial Society Committee and Rogers Fund, 1907).

the Lowell Institute in Boston, and became famous for the virtuosity he displayed in illustrating his lectures. He could sketch the human figure hurtling through space, twisting and falling, with the greatest freedom, foreshortening the anatomical forms with astonishing facility. During these years he continued his activities as a sculptor, though his output remained small.

His long years of struggle against poverty and indifference provided the dominant mood for Rimmer's work. His sculptures and drawings seem to be wrested from some deep inner pessimism. Even a work of his youth, *Despair* (Fig. 331), sets the tragic tone of his mature production. In *Despair* a dry-eyed, grim figure sits tense, constricted, and self-contained, contemplating the infinite frustrations of existence. The compact unity of the figure represents an essentially sculptural approach to expressive form seldom seen in an age when gesticulating figures and broken contours were the usual devices employed for conveying emotion. Within the simple basic form the parts of the figure move with force and certainty, conveying a feeling of quiet intensity and psychological constraint. The detailed handling of the anatomy, the sense of bones, tendons, veins, and muscles, evokes a quality of reality completely absent from the slippery idealized popular forms of the period. It is not surprising that the prim Bostonians, looking in their sculpture for sentimental echoes of the past, found the harsh immediacy of *Despair* as disquieting as the strange, intense, shy man

who created it. It is the direct expression of powerful and disturbing emotions that made Rimmer's work appear so foreign and out of tune in a day when sugary platitudes were considered sculptural masterpieces.

The *Falling Gladiator* (Fig. 332), a life-sized plaster figure from Rimmer's mature years (later cast in bronze), was exhibited in Paris, where its startling realism brought forth the accusation that it had been cast from life. Here again Rimmer's knowledge of anatomy reinforced the powerful movements of the main masses of the form to establish an authenticity and dramatic force far removed from meretricious and niggardly realism of surface detail. The startling and anguished gesture of the figure reflects the pain of Rimmer's own unrealized yearnings, the tragedy of the unrecognized artist who, knowing the merit

of his own work, saw acclaim and financial success heaped upon men whose only strength was a petty talent combined with a shrewd ability to estimate public taste. Rimmer's deeply felt, disturbing, and personal vision contributed a singular element of sincerity to the sculptural expression of the period.

PRINTS

The print processes supplied the need of an art for the masses, since paintings and sculptures were inevitably too expensive to be owned by many citizens. In the years between the Revolution and the Civil War a number of forces, most notably the industrial revolution, the growth of democratic institutions, and, above all, the great increase in literacy, created a vast middle-class audience which was responsive to the arts. With the development of a great middle-class reading public came the daily newspaper, the increase in periodical literature, and the popularity of the novel in both book and serial form. Pictorial illustrations contributed tremendously to the pleasure of the readers, and the graphic arts, implemented by technological developments, were rapidly transformed by the demands for inexpensive, easily duplicated pictures. Metal line engraving, particularly in steel plates, remained a standard medium for reproducing pictorial materials, because the plates were extremely durable, permitting mass printing. Aquatint engraving, less laborious than the earlier mezzotint engraving, almost totally replaced the latter after the turn of the century. Lithography, invented in Bavaria late in the eighteenth century, made possible extensive editions of inexpensive reproductions of unequaled richness and subtlety of tone, and after mid-century wood engraving became immensely popular and was used by master engravers with amazing virtuosity.

As the nineteenth century passion for pictures increased so did the variety of prints. The illustrated journals demanded romantic illustrations and satiric and topical sketches, as well as cartoons and caricatures. Paralleling the taste for illustrated reading matter was an increased interest in portfolios of reproductions and a desire for large prints for framing. Engraved and lithographic reproductions served to familiarize the public with works by popular painters and achieved a broad distribution. In fact, many painters augmented their income by themselves making prints from their work, which could be widely circulated. In 1780 Charles Willson Peale engraved a mezzotint print in "poster size" of George Washington (Fig. 333) that was a three-quarter length replica, with very minor alterations, of the full length portrait he had painted the preceding year for the Supreme Executive Council of Pennsylvania.

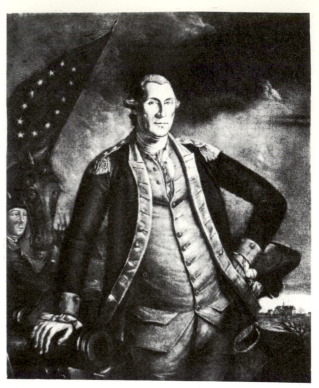

333. CHARLES WILLSON PEALE. *George Washington.* 1780. Mezzotint. New York Public Library, New York (Astor, Lenox and Tilden Foundations).

Between 1798 and 1800 William R. Birch and his son, Thomas, issued a series of twenty-eight colored engravings of views of Philadelphia, for pictorial prints portraying scenes of American cities or the natural wonders of America were in great demand. One of the most popular prints in this series, appealing, as it did, to the inflamed patriotic sentiments of the day, pictured the building, in preparation for war, of the U.S. frigate *Philadelphia*, with a view of the Southwark Swedish Church in the background (Fig. 334).

At a later date Thomas Cole's previously mentioned allegories were engraved and widely distributed, and Vanderlyn's *Ariadne*, engraved by Asher Durand, and Trumbull's *Declaration of Independence* acquired nationwide fame in the same way.

One of the finest printmakers to specialize in panoramic views of American landscapes and cityscapes was J. W. Hill (1812–79). A skillful artist as well as an engraver, he did not always engrave his own works, and a fine example of collaboration is the beautiful colored aquatint *New York from Brooklyn Heights* (Fig. 335), from the mid-thirties, engraved by one of the most sensitive and accomplished aquatint practitioners of the day, William

James Bennett (1777–1874). Bennett, trained in England, could incorporate an incredible amount of factual detail into a print without making it hard and dry in style, and he exploited the full resources of the aquatint medium to produce subtle atmospheric effects.

Reproductions of oil portraits of eminent personages engraved in line were much desired, though they tended to be pale and colorless, lacking the rich tones of the painted originals. To overcome this deficiency, early in the nineteenth century certain metal engravers began to specialize in stipple or "dot" engraving. This arduous technique, by which tonal contrasts were created through an accumulation of innumerable small engraved dots, was capable of remarkable effects in the hands of a virtuoso. James Barton Longacre (1794–1869), one of the most skillful craftsmen in this difficult technique, left a vivid example

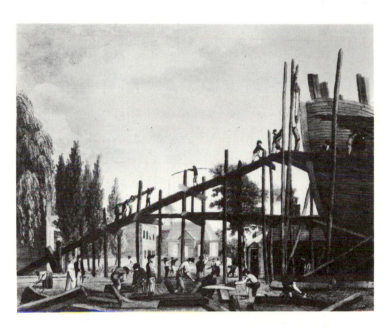

right: 334. WILLIAM and THOMAS BIRCH. *U.S. Frigate Philadelphia*. 1798–1800. Color engraving, 11 1/2 × 13 5/8″. Collection Mr. and Mrs. J. William Middendorf II, New York.

below: 335. WILLIAM JAMES BENNETT, after J. W. HILL. *New York from Brooklyn Heights*. 1836–37. Color aquatint, 31 12/16 × 19 8/16″. New York Public Library, New York (I. N. Phelps Stokes Collection).

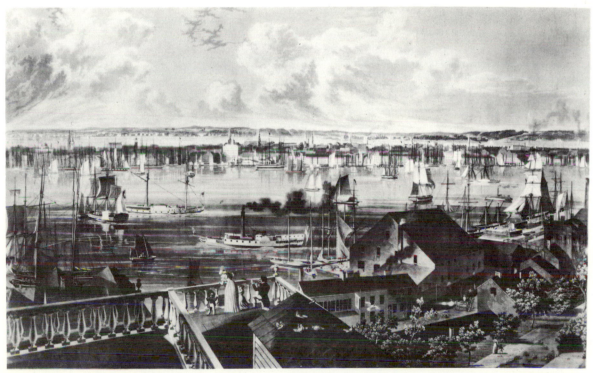

of his technical prowess in his stipple engraving, *Andrew Jackson* (Fig. 336), from the portrait by Thomas Sully. The rich values, ranging from black to white, and the smooth gradations of tone help to communicate the romantic aura which distinguished so many of Sully's portraits (see Pl. 10, p. 192).

Many prints of exceptional quality were produced and distributed under the auspices of the American Art Union and the short-lived Western Art Union. As previously mentioned, a number of painters of distinction lent their talents to the execution of fine prints, notably Asher Durand, Thomas Kensett, and Fitz Hugh Lane.

Currier & Ives

As lithography superseded the earlier and more difficult aquatint, line, and stipple engraving processes, a number of companies began to manufacture and distribute prints. The mass production of lithographs suitable for framing was the particular achievement of the famous firm of Currier & Ives, begun in 1835 by Nathaniel Currier. His partner, Merritt Ives, joined him in 1857. Their catalogue eventually covered every imaginable kind of subject— portraits of notables, religious scenes, sketches of farm and frontier life, famous catastrophes such as fires and shipwrecks, landscapes, and genre studies. These prints provide a fascinating reflection of current popular tastes, and, because of the topical and factual nature of many of them, they also serve as a valuable record of the period (Fig. 340).

Many artists contributed to the output of Currier & Ives. One of the most prolific was Mrs. Flora Bond (Fanny) Palmer (1812–76), who, in the course of her association with the firm, produced a prodigious number of prints on a wide range of subjects. During her most productive years Fanny worked directly on the stones, and her best prints provide topical interest, factual verisimilitude, technical skill, and richness of tone. Such

above : 336. JAMES BARTON LONGACRE, after THOMAS SULLY. *Major General Andrew Jackson.* 1820. Stipple engraving, 14 ¾ × 11 ¾". Philadelphia Museum of Art.

right : 337. FLORA BOND PALMER, for CURRIER & IVES. *A Midnight Race on the Mississippi.* 1860. Lithograph, 18 ⅛ × 27 ⅛". Museum of the City of New York (Harry T. Peters Collection).

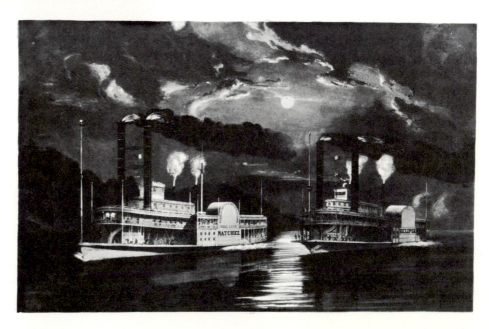

a print is *A Midnight Race on the Mississippi* (Fig. 337). The rendering of the structural details of the boats is detailed enough to satisfy the most literal-minded, but this in no way detracts from the drama of the race. The rich, velvety darks of night, the liquid reflections in the water, and the cloudy sky illuminated by a pale moon reveal both Fanny Palmer's technical and artistic skills and her feeling for public taste.

PHOTOGRAPHY

The birth of photography also occurred at this time and augmented the public's very real interest in pictures. A Frenchman, Daguerre, perfected his process for recording an image on a silvered copper plate in 1837. Americans were producing daguerreotypes and related kinds of sun pictures on metal plates almost as soon as the information concerning these processes reached these shores. Photographic studios appeared in the larger American cities in the early 1840s, and though portraits were the principal stock in trade, topographical views, similar in character to the popular panoramic engravings and aquatints of cities, harbors, and other sites, were also in demand.

The earliest photographic images were recorded on sensitized metal plates, which permitted only one image per exposure, because the processed plate became the positive print. In the early 1850s, however, the collodion process was developed, and from its glass negative a number of positives could be made. In the two decades preceding the Civil War, fine prints were obtained both by the collodion and the metal-plate processes. A Boston firm, Southworth & Hawes, produced some notable daguerreotypes, including the admirable character study of John Quincy Adams seated in his own home (Fig. 338). The same firm also made photographs of other subjects, such as views of the operating room of the General Hospital in Boston and of a Cunard liner in dry dock.

During the decade of the fifties, over eighty young photographers set up portrait studios in New York City. One of these men, Mathew Brady (1823–96), opened two such studios in New York and one in Washington, D.C., and, with the assistance of "operators," as his cameramen were called, he set about photographing every important person of his day. Many of the portraits from his collection, titled "The Gallery of Illustrious Americans," were undoubtedly from his own hands; certainly a number of them reveal a genuine capacity to project a strong sense of character by thoughtfully posing the sitter and then soberly recording his form and features.

The Civil War provided Brady with a new and challenging theme, and he immediately sensed the documentary power of the photographic medium; many of the studies of the war made by Brady and other members of his staff still remain among the great photographs of all time. It should be noted that many of the photographs credited to Brady may have been the work of his assistants. It should also be recognized that many other fine but less well-known photographers recorded both the tragic and the mundane aspects of the war with brilliant exactitude.

Brady possessed a telling sense of composition, his intuitive feeling for pictorial logic having been augmented by his study of painting with William Page. His compositional strength is well displayed in the powerful *Ruins of Richmond, Va.* (Fig. 339). In making this print he used a low eye level to create a somber and monumental mood. The blacks, grays, and whites have been clearly recorded as they move into the full depth of the picture from the ghostly nearby skeletons of broken walls to suggest the wastes of the abandoned city. Brady repeatedly revealed his mastery through his ability to select the most effective

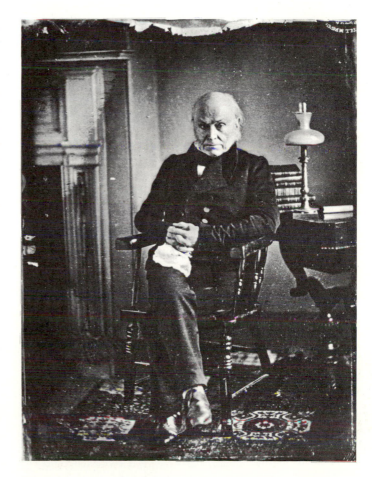

338. SOUTHWORTH & HAWES, Boston. *John Quincy Adams.* 1848. Daguerreotype. Metropolitan Museum of Art, New York (gift of I. N. Phelps Stokes, Edward Hawes, Alice Mary Hawes, Marion Augusta Hawes, 1937).

339. MATHEW B. BRADY. *Ruins of Richmond, Va.* 1865. Photograph. Museum of Modern Art, New York.

point of view from which to focus his subjects and through his full utilization of the resources of the camera of his day. Primitive though his instruments were, he captured the exact character of a particular situation.

The unquestionable authenticity of the photograph made it an important journalistic asset. Modern photoengraving processes had not yet been invented, but photographs of important events and personages were reproduced in periodicals with astonishing exactitude by skilled lithographers and engravers at mid-century.

INSTITUTIONS DEVOTED TO THE ARTS

A number of institutions devoted to the arts were established before the middle of the century. Boston had the Athenaeum; New York, the short-lived American Academy of Fine Arts, which was replaced by the National Academy of Design; and Philadelphia, the Pennsylvania Academy of Fine Arts. Each institution offered instruction in art, held exhibitions, displayed and sold works of art, and set up models of propriety and taste in the form of casts of famous statues and copies of great paintings. Other cities soon followed the example set by the big three. Hartford, Conn., acquired the Wadsworth Atheneum; Albany, N.Y., the Albany Gallery of Fine Arts; New Haven, Conn., the Trumbull Gallery at Yale College; and Cincinnati, the Fine Arts Academy. The first art galleries of the country appeared around mid-century. In 1846, Goupil & Cie., a well-known Parisian firm selling prints and engravings, sent Michel Knoedler to open a New York branch of the company. The Düsseldorf Gallery and the Belgian Gallery followed, and before long there were several salesrooms in New York prepared to capitalize on the growing picture market in America.

One of the novel and typically American organizations to appear at this time was the American Art Union, New York, organized in 1839. The Art Union was open to all for an annual membership fee. Once each year a drawing was held for a number of prizes consisting of original works of art. In addition to being eligible for the prizes, each member of the organization received a yearly engraving or statuette made from some well-known painting or sculpture by an American master. Thomas Cole, George Caleb Bingham, and Richard Caton Woodville were among the artists whose works were selected for reproduction, Cole's *Voyage of Life* being distributed to over 16,000 members. The American Art Union served a unique and useful role, since it familiarized the entire country with the work of leading artists. In the course of its existence it distributed thousands of paintings and engravings by a great number of American artists and was so successful that many cities organized their own local art unions of a similar nature. *The American Art Union Bulletin* was, in a sense, the first American periodical devoted to the arts, and the organization also maintained two free art galleries open to the public in New York. An attack upon the American Art Union spearheaded by a New York newspaper and a group of disgruntled artists brought about the demise of the institution after ten years. Court action resulted in its being declared illegal and outlawed as a lottery.

As mass interest in culture developed, there appeared a body of critical literature focused on the arts. The writings of Hawthorne, Cooper, Emerson, and Greenough reveal a lively concern with the state of the fine arts in America. In 1834 the painter and dramatist William Dunlap published the first history of the arts in America, *The History of the Rise and Progress of the Arts of Design in the United States.* The first monthly magazine devoted to the fine arts appeared in New York in 1855, when W. J. Stillman, a painter-journalist, and John Durand, a son of the painter, founded *The Crayon.* This magazine lasted less than a decade, but in its short life it wielded much influence.

At mid-century America gave promise of a new maturity in the arts. Sculpture, painting and printmaking in particular, and, to a lesser degree, architecture, the crafts, and the newly evolving industrial arts seemed ready to burst into a splendid flowering. The tragedy of civil war intervened, and the physical and spiritual strain revealed unexpected weaknesses in the cultural life of the country. Almost another half-century of growth was necessary before the promise of these early years could be realized.

part IV

Between Two Wars:
1865–1913

13

Architecture:
The Birth of the Skyscraper

France or, rather, Paris was the chief center of gestation for the dynamic artistic movements which galvanized the last half of the nineteenth century. Paris replaced London, Florence, and Rome as the major source of artistic stimulus, and after the Civil War American architects, printers, and sculptors found inspiration there with increasing frequency. Much of the character of American artistic life in the latter part of the nineteenth century and the early decades of the twentieth resulted from a conflict between the increasing vigor and corresponding cultural independence of American life and a growing cosmopolitanism of taste, primarily of Parisian orientation. These opposing ideals, as they affected architecture, can be seen most vividly by comparing the work of the Chicago school, exemplified by Sullivan (Fig. 362), with the elegant eclecticism of McKim, Meade & White (Fig. 350); in painting the differences are clearest in the contrast between the native strength of a Winslow Homer (Fig. 424) and the esthetic sophistication of a Whistler (Fig. 396) or a Sargent (Fig. 398).

The Civil War, fought to free the slaves and preserve the Union, placed the financial interests of the North in a position of power which changed the economic and social character of the entire country. Within a few decades fol-lowing the war the great commercial empires of wheat and beef, iron and copper, railways and steamships, real estate and banking were established. The geographic frontiers of America had been settled during the first half of the century, and now equally vast economic frontiers were created by the rapid expansion of the Middle and Far West and by the astonishing growth of the new metropolitan areas. By exploration and exploitation of the economic opportunities in this expanding economy the great fortunes of late nineteenth-century America were founded, and in the years just after the Civil War the millionaire became a symbol of America.

Bigness characterized the age. The vast expanse of land from coast to coast was netted with railway lines and roads and dotted with cities. The passion for size expressed itself in new industrial empires, in enormous speculative activities, and in the rapid amassing of great fortunes. It also characterized the architecture of the period. Industry required factories which covered acres of ground. Speculative builders developed miles of new metropolitan areas with row houses, apartments, and suburban villas. The new millionaires built mansions boasting hundreds of rooms and costing millions of dollars. In the metropolitan centers skyrocketing land values created wealth and

necessitated the construction of great multistoried business buildings to provide revenues proportionate to the cost of the land.

Technological advances whetted the taste for bigness. The invention of the elevator made the multistoried building practical and permitted a greater number of equally accessible stories. The rapid expansion of iron production and the perfection of the Bessemer process for steel manufacture made mass-produced, low-cost steel and iron available for building purposes. The production of glass also was industrialized, thus allowing the fabrication of the great plate-glass windows of the Victorian age. The telephone, incandescent light, modern plumbing, central heating, and a host of other inventions made possible the construction and operation of many kinds of buildings that were both larger and infinitely more complex in the interrelationship of their parts than the structures of preceding ages. This, then, was an age of technological and social changes, and its most prophetic monuments were tributes to those changes.

Three structures of this era, though not considered fine architecture by the connoisseurs of the day, revealed the new conquest of space made possible by technological advances. Only one of these was in America—the Brooklyn Bridge (Fig. 340). In 1869 John Roebling (1806–69), a German-born engineer, designed a suspension bridge to span the East River between Manhattan and Brooklyn. Employing the principles of tension structure, he supported the roadbed of the bridge with cables woven of steel wire hung from two great towers. Completed in 1883 (under the direction of Roebling's son), the Brooklyn Bridge has rarely been surpassed in clarity and directness of design. The climax of Roebling's career, it represents one of the great engineering triumphs of the century, abandoning traditional masonry construction and using steel to span a great void. Although it has been admired by the public and copied by generations of engineers, nineteenth-century architects were slow to learn its lesson. For them the masonry wall remained the symbol of the art of architecture, and the litheness of steel seemed the antithesis of architectural dignity.

Two other metal structures pointed the way to the future of architecture for those who had eyes to see. In 1851 Sir Joseph Paxton, an Englishman, had completed the famous Crystal Palace of London to house an exposition of industrial progress. The Crystal Palace was one of the marvels of the age—probably the largest building the world had witnessed to date—a great glass and cast-iron shell, prefabricated, bolted together, and demountable, in which almost a million square feet of glass covered over 17 acres of floor space.

The impact of Paxton's Crystal Palace on American building practice was tremendous, although its immediate influence on the architectural profession, like that of the Brooklyn Bridge, was nil. In 1853 New York constructed its own Crystal Palace (Fig. 341) to house an exposition of industry. The New York Crystal Palace resembled its British prototype in its use of a brittle shell of iron ribs and glass panels arched to enclose extensive unobstructed spaces. Both buildings depended for support on the precise relationship of the various parts; thus the principle of strength through precision replaced the ancient one of

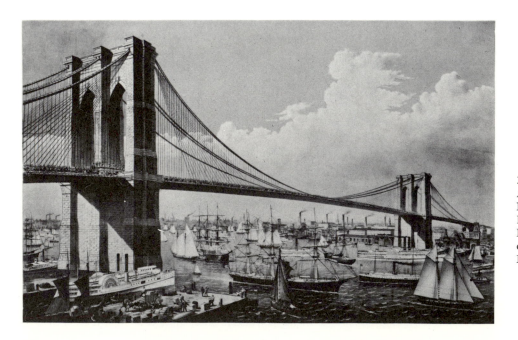

340. JOHN and WASHINGTON A. ROEBLING. Brooklyn Bridge, New York. 1869–83. Lithograph by Currier & Ives, $23\,^5/_{16} \times 33''$. Library of Congress, Washington, D.C.

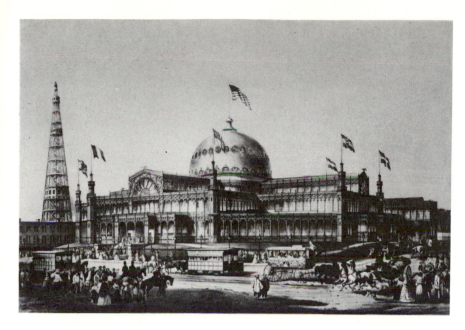

strength through mass. Effective as public persuaders, the
Crystal Palaces stimulated existing interest in iron as a
building material, and cast iron used with glass was
readily adopted by practical builders searching for efficient
materials to enclose train sheds, horticultural buildings,
commercial buildings, and to make the huge skylights
which were used to illuminate the interiors of stores,
factories, and other commercial structures (Fig. 342).

The third great structural feat of the period was the
Eiffel Tower, erected in Paris between 1887 and 1889.

This structure, too, was executed in metal, for metal
construction alone could, to quote Alexandre Eiffel, "be
planned with such accuracy as to sanction the boldness
which results from full knowledge." Eiffel's use of wrought-
iron bars in the underground concrete mats which sup-
ported the 1,000-foot soaring tower anticipated the use
of modern reinforced concrete, and his iron girders
foreshadowed the steel members used in modern construc-
tion both in profile and in general shape. Architects
thought the Eiffel Tower an eyesore (Garnier, a leading

343. Wright brothers' house, from Dayton, Ohio. 1870. Henry Ford Museum, Dearborn, Mich.

French architect, circulated a petition that the Government demolish it), but builders saw the advantages of many of the innovations introduced by Eiffel and adapted them to the needs of the multistoried buildings they were constructing.

Out of this ferment of invention, newly acquired wealth, sudden growth, and rapid industrialization, the architecture of the post-Civil War period was born. At that time the more specialized training of architects, as distinct from engineers, tended to encourage a separation of these two professions, and the rift dividing both architect and engineer from the carpenter-builder was intensified. The professional architect became increasingly an artist who designed buildings, using (or misusing) the esthetic conventions of earlier ages. The engineer, on the other hand, tending to be indifferent to esthetic niceties, was primarily concerned with using the new industrial materials and processes to answer the physical needs of a changing and expanding society. The builder was a composite figure, part businessman, part carpenter-contractor. Both architect and builder were influenced by the prevailing taste, first that of the High Victorian period and then, after 1880, by the more disciplined Beaux-Arts manner.

As stated before, the High Victorian styles combined various traditional architectural forms, or modifications of them, to achieve the picturesque, restless surfaces and the bold, irregular contours that answered the desire for ostentatious and grand effects. Though these effects were still frequently demanded, the Beaux-Arts traditionalists who followed the High Victorians sought a more proper grandeur, in which good taste and a sound knowledge of the past prevailed.

The variations in the architecture of this period may be clarified by examining the work of three separate groups: (1) the output of the undisciplined builders, a body of work which constituted the great bulk of late nineteenth-century building; (2) the more refined production of the architects trained in the Beaux-Arts tradition; (3) the new forms developed by a few imaginative designers who were able to combine the new engineering technology with the disciplined taste of the Beaux-Arts architects.

THE BUILDERS

A tremendous increase in population occurred in America in the seventies, eighties, and nineties. Cities doubled and tripled in size, and vast new territories were settled. Business buildings, factories, schools, homes, and a multitude of other structures were erected across the land, in most cases without the benefit of either architect or engineer. Professional advice often was not available, nor was the need felt for such services. As in earlier times, the carpenters' handbooks continued to supply builders with plans and exterior designs, and the average builder, true to the Yankee tradition of self-reliant tinkering, invented designs and structural devices when he could find no ready-made answer to his needs. After the mid-seventies popular magazines devoted to the art and craft of building gradually replaced the earlier handbooks.

Popular Housing

The development of a uniquely American way of building, balloon framing, has already been mentioned. The rapid creation of entire new cities and of great residential tracts

was greatly facilitated by this revolutionary mode of construction; in fact, it may well have contributed more to the rapid development of the West than did any one other factor. One observer remarked: "If it had not been for the knowledge of the balloon frame, Chicago and San Francisco could never have arisen as they did, from little villages to great cities in a single year."

Three residences from the late nineteenth century supply a picture of the builders' tastes as they appeared in homes of the period. The first is the Wright brothers' house (Fig. 343), originally built in 1870 in Dayton, Ohio, and now in Dearborn, Mich. Similar two-story frame structures were built all over America, filling endless acres in the rapidly growing cities, making up the quiet streets of small towns, and providing comfortable farmhouses. Unlike the majority of earlier houses, this was designed into the depth of the lot, rather than facing the street; the plan was adapted to the typical narrow lot by means of which subdividers squeezed a few extra dollars out of each city block. In houses of this type one entered from a spreading porch decorated with machine-turned spindles into a small vestibule, which either opened into a hall or led directly to a parlor, dining room, and kitchen. A pantry, back porch, stairway to the basement, and downstairs bedroom completed the ground story. A staircase in the front vestibule led to the second floor, where bedrooms and, toward the end of the century, a bath, opened off a central hallway. The rooms tended to be small, with no intercommunication, so that the interior consisted of small, isolated cubicles with windows opening to the outdoors and doors opening into halls. To the degree that a style sense was evident in such a structure, it was the so-called native "stick" style, created by the candid carpentered use of wood enhanced by turnings or machine-cut gingerbread decorations.

A house in San Francisco (Fig. 344) represents a more elaborate venture on the part of some builder, who was probably in the lucrative business of constructing houses on speculation for the more prosperous members of the growing city. Such a house had three full stories and a basement, with back parlors and upstairs parlors, maids' rooms and nurseries, laundries, and libraries providing for the various activities of large and busy families. The exterior illustrates what happened to that High Victorian interpretation of the late Gothic style, curiously enough termed "Queen Anne," when it was subjected to the whims of the uninformed builder assisted by the newly developed wood-working machines. Turrets, towers, porches, bays, gables, and projections divide and subdivide the basic forms of the building. Pointed arches, Tudor arches, bargeboards, pendants, brackets, pinnacles, panels, and moldings break up the forms still more. And

344. Victorian Gothic house, San Francisco. Late 19th century.

over it all the jigsaw cutouts add patterns and textures until there is not one spot on the entire tortured surface where the eye can rest. It is a triumph of energy and invention over taste, of enthusiasm over knowledge, of pretense over discipline.

Not all the energy and enthusiasm were misplaced on elaborations of the Gothic style. In the late 1870s Senator James Flood built a country home in Menlo Park, Calif. (Fig. 345), in a carpentered version of the French Baroque revival manner, also termed the "Second Empire" style, since it flourished under the aegis of Napoleon III. In the seventies and eighties, the American fad for the mansard-roofed Baroque style almost equaled that for the Gothic. In an age when wealth meant size and display, even a country house became an architectural extravaganza if the owner could afford it. In the Flood House the curious wooden translations of Garnier's Baroque ornament rose tier above tier, like a gigantic wedding cake, to culminate in a cupola and tower with a mansard roof.

Fortunately, the craze for elaboration was only part of the architectural story in America during these years. One of the distinguishing characteristics of American building, in contrast to that of Europe, was a taste for unadorned surfaces and flexibility of plan. Many of the nineteenth-century handbooks on house design, which influenced the average builder much more than did the stylish writings, advocated abandoning all pretense and frippery and planning for convenience. Lewis F. Allen, who wrote *Rural Architecture* in 1852, advocated making plans which were based on the life that would be carried on in the house. He held fitness for purpose and harmony between parts as his ideal. In 1869 Harriet Beecher Stowe and her sister, Catherine Beecher, wrote a volume dedicated to the creation of a house "contrived for the express purpose of enabling every member of the family to labor with the hands for the common good, and by modes at once healthful, economical, and tasteful." The

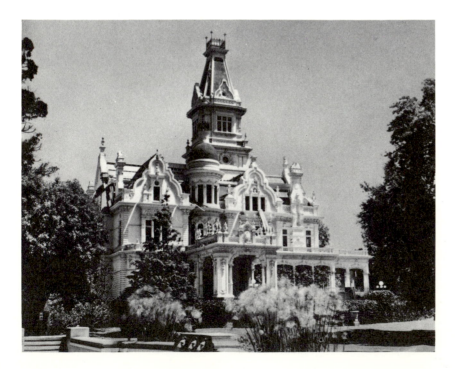

left : 345. Flood House, Menlo Park, Calif. 1875–78.

above : 346. Kitchen work area, from Catherine Beecher and Harriet Beecher Stowe, *The American Woman's Home,* New York, 1869.

opposite : 347. STURGIS & BRIGHAM. Museum of Fine Arts, Boston. 1871–76.

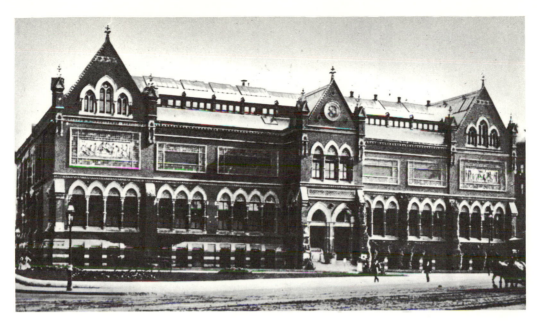

house they recommended was revolutionary in plan, with a central kitchen area (Fig. 346), a family all-purpose room with movable screens, and other features which characterize advanced house plans today. The octagon house represented another deviation from traditional modes of domestic building. In the late seventies and eighties a few architects, to be followed in turn by a number of builders, began to design spacious, unpretentious houses in what has come to be called the "shingle" style because of the predominant use of shingles for the exterior sheathing. These houses featured open plans designed for comfort and practicality, ample porches, and high-pitched gabled roofs, and they displayed a minimum of the ornamental encumbrances so characteristic of the day (Fig. 352).

The development of simple functional designs was not confined to houses. Barns, factories, warehouses, storage silos, New England meetinghouses, and Shaker buildings demonstrated a taste for simplicity that was a deep-rooted part of our native building tradition. The American sense of propriety, essentially an inheritance from our Puritan background, provided a valuable countercheck to the nineteenth-century childish delight in the capacity of machines to produce endless streams of decoration.

THE ARCHITECTS

While carpenters, contractors, builders, and real estate speculators were covering America with buildings that ranged from gingerbread Gothic to bare box, the trained architect was becoming firmly established as the professional who could make a building a work of art. As a consequence, an increasing number of mansions and civic structures in the eighties and nineties came from the drawing boards of trained men. The dominant mood remained romantic, and the Gothic style retained its popularity, although the Venetian Gothic, introduced by the English critic John Ruskin, vied with the French and English Gothic styles for popularity. Equally attractive to the world of fashion were the various Baroque and Renaissance fashions being revived in Paris. Each style had its vigorous adherents and loquacious defenders and seemed appropriate for certain types of buildings.

Gothic remained a popular choice for institutional architecture. Churches, schools, libraries, and municipal and state buildings acquired an air of sanctity and authority from the dress of the Middle Ages. In 1851–53 Ruskin published *Stones of Venice*, and his admiration for the ornamental subtleties of the Venetian Gothic style gave the Gothic Revival a new direction. Since the Venetian Gothic was based on decorative mannerisms, rather than on a structural system, it was well suited to the plans of the late nineteenth-century architect. It was easy to adapt the unbroken Venetian façades to the straight streets and rectangular blocks of a modern city. The long arcades of pointed arches so characteristic of the style provided a handsome framework for the endless rows of windows necessitated by the nineteenth-century taste for light and air. It was possible to translate the colored marble mosaics of Venice into such standard building materials as multicolored bricks, stones, and tiles. Sturgis & Brigham, a reliable if not inspired firm, designed the old Boston Museum of Fine Arts in a current version of the Venetian Gothic (Fig. 347). This dignified building,

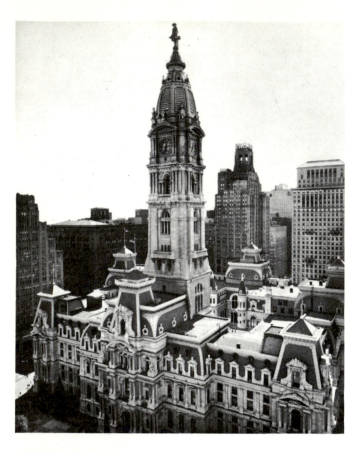

clothed in a nineteenth-century interpretation of four-teenth-century dress, satisfied the requirements of a public museum and maintained a borrowed air of authority, but, like much of the architecture of its day, it failed to achieve the synthesis of all its parts that characterizes great architecture.

Revival of the Baroque served when splendor was preferred to an air of sanctity. Two imposing structures, both built in Philadelphia in the seventies, reveal the bold handling of traditional architectural motifs that characterized High Victorian building at its best. Probably the most impressive monument to the French Baroque revival in America in both scale and richness is the Philadelphia City Hall (Fig. 348), by John McArthur, Jr. (1823–90). Covering more than 14 acres of ground, with a tower over 500 feet high, it took ten years to complete and many more to decorate. Patterned after the new Louvre, it represented a free and uninhibited adaptation of the grand aristocratic style of the seventeenth century, its florid magnificence answering the desire to symbolize municipal pride through extravagant scale and palatial splendor.

Perhaps no individual architect better epitomizes the independence, exuberant invention, and plastic strength of the seventies and eighties than Frank Furness (1839–1912) of Philadelphia. His Pennsylvania Academy of the Fine Arts (Fig. 349) recalls the Venetian Gothic only in some details such as the pointed arches, traceried cresting, and diapered brick patterning. Like a number of his other major designs, it exudes a vitality that, after decades of disdain, has only recently come to be appreciated.

The Age of Elegance

The last two decades of the century have been termed "the age of elegance." A new level of disciplined taste and sophistication characterized the period, much of the vigor of the preceding years giving way to a restrained propriety best described by the phrase "good taste." Study at the École des Beaux-Arts in Paris, a familiarity with the great monuments of the past gained through travel and photography, and the increased publication of pictorial materials contributed to the discerning eye and discriminating judgment that provided the dominant mood at the end of the century.

The great firm of McKim, Mead & White, which opened an office in New York in 1879, exemplified these characteristics. All three men were talented and well trained, and each had capacities that complemented those of the other two partners. Charles Follen McKim (1847–1909) was a graduate of Harvard, had attended the École des Beaux-Arts, and had been trained in the studio

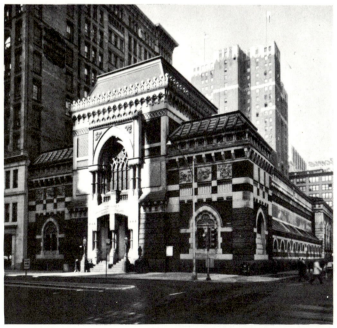

top : 348. JOHN MCARTHUR, JR. City Hall, Philadelphia. 1874–1901.

above : 349. FRANK FURNESS. Pennsylvania Academy of the Fine Arts, Philadelphia. 1871–76.

of Henry Hobson Richardson, the most important American architect of his day, whose work will be discussed later. William Rutherford Mead (1846–1928) was graduated from Amherst, worked in an architect's office, and then traveled to Italy to study the great monuments of the past. Stanford White (1853–1906), immensely talented, had worked, like McKim, under Richardson. It was not long before the ability and taste of the three men brought them many important commissions. In 1887 they designed the Public Library in Boston (Fig. 350); it was carefully patterned after the beautiful Bibliothèque Ste. Geneviève in Paris. McKim, Mead & White absorbed the disciplined formality and restraint of the French original and produced one of America's handsomest public buildings.

Though the Boston Public Library, like its counterpart in Paris, lacks the surging vitality of the greatest architecture, it is a distinguished and skillful design in which no false note or element of gaucherie mars the perfection of the performance. As during the Renaissance, the foremost artists of the day were engaged to decorate this great structure. Augustus Saint-Gaudens carved the seals above the entrance, and John Singer Sargent, Edwin Austin Abbey, and Pierre Puvis de Chavannes decorated the walls of the interior.

One of the most subtle achievements of McKim, Mead & White was the great complex of five town houses (Fig. 351) they designed for the railroad promoter Henry Villard and four of his friends. Stylistically this handsome

left : 350. McKim, Mead & White. Public Library, Boston. 1887.

below : 351. McKim, Mead & White. Villard group, New York. 1882–85.

left : 352. McKim, Mead & White. Isaac Bell House, Newport, R.I. 1881–82.

below : 353. Richard Morris Hunt. Biltmore, near Asheville, N.C. 1895.

opposite : 354. Henry Hobson Richardson. W. Watts Sherman House, Newport, R.I. 1874–76.

mansion draws on the Italian High Renaissance, but while the details of windows, stonework, and arcades may recall Bramante, the plan and the details have been worked out with originality and freedom. The Villard group is undoubtedly the most impressive Italian Renaissance design in America and probably is New York City's finest mansion. Masters of the Renaissance style, McKim, Mead & White also produced distinguished designs in the Roman, Greek, and later in the colonial Georgian revival manner.

McKim, Mead & White were among the most persuasive architects of their age, and though their designs frequently spoke the language of other times, they did not always do so. The disciplined taste that made them follow the models of the past, rather than continue with the florid exuberance of the passing High Victorian manner, also made them recognize the charm and propriety of the simpler houses, resort casinos, and hotels that Richardson and other architects had designed in the shingle style, which developed in America from the conjunction of the earlier stick style with certain English prototypes. Some of the finest examples of the shingle style came from the drafting boards of McKim, Mead & White in the eighties. Such is the Isaac Bell House in

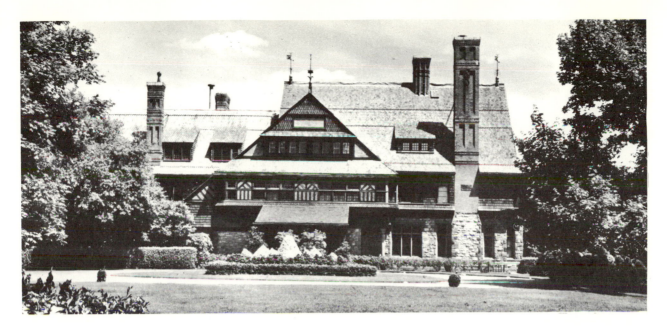

Newport, R.I. (Fig. 352). Informal and modest, with its smooth, taut, shingled surfaces, lightly framed windows, extensive open verandas, and high-pitched gabled roof, the Isaac Bell House is typical of the shingle style in its convenient, practical plan, its candid use of simple indigenous materials, and its sparsity of ornament.

In the last decade of the century, New York fortunes leaped up into the hundreds of millions. Expenditures followed accordingly, and hostesses vied with one another in their extravagances, gold plate, for instance, replacing silver. In this atmosphere Richard Morris Hunt (1827–95) moved with assurance, providing the magnificent settings for this world of luxury.

The son of a congressman, Hunt grew up in the best Washington society. Later he lived in Paris, traveled, and enrolled in the Ecole des Beaux-Arts. On his return to America he married a society woman and proceeded to develop a clientele among the wealthiest and most distinguished families.

Hunt wanted to bring the elegance and refinement of French architecture to America, and in 1881 he introduced the château style in a mansion he designed for Mrs. W. K. Vanderbilt. Before long Hunt was famous for such palatial homes. His most stupendous creation in the French chateau style was Biltmore (Fig. 353), the $4 million country house which he designed for George Vanderbilt's 130,000-acre estate in the Great Smoky Mountains near Asheville, N.C. The staircase of Biltmore is reminiscent of Blois, and its roof line and windows of Chantilly, but it is Hunt's own creation. It took five years and hundreds of foreign artisans to complete the building, which covers more than 5 acres.

The Breakers (Fig. 378), a Vanderbilt summer home at Newport, R.I., is an equally extravagant mansion in the formal French Baroque manner. Such a palatial house, representing the ultimate attempt to clothe the present in the dress of the past, stands as a final monument to a way of life and a point of view doomed for client and architect alike. The millionaires had only a few more decades before new systems of taxation and antimonopoly legislation began to restrict their activities and displays. For the architects the apparently inexhaustible well of tradition provided fewer answers to the questions presented by the industrial democracy of twentieth-century America.

Henry Hobson Richardson

The work of the only architect who seemed capable of drawing on the past for answers to the pressing problems of the emerging industrial age had begun its influence some years before the developments just discussed. Henry Hobson Richardson (1838–86) provided the bridge between Beaux-Arts architecture and the emerging Chicago school of the last two decades of the century. Richardson grew up on a plantation in Louisiana, attended Harvard, and then studied architecture at the École des Beaux-Arts in Paris. When the Civil War blocked his remittances from home, he went to work under Labrouste, where he experienced the severe discipline that distinguished the work of the leading designers of France.

Richardson returned to Boston in 1865 and began his career by designing homes for the families of his friends. His most distinguished residence of those early years was the W. Watts Sherman House (Fig. 354) in Newport, R.I.

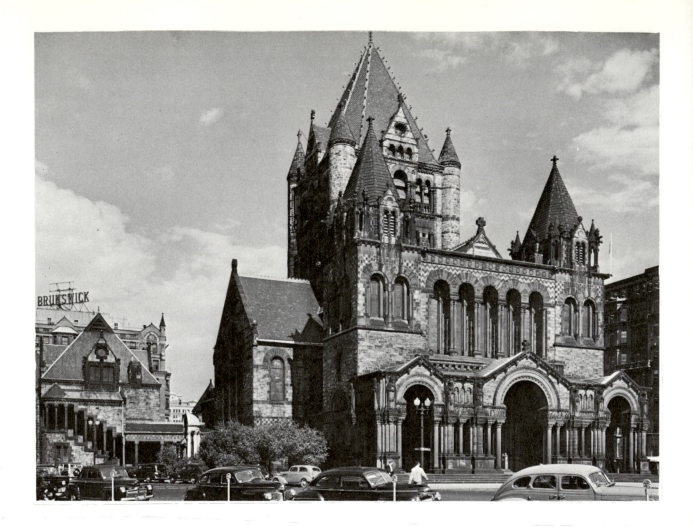

In this handsome structure, with its bold geometric shapes and its rich textures of stone, brick, wood, plaster, and shingle, Richardson abandoned the pretentious splendor of the aristocratic modes for a more modest and comfortable style. Reflecting the theories and tastes of William Morris, leader of the English Arts and Crafts Movement, and the practice of such English architects as William Webb and Richard Norman Shaw, the W. Watts Sherman House did much to influence the evolving shingle style.

Seven years after his arrival in Boston Richardson won a competition for the design of Trinity Church (Fig. 355). This building is probably his greatest achievement, as well as one of the most influential buildings in the history of American architecture. Like most American architects of the nineteenth century, Richardson had been deeply impressed with the power and richness of French architectural tradition, and like a true Romantic, he found the styles of the Middle Ages particularly compelling. Aware of the irrelevance of academic revival styles to American life, he aspired to draw on the rich

heritage of the past and from it to forge a style that would express the buoyancy and youthful energy of the United States. For this purpose Richardson chose the French Romanesque, for he found its strength, heavy vigor, and lack of standardization most compatible with his ideas of America. This choice was based on his own feelings; the prevailing taste was for the late Gothic, the Renaissance, and the Baroque. The design he created for Trinity Church was not a direct copy of any existing structure but a conception of such originality and force that the building became the foremost American church of its period. Working in the Romanesque manner, Richardson planned a structure of massive and dramatic masonry with powerful rhythms moving from its wide portals and heavy transept and apse through its many turrets and pinnacles to the great central tower, which dominates the composition by thrusting vertical masses. It was as complex, rich, and elaborate as any contemporary structure, but, unlike less talented men, its creator was able to unite all the diverse parts into a unified and

organic whole. The success of Trinity Church inaugurated the Romanesque Revival in America, and Richardson remained its most successful practitioner.

The distinguishing characteristics of the style are well illustrated by Trinity Church, although in later buildings the vocabulary of effects was enlarged. First, there is a romantic and picturesque mass, effective from any angle, made up of bulky forms, great rectangular towers, turrets, and soaring roofs. These masses are richly surfaced with heavy stone roughly hewn, brick, shingle, and colored stucco, often applied in a vigorous pattern. In Trinity, red sandstone was used to trim yellow-gray granite, and the two stones were combined in herringbone and checkerboard designs. The dramatic masses and textured surfaces are enhanced by deep arched doorways, clustered columns, and windows grouped in arcaded series.

Richardson's standards were uncompromising. Craftsmanship and materials had to be the finest. He gathered the greatest talents to design the stained-glass windows and to decorate the walls. Sir Edward Burne-Jones, John La Farge, and William Morris Hunt helped create an interior worthy of his conception.

Trinity Church brought Richardson fame and commissions. In the ten years that intervened between the completion of Trinity and his death, he became the country's most important architect. His ambitions encompassed the entire range of America. "What I want most to design is a grain elevator and the interior of a Mississippi steamboat," he once said. It was in the coherent and simple solution he provided for some of the new kinds of buildings that Richardson's impact on the future was most strongly felt. Libraries, schools, railway stations, courthouses, jails, and finally the Marshall Field Warehouse in Chicago all showed the imprint of his vigorous and clear mind.

One of his finest smaller designs is the Crane Memorial Library (Fig. 356) in Quincy, Mass. The familiar elements of Richardson's Romanesque style are apparent here —roughly hewn stone used in contrasting colors, gables, towers, clustered columns and windows, and a heavy arched entranceway. What is most noteworthy is the clear statement of function both in the plan of the building and in the outward disposition of the parts. The entranceway, large reading room, stairs to the second story, and extended area of the stacks are the major elements of this forceful design, which is equally pleasing to the eye and the mind. There is no hesitation in the disposition of the masses, no niggling compromise in the statement of the plan. It radiates vitality.

Space does not permit a discussion of all his distinguished buildings, but certainly the Allegheny County Courthouse and Jail which Richardson designed for Pittsburgh, Pa., in the mid-eighties must be singled out for mention. Like Trinity Church, Boston, it is truly High Victorian in the grandiloquence of its towers, massive stones, and heavy arches, yet the coherent unity of its many parts reveals the disciplined control that was the particular virtue of a Beaux-Arts background.

No one building designed by Richardson reveals this disciplined control, combined with the ability to think and

opposite: 355. HENRY HOBSON RICHARDSON. Trinity Church, Boston. 1872–77.

right : 356. HENRY HOBSON RICHARDSON. Crane Memorial Library, Quincy, Mass. 1883.

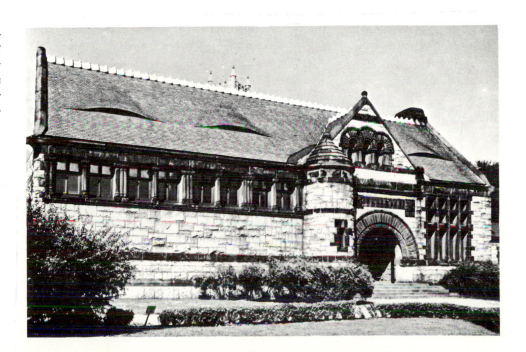

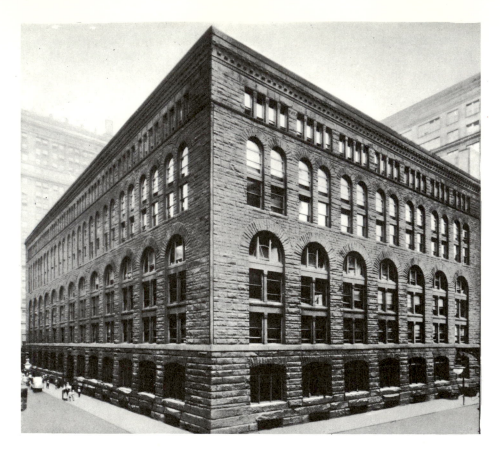

express himself in direct and fundamental terms, more clearly than the great wholesale warehouse (Fig. 357) he designed for Marshall Field of Chicago in 1885. The devastating fire of 1871 had left the city in ashes, and rebuilding the metropolis challenged some of the most inventive minds of the century. Richardson's appearance in Chicago had a most fortuitous effect on the subsequent development of building there. His direct and simple design for Marshall Field's warehouse, a seven-story embryonic skyscraper, proved his ability to grasp the essential problem and to provide a clear visual solution for it. Traditional in structure, the Marshall Field Warehouse was constructed of stone, with its seven stories arranged around a central court. The uniqueness of the building lay in the directness and simplicity of its external design, which both glorified masonry construction and described the systematic regularity and cell-like multiplicity of its internal divisions, yet avoided both monotony and picturesque eclecticism. The absence of the traditional emphasis on various focal points was a departure from the accepted compositional principles of that period; there was neither cornice nor column, pediment nor pinnacle. The main entrance was unaccented, the surface uncluttered, and the profiles were unbroken. The succes-

sion of stories was saved from monotony by the subtle grouping of windows and by the variation in size and shape of bays and window openings. The slight differences in the size and surface textures of the stone also contributed interest. Richardson saw the growing power of the commercial-industrial world and created an imposing monolithic structure as an expression of it. From this simple

and fundamental statement a school of subsequent designers took their direction.

The Marshall Field building, no longer standing, was Richardson's last achievement. Created at the moment the skyscraper was being born, it strongly influenced the new school of architecture. The sprawling, formless metropolis of Chicago was the focus of the agrarian and manufacturing empires of the Middle West. The growth of a multitude of neighboring cities and the rebuilding after the fire made it the center of the greatest construction boom in history. A number of imaginative men moved from the East to this more challenging atmosphere.

Cast iron had been used as a building material in New York and Philadelphia since the forties, and in 1848 James Bogardus built his famous factory in New York, which had a cast-iron façade. Bogardus pointed out that buildings of cast-iron modular units could be assembled at all times of the year by ignorant workmen without plumb, square, or level, as the parts needed only to be bolted together. An additional virtue of cast iron, according to Bogardus, was "its happy adaptability to ornament and decoration." In the 1850s numerous cast-iron buildings were erected in Manhattan, and in 1857 the first practical passenger elevator was installed in the five-story, cast-iron Haughwout Building (Fig. 358). This meant that buildings could be erected to any desired height; cast-iron posts and beams made it possible to pile story upon story, and the elevator made all levels readily accessible. But the top eastern architects were not really concerned with the merits of iron as a building material, for they were busy designing palaces for men of wealth. By the last decade of the century, Chicago had taken leadership as a creative center of architecture.

THE CHICAGO SCHOOL

It was in the ambitious and restless atmosphere of Chicago that the skyscraper was born. Following the fire, property values soared. The United States was leading the world in steel production, and with steel to carry the load, with the inflated cost of land, and with the invention of the elevator, the multistoried building became inevitable. In 1883 William Le Barron Jenney (1832–1907) designed a ten-story building for the Home Life Insurance Company in Chicago, using wrought and cast iron for the first six stories and Bessemer steel beams for the next four. Though progressive in its use of a metal structural frame throughout, the exterior lacked distinction, for the metal structural members were well hidden by a routine use of conventional materials.

Two young men, William Holabird (1854–1923) and Martin Roche (1855–1927), working in Jenney's office, set up their own partnership, and in 1886 they laid out the Tacoma Building (Fig. 359). Twelve stories in height, it not only employed an improved riveted-metal frame construction, but the exterior design exploited the new-found freedom of the enclosing wall from its supporting function. A continuous succession of bays ran the full height of the building, providing a maximum exposure to light and air. The brick and terra-cotta sheathing which covered the metal support was lightened, traditional ornament was eliminated, and the glass windows were exposed with unconventional frankness. There was no attempt to invest the external sheath with monumentality and weight. Here for the first time the exterior wall of a multistoried business building was treated as a thin protective skin,

359. HOLABIRD & ROCHE. Tacoma Building, Chicago. 1886.

360. BURNHAM & ROOT. Monadnock Building, Chicago. 1891.

created a more vivid impression than the Monadnock Building (Fig. 360), completed in 1891. Root stated his convictions about business structures when he said: "The relation between dwellings and trade-palaces is the relation between an orchestra and a brass band. Whatever is spoken in a commercial building must be strongly and directly said." The Monadnock Building had the directness and force of a trumpet blast. The massive regularity and bare vigor of this multistoried, many-windowed building create an impression of grandeur far beyond that achieved by the devotees of traditional monumentality. Its sixteen stories thrust themselves into the air in one sweeping and unbroken movement, without a single, distracting surface ornament or deviation of line. The soaring height is accentuated by the subtle chamfering of the corners, which widen with the rise of the mass, and by the profile of the wall, which dips in at the beginning of the second story and flares at the top like the pylon of an Egyptian temple. Despite its effectiveness, the Monadnock Building is less a forecast of the future than it is a bridge between the past and the future, for its effects were achieved by traditional building techniques. The sixteen stories are supported by masonry walls 17 feet thick at the base. Much of the structure's grandeur results from the fact that the weight and volume of the walls are acknowledged visually. Built in a moment of transition, it foretold the future and echoed the past.

Louis Henri Sullivan

It was Louis Henri Sullivan (1856–1924) who gave final form to the architectural diversity of the Chicago area. He alone seemed able to fuse the emerging new concepts of structure and design initiated by the Tacoma Building with the esthetic coherence of the Marshall Field Warehouse and the Monadnock Building. Three cities formed Sullivan's genius: Boston, Paris, and Chicago. Boston, the city of his birth, provided him with his initial philosophic orientation. Paris gave him a sense of architecture and of artistic integrity. Chicago provided him with a theater for his immense talents.

Sullivan attended the Massachusetts Institute of Technology for a short time and then left school to acquire experience in an architect's office. He arrived in Chicago in 1873, when he was seventeen years old. For him the city was "magnificent and wild: a crude extravaganza, an intoxicating rawness, a sense of big things to be done" He went to work for William Le Baron Jenney, in an atmosphere where challenging problems were being met and solved. Later Sullivan went to Paris, but he remained skeptical of French academic architectural practice, which he suspected had lost the "primal

and the exterior design was an honest expression of the multicellular interior honeycomb.

Two other energetic and imaginative men, Daniel Hudson Burnham (1846–1912) and John Wellborn Root (1850–91), also engaged in experimental building. Ambitious Burnham came to architecture from the business world. Root had been trained by some of the finest architects in the East. Together they helped rebuild Chicago. Their Reliance Building, similar in concept to the slightly earlier Tacoma Building, was somewhat more unified and elegant in design, and this element of visual distinction constituted their chief contribution to the evolving skyscraper. Of their many great buildings none

inspiration" of the past. He returned to Chicago in 1879, was employed by Dankmar Adler, and two years later became a partner in the firm. Adler had an established practice and inventive ability, imagination, and taste. Sullivan had unlimited energy and ambition and an unusual capacity to think in basic terms. Together they left their mark through more than a hundred buildings.

One of the first of their commissions was the immense Chicago Auditorium, containing a hall that would seat 4,000 people, a 400-room hotel, and a great office building. The final design reveals the influence of Richardson's recently completed Marshall Field Warehouse in its bold, simple plan, using windows grouped within arches. But Sullivan did not merely imitate Richardson's surface details. Instead, he learned from the older man to think through the complexities of a project until a large synthesis was achieved, and then to develop a plan and façades that precisely expressed that synthesis.

Though the Chicago Auditorium was an impressive achievement, it did not contribute to skyscraper design as did the Wainwright Building (Fig. 361), which Sullivan and Adler built in St. Louis in 1890. Here Sullivan, following his belief that form must follow function and express structure, gave significant visualization to the plan and the structural innovations that characterized the Chicago skyscrapers. This concept was so clearly stated in the Wainwright Building that it established the prototype for skyscraper design for the next fifty years. The building is important equally as a timely solution of a critical problem and as a great work of art.

Significant as the Wainwright Building is in plan, it is in its visual impact that the building remains timeless. Abandoning the richly sculptured forms of traditional architecture, the clean-cut edges and geometric clarity of its principal forms anticipate the precisely machined effects of twentieth-century architecture, which reflects the impersonal technology of modern industrial processes. The internal uniformity of the multicelled, multistoried office building is clearly stated by the repetitious regularity of parts in its main mass. Mechanical monotony is avoided by varying the weight and shape of the windows on the two ground floors, by stressing the string course that separates the second and third stories, and by introducing handsomely textured panels between the windows. The vigor and gaiety of the frieze that animates the area under the cornice also aids in preventing a mechanical aspect.

In some respects the Wainwright Building and the Guaranty Building of Buffalo, N.Y., that followed it retain elements of the past, notably in the three-part design. The two ground stories act as a heavy supporting base surmounted, in turn, by the main body of the building, which is capped by an attic story and cornice. The heavy

corners, too, remain traditional. Despite these vestiges of the past, the design is both prophetic and great. Its significance depends on two factors: first, its esthetic distinction and coherence which far surpassed that of any earlier skyscraper and, secondly, its dramatization of that most characteristic aspect of the skyscraper, the sense of height. Sullivan stated that he was stirred by the magnitude of a tall building and was challenged by the possibility of creating a "proud and soaring thing." The Wainwright Building soars.

Sullivan attacked other problems in contemporary design with equal success. One of his most distinguished and influential subsequent creations was the department store he designed for the Schlesinger & Meyer Company of Chicago, now the home of the Carson-Pirie-Scott Company (Fig. 362). In this great building he abandoned the vertical emphasis which distinguished both the Wainwright

361. Louis Henri Sullivan and Dankmar Adler. Wainwright Building, St. Louis. 1890.

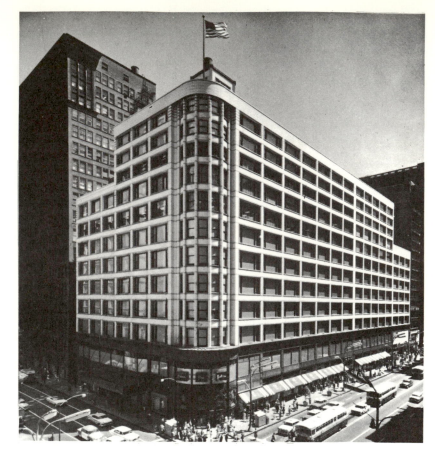

right : 362. Louis Henri Sullivan. Carson-Pirie-Scott Building, Chicago. 1904.

below : 363. Louis Henri Sullivan. Cast-iron detail, Carson-Pirie-Scott Building, Chicago. 1904.

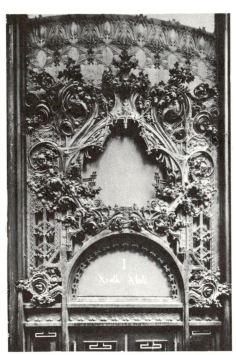

Building and the Guaranty Building for a layered grid pattern that appears to be dictated primarily by two needs: first, to reveal the continuous flow of floor space characteristic of a department store, and, second, to provide for the maximum of window area. Both piers and spandrels were reduced to a minimum, and the beautifully proportioned tripartite window, which came to be called the "Chicago" window, is the dominant feature. In no building up to this time had the nonsupportive role of the exterior walls been stressed to such a degree. The extensive surface of glass appears to be only a protective curtain, and all pretense that the ground floor supports the structure above is abandoned. The floating effect created by the horizontally layered design is intensified by the cantilevered, projecting, rounded-front corner which provides a focal entrance area. The Schlesinger-Meyer Building was particularly admired by the young architects of Europe. Many of its features, such as the daring juxtaposition of rectangular and curvilinear masses, the fluid continuity of surface, and the extensive areas of glass, became stylistic characteristics that were identified with twentieth-century architecture.

Nowhere did Sullivan's use of ornament receive a more refined expression than in the handsome cast-iron detail which decorates the two lowest stories of this building (Fig. 363). This small-scaled pattern is a curious and personal combination of leaves, flowers, geometric motifs, classical ornament, and typical Art-Nouveau elements. Sullivan had declared that original and appropriate ornament "is a perfume," and his decorations for this building add charm to the façade. The scope of Sullivan's capabilities also included the practical aspects of store design. All the paraphernalia of the modern store front—awnings, ventilators, illumination, show windows, and so on—have been used for over fifty years in the Carson-Pirie-Scott Building without requiring any major alterations.

The Transportation Building (Fig. 364), which Sullivan designed for the "Columbian Exposition" of 1893 in Chicago, represented a turning point in his career. The philosophical, social, and consequent architectural conservatism of the East was beginning to dominate the Chicago area, and Sullivan found himself in conflict with the changing mood. Daniel Hudson Burnham, in charge of planning the grounds and buildings, called in a number of such distinguished eastern architects as Richard M. Hunt and Charles Follen McKim to help plan the exposition. To Sullivan's dismay, Burnham acquiesced to the plans of the eastern designers, and a Beaux-Arts manner prevailed except in a very few buildings, among them Sullivan's Transportation Building.

Since this building was to display the newest Pullman cars and railroad engines, Sullivan designed a long arcaded shed with a boldly accented entranceway. Six huge concentric arches in a strong, low, rectangular block funneled the sightseers into the capacious entrance, which was painted in brilliant colors. The gay, typically Sullivan ornamentation that faced the arches and bordered the building was a fluid and continuous molded stucco decoration that candidly suggested poured plaster rather than carved stone. The rest of the fair was housed in pseudo-classic architecture. The great white plaster façades mirrored in the lagoons which filled the spacious courts made a deep impression on the uncritical public. Sullivan was well aware of the seductive power of this synthetic grandeur. "The damage wrought by the World's Fair," he said, "will last a half century"—and his estimate was correct. The "Columbian Exposition's" white classical architecture finished the Romanesque Revival and eclipsed the Chicago school. Classic revival became the style for institutional architecture for many decades.

Though Sullivan continued to produce distinguished structures well into the twentieth century, of particular note among them a group of handsome small-town banks, commissions became less frequent, and his lecturing and writing became increasingly important. His *Autobiography of an Idea*, in which he formulated his philosophy of architecture, and his lectures to the Chicago Architectural Club, published as *Kindergarten Talks*, spread throughout

364. LOUIS HENRI SULLIVAN. Transportation Building, Columbian Exposition, Chicago. 1893.

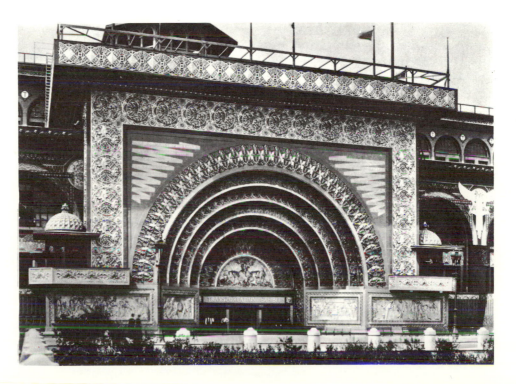

America and Europe the concept of form following function and his theories on design and ornamentation. By his work, writing, and lectures and through a small group of young disciples, including Frank Lloyd Wright, Sullivan fathered many major architectural trends of the twentieth century. A half century after he planted the seed, his concept of functional design took root and became the primary working principle of twentieth-century design.

THE TWENTIETH CENTURY

Eclecticism

In the early years of the twentieth century the skyscraper became the symbol of American business enterprise and culture. American life was often referred to as a "sky-scraper civilization." The term was used in admiration to describe American energy, inventiveness, and wealth but also to decry the domination of business interests over the national life and the increasing tendency to value size and technical organization irrespective of the human consequence. The plan and structure of the skyscraper developed in Chicago was adopted universally, but the vigor and simplicity disappeared. As Sullivan had predicted, the influence of the "Columbian Exposition" was overwhelming. The entire repertory of historical architectural devices was resurrected to be stretched across towering façades in defiance of architectural logic.

Cass Gilbert (1859–1934) completed the Woolworth Building (Fig. 365) in 1913. The vertical sweep of the great mass is overwhelming from a distance, where the frittery detail is lost in the thrust of fifty-six stories, but many occupants peer from their windows through a maze of terra-cotta gargoyles, buttresses, and pinnacles. The world was not yet prepared to be candid about its preoccupation with making money nor to accept the esthetic potential of the machine. Eclectic decorations, symbols of culture, served to obscure the predatory character of certain social patterns and to hide the industrial impersonality of modern technology.

Eclecticism completely dominated the design of public buildings during the early twentieth century. Architects from the École des Beaux-Arts returned to America in increasing numbers, and schools of architecture patterned after the French academy were established in American universities. Increased travel and the publication of authoritative books on architecture created an informed public. As a consequence, impressive monuments in the various historical styles appeared all over America, a tribute to serious intention if not to creative vitality. America built efficiently and comfortably, even imaginatively, in terms of plans and technological developments,

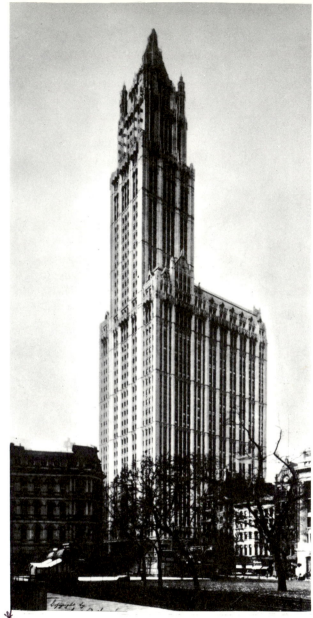

365. CASS GILBERT. Woolworth Building, New York. 1913.

during the years preceding World War I, but almost entirely in the guise of the past.

House design during these years reflected a continued attempt to reconcile comfort and efficiency with traditional concepts of beauty. Electricity, central heating, and plumbing contributed greatly to the livability of the American home, which remained more traditional in appearance than in fact. The early years of the century witnessed a revival of the colonial Georgian manner, as well as a rather thin and mechanical interpretation of

Elizabethan half-timber. In California and Florida stucco and tile were used in houses designed after the Mediterranean villas of Italy, France, and, particularly, Spain. Most of the more modest structures had no decoration except in a few focal areas such as the entrance and the overmantel. Regional differences in house design nearly disappeared; by the second decade of the twentieth century the houses in all sections of the United States were almost alike, except for a few in California and Florida. Industrial standardization made doors, window frames, shingles, siding, and a thousand other elements of house construction the same throughout the country. Goods and services and, consequently, living patterns were also becoming more uniform. The widespread standardization and leveling-off processes of modern life were beginning to be felt, and American building practices were characterized by a monotonous uniformity until the influences of the craftsman movement and of Louis Sullivan provided a fresh stimulus.

The Craftsman Movement, Structuralism, and Art Nouveau

In 1900 one might have assumed that eclecticism had won the battle of styles and that the progressive architectural trends of the Chicago school had come to naught. But the followers of Sullivan and Richardson continued their search for a style suited to the new science of building. Parallel developments were appearing in Europe, and progressive designers on both sides of the Atlantic drew inspiration and encouragement from the advances that were occurring.

Three separate but closely related aspects of the progressive forces at the turn of the century can be identified. Starting in England, the influence of William Morris made itself felt in ever-widening circles through a revival of handicraft processes, simple carpentered construction, and the use of unpretentious building materials. This interest provided the basis for the craftsman movement. Secondly, a concern with the structural possibilities of ferroconcrete, metal, and glass stimulated experiments in architectural design in Paris, Brussels, and Vienna; and this attempt to give logical architectural form to the evolving technology of the industrial age constituted a trend best described as "structuralism." Thirdly, progressive designers were finding new inspiration in the decorative arts of the Orient, in the arts of primitive peoples, in European peasant crafts, and in other unorthodox sources. The decorative style that developed from a combination of these various ingredients received its most complete expression in the movement historically known as Art Nouveau.

In America structuralism attained its clearest formulation in the work of Sullivan, which has already been described. The Art Nouveau movement, which had a very limited influence on architecture, made its chief impact on the decorative arts and graphic design. The craftsman movement, however, coming as a reaction against both sham and conventional eclecticism, had noteworthy expression in the hands of a number of American designers. In a period when pressed tin simulated ceramic tiles, cast iron pretended to be carved marble, and plaster was cast to copy stone, the conventional Beaux-Arts architects who were above such obvious tricks equated integrity with the esthetic formulas of the past. By contrast, the formulators of the craftsman movement valued honesty above all else. They believed in a sensitive and discreet use of familiar materials, a frank avowal of structural methods, and the development of plans and outward forms through an analysis of function.

Frank Lloyd Wright

The most forceful architect to lead the battle against sham and reaction in these crucial years was Frank Lloyd Wright (1869–1959). His contribution to the development of modern architecture through his "prairie style" in the first decade of the twentieth century was as significant as that of Sullivan to the preceding generation. Certainly no individual did more to give expression to the evolving craftsman style than did Wright.

Frank Lloyd Wright was born in Michigan. His father had come from the East to teach music but became a Unitarian minister instead, and Wright grew up in an atmosphere of poverty, music, morality, and Welsh sentiment. Early in life he singled out the Middle West as the home of the "real American spirit capable of judging an issue for itself upon its merits." At eighteen he quit the School of Engineering at the University of Wisconsin. Within a year he was working in the office of Adler and Sullivan. With his forthright egotism, he claimed to be "the best paid draftsman in the city of Chicago." The six years that he worked for Adler and Sullivan constituted his education in architecture. When Daniel H. Burnham tried to lure him into his office by offering to pay all his living expenses for a protracted period in France and Italy, Wright declined on the basis that Sullivan had spoiled the Beaux-Arts for him, and him for the Beaux-Arts. In 1893 he opened his own office.

From the beginning Wright practiced his profession according to his convictions. He designed what he termed "organic" architecture, in which the form was determined by the function and the construction—architecture which grew from the "inside out," as he put it—and he found

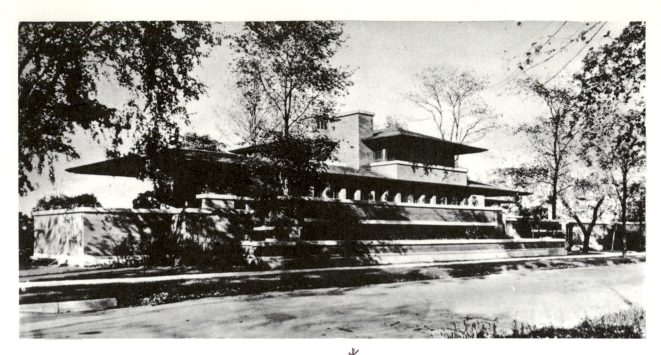

precedent for his organic concepts in the past. He admired the architecture of the Middle Ages, although he never imitated its surface mannerisms, and paid tribute to the Japanese, who, he declared, "have never outraged wood in their art or in their craft."

Wright's earliest houses were in the shingle style and showed the virtues of that style—a feeling for simple textures, for continuous exterior surfaces, and for an open plan. Under Sullivan's aegis he also created designs characterized by monumental forms and a clear statement of plan and structure. In the late 1890s these elements

above : 366. FRANK LLOYD WRIGHT. Robie House, Chicago. 1909.

below : 367. WILLIAM PURCELL and GEORGE ELMSLIE. Bradley House, Woods Hole, Mass. 1912.

fused into his "prairie style," and it was in his "prairie" houses designed early in the twentieth century that Wright's unique capacities received their initial realization. Feeling that the democratic spirit needed something better than a cell in which to develop, he proceeded to ignore the boxlike partitioning of houses into separate rooms

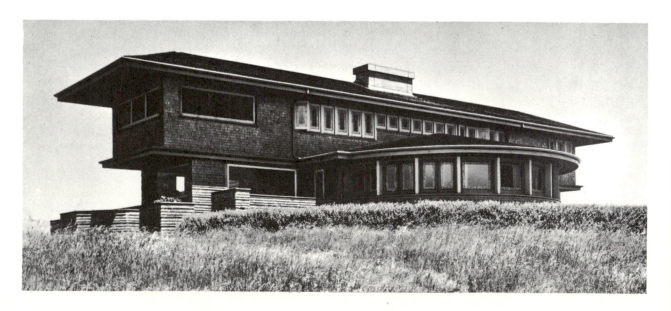

and used walls as screens to direct the flow of space and increase the mobility of living patterns within the home. A number of these houses, developed for the Great Plains area, represent an astonishing revolution in domestic architecture.

One of the most significant of his early designs is the Robie House (Fig. 366), built in Chicago in 1909, in which he achieved a most distinguished statement of the "prairie style." The keynote is the forceful emphasis on horizontal lines created by the extended floor plan, the spreading terraces, horizontally grouped rows of windows, low roofs, and broadened and lengthened eaves. This horizontal emphasis relates the house to the terrain; the form seems to emerge from the prairie and gradually build toward the massive chimney. The long, low line of the eaves also repeats the distant horizon and thereby relates the building to the spaciousness of the western plains. The overhang tempers the hot summer sun and the harsh glare of winter's snow, permitting extensive window areas, which relate the interior to the outdoors.

In the Robie House, Wright demonstrated his ability to combine weight and monumentality with exhilarating movement. This achievement depends upon the repetition of dominant lines counterbalanced by strategically placed oppositional lines. The airborne quality of the winglike spread of roof strikes an almost prophetic note. The decorative effect of great unbroken surfaces and the geometric forms are conceived as a foil for the surrounding natural forms and patterns of light and shadow. Noteworthy, too, is the simplicity of the materials. In a time of artificiality and ostentation the dramatic simplicity and integrity of the Robie House were revolutionary.

The interiors of the prairie houses (Fig. 384) followed Wright's credo as closely as did the exteriors and were as far removed from the modes of the day. In the interests of serenity and repose, they contained as few rooms as intelligent living permitted. Doors and windows were part of the structural and visual patterns, not mere holes punched in walls. Decorative effects were produced by the imaginative use of such structural necessities as exposed beams and carpentered joints. Appliances, fixtures, and furniture were assimilated into the design of the whole, thereby creating a unified and harmodious entity. Wright's contribution to interior design is discussed more thoroughly in Chapter 14.

Wright created a number of notable houses in the Middle West, but not all of his genius was expended on domestic architecture. One of his early designs for industry was the Administration Building for the Larkin Company of Buffalo, N. Y., now demolished, which set a precedent for dignity and orderliness in a business structure. In 1905 he established a milestone for ecclesiastical design in Unity Church of Oak Park, Ill., through his use of concrete, a material which had been considered lacking in any esthetic potential. He poured the concrete in great masses, relieved only by the slightest surface textures, so that the monumental forms have the dignity of an Egyptian temple without the irrelevance of an anachronism. In America Wright's activities suffered a temporary eclipse in the decade following World War I, but in the 1930s his imagination and inventive capacities again brought him to the fore. His later work will be discussed in Chapter 18.

Though Wright was the most influential architect to work in the craftsman style, others must be recognized. William Purcell (1880–1965) and George Elmslie (1871–1952), like Wright, received their initial orientation working for Sullivan. One of their most effective designs is the Bradley House (Fig. 367), built in 1912 in Woods Hole, Mass. Here two great geometric forms, the rectangular mass of the main section and the sweeping, circular bay, are composed to provide a magnificent view of the sea. The magnitude of the form is augmented by the simple texture of shingles, which provide the surface sheathing. Unlike the many beach houses which merge with the landscape, the Bradley House dominates the promontory on which it stands by the bold counterpoint of its geometric forms. Although the monumental and dramatic aspects of the Bradley House are most apparent, such houses encouraged informal living and an increased enjoyment of nature. Interiors were more open than in the conventional houses of the day, rooms larger, fewer, and designed to serve a variety of purposes. House plans were carefully adapted to their site, rooms and views opened out into garden areas, and functional arrangements facilitated easier housekeeping.

The craftsman architects from the Chicago school were also active in city planning, particularly in designing the new garden-city suburban communities, which were intended to mitigate the increasingly sterile character of city life by taking advantage of the landscape, open spaces, and nature. One of the most effective of these city planners was Walter Burley Griffin (1876–1937), who, on winning a competition for the design of Canberra, the new capital city of Australia, moved to that continent and proved to be a most influential figure in introducing there the concepts of the Chicago school.

The California School

Purcell's feeling for simple materials and informal house plans came not only from his experience in Sullivan's office but also from a stay in California. California was receptive to experiments; the mild climate, the spacious terrain, and the comfortable, rambling Mediterranean-

style buildings of the Spanish settlers contributed to a taste for informal architecture. Since most of the cities in the state were not well established until the end of the nineteenth century, there was little eclectic architecture to set a precedent. California designers were particularly concerned with sensible house design. The bungalow, the one-story cottage, planned more for comfort than for elegance, almost became a symbol of California. The state's proximity to the Orient fed the current interest in the Japanese house. Reinforcing these trends came the craftsman concern with direct carpentering and straightforward use of simple materials, particularly wood, and in California, specifically redwood.

Charles Sumner Greene (1868–1957) and his brother, Henry Mather Greene (1870–1954), attended the Massachusetts Institute of Technology and about 1894 moved to southern California. In their hands progressive influences were integrated into a vigorous and unified style.

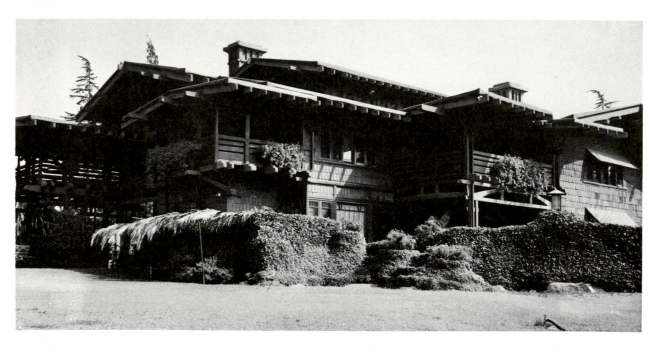

above : 368. GREENE & GREENE. Gamble House, Pasadena, Calif. 1909.

right : 369. IRVING GILL. Dodge House, Los Angeles. 1915–16 (destroyed 1970).

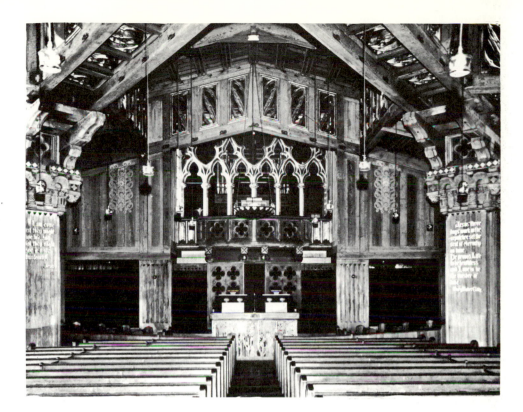

370. Bernard Maybeck. First Church of Christ, Scientist, Berkeley, Calif. 1912.

The Greene brothers were masters of the extended one-story bungalow, the rambling, capacious, informal house that became almost part of the landscape, but they also have a number of handsome two-story designs to their credit. One of the most splendid of their larger houses is the Pasadena mansion (Fig. 368) for one of the sons of Gamble of Proctor & Gamble.

The Gamble residence, built in 1909, provides a distinguished example of the work of the Greene brothers and the craftsman style. The materials are redwood and shingle stained dark brown, combined with red brick in the chimneys. The wooden construction is candidly stressed. Supporting posts carry extended beams and rafters to create an interaction of rectangular and diagonal patterns. The low-pitched roofs, broad gables, and open eaves contribute a delicate Japanese flavor that is further emphasized by the horizontal slats enclosing the porches and by the open trellises. The informal design is deceptive. The play of carpentered patterns, simple textures, and vigorous lights and shadows appears casual, but all of these details had been carefully calculated by the architects to keep the massive house from appearing ponderous and pretentious.

Not all progressive architecture in California glorified wood. Irving Gill (1870–1936) did some original and highly significant work in concrete. After a short stint with

Sullivan in Chicago, Gill moved to southern California, where, between 1907 and 1916, he arrived at a style which was prophetic in its direct simplicity. During these years he designed a number of houses and public buildings, of which the Dodge House (Fig. 369) was a most distinguished example. Using straightforward rectangular masses and some elements of the early Mission style, such as simple arched openings and smooth, unadorned surfaces, Gill achieved a severe clarity that foreshadows the functional style of the 1940s. He proved as inventive in building techniques as he was advanced in his esthetics, developing, among other methods of using concrete, a type of precast slab construction and the use of concrete in conjunction with hollow tiles and reinforcing steel bars. Gill's classic simplicity fell out of favor after 1915, when the Spanish Baroque became popular, but his precedent had much to do with the ready acceptance of modern house design in California in mid-century.

In San Francisco and the Bay area, Bernard Maybeck (1862–1957) combined elements of the craftsman style with conevntional eclectic and exotic motifs to create a body of highly colorful work. One of his most noteworthy buildings is the First Church of Christ, Scientist (Fig. 370) in Berkeley, Calif. In this original structure he gave vent to his inventive and imaginative talents by combining craftsman style elements with Gothic and Oriental motifs.

The result, particularly in the interior, has an exultant and mystical quality that appears particularly suited to a religious edifice. Maybeck's versatility is worthy of note. In some of his late buildings he combined traditional classic-revival elements with highly original plans and structural methods, as in the Palace of Fine Arts for the "Panama Pacific Exposition" of San Francisco, in 1915, and in his later Packard Showroom in the same city. No building was too insignificant for his attention; he did not scorn to expend his talents in devising innovations for the inexpensive construction of mountain cabins.

The conservative architectural tastes of the East inhibited the growth of progressive architecture there during the years when the Chicago school and the subsequent craftsman style were developing in the Middle West and California. The most conspicuous exception to the conservative tendencies of the East at this time appeared in the work of Louis Comfort Tiffany (1848–1933), whose own home, Laurelton Hall, at Oyster Bay, Long Island, was most strongly influenced by the Art Nouveau style of France, particularly in its use of decorative elements drawn from Islamic sources. Tiffany achieved his most influential expression as a designer of interiors and *objets d'art*. His accomplishments as the chief exponent of Art Nouveau in America will be discussed in the next chapter.

In the years between the Civil War and World War I, America grew with fantastic rapidity. The pressure of expansion and growth stimulated an inventive approach to building, evidenced by the adoption of balloon framing, the development of steel construction in skyscraper design, and the advanced character of American house plans. The taste for size and elaboration characteristic of the 1870s bore witness to the energy of the young nation. In the following decade Richardson combined American vigor and inventiveness with a creative, rather than an academic, use of tradition. Sullivan continued this creative approach to design when he transformed the steel-framed multistoried buildings of the Chicago area into powerful architectural forms.

Between 1900 and 1915 the rich promise inherent in the work of Sullivan and his followers appeared lost in a surge of unimaginative conventional building, but the concepts of the Chicago school and other progressive designers were too much an integral part of the evolving social and technological forces of America to be diverted. The inadequacy of the eclectic approach became increasingly evident, for the old architectural devices were not effective; nor could society pay for them. Though it was long delayed, a brilliant realization of the concepts of architectural design which had been initiated by Sullivan, his disciples, and the craftsman designers took place in the years following World War II.

14

Interior Design, Furniture, Industrial Design, and the Crafts

Eleven years after the conclusion of the Civil War, Philadelphia staged a great exhibition to celebrate the centennial of independence. Most of the nations of the world exhibited examples of their fine and industrial arts, as well as of their household wares and machinery, with displays notable for their size, elaboration, technical excellence, and novelty. The American wares were almost indistinguishable from the European except for the machines, in which a number of critics felt that American genius expressed itself most naturally. The most spectacular machine at the "Centennial Exhibition" was the great Corliss engine (Fig. 371).

The Corliss steam engine commanded the unqualified admiration both of the multitude and of the critics who visited the exposition. Towering 40 feet and weighing over 8,000 tons, it supplied the power to run all the mechanical devices on display. It was not only one of the largest and most powerful engines of its day and the dominant feature of the Hall of Machines, but it made no concession to popular notions of beauty, despite the

right : 371. Giant Corliss engine exhibited at the Centennial Exhibition, Philadelphia. 1876. Chromolithograph. Metropolitan Museum of Art, New York.

fact that it was designed to play a conspicuous role in the exhibition. Not one extraneous ornamental device marred its surfaces. The public admired the silence and smoothness with which it ran, as well as its turning wheels and massive skeletal structure. Many laymen remembered the Corliss engine long after the other exhibits had been forgotten, and a number of intellectuals understood the promise implicit in its forms. A French sculptor reported to his government that the engine had the beauty and almost the grace of the human form. A London *Times* correspondent stated that the Americans mechanized as the ancient Greeks had sculptured. The *Atlantic Monthly* philosophized: "Surely here, and not in literature, science, or art is the true evidence of man's creative power...."

The Corliss steam engine, like the Brooklyn Bridge and the Tacoma Building, pointed the way to a new approach to design, one based on the use of metals, on industrial rather than hand processes, and on a candid statement of functional form. The purely utilitarian nature of the machine encouraged this direct approach, because the necessity for operation at maximum efficiency was the primary factor in determining the arrangement of the parts. The machines of the nineteenth century were, in essence, developments of earlier tools which had been marked by restraint, directness, and simplicity. American tools, in particular, had been distinguished by their lightness and efficiency. In such a tradition there was no room for the inefficient and the diffuse, nor were there resources to spare for ornamentation. This great machine, simply designed, glorifying steel and making an unequivocal statement of utilitarian purpose, was awesome in its stark magnificence. Yet many years were to pass before its

372. Cast-iron sewing machine. c. 1857. Davenport Public Museum, Davenport, Iowa.

strength and beauty were to influence other fields of design by establishing the concept that unadorned functional form has esthetic worth.

The distinction of the Corliss steam engine and its significance to the evolving concepts of design are most apparent in comparison with typical cast-iron household wares of the day. Cast iron was one of the chief materials of industrial expansion in the late nineteenth century. There was little precedent for the design of many of the new cast-iron objects, and typical procedure was to evolve a functioning shape and then decorate it by strewing traditional ornamental borders, plaques, and architectural devices over the surface. An effective contrast to the Corliss engine is provided by a cast-iron sewing machine (Fig. 372) from Connecticut. A classical column, Rococo swirls, and a medley of other decorative motifs keep the machine from appearing plain and utilitarian. Machines manufactured for household purposes were thus reconciled with conventional standards of household *décor*.

The Corliss engine was prophetic of the esthetic revolution that was to characterize the oncoming machine age, but it certainly did not reflect the typical tastes of its day. It was in the interiors and the household furnishings that the High Victorian style and the subsequent reactions against that style assumed their most characteristic forms.

INTERIOR DESIGN AND FURNITURE

Four stages of development can be noted in the evolution of interior and furniture design between the Civil War and 1915.

1. The tendency toward weight, elaboration, and complexity reached its height in the 1870s. Diversity was valued above unity, gusto above restraint. In the homes of the wealthy, heavily upholstered and elaborately carved pieces of furniture vied with patterned carpets, draperies, wallpapers, mirrors, pictures, and *objets d'art* to create ponderous Victorian interiors. French Baroque and Rococo decorative motifs provided the chief sources of inspiration but were interpreted to suit the current taste. Comparison of a Rococo Revival room of the fifties, the Milligan Parlor (Fig. 250), with the Stanford Bedroom (Fig. 373) of the late seventies reveals the shift toward elaboration that occurred during the decades following the Civil War, when High Victorian tendencies reached their apex.

2. In the seventies and eighties the Arts and Crafts Movement came as a reaction against the pretentious nature of fashionable styles. Led by two Englishmen, first Charles Eastlake and later William Morris, progressive designers turned from the French aristocratic styles and sought inspiration in the handicraft practices of the Middle

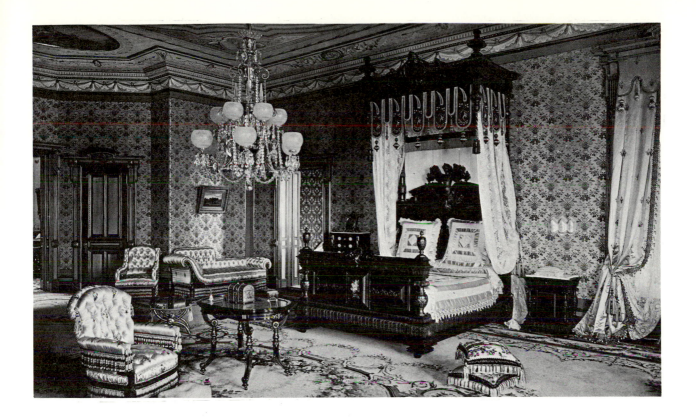

above : 373. Bedroom, Stanford House, from San Francisco. 1878. Stanford Museum, Stanford, Calif.

Ages and the Renaissance (Fig. 381). Fitness for purpose and honesty were valued above elaboration.

3. Between the eighties and 1900, eclectic practices became more decorous under the guidance of the École des Beaux-Arts and other academic sources. In very fashionable circles "authentic" period interiors replaced the earlier indiscriminate combination of styles (Fig. 378).

4. Between 1890 and 1915 the Arts and Crafts revolt against vulgarity and eclecticism crystallized into two closely related movements. The craftsman movement, as it affected interior and furniture design and certain crafts, emphasized the same values as had craftsman architecture–honesty, practicality, simply carpentered construction, and plain materials (Fig. 382). At the same time the high-style Art Nouveau flowered (Fig. 380), revealing a strain of aristocratic elegance. Art Nouveau had a very limited influence upon American architectural and furniture design, but in the household arts Art Nouveau designers introduced an element of estheticism, frequently exotic, which came as an antidote to the leveling of taste that seemed a concomitant of democracy in an industrial age.

In the late sixties and seventies the French Rococo, the dominant style in mid-century, gave way to the High

Victorian preference for heavier and more imposing effects. A bedroom from the Stanford mansion (Fig. 373) in San Francisco reveals the changing tastes. Rococo lines were replaced by a more rectangular emphasis. Forms were more frequently drawn from Baroque sources, for increased wealth demanded more massive and elaborate surroundings. Windows and doors were large, framed in rich moldings capped with crested ornaments. Complex borders alternating with moldings elaborated the cornice, and the ceiling was divided into variously shaped panels, often enclosed in ornamental molded plaster frames. Patterned wallpapers, lace curtains, heavy fringed draperies and valances, figured carpets, great crystal chandeliers, and a superabundance of furniture and *objets d'art* all contributed a profuse magnificence well suited to this aggressive and energetic age. Colors, too, were heavy, dark tones predominating, with rich reds, dark greens, and browns replacing the fresh tones of Rococo inspiration. Shiny varnish, glittering gilt, veined marbles, brocades, and damasks added textural complexity. The furniture in the Stanford room reveals typical characteristics: First, there was a tendency toward high and imposing profiles. Second, almost all pieces of furniture with any pretensions to elegance were marked by an excessive amount of ornamental detail. Third, other than in the pieces of Rococo or neoclassic inspiration, the preference

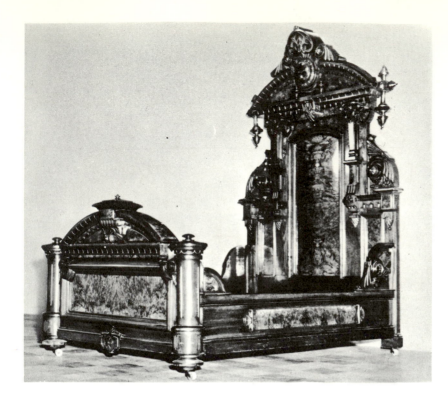

374. Victorian bed. 1870s. Walnut. Grand Rapids Public Museum, Grand Rapids, Mich.

was for bulk, often to the point of clumsiness. Stylistic purity was abandoned for original or extravagant effects.

The eighteenth century and the early nineteenth had been the age of the cabinetmaker; the last half of the nineteenth century was the age of the upholsterer. The use of inner springs and cushions was perfected, and all through the century the French designers who dictated the fashions introduced increasingly elaborate forms of upholstered furniture. Divans, circular sofas, great poufs, love seats, including fancy S-shaped sofas that enabled couples to sit face to face, and all types of easy chairs became popular. The Stanford bedroom includes three of these massive, comfortable pieces. The large divan at the end of the room, like the two chairs, is a masterpiece of the upholsterer's art, with deep cushions, heavy springs, elaborate tufting, and long fringe creating the fashionable bulky silhouette.

While the mode was to cover the frame of upholstered pieces completely, other types of furniture featured intricately carved frames, which were further ornamented with inlay, gilding, and metal mounts. The table in the foreground is characteristic, with its thin, mechanical carving, gilt striping, and contoured legs interrupted by turnings. Designers drew on all periods of the past for ideas, but current tastes determined the final effects more than the original source of inspiration. This tendency is well illustrated by the bed, with its Jacobean-flavored

footboard and its crested headboard surmounted by a French Baroque canopy. Regardless of its source of inspiration, High-Victorian furniture, like the architecture, remained High Victorian.

High-Victorian Furniture

Three pieces of furniture from this period will help to round out the picture of its exuberant tastes. A bed of the 1870s (Fig. 374) from Grand Rapids, Mich., the center of late nineteenth-century furniture manufacture in the United States, is an extreme example of the massive proportions and excessive detail that were so admired. Though the general effect is Baroque and some of the detailing suggests a Baroque origin, much of the ornament, such as the curious turned pinnacles and pendants that flank the heavy top crest, seems pure invention on the part of the designer. Typically, the high profile, irregular contour, and heavy carving are further enriched by grained veneers. The manufacturing processes that permitted covering a cheaper wooden core with thin veneers of finer wood were perfected during this period.

An armchair of the same period (Fig. 375) displays the proficiency of the upholsterer's art. Wire framing, deep springing, webbing, and tufting were perfected so that eccentric shapes such as the leg-of-mutton armrests would retain their form. Though relatively restrained, this

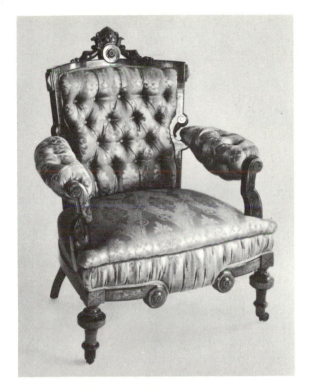

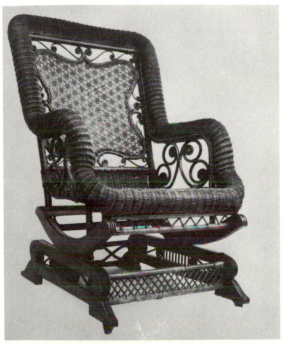

chair, too, reveals the much desired variety of textures and forms. The appearance and disappearance of the framing, its swollen turnings, and its sudden surprising changes of direction provide the energetic discontinuity which was preferred to a synthesized and unified effect.

A wicker platform rocker from this period (Fig. 376) exemplifies the enthusiasm with which hinges, springs, and other mechanical devices, as well as new materials and methods of manufacture, were exploited. Early in the century Thonet, an Austrian, had invented a widely popularized method for steaming and bending wood, which probably inspired the elaborate cane volutes that form the principal decorative feature here. This unorthodox combination of materials and forms reflects the inventive capacities of the age, its feeling for comfort, and its delight in heavy forms enriched by intricate and involved, if not always well-related, patterns. Because High-Victorian design violates so many traditional standards of taste, one is apt to overlook its vigor and gusto.

The "Artistic" Styles and the Craftsman Movement

In mid-century, motivated both by the enthusiasms of such medievalists as John Ruskin and by the vulgar showiness of most machine-made household goods, an attack was launched against the false aping of aristocratic elegance. The chief protagonists were two Englishmen, writer-architect Charles Eastlake, who published his *Hints on Household Taste* in Great Britain in 1868 and in America in 1872, and William Morris. Eastlake made an eloquent plea for honest craftsmanship, advocating that materials be treated in a way to reveal their essential character and that design grow from function. His writing gave direction to the emerging reform movement and encouraged propriety and restraint in the designing of interiors and household furnishings. Turning to the handicraft traditions of the late Middle Ages, but also selecting stylistic details from sources as diverse as the Jacobean, Queen Anne, Japanese, and Near Eastern styles, Eastlake recommended rectangular, straightforward frame construction; rather flat paneling; the use of simple turnings; and shallow carved ornamentation employing naturalistic foliate and floral patterns.

Following his prescription, oak, cherry, and other light-colored woods were finished to bring out their natural color and grain. Tile insets were considered practical and attractive, and the use of large, handicrafted hardware was encouraged. Many of the devices suggested by Eastlake appeared to be well adapted to machine techniques of production, even though they were inspired by the processes of craftsmanship from earlier times.

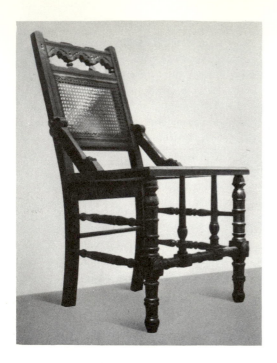

Rectangular forms and carpentered construction with vertical supports, horizontal crosspieces, and diagonal braces were prescribed for furniture. Dowels, pegs, and chamfers were to be clearly evident, and the use of quite simple ornamental carving was recommended. Unfortunately, in the hands of designers without taste these devices frequently led to clumsy heaviness.

Eastlake's theories on furniture design had considerable influence on American manufacturers and accounted for much bad and some sensible and attractive furniture. A chair (Fig. 377) of the 1880s in the Eastlake manner offers a welcome relief from the extravagance of much of the fashionable furniture. The rectangular frame is strong but not too heavy, and the joints are stressed to indicate structure. The back has a slight rake, and this, together with the sturdy proportions, is a concession to a sensible level of comfort but certainly not to sybaritic indulgence in lounging. Such decorative elements as the channeled grooves, simple turnings, strongly articulated brackets, and flat, incised patterns represent an attempt to reconcile beauty with honesty, or at least with common sense and practicality. Eastlake furniture was frequently executed in fruitwoods or oak and was finished in a soft, natural manner, rather than with the high-gloss varnish often used to obscure poor materials and faulty workmanship.

William Morris, dedicated author and designer, established a firm in England in 1862 for the production of textiles, wallpapers, carpets, furniture, stained glass, and other decorative arts, seeking to stem the debasing tide of machine production and aspiring to the integrity of craftsmanship that characterized the medieval and early Renaissance arts. He, too, influenced reform in America.

The Beaux-Arts Ideal

The idealistic tenets of Eastlake and William Morris did not coincide with the mainstream of popular Victorian taste. Before moving on to a detailed study of reform movements of the day, a glance at the more conventional Beaux-Arts reaction against Victorian display is illuminating. Richard Morris Hunt, the Parisian trained spokesman for the "age of elegance," designed The Breakers for the Vanderbilt family. Forsaking the unbridled extravagance of the High-Victorian Baroque Revival style, he emulated the restrained grandeur of French eighteenth-century architecture in this mansion. The central hall (Fig. 378) features two-story pilasters capped by handsome Corinthian capitals, classical moldings, swags, cartouches, and other components of palatial splendor, all executed in marble enriched with gilt and precious materials. Studied and disciplined though the design may be, its cold elegance seems particularly inappropriate for a summer home in Newport, R.I. It is a monument marking the end of an epoch in American cultural history. That houses like The Breakers were not typical of their day makes them no less significant, for they represented an unrealized ideal for many Americans. It was against this ideal, as well as against the more vulgar aspects of High Victorian design, that the reform movements to be discussed below were directed.

The "Artistic" Styles: Orientalism and Art Nouveau

The search for a fresh vocabulary of forms constituted an important part of the reform movements which terminated in Art Nouveau and the craftsman style. One aspect of this search, an interest in the arts of the Near and Far East, existed all through this period and reached its height toward the end of the century. In the eighties a vogue for the wares of North Africa took a number of forms. Not only did serious designers find inspiration in Oriental arts and crafts, but on a popular level an element of exoticism was introduced into many an already overdecorated room in the form of a Turkish corner, an area adorned with Oriental hangings, a table inset with colored tiles, lamps of damascened brass, and similar curios.

Not all the Orientalism of the eighties was on such a superficial level. A concern with clarity of structure and the evolution of a fresh decorative style inspired a Moorish room (Fig. 379) in the John D. Rockefeller House in New York in 1884, a room that might be considered both proto-Art Nouveau and proto-craftsman style. The rectangular framework of moldings and wood paneling provides a structural setting for the rich patterns which decorate all available surfaces. Geometric and conventionalized floral motifs of Islamic inspiration cover the walls, ceiling, and carpet, and the woodwork and furniture are ornamented with borders and panels of the same Oriental style. All these rich and exotic patterns are held within definite boundaries. A growing concern with structure is evident in the firm architectural framework which dominates the Rockefeller Moorish room.

The Orient continued to provide inspiration, but the Near East soon gave way to Japan as a major stimulus to designers, particularly those who helped to formulate Art Nouveau. Some of the most distinguished architectural, interior, and furniture design produced in Europe in the last two decades of the century was in the Art Nouveau style. However, in America the influence of Art Nouveau was limited, affluence and elegance most often expressing themselves here in Beaux-Arts propriety.

The most handsome Art Nouveau interiors in America were those designed by Louis Comfort Tiffany (1848–1933). A view of the studio in his New York City house (Fig. 380), with its four-sided fireplace, reveals the curious combination of exotic elegance and simplicity that characterized this style. The organic forms, sometimes swelling and sometimes attenuated; the elaborate convolutions of line enriched with tendril, bud, and leaf patterns; the hanging lamps, creating an "Arabian Nights" air; and the casual scattering of *objets d'art* about the room contribute

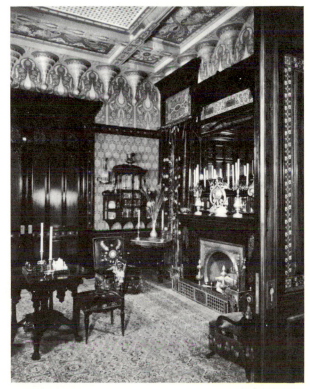

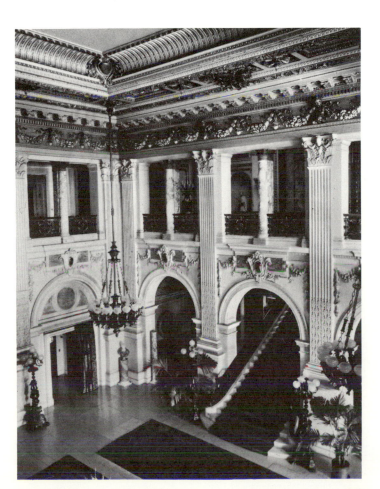

left : 378. RICHARD MORRIS HUNT. Central hall, The Breakers, Newport, R.I. 1892–95.

above : 379. Moorish room, from John D. Rockefeller House, New York. c. 1884. Brooklyn Museum.

to both elegance and informality. Earthy pottery, translucent glass, gleaming metal, and Oriental rugs contribute jewel-like sparkles of color to animate the all-pervasive sense of spacious quietude.

The Craftsman Style

The exoticism and preciosity of much Art Nouveau makes it seem far removed from the simple honesty of the craftsman credo. Yet both movements grew from the same search for a valid style rooted in the beliefs and practices of a changing world. Art Nouveau focused primarily on decorative practices, while the craftsman movement was more concerned with considerations of plan, use of materials, and structural methods. Still, the practical concerns of the craftsman designers did not rule out esthetics; in fact, the fundamental purpose of the craftsman designer was to evolve an esthetic of integrity. Both Charles Eastlake and William Morris made their initial impact as esthetic philosophers, and from their philosophy developed the English Arts and Crafts Movement.

The first important American exponent of this reform movement, as noted previously, was Henry Hobson Richardson. A view of the interior staircase of his R. T. Paine House (Fig. 381) provides a handsome example of

above: 380. LOUIS COMFORT TIFFANY. Studio in the artist's house, New York. 1883. From H. W. Desmond and H. Croly, *Stately Homes in America*, New York, 1903.

right: 381. HENRY HOBSON RICHARDSON. Staircase, R. T. Paine House, Waltham, Mass. 1884–86.

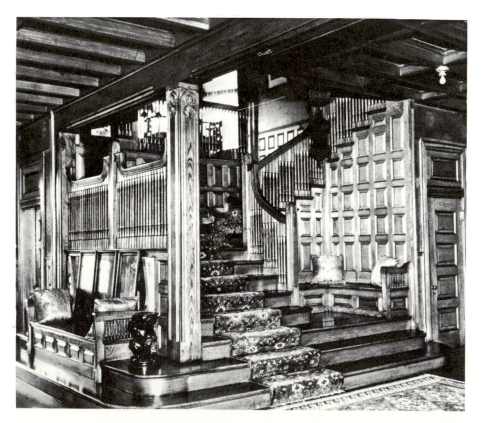

the type of interior Richardson and his followers planned for their substantial yet unpretentious shingle houses. An ample hallway serves both for a spacious entry and easy circulation to the various parts of the house. Most noticeable is the complete absence of Baroque ornament and the trappings of aristocratic splendor. Instead, there is a straightforward use of stained wood, with vigorous exposed framing, open-beamed ceilings, small panels framed by flat boards, and simply turned balusters supporting the stair rail. The calculated relationship between the flowing open spaces and the mounting masses of stairs and walls, with the vertical beams and balustrades emphasizing the spatial intervals, forecasts Frank Lloyd Wright and twentieth-century space composition.

The example set by Richardson, by McKim, Mead & White, and by other designers of shingle-style houses in the eighties had its greatest impact upon the educated middle classes and intellectuals, who valued its common-sense emphasis upon comfort, practicality, and honesty. These qualities received their most widespread and explicit formulation in the publications and designs of Gustav Stickley (1848–1942), the most influential popularizer of the style on a middle-class level. A design for the stairway and corner of a living room (Fig. 382), taken from his book *Craftsman Homes*, published in 1909, reveals his characteristic interpretation of the style. Straightforward carpentered construction was employed throughout, with unadorned vertical posts supporting heavy horizontal crossbeams, which, in turn, carried smaller ceiling beams. Walls were usually paneled to door height, and plain plaster or patterned paper filled the area between the top molding and the ceiling. Moldings were broad and flat; simple board-and-batten construction constituted the usual type of paneling. Windows were frequently small and arranged in groups and were glazed with small, square panes of glass; bookcases and interior doors were often treated similarly. Built-in corner seats, fireplace nooks, and other cozy devices were popular. Wood was stained or waxed, and dark colors were preferred.

The heavy beam construction permitted the elimination of many enclosing walls and encouraged an open plan. Living rooms frequently opened into dining rooms or sun porches. Open stairs and wide, double sliding doors also contributed to a sense of continuity between parts of the house. Broad verandas, large sun porches, and open dining rooms encouraged the easy movement between indoors and outdoors that has become such a vital part of contemporary living. At its best the craftsman house was comfortable, modest, and charming—easy to care for and well adapted to middle-class family living.

The general principles of the craftsman movement also called into being a simple, sensible kind of furniture which rapidly became known as "Mission" furniture. Stickley was a leader in its manufacture. An occasional chair (Fig. 383) shows the characteristics of the Mission style. The structure is rigidly rectangular; the original Mission furniture of the Southwest was supposedly hewn from rough timber and joined together with mortise, tenon, and dowel, with no nails or glue used. Lines are severely straight and simple, and the only concession to decoration

is in the occasional use of small brackets to support arms or other extending parts. Upholstery consists of lightweight leather cushions; frequently there were springs beneath the cushions for added resiliency. Oak became the standard wood used in such pieces, and it was finished in various weathered colors or in a light, dull-finished golden brown called "fumed oak." The first Mission furniture introduced to the market was of heavy proportions, but later pieces were lighter, more graceful, and almost slender.

If Stickley was the most popular spokesman for the craftsman movement, Frank Lloyd Wright was its most distinguished exponent. In a number of his "prairie" houses he transformed the honest prose of the craftsman style into eloquent architectural poetry.

Wright penetrated deeply into the problem of interior design in his concern with the floor plans that shaped the original and striking exteriors of his houses. He re-examined the living patterns of his day and sought to design interiors which would contribute to both a more efficient and a more dignified way of life. In his best houses, such as the Coonley House (Fig. 384) in Riverside, Ill., the conventional division of the interior into cell-like cubicles gave way to a free movement from room to room which would further group living. Walls became screens directing the flow of space without creating re-strictive barriers. Long banks of windows and numerous doors provided communion with and access to the surrounding landscape.

Most of the concepts Wright employed were common to the craftsman houses of the day: the opening of rooms into one another to convey a sense of spaciousness, the easy access between indoors and outdoors, the use of heavy timbered framing combined with cantilevered construction, the candid statement of structure, and the use of unpretentious materials. A view into the living room from the hall of the Coonley House reveals Wright's capacity to cast the craftsman mode into rich and original esthetic forms. There is an exciting continuous flow of form and space, augmented by the open beams (which recall both colonial structures and the barns of the Midwest) and the newel posts, which act as space modulators. Together they create an airy contrast to the massive elements of the woodwork. The low-pitched ceiling, pierced by skylights patterned in Wright's typical multisized rectangles, provides an engaging play of angles. As in most of Wright's great designs, this interior combines space, movement, and monumentality with a feeling for informality and the dramatic use of familiar materials.

In California many craftsman-style interiors combined great visual distinction with practicality; most noteworthy were those by the Greene brothers and by Maybeck.

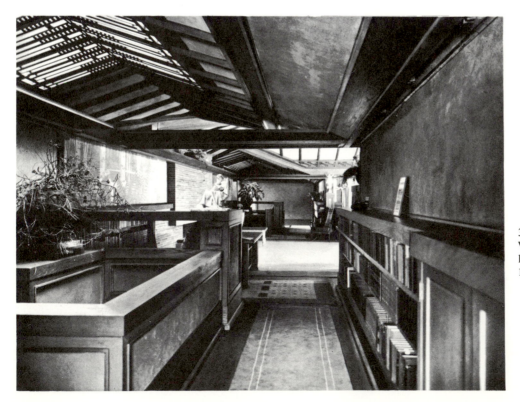

384. FRANK LLOYD WRIGHT. Hallway, Coonley House, Riverside, Ill. 1908.

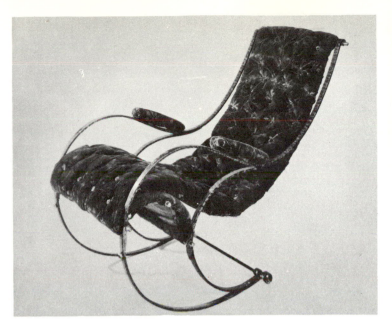

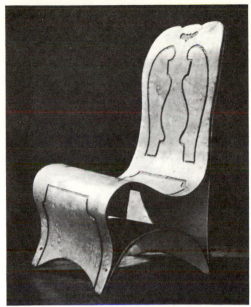

INDUSTRIAL DESIGN

A penchant for inventing ingenious mechanisms that would contribute to increased comfort and efficiency was evident throughout American history. Benjamin Franklin, challenged by the problem of effective heating, applied his talents to the development of the Franklin stove, and Thomas Jefferson derived pleasure from devising amenities to lighten housekeeping chores. During the latter half of the nineteenth century folding beds, adjustable chairs, combination sofa-bedsteads, and collapsible tables were among the many useful inventions; they gave evidence of busy minds at work harnessing the productivity of the machine and utilizing the new industrial sciences. The surface ornament that characterized most household goods seldom provided a clue to the forward-looking character of the internal mechanisms.

Objects designed for outdoor use often revealed the simple, unceremonious conformation of form with purpose which was to become increasingly characteristic of American industrial wares in the twentieth century. Boats, bicycles, rifles, and carriages frequently had a lithe beauty, free of excessive decoration and imitative splendor, that foretold the new industrial style. In the 1880s reapers and mowing machines employed the cantilever principle by carrying a shaped seat on a column of spring steel, a forerunner of the metal chairs of the twentieth century. An iron rocking chair from mid-century, painted to imitate blonde tortoiseshell (Fig. 385), indicates that invention was not confined to machinery. An experiment in functional design, the form of this chair was dictated

left : 385. PETER COOPER (?). Rocking chair. c. 1855. Painted strap iron with button-tufted upholstery. Cooper Union Museum, New York

right : 386. Model for chair submitted to U.S. Patent Office. 1874. Bent plywood. Museum of Modern Art, New York.

both by the laws of balance and movement and by the special character of metal. In the seventies molded plywood provided for mass seating in ferry boats and railway stations, and a model for a bent plywood chair (Fig. 386), submitted for patent in 1874, reveals the advanced thinking that was directed toward utilizing the new industrial processes and materials to satisfy living needs.

Unfortunately, though prophetic of the future, such advanced designs were not widely accepted. The parlor echoed the past, and changes were concealed beneath carving, upholstery, and fringe. It was the kitchen and bathroom which gave direct evidence of the revolution that was taking place in living patterns. Harriet Beecher Stowe and her sister, Catherine Beecher, had already designed a kitchen (Fig. 346) with built-in storage units and movable screens, antedating the modern concepts of flexible space and modular units of design. Plumbing provided running water in the home, and this convenience changed cooking procedures and initiated a host of new utensils. The indoor bathroom faced designers with another challenge. The development of the dynamo in the sixties resulted in incandescent lighting in the seventies. The next two decades introduced a flood of new machines, tools, and services into the household.

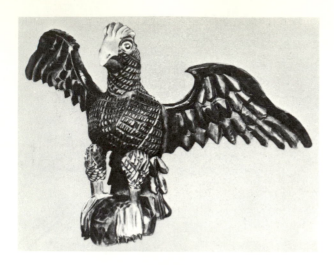

left : 387. WILHELM SCHIMMEL. Eagle. Late 19th century. Carved and painted wood, height 13″. Wells Historical Museum, Southbridge, Mass.

below : 388. Locomotive weather vane, from Michigan. c. 1870. Brass, copper, and iron. Private collection.

opposite : 389. Vase, Rookwood Pottery Company, Cincinnati, Ohio. 1887. Glazed earthenware (decorated by MATT A. DALY), height 14 ½″. Brooklyn Museum (gift of Mrs. Carll De Silver).

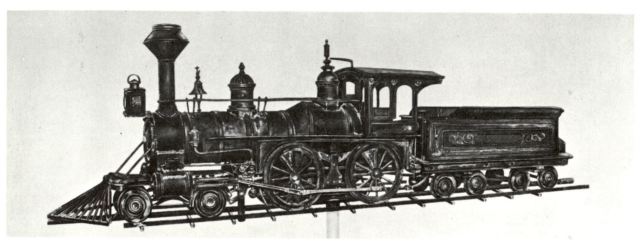

A changing philosophy prevailed in relation to these inventions. They were regarded as tools designed to make life easier and were made to be sold, used, discarded, and replaced. Little thought was paid to shaping objects so that they would be permanently satisfying to the eye or touch. Use and beauty were considered separate and un-related qualities, the machine creating the useful things, while the craftsman made what was beautiful. Though there was a churning ferment beneath the surface, American industrial design in the years before 1915 did not live up to the promise inherent in the Corliss engine. Another quarter-century had to pass before there would be awareness of the esthetics of machine production.

CRAFTS

Mechanical invention and growth provided a veneer of metropolitan sophistication to much of American life, but the older patterns prevailed in many areas well into the twentieth century. Large-scale wooden animals and fanciful figures for carrousels and circus wagons retained the vigor of earlier shop figures. In the mountains of Tennessee and Kentucky women still wove bedspreads and embroidered samplers which followed the patterns of long ago. As the older craft traditions disappeared from the building industry, cast iron began to replace the stone, wood, and wrought-iron decorations of the preceding period. Small foundries and blacksmith shops produced ingenious and amusing cast-iron hitching posts, lightning deflectors, garden sculptures, weather vanes, and other architectural ornaments. Glass and ceramic crafts fared less well. Mass production of glass became almost uni-versal, and hand-thrown redware and stoneware almost disappeared.

On isolated farms and during long sea voyages lonely men still whittled in the evenings or in spells of bad weather. One of the most famous wood carvers in the last half of the nineteenth century was Wilhelm Schimmel,

In the decades following the Civil War commercial pottery shaped in molds became almost universal. The most popular types were heavily decorated with naturalistic fruit and flowers, either in relief or painted on the surface. However, the influence of the English Arts and Crafts Movement began to be felt in the 1870s, and the exhibitions of ceramics at the "Centennial Exhibition" of 1876 stimulated potters with art training to produce wares which represented a distinct departure from those of the commercial manufacturers. The new "art pottery," as it was termed, represented a conscious effort to recapture the simple forms and the rich surface textures and glazes found in the hand-made potteries of earlier periods and cultures. The most consistent manufacturers of fine art pottery in the late nineteenth and early twentieth centuries were the Rookwood potters of Cincinnati, Ohio. Rookwood pottery was produced in subtle, dull colors and mat glazes, and the forms and decorations reflected Art Nouveau influences (Fig. 389).

Sharing the revival of the ceramic arts was an increased interest in tiles. A demand for architectural ceramics, stimulated by Eastlake, had been reinforced by the popularity of the Oriental styles. The Low Art Tile Company, Chelsea, Mass., was the first firm to manufacture decorative and plain ceramic tiles for architectural use. With the expanding popularity of the craftsman styles, a number of companies in New Jersey, Ohio, and California started production of commercial building tiles, and their use in bathrooms and kitchens soon became standard practice.

Louis Comfort Tiffany

At the end of the nineteenth century, when the machine appeared to be ousting the artisan from industry, an increasing number of young artists began to concern themselves with the production of fine household wares. The leader in this movement in America was Louis Comfort Tiffany, who endowed the products of his studios with the same sophistication and elegance that characterized his own home. At the age of eighteen, Louis Tiffany decided to become a painter, rather than enter the family business. He first studied with the landscape artist George Inness, then went to Paris, and subsequently traveled in the Orient. On his return to America Tiffany became involved in a number of decorating and manufacturing projects, one of the most important being the production of stained glass for architectural use. His finest stained-glass designs, produced between 1890 and 1910, reflect the character of current French painting and Art Nouveau design. A window from the Heckscher House (Fig. 390) in New York illustrates the typical use of naturalistic patterns combined with geometric and structural lines.

an itinerant farm worker who frequented the Shenandoah Valley. He is most noted for his eagles (Fig. 387), but he carved a variety of birds and animals in a spontaneous and vigorous manner. The animated silhouettes are enlivened by conventionalized patterns of fur and feathers and by the incisive marks of knife and chisel.

One of the most astonishing house decorations from the last century is a 9-foot weather vane (Fig. 388) from Michigan, made in the round as a virtual replica of a locomotive. Cast-iron weather vanes were usually made by molding the metal in two thin sheets, which were then soldered together to form a relatively light, hollow object. Copper, brass, and zinc details were often included to provide variety of color. The detailed verisimilitude of the locomotive testifies to the love of the people for the machines which were transforming society and providing new symbols of American pride. Though the parlor might belong to the past, the housetop proclaimed the glory of the present and the future.

Here both translucent and opaque colored glass were used in an intertwined grape and gourd motif to frame areas of clear glass.

The hand-blown bowls and vases (Pl. 13, p. 291), named Favrile glass by Tiffany, were probably the best-known products of the Tiffany Glass and Decorating Company, which the artist set up for producing his designs commercially. The graceful, elongated, swelling, and tapering shapes were executed in iridescent or translucent colored glass and decorated with the swirling lines, veinings, spirals, and floating forms so natural to the process of blowing glass, for one of the chief tenets of the Art Nouveau movement was that decoration should be a natural outgrowth of a medium and the process of manufacture. Designs based on plant and flower forms were also popular, and Favrile glass was frequently designed in lily or leaf shapes.

Tiffany also sponsored a variety of fine metal crafts and produced bronze lamps, candlesticks, and lighting fixtures in a fascinating variety of sizes and shapes. The three bronze candlesticks illustrated (Fig. 391) have the delicate elongation of form favored by Art Nouveau designers, as well as the somewhat whimsical details that suggest roots, stems, buds, and flowers.

The period between the Civil War and World War I was a time of great diversity and complexity. Despite the mediocrity of most architecture, furniture, industrial wares, and crafts, a new style—the style of the industrial age—was in gestation. A number of men helped to shape the esthetic concepts of the rising industrial age. Early in the century Horatio Greenough had given literary expression to a credo which made an honest use of materials and functional design prerequisites to significant form

opposite : 390. Louis Comfort Tiffany. Window from the Heckscher House, New York. c. 1910. Stained glass (executed by the Tiffany Studios, New York). Collection President and Mrs. Hugh F. McKean, Rollins College, Winter Park, Fla.

right : 391. Louis Comfort Tiffany. Candlesticks. c. 1910. Bronze. Collection Joseph Heil, New York.

in the arts. Throughout America were such examples of straightforward design as Shaker architecture and furniture, simply carpentered houses, and a popular vernacular of tools and household objects. Close to our consciousness were the theories of the English esthetic philosophers, Charles Eastlake, William Morris, and John Ruskin, encouraging escape from the shams of the Victorian pseudo-aristocratic styles. Richardson and others were designing the great shingle and half-timbered summer homes which reintroduced Americans to such elements of their colonial heritage as honestly carpentered construction and the use of stained wood, brick, tile, and other familiar materials. In commercial architecture the Chicago school, particularly in the work and writings of Louis Sullivan, gave forceful expression to a basic concept of functional design that grew out of American tastes, needs, and building procedures. Between 1900 and 1910 all these influences were synthesized in the work of Frank Lloyd Wright, Gustav Stickley, and other craftsman designers. Their houses exhibit a unified relationship between exteriors, interiors, and furnishings that was unique for that age and heralded the future. Only today, well along in the second half of the century, is the promise inherent in their work beginning to be realized.

15

Painting: Cosmopolitanism versus the Native Schools

Mid-nineteenth-century American painting had shown an unprecedented degree of inner confidence and independence. Though the Hudson River painters, Bingham, Mount, and many of the portraitists of the time, were conscious of their European heritage, their primary concern was to paint the American experience. While this tradition of independence and pride continued and accounted for the most forceful painting of the post-Civil War period, most late-nineteenth-century American artists of distinction were also aware of, and to a degree influenced by, the artistic currents which were exciting Paris and such cultural satellites as Munich.

Early in the century French painters had developed a vigorous school of realism in response to the growing scientific and democratic temper of the times and as a protest against the prevailing schools of academic classicism and overwrought Romanticism. First came the Barbizon painters of landscapes and peasants, then, at mid-century, the more militant social realists such as Daumier and Courbet. In the latter half of the century the Impressionists and Postimpressionists increased the ferment by reacting as violently against traditional standards of esthetics and technical proficiency as the earlier realists had against what seemed remote and artificial

subject matter. The dynamic Parisian art world of the late nineteenth century drew young students from all over the world, and young Americans, whether they visited Paris in person or were stimulated from afar, found the excitement contagious. In retrospect there is a certain drama in the way French influences at times strengthened and enriched the native American school and then again contributed a distracting and occasionally indigestible sophistication.

Immediately following the Civil War, as the Romanticism of the early years gave way before an increasingly pragmatic outlook, the taste for sententious historical canvases disappeared. Though the Civil War stirred up intense sentiments and loyalties, painters were not moved to record its great events on canvas or on the walls of public buildings. Winslow Homer painted and drew scenes from the Civil War, and a Chicago businessman commissioned a French painter to commemorate the Battle of Gettysburg on a vast cyclorama, but otherwise there was little interest in exploring the heroic vein. This turn in itself indicates the degree to which the grand tradition of historical painting, whether treated with neoclassic austerity or romantic ardor, gave ground before the advancing tide of realism.

COSMOPOLITANISM

The Traditionalists

A bright and lively competence, rather than a deep concern with style, had characterized the successful portrait painters of mid-century. One of the first artists whose portraits and figure paintings represented a sharp departure from popular standards was William Page (1811–85). Page shared Washington Allston's admiration for Venetian painting, and an extended period of study in Italy intensified his feeling for the grand tradition of the Renaissance. The portrait Page did of his wife (Fig. 392) is in the painter's mature style. Large, simple masses are drawn in monumental verticals and quiet horizontals. Both the limited tonal range, dominated by middle grays, and the rich and subdued color contribute to the general air of restraint and dignity. The somber mood of his canvases stands in striking contrast to the bright, clear effects of most of the painting of his day. Also, the simplified, somewhat flat pattern evident in the portrait of Mrs. Page was in conflict with the current taste for fully developed three-dimensional form. Page also executed some mythological and religious allegories reflecting his enthusiasm for the art of the Renaissance.

A few echoes of early nineteenth-century neoclassicism lingered on in the smoothly painted classical and religious canvases of Daniel Huntington (1816–1906) and Henry Peters Gray (1819–77), both of whom were much admired by their contemporaries.

One of the most influential of the group of American painters who turned to France in their attempt to introduce a loftier vein at home was William Morris Hunt (1824–79), the brother of the famous architect. Unsympathetic to the picturesque naturalism of the Düsseldorf school, Hunt moved to Paris, where he became interested in the mid-century movements in French painting as practiced by the Barbizon school. His *Self-portrait* (Fig. 393), a grave and sensitive work, reveals the characteristics he acquired there: a taste for the direct use of a heavily loaded brush; simple, broad compositional concepts; warm but subdued color; and a somewhat generalized conception of form. Hunt's approach to portraiture was essentially that of the figure painter, and his paintings helped to educate the discriminating public away from the popular concepts of portraiture.

above: 392. WILLIAM PAGE. *Portrait of Mrs. William Page.* c. 1860. Oil on canvas, 5′ ¼″ × 3′ ¼″. Detroit Institute of Arts.

right: 393. WILLIAM MORRIS HUNT. *Self-portrait.* 1866. Oil on canvas, 30 × 25″. Museum of Fine Arts, Boston (W.W. Warren Fund).

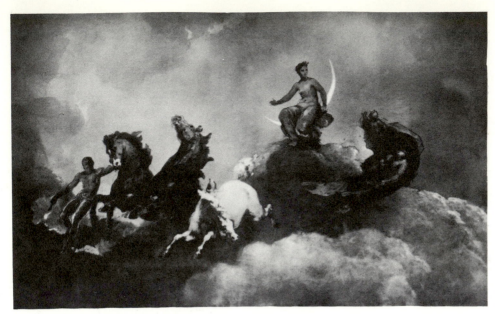

394. WILLIAM MORRIS HUNT. Study for *The Flight of Night*. 1878. Pastel, 5′ 2″ × 8′ 3″. Pennsylvania Academy of the Fine Arts, Philadelphia.

Though Hunt was best in small easel painting, he considered the great wall paintings of the Renaissance to be the most significant form of the painter's art. His *Flight of Night*, painted for the New York State Capitol at Albany and best known from his preparatory studies (Fig. 394), was undoubtedly the handsomest mural in the America of its day. Hunt did much to establish mural painting as an important part of an architectural ensemble.

Another painter of the late nineteenth century who brought French tastes and ideas back to America was John La Farge (1835–1910). La Farge was sent to France for his education, became interested in painting, and on his return to America decided on a professional art career. His easel painting is characterized by an easy naturalism, direct, free application of paint, and luminous, rich color. Like Hunt, La Farge was concerned with the revival of mural painting, and he executed a number of murals in which he turned to the Venetians for his compositional concepts and for his glowing color (Fig. 395). Richardson used his paintings, as did McKim, Mead & White; and Richard Morris Hunt also employed him to decorate some of his most splendid structures. The completion of the decorations for Trinity Church initiated a wave of mural painting in America. La Farge did not restrict his activities as a decorator to one field. In his stained-glass windows he eliminated as many as possible of the leads which traditionally separate the areas of color, thereby transforming the entire window into one luminous color composition.

The spell of the past cast its magic over other American figure painters during these years. Abbott H. Thayer (1849–1921) and George de Forest Brush (1855–1941) both studied in Paris and acquired a disciplined technical skill, as well as a taste for idealizing the human form to create symbols of nobility and morality. The paintings of Page, Hunt, La Farge, Thayer, and Brush all have qualities in common: technical proficiency, refined tastes, and painting concepts based largely on the Renaissance. Like the Beaux-Arts architects, these men submerged themselves in the great traditions of earlier times, hoping thereby to create a rich and valid culture for their own day. Other Americans found more inspiration and excitement in the new movements that were springing up in opposition to the academies. Impressionism made a particularly forceful impact upon a number of Americans living and traveling abroad.

The Expatriates: Whistler, Sargent, and Cassatt

From 1860 on, many American painters spent most of their lives abroad, and Paris was the magnet for these expatriate artists. The Parisian ateliers provided an exciting variety of attitudes: some sustained the traditional academic values; some stressed painterly facility and distinction of handling; others propounded the new realism. Each young artist found the environment best suited to his temperament and, after a period of study, developed his own particular style, inevitably a style more esthetically sophisticated than that which prevailed at home.

James Abbott McNeill Whistler (1834–1903) was the son of an American army engineer. He grew up in Russia,

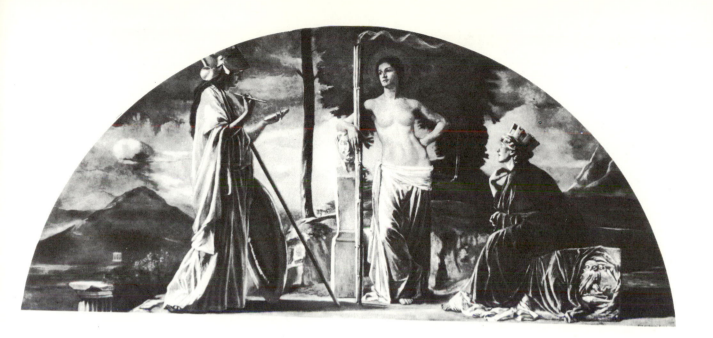

where his father was engaged in the construction of a railroad, and, except for a brief interval at West Point and Washington, D.C., he spent his life abroad, knowing America only from a world of expatriates and travelers. In 1855 Whistler entered the atelier of Courbet in Paris. Courbet encouraged his students to go directly to nature for their subject matter, but Whistler, poetic by temperament and impatient with the mundane, soon found the tenets of Manet and the young Impressionists more congenial to his tastes. Like many of the Impressionists, he shared the contemporary enthusiasm for Japanese prints and the elegant tonalism of Velázquez. In the sixties Whistler moved to London and became a leading figure in the English art world. His fame in England rested partly on the distinction of his tonal impressionism and partly on his disputatious and exhibitionist personality.

English painting in the last half of the nineteenth century did not share the progressive characteristics of the French and German schools. For the most part the English were out of sympathy with the sophisticated tastes of Whistler. More than any other individual artist he championed the concept of a painting as an organization of colors, textures, and dark-and-light patterns. His "nocturnes" and "symphonies" were conceived, as is implied by their musical names, not as depictions of events or places but as esthetic experiences capable of giving pleasure almost completely independent of their representational value. *Nocturne in Black and Gold: The Falling Rocket* (Fig. 396) illustrates the essentially abstract and evocative nature of much of his work. His contribution as the champion of "art for art's sake" proved

above : 395. JOHN LA FARGE. *Athens.* 1893–94. Oil mural, radius 12′. Bowdoin College Museum of Art, Brunswick, Maine.

below : 396. JAMES ABBOTT MCNEILL WHISTLER. *Nocturne in Black and Gold : The Falling Rocket.* c. 1877. Oil on panel, 24 ³/₄ × 18 ³/₈″. Detroit Institute of Arts.

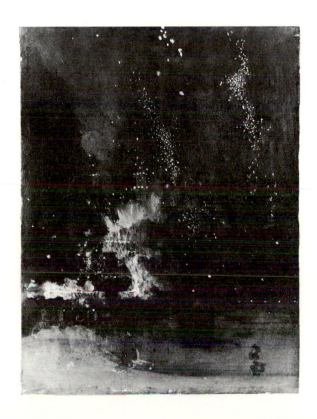

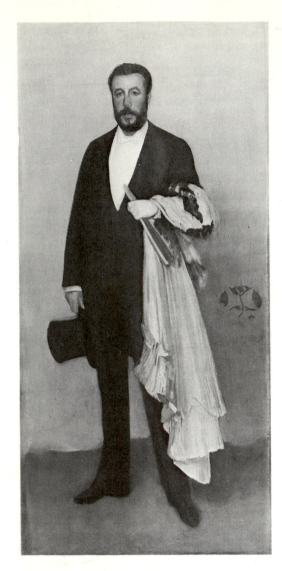 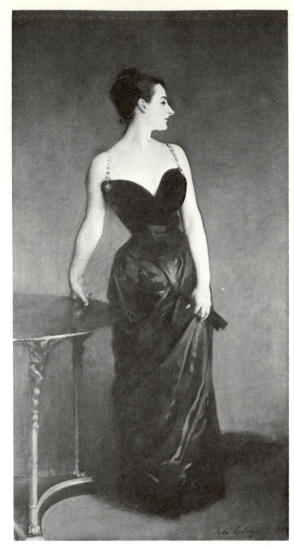

left : 397. JAMES ABBOTT McNEILL WHISTLER. *Arrangement in Flesh Color and Black : Portrait of Théodore Duret*. 1883. Oil on canvas, 6′ 4 ¹/₈″ × 2′ 11 ³/₄″. Metropolitan Museum of Art, New York (Wolfe Fund, 1913).

right : 398. JOHN SINGER SARGENT. *Madame X*. 1884. Oil on canvas, 6′ 10 ¹/₈″ × 3′ 11 ¹/₄″. Metropolitan Museum of Art, New York (Arthur H. Hearn Fund, 1916).

particularly important in relation to the subsequent development of abstract modes of painting.

Not all Whistler's painting was as radical as the views he so eloquently espoused. His portrait of Théodore Duret (Fig. 397) is an elegant tonal study in which the simplified and somewhat flat patterns suggest the influence of Manet and Degas. The portrait, signed with the butterfly symbol that Whistler adopted from Japanese prints, presents a face and pose full of character set within the carefully calculated composition that distinguishes all his paintings.

Another famous American cosmopolite was John Singer Sargent (1856–1925). Sargent was born in Florence of a respected Philadelphia family who had retired to Italy. A member of the world of cultivated leisure, Sargent seemed particularly fitted to become the foremost painter of the fashionable international set. In Paris, at eighteen, he entered the studio of Carolus-Duran, a man who understood the importance of a broad massing of tone, a fluid continuity of line, and a direct and skillful manipulation of paint. Sargent proved to be a precocious pupil. He rapidly absorbed his master's precepts and settled down to painting portraits and occasional genre scenes for the brilliant society in which he moved. A portrait from his very early years, *Madame X* (Fig. 398), demonstrates the

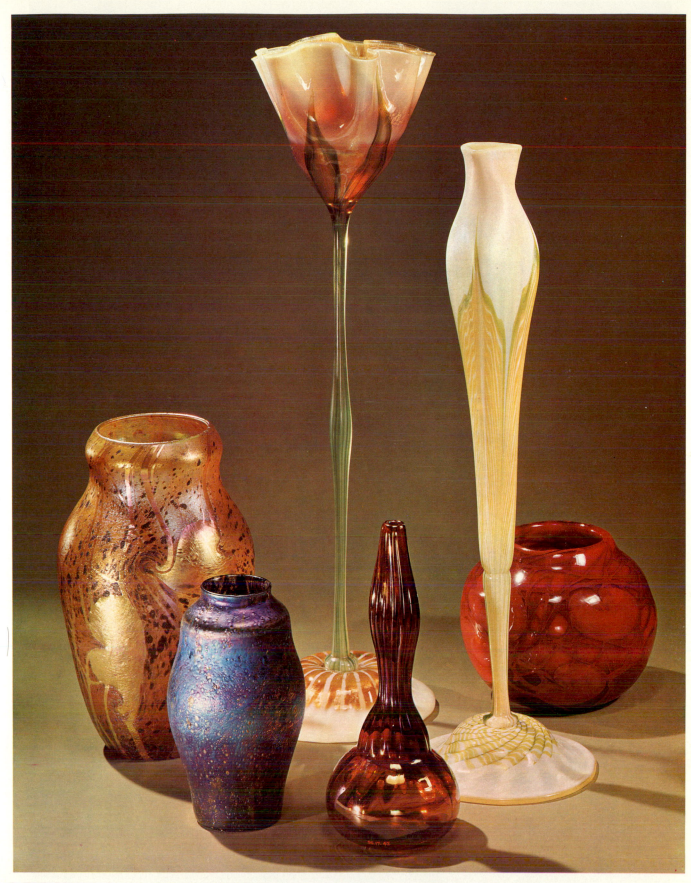

Plate 13. LOUIS COMFORT TIFFANY. Favrile vases. Late 19th–early 20th century.
Blown glass. Metropolitan Museum of Art, New York.

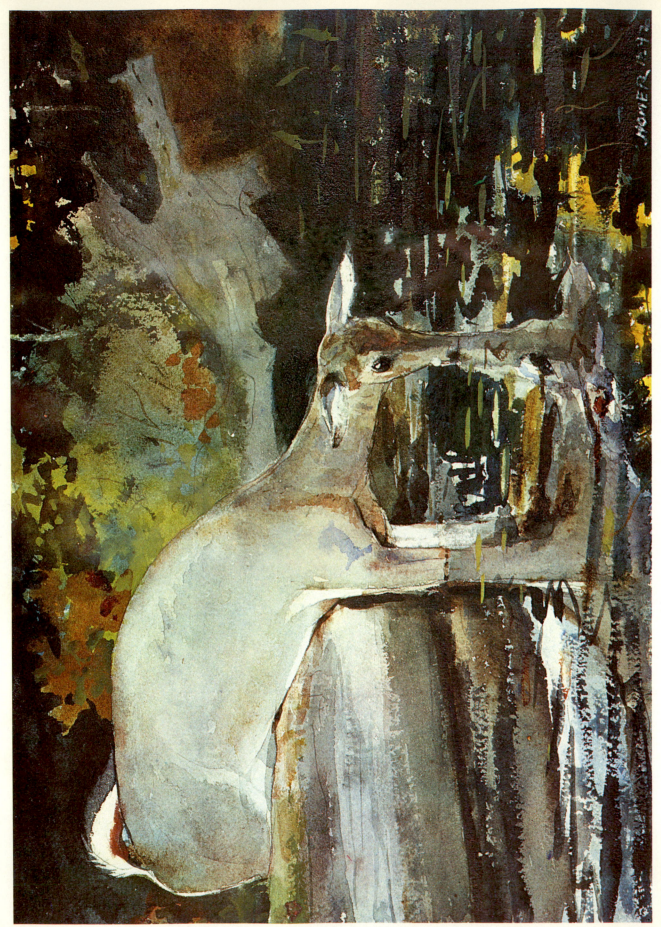

Plate 14. WINSLOW HOMER. *Deer Drinking.* 1892. Watercolor, 14 × 20″. Private collection.

seductive facility that made him the most popular and expensive portraitist of his day. The simplicity of the conception is the most striking feature of *Madame X*. The single figure stands with fluid, controlled, but compelling grace; no distracting countermovements confuse the eye. The sweep of the vertical lines is reinforced by the subtle beauty of the tonal pattern, in which creamy, alabaster flesh tones contrast with luminous grays and blacks. The effortless execution contributes greatly to the distinction and grace of the painting, as, of course, does the striking pose of the subject. Madame Gautreau stands as a symbol of fashionable elegance—beautiful and slightly disdainful. It was this ability to create a symbol of social position that attracted Sargent's wealthy sitters and enabled him to charge thousands of dollars for his portraits.

Sargent's very strengths contributed to his weaknesses as an artist. His technical facility mitigated against his studying the sitter's character. He could so easily catch the external appearance that he ceased to explore beyond the momentary impression. One knows the sitters only to the degree that is socially admissible—as one might see them at a fashionable gathering. Many portraits from his later years, distinguished chiefly by vivacious execution, seem to be mere records of beautiful clothes and elegant postures, which bore us despite their painterley brio. His immense talents matured early, and the most effective examples of his unparalleled virtuosity come from his early years.

A visit to Spain in 1879–80 introduced Sargent to the great masterpieces of Velázquez and influenced much of his subsequent painting. The Spanish master's amazing ability to translate the visual image into planes of tone and color was particularly suited to Sargent's gifts. The airy spaciousness of Velázquez' great compositions, the effortless precision of his drawing, the luminosity of his surfaces as they receive or reflect the light all gave direction to Sargent's rich endowment. These qualities are most apparent in the *Daughters of Edward Darley Boit* (Fig. 399).

The four children seem to have been captured in the midst of play. The scattered and irregular placement of the figures and the spontaneity of the poses appear completely unpremeditated until one observes the unifying relationships that are established between the figures by the careful counterbalancing and repetition of line movements. A great, shadowy room provides the setting, and from the airy depths luminous reflections shine forth like deep, reverberating sounds. A whole way of life is

399. JOHN SINGER SARGENT. *Daughters of Edward Darley Boit*. 1882. Oil on canvas, 7′ 3″ square. Museum of Fine Arts, Boston (gift of Mary Louisa Boit, Julia Overing Boit, Jane Hubbard Boit, and Florence D. Boit, in memory of their father, Edward Darley Boit).

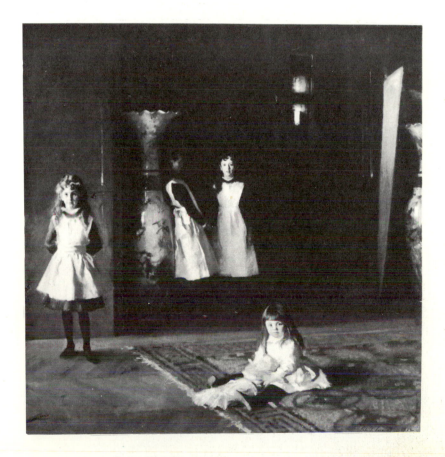

pictured with an effortless charm that is unsurpassed. The shy, well-brought-up children standing in their starched dresses move back into the spacious and quiet dark of the apartment with the certainty of a vivid memory—a memory of both Velázquez and the nineteenth-century way of life. Like a musician whose prodigious technique leaves one breathless despite the familiarity of his themes, Sargent's performance here is memorable less because of what he has to say than because of the mastery with which he says it. Even so, the achievement should not be underestimated, nor should the impact which his painterly genius had upon his contemporaries.

Sargent's activities as a mural painter and water-colorist should also be mentioned. His mural decorations for the Boston Public Library and for the Boston Museum of Fine Arts, probably the most effective murals painted in America in this period, reveal an impressive ability to discipline his talents to the needs of a large decorative project. When Sargent traveled, he made rapid water-color sketches that still astonish us with their brilliant color and breadth of handling. Sargent's undeniable gifts may have been held in too high esteem when critics and public alike were blinded by his virtuosity. Today we tend to underestimate his very real gifts. Sargent may not have been a supreme artist if, by artist, we mean one who enlarges our vision of the world, but he was undoubtedly an estimable painter.

Mary Cassatt (1844–1926), America's great Impressionist, was the daughter of a wealthy Philadelphia family who settled in Paris, where she became one of the few artists to work under Degas. From Degas and the Impressionist group she absorbed her precise, clear-eyed, and distinguished style.

La Toilette (Fig. 400) depicts one of her typical mothers caring for a child. This was the motif she chose to paint most frequently, although she occasionally did other aspects of domestic life or the theater. With a warm heart and a sharp eye, Cassatt, an incisive draftsman, caught every gesture and shape with unerring exactitude, and from these accurately observed forms she arranged her ingenious and surprising compositions. She employed typical Impressionist compositional devices, frequently painting her figure groups from above, so that the curious bird's-eye view throws familiar objects into unexpected shapes. Objects fill the canvas and run out of the edges of the composition, creating an effect of casual intimacy similar to that revealed by the evolving art of photography. Patterns are sharp and clear-cut, and the painter is not dependent upon shadowy and ambiguous atmospheric moods. Instead, the character of a situation is established by the exact realization of the nature of the objects described. Her color is fresh, light, and clear, sometimes almost sharp. She painted with a trenchant realism, revealing a vision as objective as that being employed in the expanding empirical sciences. This objectivity was endowed with esthetic significance by Cassatt's scrupulous taste and the serene affection with which she regarded her subjects. In fact, it is this projection of regard and warmth for her subjects, as well as her preference for the domestic scene, that distinguishes her work from that of Degas.

Cassatt's prints (Fig. 442) were as unique and personal as her paintings, but she had few followers. The sharp clarity of vision that characterized her work did not make for popularity at the turn of the century; indeed, she was better known in France than in America.

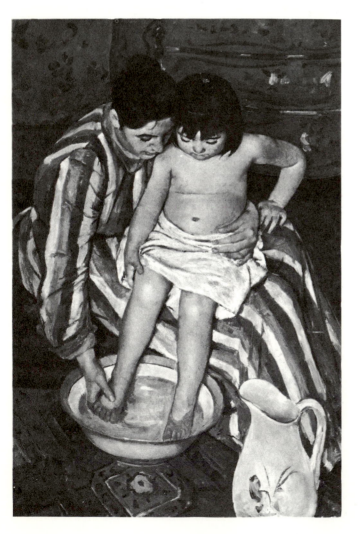

left : 400. MARY CASSATT. *La Toilette.* c. 1892. Oil on canvas, 39 × 26″. Art Institute of Chicago (Robert Alexander Waller Memorial Collection).

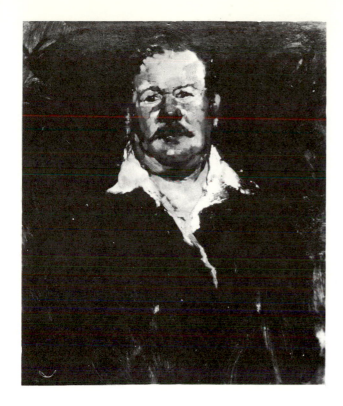

The Munich School: Duveneck and Chase

Though Paris was the leading center for European study, Munich was a close second, particularly in the seventies. Frank Duveneck (1848–1919), the precocious and talented son of German immigrants, went to Munich about 1870. There he contributed to the development of the style of painting that came to be called the "Munich style"; it is characterized by vigorous brush work and the dexterous manipulation of pigments, with flashing lights painted as directly as possible into warm, dark backgrounds. Picturesque persons and things drawn from everyday life provided the subject matter. The uniqueness of each subject was stressed, in contrast to the tendency of academic painters to idealize and generalize. It was essentially a painterly style, by which unpretentious subjects were dramatized and given significance through the brilliant handling of the paint.

In 1875 Duveneck showed a group of his canvases in Boston. The bold brush work, the rich color, and the forceful presentation of personality that characterized the portraits created a sensation. *The Blacksmith* (Fig. 401) displays the vigor of his style and the velocity of his brush work. The character of the sitter is established by stressing the uniqueness of feature and the accidents of light and shadow. Though Duveneck spent much of his life in Europe, his influence on his contemporaries was great, first on William Chase and his followers and, later, on the "Ash Can" school.

William Merritt Chase (1849–1916) also studied in Munich and was a close associate of Duveneck. Less concerned with characterful portraiture than Duveneck, Chase painted still-life and genre scenes with both taste and skill, and the charm of his work made him one of the most popular and influential painters of his day. A facile painter, ohe cmbined in much of his work the clear color and ingenious arrangements of the Impressionists with the adroit brush work and fresh, luminous paint of the Munich school. *A Friendly Call* (Fig. 402)

above: 401. FRANK DUVENECK. *The Blacksmith*. c. 1879. Oil on canvas, 27 × 21 ⅞". Cincinnati Art Museum, Cincinnati, Ohio.

right: 402. WILLIAM MERRITT CHASE. *A Friendly Call*. 1895. Oil on canvas, 30 ¼ × 48 ¼". National Gallery of Art, Washington, D.C. (gift of Chester Dale, 1943).

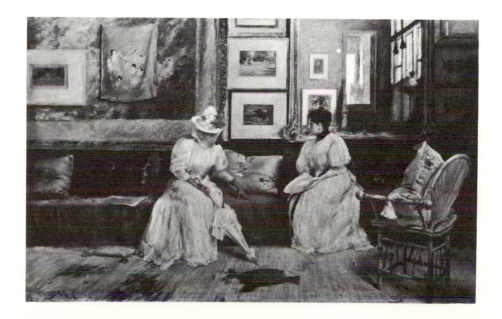

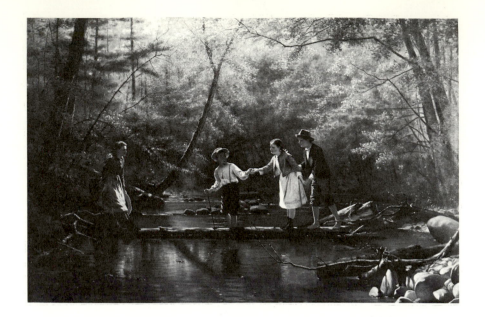

shows his special talents effectively. The seated figures are elements in an extensive ensemble designed to exploit the painter's facility in depicting the varied textures of an interior. Chase was an extraordinarily stimulating teacher who turned many of the next generation toward a type of studio painting in which essentially conventional subjects were endowed with a certain distinction through careful arrangement and effective painterly technique.

GENRE PAINTING

The painting from this period of most interest to us today is that which reflects a new level of esthetic sophistication, but most of the purchasing public in America still showed a preference for familiar subjects described in a lively, objective style. Landscape in the tradition of the Hudson River school and genre were most in demand.

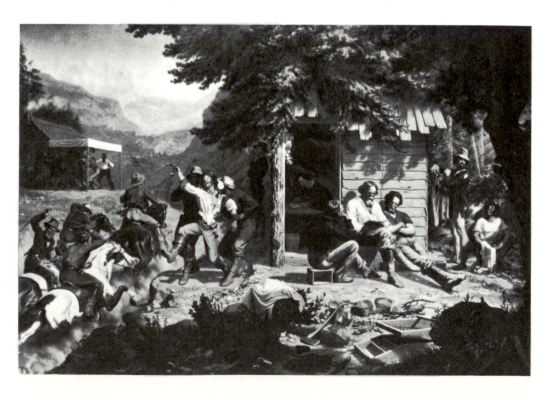

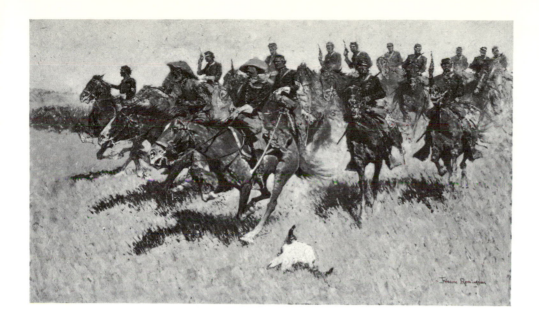

Landscape painting, because of its extensive nature, will be discussed in the following chapter.

Genre painting, which depicts scenes and subjects from everyday life, often with a narrative emphasis, was very popular both in America and abroad. The number of competent genre painters was far too great for complete coverage here, and many of them remain interesting only because they reflect the tastes of the period. Much of the work of Cassatt, Eakins, Homer, and others is essentially genre painting, but it is distinguished from the more commonplace by original and unconventional perceptions, compositional power, and painterly execution.

Anecdotal Painting

Story-telling genre pictures were quite popular until the end of the nineteenth century, and certain painters excelled in special subjects. Thomas Waterman Wood (1823–1903) was skillful at depicting rustic episodes and picturesque types. William Beard (1824–1900) painted moral and sentimental stories in which animals personified human types. John George Brown (1831–1913) was noted for his urchins and ragged newsboys. His *Country Gallants* (Fig. 403) tells its story in a charming sylvan setting. The detailed execution, careful observation of surface effects, and amusing nature of the sentimental scene being described ensured his popularity.

Painters of the Far West

The painters of the western frontier specialized in picturesque characters and violent action. Much of this painting was illustrational and obvious in its appeal. Charles Christian Nahl (1818–97), born in Germany, first painted in New York and after the Gold Rush settled in San Francisco. *Sunday Morning in the Mines* (Fig. 404) is one of his most ambitious and successful canvases. The different vignettes of life in a mining community have been skillfully integrated into a unified composition. The generally warm and sentimental portrayal of incidents is enriched with much freshly observed detail, such as the scattered mining instruments in the foreground, the hand-hewn shingles and boards of the cabin, and the distant ranges of receding hills. Nahl's paint is applied with a smooth enamel-like finish, and his hot, bright color seems well suited to the vivacity of his style.

The best-known painter of the Far West was Frederic Remington (1861–1909), whose records of the life of the cowboys, the Plains Indians, and the open range reveal an exact and intimate knowledge of his subjects. Remington came from a comfortable upstate New York family and studied art at Yale. At nineteen he headed for the Far West, where he worked as a cowboy and ranch cook. Fascinated by the panorama of western life, he began to record it with pencil and brush before its elemental quality disappeared forever. He found a ready market for his sketches and paintings in the publishing world. From then on he created thousands of paintings and illustrations, as well as a small number of bronzes depicting the tense drama of frontier existence. *Cavalry Charge on the Western Plains* (Fig. 405) shows his direct, animated style. With an unerring eye and a few sharply accented strokes, he could capture a movement or a gesture or establish a vivid character. His dashing skill left no room

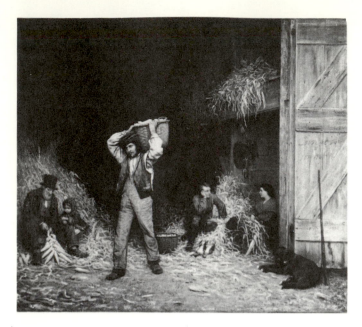

above : 406. EASTMAN JOHNSON. *Corn Husking.* 1860. Oil on canvas, 26 × 30″. Everson Museum of Art, Syracuse, N.Y.

below : 407. EASTMAN JOHNSON. *The Hatch Family.* 1871. Oil on canvas, 4′ × 6′ 1 ³/₈″. Metropolitan Museum of Art, New York (gift of Frederick H. Hatch, 1926).

for depth of feeling or monumentality of effect. Charles Russell (1864–1926), though not quite the equal of Remington, also painted Indians and cowboys with vigor and understanding.

Everyday Life: Eastman Johnson

Eastman Johnson (1824–1906) produced story-telling genre scenes from daily life of an honesty in sentiment, a painterly vigor, and a compositional strength that make his work altogether superior to that of most late nineteenth-century genre painters.

Johnson was born in Maine, studied with a lithographer in Boston, and at eighteen was professionally sketching crayon portraits with great success. He subsequently painted in Düsseldorf, then traveled around Europe, and spent an extended period in Holland studying the seventeenth-century Dutch painters. His admiration for the "Little Dutchmen" influenced his mature style toward a taste for warm brown and tan color harmonies and subdued tonalities. He preferred the dignified compositional effects of the Dutch masters to the more brilliant arrangements of the Düsseldorf school.

Johnson returned home in the mid-fifties and settled in New York. *Corn Husking* (Fig. 406), like much of Johnson's painting, is focused on a commonplace of American experience. However, no overemphasis on

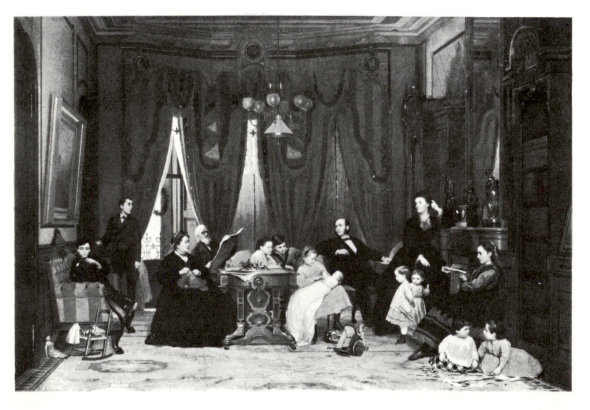

anecdote or picturesque exaggeration detracts from the sincerity of his statement. A simple monumentality of composition, accurately observed gestures, and textural variety create a handsome, richly painted work.

Johnson's famous portrait of the Hatch family (Fig. 407), painted in 1871, is in the most polished style of his later years. The predominant color note in the high-ceilinged interior is a warm, shadowy red, almost a red-gold. The draperies, tables, and upholstery repeat the color. In the diffused glow of tempered light, amidst the gleam of figurines and the sheen of rosewood and mahogany, are the fifteen members of the Hatch family. The easy disposition of the large group is achieved without any loss of individual personalities, yet Johnson has no recourse to theatrical characterizations or gestures. The individual figures stand defined and united by the all-pervasive blond-red light and the sense of interacting personalities. *The Hatch Family* is one of the few great family portraits from nineteenth-century America, and it provides an unexcelled record of a way of life.

STILL LIFE

The most distinguished still-life painter of the last half of the century was William Michael Harnett (1848–92). Harnett was born in Ireland but grew up in Philadelphia. At seventeen he was apprenticed to an engraver and subsequently supported himself by engraving silver while he attended art school and learned to paint. Even his early still lifes, carefully rendered, tight little compositions, are personal and unique in their selection of subject matter, for he preferred worn and picturesque household objects—pipes, newspapers, a beer mug, old books, a quill pen, and frayed bills of worthless money—to the more conventional fruits, flowers, and tablewares. These still lifes sold well enough to enable him to study abroad. He spent most of four years in the early eighties in Munich, where he enlarged both his sense of composition and the size of his paintings and developed a richer and more painterly use of his medium.

After the Hunt (Fig. 408) provides a striking illustration of Harnett's fully developed powers. Like much of his work, it is a *trompe l'œil* composition, in which a still life with narrative implications is depicted with striking illusionism and an effective decorative sense. The picture is large, almost 6 by 4 feet. It is beautifully organized, with the vertical lines of the rabbit, the birds, and the boards and the horizontals of the great hinges stabilizing the complex criss-cross of diagonals which lead to the circular forms of the hat and the horn, antlers, and powder horn. The organization of the volumes parallels that of the line movements. The greatest depth in space

is established by the hat, at which point there is also the most interesting assembly of shapes. As one's eye travels from this point back to the edge of the canvas, the depths diminish, as do the dark-and-light contrasts, the variety of forms, and the complexity of the line movements. To keep this carefully structured composition from being obvious, a few of the most fascinating elements of the design have been placed on the outer perimeter of the canvas—the handsome spiraling hinges and the intriguing key and keyhole. In addition, many delightful *trompe l'œil* elements have been exploited with zest—the spots of rust, the cracked and streaked paint, and the tricky iridescence of mother-of-pearl. Even while playing his most ingenious pranks on the eye, Harnett remained sensitive to the subtleties of painting as an art and a craft. The colors are richly, even somberly, orchestrated; the textures of the paint please, even while they deceive.

John F. Peto (1854–1907) was strongly influenced by Harnett and was sufficiently skillful so that some of

408. WILLIAM HARNETT. *After the Hunt*. 1885. Oil on canvas, 5′ 11″ × 4′. California Palace of the Legion of Honor, San Francisco (Mildred Anna Williams Collection).

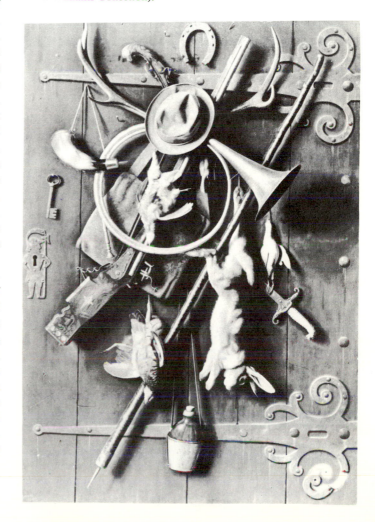

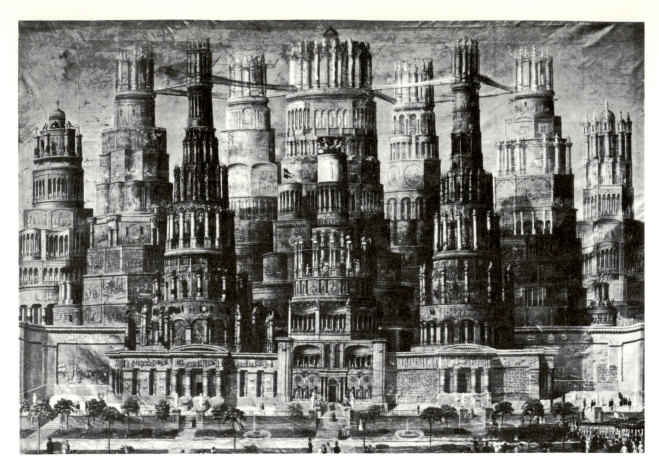

above : 409. ERASTUS SALISBURY FIELD. *Historical Monument of the American Republic.* c. 1876. Oil on canvas, 9′ 3″ × 13′ 1″. Museum of Fine Arts, Springfield, Mass. (Morgan Wesson Memorial Collection).

his work has been confused with that of the older man. The same cannot be said of the other painters in this period who attempted *trompe l'œil* still life but lacked the technical skill and sense of composition that distinguished Harnett and Peto.

THE PRIMITIVES

While painters on all levels of competence were depicting America with varying degrees of sophistication, the folk artists continued to paint their naïve versions of the American scene for their own pleasure. Still lifes, landscapes, portraits, and a wide range of genre subjects engaged the talents of the untrained folk painters. One of the most ambitious, Erastus Salisbury Field (1805–1900), left us a large canvas which provides a strange swan song to the patriotic canvases that appeared in the early years of the Republic. Almost totally without training,

Field prepared his 13-foot *Historical Monument of the American Republic* (Fig. 409) at the age of seventy, as his contribution to the centennial celebration of American freedom. From a massive architectural base situated in a pleasant park peopled with strolling sightseers, rise eight great towers, which diminish in circumference as they raise their circular or polygonal shafts into the air. Elevated bridges connect the towers at the top. These towers are encrusted with statues, columns, arcades, and fantastic bas-reliefs depicting episodes of our national history, ranging from the Bill of Rights to the discovery of the steamboat. Field also painted portraits and Biblical subjects which project a grave charm and sincerity.

Joseph Pickett (1848–1918) and John Kane (1860–1932) were also untrained painters who looked at their world and recorded what they saw with earnest strength and directness of vision.

During this period, when much painting tended to become farther and farther removed from the common denominator of popular visual experiences, the works of the naïve folk painters continued to provide valuable and refreshing reminders of the magic of direct, unsophisticated expression.

16

Painting: Landscape,
The Independents, The Eight

LANDSCAPE

The popularity of landscape painting, undiminished after the Civil War, continued through the first decade of the twentieth century. In the 1870s and eighties the grandiose panorama introduced by the early Hudson River painters reached a climax. Large, skillful paintings of awesome scenes were much admired, and they created an imposing addition to the heavily decorated mansions of the affluent High Victorians. Frederick Church remained productive, roaming the world to portray the wonders of nature. Others found ample inspiration at home, particularly in the newly explored Far West.

The paintings of Albert Bierstadt (1830–1902), more than those of any of his contemporaries, reflect the popular tastes of the wealthy upper middle class. Bierstadt came to America as a small child. When he was in his twenties, he returned to Germany and spent four years studying in Düsseldorf, during which time he acquired a formidable technical facility. On coming back to America in the late fifties, he joined an expedition sent to map an overland wagon route to the Pacific. Bierstadt spent the summer sketching in the Shoshone Mountains and along the Wind River. On his return to New York, the series of paintings he made from these sketches brought him immediate recognition.

During the following two decades Bierstadt enjoyed a spectacular success. His enormous canvases of scenes in the Rockies and California found a ready market and sold for unprecedented prices in an age when large canvases brought from $10,000 to $15,000. Paintings such as *The Rocky Mountains* (Fig. 410) enjoyed popularity because of their impressive size and rich abundance of skillfully portrayed detail. Bierstadt, like all painters of the Düsseldorf school, described surface texture with great skill, and his predilection for dramatic lighting effects and picturesque incidental figure groups was in direct accord with the tastes of these years.

Although Bierstadt is best known for his large canvases, the small sketches he made on location as studies for his major works reveal a more subtle artistry. Executed with easy facility, jewel-like in color, and skillfully generalized, they display a genuine talent that was not dependent on size, detail, or the theatrical effects that frequently give an air of strained virtuosity to his more imposing endeavors.

Depicting the wonders of the Far West brought success to other artists in the seventies and eighties. Thomas Moran (1837–1926) painted the Grand Canyon,

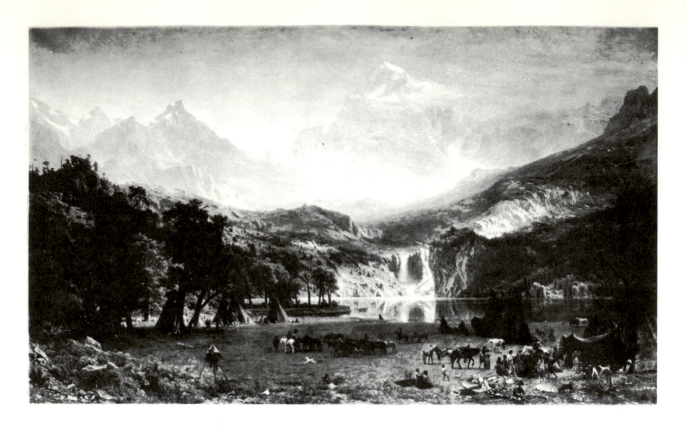

the Teton Range (Fig. 411), and the Sierra Nevada. Thomas Hill (1829–1908), a follower of Bierstadt, and William Keith (1838–1911) both settled in California, specialized in the wonders of Yosemite and the great groves of redwoods, and established what would become an important school of California painters.

The Luminists

While Bierstadt and his followers were catering to the taste for spectacular canvases, other artists, termed "luminists," were continuing the tradition established by Durand, Kensett, and other Hudson River painters of mid-century. Choosing their subjects from the settled communities of the east, this group of men painted the woods, marshes, waterways, and farmlands of the nearby countryside. The turbulent Romanticism of the earlier years of the century gave way to a more tranquil vein, distinguished by a poetic sensitivity, which found expression in depiction of familiar scenes transmuted by varying moods of weather. The main concern of the luminists was the character of light, especially the tonality of changing lights on sky and water. Two sensitive members of this group were Worthington Whittredge and Martin J. Heade.

Worthington Whittredge (1820–1910), born on the frontier of southern Ohio, spent much of his life in

Cincinnati, where there was a vigorous artistic life. In his youth he went to Europe with Bierstadt, a firm friend despite the differences of temperament revealed by their work. *Camp Meeting* (Fig. 412), like many of Whittredge's paintings, verges on the genre, but the landscape is preponderant in the scene. The solemn dignity and delicate grace of the trees, the quiet stream, the tremulous light in the clearing, and the airy distances are the real subjects of the painting. The people animate the scene, establish an effective sense of scale, and provide multi-colored surfaces on which the light can vibrate. The composition is a characteristic one; long horizontal lines and stabilizing verticals dominate the picture and establish a sense of deep serenity. Though the artist's attitude is reverent, it is not ponderous or didactic. The fine scale of the detail, the delicacy of touch, and the discretion with which the literal treatment is controlled all contribute to the poetry that characterizes Whittredge at his best.

Martin J. Heade (1819–1904) was born in Pennsylvania and spent much of his time painting in New Jersey, although he traveled extensively. His particular sensitivity was for the dreamlike strangeness of the familiar scene when viewed under the light of early morning, late day, or, particularly, during a storm. His *Storm Approaching Narragansett Bay* (Fig. 413) achieves its startling intensity by the brilliant contrasts of tone, the rich and curious

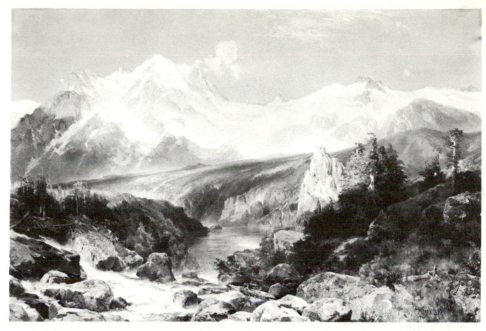

opposite : 410. ALBERT BIER-
STADT. *The Rocky Moun-
tains*. 1863. Oil on canvas,
6′ 1 ¼″ × 10′ ¾″. Metro-
politan Museum of Art,
New York (Rogers Fund,
1907).

top : 411. THOMAS MORAN.
The Teton Range. 1897. Oil
on canvas, 30 × 45″. Met-
ropolitan Museum of Art,
New York (bequest of Mo-
ses Tanenbaum, 1939).

center : 412. WORTHINGTON
WHITTREDGE. *Camp Meet-
ing*. 1874. Oil on canvas,
16 × 40 ¾″. Metropolitan
Museum of Art, New York
(Lazarus Fund, 1913).

right : 413. MARTIN J.
HEADE. *Storm Approaching
Narragansett Bay*. 1868. Oil
on canvas, 2′ 8 ⅛″ × 4′ 6 ⅜″.
Collection Ernest Rosenfeld,
New York.

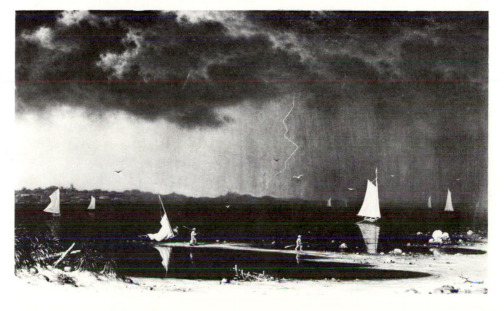

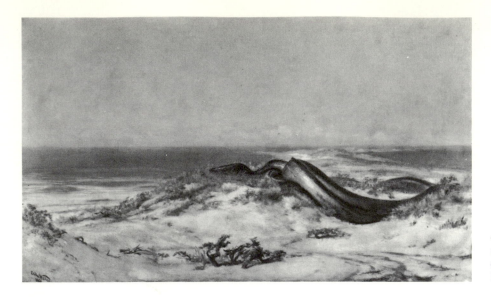

414. ELIHU VEDDER. *The Lair of the Sea Serpent*. 1864. Oil on canvas, 21 × 36″. Museum of Fine Arts, Boston.

color, and the hallucinatory clarity of detail. His landscapes depicting the pearly mists of early morning floating over the meadows of New Jersey have an iridescence and a subtlety of tone that place Heade in the vanguard of American colorists. In another entirely different category from his landscapes are his flower paintings, many of which depict tropical orchids painted against the background of the exotic jungle. Because his precise edges, detailed treatment of forms, and thin, even texture of paint did not conform to subsequent tastes, Heade was virtually forgotten until the mid-twentieth century.

The Mystics

Ever since Allston had introduced a note of reverie in his later landscapes, a group of painters had continued his subjective vein and explored their inner moods of wonder and solitude. It was probably inevitable that this brooding note would receive its most intense expression when the extroverted aspects of American energy were at their height. In the years following the Civil War, when expansion, success, money, and progress were the predominant features of American life, many spoke for another point of view. For every man of action there was a dreamer; for every success there were many failures; and for every Bierstadt there were artistic and temperamental opposites. Three painters who explored this subjective mood of reverie were Elihu Vedder, Ralph Blakelock, and Albert Ryder.

Elihu Vedder (1836–1923) was descended from early Dutch settlers. After study abroad, he returned to New York but later spent much of his life in Italy. He loved to wander among the mountains and through the remote villages of Europe, and some of his most sensitive paintings are the warm, quiet little sketches he made on such trips. Vedder's most distinctive works are those in which he used the landscape as a background for the unexpected and spectral images of his mind, such as that pictured in *The Lair of the Sea Serpent* (Fig. 414). Against a quiet stretch of distant sea and sandy dunes the serpent glides, monstrous and ominous, shining as in some vivid dream. This combination, a desolate landscape depicted with literal exactitude united with a sinister or strange image to create an atmosphere of isolation and fantasy, gives a singular force to much of his work. Vedder also produced a number of murals and a notable series of illustrations for *The Rubaiyat of Omar Khayyam*, a project well adapted to his taste for the exotic.

Ralph Blakelock (1847–1919) is one of the most tragic figures in the history of American painting. Like so many others, he started his career on a trip west. The awesome wilderness impressed him deeply, and his memory of the great woodland areas, flooded with moonlight or seen through the glowing mists of twilight, supplied the images for his haunting landscapes. His moonlight scenes (Fig. 415) appealed to only a limited market, and his inability to cope with the business world and support his large family by painting finally drove him insane. He spent most of his mature years in an asylum, from which he was released only a few months before his death.

Albert Pinkham Ryder (1847–1917) was the greatest of the mystic painters. He grew up in New Bedford, Mass., with the sea as a constant companion. When he was twenty-one, his family moved to New York, and he accompanied them and for a brief period of time studied painting. However, he was essentially self-taught; both the design

of his paintings and his method of applying the paint were highly personal and unrelated to the studio practices of his day. Ryder lived alone, a solitary in the midst of the crowded city. His one-room studio, almost without furniture, was a confused litter of papers, dishes, and rubbish. Here he painted pictures composed from the depths of his imagination, augmented by memories of his youth and observations made during his lonely walks late at night. His simple wants were cared for by the occasional sale of a picture.

Many of Ryder's paintings were inspired by the ocean at night. He was obsessed by a sense of the mystery and power of the sea, and to convey the intensity of his feelings he developed a style that drew less upon his visual perceptions than on his unique capacity to translate subjective feelings into expressive images. Ryder probed deep within himself to project his feelings with eloquence; clouds, waves, boats, an occasional figure or headland were simplified in shape and organized into broad, slow-moving rhythms (Fig. 416). *Moonlight* eliminates the

top : 415. RALPH A. BLAKELOCK. *Moonlight*. 1882. Oil on canvas, 27 ¼ × 32 ¼". Brooklyn Museum (in memory of Dick S. Ramsay, 1942).

left : 416. ALBERT PINKHAM RYDER. *With Sloping Mast and Dipping Prow*. Late 19th century. Oil on canvas, 11 ½ × 10 ½". Smithsonian Institution, Washington, D.C. (gift of John Gellatly).

right: 417. ALBERT PINKHAM RYDER. *Siegfried and the Rhine Maidens.* 1875–91. Oil on canvas, 19 ⅞ × 20 ¼″. National Gallery of Art, Washington, D.C. (Andrew Mellon Collection).

below: 418. THEODORE ROBINSON. *Willows.* c. 1891. Oil on canvas, 18 ⅛ × 21 ¹³/₁₆″. Brooklyn Museum (gift of George D. Pratt, 1914).

details and bathes the forms in its strange, cold color. Ryder was almost never satisfied with his paintings. Long after they were completed and sold, he continued to work over them, glazing the surfaces with layer upon layer of transparent color until the translucent masses glowed like jewels. Technically many of the procedures he employed are inadmissible; the paintings have cracked and discolored badly, but this cannot destroy their magic.

Not all Ryder's paintings were based on the sea. A number of them, such as his *Siegfried and the Rhine Maidens* (Fig. 417) drew on literature for their subject matter. These tend to be more complex in design than his sea and boat paintings but share the other general characteristics of his style. Though based on subjects drawn from Shakespeare, the Bible, and various other literary sources, they are less illustrations than symbolizations of subtle, poetic moods. Ryder expressed the nature of his strange explorations very well when he said: "Have you ever seen an inch worm crawl up a leaf or twig, and then clinging to the very end, revolve in the air, feeling for something to reach something? That's like me. I am trying to find something out there beyond the place where I have a footing."

The Impressionists

In the last two decades of the century a number of young Americans, while studying in France, were attracted to the experiments of Monet, Pissaro, and other French Impressionist painters of the out-of-doors.

Theodore Robinson (1852–96), the only American Impressionist to study with Monet, discovered Impres-

sionism in the eighties and adopted the new technique of using high-keyed, broken color to convey the shimmer of light and the cool tones of shadows. *Willows* (Fig. 418) is typical of Impressionist landscape painting in its breadth of handling, its bright color, and its informal, flat-patterned composition.

In 1895 a group of American painters, most of them strongly influenced by the tenets of Impressionism, exhibited together under the name of "Ten American Painters." Among the more important painters in the group were John Twachtman (1852–1902), Childe Hassam (1859–1935), and J. Alden Weir (1832–1919). Both Twachtman's *Three Trees* (Fig. 419) and Hassam's *Street Scene in Winter* (Fig. 420) reflect the aims of American Impressionism. Familiar scenes provided the motifs from which the artists created subtle webs of color and pattern. The visual world was relieved of its weight and volume and transposed into exquisite arrangements which reveal the surprising shapes embedded in the everyday milieu. Despite its light and fragile tone, Impressionism was a serious effort to eliminate the trite and conventional elements from painting without having recourse to the exotic and remote. Impressionism represented, in essence, a turn-of-the-century combination of visual realism and esthetic sensitivity.

THE INDEPENDENTS

Both cosmopolitanism and provincialism set forth valid aspects of late nineteenth-century America; neither alone provided a true measure of the increasing depth and integrity of American culture. From the profusion of prevailing influences, movements, and talents there emerged a few artists of sufficient stature to create an art that was both native and distinguished by esthetic maturity.

George Inness

Taken in its totality, the work of George Inness (1825–94) best summarizes the range of late nineteenth-century American landscape painting. His youthful canvases reflect the robust vigor of the early Hudson River school; those of his middle years, a rich painterly quality and emotional warmth of Barbizon inspiration; whereas his late work often combines the introverted mood of the mystics with the esthetic sophistication of impressionism. No eclectic, he revealed in these changes the gradual unfolding of a deeply poetic nature. Inness was born in Newark, N.J., and because, as a youth, he seemed an impractical dreamer, his merchant father set him up in business. His heart, however, was not in commerce, and therefore he was sent abroad, where he saw the work

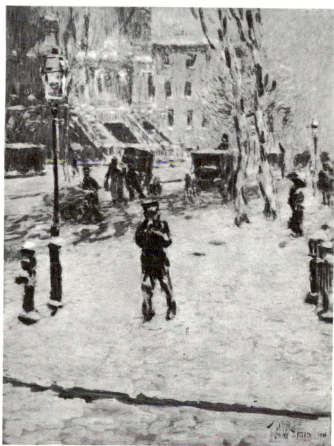

top : 419. JOHN H. TWACHTMAN. *Three Trees.* Late 19th century. Pastel, 13 × 17 1/26″. Brooklyn Museum.

above : 420. CHILDE HASSAM. *Street Scene in Winter.* 1901. Oil on canvas, 16 × 12″. Metropolitan Museum of Art, New York (bequest of George D. Pratt, 1935).

of the great English landscape painters, as well as that of Corot, Rousseau, and the French Barbizon group. On his return home he embarked upon a painting career, and though success came slowly, he was able to make a living by painting.

"The true artistic impulse is divine," said Inness, and this lyric and visionary point of view characterized his life. He was indifferent to success and money, and he valued recognition only because it enabled him to support his family. His all-consuming passion was to translate the beauty of low, rolling hills, stretches of quiet meadow, or the poetry of the woods into a richly executed harmony of tone and color. *June* (Fig. 421) provides an excellent example of the style of his middle age, when the sharp delineation of details that characterized his early work gave way to a simplified, broadly brushed handling. The colors are cool and grayed: blues, blue-greens, and soft ocherous greens that fade into rosy browns. The forms move back into space through easy, undulating planes. Though the drawing is firm and knowledgeable, it remains subordinate to an over-all harmony of tone and color. The style of painting recalls both Constable and the French Barbizon painters, but there is nothing foreign in the open fields, meandering creeks, and scattered trees. These were drawn from the typical landscapes that surrounded Inness' homes in Brooklyn, New Jersey, and Massachusetts.

In his last years strong religious and mystical tendencies predominated in his work. The familiar landscape continued to be his subject, but it was treated less objectively. A dreamy mood prevailed, with transcendental overtones, drawn from the inner recesses of his mind (Fig. 422). The close values, strangely grayed colors, flickers of light, and quivering shadows create an unsubstantial world

right : 421. GEORGE INNESS. *June.* 1882. Oil on canvas, 31 ¼ × 45″. Brooklyn Museum (bequest of Mrs. William A. Putnam, 1941).

below : 422. GEORGE INNESS. *The Home of the Heron.* 1893. Oil on canvas, 30 × 45″. Art Institute of Chicago (Edward B. Butler Collection).

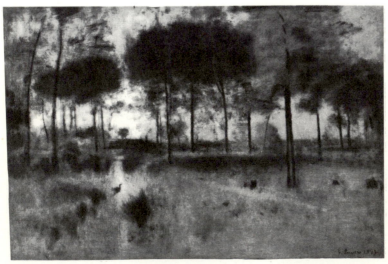

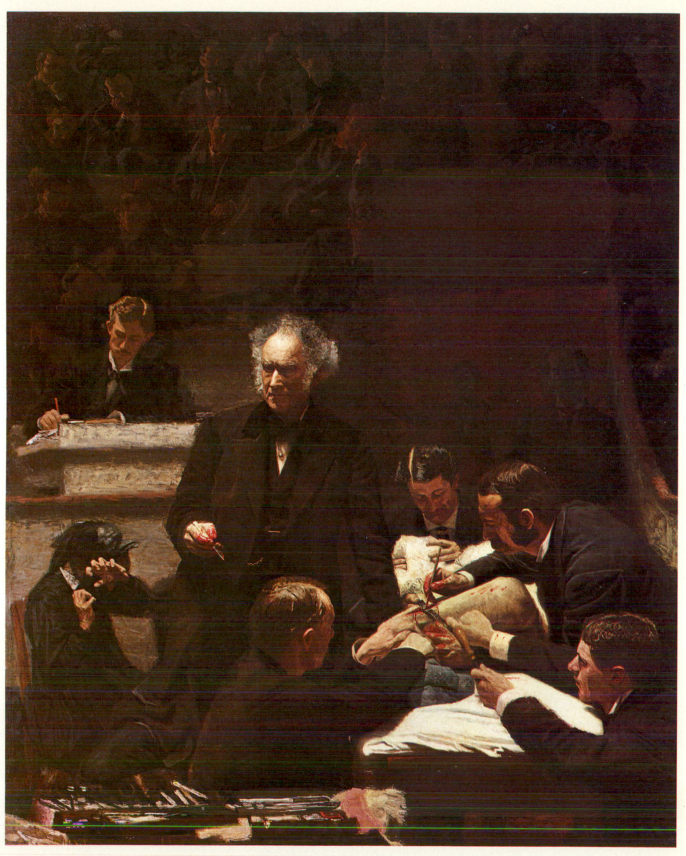

✳ Plate 15. THOMAS EAKINS. *The Gross Clinic*. 1875. Oil on canvas, 8′ × 6′ 6″.
Jefferson Medical College, Philadelphia.

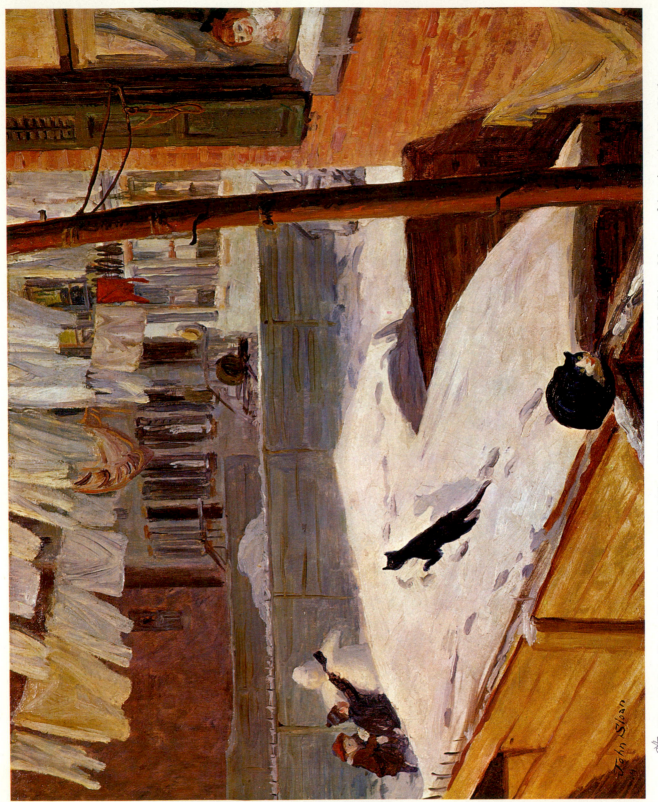

Plate 16. JOHN SLOAN. *Backyards, Greenwich Village.* 1914. Oil on canvas, 26 × 32″. Whitney Museum of American Art, New York.

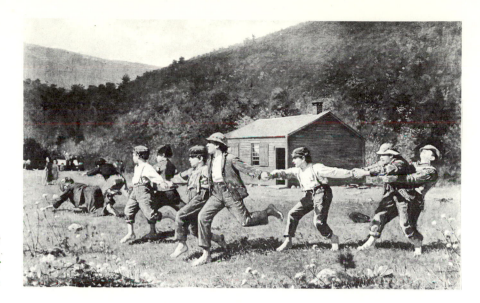

423. WINSLOW HOMER. *Snap the Whip*. 1872. Oil on canvas, 22 × 36 ½″. Butler Institute of American Art, Youngstown, Ohio.

that expresses deep feelings of awe. For Inness that was enough. "The aim of art," he said, "is not to instruct, not to edify, but to awaken an emotion."

Winslow Homer

Many diverse and seemingly contradictory tendencies come together in the work of Winslow Homer. The life of the frontier and the backwood is portrayed, not melodramatically but with the color and flavor of everyday life. The bold directness of his brush work equals that of the Munich school, the simple breadth of his compositions rivals that of the Barbizon painters, and his clarity of visual analysis matches that of the Impressionists. Homer chose his American experiences as his point of departure, and his masculine taste removed him from the fashionable world, with its undue concern for trivial refinements of style and taste. All these qualities give a stature to his canvases that lifts them far above the general level of his day.

Winslow Homer (1836–1910), born in Boston, came from a family of seventeenth-century American settlers. His father was a merchant, but because Homer preferred a career in art, he was apprenticed to a lithographer at nineteen and eventually became a free-lance illustrator. He worked for seventeen years in this capacity, largely for *Harper's Weekly*, and this invaluable experience in disciplined observation intensified his natural enjoyment and understanding of people and of the workaday world. This earlier phase of his career received its best-known expression in the drawings and paintings he made of the Civil War. They are distinguished by their freshness of observation, their direct vigor of line, and their forceful

but simple relationships of tone. Since these studies were done as illustrations, they had to be sufficiently simple to be translated into wood engravings for reproduction. *The Sharpshooter* (Fig. 436) reveals the energy, sweeping line, and strong tonality of these sketches.

After serving this apprenticeship, Homer continued to depict incidents from American life very much in the popular manner of the day. *Snap the Whip* (Fig. 423), from the early seventies, reveals both the conventional and the original aspects of this early period. The narrative element is obvious, as are the rural setting and the spirit of prankish, youthful play. It was a subject that might have been selected by many a genre painter of the times. On the other hand, many elements of the painting distinguish Homer from the lesser talents. The composition has a surprising amplitude and continuity. Moving from the far right, the eye is carried forward, then back into the distance, in a swinging arc. The simple cabin in the middle distance moves in the same spatial continuum, thereby both reinforcing the action projected by the line of players and, by its angularity, emphasizing the whiplash of their play. The diagonals in the clouds and distant hills repeat these lines of action. Yet there is nothing rigidly structured or calculated about the composition. It seems to flow inevitably from the subject. Equally impressive is Homer's unerring sense of light, the bright, sharp light of America. Like the Impressionists abroad, he was concerned with the verities of season, time of day, and place, permitting no studio conventions to blur the objectivity of his vision. Lastly, the instinctive force of the drawing, the deft certainty with which the paint is applied, and the lively, yet unified color reveal a major independent talent in the unfolding.

In the last half of his life Homer abandoned the narrative style of his early years for a more simple and monumental one. In 1881 he gave up his career as an illustrator. After a two-year interval in England, he settled at Prout's Neck on the coast of Maine, where he produced the large oil paintings that mark his mature style. These canvases are concerned with the sea—gray, granite-bound, powerful, and mysterious—and with the fisherfolk of New England. The endless conflict between man and the forces of nature provided the drama which Homer treated with understanding and dignity.

The Lookout—"All's Well" (Fig. 424) reveals his ability to take the fisherman's life, as commonplace and routine for that time and place as that of a truck driver is today, and from that material to create a monumental symbol characterized by plastic power, vigor, and authenticity of atmosphere. As in all Homer's paintings, the basic design is simple. The rather large forms move across the canvas in simple diagonal directions that suggest the rolling and unstable motion of a boat. The forms are modeled simply and broadly, as though the misty and diffused sea light eliminated the details that might distract the eye from the essence of form. The world of ropes and heavy clothing and the harsh struggle with the sea are neither romanticized nor idealized, though Homer was fully aware of the lyric grace of the bell and the curl of the strap that hangs free from the oilskin hat. The direct, almost brusque quality of the brush work contributes to the vitality of the surface and reveals the painter's feeling for his medium. The color, carefully observed and harmonized, not by formula but by feeling, provides a full-bodied accompaniment to the forms.

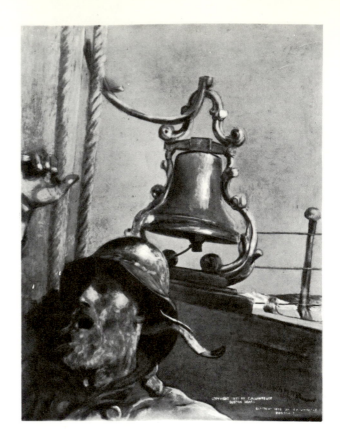

above : 424. WINSLOW HOMER. *The Lookout—"All's Well."* 1896. Oil on canvas, 39 ¾ × 30″. Museum of Fine Arts, Boston (Warren Collection).

below : 425. WINSLOW HOMER. *Huntsman and Dogs.* 1891. Oil on canvas, 28 ¼ × 48″. Philadelphia Museum of Art (William L. Elkins Collection).

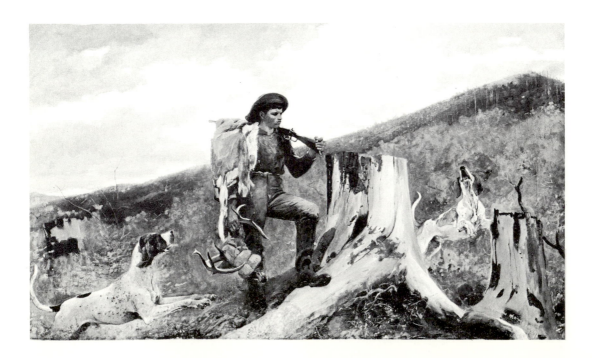

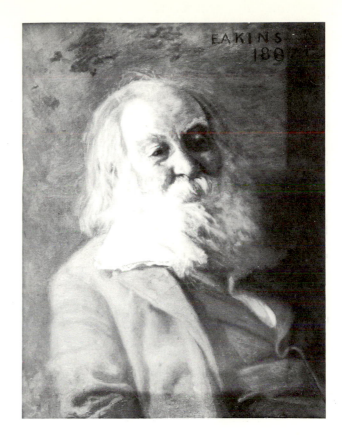

Throughout his years in Maine, Homer took long trips for a change of scene. The Caribbean islands, the Adirondacks, and the Canadian woods were favorite spots. On these trips he made the lively watercolor sketches that established that medium as a major one for American landscape painters. *Deer Drinking* (Pl. 14, p. 292) has the same authority of handling with the strength and simplicity of design that distinguish his oils. The deer, water, and distant foliage are depicted with effortless grace, as are the woodland darks, cool shadows, and bright glints of light. Although watercolor had been used for sketching purposes by many painters before Homer, few had handled it with his distinction and masculine vigor.

Hunting and fishing episodes inspired some of the great oils of Homer's last years. His *Huntsman and Dogs* (Fig. 425) transforms a facet of the American adventure into an austere and powerful canvas. Against a luminous cloudy sky the dull mass of the mountain raises its long, sweeping silhouette. The lines of the diagonal cloud, the mountainside, the tree root, and the dogs repeat the same movement, but with animation. The verticals of the great stump, the boy's body, and the deerskin work in somber, dignified contrast. It is the harsh, brooding, and graceless world of the hunter that is depicted, and the authenticity of tone adds to the drama implicit in the theme.

This quality of crude strength disturbed the critics and public of Homer's day, but they could not deny the power of the canvases. Henry James, that most perceptive of critics, found the paintings "almost barbarously simple," but he granted that Homer had managed to treat the least pictorial features of our civilization as though they were "every inch as good as Capri or Tangiers." The significance of Homer's work stemmed from his ability to participate imaginatively in the common experiences of American life and in so doing to create timeless symbols of man's work and play. The impact of these symbols derives from their dual authenticity—their authenticity as powerfully wrought works of art and as sympathetic and informed observations of a way of life.

Thomas Eakins

Thomas Eakins (1844–1916) was born and spent his life in Philadelphia, except for a period in Paris in the 1860s. In Paris he studied with Gérôme and Bonnat. From Gérôme he acquired his disciplined knowledge of traditional techniques, his love for the human figure, and his respect for fact. From Bonnat he probably acquired his taste for bolder brush work and a richer impasto. Europe also provided him with an opportunity to see the work of the old masters. In Rembrandt, particularly, he saw the power of compassionate realism and the evocative potency of the transparent shadow, two qualities that distinguish much of Eakins' later work. Study abroad turned the eyes of many American painters away from the realities of home, but European culture enabled Eakins to see the life about him more clearly. After he returned to Philadelphia, he devoted the remainder of his years to painting the life he knew—the sports, recreations, home life, and, above all else, the people of his native city.

"I never knew of but one artist, and that's Tom Eakins, who could resist the temptation to see what they thought ought to be rather than what is," said the poet Walt Whitman in relation to his portrait (Fig. 426) by Eakins. It is this clarity and honesty of perception that distinguishes Eakins and constitutes his chief significance. In an age when manner, sentiment, and an overconcern with style were dulling the force of the artist's perceptions, and when the arts were becoming separated from the life of their day, Eakins performed the service of rediscovering the rich source of stimulation existing in the immediate environment. His objectivity was of signal importance in that period of sentimentality and evasive symbolism, but his

particular strength lay in his ability to cast his objective perceptions in firmly structured artistic form and give them the warmth of feeling and the compassionate understanding with which he regarded his environment and the friends who peopled it. Walt Whitman looks out of his portrait—expansive, optimistic, disheveled—loving the world, yet not quite able to face its uncompromising realities. Eakins saw and painted the tender poet underneath the blustering exterior.

Most of Eakins' sitters were drawn from his circle of acquaintances: college professors, scientists, and his own immediate family. He preferred to depict them in contemplative moods, turned in upon themselves. A flood of clear light throws the forms into relief against the simple background of home, laboratory, or study. The color is warm and dark, the brush work controlled but far from tight or lacking in richness and variety. There is no daring display of technique or theatricality of composition to throw a false aura of glamour over the familiar personages or scenes. Nowhere are Eakins' uncompromising honesty, power of analysis, and strength of feeling more apparent than in the handsome genre portrait *Pathetic Song* (Fig. 427). Eakins painted a number of canvases depicting

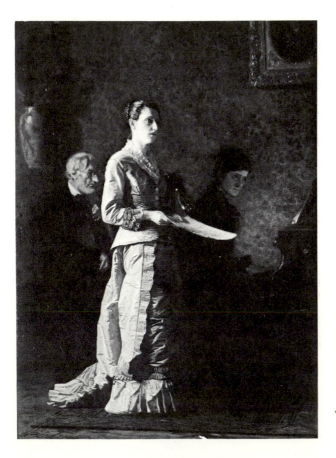

performing musicians, but none surpasses this in its power to evoke the magic moment when performers and audience alike fall under the spell of the music. And no work from his hand reveals more thoroughly his skill in the far from simple craft of brushing paint upon a canvas.

Loving the brilliant out-of-door light, and, in this characteristic, antedating the Impressionists of the next generation, Eakins painted scenes of typical sports of the day: men fishing, rowing, sailing, and swimming. *Max Schmidt in a Single Scull* (Fig. 428) is based upon painstaking studies, but its sharp clarity and brilliant exactitude of form are misleading, for the literal surface hides a firmly structured composition. Long, flat diagonal and horizontal lines frame the seated figure, which is stabilized by the arch above the head. The deep space is bathed in sunlight, but this does not destroy the substantiality of the forms. Instead, it is the primary means by which a sense of energy is communicated to the quiet scene.

Perhaps no group of paintings better illustrates Eakins' ability to paint the Philadelphia of his day in terms of the grand tradition of the Baroque masters, particularly as interpreted by Rembrandt, than his two great portraits of distinguished surgeons, *The Gross Clinic* (Pl. 15, p. 309) and *The Agnew Clinic*. The theme of the anatomical lecture was a popular one in the seventeenth century, and it had been treated effectively by Rembrandt in two canvases, the most familiar being the famous *Dr. Tulp's Anatomy Lesson*. In *The Gross Clinic* a surgical demonstration provided Eakins with the subject, and a compositional analogy to the Rembrandt painting was established by placing the lecturer and patient within a circular grouping of secondary figures. However, the Rembrandt-like quality of the painting resides less in the organization than in the way in which the essentially objective presentation of the subject is endowed with dramatic and emotional overtones through the expressive use of coruscating light and deep, evocative shadow.

Building up from a pyramidal grouping of forms, the powerful white-haired head of Dr. Gross dominates the spacious canvas. A subsidiary focus of attention is created by the exposed thigh of the patient, the anesthetist, and the assisting surgeon. A sequence of supplementary figures reinforces the drama: the cowering relative of the patient in the lower left, the man taking notes in the middle distance, and the students sitting in rapt attention in the shadowy background. The great canvas is alive in all its parts. The color is rich, though subdued, with the bright accent of blood on the extended hand and scalpel creating,

left: 427. THOMAS EAKINS. *Pathetic Song*. 1881. Oil on canvas, 45 1/8 × 31 3/4″. Corcoran Gallery of Art, Washington, D.C.

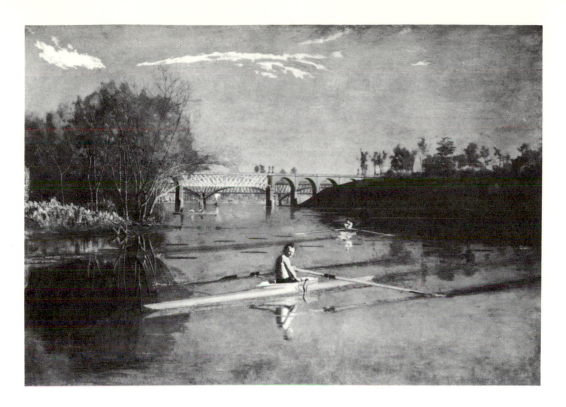

above : 428. THOMAS EAKINS. *Max Schmidt in a Single Scull.*
1871. Oil on canvas, 32 ¼ × 46 ¼″. Metropolitan Museum
of Art, New York (Alfred N. Punnett Fund and gift of George
D. Pratt, 1934).

like the incision, an intensification of color that functions
as a compositional accent at the same time that it sharpens
the authenticity of the scene. One of the great paintings
of the era, *The Gross Clinic* testifies to Eakins' power
as a painter and explains the intellectual leadership he
provided to a period which tended to consider the serious
realities of life as fit subject matter for the arts only if
prettified by sentimentality or veiled in allegory.

Eakins' importance as a teacher is worthy of particular
note. He introduced living models into the Pennsylvania
Academy of the Fine Arts and taught his students to
"paint with the brush" rather than to think of painting
as a colored drawing. Most important, he turned his
students to their surroundings for subject matter. His
contribution to the American tradition of painting was
probably as great as that of any painter of his day, for he
carried forward the long-standing heritage of realism
initiated by Copley, Peale, and others. Through his
student Thomas Anshutz (1851–1912) an interest in
painting contemporary genre was transmitted to Robert
Henri, John Sloan, George Luks, and other members of
that vigorous group of painters termed "The Eight."

THE EIGHT

The artists singled out here as of particular significance
to American painting at the end of the nineteenth century
were not the individuals who constituted the official world
of the arts. The world of exhibitions, art schools, and
critical approval was dominated by the mood of genteel
refinement set by the "Ten American Painters" when
they first exhibited in Boston in 1895. The major schools
of painting featured a combination of watered-down
Impressionism and suave brush work. Familiar subjects
were arranged in pleasing patterns. Colors were discreet
and harmonious. It was an art created for a few people
insulated from the raw vigor of much of American life
by the amenities of well-ordered living, money, social
position, and conventional education. But American life
and culture were too turbulent and vigorous for such
anemic fare, and in the first decade of the twentieth
century a new group of painters challenged the decorous
taste of the official art world. This group called itself "The
Eight," but the critics and public who were disturbed by
the raw candor and challenge of their work called them
"the Ash Can school."

The leader of The Eight was Robert Henri (1865–1929).
Henri was born in Cincinnati. He studied under Anshutz,
who continued the tradition of Eakins at the Pennsylvania
Academy of the Fine Arts. Later Henri studied in Paris

and then returned to teach in Philadelphia. A magnetic teacher, he gradually established a coterie of followers. In 1900 he commenced teaching in New York, where he became the very articulate spokesman of a philosophy of painting which stressed the importance of "life" in art, rather than style. Henri urged his followers to immerse themselves in the vigorous metropolitan atmosphere, to enjoy the flavor of its masses of humanity, and to paint this world with freedom and spontaneity. His philosophy of art was put forth in a collection of his lectures and criticisms called *The Art Spirit*. Robert Henri's most characteristic paintings are direct, broadly brushed portraits and figure studies. He selected his colorful sitters from the poorer sections of New York City: immigrants, workers, the very old, and the very young. *Eva Green* (Fig. 429) displays the fresh, vivacious execution by which he captured his sitter's personality.

In 1907 the jury of the National Academy of Design rejected a number of paintings by Henri's friends and followers. The intolerance of the jury nettled Henri, and he withdrew his own entry in protest. The following year the Macbeth Galleries in New York, the first gallery to specialize in American painters, sponsored an exhibition of the rejected artists and some sympathetic fellow painters. There were eight in all: Henri and four of his followers —William Glakens, George Luks, John Sloan, and Everett Shinn—and three painters who were affiliated

429. ROBERT HENRI. *Eva Green*. 1907. Oil on canvas, 24 1/8 × 20 3/16″. Wichita Art Museum, Wichita, Kan. (Roland P. Murdock Collection).

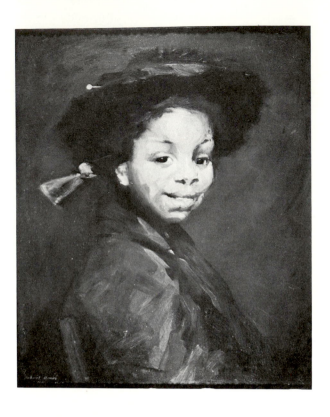

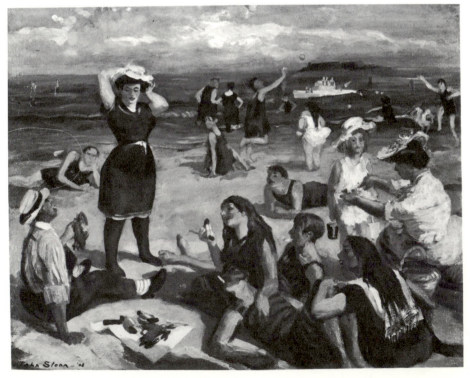

left : 430. JOHN SLOAN. *South Beach Bathers*. 1908. Oil on canvas, 25 7/8 × 31 7/8″. Walker Art Center, Minneapolis, Minn.

opposite : 431. GEORGE LUKS. *The Old Duchess*. 1905. Oil on canvas, 30 × 35″. Metropolitan Museum of Art, New York (George A. Hearn Fund, 1921).

with Henri's group more through temperament than style —Maurice Prendergast, Arthur Davies, and Ernest Lawson. The impact of The Eight was enormous. They achieved for American artists what Theodore Dreiser, Sinclair Lewis, Sherwood Anderson, and a subsequent generation of writers realized for the literary world: they turned the eyes away from the niceties of the genteel tradition toward a more incisive and all-inclusive picture of the country and its people.

John Sloan (1871–1951) remains the most original and powerful painter of The Eight. Before coming under Henri's influence, Sloan had been a newspaper artist, and the illustrative emphasis provided an important element of his style in later years. He moved from Philadelphia to New York in 1904; there the swarming life of the city provided him with his principal motif. True to the teachings of Henri, he immersed himself in the urban environment—the crowded streets, parks, homes, and places of entertainment—and his spontaneous records reflect the zest with which his keen eye and lively mind reported on his experiences.

South Beach Bathers (Fig. 430), painted in 1908, captures the enthusiasm of his early years in New York. Like most of Sloan's early works, it is conceived in broad masses of dark and light, so that a posterlike vigor characterizes it. The breadth of gesture and the almost vulgar vitality of the scene illustrate the aptness of the

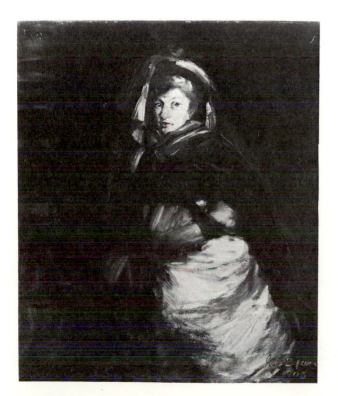

statement by Lloyd Goodrich that "his art had that quality of being a direct product of common life, absolutely authentic and unsweetened, that has marked the finest genre of all time." It was not surprising that the advocates of quiet arrangements, pleasing subjects, and gentle color harmonies dubbed The Eight the "Ash Can school."

Backyards, Greenwich Village (Pl. 16, p. 310) again shows Sloan's ability to invest a drab city scene with his own zest, to perceive the lusty pursuit of human activities behind the façade of the city slums. The grubby buildings, broken fences, telephone poles, and clothes lines provide the background for the busy children and animals. Though the setting might appear grim, according to the conventional and proper standards, Sloan infused the scene with his own love of life and saw it glowing in color, employing the broadened and heightened range of hues popularized by the Impressionists. The areas catching the sun reflect its warmth, while the shadows are cool and bluish. Painted in a richly brushed, heavy impasto, full-bodied in color, but never false or pretty, the entire work reflects a positive, sensual delight in the unsweetened vigor of urban life. After 1930 Sloan abandoned his reporting of the American scene for studio painting.

Sloan contributed considerably to the revival of interest in prints that occurred among artists and collectors early in the twentieth century. His background as a newspaper illustrator provided him with unusual graphic facility, and his etchings are delightful commentaries on the human foibles and fancies revealed by the metropolitan milieu.

George Luks (1867–1933) recorded the same world as Sloan, but Luks was concerned more exclusively with the human component. His was a colorful personality with a flair for depicting the colorful personalities of others. *The Old Duchess* (Fig. 431) is typical in subject matter and handling. Luks, admiring Frans Hals beyond all other painters, subordinated his sense of color to his taste for dramatic dark tonalities. He applied his paint in broad, flat masses, and there is a suggestion of Manet in the simplicity of his planes and the way in which form is suggested by the subtle modeling of the edge of a plane.

In some ways certain members of The Eight failed to fulfill their initial promise, but their importance in the first decade of this century cannot be overestimated. This was particularly true of William Glackens (1870–1938) and Everett Shinn (1876–1953). Glackens, like Sloan and Luks, started his professional life as a newspaper illustrator and then became a painter. *Hammerstein's Roof Garden* (Fig. 432), from his early period, exhibits an unabashed delight in the vivacious world of theaters and restaurants, a delight revealed by the choice of subject, the animated composition, and the lively way in which it is painted.

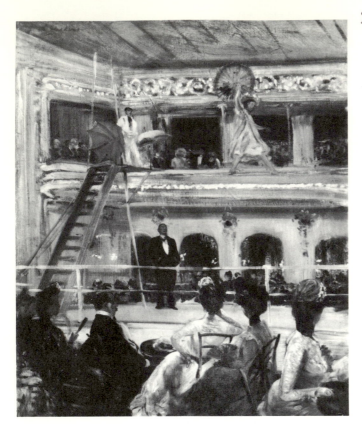

of flat planes which build up into a tapestrylike surface of rich color. Prendergast's color was based on that of the Impressionist landscape painters, with yellow and orange tones dominating the sunlit areas, while blue and violet shadows replaced the browns and blacks of the more conventionally oriented colorists. His favorite subjects were crowds of people on the beach or walking along the streets or quays of foreign villages and groups of nursemaids and children playing in the park. These scenes are composed in strong vertical and horizontal relationships, with generalized simplifications of form contributing a certain gaucherie. For Prendergast the world appeared as a rich visual fabric in which the human element was only part of a vast encompassing glitter.

Ernest Lawson (1873–1939), primarily a landscape painter, used the roughly textured manner of Monet and Pissaro, but his subject matter is urban and industrial America, and his color intensifies, rather than softens, the stern realities.

Stylistically Arthur B. Davies (1862–1928) was quite unrelated to the group, but he was a leader in the fight against academic timidity, and it was largely through his efforts that The Eight held their initial showing. A painter of idyllic reveries, his typical canvases show handsome nude figures in quiet landscape settings. Rhythmic line movements and muted colors contribute to the sensuous charm of his dream world (Fig. 434). Some of his late works abandon his familiar style for Cubist-like forms faceted into geometric planes and painted in bright colors.

The lively journalistic manner that characterized the work of the early students of Robert Henri in the first decade of the century gradually gave way to a more formal and carefully structured style. Both the example set by the advanced European painters featured in the famous Armory Show of 1913 in New York and the sober and questioning intellectual atmosphere that followed World War I encouraged a more analytical and disciplined kind of art than that just discussed.

No body of work better illustrates the transition between the two styles than that of George Bellows (1882–1925). Bellows first studied with Robert Henri in New York and began to exhibit about 1905. During the early years of his career, like Sloan, Luks, Shinn, and Lawson, he chose for his subjects moments when life ran high—the teeming streets of New York, the circus, the boxing ring, and the waterfront. *Forty-two Kids* (Fig. 435), painted on the East River in New York and the first work he sold, is one of the high points in his early endeavors.

Under the influence of Renoir, Glackens' later work achieved larger, simpler forms, rhythmic line movements, and rich color but lost the happy energy of his youthful period. Everett Shinn, like the young Glackens, loved the world of fashion, restaurants, and the theater and painted gay, illustrational street scenes and vignettes of theatrical life.

While, as a group, The Eight were opposed to the pallid academic Impressionism being produced by many of their American contemporaries, they were close to what had been the original spirit of the French Impressionists. Manet, Degas, and others of the French group, like The Eight, had painted the colorful life of the city about them without stressing symbolic or moralistic values. The French Impressionists also were admirers of Hals, Velázquez, and Goya as masters of vigorous brush work and dramatic tone. But though The Eight were influenced by the spirit of French Impressionism, they avoided the more obvious aspects of its manner.

These traits are most evident in the paintings of Maurice Prendergast (1859–1924). Unlike the other members of the group, Prendergast, a Bostonian, traveled and painted abroad, and lived in New York only for the last years of his life. *Central Park in 1903* (Fig. 433) exemplifies the highly personal style of his oils—a mosaic

As in many of his early works, Bellows composed a large number of seemingly unrelated forms into an energetic and unified composition. The organization appears casual at first glance, but careful observation reveals that the figures build to a pyramidal group, which fragments into animated individual units at the periphery of the mass. Brushed in long, fluid strokes, the spirited and frequently foreshortened and twisting thin, adolescent figures reveal his unusual powers as a draftsman; despite the large cast of characters, there is not an awkward or unconvincing figure in the group.

Even this very early work reveals a strong sense of pictorial structure and order, but one feels that the arrangement is almost intuitive and grows from the desire to intensify the vitality of the scene by relating the parts, rather than from a concern with formal precepts of composition. In Bellows' later work this natural tendency was reinforced by the more formal and intellectual approach that prevailed in the subsequent period. After World War II both his paintings and his lithographs revealed more consciously manipulated line movements, careful massing of forms, and a more finished and

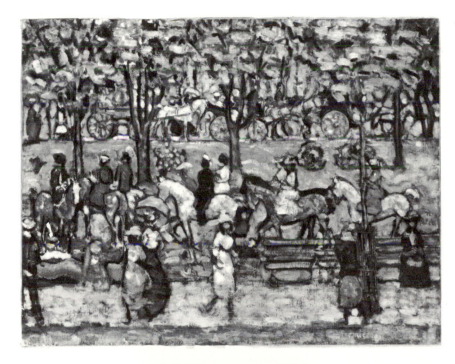

left : 433. MAURICE PRENDERGAST. *Central Park in 1903.* 1903. Oil on canvas, 20 ¾ × 27″. Metropolitan Museum of Art, New York (George A. Hearn Fund, 1950).

below : 434. ARTHUR B. DAVIES. *The Dream.* Before 1909. Oil on canvas, 18 × 30″. Metropolitan Museum of Art, New York (gift of George A. Hearn, 1909).

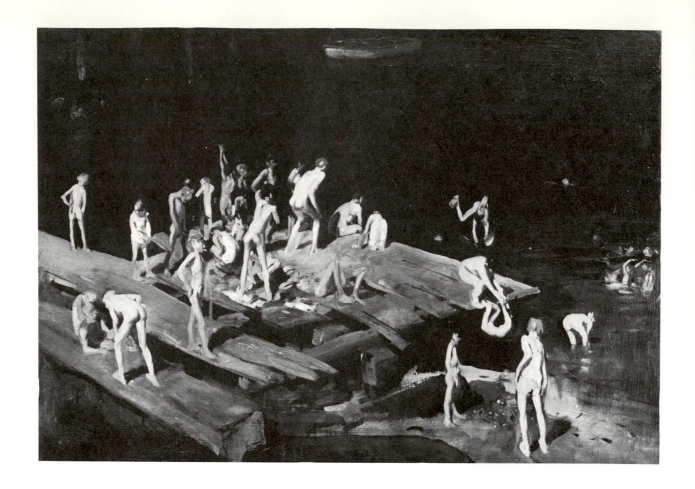

above : 435. GEORGE BELLOWS. *Forty-two Kids.* 1907. Oil on canvas, 3′ 6″ × 5′. Corcoran Gallery of Art, Washington, D.C.

restrained execution, as can be seen in his famous *Dempsey and Firpo* (Fig. 617). Because his work forms a bridge between The Eight and the American scene painters of the following period, Bellows represents a turning point in twentieth-century painting.

In 1913 a number of America's most progressive artists, including most of the members of The Eight, arranged the famous Armory Show in New York. This extensive exhibition was designed to acquaint the public at large with the new movements in painting at home and abroad. At the Armory Show an astonished American audience was introduced to the vanguard of French and Continental painting and sculpture—Cubism, Expressionism, and the violent Fauvism—as well as to the trenchant realism and the highly personalized styles of the younger Americans. Though scorned by most critics and laughed at by the public in general, the show had an impact that could not be erased; the Armory Show signaled the eclipse of academic Impressionists and of devotees of the "genteel tradition." From then on American painters, like those in Europe, were involved in a number of new approaches to painting which, for lack of a better name, we know as "modern" painting. This complex body of work will be outlined in later chapters.

17

The Graphic Arts, Photography, Sculpture, and Art Patronage

THE GRAPHIC ARTS

Illustration

Producing illustrations for an ever-increasing flood of books and periodicals provided a livelihood for many artists after the Civil War. A number of important painters, including Winslow Homer, served their artistic apprenticeship in this capacity (Fig. 436). Certainly Homer's drawings and engravings of the Civil War and, later, of frontier life and other genre subjects, strongly composed, incisive in their delineation of form and texture, and bold in dark and light, remain among the great examples of journalistic narrative art.

Few of those who made a lifetime career of illustrating books, magazines, and newspapers were sufficiently forceful to achieve genuine distinction. One of them,

436. WINSLOW HOMER. *The Sharpshooter*. 1862. Wood engraving, 9 ¼ × 13 ¾". International Business Machines Collection, New York.

however, created works of such originality and power that they have become part of the American art heritage. That man was Thomas Nast (1840–1902). Nast, from a family of liberal German refugees, spent his professional life fighting for social reform as a staff artist for *Harper's Weekly*. In this capacity he developed a forceful style of caricature with which to conduct his warfare against the corruption and evil that were eating into the full realization of America's promise. His vitriolic attacks upon the scandalous Tweed Ring, which dominated New York City in the latter half of the nineteenth century, were probably the most effective editorial cartoons ever produced in America. Nast helped to unseat the Tweed Ring and in so doing created political symbols that have remained a part of our national imagery—the Tammany tiger, the Republican elephant, and the Democratic donkey. One of his most frequently reproduced cartoons is *A Group of Vultures Waiting for the Storm to "Blow Over"—"Let Us Prey"* (Fig. 437). Most evident here is his remarkable ability to translate personalities, events, and social forces into vivid and readily understood symbols. Nast made his original drawings in pencil with clear, incisive lines which could easily be translated into the linear style of wood engraving. This linear, hard-textured style has an aggressive, masculine vigor well adapted to the combative role of his work. Nast, more than any other individual, established the cartoon as an important political force in America.

Prints

In the last half of the nineteenth century, before the advent of modern photoengraving, book and periodical illustrations were produced by the printmaking processes, particularly lithography and wood engraving. Wood engraving, in particular, seemed practical for the requirements of mass printing, for, correctly cut, the blocks could produce thousands of duplicate prints with clarity, brilliance of tone, and a wide range of textural effects. One of the most skillful of the late nineteenth-century wood engravers was Timothy Cole (1852–1931). His virtuosity with the burins, gouges, and various "tinting tools" was such that, by patient stippling, subtle hatching, and the use of sequences of parallel lines which swelled and shrank to create smooth gradations of tone, he could reproduce drawings, paintings, and even photographs with the utmost fidelity. The most famous of his works were the series of engravings of the old masters he executed for *Century Magazine* in the eighties, in which extraordinarily subtle tonal and textural effects were reproduced. His engraving of Constable's *The Hay Wain* (Fig. 438), because it is one of his less complex works, reveals with singular clarity his power to transpose what the painter said with brush and color "into the language of the burin." In his later years Cole became less interested in using wood engraving to duplicate the effects created by others and began to glorify it as an artistic medium in its own right.

While wood engraving and lithography flourished as means for commercial illustration, both lithography and the various etching processes became increasingly popular with painters in search of additional media through which they might express themselves. Thomas Moran, for instance, was a painter who occasionally turned to printmaking. His *Tower of Cortes, Mexico* (Fig. 439) has a vigor of line and a textural richness which suggest that Moran may have had more of an innate feeling for the graphic media than for paint. Certainly the small drawings by which he recorded scenic wonders lost less of their power in being transcribed into etchings than when they were enlarged into enormous studio paintings.

left : 437. THOMAS NAST. *A Group of Vultures Waiting for the Storm to "Blow Over"—"Let Us Prey,"* from *Harper's Weekly,* Sept. 23, 1871. Wood engraving, 14 ½ × 9 ½". New York Public Library, Prints Division (Astor, Lenox, and Tilden Foundations).

below : 438. TIMOTHY COLE. *The Hay Wain*, after Constable. 1899. Wood engraving, 5 3/16 × 7 13/16″. Philadelphia Museum of Art.

right : 439. THOMAS MORAN. *Tower of Cortes, Mexico.* 1883. Etching, 11 ½ × 9 ½″. International Business Machines Collection, New York.

bottom : 440. JAMES ABBOTT MCNEILL WHISTLER. *Black Lion Wharf.* 1859. Etching, 5 7/8 × 8 7/8″. International Business Machines Collection, New York.

bottom right : 441. JAMES ABBOTT MCNEILL WHISTLER. *Venice.* c. 1886. Etching, 10 × 7″. Museum of Fine Arts, Boston (gift of Denman W. Ross).

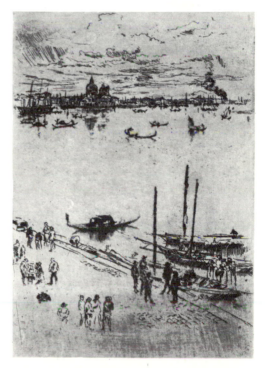

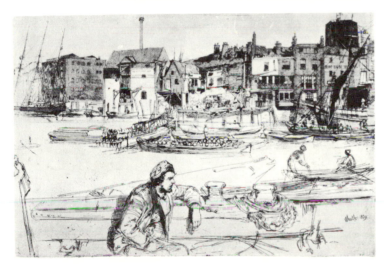

Whistler, as much as any other individual artist, contributed to the reestablishment of printmaking as a fine art. Although he produced both lithographs and etchings of distinction in numbers, his graphic power, particularly his trenchant use of line, probably received its most forceful expression in etching. His earlier etchings, like the works of the French mid-century realists, particularly Courbet, depict commonplace subjects with keen-eyed realism. *Black Lion Wharf* (Fig. 440), from his early

London years, combines a solid composition with a charming blend of accurate delineation and sketchy freedom that Whistler might have considered too obvious for his full-sized paintings. The vitality of these etchings reveals an unexpected dimension in Whistler's talents.

The etchings of Whistler's later years replaced illustrative animation with the exquisite arrangements of pattern that distinguished his paintings. In the Venice etchings of the eighties (Fig. 441) large areas of white paper act as a foil

for the delicate broken lines and subtle textures which evoke an Impressionist atmosphere. Widely circulated and rapidly acquired by connoisseurs, Whistler's etchings and other prints exerted a strong influence on his contemporaries and on the art of printmaking in general at the end of the nineteenth century.

Mary Cassatt, like many of the French Impressionists, reflected the prevalent enthusiasm for Japanese wood blocks and abandoned conventional pictorial values in her prints for decorative effects of great refinement and sophistication. In the early nineties she combined drypoint, soft-ground etching, and colored aquatint to create a series of prints of much originality and beauty. In *The Fitting* (Fig. 442) the delicately modulated color, like the charming scattered patterns, creates a composition that is forceful and at the same time sensitive and feminine. Here again one finds that characteristically Impressionist transposition of commonplace themes into elegant and surprising compositions. Most late nineteenth-century prints were in black and white. Mary Cassatt was one of the first to introduce color as an important element in them.

The distinctive style of Whistler's later works affected a number of American etchers. Frank Duveneck, who spent some time in Venice while Whistler was working there, produced some fine etchings that reflect Whistler's concern with interesting and unusual compositions. Joseph Pennell (1860–1926), an illustrator whose crisp pen-and-ink drawings reproduced with clarity and effectiveness, learned much from Whistler concerning the force of carefully selected details when contrasted with open areas of paper. His etchings, like his drawings, reveal an admirable economy of means (Fig. 443). Pennell discovered the power of American industrial architecture, and some of his etchings of great constructional projects or of steel mills belching forth smoke were most original in their perception of the visual grandeur of our industrial centers.

John Twachtman and J. Alden Weir (1852–1919), along with other members of the "Ten American Painters" who were attracted to Impressionism, etched quiet landscapes and stretches of water which display many of the effects found in Whistler's later prints. Childe Hassam, on the other hand, developed from Impressionist painting a bold handling of cross-hatched lines that was admirable in the effectiveness with which it evoked the sparkle of sunshine and the transparency of shadow. *House on Main Street, Easthampton* (Fig. 444), from the twenties, is a solidly wrought composition in which the etched textures create an equivalent of the vibrations achieved by the pointillist method of applying paint.

With The Eight, printmaking ceased to be an exercise in tasteful arrangements or technical virtuosity and became increasingly a vehicle for pungent comment. Both

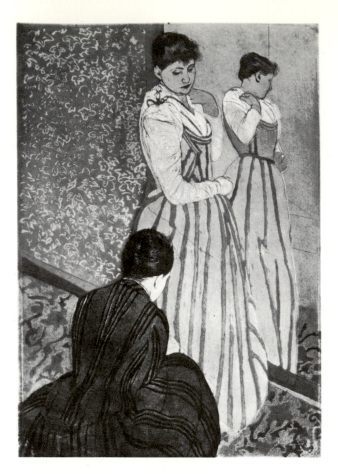

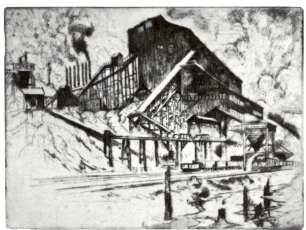

John Sloan and George Bellows made prints on social and political themes which have a satiric thrust absent from most of their paintings. Sloan's *Fifth Avenue Critics* (Fig. 445) achieves its aim as an amusing social commentary without weakening its impact as a richly designed and toned etching. Bellows' *Dance in a Madhouse* (Fig. 446), taken from a drawing of 1907, has a power far

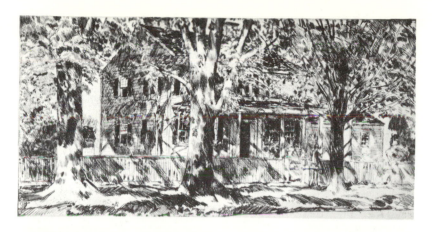

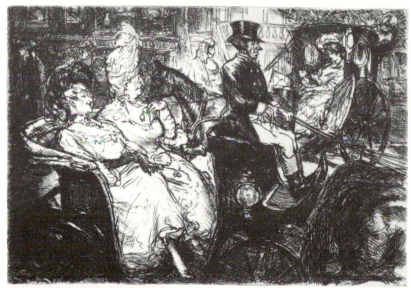

opposite above : 442. MARY CASSATT. *The Fitting.* 1891. Drypoint, soft-ground etching, and aquatint, $14^3/_4 \times 10^1/_8$″. Metropolitan Museum of Art, New York (gift of Paul J. Sachs, 1916).

opposite below : 443. JOSEPH PENNELL. *The Things That Tower: Collieries.* 1909. Etching, 8×11″. Metropolitan Museum of Art, New York (gift of David Keppel, 1917).

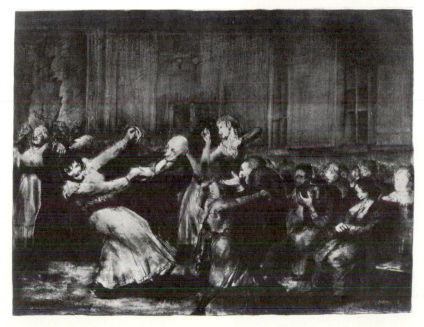

top : 444. CHILDE HASSAM. *House on Main Street, Easthampton.* 1922. Etching, $6^1/_{16} \times 12^1/_8$″. Museum of Modern Art, New York (gift of Abby Aldrich Rockefeller).

above : 445. JOHN SLOAN. *Fifth Avenue Critics.* 1905. Etching, $6^7/_8 \times 5$″. Whitney Museum of American Art, New York.

left : 446. GEORGE BELLOWS. *Dance in a Madhouse.* 1917. Lithograph, $18^1/_2 \times 24^1/_8$″. Whitney Museum of American Art, New York.

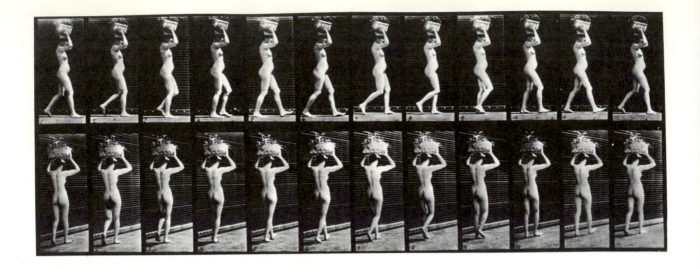

beyond the journalistic zest that characterized his early paintings. The tragic scene is depicted with compassion and irony. The spirit with which the dancers cavort in the gloomy ballroom, surrounded by the depressed and isolated onlookers, creates a paradox with overtones of both humor and horror. In such prints Bellows exploited the lithographic medium to produce the velvety blacks, luminous grays, and sharp whites which contribute to the dramatic effectiveness of the scene.

PHOTOGRAPHY

During the seventies and eighties startling advances in the photographic processes made the cumbersome collodion wet plate and other early methods obsolete. A means of using gelatin to bind the sensitive silver salts to a glass surface made it possible to prepare photographic plates in advance for use and processing at the photographer's convenience.

The camera became an indispensable adjunct to exploration. With the opening of the West, photographers came to be important members of official government expeditions, and notable pictures were taken of such subjects as the topography of the land, the life of the Indians, archeological sites (Fig. 28), and the building of the transcontinental railway. Though created essentially as documentary records, many of these photographs remain impressive examples of camera art.

In the eighties the light-sensitive, dry-plate technique had been developed to the point of permitting exposures of 1/500 second, thus enabling Eadweard Muybridge (1830–1904) and Thomas Eakins to make their brilliant studies of animals, birds, and human beings in action (Fig. 447). These constituted the first actual records of

locomotion, and since they caught the sequence of actions that make up a complete movement, they foreshadowed the motion picture.

It was also in the eighties that George Eastman invented the Kodak with a roll holder for paper film, which made photography a popular hobby. While the public at large used the newly improved equipment primarily for memorabilia of their families, friends, and special occasions, an increasing number of individuals began to view photography as a form of art. Camera clubs flourished in the cities, and publications devoted to the subject began to appear. A quarterly, *Camerawork*, published under the leadership of Alfred Stieglitz (1864–1946), soon became the most influential journal dedicated to the new art.

Stieglitz, who was later to play an important role in introducing Americans to modern painting, showed himself to be equally perceptive to the artistic potential of the camera. Unlike many writers who stressed only the technical aspects of photography, Stieglitz encouraged a conscious esthetic emphasis, since he believed that he was dealing with a major art medium. He recognized the special capacity of the camera to record the exact character of a situation at a particular moment of time. Many of his earliest prints foretold the "purist" photography of later decades, since he deliberately eschewed both formally arranged compositions and studied tonal harmonies, concentrating instead on catching the unique flavor of a living moment (Fig. 448).

However, not all of Stieglitz' photographs were as direct and forceful as *Steerage*. In his desire to explore the full possibilities of the medium, he, like many of his contemporaries, frequently sentimentalized or dramatized the camera's image by manipulations during the exposure of the film, the development of the negative, or the print-

opposite : 447. EADWEARD MUYBRIDGE. *Nude Woman, Basket on Head*. 1885. Photographic sequence. George Eastman House, Rochester, N.Y.

below : 448. ALFRED STIEGLITZ. *Steerage*. 1907. Photograph. Philadelphia Museum of Art (Stieglitz Collection).

right : 449. EDWARD STEICHEN. *The Photographer's Best Model—G. Bernard Shaw*. 1907. Photograph. Museum of Modern Art, New York.

brushes were used to enrich negatives, and tissue paper was placed in front of the lens to effect the much-admired diffusion characteristic of Impressionist painting.

One of the most influential and talented photographers to explore the various painterly devices, without losing sight of the documentary nature of the camera's eye, was Edward Steichen (1879–1973). His portrait entitled *The Photographer's Best Model—G. Bernard Shaw* (Fig. 449) is both a telling character study and a consciously harmonized tonal exercise, in which the viewer's eye is carried through the long curve of the back to the adroitly placed hand and head. The entire figure is, in turn, framed by the light rectangular background in a manner reminiscent of Whistler's famous portraits of his mother and Thomas Carlyle.

In the hands of a few who were unconcerned with painterly effects, the camera became an instrument for social reform, because the validity of the unedited photographic image was not to be questioned. Jacob Riis (1849–1914), a Danish immigrant who became a police reporter, shocked by the sordid conditions of immigrant life, which he knew at first hand, used the camera to expose the inhumanity of urban squalor and the debasing horrors of poverty and

ing of the positive. Thus a special kind of "art" photography came into being. A continuous effort was made in the first decade of the twentieth century to discover new ways whereby the photographer might rival the painter in producing artistic or picturesque effects. Studio subjects were carefully arranged in pleasing compositions. Unusual textures were created by making prints on heavily grained or very thin papers. Etching needles and painters'

left : 450. JACOB RIIS. *Bandit's Roost* (15½ Mulberry Street, New York). c. 1888. Photograph. Museum of the City of New York (Jacob A. Riis Collection).

evil. *Bandits' Roost* (Fig. 450) is one of the many bitter scenes Riis photographed in his campaign to alleviate the tragic situation of the slum dwellers of New York.

SCULPTURE

By the conclusion of the Civil War the enthusiasm for white marble sculpture and classic idealization of form had declined. An increasing number of sculptors prided themselves on the fact that both their subject matter and their style were typically American. The foremost example of a sculptor whose success was based on his homespun tastes was John Rogers (1829–1904).

Rogers enjoyed a phenomenal success as the producer of small sculptural groups depicting genre subjects, amusing anecdotes, and current events of historical and topical interest. When Rogers discovered the wide appeal of his figure groups, he developed a flexible mold that would permit the manufacture of plaster copies of the originals. He set up a factory in New York, employed as many as sixty workmen, and mailed out printed circulars listing the various items and their dimensions and prices. *Checkers up at the Farm* (Fig. 451), one of his most popular groups, displays the characteristic combination of a vivacious narrative, convincing details, warmth, and humor. The forms, though not monumental, are active, full-bodied, and well observed. Rogers shows an enviable facility in composing his groups to tell their story clearly and forcefully. The direction of gestures and glances moves in lively interplay with the main masses of form to create an animated relationship of all the parts. It is far from great sculpture, but it is honest, unhackneyed, and closely attuned to the life of the country. The verisimilitude of surface details; of textures in cloth, hair, basket, and barrel; and of convincing facial expressions and character types are sculptural equivalents of the qualities that distinguished popular genre paintings.

John Quincy Adams Ward (1830–1910) shared Rogers' skill in creating small figure groups, but he did not restrict his activities to small-scale sculpture. Ward was one of the first of the mid-nineteenth-century sculptors to develop what was then considered an "American" style of handling life-size figures, which meant a somewhat dry and detailed realism. Ward was born in Ohio and in his youth showed an interest in modeling. At nineteen he went into the studio of Henry Kirke Brown, where he served a short apprenticeship while Brown was working on the great equestrian statue of George Washington for the city of New York. Ward had no other formal training.

After leaving Brown's studio, Ward spent a few years traveling on the western frontier and living among the Indians. The *Indian Hunter* (Fig. 452), which now stands in New York's Central Park, was inspired by his observations of Indian life. The lithe, heavily muscled figures of the scowling Indian and his dog move in tense unity. Though the details of muscles, hair, and fur are sharply articulated, the powerful sense of movement and form carries the detail along with it. *Indian Hunter* was the first of a long line of sculptures by Americans depicting the Indians and their life.

After Ward's return to the East he was commissioned to do a number of life-size bronze figures, of which his portrait of *Henry Ward Beecher* (Fig. 453) is the acknowledged masterpiece. The heavy, characterful crusader stands firm, relaxed, and unafraid, ready to carry on his fight for the freedom of the slaves. Ward appears to have been equally untouched by the corrosive devices of neo-classicism, with its togas and rhetorical gestures, and by sentimental Beaux-Arts idealizations. Instead, he created a monumental symbol of the courageous minister through his sympathetic presentation of the confident and dedicated personality. Without the obvious trappings of leadership, Ward's *Beecher* stands resolute, a leader of men. The strength of this work leaves no question as to Ward's natural endowment as a sculptor.

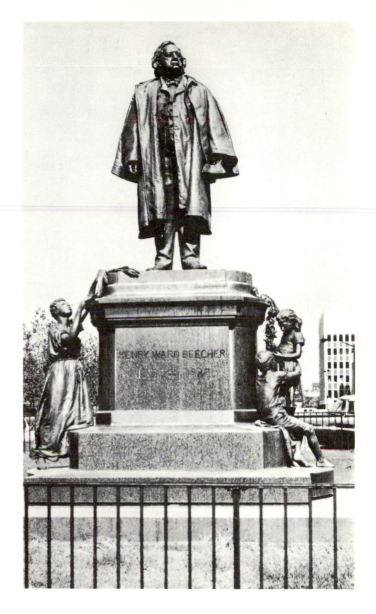

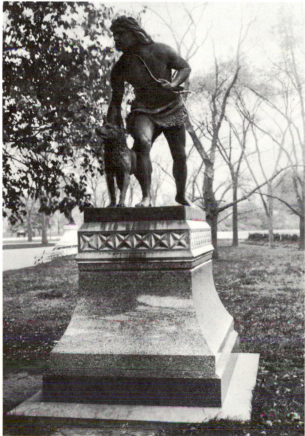

above left : 451. JOHN ROGERS. *Checkers up at the Farm.* 1875. Plaster, height 20″. New York Historical Society, New York.

left : 452. JOHN QUINCY ADAMS WARD. *Indian Hunter.* 1868. Bronze, life size. Central Park, New York.

above : 453. JOHN QUINCY ADAMS WARD. *Henry Ward Beecher.* c. 1891. Bronze, height 8′. Metropolitan Museum of Art, New York (Rogers Fund, 1917).

Sculptors of the Far West

Indian lore and the life of the frontier provided some indigenous themes for the sculptors who preferred vivid local color. Frederic Remington, best known as a painter and illustrator, created some animated small bronzes of cowboys and horses which are sculptural equivalents of his paintings. *Bronco Buster* (Fig. 454), with its strenuous action and convincing character, reveals his analytical eye as well as his thorough knowledge of the life of the cowboy. Remington's sculpture, like his paintings, shows little interest in academic concepts of design. Instead, the tense and nervous forms and the broken surface textures of his figures express his direct reaction to the rigors of frontier existence.

The Borglum brothers also portrayed typical western subjects. Solon Borglum (1868–1922) created lively small bronzes of bucking broncos and stampeding horses. Gutzon Borglum (1871–1941), the better known of the two brothers, is most famed for the two great sculptural projects in which he shaped the sides of mountains into the images of some of America's heroes. His portraits of Robert E. Lee on Stone Mountain in Georgia and of Washington, Jefferson, Lincoln, and Theodore Roosevelt on the face of Mount Rushmore in South Dakota are among the largest sculptural projects ever attempted. Though they are tributes to the energy and engineering skill of the artist, their very size precludes the possibility of subtle sculptural values. Gutzon Borglum's *Mares of Diomedes* (Fig. 455), despite its classical title, was obviously inspired by a western stampede. The plunging mass of mares has been translated into sweeping lines,

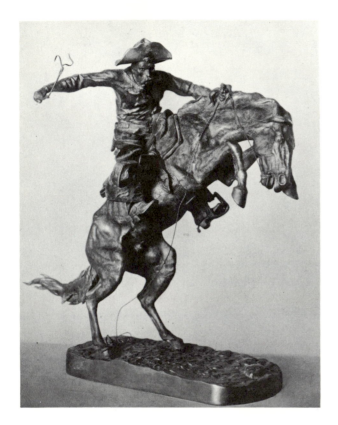

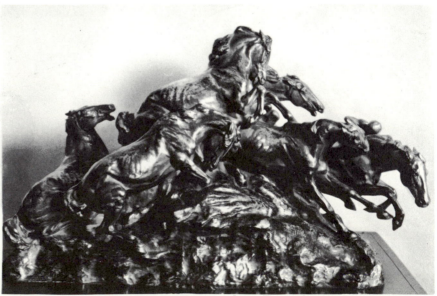

broken textures, and catapulting planes without violating the unity of the group or the character of bronze. Though many American sculptors prided themselves on constituting an American school of sculpture, there was a constant interplay between American and foreign, particularly French, influence. Even Borglum, an enthusiastic patriot, studied abroad, and the *Mares of Diomedes* owes much of its sketchlike intensity to the example of the French master, Auguste Rodin.

The popularity of Indian themes has already been mentioned. An awakening public conscience, increasingly aware of the toll exacted from the Indians by Western civilization, led to attempts at atonement for the injustices by memorializing them through noble sentimentalizations. Cyrus Dallin (1861–1944) was one of many sculptors to specialize in Indian subjects. His *Medicine Man* (Fig. 456), a life-size equestrian figure, generalized and somewhat academic in form, achieves dignity if not power.

Augustus Saint-Gaudens

In the last decades of the century most American sculptors, like the painters, profited from French training. French sculpture, particularly as exemplified by the École des Beaux-Arts, remained more traditional in its orientation than French painting, going primarily to classic sources, the Renaissance, and the Baroque masters for inspiration.

No sculptor better illustrates the increased maturity of conception inspired by familiarity with the grand tradition than Augustus Saint-Gaudens (1848–1907), who from 1880 until his death was, without question, the dominant figure in American sculpture. Saint-Gaudens was born in Ireland of an Irish mother and a French father, who immigrated to America while Saint-Gaudens was an infant. He commenced his study of art in New York, after a short time continued it in Paris, and followed this with a trip to Rome, where he had an opportunity to observe the great sculptural monuments of the Renaissance. On his return to America his sincerity and talent were readily recognized, and by 1880 he was established as America's leading sculptor. Inspired by the great monuments of the past, Saint-Gaudens brought a grandeur of conception and subtlety of design to American sculpture that had previously been lacking, though his sober realism and emotional restraint are typical American traits, and his subject matter was drawn largely from American history. Saint-Gaudens' work falls into three general categories:

large public monuments, which represent his most ambitious undertakings and which added to the dignity of many American cities; full-length symbolic figures; and numerous sensitive portraits executed either in the round or as bas-relief plaques.

Saint-Gaudens introduced a number of innovations in designing public monuments. In collaboration with the architect Stanford White, he evolved a new type of base for a monumental figure, in which the pedestal rises from a handsome high-backed bench decorated in bas-relief motifs related to the main figure. One of the early and very successful designs of this type is the Farragut Monument (Fig. 457) in New York City. The commanding figure of Admiral Farragut reflects the Renaissance ideal of monumental realism by combining richly massed forms with selective detail. The energetic stance of the standing figure reveals a careful counterbalancing of the thrusting vertical with restrained curves to create a convincing symbol of action and authority. The subtle bas-relief pattern in the base, which combines allegorical figures with a fluid design of waves, provides a poetic counterpoint to the towering form above.

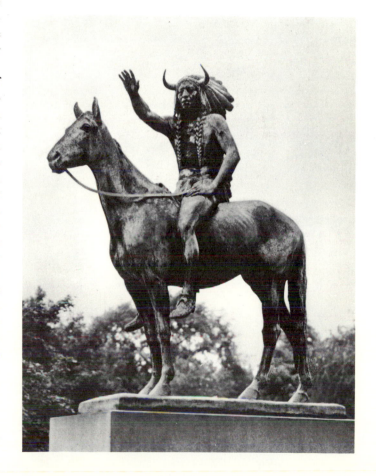

right : 456. CYRUS DALLIN. *Medicine Man*. 1899. Bronze, life size. Fairmount Park, Philadelphia.

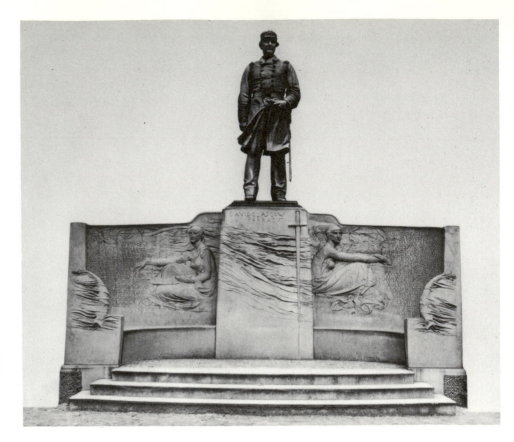

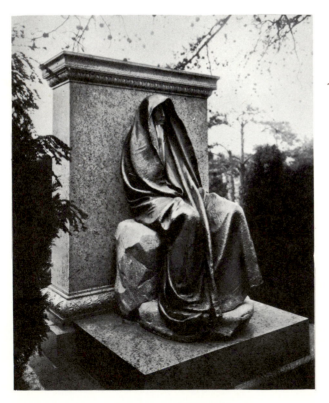

Another innovation that Saint-Gaudens introduced into his monuments was the use of ornamental lettering of great distinction as an element in the total decorative ensemble. The thoughtful interrelating of all parts of a complicated sculptural group—the base, figures, lettering, and ornamental detail—created new standards of excellence to be emulated in the design of commemorative statuary.

One of the handsomest memorials created by Saint-Gaudens was the tomb designed for Mrs. Henry Adams (Fig. 458) in Rock Creek Cemetery, Washington, D.C., at the request of her husband. The tomb is simple and austere in conception. A seated bronze figure, wrapped in voluminous draperies, leans against a great, unbroken block of granite. The forms are broad and generalized, and the disposition of light and shadow is masterly. The flowing contours of the draperies envelop the brooding head in a wavering, triangular arch, and from the shadow the face projects its grave poetry. The strength with which this figure evokes its mood of inner quietude made it a landmark in an age when sculptured memorials tended to be rather obvious in their elaboration and trite in their symbolism. The quiet figure lost in reverie has been variously interpreted as a symbol of grief, death, or divine

peace. Though its specific meaning is obscure, a mysterious and solemn spirit emanates from the figure.

Saint-Gaudens executed a number of portraits of great Americans in which the nobility of character is interpreted with both reticence and frankness. His portraits of Lincoln have become national symbols, and they, in particular, reveal the sculptor's ability to endow the outward forms with a rare inner grace almost at variance with the forthright naturalism of external appearance. Saint-Gaudens even translated the awkward clothing of his era into bronze without any loss of realism or sculptural distinction by combining the broad simplifications of form necessary to achieve monumental grandeur with delicately articulated detail.

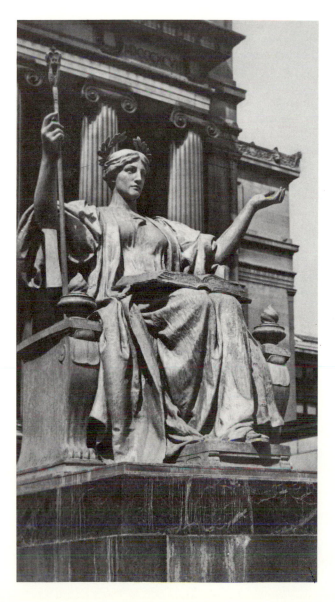

left: 459. DANIEL CHESTER FRENCH. *Alma Mater*. 1903. Bronze, height 7′. Columbia University, New York.

Daniel Chester French

Daniel Chester French (1850–1931) shared the major commissions of the late nineteenth century with Saint-Gaudens. Though French was not so powerful nor so sensitive as Saint-Gaudens, his ability to translate American types of men and women into idealized sculptural symbols ensured his continued popularity well into the twentieth century, when he remained the chief practitioner of commemorative sculpture in the Beaux-Arts vein. French was born in New Hampshire, studied with Ward for a very short time, attended Rimmer's exciting lectures in anatomy, and with this sketchy preparation proceeded to design a number of monuments. His early commissions were carried out in a somewhat dry and detailed manner. Later he spent a year in Italy, and in the eighties he studied in France. While abroad, he acquired the freer and more sensitive modeling and the nobler forms which distinguished the work of his later years. After his return from abroad, French executed a great number of sculptural monuments, which, along with those of Saint-Gaudens, dominated the character of American sculpture until after World War I, when a more abstract and stylized manner replaced the traditional Beaux-Arts treatment of form.

The *Alma Mater* (Fig. 459) at Columbia University reveals both the strength and the weakness of French's personifications. The general massing of the form is broad and attractive, and the figure has a quiet dignity well suited to its role. However, the abstracted head, the broad gestures, and obvious symbolism appear conventional and trite, and the figure is without tension or a sense of inner life. Though conscientious and skilled, it lacks conviction and urgency.

French appeared at his best working with the seminude figure. His easy disposition of a decorative flow of lines can be seen most effectively in such monuments as his *Mourning Victory* (Fig. 460). This memorial to three brothers who lost their lives in the Civil War is impressive because of its simplicity and because of the effective manner in which the handsome mythical figure emerges from the stone stele. The full-bodied, almost sexless form is enveloped in an easy flow of draperies, which move with the elongated rhythms of the Art Nouveau designers. The obviously facile perfection of the figure is accented by the subtle play of textures, of smooth skin against rough draperies, which contrast, in turn, with the slightly horizontal pattern of chisel marks on the main mass of the stele. The rhythms of the figure are paralleled and

complemented by the movements of the draperies. As the forms rise, the rhythmic swirling of the draperies quickens and the space relationships deepen and become more complex. Though *Mourning Victory* is conventional in sentiment, the intelligence, taste, and skill of the artist almost obscure the lack of strong feeling.

French is probably best known for his seated Lincoln, in the Lincoln Memorial in Washington, D.C. The effectiveness of the figure results from the scale, the setting, and the dramatic lighting, for French was least effective in the monumental portrait. His was an art of sentimental idealism and technical proficiency, which achieved a borrowed elegance by adopting the academic skills and tastes of late nineteenth-century France.

Taft, Barnard, and Others

At the turn of the century Lorado Taft and George Grey Barnard were the leaders of a younger group of Paris-inspired men who reflected the powerful influence of Auguste Rodin. Whereas the École des Beaux-Arts inpired suavity of handling and elegance of effect, Rodin encouraged his disciples to work for intensity of feeling. Particularly persuasive were Rodin's vigorous, roughly modeled surfaces and his practice of allowing the partially completed figure to emerge like a nascent form from the surrounding amorphousness of material.

Lorado Taft (1860–1936) was born in Illinois, attended the University of Illinois, and then spent three years at the École des Beaux-Arts in Paris. Taft's major commissions were large projects such as *The Fountain of Time* (Fig. 461) in Chicago. His early sculptures espoused the Renaissance mode; his later works reveal the influence of Rodin in that their detailed forms fuse with and emerge from the enveloping matrix. In *The Fountain of Time* the great panorama of civilization is symbolized by a sequence of figures representing crucial periods and episodes in history. This ambitious project, too pictorial to carry as a sculptural whole, has some fascinating and powerful details, but a tendency toward mawkishness and obvious idealization frequently detracts from the effectiveness of the conception. In addition to his great

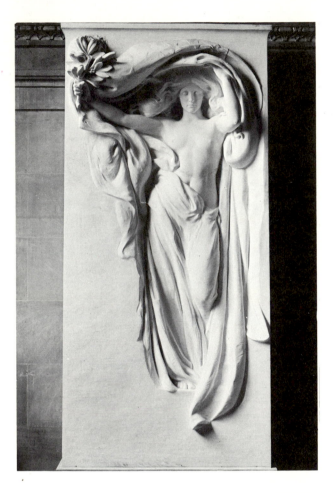

above : 460. DANIEL CHESTER FRENCH. *Mourning Victory* (the Melvin Memorial). 1915. Marble, height 12′2″. Metropolitan Museum of Art, New York (gift of James C. Melvin, 1912).

right : 461. LORADO TAFT. *The Fountain of Time* 1920. Washington Park, Chicago (Chicago Historical Society).

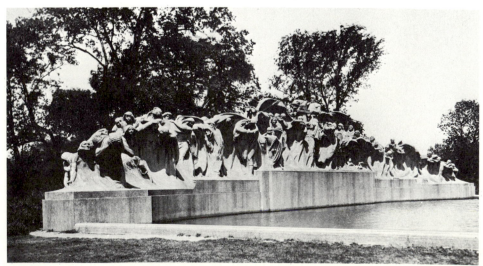

fountains Taft produced a number of sculptural portraits and memorial figures. He also taught and lectured at the Art Institute of Chicago and wrote the first history of American sculpture.

George Grey Barnard (1863–1938), born in Pennsylvania, spent most of his youth in the West. Driving ambition and an ability to endure great privation enabled him to spend twelve years living and working in Paris, where he studied the great masterpieces in the Louvre and profited by the example of Rodin and the other late nineteenth-century French sculptors. Barnard was an ardent admirer of Michelangelo and, like him, chose the nude as the vehicle for expressing intense emotions and symbolizing moral values. A work of his youth, *The Struggle of the Two Natures in Man* (Fig. 462), is an effective embodiment of his talents. In this work Barnard illustrated man's conflicting nature—his base and noble potentialities—through a pair of powerful figures bound together in a handsome baroque swirl of movement. The massive figures, inspired by Michelangelo's slaves and carved directly from a great block of marble, reveal Barnard's driving energy and philosophical temperament. Though the stone surface has been carefully finished and some of the anatomical detail fully elaborated, the total effect is unlabored and free, because many areas have been left undeveloped, and sweeping movements carry through all parts of the composition. *The Struggle of the Two Natures in Man* remains Barnard's best-known work. Its success rests not only on its visual effectiveness but also on the universality of its theme.

Olin Levi Warner (1844–96), Paul Weyland Bartlett (1865–1925), Henry Kitson (1865–1947), Gertrude Vanderbilt Whitney (1877–1942), and a number of other competent sculptors, following the Beaux-Arts ideal, contributed to the turn-of-the-century sculptural tradition in America. Among the most colorful of these lesser figures was Frederick W. MacMonnies (1863–1937), who introduced a gayer and more sensuous note. MacMonnies was born in Brooklyn and was a student of Saint-Gaudens from his sixteenth to his twenty-first year. Temperamentally he had little in common with Saint-Gaudens, although he acquired an admirable technical training from the American master. His style was strongly influenced by his later years in Paris, where he developed a vivid pictorial manner characterized by animated surface modeling. MacMonnies executed a number of public commissions, not all of which were well received. His bronze *Bacchante* (Fig. 463) reveals his taste for a vivacious, charming subject. Originally presented to the Boston Public Library, this joyous nude aroused a storm of protest because of both its nudity and its glorification of wine. Like most of MacMonnies' work, it has no hidden significance or

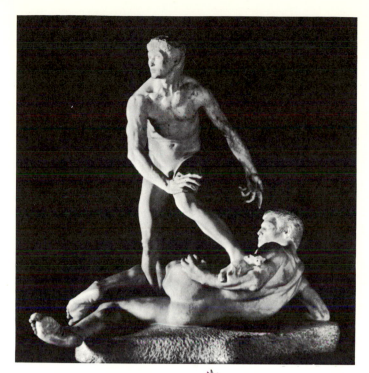

above: 462. GEORGE GREY BARNARD. *The Struggle of the Two Natures in Man.* 1893. Marble, 8′ 5½″ × 8′ 3″. Metropolitan Museum of Art, New York (gift in the name of Alfred Corning Clark, 1896).

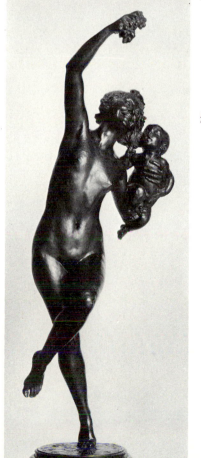

left: 463. FREDERICK MAC-MONNIES. *Bacchante.* c. 1894. Bronze, height 6′ 11″. Metropolitan Museum of Art, New York (gift of C. F. McKim, 1897).

earnest message—it exists as an end in itself. The introduction of this Gallic note of candid delight in sensuous beauty particularly distinguished MacMonnies from the other sculptors of his day.

Mention should also be made of Hermon Atkins MacNeil (1866–1947), who designed imposing architectural sculptures for a number of major public buildings and expositions; Edward Kemeys (1843–1907) and Alexander Phimister Proctor (1862–1950), both primarily sculptors of animals in action; and Alexander Stirling Calder (1870–1945), son of the sculptor whose figure of William Penn tops the Philadelphia City Hall and father of Alexander Calder, whose work will be discussed in a later chapter.

In the first decade of the twentieth century certain innovations which were to flower in the period following World War I began to be evident. Sculptors abandoned the practice of modeling forms first in plaster and worked, instead, directly in permanent materials. The more progressive sculptors turned to the arts of the Orient, to archaic cultures, and to primitive peoples for fresh inspiration and variety. Most significantly, monumental realism, the goal of sculptors since Renaissance times, and the use of allegory and symbolism gave way to a greater concern with purely visual elements of sculptural design.

INSTITUTIONS AND ART PATRONAGE

Private collections of distinction became more numerous in the years following the Civil War. In 1864 James Jackson Jarves, whose own collection was to form part of the nucleus of the Yale University Art Gallery, noted: "It has become the mode to have a taste . . . private galleries in New York are becoming almost as common as private stables." Just as the Jarves acquisitions laid the foundation for the Yale collection, the collection formed by William Thompson Walters and his son Henry provided the start for the Walters Art Gallery in Baltimore, the works of art accumulated by William Wilson Corcoran were donated with the Corcoran Art Gallery in Washington, and in Sacramento the E. B. Crocker Art Gallery houses privately collected art objects. Not only were private collections of significant proportions being formed, but by 1870 the National Museum in Washington was receiving Federal support and a number of state museums had been established. Within the next few years two of the most important museums in the United States were instituted—the Metropolitan Museum of Art in New York and the Museum of Fine Arts in Boston. Both of these were chartered with boards of trustees to direct their affairs, and they received municipal financial support.

Through their organization these institutions established the pattern for the major American museums, many of which were founded between 1870 and 1915. While at first the museums of art concentrated upon the acquisition of paintings and sculpture, in 1906 the Metropolitan Museum acquired an extensive collection of decorative arts and established a department of European decorative arts. Soon such departments were introduced into the collections of most of the major museums.

James Jackson Jarves not only affected American taste through his distinguished collection, but he also pointed to the need for schools which would provide a more solid foundation of skill in the arts. By the time of his death in the 1880s, the Pennsylvania Academy of the Fine Arts, Philadelphia, and Cooper Union and the Art Students League, both in New York, were well established, and such mature painters as Hunt, Eakins, Chase, and Duveneck were teaching on their staffs.

American universities also reflected the growing interest in the arts. Charles Eliot Norton of Harvard initiated a series of lectures on art history. Bernard Berenson, the great critic of Renaissance art, and Mrs. Jack Gardner, one of Boston's most ambitious collectors, both came under Norton's sympathetic tutelage. Under the stimulus of Norton's example at Harvard, other universities instituted courses in art history. As a liberal philosophy of education began to permeate the American schools, courses in painting, drawing, and design became part of the university curriculum.

Instruction in art in the public schools began in Massachusetts in 1872, when Walter Smith was brought from England to become the State Director of Art Education. He served as the first principal of the Massachusetts Normal Art School, where he drafted a curriculum to train qualified teachers of art for the public schools. Within a relatively short time art instruction was introduced in the upper grades and in secondary schools in many parts of the country. Simultaneously a wide variety of art activities was included in the growing kindergarten movement, for one of its chief tenets was to avoid undue emphasis upon verbalization and to stimulate small children to work freely with various materials to develop their creative powers.

Concurrent with the growth of museum facilities and art education, there was an increase in the publication of periodicals and books devoted to the arts. By 1914 America had achieved an impressive level of maturity and a unique identity in all the arts—architecture, painting, sculpture, industrial design, and crafts—when another great cataclysm, World War I, projected her into the deep and conflicted currents of twentieth-century international culture.

part V

The Modern Period

18

Contemporary Architecture

Travel, the universality of literature, pictorial materials, museum collections, and technological practice have made contemporary culture international. Each year architecture, painting, sculpture, and the household and industrial arts grow more alike all over the world. Modern architecture in particular, shaped by an increasingly international technology, is an almost world-wide style, modified to some degree by national and regional traditions, climates, building materials, and the local impact of a few forceful creative personalities.

Change, one of the outstanding characteristics of twentieth-century life, became increasingly rapid in the years following World War I, especially in the United States. New modes wrought by the acceleration of industrialization and the attendant standardization of goods resulted in the disappearance of age-old traditions and handicraft practices. Though eclecticism appeared to have retained a firm hold on architectural styling in America until World War II, it was a most superficial manifestation with a precarious hold. Innovations in plans, modern methods of construction, and the expansion of plumbing, heating, lighting, ventilation, and related services brought about radical changes in building practices before 1940, a fact which was hardly obscured by the retention of a few

time-honored and traditional decorative motifs on such areas as the façades and entranceways of buildings.

A brief outline of the steps through which building styles have evolved in the United States since 1915 may help to clarify this complex period.

1. In the years between 1915 and 1930 the innovations of Sullivan, Wright, and the craftsmen designers were in eclipse. Most of the building in these years was sensible, practical, but uninspired, with technological advances receiving little stylistic acknowledgment.

2. From 1930 to 1940 the mechanized, geometrically precise styles that grew so naturally from modern standardized and industrialized building practices received a novel and brilliant expression in skyscraper design (Fig. 465). During these same years Frank Lloyd Wright assumed the position of leadership foretold in his early work. Wright "humanized" the architecture of the industrial age, introducing a fresh feeling for materials and site, as well as for dramatic and emotional values into contemporary practice (Pl. 17, p. 375).

3. Many European designers were forced to flee to America in the thirties, and their influence was increasingly apparent by 1940. These men practiced a logical, refined,

and esthetically conscious interpretation of precise mechanized architecture. Termed the "international style," this type of architecture became firmly integrated into American building practices in the years following World War II (Fig. 477). Stylistically the international mode might well be identified as "technological classicism," as opposed to the "organic romantic" tradition exemplified in the work of Frank Lloyd Wright and later by Louis I. Kahn and others.

4. Since 1945 our technological potential and industrial organization have stimulated startling innovations in architectural design. Metal, glass, plastics, and concrete, in particular, have been used to create forms of unparalleled variety and of a virtuosity comparable to that of the Gothic period.

5. Some striking solutions have occurred recently as a result of the pressing need for redesigning our cities. Urban congestion and decay, along with the attendant social evils, had made large areas of our cities uninhabitable. The consequent social and economic pressures resulted in a number of large urban renewal projects that are distinguished both by magnitude of scale and by imaginative departures from traditional groupings of streets, office buildings, apartment houses, and shopping and recreational facilities (Fig. 503).

6. In the thirties and forties modern architects disdained decoration, equating it with the preceding eclecticism. The bare, cold look which at first provided a relief from hackneyed decorative motifs became sterile with familiarity. Since the fifties architects have enriched surfaces with tiles, mosaics, and bas-relief and with increasing frequency have included sculpture, mural painting, and other art forms in the architectural ensemble (Fig. 501). There is evidence that increasing visual richness will distinguish the architecture of the future.

THE SKYSCRAPER

By 1915 it appeared that the vigorous and direct expression of form through function that had characterized skyscraper design in the Chicago area at the end of the nineteenth century was destined to disappear. In the battle between the progressive architects and the academicians the conservative forces won, as they had in many other areas of American life during these years. The business districts of our major cities grew at a startling pace, particularly during the twenties, and buildings soared ever higher in a continuous effort to increase revenue. As though to hide the purely commercial nature of these edifices, the street façades were ornamented with classical devices (attached columns, pilasters, arches, and moldings) or with Gothicisms. The entire composition was usually capped by a heavy projecting cornice, the final and deci

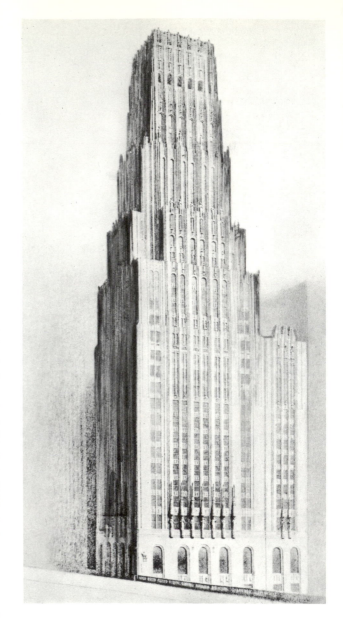

sive device for making a twentieth-century commercial building academically respectable. Revealing a fundamental esthetic dishonesty was the custom of decorating only the street façade, leaving the remaining walls ugly surfaces of brick or concrete punctured with windows.

As the buildings towered higher in our large cities, the narrow streets became shadowy canyons, congested and cut off from light and air. During the hours when the great buildings disgorged their workers, the streets became virtually impassable. In order to control the growth of these chasms, in 1916 New York City passed a zoning ordinance that limited the height to which buildings could rise directly from the sidewalks. This law forced builders

opposite: 464. ELIEL SAARINEN. Second-prize design for Chicago *Daily Tribune* competition. 1922. Architectural rendering.

right: 465. RAYMOND HOOD. Daily News Building, New York. 1929.

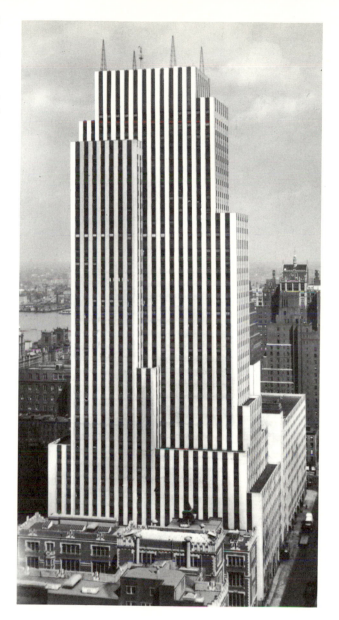

to design very high buildings, or buildings facing narrow streets, in a series of setbacks, creating a sequence of receding building blocks placed one above another. These receding steps not only permitted light and air to enter the street below but also provided more variety of form in the buildings. Soon other American cities followed the example of New York and passed ordinances limiting both the total height of buildings and the height to which they could rise directly above the curb.

In 1922 the Chicago *Daily Tribune* held an international design competition for a great skyscraper to house its main offices and provide rental space. More than 250 designs were submitted. The prize-winning design by John Howells and Raymond Hood combined certain characteristics of the evolving stepped-back skyscraper with such Gothic details as flying buttresses, pinnacles, and stone tracery. Though more suave than the Woolworth Building of twenty years before and bolder in its vertical thrust, their plans made no significant contribution to skyscraper design. The second-prize design (Fig. 464), by a Finnish architect, Eliel Saarinen (1873–1950), appeared at a most propitious moment. Architects were striving to find a form for the piles of building blocks created by the new zoning laws, and Saarinen suggested an original solution. His design for the Tribune Tower is made up of a series of soaring rectangular masses, continuously reinforced by rhythmic vertical accents, which build into a central shaft. All cornices and horizontal accents are eliminated, so that the vertical piers between the windows and at the corners of the building move upward until they appear to pierce the skyline. Instead of conceiving of the skyscraper as a pictorial composition of flat façades, Saarinen approached it as a problem in three-dimensional composition. Seen from the perspective of time, Saarinen's conception seems tentative and fussy in detail, but its importance lay in the timely direction it gave to skyscraper design. Its influence was tremendous and immediate. A vertical emphasis, the play of rectangular masses of form against one another, and a stylistically effective simplicity became characteristic of the new school of architecture.

Raymond Hood

Raymond Hood (1881–1934), one of the creators of the Chicago Tribune Tower, participated in designing a number of brilliant and original skyscrapers between 1925 and 1935, a decade which produced some of America's largest and most impressive buildings. In his Daily News Building (Fig. 465), New York City, the skyscraper concept was reduced to its essentials. Here the tendency toward simplification, which grew from the underlying pressure for economy as well as from the impersonal character of modern industrial processes, became a deliberate stylistic and esthetic device. In the Daily News Building regularity and impersonality are translated into continuous, cold, polished surfaces, soaring lines, and the precise geometry of sharp-edged forms. Even the windows, by being tied into continuous vertical stripes through the insertion of dark-colored surfacing between them,

cease to relate the scale of the building to man, thereby increasing the impersonal and abstract character of the structure. No sculptural ornaments relieve the flat planes of the surfaces; no moldings or cornices encumber the sheer, clifflike walls. The Daily News Building owes its effectiveness to the clarity with which it states the skyscraper concept without concession to traditional tastes.

Raymond Hood was not content to repeat the formula that was used so successfully in the Daily News Building. In 1930 he designed the McGraw-Hill Building (Fig. 466), which provides an equally brilliant statement of another aspect of the skyscraper. The McGraw-Hill Building dramatizes the role of glass in providing a protective sheath by stressing the continuity of the bands of windows which encircle the structure, story above story, so that at the corners the building becomes transparent. As in the Daily News Building, the traditional devices which suggest weight and sculptural richness have been eliminated, but here the predominant pattern is the horizontal striping created by the windows. The great monumental bulk of the building soars above its surroundings, a powerful tribute to the technology of the industrial age and to the industrial empires of America.

Rockefeller Center (Fig. 467), on which Raymond Hood collaborated, presents another milestone, in that it was the first extensive assemblage of skyscrapers to be erected in a related scheme. The size of the entire project, as well as of the individual buildings, is awesome. The RCA Building lifts its seventy-story tower in one sheer upward thrust. The fifteen buildings which make up Rockefeller Center, often called a "city within a city," achieve their effectiveness by size, by the dramatic relationships between towers, lower buildings, and sur-

below left: 466. RAYMOND HOOD and associates. McGraw-Hill Building, New York. 1931.

below: 467. RAYMOND HOOD, REINHARD & HOFMEISTER, and others. Rockefeller Center, New York. 1931–35.

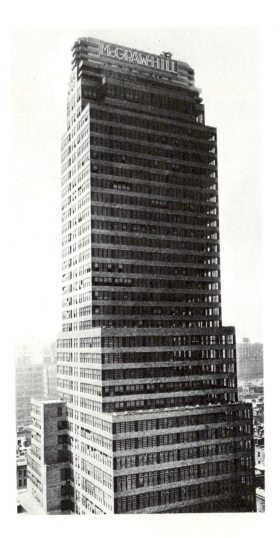

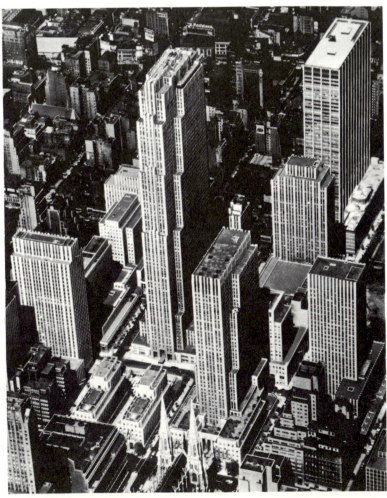

rounding empty spaces, and by the brilliant elimination of trite ornamental devices. The entire project represented the ultimate development of the multistoried business building as it had been conceived of in the period before World War II and at the same time foreshadowed the redevelopment of urban centers that would take place in the fifties and sixties.

The skyscraper was the most obvious architectural symbol of American society in the early twentieth century. A direct outgrowth of the wealth, power, and technological efficiency of our industrial order, as well as of the mercantile orientation of our culture, it expressed both the scale of our financial empire and the cold impersonality that characterized many aspects of the society. After 1945 innovations which were largely the result of new methods of handling concrete resulted in some startling changes in skyscraper design, rectangular masses frequently giving way to curved and circular towers. These changes will be discussed later.

The skyscraper, though the most spectacular, represents only one of many original architectural forms developed in these productive years. Motion-picture theaters, department stores, schools, hospitals, and hundreds of other special types of buildings designed in response to the increased complexity and specialization of American life reveal the endless adaptability, ingenuity, and inventiveness of the architect. The great factories and industrial complexes (Fig. 468) provide a particularly forceful expression of dynamic vigor and magnitude. In these the stark power of the industrial world stands undisguised. The formidable cubes, spheres, and interlacing runways and scaffoldings, sheathed in iron, glass, concrete, and brick, are not softened by any sensuous enhancements but express with a magnificent, albeit brutal, strength the complex processes and interrelationships they serve. The skyscraper provided the façade for the American industrial system; the factory disclosed the workshop.

Frank Lloyd Wright

The foremost American architect of the twentieth century, Frank Lloyd Wright, never was primarily concerned with the problem of skyscraper design, though he did have a mile-high skyscraper on the drawing boards when he died. In general, however, he stood as the opponent of skyscraper culture and spent his life in a continuous battle against size for its own sake, against mechanization irrespective of human values, and against the antisocial aspects of metropolitan life. In his work Wright, more than any other individual, achieved a synthesis of all the varied and conflicting tendencies which characterized progressive twentieth-century architecture. Particularly

468. Ford Factory, Dearborn, Mich. 1937.

significant was his ability to accept and utilize the machine and industrialization without sacrificing dramatic and emotional values.

Wright's early achievements, particularly his influence on the craftsman movement through the formulation of his "prairie" style in domestic architecture, have already been noted. The dozen years between World War I and 1930 appear to have been his least productive. With the exception of the Imperial Hotel in Tokyo (which is now demolished) Wright received few major commissions. But these were years of gestation and reassessment, for it was during this period that he explored the structural possibilities of the new materials being made available by modern industry. Though he utilized steel, glass, concrete, and modern synthetics, he remained devoted to traditional materials as well: wood, stone, brick, and tile. In exploiting glass and steel and open space, he never lost his mastery of weight and monumentality. In a series of houses built during the twenties, excited by the archeological discoveries being made in Mexico, Wright explored a

left: 469. FRANK LLOYD WRIGHT. Johnson Wax Company Research Laboratory Tower, Racine, Wisc. 1951.

below: 470. FRANK LLOYD WRIGHT. Lobby, Johnson Wax Company Administration Building, Racine, Wisc. 1937–39.

Mayan vein, in which he continued to employ ornament as a lyric modulation of the surface, a delicate "perfume" adding another dimension of beauty to architecture.

The work of Wright's later years reveals his inventive approach to structural problems and his rich feeling for form and materials. One project, the Research Center and Administration Building (Fig. 469) for S. C. Johnson & Son in Racine, Wisc., is composed of two related buildings, one constructed in the thirties, the other in 1951. The interior of the Administration Building is distinguished by its great "lily-pad" columns (Fig. 470). These columns represent a structural device of great visual beauty and efficiency. They spring from a narrow base, expanding at the capitals to support a most unusual ceiling of Pyrex glass tubing which admits a pleasantly diffused light. The later Research Center has been defined as a "web of glass spun around a hollow reinforced concrete stem." The smooth bulk of the towering mass reconciles conflicting architectural ideals by appearing both monumental and without weight.

471. FRANK LLOYD WRIGHT. Kaufmann House ("Falling Water"), Bear Run, Pa. 1936.

As early as the thirties, Wright also developed some highly prophetic skyscraper designs in which the floor levels were cantilevered out from a central concrete core containing the elevators and the ducts and channels which carried the necessary utilities and services. In 1955 Wright saw his earlier conceptual design translated into reality in his only skyscraper, the Price Tower in Bartlesville, Okla. However, his conception of a central core containing service facilities and at the same time providing the support for the cantilevered floor levels was utilized by a number of architects in the sixties.

One of Wright's great houses from the thirties, the Kaufmann House, or "Falling Water" (Fig. 471), at Bear Run, Pa., has been described as "a matchless fusion of fantasy and engineering." The great projecting cantilevered levels of the house, which hang over a turbulent mountain stream, have been anchored into the surrounding stony walls of the mountain. The house is built largely of rough stone, though photographs emphasize the projecting white concrete porches. The three main elements of structure—the handsome stone masonry masses, the horizontal cantilevered concrete porch forms, and the great expanses of glass—create a beautiful abstract crystalline structure, which is at the same time an admirable country home. Falling Water combines the smooth continuity of line and the light spaciousness of the contemporary style with a romanticist's love of natural materials and feeling for nature.

This fusion of today and yesterday also distinguishes the two dramatic and highly original houses Wright built for himself. In speaking of Taliesin East, his summer studio-home in Wisconsin, Wright said," No house should ever be on any hill. . . . It should be of the hill, belonging to it." Both Taliesins stand as a tribute to his belief that the character of a building must be inextricably related to its site. Taliesin West (Pl. 17), built later, was Wright's winter studio-home near Phoenix, Ariz. Built of red desert stone, canvas, and weathered timbers, Taliesin West spreads its angularities of form and startling contrasts of color and tone into the brilliant glare of the desert light with an assured sense of the drama of the southwestern landscape. This conception, of sufficient power to hold its own amidst the vast spaces and powerful forms of the desert, is a testimony to Wright's ability to invent the forms demanded by the landscape. Though living in a period when mechanization seemed about to exclude all earthy, warm, and human touches from building, Wright proved able to accept the machine and utilize it while remaining free of its domination. In an age increasingly urban in outlook, Wright remained committed to the rural. Human nature, the rich heritage of world culture, the landscape, and a wealth of simple building materials continued to be his sources of inspiration. The machine remained his servant.

One of his last and most original inventions was the building Wright designed for the Solomon R. Guggenheim

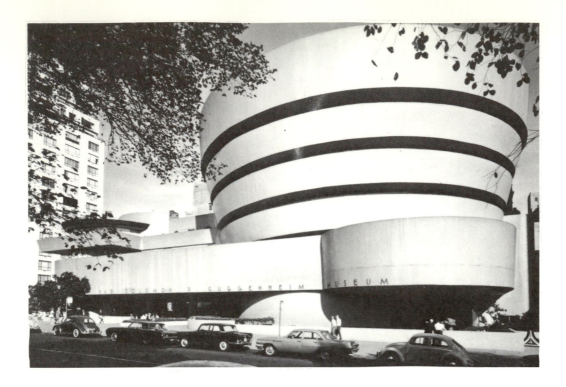

Museum of New York City (Figs. 472, 473). The Guggenheim Museum has been subject to lavish praise and endless criticism. The drama and daring of its conception are beyond question. However, its exterior forms seem crowded by the confined space in which it is located; it is almost impossible to view the building as a whole from the streets around it. The success of the continuous internal ramp as exhibition space has also been questioned. The viewer may not feel free to wander back and forth, to see and see again according to his will. One is almost forced to move continuously, either up or down, because of both the dynamics of the form and the movement of other viewers. The slanting ramp does not encourage one to stand restfully, and it is frequently difficult to cut off peripheral views and concentrate on a single work of art.

Despite these criticisms the building constitutes a final monument to the imagination and the technological mastery of Frank Lloyd Wright. The gallery consists primarily of a great spiral ramp which ascends without break from the ground floor to the top, thereby providing a continuous flow of exhibition space, as well as a dynamically moving form. This interior space culminates in a great glass dome providing a uniform flow of light that emphasizes the continuity of the internal forms and spaces. The exterior of the building affords a striking play of rectangular, curved, and spiraling thrusts, which move unhesitatingly from an essentially rectangular base, through the expanding helix of the main mass of the building to the angular shapes which relate the top of the building to the base. In the Guggenheim Museum Wright utilized the potentials of glass, steel, and concrete to create a sculptured configuration whose dynamic internal volume is equalled only by its external monumentality.

EUROPEAN INFLUENCES

Except for Wright there was little progressive architecture in the second and third decades of the century. America was content to build bigger and more comfortably, if not better and more beautifully, and the center of progressive architectural design shifted to Europe. France witnessed experiments in architectural design as daring as those which were revolutionizing French painting and sculpture. The Scandinavians, in a period of social enlightenment and economic expansion, undertook extensive building programs. Germany, Austria, Czechoslovakia, and Holland, recovering from World War I, were in the throes of reconstructing their demolished cities and reorganizing their dislocated economies. The older architectural concepts, which stressed a weighty, monumental, ornamented mass, were unsuited both to the exigencies of the new day and to changing social ideals. The urgent need was to rebuild and expand the cities so as to provide business and manufacturing facilities and housing for the middle and working classes. Under great economic pressure, the progressive European

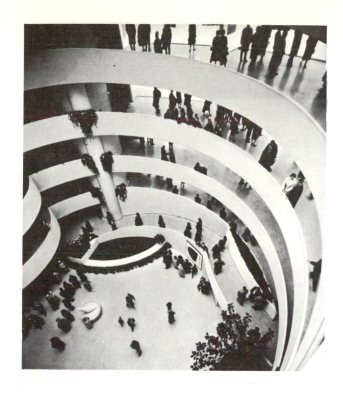

of the "international style" was the Bauhaus school of design in Dessau, Germany.

Two social catastrophes united the architectural developments in Europe and America. In Germany in the early thirties the advent of Nazi rule forced a large number of the most progressive designers to flee for refuge to America. Here, a great economic recession, followed by World War II and the subsequent construction boom, revealed the need for a fresh evaluation of American building practices. Among the distinguished architects who sought asylum in America were Walter Gropius (1883–1969), Ludwig Miës van der Rohe (1886–1969), Eric Mendelsohn (1887–1953), Richard Neutra (1892–1970), and Marcel Breuer (1902—). These men established themselves as teachers and designers in the thirties and in the period of expansion after World War II had a significant influence on American architecture.

Walter Gropius

Walter Gropius led the Bauhaus from its inception because of his clear formulation of the role of the arts in an industrial age. Founder of the Bauhaus and its first director, he designed the buildings for the school when it moved to Dessau, and in so doing provided one of the purest statements of the new style. Gropius believed that modern designers had to be trained in the resources of industry and machine production to provide an all-embracing esthetic philosophy governing architecture, the applied arts, painting, and sculpture. In America, Gropius continued to direct contemporary thinking as the head of the Graduate School of Design at Harvard. In addition, he remained active as an architect through The Architects Collaborative, in which he worked with Marcel Breuer and others. This fruitful interplay of talents produced the Junior High School (Fig. 474) in

architects of the postwar years shifted from a building tradition founded on ancient handicraft practices to a modern mass-production basis. At the same time they faced the problem of evolving a modern style which would offer a refined but powerful esthetic expression to the technological resources and the social forces of the modern age. The architectural style of the twentieth century, the "international style," was their answer. The term "international style" became widely accepted, because the technology and social organization that brought the style into being overrode national and local boundaries. One important center for the early formulation

opposite: 472. FRANK LLOYD WRIGHT. Solomon R. Guggenheim Museum, New York. 1959.

top: 473. FRANK LLOYD WRIGHT. Interior, Solomon R. Guggenheim Museum, New York.

right: 474. THE ARCHITECTS COLLABORATIVE. Attleboro Junior High School, Attleboro, Mass. 1948.

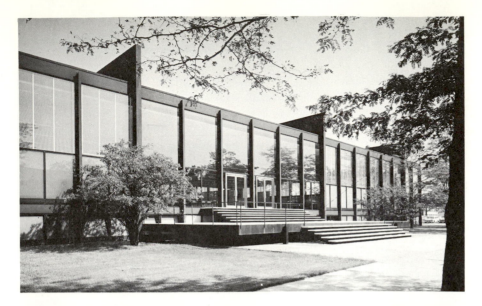

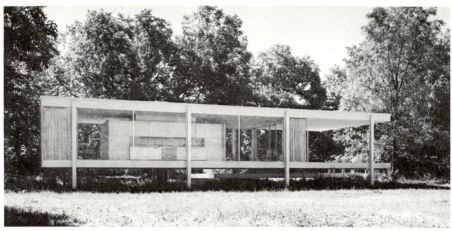

Attleboro, Mass., a skillful design which takes advan-
tage of an uneven site to avoid the monotony that
so often characterizes a public school. The classrooms
form the main two-story block of a group of interdepen-
dent connected buildings. The gymnasium and the
auditorium establish their individual entities through
differences in height and specialized forms. The view of
a wing of classrooms and an inner court from a corridor
reveals the serenity that results from a regular rhythm
of forms integrated into a functional arrangement.

Ludwig Miës van der Rohe

One of the prophetic individuals in formulating the
principles of the "international style" was Ludwig Miës
van der Rohe. As a result of the distinction of his designs
in the early twenties, Miës was appointed director of the

Werkbund exhibition in Stuttgart in 1927, which presented
one of the first summaries of the advanced practices cur-
rent in architectural design. His first major commission
executed in the United States was his design for the
Illinois Institute of Technology. This great project, con-
structed over several city blocks and many years, includes
classrooms, laboratory buildings, a chapel, faculty living
quarters, and subsidiary buildings (Fig. 475). Miës related
and unified this great complex of specialized buildings by
developing his plan in 25-foot units applied like a grid
over the entire site. The individual buildings have been
conceived primarily as problems in structure. The steel
supporting frames, clearly articulated, supply the element
of visual regularity so essential to the anonymous dignity
that characterizes the buildings. Panels of brick and glass
provide the enclosing walls. The austerity of the pro-
ject comes as a surprise after the elegance of Miës'

distinguished European buildings until one recognizes that the same high standards of craftsmanship and the same clear statement of structure are dominant elements both here and in his earlier designs, and that the visual differences are a logical outgrowth of the differing functions of the buildings and of the building materials.

The Farnsworth House (Fig. 476), built in 1950 by Miës van der Rohe, reveals a number of elements traditionally associated with his name: the extensive areas of glass; the dominantly horizontal emphasis; the transparent openness; the graceful, light supports and thin, floating horizontal planes; and the machined elegance that results from exquisite craftsmanship. The house consists of a floor and roof plane supported by eight steel columns. A broad, low platform, also supported by steel posts, is set to one side of the main slab and provides a terrace for outdoor activities. A wood-paneled enclosed area at one side of the interior contains heating, bathroom, kitchen, and storage facilities. The glass exterior walls are draped. The concept of architecture embodied in such a structure is a crystallization of both contemporary building techniques and a way of living as radical as the architectural style.

A number of the characteristics of the "international style" which have received an unusually pure and brilliant expression in this building and in the Institute of Technology might well be summarized here. The use of steel and concrete for structural purposes eliminated the load-bearing function of the wall and permitted the enclosure of extensive interior spaces with glass and other lightweight surfacing materials. Walls, freed from their load-bearing role, served as baffles or boundaries to define the movements of space and light, and the continuous flow of light and air became as important a factor in the modern style as weight had been in earlier times.

The "international style" depended on the factory and the industrial technology of our age, on standardization, mechanization, and the prefabrication of interchangeable parts. Instead of striving for the picturesque and unique effects savored by the nineteenth-century Romantics, the "international style" probed the esthetic possibilities of regularity, of repetition, of mechanical perfection, and of a certain abstract impersonality. Making a virtue of necessity, the designers forthrightly emphasized the varied forms demanded by the specialized nature of modern building to create stark and expressive shapes of great diversity. Extensive expanses of bare wall, long, continuous bands of window glass, and geometric patterns of structural steel and open beams became positive stylistic factors. Applied decoration was eliminated, making color and surface texture important esthetic elements. The exterior sheathing provided a smooth skin, stretched tight over the surfaces like a protective membrane.

In general the "international style" was technological rather than geographical in its orientation, and urban rather than rural. The contribution of Miës van der Rohe to metropolitan life, as the most distinguished practitioner of the "international style" in its pure form, appeared in the fifties and early sixties in such magnificient projects as the Seagram Building in New York (1958), designed in conjunction with Philip Johnson (1906—), Miës' most brilliant American disciple; the Lakeshore Apartments in Chicago (1957); and Lafayette Park, a distinguished group of tall apartment towers and two-story terrace houses which were designed and built in Detroit between 1955 and 1963 (Fig. 477).

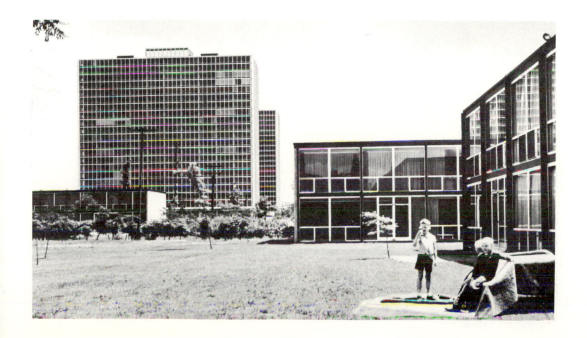

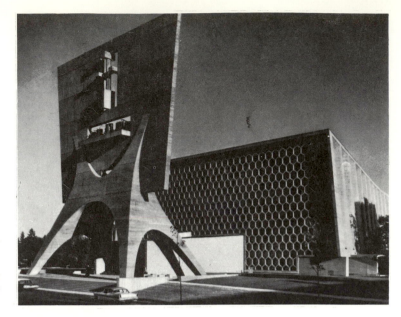

right: 478. MARCEL BREUER. St. John's Abbey Church, Collegeville, Minn. 1952–55.

below: 479. MARCEL BREUER and HAMILTON SMITH. Whitney Museum of American Art, New York. 1966.

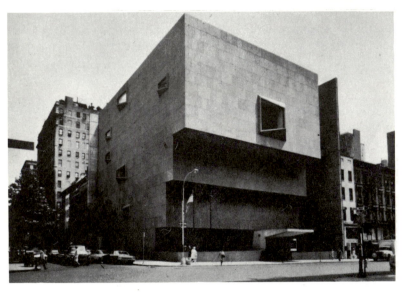

As a result of the collaboration of Miës van der Rohe and the city planner Ludwig Hilberseimer, the apartment towers and terrace houses of Lafayette Park form a complete and distinct entity within the surrounding city. The entire complex has a ring road around it, with access roads routed so as to leave traffic-free verdant zones in the center for play and recreation in close proximity to living areas. Parking facilities were lowered to make them less conspicuous, thus minimizing one's awareness of that ever-present element of metropolitan life, the automobile. Stylistically the buildings that make up Lafayette Park present a pure version of the Miës van der Rohe idiom. Precisely delineated structural elements provide a delicate and elegant framework for the smooth, extended planes of concrete and glass. The horizontals of the two-story terrace houses stand in contrast to the towering blocks of the high-rise apartments, but the opposing shapes are harmonized by the omnipresent rectangularity that relates the various structures and the parts within them.

The "international style" demanded a fresh evaluation of contemporary living patterns to provide plans commensurate with current social needs and practices. Sheathing the exterior of the Farnsworth House with glass or planning a traffic-free urban complex of towers, houses, and recreational facilities such as Lafayette Park involved a sympathetic acknowledgment of the changes in modern life.

Marcel Breuer

In his early years in the United States Breuer worked closely with Gropius at Cambridge, Mass., sharing his basic ideas and methods. In 1941 Breuer moved to New York, and during the subsequent decade most of his work was confined to private residences. In the fifties and sixties he received a number of large commissions in which the original and vigorous character of his designs is particularly evident. Breuer remained a true functionalist, his ideal being that the various requirements of a building be sharply defined and clearly expressed in different and separate forms. Thus his buildings not only differ greatly from one another, depending upon their varying functions, but the separate parts of a single building usually are clearly differentiated from one another in form and even materials, so that his designs exhibit a greater variety than much other work in the "international style."

The striking character of Breuer's designs is particularly evident in two very different structures, his St. John's Abbey Church in Collegeville, Minn. (Fig. 478), and the new Whitney Museum of American Art in New York City (Fig. 479). St. John's Abbey Church proclaims its identity by an almost aggressive statement of the bell tower and cross, carried on a great slab supported by spreading concrete piers. The vertical and expanding bell tower stands in bold contrast to the horizontal block of the entrance and the clearly articulated sanctuary.

The Whitney Museum of American Art occupies a small corner, 104 by 125 feet, on upper Madison Avenue. In this restricted space Breuer and his associate, Hamilton Smith, were faced with the problem of creating a building of sufficient grandeur and originality to symbolize the role of the arts in contemporary society. At the same time it was necessary to provide the extended space needed to care for the multiple functions of a modern museum, foremost of which is the housing and exhibiting, with dignity and grace, of a large collection of paintings and sculpture. The building designed to answer these needs has a basement, five floors of exhibition and storage space, and one floor for offices, with mechanical equipment and services occupying the top level. The mass of the building on the street level is set back to create a sense of space around the museum. The entrance bridges a sunken court on the basement level, which provides an outdoor area for the display of sculpture. On the façade the upper stories are cantilevered in three forward-projecting masses, thereby creating more spacious interior areas and a dramatic abstract form. The interior, except for the great two-story windows of the sunken court and entrance level, relies on artificial lighting, so that the smooth surfaces of the upper stories are almost unbroken except for an occasional window, angled so as to keep out direct sunlight. This arrangement creates clearly articulated polyhedrons in effective contrast with the rectangular, granite-faced main masses of the building.

In both these buildings, as well as in a number of other major commissions, Marcel Breuer has expanded the vocabulary of contemporary building without sacrificing either taste or the discipline of functionalism.

A number of the influential architects who came from Central Europe during the postwar years were not directly associated with the Bauhaus. Eric Mendelsohn's most striking early work in Germany had been more related to Expressionism than to the mechanistic style of the Bauhaus group. He designed Maimonides Hospital (Fig. 480) in

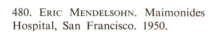

480. ERIC MENDELSOHN. Maimonides Hospital, San Francisco. 1950.

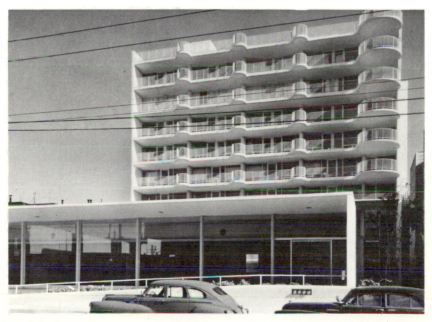

San Francisco using the syntax of the "international style," but the rhythmic semicircular extensions of the balconies recall his earlier taste for a sculptural treatment of architectural form. A one-story entrance pavilion leads to a landscaped inner court and then to the fourteen-story main building. The continuous glass façade, the ramp, the doorway, and the protective overhang of the entrance pavilion have been treated with the impersonality of a geometric theorem. No dramatic or decorative interruptions soften the severe regularity of the edifice. On the garden façade rise the successive balconied stories, cantilevered out from the supporting columns and framed by projecting end walls. The curved balconies enclosed by light iron railings, both useful and visually diverting, create a buoyant composition of mathematical precision. The building embodies a pure, lucid, and impersonal solution of the specialized problems of a convalescent hospital, using modern building techniques without sacrificing vivacity or variety.

Southern California had been the center of inventive and unconventional building since the beginning of the century, not all of it in the shingled craftsman tradition initiated there by the Greene brothers. Irving Gill, as noted in Chapter 13, had worked with concrete in his straightforward, functional structures, and a similar idea was expanded in the work of a young Viennese who predated the "international style" refugees, Rudolph M. Schindler (1887–1953). Schindler had been trained in the progressive atmosphere of the Vienna Academy under Otto Wagner at the turn of the century. Arriving in Chicago in 1914, Schindler was drawn into the orbit of Frank Lloyd Wright and finally became a draftsman in his office. After going west with Wright, he decided to set up his own practice in fast-growing Los Angeles in 1921. From then on Schindler created some of the most advanced designs to appear in America in the twenties, designs in which elements of the modern vocabulary were combined in clean-cut rectangular masses. Most of Schindler's practice was residential (Fig. 481).

Richard Neutra settled in Los Angeles in the mid-twenties and continued the development which had been initiated by Gill and Schindler. One of his important early contributions to California architecture was his use of regular 4-foot modules to ensure both efficiency and visual consistency. Neutra was one of the first to use light steel posts and to derive an esthetic from mass-produced doors, windows, roofs, and built-in furniture. Particularly important were some of his early schools and housing projects, in which efficiency and esthetic honesty were achieved within the restrictions of mass production. The handsome houses of his later years are more expensive and luxurious than his early work.

In the late thirties the paralyzing grip of the economic depression that began in 1929 started to lift, and America was about to resume building, but World War II stopped all normal activity. By the end of the war there was an acute need for housing, industrial architecture, and commercial building. Costs soared, and there were few experienced craftsmen. The inadequacy of the older eclectic revival modes of building was apparent to even the most conservative designers. The "international style" as practiced here by the distinguished *émigré* designers answered many of America's building problems. In the years since World War II a new, incisive kind of thinking, accompanied by intensive technological developments, has resulted in much exciting architecture.

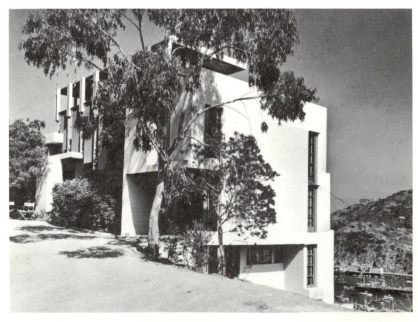

left: 481. RICHARD SCHINDLER. Wolfe House, Santa Catalina, Calif. 1928.

opposite left: 482. SKIDMORE, OWINGS & MERRILL. Lever House, New York. 1952.

opposite right: 483. SKIDMORE, OWINGS & MERRILL. Alcoa Building, San Francisco. 1967.

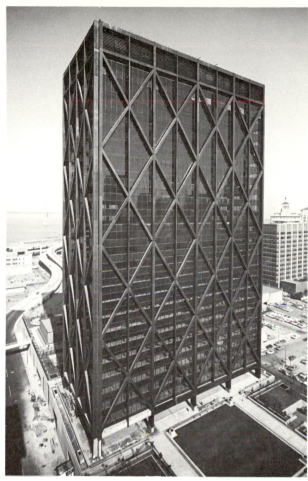

TECHNOLOGICAL FRONTIERS

Metal and Glass

Four skyscrapers from the postwar period reveal the impact of the "international style" and of the changing contemporary technology on American architectural practice. One of the most effective designers of large-scale commercial structures is the firm of Skidmore, Owings & Merrill. The refined and precise elegance of their designs recalls the manner of Miës van der Rohe. Lever House (Fig. 482), on Park Avenue, New York, built in 1952 to house the executive offices of the soap-manufacturing company, demonstrates an effective use of the curtain wall in skyscraper design. Since the multistoried tower of the building covers only a part of the ground area, it stands free, surrounded by space, light, and air, and its beauty is visible from a number of vantage points. The shimmering surface of the tower, sheathed in glass and stainless steel, is divided into handsomely proportioned rectangles and reflects the

surrounding buildings and the patterns of the sky in a geometric mosaic. This enormous structure conveys little sense of weight or bulk. Its crystalline surface and soaring forms appear to float above the thin piers and open sections of the ground floor.

A cantilevered, two-story ground floor covering the full block affords open space around the great tower, creates a spacious entrance, and contains the lobby of the building. The lobby expresses a particularly effective relationship between the outer world and the area within the building through the ever-present transparent and reflecting glass. The planters and shrubs also continue the movement between indoors and out. The shadowy serenity of the sheltered ground floor comes as a happy contrast to the confusing press of activity on the street.

A second Skidmore, Owings & Merrill structure, distinguished by a fresh approach to urban design and a provision against the threat of earthquake, is the Alcoa Building (Fig. 483), completed in San Francisco in 1967. An office building, the Alcoa skyscraper is part of Golden

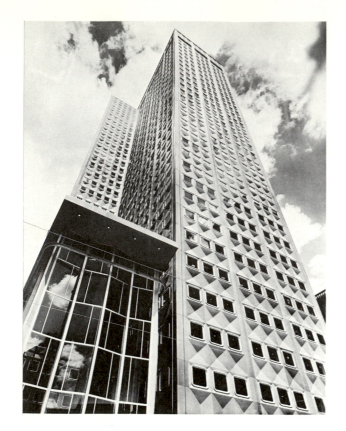

to earthquakes and to give this fact prominence in the exterior appearance. The diagonal grid of aluminum-sheathed steel braces criss-crossing the twenty-five-story building makes a resilient frame which, in theory, would enable it to withstand another catastrophic quake such as demolished the city in 1906.

The Alcoa Building, like the rest of the Center, rises from a three-story facility that takes care of traffic and parking. Thus this building is designed, like the best forward-looking structures of the late sixties, as part of a multilevel complex. Below the surface level a service network of several stories cares for vehicular transport, freight and shipping services, and parking. Above these a pedestrian level is provided free from the encroachment of traditional street and traffic patterns. The external protective struts which give this building its unique visual pattern are no more significant than the less conspicuous multilevel street concept. Both give evidence of the inventive ingenuity with which traditional patterns of municipal and architectural design were being challenged in the late sixties.

One of the most original interpretations of the curtain wall may be seen in the Alcoa Building (Fig. 484) in Pittsburgh, designed by Harrison & Abramovitz. The wall is composed of light, 6-by-12-foot panels of aluminum only 1/8 inch thick. These permit the very rapid sheathing of the exterior. Stamped in a pattern of triangular facets for greater rigidity, and attached to the supporting framework, the panels were sprayed with a 4-inch layer of perlite and sand for insulation. The almost square reversible windows are literally holes punched in the center of the panels, equipped with a single pivoting unit of green-tinted, heat-resisting glass. As seen from

Gateway Center, an urban renewal project designed to transform what had been a shabby neighborhood of warehouses and wholesale produce houses into a handsome residential and commerical complex. The Alcoa Building is the first San Francisco skyscraper to recognize frankly in its construction the fact that the city is subject

above: 484. HARRISON & ABRAMOVITZ. Alcoa Building, Pittsburgh, Pa. 1952.

right: 485. WALLACE K. HARRISON and others. United Nations Headquarters, New York. 1952.

opposite: 486. MATTHEW NOWICKI and others. State Fair Arena, Raleigh, N.C. 1953.

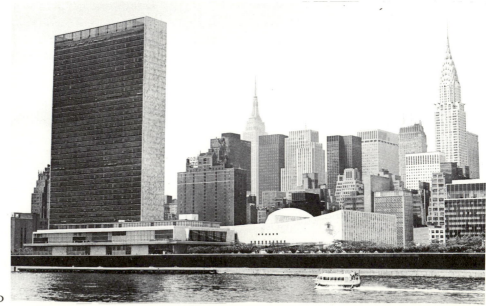

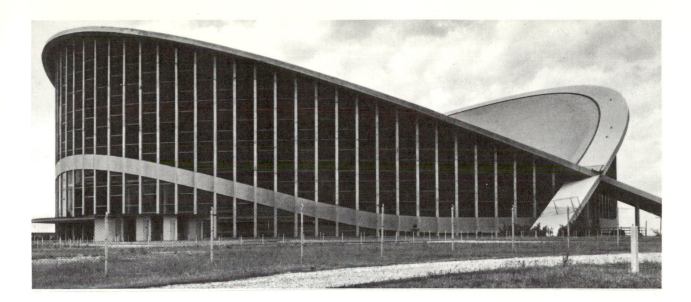

the street level, the triangular facets of the panels break the light into shifting geometric patterns, while the round-cornered windows contribute interest through contrast of shape. The use of aluminum for surface sheathing reveals changing building techniques and relates to the nature of the business housed within the skyscraper.

The United Nations Secretariat Building in New York (Fig. 485) was the joint achievement of architects from many countries working with Wallace K. Harrison (1895—). In it the concept of the office building as a great, glass-surfaced, unbroken slab received its ultimate expression. The thin, shimmering rectangle rises directly from the ground for thirty-nine stories and is terminated by an aluminum grill which conceals the elevator equipment and other services. The main façade is divided into three bands by two floors faced with aluminum grills that cover additional servicing equipment. The façade is sheathed with green-tinted glass and the windowless end walls are faced with grayish white marble. Slender and lyrical, the Secretariat is, in essence, a soaring vertical shaft, a multifaceted mirror in a white marble frame; a symbol of hope for the world which also houses about 3,400 workers. Acting as a horizontal foil to the Secretariat is the low conference area and the General Assembly Hall, with a smooth, almost unbroken, curved façade.

Concrete

Probably no material has passed more rapidly from a cheap substitute for something better to a major medium for architectural innovation than concrete. The most impressive developments have occurred in the structural uses of reinforced concrete. Primarily a substitute for

stone in its early years, concrete was poured into the rectangular or heavy arched forms of its masonry precursors; later, the use of concrete in conjunction with skeletal steel construction also predisposed the designers toward rectangular forms. However, after the 1930s, stripped of its masonry connotations, reinforced concrete (ferroconcrete) was used in sinuous, flowing lines, particularly in highway and bridge construction, and the structural efficiency of concrete poured into curved or bent shapes was explored.

In the work of a number of architects, most notably in Italy by Pier Luigi Nervi, many experiments in the tensile strength of concrete were initiated, in which either a thin shell or light, ribbed skeletal frames of concrete were used to span huge spaces. Thus the enclosure of great areas by means of a light skin of concrete was achieved by utilizing the principle of "strength through form," resulting from the basic tensile stability inherent in the form itself. In such structures, a thin concrete surface, like the shell of an egg, can enclose vast spaces by means of a continuous self-supporting form. Similarly, utilizing the strength of a thin slab or beam of ferroconcrete encouraged a freer exploitation of architectural forms.

In America the techniques for exploiting the new potentialities of reinforced concrete developed rapidly. Slab construction, in which great thin panels were poured flat on the ground and then hoisted into position, the use of molds for casting structural members, and the spraying of concrete on a light framework have permitted an unprecedented variety of architectural forms, many distinguished by a lithe fluidity of line as well as a slim elegance. These qualities are apparent in the handsome pavilion (Fig. 486) for judging livestock in Raleigh, N.C.

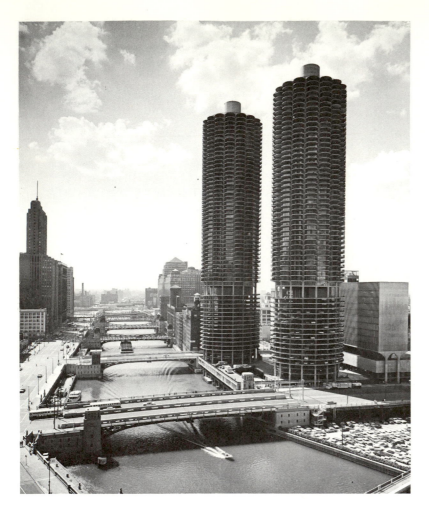

487. BERTRAM GOLDBERG ASSOCIATES. Marina City, Chicago. 1962–64.

Conceived by Matthew Nowicki (1910–49), the project was completed by William Dietrich (1905–). Two great concrete and steel arches which interlock near the ends are supported by thin steel box columns. The roof is carried on free cables passing between the two arches to create an interior of uninterrupted space bounded by graceful forms. Here is a structural conception derived from bridge design, as contemporary in its esthetic appeal as in its engineering and technical aspects. Steel, concrete, and glass create a rhythmic series of forms that appear to be enclosed in a translucent curtain of light.

Two brilliantly conceived, large-scale architectural projects which reveal the unorthodox forms made possible by modern uses of concrete are worthy of study, one an urban redevelopment project (Fig. 487), the other an air terminal (Fig. 488).

Marina City, designed by Bertram Goldberg Associates (Bertram Goldberg, 1913–), standing in the middle of old Chicago, covers over 3 acres, of which 300 feet face the Chicago River. The project consists of five

buildings. A two-story service building covers the entire area. Two tower structures sixty-five stories high have parking facilities occupying the first eighteen stories, automobile servicing facilities on the nineteenth floor, laundry rooms and storage lockers on the twentieth, and apartments located in the top forty-five stories. The fourth building, the rectangular building to the right of the towers, houses offices, and the fifth structure in the complex is a theater. Thus, a great self-sufficient metropolitan area has been created with apartments, offices, and shopping and recreational centers all contained within one traffic-free covered area in which inclement weather conditions and the tensions of crowded streets are minimized.

Concrete, in its raw, unpolished structural form, has been used as the unifying material throughout. Equally pervasive is the idea that strength in the structures must derive from the form rather than from sheer weight. Each of the two apartment towers, almost 600 feet high, derives much of its rigidity from the great cylindrical concrete core, which not only plays a major role in supporting

the mass of the building but, like a vertical street, carries the utilities. From this central core radiate the horizontal beams that support the floors and carry the weight out to the exterior columns. The balconies, which project from between the outside columns, repeat the forms used in the lower ramps, thus relating the entire exterior. The radiating structural and central service system, developing outward from the central core, was followed in the design of the individual apartments. The utility areas, such as kitchen, baths, and closets, are grouped toward the center, while the living areas are located toward the perimeter and the light. Thus the circular form of the towers, a sharp departure from the ubiquitous rectangularity of

traditional skyscrapers, was not the result of a superficial search for novelty but was an outgrowth of the intrinsic structural scheme. Among the many novel features of the main plaza, with its typical urban facilities, is the marina of the river, allowing space for 500 boats beneath the overhanging assemblage of restaurants and shops.

The Trans World Flight Center at Kennedy International Airport, New York, one of the last great buildings designed by Eero Saarinen (1910–61), son of Eliel Saarinen, provides a most beautiful example of the fluid forms and curvilinear rhythms into which concrete can be cast (Figs. 488, 489). Almost a tour-de-force of flowing lines, it has no element of rectangularity or of geometric regu-

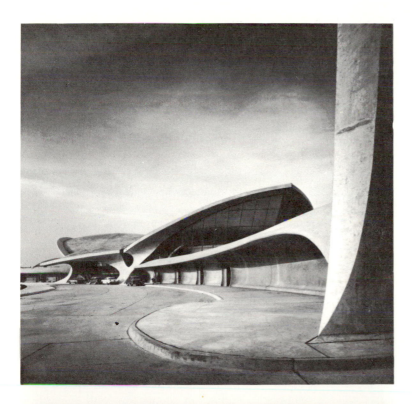

left: 488. EERO SAARINEN. Trans World Flight Center, Kennedy International Airport, New York. 1962.

below: 489. EERO SAARINEN. Interior, Trans World Flight Center, Kennedy International Airport, New York.

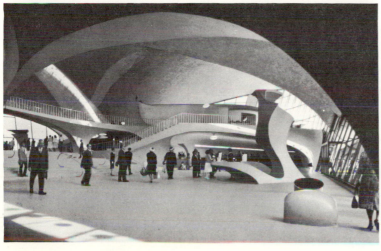

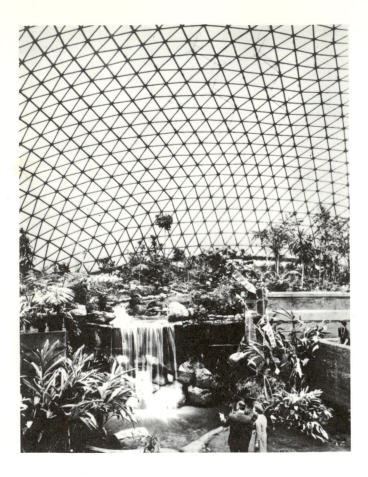

left: 490. R. BUCKMINSTER FULLER. "Climatron," Botanical Gardens, St. Louis, Mo. 1960.

opposite: 491. R. BUCKMINSTER FULLER. United States Pavilion, Expo 67, Montreal. 1967.

architecture: first, it demonstrates the special potentialities of concrete as a building material; second, it reveals how freely the modern architect, released from the heavy hand of tradition, creates new forms to provide for the highly specialized and complex needs of today.

One of the last and most noteworthy of Saarinen's designs was the Dulles International Airport Terminal for Washington, D.C., completed at Chantilly, Va., in 1963. Less of a virtuoso performance, visually, than the T.W.A. Flight Center, it covers a tremendous area by means of a lucid plan majestically integrating contemporary engineering practices and modern esthetic values.

R. Buckminster Fuller

Structural engineers, both in theory and practice, have for many years concerned themselves with the relation of materials and form to weight and tensile strength, particularly as applied to the enclosure of space. In the work of R. Buckminster Fuller (1895—), these problems, common to both architects and engineers, have been of primary concern. Often proclaimed not an architect because of his indifference to traditional building materials, concepts of design, and established esthetic values, Fuller has dealt with the problem of the economical enclosure of space for more than forty years. Approaching the problems of construction as an engineer of the machine age, Fuller has been primarily concerned with utilizing the most economical methods and materials in providing for man's needs with the maximum of efficiency. In 1927 he designed the Dymaxion house ("dynamic" plus the "maximum" of service), an octagonal structure supported by a central core, most correctly viewed as an assemblage of services in conjunction with living areas which could be factory-produced and assembled with a minimum of time, effort, and skilled labor. The Dymaxion house was too unconventional to be sufficiently popular to justify the mass production necessary to make it economically feasible.

Since then Fuller has concentrated on the perfection of geodesic domes (Figs. 490, 491), structures of metal, plastic, and even cardboard in which octahedrons and tetrahedrons of light structural materials are used to enclose vast spaces. In the "Climatron" (Fig. 490) of the St. Louis Botanical Gardens, the spaces between the light aluminum-tubing structural members are filled with transparent plexiglass. The dome shape was used here,

larity to meet the eye, either on the exterior or on the interior. This great building, with its unlabored aerial movements, seems formed as much by the concept of flight as by the actual business of receiving and dispatching passengers and baggage. The necessary waiting rooms, check-in stands, luggage facilities, restaurants, bars, and rest rooms, as well as the extended corridors which provide access to embarkation and disembarkation centers, create a unique form that spreads across the landscape like a giant organic sculpture.

The curving lines and fanciful shapes that result have not been without criticism. Some find that its forms lack a clear statement of structure and function, being modeled too exclusively by the desire to exploit the modern technique for handling concrete. For the advocates of classic architectonic values, some parts, such as the information booth in the center of the main waiting room, seem whimsical and arbitrary, constituting a sculptural abstraction that only incidentally serves a practical function. Even the building's staunchest admirers feel that this criticism has some justification. However, though it may be lacking in architectural rigor, the T.W.A. Flight Center provides a brilliant illustration of two new aspects of contemporary

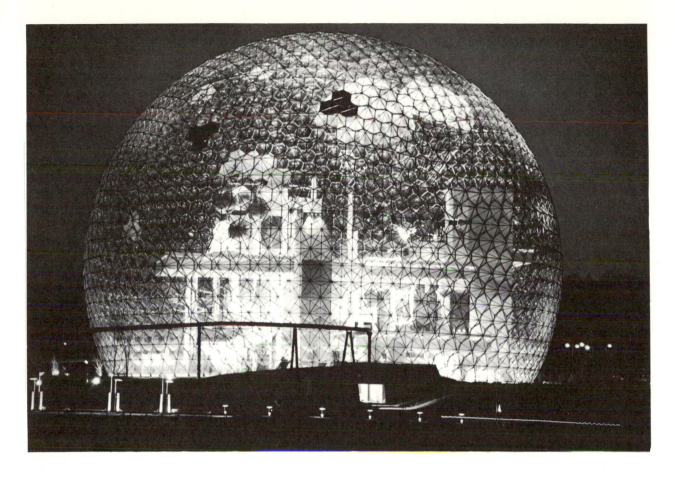

as in Fuller's other major structures, not because it is an esthetically "ideal" form, but rather because it provides the greatest enclosed space with the minimal enclosing area. Seventy feet high and covering over half an acre, the "Climatron" furnishes a wide range of climatic and atmospheric conditions. The mechanical equipment which regulates the air circulation, humidity, temperature, fans, and other services is controlled from the supervisory data center just inside the main entrance. Thus climatic variations can be maintained in different areas ranging from a temperate zone to sweltering Amazonian forest conditions.

One of Fuller's best-publicized and most spectacular geodesic domes was the United States Pavilion for the Montreal World's Fair, Expo 67 (Fig. 491); 250 feet in diameter and 200 feet in height, this twenty-story-high bubble was the tallest structure in the fair. It enclosed a series of platforms, connected by escalators, bridges, and elevators, which displayed exhibits of American creativity in the arts, science, and technology. During the day the entire interior was lighted by normal daylight, which filtered through the plastic panels that formed the skin of the dome. From the inside the sky, the landscape, and

other buildings were completely visible, but unpleasant aspects of heat, glare, and dust were deflected by the protective surface.

Structural rigidity was provided by a double steel frame composed of triangular shapes on the exterior and hexagonal sections on the interior. This double frame held the domed plexiglass panels which constituted the skin of the sphere. The steel frames were graduated in weight, being heavier at the bottom and lighter at the top. The statistics on the yards of structural steel pipe employed, of cubic feet enclosed, of plastic panels involved in the Montreal pavilion are awesome, but even more impressive is the technological precision that made possible the rigid control of climate within this great sphere. The plexiglass panels, tinted gray-green to control heat and glare, were graduated from darkest in color at the top of the dome to lightest at the bottom. The top panels were pierced to provide ventilation, the openings being capped with smaller domes to keep out rain. On the interior surface aluminized fabric shades were affixed to keep the direct rays of the sun from striking the exhibition platforms. These triangular shades were drawn and retracted by motors controlled by a punched tape program made up of six

basic daily arrangements designed to cover the life of the fair, each daily program providing a shading configuration every twenty minutes to follow the sun on its path across the sky. This device provided only the minimum area of shade necessary to shield the platforms while maintaining the transparent effect of the open bubble.

Even the United States Pavilion at the Montreal fair represents a modest and even somewhat prosaic example of Fuller's imaginative proposals. He has envisaged the covering of entire cities and the creation of vast shelters for communities in undeveloped areas of the world, all to be transported by air and assembled on location in weeks or days. Because technological and sociological problems challenge Fuller's imagination far more than concern for esthetic refinements, his thinking and work have been a major catalyzer in the service of contemporary architectural progress.

HOUSE DESIGN

The range of contemporary architectural practice is nowhere more apparent than in house design. In the postwar period the need for all types of housing was pressing, and vast tracts appeared all across the country. Planned largely to appeal to the common denominator of public taste, the designs for tract houses ranged from split-level pseudo-colonial to progressive modern. In private homes built for more discriminating clients, the most original and extreme designs appeared.

The increased use of structural steel in conjunction with broad expanses of glass initiated some interesting experiments. The Farnsworth House, designed by Miës van der Rohe (Fig. 476), has already been mentioned. Almost better known as the epitome of custom-made technological elegance is the all-glass house built by Philip Johnson in New Canaan, Conn. (Fig. 508). Charles Eames (1907—) built his Case Study House (Fig. 492) in Santa Monica, Calif., for his own use and as part of a research program in the use of prefabricated parts for the magazine *Arts and Architecture*. Essentially a two-story cage, the house was built with standard factory-produced elements, utilizing readily available steel-frame windows, sliding doors, structural beams, and other prefabricated units. Though Eames considered the enclosure of the maximum amount of space at the minimum expense his major problem, he achieved a design of singular distinction. Occasional opaque stucco walls and transparent and translucent glass areas of different sizes vary the patterns of steel frame to extract an unexpected Japanese flavor from the industrial techniques. While the walls actually function as a shield against the weather and the intrusion of the outdoor world, visually they bring inside and outside together, serving as space and light modulators by defining the planes of the various surfaces as they transmit or reflect images. Modern science and technology work together here to create a house that can be constructed rapidly at moderate expense and, at the same time, reintegrates man with nature.

left: 492. CHARLES EAMES. Case Study House, Santa Monica, Calif. 1949.

opposite: 493. CHARLES DEATON. Sculptured house, near Denver, Colo. 1967–68.

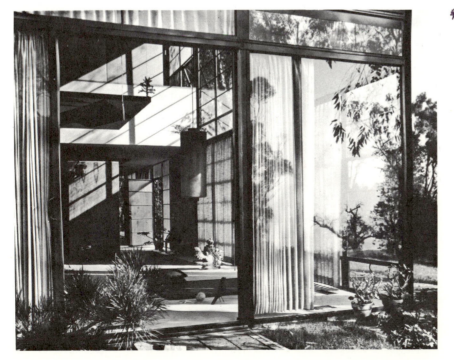

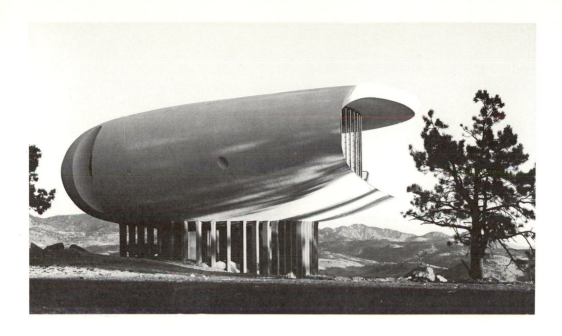

At the opposite end of the architectural spectrum is the "sculptured" house which Charles Deaton (1921—) designed for himself on a Colorado mountainside, 25 miles west of Denver (Figs. 493, 510). Deaton states that as a child, on trips with his geologist father, he was deeply impressed with "the canyons and gulleys, the fantastic caves, the great rocks, the potholes. Some of the potholes made large, rounded rooms, and some of the rooms were even joined together." Deaton felt that in designing a sculptured house he was following atavistic instincts as much as creating something new, for "man lived with the rolling hills and curvilinear caves, rounded thatched roofs, and molded mud huts long before Euclid's geometry squared up our cities." His house was first conceived as a hollow sculptured form that could subsequently be divided into separate rooms. The great flattened egg shape, cleft on the front like a partially open clamshell, rests on a stable pedestal and a great jutting rock to become part of the earth on its 8,000-foot-high perch. The open front of the form faces toward the panorama of the Continental Divide. The back, which receives the full force of the prevailing winds, is pierced by a few porthole-like windows which were "cut into the sculpture as one would cut into a melon." Inside the cast-concrete shell are eight rooms distributed on three levels. Few straight lines appear, except in the kitchen, where rectangular household appliances must fit. Like all architects of a philosophic bent, Deaton wants to free contemporary man from technological servitude; he wants technology to become the servant of man's esthetic needs. He says: "I believe we feel a great need for houses we care about,

beyond the traditional functions of shelter, fashion, device, and symbol. . . . The sculptural concept in building design will help architecture to make technology and geometric reason the servants of art."

REINTEGRATION: PAST AND PRESENT

Change appears to be a key word in contemporary life, but the past is not forgotten. Heavy-beam construction, a revival from our colonial heritage, facilitated by the use of laminated wood beams, has been reintroduced into current practice to enclose extensive areas when neither concrete nor steel is desirable. Brick, stone, and wood retain their place beside glass, steel, and modern synthetic building materials. One of the interests that the historical approach brings to the study of art comes from perceiving the continuity of tradition fused with new developments. California, in particular, where the craftsman tradition had developed with vigor and authenticity in the early years of the century, in more recent years has witnessed the revival of traditional craftsmen materials and devices to provide a fresh note in the contemporary idiom. A brief glance at a few contemporary structures combining yesterday and today will add another dimension to the discussion of twentieth-century architecture.

William Wurster (1895—) began his career designing buildings which appear deceptively casual, for close examination reveals an unusual degree of elegance in his interpretation of the California carpentered-redwood tradition. Wurster's early success encouraged him to organize the firm of Wurster, Bernardi & Emmons; this

talented team has explored a number of fresh and original ways of reconciling the past with the contemporary idiom. The Center for the Advanced Study of the Behavioral Sciences, at Stanford, Calif., was designed to provide work space in a rural setting for fifty scholars, permitting the maximum of privacy and yet offering ample opportunities for informal discussions and larger group conferences. A series of secluded offices connected by sheltered walks crowns the crest of the hill on which the Center is located. The windows of these private offices face out on the quiet landscape, creating an atmosphere conducive to work and devoid of pressure. A central group of offices and conference rooms (Fig. 494) houses the administrative agencies and provides for group discussions. The pitched roofs extend across the walks on simple redwood posts and beams, creating the sheltered galleries that constitute such an attractive part of California's architectural heritage. Extensive windows and glazed walls contribute light, air, and charming vistas of rolling hills. Broad eaves afford a sense of shelter and minimize discomfort from the bright sunshine. Carefully calculated proportions and fine craftsmanship add refinement and sophistication to the simple materials and direct construction. The various needs of an unusual institution have been met with great effectiveness in this complex of buildings designed in the airy, light, spacious contemporary manner, while retaining many elements of traditional California architecture.

Another California architect whose designs combine contemporary structural and planning concepts with traditional materials, often cast in monumental forms of great dignity, is Ernest J. Kump (1911—). The son of an architect, Kump first came into national prominence in 1942, when his design for the Fresno City Hall, Fresno, Calif., received an award from New York's Museum of Modern Art. Though the specialty of Ernest J. Kump Associates has become schools, first elementary and secondary schools and later colleges and universities, Kump has handled a wide diversity of assignments with equal diversity of manner. One of his most striking recent buildings is the Pacific Lumber Company Office Building in San Francisco (Fig. 495).

Though difficulties were presented by the site, a narrow, triangular-shaped lot that slants rather sharply toward the apex, this awkwardness was utilized in a positive way for creative design. The architectural objectives were to achieve a building which would live well with the potpourri of buildings that makes up its colorful Bohemian neighborhood; would serve the needs of the company management staff, which is so organized into individual and small group functions that the majority of spaces are offices occupied by one or two persons; and, lastly, would project the company's image by demonstrating the versatility and virtuosity of wood.

Above the concrete foundation, tall concrete columns work in conjunction with great laminated wood beams as the basic structural supports. The panels between the structural supports utilize a wide range of redwood lumber and redwood plywood panels, thus furnishing a striking illustration of the effectiveness of redwood as a building

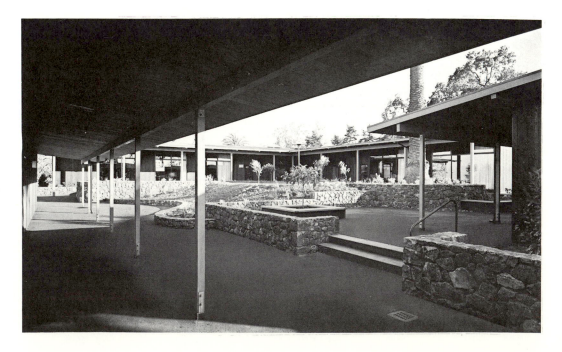

material even in the urban context. The careful design of rectangular bays, articulated by the concrete columns, provides a lively counterpoint to the triangular site. Trellislike projecting redwood beams top the structure with a bold pattern that reflects the vivacious range of structural and decorative potentialities inherent in modern wood products without sacrificing a dignified business-like air.

Louis I. Kahn

Probably the most original and influential integration of traditional and contemporary values appears in the later work of Louis I. Kahn (1901—). Born in Russia, Kahn's parents immigrated to the United States when he was a small child. He grew up in Philadelphia and attended the University of Pennsylvania, where he received the rather conventional training that prevailed in the universities of that day, acquiring a feeling for monumental forms and considerable skill in architectural rendering. A subsequent trip to Europe reinforced his taste for grand relationships of mass and space, but the economically depressed America to which he returned offered few opportunities for imposing commissions. However, the great depression of 1929 played an important and constructive role in his development. The public housing which engaged his talents during the thirties demanded stringent economies and forced him to analyze basic functional problems and devise plans and structural solutions in the most direct and simple method possible. Philosophic by tempera-

ment, he became interested in the writings of Le Corbusier, whose disciplined theories aided Kahn in reconciling his esthetic and technological concerns with the economic factors that constantly challenged him during these years.

In the early forties Kahn joined the staff of the School of Architecture at Yale, where the discipline of teaching further clarified his ideas. Among the first works in which his mature style became apparent was the Yale University Art Gallery. In the interior, where he was free from the problem of relating his design to an earlier part of the building, Kahn developed a design in which many elements are characteristic of his later buildings. The utilities and the circulation facilities are gathered together in a rectangular mass that rises through the center of the building. From this central core, concrete spans made up of tetrahedral elements were poured into place, and the grid thus produced supports concrete slabs that form the floor of the next level. Channels between grids and floor slabs carry ducts for the flexible lighting and ventilating services from a central core throughout the galleries. The uniform geometry of the coffered ceiling, which, left in rough concrete, extends throughout the exhibition areas, lends an impressive element of weight and mass to complement the great open spaces and the light, flexible, screenlike partitions between the interior areas.

Kahn left Yale and teaching to return to the full-time practice of architecture in the mid-fifties, and in 1957 he began work on the design for the Richards Medical Research Laboratories at the University of Pennsylvania, the building that established him as one of the foremost

opposite: 494. WURSTER, BERNARDI & EMMONS. Court and offices, Center for the Advanced Study of the Behavioral Sciences, Stanford, Calif. 1954.

right: 495. ERNEST J. KUMP ASSOCIATES. Pacific Lumber Company Office Building, San Francisco. 1965.

influences in contemporary architectural design (Fig. 496). One of the first steps in designing this complex structure was to analyze the various functions and attendant services that made up the life of the building. Great towers were designed to hold the stairs, the intake and exhaust ducts, and the many utilities and facilities involved in modern scientific research. In contrast to these great service towers, which provide striking visual forms on the exterior, the interior floors have been left as continuous, horizontal open spaces intersected by powerful, structural vertical and horizontal beams, which often stand free of the walls dividing the cubicles of working space. On the exterior the contrasts of solid towers, firm, horizontal floor levels, and transparent strata of glass are equally expressive of the three fundamental elements which make up the complex. Subsequent structures by Kahn have continued to be distinguished by the clarity with which "servant and service" areas are delineated, by the bold translation of structural elements into noble and monumental forms, and by his orderly but not mechanical juxtaposition of solid masses and open spaces.

In the sixties a tendency toward an almost formal symmetry and a geometric ordering of relationships, increasingly a characteristic of Kahn's mature work, became more apparent. The motivating idea behind each building Kahn creates is that the functional requisites of the building be crystallized into meaningful new shapes. "Form," in Kahn's thinking, is conceived as an orderly relationship of parts; "design" is the conversion of form concepts into material being. To reconcile the complicated requirements of each particular structure and his desire for formal order into an expressive unity remains his fundamental aim. This esthetic rationale is visible in the First Unitarian Church of Rochester, N.Y. (Fig. 497).

The functional necessities for this structure, as for all modern churches, were varied: an entrance lobby, a large meeting room, a library, minister's room, women's workroom, committee rooms, and classrooms. Kahn satisfied the various special requirements and brought them together in a unified format that relates all the parts visually, yet emphasizes the dominant position, both physically and ideologically, of the centrally located meeting room. The symmetrical massing of the regularly repeated projecting bays, which create the indirect illumination Kahn prefers, provides for great visual coherence. Though the units are many and of considerable variety, the eye perceives the repetitions and the systematic arrangement at a glance, so that the prevailing effect is one of formal order. Dignity, order, simplicity, directness, and strength, all essentials of Unitarian thought, are communicated in forceful terms by this imposing building.

Kahn has shown a predilection for a flow of light that comes from overhead wells, thereby sculpturing the strong interior forms without the disturbing glare of windows. An interior view of the meeting room in the Rochester Unitarian Church (Fig. 498) reveals the solemn beauty of unpunctured walls flooded from above by daylight. Clean-cut columns support the cross beams from which the

496. LOUIS I. KAHN. Richards Medical Research Laboratories, Philadelphia. 1960.

ceiling slabs gently slope toward the higher voids that house the skylights. Here, as on the exterior, we see the dramatic contrast of solid masses, open spaces, and strong supports. Typical also is the almost crude effect of the great rectangular blocks that wall the sanctuary, as though elegance of surface, like too-facile speech, might contribute to superficiality; an almost puritan ethic is implied by the bare magnitude and simple finish of the interior.

At times the massive geometry of the weighty forms Kahn employs seems brutal, in contrast to the elegance that characterizes the prevailing idiom, whether in rectangular glass and steel or flowing concrete forms. His taste for dramatic space-form relationships has been declared "romantic"; in fact, Vincent Scully, Jr., has likened the service towers of the Richards Medical Building to the towers of San Gimignano, which Kahn admired enough to sketch during his early travels in Italy.

Categorizing Kahn as either a romanticist or a classicist is somehow academic and irrelevant. His contribution has been two-fold. His chief role, like that of all

above: 497. Louis I. Kahn. First Unitarian Church, Rochester, N.Y. 1962.

right: 498. Louis I. Kahn. Meeting Room, First Unitarian Church, Rochester, N.Y.

great architects, has been to design handsome, service-able buildings that epitomize man's potential for creating enduring symbols of his social, technological, and esthetic ideals. Secondly, Kahn has provided the most forceful contemporary statement against that too-slick use of glass, steel, and concrete which has lined our modern city streets with cold, lifeless, and monstrous parallelepi-peds, for he has reintegrated weight, symmetry, mass, and formal geometric relationships into modern building.

Architecture and the Fine Arts

When the curtain wall replaced the monumental masonry façade, architects were loath to burden the light surfaces with enrichments, for, traditionally, architectural deco-ration had been sculptural, and such ornament increased the suggestion of volume and weight. Except for Wright, who never succumbed to the chill beauty of the bare wall, most progressive architects of the thirties and forties chose to exploit the drama of sheer surfaces and weightless volumes, thereby avoiding trite effects and decorative clichés. The aseptic, clean style which resulted was refresh-ing at first, but with the passing of time the stark walls, sharp forms, and cold surfaces began to appear sterile and mechanical, lacking in lyricism and exuberance. In the

fifties and sixties, a new vocabulary of decorative forms appropriate to modern architecture began to appear. Colored tiles, mosaics, pierced or molded cast-concrete blocks, and pebbles and stones employed in exposed aggregate all began to enter into surface enrichment. Metal grills and louvers, often used to protect interiors from undue exposure to the hot sun, also provided light and lively patterns.

One of the leaders in the movement to reintroduce surface enlivenment into modern architecture is Edward Durell Stone (1902—). The device most readily associated with his work is the use of walls and screens of concrete tiles cast in open, pierced patterns. Such walls create deco-rative baffles which enable the eye, as well as light and air, to move freely through masses and spaces. In his designs for the new Stanford Medical Center (Fig. 499), walls of pierced concrete tiles permit the ready perception of the interrelated outdoor courts and enclosed areas. In addi-tion, the solid concrete wall has been cast in related block patterns, and these recessed geometric reliefs, assisted by the great aerial planters, augment the imposing scale of the three-story columns that support the broad extended eaves. The patterns not only add visual interest but con-tribute a reassuring sense of weight.

The enriched surface employed by Edward Stone appears related to a general promise of a new architecture ennobled by the plastic values that have distinguished the great architectural periods of the past. The W.P.A. projects initiated by the Federal government during the depression and the subsequent section of fine arts set up under the auspices of the Treasury Department had reintroduced mural painting as an element of public architecture. After World War II, private enterprise, not to be outdone by government as a patron of the arts, began to integrate works of art in the design of commercial and industrial buildings. Large companies also began impressive acqui-sition programs, using works of art in offices, waiting rooms, and conference rooms and forming collections which could be circulated as public-relations campaigns.

This planned integration of the fine and decorative arts into modern architecture holds great promise for the future. Since 1950 an increasing number of architects have utilized stained glass (Fig. 527), sculpture (Fig. 500), cast-concrete relief (Fig. 501), tile, mosaic, and a wide variety of other art forms to enhance modern buildings. The Fifth Avenue office of the Manufacturers Hanover Trust Company of New York was one of the first to employ sculpture on the grand scale both for practical and visual purposes. A sculptured screen 70 feet wide and 16 feet high, by Harry Bertoia (1915—), divides the main banking room of the second floor, separating the public lobby from the employees. A close-up detail (Fig. 502) of

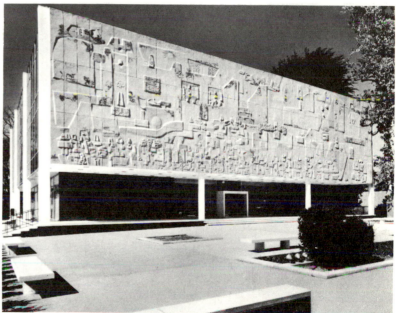

opposite: 499. EDWARD DURRELL STONE. Stanford Medical Center, Stanford, Calif. 1959.

right: 500. ISAMU NOGUCHI. Sculptural decoration. 1963. Marble. Beineke Rare Book and Manuscript Library, Yale University, New Haven, Conn.

below right: 501. CONSTANTINO NIVOLA. Architectural bas-relief. 1958. Sand-cast concrete. Mutual of Hartford Insurance Building, Hartford, Conn. (SHERWOOD, MILLS and SMITH, architects.)

below: 502. HARRY BERTOIA. Sculptured screen (detail). 1954. Metal, full size 16×70′. Manufacturers Hanover Trust Company, New York.

the abstract screen reveals rich surface textures and a play of geometric forms in space which make it particularly appropriate for use in a modern architectural setting. A number of other sculptures and handsome paintings were included in the *décor* of this building, producing an effect of elegance and opulence far beyond the current standard of business buildings in the fifties. By enriching our brilliant contemporary style of building with the emotional warmth and spiritual amplitude of the fine arts, the modern architect again contributes to the satisfaction of man's most essential human needs.

PLANNING

Any discussion of modern architecture that isolates it from the urban scene takes it out of context, for our age is truly an urban one. Over much of the country the metropolis has given way to megapolis, a giant, all-consuming spread of city to city or of city into the surrounding suburb, which fades, in turn, into the next city without any visible separation. Less than 5 per cent of the total United States population are now true rural dwellers, and even that 5 per cent move so easily over the great highways that they, too, much of the time, are part of the city.

In the nineteenth century and the first two decades of the twentieth, the paradoxical trend toward urbanization and urban deterioration become apparent. Suburbs began to spring up around the large cities, and steps were taken to ensure urban health in the form of the "city beautiful." The "city beautiful" concept concentrated primarily on large parks, such as Golden Gate Park in San Francisco and Central Park in New York, and on impressive monuments, chiefly in the form of "civic centers" of government buildings, which were frequently the only elements of dignity and idealism in the municipality. The prototype for this idea of city planning came from the capitals of Europe, chiefly Paris, where great palaces and government buildings presented an imposing termination to an extended vista of spacious streets, and the great parks surrounding the former palaces provided relief from the crowded and arid streets.

In the twenties community controls in the form of zoning laws began to be initiated. These laws limited the height of buildings, established setbacks for houses in residential areas, restricted the types of buildings which could be erected in certain sections, whether single or multiple dwelling, industrial or commercial, and so forth. However, city beautification and zoning restrictions served only to ameliorate some of the surface problems. Since the thirties more stringent programs of urban rehabilitation and redevelopment have been set up in many American cities to meet the threat of the "urban jungle."

Three main areas of focus are discernible in modern city planning. The first development, commencing in the thirties, was the appearance of rather ideal suburban communities patterned after certain nineteenth-century prototypes and also after the English "garden cities." Frank Lloyd Wright's "Broadacre City" represented such a plan, and, though never realized, it influenced some of the more successful projects that were carried out, such as Greenbelt, Md., near Washington, D.C. These communities, essentially residential and insulated from industry and heavy commerce by a protective surrounding belt of parkland or farmland, had spacious and graciously disposed streets, with houses well protected from traffic. They provided a residential retreat for commuters from the nearby cities but did little to improve conditions within the city proper.

A second step, commencing a decade later, was the development of urban housing projects. Slum areas were cleared, and large blocks of apartment dwellings were constructed and arranged so that play and garden areas were alternated with high-rise or clustered smaller units, thus providing not only greater living amenities (air, light, sensible floor plans, and some degree of privacy within the apartments), but also relief from crowded streets, playgrounds for children, and out-of-door recreation areas for adolescents and adults within close proximity to the buildings. These large-scale housing projects were initiated by Federal, state, and city agencies, as well as by private enterprise, and though they did much to upgrade the appearance of the areas when they replaced decayed slums, they frequently failed to improve the lot of the slum dwellers, since the new living units, particularly those built by private investors, rented at prices beyond the income of the former slum inhabitants. In some of the most recently conceived developments, such as Chicago's Marina City (Fig. 487), the concept of the housing project has been enlarged by attempting to create a self-sufficient entity, a "city within a city," in which shopping, entertainment and recreation facilities, office space, and commercial enterprises all form an integrated unit, withdrawing its denizens from the already overcrowded streets of the surrounding metropolis.

The most recent attack upon the problem of urban decay, often described as "urban renewal," is an attempt to rehabilitate the centers which, already dying of automotive-arterial sclerosis, had been dealt an economic deathblow by the great suburban shopping plazas that were rapidly making the older downtown commercial areas obsolete. In the major projects of this type, large sections in the hearts of old cities were cleared of antiquated structures. Streets were blocked off and replaced by overhead and underground freeways and parking facil-

503. CHARLES DUBOSE. Constitution Plaza, Hartford, Conn. 1960–66.

ities. New and handsome shopping, entertainment, hotel and cultural centers were spaciously alternated with parks, flower beds, fountains, and other amenities. Rockefeller Center in New York provided the prototype for the concept, but Pittsburgh, Pa., was the first city to undertake a massive redevelopment program to replace its grimy, smoke-blackened, congested old center with a new and attractive image. One of the most successful examples of urban renewal has occurred in Hartford, Conn. (Fig. 503). Constitution Plaza, a complex of handsome buildings, plazas, a great open mall with fountains, planted areas, and hidden parking facilities, has replaced the decayed heart of the old city. Some city centers have been revived by much simpler expedients. Fresno, Calif., diverted street traffic from part of the central shopping district, introduced planting, fountains, and handsome sculptures, and did a face-lifting job on the more unsightly buildings to bring life back to a dying shopping area.

Not all aspects of the urban renewal programs have been without criticism. In many cases characterful older buildings have been torn down without regard for their architectural interest. In Philadelphia, for example, much architecture of historical interest has been lost, and some districts that were redolent with atmosphere have been replaced with uninteresting new structures. As a result, the city has lost some of its visual past. Such amputation lessens the sense of time and historical continuity that constitutes part of the fascination of a great city.

The line that separates engineering and architecture remains tenuous. Many of the dams, electric generators, bridges, highways, and freeways which serve our society, though conceived primarily as engineering achievements, have the elegance of line, clarity of form, and monumental grandeur that are fundamental qualities in great architecture. One cannot move through the majestic mazes of our great freeways (Fig. 504) or view their flowing interlacings from an airplane without sensing their strength and unself-conscious beauty.

Engineering and architecture were fused with rare purity by the genius of Eero Saarinen, in the great Gateway Arch designed for the Jefferson Westward Expansion Memorial in St. Louis, Mo. (Fig. 505). Appropriately enough, Saarinen drew upon contemporary technology, rather than upon the traditional symbolism of commemorative architecture, to create this 630-foot-high catenary curve of stainless steel. Visible for 30 miles, the pure soaring form of the Gateway Arch reveals man's present freedom from the earth-bound building conventions of the past. Inherent in such a memorial statement is the promise of a society equally free from the restrictions of outmoded habits of thought and patterns of social behavior.

Through the ages man has shaped the great conformations of the land to provide places of assembly. No more majestic site can be imagined than the rock-framed sloping valley near Morrison, Colo., where Burnham Hoyt

(1887–1960) placed one of the most monumental outdoor amphitheaters in the world. Red Rock Amphitheater (Fig. 506), designed for the city of Denver, is a great horseshoe-shaped embankment of seats which flows down a sloping valley between the cliffs of two converging buttes to focus on a simply curved proscenium framed by massive stone walls. The potentialities of this unusual site were realized with rare sensitivity by incorporating the towering buttes into the plan and hiding much of the man-made structure. This fortuitous shaping of nature provides a dramatic example of the way in which modern technology can serve the needs of the ever-growing, gregarious population without violating the landscape— the ultimate aim of all creative plans for site development.

Architecture is a communal art. Modern architecture, like many great examples of the past, involves the talents of a large section of society. Social organization and the

above: 504. Carquinez Bridge approach, Calif. 1958.

right: 505. EERO SAARINEN. Gateway Arch, Jefferson Westward Expansion Memorial, St. Louis, Mo. 1966.

current technology supply the means for shaping the environment to suit man's needs. A corps of designers, engineers, draftsmen, technical consultants, and businessmen work in close collaboration to produce the magnificent steel, concrete, and glass buildings of today. In addition, an army of workers contribute their services: the men who mine and mill the raw materials, the factory workers who fashion these materials into prefabricated parts, the transport workers, as well as the host of technicians who provide the various utilities and services necessary for the life of the building.

But architecture is more than technology. The ultimate values of a society determine its forms. Whether man lives within the shadow of a skyscraper or in the

506. BURNHAM HOYT. Red Rock Amphitheater, Morrison, Colo. 1941.

open country, whether the most imposing structure in a community is the department store or the library, depends upon the ultimate goals of the social order. The capacities of our technology to provide a benign environment and of our architects and designers to shape that environment have barely been broached. The handful of masterpieces that distinguish the current scene promise well for the future. The degree to which this promise will be realized depends on the ideals and social forces which shape our future—ideals and social forces which, in the final analysis, depend on each individual citizen.

19

Interiors, Furniture, Crafts, and Industrial Design

INTERIORS

Between 1900 and 1915 the modern interior received its initial formulation in the craftsman rooms. The general characteristics of this style and Frank Lloyd Wright's particular conception of it in his "prairie" houses have already been observed (Fig. 384).

After 1930 the impulse initiated by Sullivan and Wright early in the century returned from Europe via the "international style." Though Wright retained his feeling for monumental volumes, he explored anew the esthetics of the machine age. The interiors of both the Johnson Administration Building (Fig. 470) and the Guggenheim Museum (Fig. 473) reveal typical features: flowing, continuous surfaces; the use of metal, glass, and other smooth materials; and the regular repetition of geometric elements.

Skillful and distinguished though these interiors may be, it is in Taliesin West (Fig. 507) that Wright reveals his particular genius, for it is here that the two divergent trends of modern design seem reconciled. Machined precision and craftsman-style picturesqueness contribute to an increasing boldness in the disposition of the visual and structural materials. The opposing diagonals of walls and ceiling, the rough concrete, stone, and wood, and

the large scale of the beams create a sense of excitement that makes the Coonley interior of thirty years earlier seem decorous and well-mannered. Through a dynamic organization of stone and heavy timbers, timeless elements of our architectural heritage have been combined with the contemporary taste for sweeping spaces, intersecting planes, and geometric patterns. Though modern industry cooperates in providing the structure, Taliesin West seems close to nature, not only because one continuously sees the out-of-doors, but even more because so many of the materials relate to the landscape in form, texture, and color.

None of the visual drama of Taliesin West disturbs the serene quietude of Philip Johnson's home in New Canaan, Conn. (Fig. 508), which is a pure and uncompromising interpretation of the "international style" in an interior by one of America's most distinguished architects. Here the flow of unobstructed space appears continuous from indoors to outdoors. The planes of ceiling and floor seem to float, and in so doing project the eye to the lawns, the sky, and the distant hedge of shrubs which provides privacy. The steel posts that serve as structural supports, like the islands of furniture in the room, the sculpture, and the receding trunks of trees, act as space modulators

above : 507. FRANK LLOYD WRIGHT. Interior, Taliesin West, Phoenix, Ariz. 1938.

below : 508. PHILIP JOHNSON. Interior, Glass House, New Canaan, Conn. 1949.

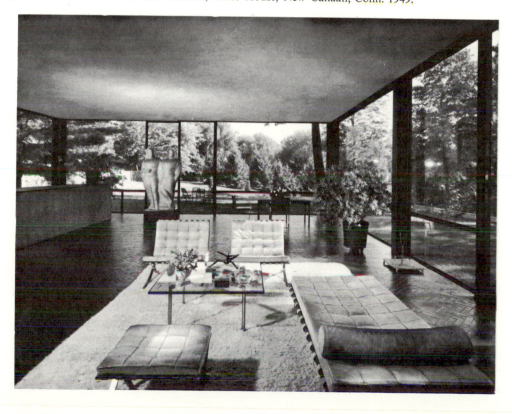

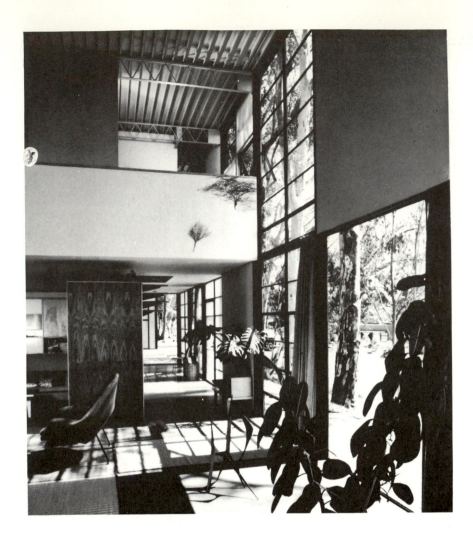

509. CHARLES EAMES. Interior, Case Study House, Santa Monica, Calif. 1949.

by giving vertical indications of the spatial intervals. An effect of machined perfection is obtained by the shining surfaces and the continuous rectangularity of the principal forms. Here, as in Taliesin, nature and the machine are reconciled, but this is an exceptionally civilized nature, with such discordant elements as bad weather excluded by a brilliantly harnessed technology, just as all discordant elements of taste are excluded by an impeccably disciplined esthetic standard. The soft textures of rug and leather, the richly formed sculpture, and the plants provide a foil for the smooth surfaces and contribute a needed warmth, without which machined elegance and disciplined taste may border on sterility.

The refinement of the Philip Johnson house suggests great expense and none of the rough and tumble of mundane family living. But much of the character of the "international style" grew from the desire to reconcile the practical requirements of normal daily life and the beneficent productivity of the industrial age with esthetic integrity. A look into the interior of the Charles Eames house (Fig. 509) suggests both abundant life and beauty achieved within a modest budget. There is an all-pervasive sense of space, air, and light. Partitionlike sections of wall separate the areas within, so as to provide for the various aspects of family living. While the forepart of the living room is two stories high, the farther section has an open balcony with sleeping space above the dining and kitchen areas. Since the interior walls are essentially partitions, rather than supporting members, the space is flexible and rooms can be shifted as family requirements change. The lightly framed walls and windows minimize the sense of separation between the indoors and the sunny outdoors, while the mass-produced metal structural elements seen in the window-walls and in the ceiling have their own unpretentious charm and offer a lively visual counterpoint to the pattern of leaves and branches.

The curvilinear and ovoid forms on the exterior of the Deaton sculptured house (Fig. 493) also characterize

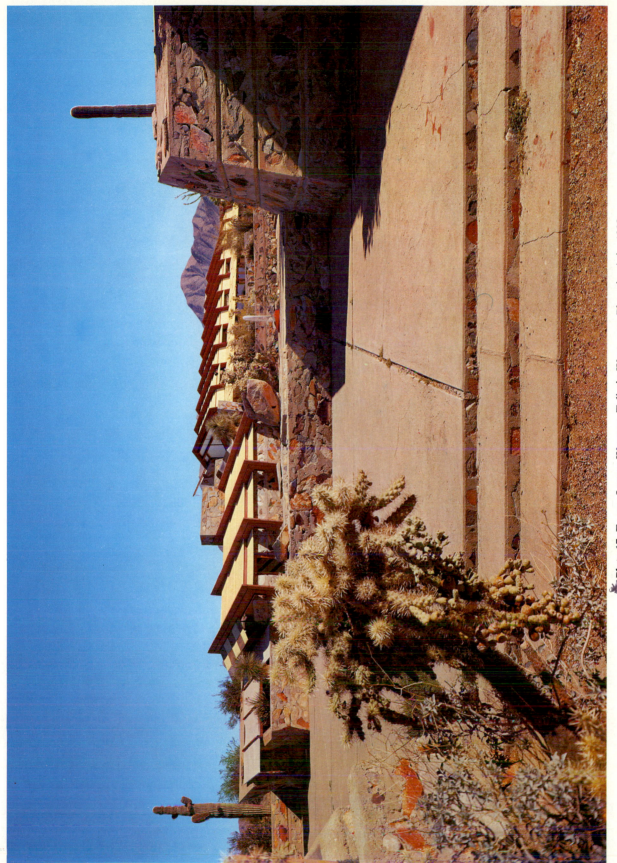

Plate 17. FRANK LLOYD WRIGHT. Taliesin West, near Phoenix, Ariz. 1938.

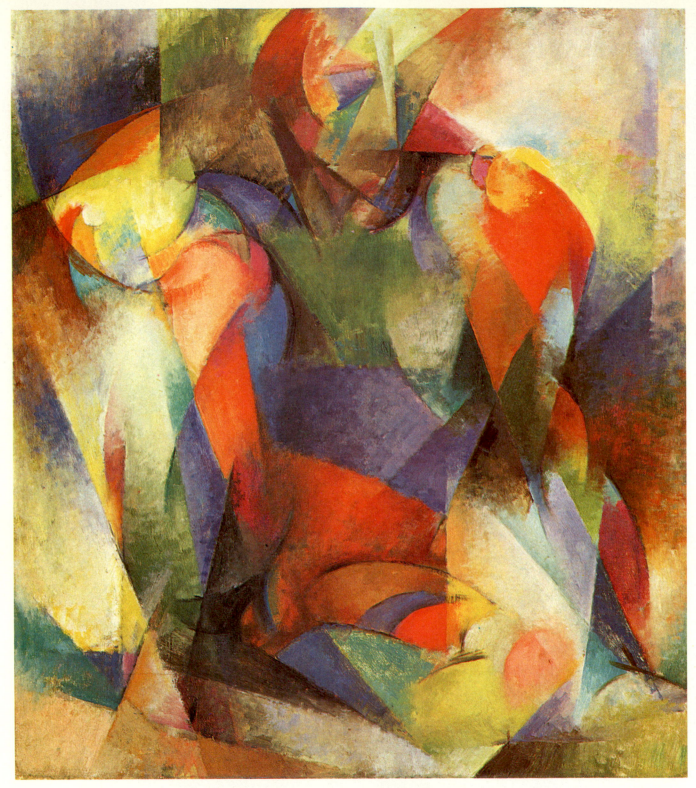

Plate 18. STANTON MACDONALD-WRIGHT. *Synchromy in Green and Orange*. 1916.
Oil on canvas, 34 ½ × 30 ½". Walker Art Center, Minneapolis.

the interior spaces (Fig. 510) and present an exhilarating change from the standard rectangularity of most modern interiors. The floor plan reveals the fluid contours which eliminate sharp corners, permit ease of movement from part to part, and create a graceful linear continuity that relates all the internal spaces and forms. The living room enjoys a sweeping view of the vast panorama of the Rockies, with the major seating arrangements opposite a curved wall of glass. An internal passage leads to bedrooms, baths, kitchen, and dining room, each of which has a porthole, window, or glass wall, depending upon its needs. The new concrete technology enables the designer to provide "biomorphic" enclosing forms of shelter in response to some need in man to relate to his organically oriented body and the forms of nature. Technology and taste appear to be responding to a social philosophy in which pliant, humane values will replace a conforming, mechanistic social order.

A few generalizations concerning the modern style can be drawn from the observation of these four interiors. The generalizations can be made more meaningful by a quick glance back at the Stanford Bedroom (Fig. 373). The open plan and the absence of cell-like enclosed rooms give an effect of airy spaciousness. Rooms are arranged to function efficiently and to be visually expressive of the life carried on in them. Furniture is grouped in relation to daily activities—eating, sleeping, conversation, listening to music, or watching television—and also in relation to windows, the fireplace, and other architectural elements. Most designers today prefer a somewhat spacious, almost empty-looking room to a crowded or a cluttered one. In general, pattern is used sparingly. Draperies, upholstery fabrics, curtains, and carpets are usually solid-colored and provide a textural foil to the wood, plaster, concrete, and brick of the walls, floors, and ceilings. Furniture is low in contour, simple in shape, and usually without carving or applied ornament.

The architectural decorations of earlier times—moldings, wall paneling, and the framing of doors, windows, and mantels—have been eliminated. Ease of upkeep and a clean look are primary goals in planning contemporary rooms. Wall-to-wall carpeting, glass-topped tables, formica or plastic work surfaces, the general absence of heavy carving, and the elimination of elaborate objects and looped and festooned draperies all provide for ease of maintenance. Smooth reflective surfaces and the avoidance of furbelows contribute to the air of polished understatement desired by today's interior designers.

Paintings, sculptures, and ceramics play a most important role in modern interiors, for the general lack of pattern and applied ornament focuses all attention upon the art object. Since much of the furnishing used

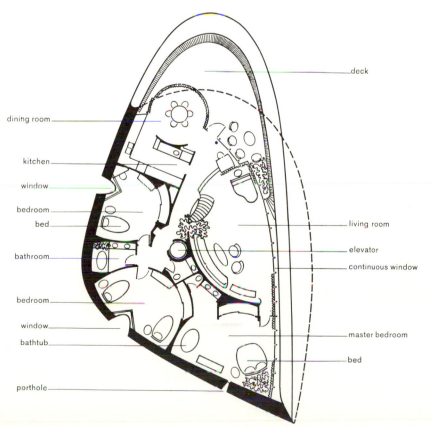

510. CHARLES DEATON. Interior plan, sculptured house, near Denver, Colo. 1967–68.

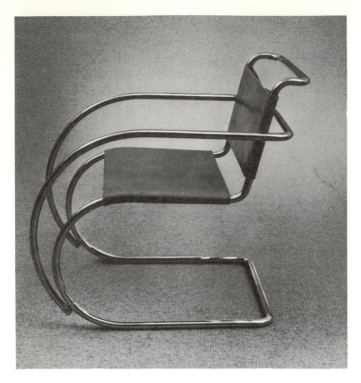

in contemporary rooms is rather standardized, expression of the more subtle and intimate qualities of personality is achieved through works of art. At its best, modern interior design is dedicated to a most austere and lofty ideal: to create a living environment expressive of both our highly organized technology and the individual personality, or, to quote the Swiss architect Le Corbusier, to produce a practical, functioning "living machine," which is, at the same time, unique and esthetically distinguished.

FURNITURE

There was little progressive furniture design in the years immediately following World War I. Even the straight-forward Mission style gave way before the anemic traditionalism which dominated furniture production. During the twenties and early thirties the older styles of furniture were scaled down in size, and the rich, carved ornament of former days was simplified in response to the exigencies of machine production and the general taste for unpretentious effects. Many of the simpler historical styles were revived during this period, early American and Shaker furniture, Windsor chairs, French provincial, and modified versions of Jacobean and William and Mary replacing the more extravagant Baroque and Rococo modes so popular during the Victorian age.

A more vigorous and experimental spirit prevailed in Europe during these decades. In Germany and Austria

above : 511. LUDWIG MIËS VAN DER ROHE. Armchair. 1926. Chrome-plated steel with leather, height 32". Museum of Modern Art, New York (gift of Edgar Kaufmann, Jr.).

below : 512. PAUL McCOBB for Calvin Furniture Co., Grand Rapids, Mich. Irwin Collection of living-room furniture. 1951.

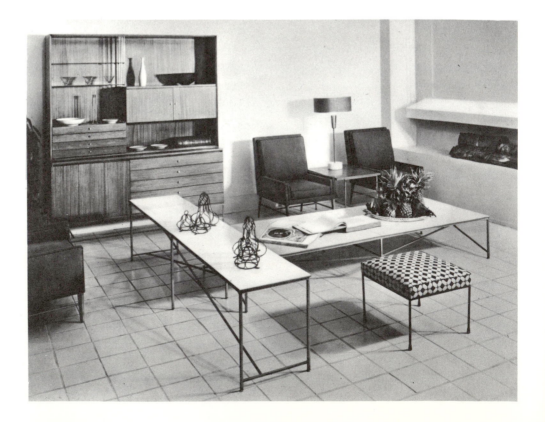

right : 513. Charles Eames for Herman Miller Furniture Co., New York. Chair. 1946. Molded plywood.

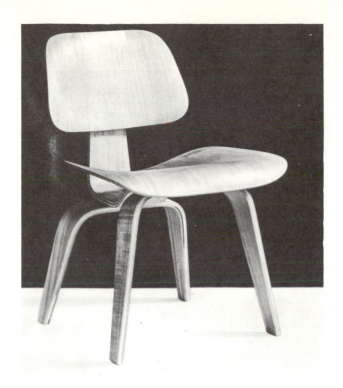

a heavy geometric modern style appeared, characterized by unrelieved rectangular forms and smooth surfaces. The Scandinavians experimented in bent-wood and molded plywood furniture, and the curvilinear elements introduced by these methods of shaping wood provided a welcome relief from the ponderous rectangularity that characterized much of early modern furniture styling. During the mid-thirties a few of the more progressive American furniture manufacturers, influenced by refugees from the Bauhaus, began to incorporate the newer trends into their designs, particularly the use of bent-wood and tubular metal framing (Fig. 511). Since that time furniture has responded rapidly to the changing technology, architectural styles, and tastes of our day.

A contemporary designer divided modern furniture into three basic types: furniture having the machine look (Figs. 511, 512), the handicraft look (Fig. 515), and the "biomorphic" or sculptural look (Fig. 514). Though few pieces of furniture conform entirely to any one of these categories, the classifications provide an excellent orientation to contemporary trends.

A collection of furniture designed by Paul McCobb and assembled for display purposes (Fig. 512) is dominated by the machine look of modern architecture. The forms are consistently rectangular, supports are predominantly vertical, surfaces are smooth and continuous, and, as in modern architecture, the general effect is light, airy, and open. Even the cushions and the padded areas of upholstered chairs have been kept thin so as to avoid bulk and to stress the predominantly planar effect. The large coffee table topped with white glass is carried on a brass frame, and slender metal rods support the ottoman. The handsome cabinet against the wall provides both enclosed space for storage and open areas for display; the resulting alternations of recessed and built-out rectangles create an interesting play of forms and spaces. The contrast between the major horizontal divisions and drawers of the cabinet and the prevailingly vertical wood grain animates the surface. Practicality, comfort, and a certain light grace have been achieved; and, although the results are not distinguished, the total effect is pleasant.

While modern tables, cabinets, and storage units most frequently have an architectural machined look, many chairs and related pieces are distinguished by molded and flowing forms of a "biomorphic" orientation. "Biomorphic" is a word coined by modern designers to describe forms related to living organisms, and the "biomorphic" approach to chair design involves consideration of anatomical forms and the problems of support and action involved in sitting. "Biomorphic" designs for furniture are often executed in molded plywood, plastics, rubber, and metal.

Charles Eames, an early and extremely inventive designer of modern American furniture, has shown particular sensitivity in adapting plywood, plastics, and metal to contemporary requirements. Eames designs parts that can be manufactured by mass-production methods and assembled rapidly and easily. One of his earliest and most successful designs for a chair was made from molded-plywood parts, which were cut and shaped by machine and then assembled (Fig. 513). The seat and back were formed to support the body comfortably, and the graceful shapes were as efficient as they were pleasing to the eye. The Eames chairs were assembled with metal and rubber mounts, which provided a desirable flexibility, permitting the chairs to respond to changes in body position and so combining some of the support of rigid chairs with some of the comfort of upholstered furniture. Here Eames finally devised a gracious solution to the problem of the molded-plywood chair initiated sixty years earlier (Fig. 386).

The "biomorphic" concept seems particularly congenial to the processes by which modern plastics are shaped. The late fifties witnessed the introduction of a number of designs for chairs and tables which utilized a light-weight, pressed-plastic shell to create forms of great beauty and serviceability. A chair designed by

Eero Saarinen (Fig. 514) has a fluid enveloping shell poised upon a graceful pedestal base. A foam cushion provides a resilient seat as well as visual bulk that, by contrast, emphasizes the grace of the plastic envelope that surrounds it. A chair like this is conceivable only in terms of contemporary materials and manufacturing processes.

Much fine furniture which relates closely to traditional handicraft practices is still produced. An unstained birch breakfast table and chair (Fig. 515), designed by George Nakashima, suggest early American prototypes. The chair has a heavy, shaped plank seat with inset legs and spindles, which recall, as does the circular back rest, the traditional Windsor chairs. The absence of turnings and the sleek, simply modulated forms are, however, more in character with the machine concept of design than with the sculptural forms of earlier times. The table also reflects colonial and Shaker modes. The subtle shaping of the

top and the tapered legs inject a note of style into an extremely simple piece of furniture.

An upholstered chair and stool (Fig. 516), designed by T. H. Robsjohn-Gibbings, were intended for more conventionally elegant interiors than the furniture just discussed. The separation of the wooden supporting frame from the cushions suggests contemporary Scandinavian practices. The frame, which has been treated as a delicately sculptured wooden support for the heavier cushions, is subtly shaped so that the taperings and swellings carry the eye from part to part with an easy continuous movement. The suave contours and delicately molded surfaces of the frame involve certain traditional handicraft practices; consequently, such furniture is more expensive than that conceived in the modern industrial idiom. Despite a constant concern with practicality, modern furniture at its best, whether custom-made or mass-produced, achieves a quality of grace and elegance that makes it comparable to the fine furniture of earlier days.

Innovations in the fine arts have proven to be an important stimulus to unorthodox furniture design during recent decades. A handsome coffee table designed by the sculptor Isamu Noguchi in the mid-forties (Fig. 517) drew upon the abstract curvilinear sculpture of that period for its stylistic inspiration. The heavy piece of glass which forms the top rests on an ingenious wooden sculptural base made of two free forms, and part of the interest comes from knowing that the weight of the glass

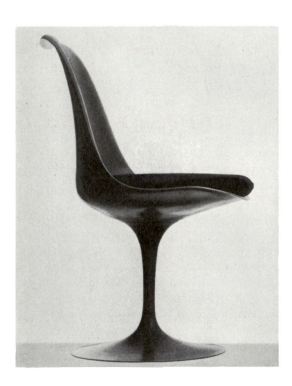

above : 514. Eero Saarinen for Knoll Associates, Inc., New York. Single-pedestal chair. 1958. Molded reinforced plastic.

right : 515. George Nakashima for Knoll Associates, Inc., New York. Chair and breakfast table. c. 1948. Birch.

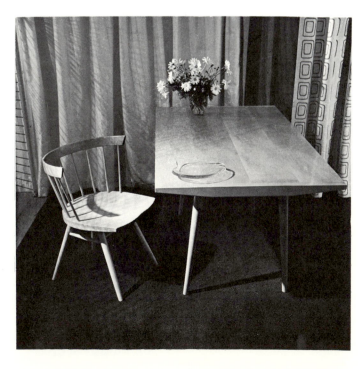

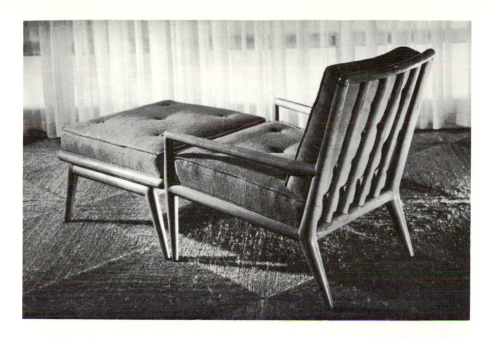

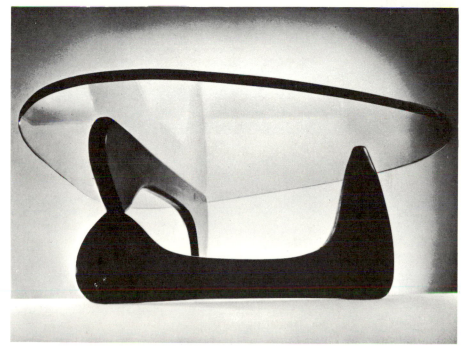

holds the supports in place. The beauty of this table results from the sensitive use of materials, the transparency of the glass, and the strong organic forms of the wooden supports. Despite the weighty parts, the fluid lines, a transparent top, and the open supports keep the table from appearing ponderous.

In the sixties the playful note that was one of the characteristics of "Op" and "Pop" art enlivened some of the more imaginative designs for furniture and household objects. A chair by Neal Small (Fig. 518) of one-piece, plexiglass construction is entertaining for its original design, in which folds in the flat sheet of plastic provide the structural rigidity necessary for strength and stability. Here transparency creates an interesting element of novelty, for the linear patterns produced where the folds and edges catch and reflect the light introduce some of

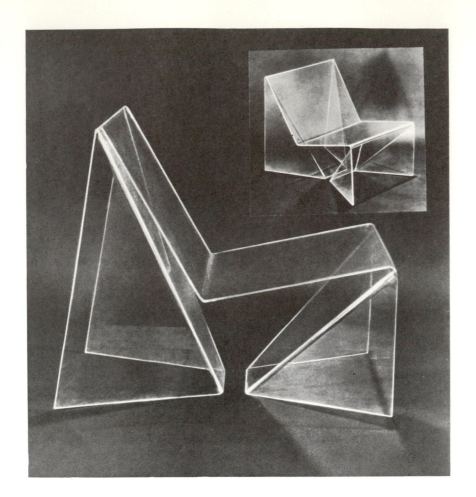

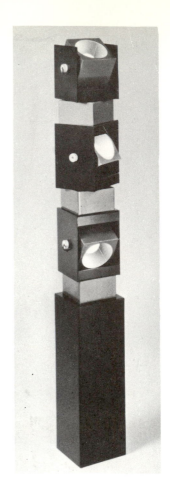

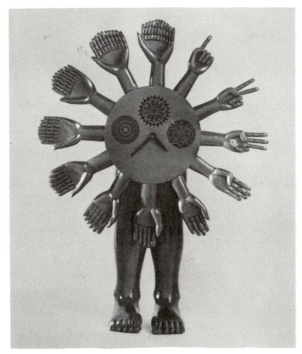

above left: 518. NEAL SMALL. Chair. 1966. Plexiglass, 24 × 30 × 30″.

left: 519. PEDRO FRIEDEBERG. Clock. 1961. Painted wood, height 13″. Courtesy Byron Gallery, New York.

above right: 520. IRVING RICHARDS for Raymor Manufacturing Co., Union City, N. J. Adjustable floor lamp. 1967. Black and gray metal with chrome, height 4′ 3″.

the visual ambiguity that characterized much "Op" art (Fig. 640).

"Pop," too, has had its impact upon the sober standards of conventional good taste. A red-painted wooden clock by Pedro Friedeberg (Fig. 519) has a high-spirited element of humor, recalling the amusing figures in a shooting gallery or the shop signs of long ago without losing any of its decorative value. Such departures from orthodox forms have contributed to a vivacity in the contemporary decorative arts and added a welcome dimension to the somewhat austere simplicity of early modern interiors.

The minimal sculpture of the sixties, too, has made its impact upon contemporary design. A floor lamp (Fig. 520)

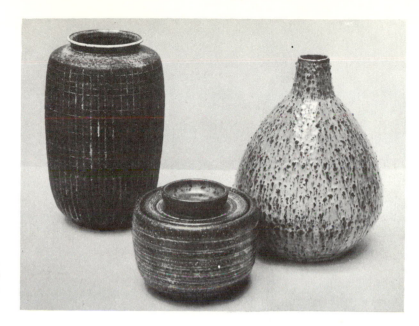

521. FRANS WILDENHAIN. Ceramic forms. c. 1955. Thrown pottery, height of tallest vase 11″. M. H. de Young Memorial Museum, San Francisco.

by Irving Richards, in black and gray metal with chrome accents, exploits the minimal interest in cube forms. The adjustable light boxes can be turned both horizontally and vertically, thus permitting a "kinetic" range of positions for visual and functional variety.

CONTEMPORARY CRAFTS

The flourishing state of contemporary crafts is one of the paradoxes of today. In the late nineteenth century handicrafts seemed doomed. The machine appeared to have taken over, except in isolated instances. Only a few reformers, William Morris in England, Sullivan and Wright in America, protested against the debauched standards of prevailing design and envisaged a day when men would live and work in a benign environment and produce beautiful, well-made objects for everyday use. Though they seemed lost voices, these men did much to perpetuate and revive handicraft traditions and practices. Today a large number of craftsmen are working in ceramics, glass, metal, wood, and plastics and are weaving handsome textiles. The products of their hands supplement the abundant body of machine-made merchandise which, for the most part, satisfies the mass markets.

The areas of modern craft activity remain traditional. Silversmithing is still a popular craft, though the majority of craftsmen prefer to make jewelry rather than household silver. The increased use of iron, bronze, and lead as sculptural media has almost obliterated the distinction between artists and craftsmen among metalworkers. Metal sculpture is discussed in Chapter 23. Ceramics is one of the most widespread contemporary crafts, because the equipment and materials necessary for pottery making are relatively simple and accessible. Happily, after a long period of neglect, glass, too, is becoming an area of amateur craft activity. A number of fine weavers are at work today, and it is almost impossible to draw the line between commercial and amateur weaving, for many hand weavers design fabrics for industrial production by machine-powered looms.

Ceramics

The ceramic arts constitute one of the most vital fields of contemporary craft activity. Modern potters continue to make traditional vase and bowl forms to be used for flower arrangements, as storage containers, and as tablewares. They also make an increasing number of pieces that are handsome essays in the ceramic arts with no other purpose than to provide visual pleasure.

Contemporary ceramic artists have been primarily concerned with reviving the art of throwing pottery, that is, of using the potter's wheel to replace the molds and casting processes employed in commercial ceramic production. In doing this, they have rediscovered the character of clay, its weighty, full-bodied plasticity, as well as the tremendous range of interesting surface textures that can be produced in the processes of throwing, firing, and glazing. Three pieces of pottery by Frans Wildenhain (Fig. 521) illustrate the character of mid-century thrown ceramics. The simple forms, classic vase, bowl, and flask shapes, which serve as efficient containers and flower

left : 522. WILLIAM WYMAN. Branch holder. c. 1955. Partially glazed thrown pottery, 14 × 10″. Museum of Contemporary Crafts, New York.

below left : 523. PETER VOULKOS. *Tarantas.* 1957. Cut and hammered slab pottery, height c. 42″.

holders, sit solidly and have a pleasant, substantial effect. Varied surface textures have been combined with the rich colors and soft sheen of the glazes to create handsome, unpretentious examples of the potter's art.

Modern ceramic artists, like modern painters and sculptors, have found inspiration in the arts of primitive peoples and exotic cultures. A partially glazed branch holder (Fig. 522) by William Wyman is very much of today, yet there is also something reminiscent of the past in its forms and surface textures. The simple purity of its contours as well as its gracefully shaped openings recall an early Greek amphora. The multiple openings suggest some types of folk pottery. The unglazed surface, enriched only by the simple lines of the potter's tool and a swipe of glaze, remind us of the pottery of ancient and primitive cultures. The varied placement of the openings makes this contemporary branch holder well adapted to the creation of interesting and decorative arrangements for the modern home.

Peter Voulkos began his career making pots and bowls. In the fifties his ceramics moved into the realm of sculpture. An example of one of his bold ceramic forms (Fig. 523) stands about 42 inches high and, like much modern painting and sculpture, shows the directness and vigor with which the materials have been manipulated. The rather crude spherical masses that constitute the main form have been textured by such processes as hammering, scraping, and smearing. The result is as astonishing as an impertinence, and yet the weighty character of the forms contributes a sculptural dignity to the whole.

Daniel Rhodes, like Peter Voulkos, began his career working with traditional ceramic forms. After 1955 Rhodes turned from the potter's wheel to hand-built forms and began to abandon glazes for rough, buff-colored bisque surfaces, often crudely textured with an impasto of sandy clay slip. His most recent works depart even farther from traditional forms and processes. Into the clay he puts layers of fiberglass, which, when fired, fuse with the clay to create a material of sufficient tensile strength to permit structures of a nature and complexity hitherto impossible for the ceramic artist. An untitled work (Fig. 524) displays the convoluted and enfolded forms with interpenetrating open areas permitted by this process. The ceramic sculptures that result have an expressionistic turbulence of movement and roughness of surface that seem to be the complete antithesis of the smooth

an entertaining departure from the solid colors and dull glazes that had become the standard for the commercially produced "artistic" pottery of today.

Glass

Most contemporary table glass, whether blown or pressed and shaped in molds, is simple and functional and either exploits the tendency of molten glass to assume rich globular shapes or glorifies the elegance of thin, crystalline forms. In decorative glass there is a tendency to employ a minimum of applied pattern and to use heavy forms which distort the transmitted light into fluid, rhythmic patterns. Some of America's finest glass combines the talents of the glass blower and of the modern designer. *Air Trap* (Fig. 526), a vase of colorless crystal by John A. Dreves, has been decorated by a manipulation of bubbles introduced between the inner and outer walls of the vessel during the blowing process. The properties of glass and the twisting actions involved in glass blowing have been brilliantly exploited to create rhythmic elongated spirals.

above left : 524. Daniel Rhodes. *Untitled.* 1966. Clay and fiberglass, height 24".

left : 525. Roy Lichtenstein for Durable Dish Co. Tableware. 1966. China.

below : 526. John A. Dreves. *Air Trap.* 1947. Clear crystal vase with air spirals, height 7^{11}/$_{16}$". Metropolitan Museum of Art, New York (Edward C. Moore Gift Fund, 1950).

elegance which in earlier times represented the apex of the ceramic arts.

The vigorous contemporary revival of the ceramic crafts has had a strong influence upon commercially produced tablewares, so that earthenware and pottery have made impressive inroads on the popularity of the thin-walled, fragile porcelain that constituted the ideal of "good" table china a few generations ago. Much of the tableware of the last few decades has revealed a taste for simple, heavy forms, earthy colors, and dull textures. Recently, lively patterns have added an unexpected vigor to *avant-garde* table ceramics. Roy Lichtenstein has designed a limited-edition line of dishes using the large Ben Day dots and the heavy contour lines that characterize his "Pop" style (Fig. 525). Striking, rather than decorous, this strong black-and-white pattern represents

Stained glass is another medium that is being revived by modern craftsmen and being adapted to the requirements of modern architecture. Robert Sowers designed a stained-glass door (Fig. 527) for the chapel of Stephens College at Columbia, Mo. The large translucent areas contrast with the heavy leaded divisions to form a thoroughly contemporary architectural decoration.

Textiles

Never before in history have the textile arts displayed the variety of today. To satisfy our many needs modern textiles are woven in every conceivable combination of natural and man-made fibers to create textured effects that range from silky smoothness to an almost sculptural roughness. The fabrics are decorated by an equal variety of printing, embroidering, weaving, and dyeing techniques. Both the textural character and the decoration of modern textiles have been strongly influenced by current art trends, handwoven textiles providing models for commercial production, and manufacturers tending to draw upon the more imaginative hand weavers for their ideas and inspiration. The designers of contemporary woven textiles strive to achieve surface interest through subtle and varied textures, and handicraft weavers have led the way through their use of unconventional materials. A number of hand weavers create striking fabrics by combining a variety of materials in a single textile. A handwoven fabric (Fig. 528) by Dorothy Liebes combines wool, cotton chenille, raw silk, three types of metal strips, and silk cord; thus crinkly, rough, smooth, sparkling, and dull effects are achieved in one cloth. As the hand weavers expand the range of textures, the commercial weavers adapt the innovations to the mechanical looms, often with surprising success.

The renaissance of textile arts in our day has brought about a revival of such traditional arts as appliqué and tapestry weaving, with their sumptuous colors and rich textures. *The Phoenix and the Golden Gate* (Fig. 529), by Mark Adams of San Francisco, provides a brilliant example of a tapestry designed to be an integral part of the reading room of a library. Robert Pinart designed for Congregation B'nai Israel of Bridgeport, Conn., an ark curtain (Fig. 530) which achieves a rich variety through its combination of appliquéd silk materials and embroidered stitches. Intriguing both as a decoration and as religious symbolism, it illustrates a phase of the contemporary revival of liturgical arts.

Contemporary craftsmen make no attempt to compete with the machine. Instead, they supplement its somewhat standardized output by producing objects which are

above : 527. ROBERT SOWERS. Chapel door. 1956. Stained glass. Stephens College, Columbia, Mo.

below : 528. DOROTHY LIEBES. Hand-woven textile (detail). c. 1946. Cotton, wool, chenille, silk, and metal.

unusual and distinguished because they reflect the unique abilities and ideas of creative individuals who wish to explore beyond the common denominator of contemporary taste. While a limited number of contemporary craftsmen make a living through their craft products, many are amateurs who enjoy the doing as much as the results. In this age when mechanization takes over an ever-increasing share of human activities, people derive great satisfaction from exercising their manipulative skills. Distinguished achievement in the crafts, as in any other field of expression, is a matter of taste and creativity and draws on the full potential of the craftsman.

The activities of the contemporary amateur and professional craftsmen also have a vital relationship to the

great body of machine-made merchandise being produced for the mass markets. The industrial designer of today, whose creations are sold by the thousands, is tied to the drawing board, the machines, and the complexities of large factories and routine sales channels. The artist-craftsman is much freer to experiment and explore. As a consequence, he may create new modes and evolve new ideas which later enrich the more conventional avenues of production.

INDUSTRIAL DESIGN

A systematic survey of the endless stream of objects shaped by the contemporary industrial designer is beyond the confines of these pages, but note should be made of the vigor and variety of industrial production today. Though the apprehensive opponents of industrialization in early times foresaw only sterility and uniformity for the products of the machine, the vitality and complexity of modern life are too great to permit the domination of any single stylistic trend or simple formula of design.

Much of our industrial production continues to display the simplified functional forms and the sparse grace that has been typical of American artifacts. In the pots, pans, kitchen equipment, tools, machines, and innumerable objects so essential to modern living, efficiency of form is often augmented by the superb finish made possible by modern technology. A concern with color, texture, and form for their own sakes is also evident.

The industrial designer, working within the framework of our industrial system, repeatedly draws upon the fine arts, as well as the aforementioned crafts, for inspiration. The painter and the sculptor, even less restricted than the craftsman by the demands imposed by functional usage, are free to explore and create the esthetic idiom of their day. In this respect the relationship between the industrial designer and the artist remains similar to that which exists between the engineer and the scientist doing pure research in his laboratory. The interdependence of the fine and industrial arts is most obvious, as one would expect, in the household and decorative arts. A comparison of two modern sculptures (Figs. 681, 670) with a chair

opposite : 531. Raymond Loewy William Snaith, Inc. Pennsylvania Railroad locomotive. 1942.

right : 532. Hyster embankment compacter. 1967.

(Fig. 514) and a floor lamp (Fig. 520) reveals the way in which the changing sculptural styles have influenced the design of home furnishings.

Two great machines from the world of heavy industry, an area that would appear farthest removed from any primary concern with either esthetic refinements or style changes, reveal the vigor and refinement, as well as the continuously shifting styles, of modern industrial production.

There is an appropriate implication of movement beneath the smooth-flowing contours of many modern machines. In a locomotive designed by Raymond Loewy Associates for the Pennsylvania Railroad Company (Fig. 531), the forms of the great all-encompassing shell appear as the concrete embodiment of speed and power, while the exposed mechanism of wheels, main rods, and other moving parts reveals the dynamic elements of its function. Raymond Loewy sought to combat the disconnected and clumsy look of earlier locomotives by simplifying and unifying the body shapes with a welded envelope, which also eliminates the unsightly patchwork of riveted sections. In so doing, he lowered manufacturing costs by many thousands of dollars, simplified maintenance problems, and produced a design that was both satisfying visually and expressive of function. At the same time Loewy's design was closely related to the "biomorphic" forms that characterized much of the abstract sculpture of the forties.

An interesting contrast is provided by a great embankment compacter of the late sixties (Fig. 532). As is appropriate for a powerful machine whose primary function is to provide weight rather than speed, its forms are massive, blocky, and suitable for the world of heavy labor. At first glance the strong frames, the high-riding seats, the elephantine rollers with their sheep's-foot studdings, the massive dozer blade in front, the air ducts, and the heavily bolted circular plates seem designed with only work in mind. But thoughtful examination reveals a consistent repetition of rectangular forms, of related diagonals, even of circular shapes. By a considered shaping of parts this magnificent machine achieves a monumental and brutal strength consonant with the qualities we admire in certain sculptures and buildings of the sixties. That our industrial technology has done much to shape the contemporary artistic *Zeitgeist* is undeniable, but the fact remains that the artist explores, and the designer applies; both work within the spirit of the age, shaping its ideals and its physical forms.

The varied products of modern industry constitute a most significant facet of the arts of our age. Today's machines are the tools by which man shapes his environment to serve his needs. To an increasing degree each year the machine frees man from unending toil and produces the goods that enable him to live with greater self-realization. Much that is produced displays the sure sense of form and fitness to purpose that comes only with maturity.

20

Modern Painting: The Formative Years

What has come to be called "modern" (nontraditional) painting appeared in America in three successive waves. The initial introduction occurred, before the famous Armory Show of 1913, when the work of a small group of American artists who were exploring the new avenues of expression opened up by French painters was shown in New York by Alfred Stieglitz in his famous gallery at 291 Fifth Avenue. A second and larger wave followed the Armory Show, and again Stieglitz played a vital role by showing and championing a number of the most important progressive young painters. Before many years a large group of artists and intellectuals all over America were dedicating their lives to the new movements. The third wave of advanced painting appeared after World War II, when the tide toward abstraction and expressionism appeared so overwhelming as to overshadow a vigorous school of more traditional painting which had continued to flourish in America.

Although progressive American painters and intellectuals in the early twentieth century were familiar with advanced European painting, the public at large first confronted modern art at the Armory Show in 1913, so called because it was held in the 69th Regiment Armory building in New York. The show was probably the most in-fluential exhibition of art ever held in America. It was organized by a group of young American painters, including most of The Eight and certain other artists who had been abroad and were committed to the progressive movements they had witnessed there. More than fifteen hundred paintings and sculptures were shown. Over three hundred Americans exhibited, primarily those who wished to move beyond the genteel academic tradition favored by the public and by popular critics and who, consequently, found few opportunities to show their work in America. Sadly for them, but not surprisingly, the American exhibitors attracted far less attention than the more revolutionary Europeans. It was the International Section that created the greatest furor; in fact, the International Section was sufficiently controversial to be shown subsequently in Chicago and Boston.

The viewers in general were astonished, confused, and even indignant at works which violated their established concepts of art. The press, always aware of the news value of the novel and sensational, made the most of the shock value of the exhibition. Critics laughed derisively at such paintings as Marcel Duchamp's *Nude Descending a Staircase* and encouraged the public to attend the exhibition in a carnival spirit. Most of the onlookers were

amused or outraged, but the impact of the exhibition remained. A small group of painters, intellectuals, and collectors were deeply impressed, and the abstract and stylized modes of painting and sculpture seen by many for the first time were to become intrinsic elements of American art. Despite the vigorous schools of modern painting in Germany and Italy, the influence of Paris dominated the Armory Show and later American painting.

The continuous swing after 1913 toward abstraction and emotional intensification was, of course, not entirely the result of the Armory Show. Changing intellectual concepts and social tendencies led man's inquiring eye in new directions. The impulse toward exploration and deeply felt expression penetrated all phases of intellectual and artistic life in both Europe and America; the Armory Show served to crystallize that impulse here.

The terms that most conveniently describe the three poles around which contemporary art movements gravitate are "abstraction," "Expressionism," and "realism." These terms themselves are subject to a wide range of interpretations. Classification of styles as abstract, expressionistic, or realistic is complicated by the fact that these general terms represent tendencies inherent in all art. Abstraction results from a tendency to formalize, simplify, and generalize. Expressionism represents a tendency to emphasize, exaggerate, and editorialize. Coexistent with these two in the world of contemporary art, though often underestimated, is a trend toward visual realism, which is a tendency to scrutinize, analyze, objectify, and particularize.

All three of these tendencies represent attempts on the artist's part to arrive at essences. The abstract artist seeks to strip form of all distracting surface manifestations and irrelevancies in order to achieve a formal statement of the fundamentals of visual experience. The Expressionist strives to pictorialize his inner emotional experience, to express the intensity and character of his feelings through the art form. The realist, by contrast, believes that the complex surface appearance of objects is the outward manifestation of their total being, and that to describe this appearance embodies not only the artist's perception of their essence but also his feelings about them.

As it is impossible to say where realism ends and abstraction or Expressionism begins, no system of classification is valid that does more than group artists according to their most general tendencies. In the discussion of contemporary American painting in the next two chapters an attempt has been made to provide a general perspective, rather than to classify the bewildering number of modern "movements" by an arbitrary pigeonholing; any too-rigid system tends to distort, by oversimplification, the complexity of the artistic impulse.

SYNCHROMISM

The tendency toward abstraction initiated by Cézanne, the Fauve painters, and the Cubists received one of its earliest, most original, and most fully developed manifestations in the work of a group of painters who termed themselves the "Synchromists" because of their focus on color as the dominant factor in the creation of a painting. Though the movement involved a number of young Americans working in France, its fullest development occurred in the paintings of Morgan Russell (1886–1953) and Stanton MacDonald-Wright (1890–). By 1912 Russell had already expressed his interest in the structural use of color when he said that he wished to "do a piece of expression solely by means of color and the way it is put down, in showers and broad patches, distinctly separated from each other, or blended . . . but with force and clearness and large geometric patterns, the effect of the whole as being constructed with volumes of color." *Synchromy in Orange: To Form* (Fig. 533), a monumental canvas in both size and conception which Russell had completed by 1914, reveals the dynamism, strength, and compositional unity that characterized the early work of this pioneer abstract painter. Russell, who

533. MORGAN RUSSELL. *Synchromy in Orange: To Form.* 1913–14. Oil on canvas, 11′ 3″ × 10′ 3″. Albright-Knox Art Gallery, Buffalo, N. Y. (gift of Seymour H. Knox).

left : 534. JOHN MARIN. *Sunset.* 1914. Watercolor, $16^1/_2 \times 19^1/_8''$. Whitney Museum of American Art, New York.

experiences of home as a stimulus toward productivity. They found the familiar scene illuminated by their new and more unconventional ways of seeing.

THE STIEGLITZ GROUP

Alfred Stieglitz opened his gallery at 291 Fifth Avenue in 1906 as a place to show new trends in photography. In 1907 he commenced to show paintings by French and American moderns, and between that time and 1920 he sponsored a number of the progressive young Americans, including John Marin, Max Weber, Marsden Hartley, Arthur Dove, Georgia O'Keeffe, and Stanton Mac-Donald-Wright, whose work has already been mentioned.

One of the first of the American painters to develop a personal vehicle of expression from the new movements abroad was John Marin (1870–1953). Marin drew on French contemporary sources for many of his stylistic and technical devices, but he found his source of inspiration at home, did most of his painting here, and retained many traditional American elements in his work. While there is much of Cézanne and the Fauves in Marin, there is also much of Winslow Homer in his direct, fresh reaction to the coast of Maine and the out-of-doors. Marin went abroad between 1905 and 1910, returned home, and became one of Alfred Stieglitz' protégés.

Stieglitz recognized Marin's ability and originality, exhibited his work and sold it to collectors, and introduced him to modern painters from abroad. In this catalytic atmosphere Marin developed his natural bent toward a spontaneous, uninhibited, bold, and generalized style of painting. His earliest and best-known paintings are in watercolor. *Sunset* (Fig. 534), 1914, reveals the character of that early work. The compositional arrangement is simple. The main masses establish the spatial relationships between the foreground and the sparkling agitated water, sun-drenched distant islands, and radiant sky. The artist invented his own symbols to convey his elation at the splendor of the scene before him, and there is a perfect union between the direct, free manner in which he worked and the watercolor medium. The fresh washes, the direct calligraphy of the brush work, and the range of texture all convey the painter's excitement. The color is equally expressive, intense but neither arbitrary nor literal.

In a watercolor of a later date, *From the Bridge, New York City* (Pl. 19, p. 393), Marin employed a compositional device suggested by Cubism but adapted in a very personal and original way. The paper is composed by the arbitrary

stayed in France, gradually abandoned abstract and returned to figurative painting.

Stanton MacDonald-Wright, who returned to New York in 1916 and later moved to California, became the chief exponent of abstract, Cubist-oriented Synchromism. *Synchromy in Green and Orange* (Pl. 18, p. 376) provides an excellent example of MacDonald-Wright's style during this period, a style which might best be described as a dynamic interpretation of Cubism in which Cubist planes interpenetrate and overlap in richly modulated colors. He often employed a basically complementary color scheme, such as the blue and orange which predominates here, and then proceeded to harmonize and expand the color relationships by a third dominant hue, in this case green. This formula was established on the then-current theory of a color triad (three colors selected from approximately equidistant points on the color wheel). Upon this theoretical scaffolding he proceeded to work intuitively, introducing smaller quantities of intermediate hues, which were then modulated toward pale values with white and toward darks with black, to create beautifully organized, symphonic compositions. Color, abstract form, and dynamic movements provided his motifs.

Few American painters in the second and third decades of the century went as far toward abstraction as Russell and MacDonald-Wright; most preferred to retain identifiable subject matter in their compositions, and that subject matter seemed most often to be drawn from the American environment. After an extended period abroad most of the artists returned home, their tastes and attitudes immeasurably broadened. Excited, dedicated to new avenues of expression, they seemed to need the sights and

Plate 19. JOHN MARIN. *From the Bridge, New York City.* 1933. Watercolor, 21 7/8 × 26 3/4". Wadsworth Atheneum, Hartford, Conn.

Plate 20. CHARLES DEMUTH. *My Egypt*. 1927. Oil on composition board, 35 ¾ × 30″.
Whitney Museum of American Art, New York.

Plate 21. STUART DAVIS. *Report from Rockport*. 1940. Oil on canvas, 24 × 30″. Collection Mr. and Mrs. Milton Lowenthal, New York.

Plate 22. EDWARD HOPPER. *Early Sunday Morning.* 1930. Oil on canvas, 2' 11" × 5'. Whitney Museum of American Art, New York.

superimposition of a symbol of New York over a pattern of waves topped by a sky punctuated by a great, red, radiating sun. Freely rendered diagonals suggest elements of the bridge but serve primarily as a dynamic device for energizing the total composition, creating at the same time a sense of foreground, space, and distance. Arbitrary framing lines focus attention on the central elements of the arrangement. Here again the direct brush work, fresh textures, untouched areas of paper, and fluid nuances of color evoke the atmosphere of the island city surrounded by water and, more important, communicate the painter's ardor. Marin was one of the first American moderns to attract buyers, and his success encouraged other artists to free themselves from tradition and explore new ways of working.

Max Weber (1881–1961) was another early American modernist to explore the Cubist idiom. Arriving in Europe in 1905, he spent three years there, mostly in Paris, where he became acquainted with Matisse, Picasso, and other young radicals. Returning to America, he was one of the first to exhibit works in the modern manner, and, like most pioneers, he found little acceptance except for Stieglitz. His *Chinese Restaurant* (Fig. 535), painted in 1915, remained closer in both spirit and methodology to the synthetic Cubism being developed in Paris than did most American painting. Here a series of planes, enriched with patterns derived from a Chinese restaurant, are arbitrarily juxtaposed in a succession of kaleidoscopic

movements to shift the eye in space, suggesting multiple perspectives and a variety of simultaneous impressions. As the years passed, Max Weber, like the Cubists abroad, abandoned Cubism for less formal modes of expression. His later themes, drawn from New York Jewish life, are treated with expressionistic exaggerations (Fig. 536) to create a fervent but affectionate kind of caricature, somewhat akin to the work of Marc Chagall, a Russian-born Expressionist.

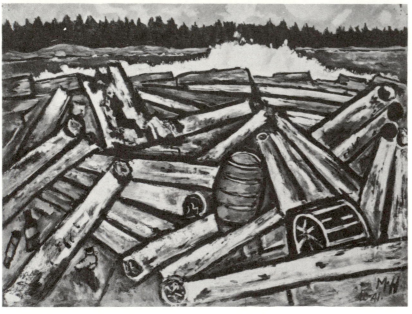

Arthur Dove (1880–1946), after his initial period of influence, almost disappeared for three decades from the public consciousness, only to be recognized in the early sixties as a masterful innovator. Dove went to Paris in 1907, and when he returned home, he naturally gravitated into the Stieglitz orbit. Essentially a nature painter, he distilled nature's forms into expressive symbols, and in his most original works his inner moods and emotions were more important to him than either external facts or concerns with formal elements of composition. By 1910 his "extractions," as he termed these early distillations from nature, were completely abstract, so that he must be recognized as one of the earliest abstractionists, American or European. *Distraction* (Fig. 537), a later work, painted in 1929, is also prophetic, for it forecasts elements of the Abstract Expressionism of the fifties in its impulsive lyricism. The broadly painted symbols appear to have been put down without premeditation, according to the dictates of momentary feelings. The patterns might be interpreted as flower and landscape forms treated with childlike naïveté, but the symbolic content is less important than the lyric mood. Arthur Dove was also one of the first Americans to try collage. His portrait of his grandmother was made of a bit of her needlepoint, a page from

her Bible, and a few ancient pressed flowers assembled on a weathered shingle background.

Marsden Hartley (1877–1943) observed the new trends in Italy, Germany, and France, but it was German Expressionism that made the strongest impact on his style. A number of his early paintings from about 1915, symbolic, vigorously patterned, and almost abstract, suggest turbulent, intense feelings constrained by a strong sense of organization. It was not until the thirties that Hartley discovered his subject matter, the landscape of Maine, and his ultimate manner, which conveyed strength of feeling through tense, calculated compositions. These later paintings are rugged to the point of a seeming awkwardness, the result of a conscious avoidance of slick formulas and obvious clichés. The forms are generalized, composed with powerful angular rhythms, and painted in a thick impasto with sharp lights and heavy darks. *Log Jam, Penobscot Bay* (Fig. 538) reveals the strength of his mature style. The forms of the landscape have been reduced to their fundamentals of pattern, tone, and color. By eliminating the literal and the trivial, Hartley communicates the truth of his insight and the intensity of his feeling. No attempt is made to alleviate the menace or lighten the brooding darkness of the Maine landscape. Though his idiom is of the twentieth century, Hartley's love of the sea, emotive impact, and direct honesty relate him to both Albert Ryder and Winslow Homer.

Not all of Stieglitz' protégés found inspiration abroad. Arthur Wesley Dow, Professor of Art at Teachers College, Columbia, introduced a number of students to the abstract elements of art and to the value of artistic organization as distinct from representation. The drawings of one of Dow's students, a young art teacher from Texas, came to the attention of Stieglitz, who promptly recognized their originailty and arranged to exhibit them. Eight years later he married this young woman, Georgia O'Keeffe (1887—). Her early works were frequently pure abstractions, sometimes flower forms enlarged until they lost their identity as flowers and became abstract compositions which reveal her sensitivity to rhythmic line movements and bold arrangements of color and dark and light (Fig. 539). In her later work the subject matter is clearly recognizable. Her paintings are typically feminine, intense, and lyrical. Blue sky above, flowers in hand, clean, white siding of a barn, or blanched skull in the sagebrush of New Mexico all stimulated her to transmute commonplace experiences into clear, elegant patterns.

THE TWENTIES AND THIRTIES

During the twenties and early thirties New York was unquestionably the center of modern art in America. The sympathetic critics and periodicals were there, and a number of progressive galleries, successors to 291 Fifth Avenue, appeared. Greenwich Village was the heart of the New York art world; Fifty-seventh Street was becoming the showcase. Artists from all over America were drawn to the metropolis in search of inspiration and recognition, and for many it also became a source of visual inspiration, its towering young skyscrapers and harsh industrial forms providing a living geometry for the Cubist-inspired enthusiasts.

Joseph Stella (1876–1946) found his stimulus in the American city, but he was moved most by its tempo rather than by the facts of its appearance. Italian-born Stella came to America when he was nineteen and began his career as an illustrator. A return trip to Europe brought him into contact with the French Cubists and the Futurists of his native Italy. The Italian Futurists, particularly concerned with portraying the dynamics of the new industrial age, frequently painted machine forms and other objects in a sequence of positions suggesting motion. Like the Cubists, they also portrayed their subjects as though seen simultaneously from a variety of points of view. Aware that these devices were well suited to his needs, Stella returned to America prepared to describe the exciting

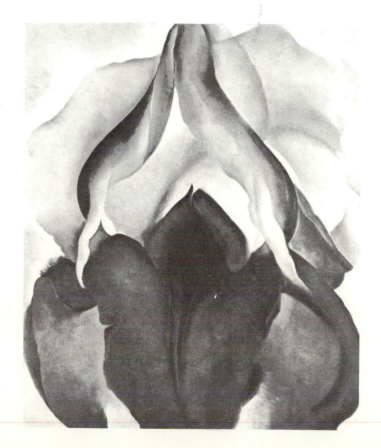

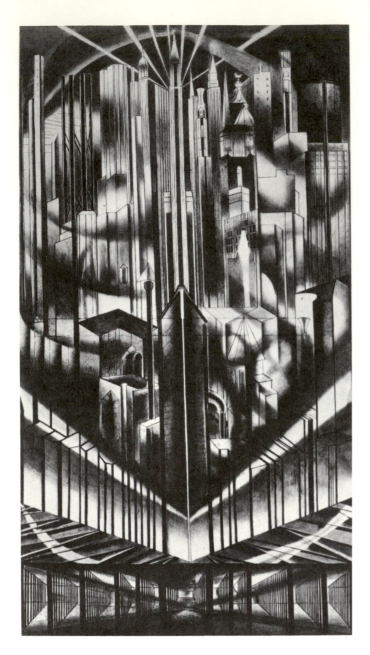

Cubism. Like many American painters of the twenties, Dickinson found that the city provided him with the play of angles, planes, geometric forms, and spatial thrusts that he loved. He did most of his paintings in Quebec and New York, working in turn with oils, watercolors, and pastels, all of which he used with sensitivity and vigor. In *Bridge* (Fig. 541) the foreground plane is firmly established with a few bold, clean forms. The bridge projects the eye forcefully into space, while the horizontal lines of the distant shore close the space and resolve the movements initiated by the heavier forms in the foreground. Cubism revealed to Dickinson the fascination of precise geometric patterns, shifting planes of movement, and active compositional arrangements; and Dickinson perceived these qualities in the cityscape. Unfortunately for the course of American painting, he died before reaching the age of forty.

left: 540. JOSEPH STELLA. *Skyscrapers.* 1922. Mixed media on canvas, 8′ 3 ¾″ × 4′ 6″. Newark Museum, Newark, N. J.

below: 541. PRESTON DICKINSON. *Bridge.* c. 1920–25. Watercolor, 18 × 12″. Newark Museum, Newark, N. J.

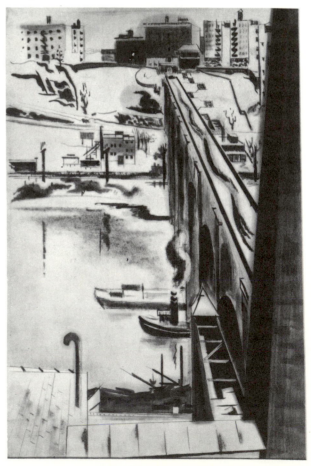

world about him. *Skyscrapers* (Fig. 540) is one of five panels called *New York Interpreted*. The patterns of the buildings rise in soaring lines, the vibrating darks and lights and shifting planes creating an intense and very personal vision of the city. The colors have the bright, sharp quality of artificial illumination. Stella's paintings have the geometric precision of the forms of the new industrial age, but, more important, they convey the dynamics of the American city, a sense of unlimited energy and movement.

Preston Dickinson (1891–1930) developed a strong individual style out of French Postimpressionism and

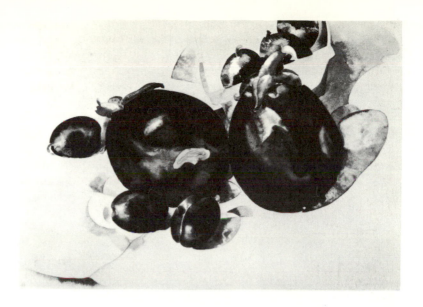

542. CHARLES DEMUTH. *Eggplants and Plums.* c. 1925. Watercolor, 11 ⅝ × 17 ¼". Art Institute of Chicago (Olivia Shaler Swan Memorial Collection).

The Immaculates

A number of the Cubist-realists in the twenties and thirties who found inspiration in the city and the forms of the industrial age came to be called "the Immaculates" or later "the Precisionists." Along with the Cézannesque and Cubist-derived devices which they adopted, there was an element of the early American puritanical tradition in their admiration of fine craftsmanship, in their precisely rendered, clean-edged forms, and in their need to reconcile the much-admired geometric patterns of Cubism with the facts of their environment. Preston Dickinson, Niles Spencer (1893–1953), Ralston Crawford (1906—), and, most notably, Charles Demuth and Charles Sheeler were the artists most frequently placed in this category.

Charles Demuth (1883–1935) was fascinated with the pattern-making potential of that which he saw about him. Born in Lancaster, Pa., he studied at the Pennsylvania Academy of the Fine Arts and visited Paris in 1904 and again between 1910 and 1914. Cubism heightened his sophisticated esthetic tastes and his sensitivity to simple shapes, clean lines, and geometric forms. An aloof elegance distinguished his paintings, which ranged in subject from illustrations of vaudeville and café life through still life to his most fully realized works, extolling the indigenous architecture of America. In *Eggplants and Plums* (Fig. 542) the crystalline clarity of the watercolor is matched by the precise elegance of the forms of fruit and vegetables, disembodied, weightless, and translated into a network of delicate planes, clear colors, and bold patterns. *My Egypt* (Pl. 20, p. 394), the title of which relates the past and present, is one of the first paintings to reveal the monumental nature of the industrial architecture of

America. The Cubist design which overlies the forms serves to emphasize the geometric components of the architecture and evokes a sense of the timeless grandeur of these severe utilitarian structures. In an age of pallid, imitative buildings, Demuth was one of the first to recognize the dignity and distinction of the vernacular. Demuth's color shares the cool clarity of his forms. In *My Egypt* the gray-white of the concrete grain elevators stands against the sharp turquoise of the sky. The sand and terra-cotta buildings at the bottom add a warm note which serves as a foil to the predominantly cool color harmony. It is a discreet and controlled color scheme, consistent with Demuth's reserved tastes.

Charles Sheeler, in his early years a most distinguished member of this group, will be discussed later.

Lyonel Feininger and Stuart Davis

Two more painters with an essentially Cubist orientation provided an additional important dimension to the modern movement in America. Lyonel Feininger (1871–1956), born in the United States, went to Germany at the age of sixteen and did not return here to live until 1937. An associate of Germany's *avant-garde,* he taught at the Bauhaus in its early years and was in close contact with the famous "Blue Rider" group, in terms of influence probably the German equivalent of the French Fauve and Cubist groups. Feininger's early style is well exemplified in *The Steamer "Odin"* (Fig. 543). Retaining identifiable elements of subject matter, Feininger developed a Cubist-oriented, almost abstract manner, in which a very logically structured composition was executed with great control. Sensitive relationships of large and small, rich color, and

graduated contrasts of value provide dramatic elements that prevent his carefully considered compositions from appearing cold.

The paintings and drawings done after his return to the United States provide an interesting contrast to his earlier work. In *Tug* (Fig. 544), similar in composition to *The Steamer "Odin,"* he achieved a subtle distillation of feeling through his logical composition and use of the watercolor medium. An almost architectural simplification of the great planes of water, sky, and floating smoke is infused with a vivid sense of the poetry of light, air, and space. The delicacy of the ink lines and fluid washes is such that one is barely aware of the strength of the organization. Feininger was one of the Americans to concern himself particularly with that logical approach to media and artistic structure which was the particular province of the Bauhaus.

Stuart Davis (1894–1964) commenced to paint under the influence of Robert Henri, and this influence may partially account for his continued concern with the colorful aspects of American life. A trip to Paris in 1928 confirmed his taste for the kind of stylized abstraction developed by the Synthetic Cubists, after which he developed his posterish, witty style. *Report from Rockport* (Pl. 21, p. 395)

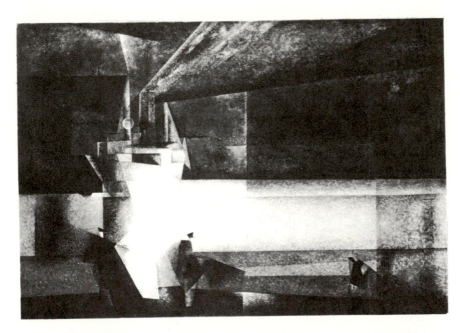

left : 543. LYONEL FEININGER. *The Steamer "Odin."* 1927. Oil on canvas, 26 ½ × 39 ½". Museum of Modern Art, New York.

below : 544. LYONEL FEININGER. *Tug.* 1941. Watercolor and ink, 12 ½ × 19". Solomon R. Guggenheim Museum, New York.

opposite : 545. STUART DAVIS. *Colonial Cubism.* 1954. Oil on canvas, 3′ 9″ × 5′. Walker Art Center, Minneapolis, Minn.

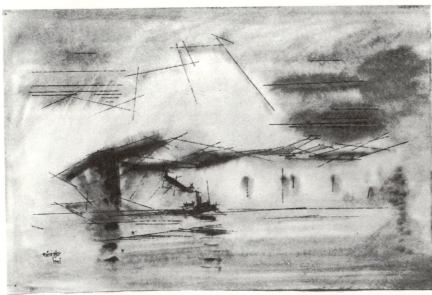

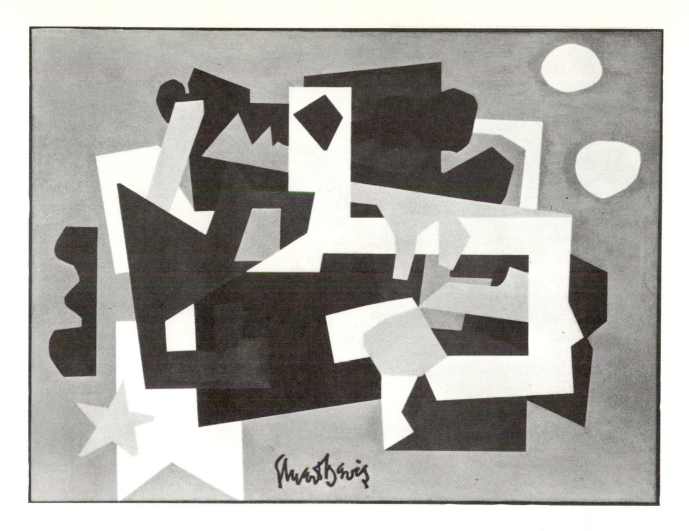

is typical of his work from the late thirties and early forties. The motifs that make up this lively composition are derived from the resort atmosphere of Rockport, Mass., in summer. Some of them are easily identified: the gasoline pump, the street signs, the numbers. Others are abstracted beyond recognition, but the prevailing atmosphere is of summer vacationing. The colors, though subtle, are bright and appealing. Yet, at the same time as they provide sensuous charm, they function as elements in an organization that both respects the validity of the picture plane and projects a convincing sense of space.

Though an abstractionist, Davis was a painter of America; he loved jazz, with its precision, rhythm, vigor, and inventiveness—qualities which are reflected in his paintings. He saw many things about him that made him want to paint—"the brilliant colors on gasoline stations, chain store fronts, and taxicabs—fast travel by train, auto, and airplane—electric signs." In texture, character, and tempo his paintings suggest American life. *Colonial Cubism* (Fig. 545) represents his later paintings, which

tend to be simpler, more geometric in form, more confined to basic hues. Like his earlier work, they reflect a gay, carefree, contemporary mood. The handsome colors, ingenious interlocking patterns, dynamic rhythms, and frequent surprises reveal taste, wit, and originality. It is a sophisticated art which was developed from our rich cosmopolitan culture.

An element of hedonism, of sensual delight in the beauties and pleasures of nature and people, constituted an important element of Fauve painting, particularly that of Matisse. While the Immaculates found satisfaction in their somewhat cold, Cubist-inspired realism, other Americans found in modern French painting inspiration for a more free, direct, and personal mode of expression.

Walt Kuhn (1880–1949), excited by the Fauves, painted acrobats and entertainers with a broad simplification of form and a free style of execution that recall the early work of Matisse. The Fauves also proved a source of inspiration to two later figure painters, Milton Avery and Yasuo Kuniyoshi.

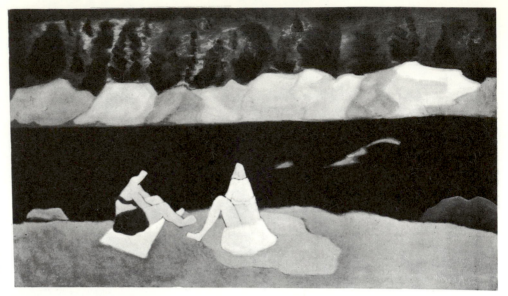

right : 546. MILTON AVERY. *Swimmers and Sunbathers.* 1945. Oil on canvas, 28 × 48¹/₈″. Metropolitan Museum of Art, New York (gift of Mr. and Mrs. Roy R. Neuberger, 1951).

below : 547. YASUO KUNIYO- SHI. *Amazing Juggler.* 1952. Oil on canvas, 5′ 5″ × 3′ 4¼″. Des Moines Art Center, Des Moines, Iowa (Edmundson Collection).

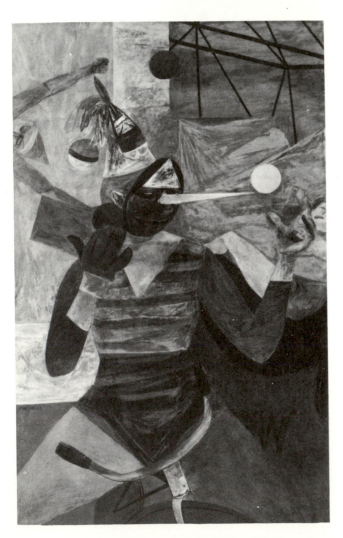

Few artists maintained a consistent style as long as Milton Avery (1893–1965); his deceptively simple canvases, radiating a serene, untroubled, sensuous charm, attracted a loyal following among critics and collectors over many decades. His typical canvases are composed in a landscape or interior setting with subordinate human figures providing a counterpoint to the other forms (Fig. 546). Avery learned much about color composition and the role of simplification from Matisse, but his angularities of form and strongly organized spatial compositions are more calculated and less frankly decorative than the later Matisses. In *Swimmers and Sunbathers* the bold piercing of the parallel landscape masses by the awkward figures is startling; yet, through the stark contrasts, a charming and almost ingenuous statement concerning man's intrusion on nature is made.

Yasuo Kuniyoshi (1893–1953) came to America from Japan when he was in his teens, and the naïveté of style that distinguished his early work has been attributed to his lack of schooling in perspective, life drawing, and the other elements of the Western artist's traditional training. Whatever the reason, his paintings of the twenties employ many of the mannerisms of folk art but in a witty and cosmopolitan way. Exposure to the school of Paris, particularly to Jules Pascin, brought an additional painterly sophistication to his already playful manner. *Amazing Juggler* (Fig. 547) contains many elements typical of his highly personal and charming style. The subject, drawn from the lighthearted world of entertainment, is enriched by the piquant, slightly ominous overtone of the slit-eyed, sword-nosed mask worn by the juggler. The clumsy hands almost contradict the deftness of the juggler's craft. The

beautifully composed forms rise from a stable base to culminate in light, vivacious movements. Lastly, the sensuously brushed pigment, iridescent, even sharp, in color, adds another stimulating element. Through a very individual idiom Kuniyoshi was able to project his pleasurable world of fantasy-reality in paintings of great appeal.

Abraham Rattner (1895—) was born and raised in the United States but spent most of the twenties and thirties living and painting in Paris, where he absorbed many of the ideas of Picasso, Braque, and Rouault. His mature paintings are rich and full-bodied in color, using jewel-like, intense colors in complexly orchestrated relationships. The paint is applied in a thick impasto, so that it has a heavy, glittering texture, and frequently the masses of color are outlined with black or strong darks to stress the formal aspects of the design. *The Emperor* (Fig. 548) employs a number of Picasso-like devices: the head, seen in profile and then full face, the arbitrary dislocations of anatomical forms and space relationships, and the vigorous angularities of pattern. *The Emperor*, like many of Rattner's paintings, uses an accepted symbol as the basis for a multifaceted statement with broad philosophic implications. The emperor, a ruler of men, appears at the same time a questioning, uncertain, perhaps even a frightened man. Though he imposes his will on others, he, too, seems like a pawn in a chess game. It is an ambiguous statement, full of ironic implications, a stimulus to further thought and observations.

THE AMERICAN SCENE

The late twenties and early thirties witnessed a change of mood. This change of emphasis had already been foreshadowed in the later work of George Bellows. A significant number of artists seemed to feel the need to integrate the findings of Cubism and Expressionism with the older American tradition. Most of the expatriates had returned home, more sophisticated and wiser, accepting the creative artist's need for his native environment. They had learned much from the disciplines of Cubism, Expressionism, and abstraction. Even when they were painting with photographic fidelity to actual appearances, as Sheeler did, they thought in terms of formal and abstract elements, building their line movements, dark-and-light patterns, and color harmonies into calculated compositional structures. Though carefully designed, their paintings were also strongly felt, and the sensitivity to formal values did not preoccupy the artists to the exclusion of simple human values. Three men, Charles Sheeler, Edward Hopper, and Charles Burchfield, stand out in retrospect as having done more than any others to fuse the experiments that followed the Armory Show with the older American-scene tradition of Winslow Homer, Thomas Eakins, and The Eight.

Charles Sheeler

The early Charles Sheeler (1883–1965) had much in common with the Immaculates. Born in Pennsylvania, he was introduced to Cubism abroad. In American traditional architecture and contemporary industrial buildings, Sheeler discovered clear forms consonant with Cubist tastes and ideals. Cubism sharpened his vision, and photography, a means of earning a livelihood, also revealed the formal potential of realism. From these two disciplines, he evolved his sharp, objective style of painting. Sheeler believed that "a picture could have incorporated in it the structural design implied in abstraction, and be presented in a wholly realistic manner" and that the greatest artists present an object "in all its three hundred and sixty degrees of reality rather than the hundred and eighty degrees which the physical eye takes in." *Upper Deck*

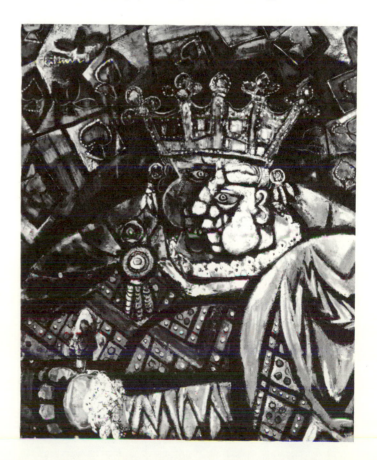

right: 548. ABRAHAM RATTNER. *The Emperor*. 1944. Oil on canvas, 28 ¾ × 23 ¾". Whitney Museum of American Art, New York.

left : 549. CHARLES SHEELER. *Upper Deck*. 1929. Oil on canvas, 29 × 21 ¾". Fogg Art Museum, Harvard University, Cambridge, Mass. (Louise E. Bettens Fund Purchase).

below : 550. CHARLES SHEELER. *Incantation*. 1940. Oil on canvas, 24 × 20". Brooklyn Museum (Ella C. Woodward Memorial Fund, 1949).

(Fig. 549) has been viewed with both the physical eye and the mind. Its clarity of form is supravisual, a reflection of the discerning artist who sees in the utilitarian ventilators and motors fascinating complexities and beauties of form.

Sheeler made a number of paintings of the great industrial plants around Detroit between 1927 and 1930, and these paintings are permeated with an optimistic feeling of confidence in the scene before him. Man was ordering nature along rational and productive patterns, and in Sheeler's paintings the towering factories and storage silos stand with the same grandeur and dignity as the columned temples of ancient Greece. Where others a few years later would see the industrial scene as a source of exploitation, injustice, and conflict, Sheeler saw it as serene and orderly.

Much of Sheeler's love of industry grew out of his love for geometric patterns, and many of the paintings of his later years are dominated by this taste. *Incantation* (Fig. 550) approaches abstraction. Here the rational, even formal, compositional arrangement, the striking simplifications, the well-disciplined techniques, and the austere elegance of the painting all serve to reveal the artist's essentially classic orientation. It is this unique and timely combination of the abstract painter, the realist, and the classicist that has made Sheeler a particularly significant figure in the art of our day.

Edward Hopper

Edward Hopper (1882–1967) also served his apprenticeship in Paris and went through the experience of modern experimental painting, but his deep need to create an art of intense reality out of the familiar world led him to abandon the rising tide of the stylish international modes. Hopper stated his credo as, "Instead of subjectivity, a new objectivity; instead of abstraction, a reaffirmation of representation and specific subject matter; instead of internationalism, an art based on the American scene." The first of Hopper's paintings to attract the attention of critics and collectors were of New England—views of homes and lighthouses illuminated by the cool light of the seashore. Even after Hopper found the subject matter of his mature years in the life of the city, this sensitivity to the quality of light, whether electricity, dawn, or dusk, remained one of the deeply emotive elements of his art.

Architecture, too, plays a role in Hopper's work by providing a setting for the drama, for his paintings always imply a drama, albeit one of routine human life. They are never melodramatic but rather describe everyday living, and the human factor is ever present, suggesting the continuous flow of life. This suggestion distinguishes Hopper's paintings from those of most of his contemporaries and gives them an added importance. One is keenly aware of the quality of human life behind his façades—life in all its loneliness, ugliness, affection, and nobility. An archetype of commonplace existence, each Hopper painting sums up a myriad of familiar visual experiences and from them creates a powerful, deeply emotive work of art.

Early Sunday Morning (Pl. 22, p. 396), painted in 1930, is one of Hopper's greatest canvases. As in all his major works, the subject is drawn from the most common level of experience. A sense of drama is created by the absence of people, ordinarily an integral part of the scene, and by the warm, low light of early morning. The rising sun catches the ripple of an awning and throws the long shadows which, like a stir of life, silently foretell the coming day. The somber harmony of red brick and green store fronts is relieved by a few sharp, bright accents, the striped barber pole and yellow window shades. Color is never used for its sensuous charm alone, just as no forms are introduced merely to satisfy an arbitrary concept of composition.

The play of rectangles in the second-story windows, like the alternate door and window shapes of the ground floor, are varied as slightly as the monotonous street, continuously the same and continuously different. This is not the clear-cut, exciting geometry of Sheeler's industrial world, but the pattern of everyday living—the shabby rectangularity of prosaic life, with its chipped corners, its leaning verticals, its prophetically sagging horizontals. There is nothing depressing in the vision, for Hopper was not cynical about life. The commonplace world is seen in dignified, monumental terms, and enriched with feeling.

Most of Hopper's paintings are in oil, and he handled the medium in broad planes without a flourish. He neither made a fetish of a painterly handling of oils nor lost sight of their rich heaviness. His watercolors reveal an equal sensitivity to that medium, never lapsing into thin generalities or brushy virtuosity (Fig. 551).

New York Movie (Fig. 552) takes as its subject the gaudy, synthetic baroque movie palace of the city, with

above: 551. EDWARD HOPPER. *The Mansard Roof*. 1923. Watercolor, 13 3/4 × 19 9/16″. Brooklyn Museum.

left: 552. EDWARD HOPPER. *New York Movie*. 1939. Oil on canvas, 32 1/4 × 40 1/8″. Museum of Modern Art, New York.

its promise of life, warmth, and excitement. Its glowing lights and ornate furnishings, like the glamorous events on the luminous screen, seem designed to keep out the cold, dark streets and shabbily furnished apartments from which the patrons seek escape. Hopper composed the various elements involved in this drama of space, light, form, and human experience with admirable power. The great vertical mass of the foyer wall provides a ponderous, immovable form that establishes both the actual scale and the pretense of the interior. On one side of the wall, the emotive space of the auditorium carries one's eye to the diffused image on the far screen. In the shallow, undistinguished aisle at the right, the usher stands in boredom, as mesmerized by her thoughts as the patrons are by the shadows on the screen. The forms and spaces are solid realities, weighty, voluminous, tangible. The light provides the drama; the human dream, the mood. A myriad of such ordinary impressions register in our unanalytical consciousness each day and lie dormant, a potential reservoir of deep feeling. Hopper's unique capacity was his ability to cast these impressions into memorable monumental patterns.

Charles Burchfield

Charles Burchfield (1893–1967) also loved the face of America, but whereas Sheeler found beauty in the contemporary technology and Hopper in the big city, Burchfield was the interpreter of the American small town and rambling suburb. Burchfield grew up and did his first paintings in Salem, Ohio—a town with a railway line, a few factories, stores, quiet streets, and modest houses set amidst farm lands, a link between America's past and present. Later a position designing wallpaper took Burchfield to live in Buffalo, and he purchased a home in a small nearby town. There he proceeded to develop as an artist. In his earliest work Burchfield employed decorative, somewhat expressionistic simplifications of line and pattern to communicate his strong sense of the rhythmic forces of nature. As he matured in his control of form, space, and color, he kept his tendency to simplify and dramatize. *Ice Glare* (Fig. 553), from his middle period, is

above : 553. CHARLES BURCHFIELD. *Ice Glare*. 1933. Watercolor, 30 ¾ × 24 ¾". Whitney Museum of American Art, New York.

right : 554. CHARLES BURCHFIELD. *Sun and Rocks*. c. 1950. Watercolor, 3' 4" × 4' 8". Albright-Knox Art Gallery, Buffalo, N. Y.

555. REGINALD MARSH. *Coney Island Beach, Number 1*. 1943. Watercolor and ink, 21 ½ × 29 ½″. Whitney Museum of American Art, New York.

in his mature, though not his final, style. Burchfield worked most effectively in watercolor, but his use of the medium was personal and unique, consisting of small brush strokes of transparent color laid one over the other to build up solidly wrought forms and spaces. *Ice Glare* could represent a winter's day in Buffalo or in the back streets of any middle-sized Midwestern community. It reveals a world of awkward angularities—porches, brick warehouses, and treeless streets, unrelieved except for the harsh accents of telephone poles. The frame houses and brick buildings typify everything the expatriates hated about America, but Burchfield, like a host of writers of the same period, knew these prosaic scenes with both love and hate and from his ambivalence could create powerful images. In this shabby and unprepossessing setting the sharp sunlight and bold shadows create a world of energetic shapes; the artist seized the vigor and sense of life evoked by these patterns. Burchfield, like Hopper, was a master of light, light as it reveals, conceals, and dramatizes, and by its use he created patterns which are known to us and therefore have power to move us.

In his late work Burchfield returned to the awarenesses of his childhood, to the wonders of nature revealed as he wandered through the woods. The wind and the sun, the changing seasons, the forces of growth and decay provided his subject matter (Fig. 554). By means of stylized simplifications of form and sweeping rhythms of line suggesting the expressionistic style of his earliest works, he symbolized the mysterious forces of nature. Burchfield created in big, broad patterns to convey his strong feelings. The rhythmic movements with which he designed his large compositions are as fundamental as his human con-

victions, and the strength, honesty, and simple humanity of his paintings helped to counterbalance the overwhelming sophistication of much contemporary expression.

The New York Scene

Generations of painters had found a special magic in New York City. It had inspired The Eight, many of the later Cubist-oriented painters, and a host of others who cannot be discussed in detail here, among them Abraham Walkowitz (1880–1965), Glenn Coleman (1887–1932), and Kenneth Hayes Miller (1876–1952). Miller was particularly important in the late twenties, for he not only turned the eyes of his students to the genre of New York life, but he also revived an interest in the technical methods and compositional theories of Renaissance and Baroque masters. It is not surprising, then, that in the thirties and forties, when "regional" schools of painting sprang up all over America, New York had its special advocates.

No painter chronicled the throbbing, intense life of the modern metropolis with more enthusiasm than Reginald Marsh (1898–1954). After graduation from Yale, Marsh studied with Sloan and Luks and served as an illustrator for magazines and the tabloid *Daily News*. This experience, his own temperament, and later study with Kenneth Hayes Miller turned him toward his eventual subject, the life of New York and its continuously fascinating human types and activities.

Marsh's characteristic paintings depict the energy and vitality of the city. His preference was for the crowded streets, the burlesque shows, the honky-tonks, and the teeming beaches. He painted Coney Island (Fig. 555)

left : 556. RAPHAEL SOYER. *Farewell to Lincoln Square.* 1959. Oil on canvas, 5' × 4' 2". Joseph H. Hirshhorn Foundation, New York.

below : 557. ISABEL BISHOP. *Two Girls.* 1935. Oil on canvas, 20 × 24". Metropolitan Museum of Art, New York (Arthur H. Hearn Fund, 1936).

endlessly, because "a million near-naked bodies can be seen at once, a phenomenon unparalleled in history." The cavorting beach crowd provided him with a panorama of the thin, the fat, the old, and the young, struggling, making love, sleeping—without dignity or beauty, or, for that matter, ugliness, but living and exuding energy. It is this sense of overwhelming energy that provides the reaffirming note in Marsh's paintings. Marsh drew on the Renaissance and Baroque traditions rather than the Impressionist, Postimpressionist, and modern. Hogarth and Rowlandson, Rubens, and the great Venetians suggested his mode of representing the human figure through a clearly articulated anatomical structure. The Renaissance masters also inspired his compositional arrangements, for it was by building up pyramidal structures from the masses of undignified, writhing bodies that he endowed his beach scenes with monumentality of scale. Marsh painted in a variety of media. *Coney Island Beach, Number 1*, like many of his later paintings, is in watercolor and ink, with only occasional additions of pale color animating the black, white, and gray. The light, airy tonality achieved by the limiting of color provides a note of esthetic restraint which keeps the exuberant action and complicated design from overwhelming the observer.

The Soyer brothers, Moses (1898—), Isaac (1907—), and Raphael (1899—) were also painting the New York scene in the thirties and forties. The theater, shop girls, public parks, and street scenes provided the subjects for their Degas-like vignettes. Raphael, the most original and powerful of the trio, continued his particular vein well into

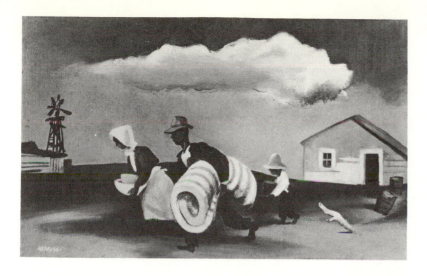

558. WILLIAM GROPPER. *Migration*. c. 1932. Oil on canvas, 20 × 32″. Arizona State University, Tempe, Ariz. (Oliver B. James Collection of American Art).

the sixties, his color becoming richer, his brush work freer, and his compositions more complex in his later years. *Farewell to Lincoln Square* (Fig. 556) strikes a note that is both sentimental and reticent. Strongly composed, with its wedge of sharply delineated characters moving forward in a mood of nostalgic reverie, the scene is invested with quiet dignity. Soyer's own face peering out from between the two girls is a masterpiece of painterly characterization.

Alexander Brook (1898—), Louis Bouché (1896—), and Isabel Bishop also concentrated on the human aspects of the city. Isabel Bishop (1902—), like Marsh a student of Kenneth Hayes Miller, preferred the full, rounded forms and the stable compositional arrangements of the old masters. Her *Two Girls* (Fig. 557), with its pale colors and richly textured surface, reveals sympathetic observation and sensitive and persuasive draftmanship.

THE SOCIAL COMMENTATORS

The affirmative note that distinguished the paintings of the American scene was not to be maintained for long. A new and more strident tone was forthcoming, for the American economy and way of life was to be challenged by a series of economic and social disasters. The crash of the stock market in 1929, the Great Depression of the thirties, the threat of Fascism abroad, and the second World War in the early forties introduced a critical and, at times, combative note that was new to American painting.

The Depression was to the artists of the thirties what the Armory Show had been to those of the twenties, providing the key to the chief departures from the dominant conventions of the preceding period. The painter of the twenties saw no need to concern himself, as an artist, with the general problems of our economic life and social organization, feeling that if he painted honestly and

managed to support himself he was satisfying his obligations. The Great Depression of the thirties turned many to an awareness of the fundamental human problems of social and economic dependence. Artists, never too secure, found themselves in a particularly precarious situation. As private fortunes shrank, the artists' regular patrons disappeared. Isolated from the general public by a long tradition of mutual distrust and indifference, artists realized that even the tax-supported relief program instituted by the government depended on public sympathy. Esoteric concerns on the part of the artists could alienate the public and endanger the little financial assistance available.

It was not only personal need that turned the artists' attention to economic problems and away from an exclusive concern with matters of style. As the Depression deepened, many became conscious of inequalities which threatened the democratic way of life. The tragic plight of the vast numbers of unemployed necessitated heavier taxes for public relief programs, which made inroads on the comforts and privileges of the upper-middle and wealthy classes and intensified conflict between the haves and the have-nots. Since the Renaissance artists have participated in political and social struggles. Many American artists of the thirties jumped into the fray, and a vigorous school of social propagandists appeared.

Problems of style, naturally, remained fundamental, but style was disciplined to achieve social effectiveness. Some of the most belligerent of the painters adopted a journalistic manner in which broad, almost caricatured simplifications were used to provide maximum impact. William Gropper (1897—) was one of the most vigorous of these. A professional caricaturist, he employed in his paintings the same broadly conceived, simplified symbols of workers, capitalists, politicians, and other figures as in his journalistic production. *Migration* (Fig. 558)

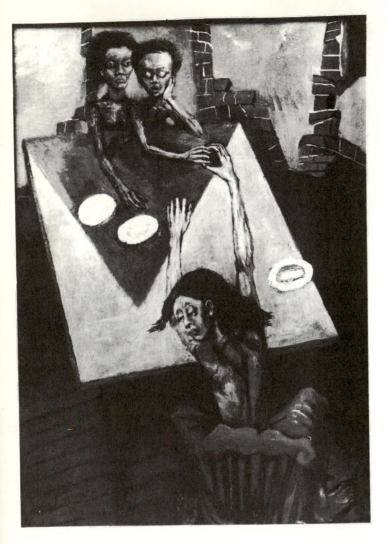

dramatized the plight of dispossessed farmers of the southwestern dust bowl, forced to leave their arid and barren farms and wander across the face of America in search of a livelihood. The gaunt forms, harsh tonalities, and simple compositional relationships were carried so far that they ceased to provide moving symbols of this great and tragic drama and instead become visual clichés. Despite the obvious limitations of Gropper and his fellow propagandists, their passionate indignation helped make America aware of mounting social responsibilities.

However, not all the painting which focused on the social problems during the thirties and early forties drew on journalistic caricature for stylistic inspiration. Philip Evergood (1901—) achieved his angry protests against hunger, war, and injustice through intense and vehement expression. *Don't Cry, Mother* (Fig. 559) drew on deep levels of bitterness for its powerfully realized forms. The curious triangle on the table top dramatizes the empty plates and reinforces the anguished gesture of the mother and the hopeless apathy of the starving children. Evergood's manner was derived largely from the Expressionists and the social realists of central Europe, and he employed typical Expressionistic distortions of anatomical forms, exaggerations of details, and violations of perspective. He is best known for his later paintings, in which social protest gave way to a personal, often obscure symbolism combining fantastic and realistic elements.

Among the many areas of social conflict brought about by the Great Depression was that of racial exploitation. Robert Gwathmey (1903—) frequently painted Negroes in a manner which combined social indignation with esthetic sophistication (Fig. 560). Jacob Lawrence

above: 559. PHILIP EVERGOOD. *Don't Cry, Mother.* 1938–44. Oil on canvas, 26 × 18″. Museum of Modern Art, New York.

right: 560. ROBERT GWATHMEY. *End of Day.* 1943. Oil on canvas, 30 × 36″. International Business Machines Collection, New York.

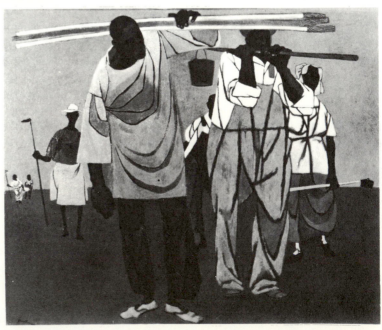

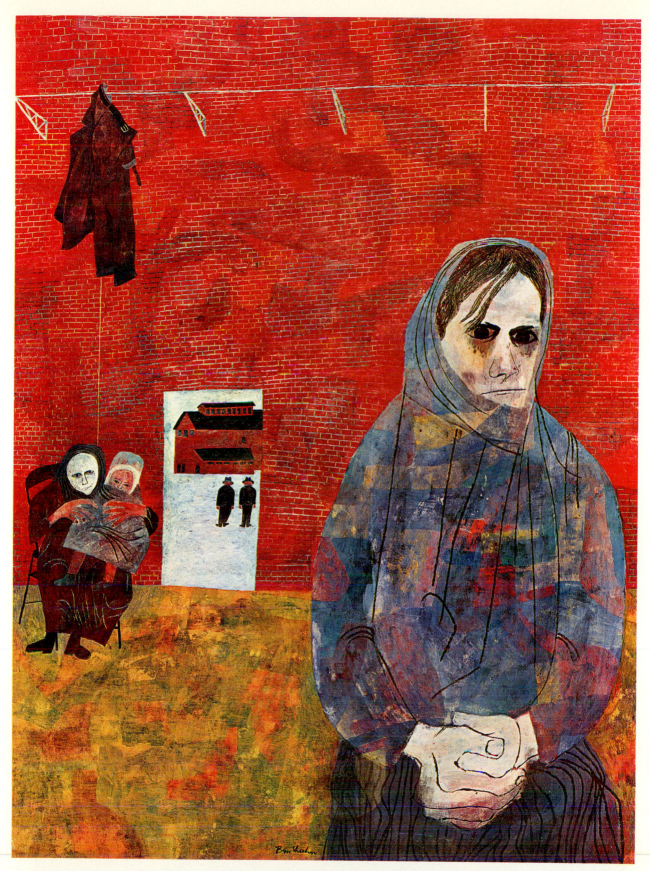

Plate 23. BEN SHAHN. *Miners' Wives*. 1948. Oil on canvas, 48 × 36″.
Philadelphia Museum of Art.

Plate 24. ANDREW WYETH. *Christina's World.* 1948. Tempera on gesso panel, 32 ¼ × 47 ¾". Museum of Modern Art, New York (purchase).

(1917—), himself a Negro, was intensely concerned with social iniquities, particularly racial injustice. At times content merely to chronicle the shabby world of the urban ghetto, he created his most powerful works as statements of protest, such as his *One of the Largest Race Riots Occurred in East St. Louis* (Fig. 561), from *The Migration of the Negro* series. The startling vehemence of this painting is achieved through its tense composition and its use of harsh angularities of pattern and bold simplifications of form. The strange dislocations of size and space relationships appear to reflect elements from Expressionism, primitivism, and even Cubism, but in the final analysis they grow from the artist's unique capacity to draw upon the depths of his feeling and speak with intuitive urgency. Lawrence, like so many other artists of social

protest in the thirties and forties, commenced his career in a settlement-house art class and in his early years was supported by the Depression-born W.P.A. (Works Projects Administration) Art Project.

Peter Blume (1906—), born in Russia, came to America as a child, lived on the lower east side of New York, and later moved to Brooklyn. Having grown up in an atmosphere of skepticism concerning the established order, he included an element of social criticism, either directly stated or implicit, in his painting. His style reveals the impact of the meticulous, sharp-focus manner of the German social realists of the twenties, who combined awkward angularities and curious, almost caricaturelike distortions in precise, clear images. *Light of the World* (Fig. 562), like much of his painting, implies a generally

right : 561. JACOB LAWRENCE. *One of the Largest Race Riots Occurred in East St. Louis.* Panel 52 from the series *The Migration of the Negro.* 1940–41. Tempera on composition board, 12 × 18″. Museum of Modern Art, New York (gift of Mrs. David M. Levy).

below : 562. PETER BLUME. *Light of the World.* 1932. Oil on composition board, 18 × 20¼″. Whitney Museum of American Art, New York.

critical attitude toward modern life rather than an attack on a particular facet of the social order. A marvelously radiant symbol of electricity occupies the center of the canvas. It is surrounded by awestruck, gaping people, who, though obviously bewildered, look to the miracle of modern science and engineering for their salvation. The church, the "light of the world" in past ages, stands in darkness. Much of Blume's later work, complex and elaborate in its symbolism and in its composition, is less direct in its criticism of the social order.

Ivan Le Lorraine Albright (1897—), a Chicagoan, is less a social critic than a poetic pessimist. Stylistically, Albright seems an independent. His meticulous detail, as exacting as that employed by Blume or the German social realists, makes his pessimism even more all-pervasive. Albright first came to national notice in the thirties, when the regionalist movement focused attention on the ferment and originality of Middle Western culture. Albright is a painter of people and things, and his pinpoint vision is attuned to the corrosive, sad poetry of time. In *Fleeting Time, Thou Hast Left Me Old* (Fig. 563) he developed the theme in his typical manner. The forms are bathed in a harsh, raking light that reveals all the worn surfaces —the wrinkles, hairs, and veins with which age covers the human body, as well as the frayed, tattered, mildewed, and cracked surfaces which the passing of time brings to things. From such tawdry material Albright created a strange, melancholy, and haunting vision of curious strength and originality. He works on each of his canvases for many years, slowly building up the intricate surface textures and involved forms to achieve his own particular intensity. The title of one of his latest canvases, on which he labored for over fifteen years, sums up his unique and pessimistic attitude toward life: *Poor Room—There Is No Time, No End, No Today, No Yesterday, No Tomorrow, only the Forever, and Forever, and Forever, without End.*

The affinity between the social realists and the Expressionists of central Europe was strengthened by the arrival here of a number of refugee artists who left Germany after the advent of Hitler. Hitler declared war on all progressive artists, particularly the propagandists who had attacked reaction and Fascism. George Grosz (1893–1959), probably the most influential German refugee artist to seek asylum in America, had been one of the vitriolic critics of the greedy parasitic groups who exploited disorganized Germany after World War I. After his arrival in America, Grosz continued painting in the brilliant, ironic, and bitter style that had brought him renown in Europe. Grosz was, above all else, master of the Expressionistic watercolor. *Couple* (Fig. 564) reveals his unique ability to expose the weaknesses and complacency of the soft, luxury-loving, self-satisfied urban dweller. The human animal is seen stripped of all nobility and virtue, the self-indulgent product of a decaying society. Grosz was particularly deft at describing a wide variety of surface textures with watercolor, using biting lines and shimmering luminosities to suggest crepey skins, boney protuberances, rouge, satin, fur. No artist has used watercolor with a greater sense of its fluid loveliness, but the sensuous charm of the medium never softens his bite.

Shahn and Levine

Tragic events of an all-encompassing nature evoke reactions of corresponding intensity. Two artists of particular originality who reacted with power and maturity to the violence of Fascism and World War II were Ben Shahn and Jack Levine.

Ben Shahn (1898–1969) was born in Lithuania and came to New York as a child. He grew up in a tough, realistic atmosphere in which hatred of injustice and distrust of authority were both common, and he has used his art to give an impassioned expression to these attitudes. At the age of sixteen he went to work as an apprentice in a lithography house, where he developed his certainty of line and uncanny sense of telling detail. In the twenties he traveled and studied in Europe; then he returned to America to resume his fight against the evils of a society that was daily sinking deeper into a slough of despondency and conflict. *Scotts Run, West Virginia* (Fig. 565) is in the bitter and powerful style which first attracted attention to his painting. The men stand idly among the lean, shabby houses and angular boxcars. Their sad eyes, hard, hopeless faces, and lax gestures are endowed with a biting intensity through Shahn's harsh delineations and expressive exaggerations. The deep compassion that lies behind this harrowing protest against the tragedy of dispossessed people and wasted lives is made all the more effective by Shahn's avoidance of the stylistic clichés of righteous indignation and moral fervor.

A number of the devices by which Shahn achieved his impact were rooted in the styles of the early twentieth-century German Expressionists. His acid line often reminds one of the early George Grosz, as does his use of oversized hands; his unidealized segments of reality recall the social realism of Otto Dix. It was in this latter vein that Shahn was at times content merely to evoke the acrid

above : 564. GEORGE GROSZ. *Couple.* 1934. Watercolor, 25 ¼ × 17 ¾″. Whitney Museum of American Art, New York.

left : 565. BEN SHAHN. *Scotts Run, West Virginia.* 1937. Gouache, 22 ³/₄ × 27 ¹/₈″. Whitney Museum of American Art, New York.

left : 566. BEN SHAHN. *Hand-ball*. 1939. Tempera on paper over composition board, 22 ¾ × 31 ¼″. Museum of Modern Art, New York (Abby Aldrich Rockefeller Fund).

opposite : 567. JACK LEVINE. *Welcome Home*. 1946. Oil on canvas, 3′ 4″ × 5′. Brooklyn Museum.

atmosphere of metropolitan reality. *Handball* (Fig. 566) reveals Shahn as a master of analytic observation. Here moral fervor gives way to describing the familiar environment with a passionate clarity of vision.

In the late forties and fifties the direct manner of his earlier years became modified by esthetic sophistication; his surface textures became more calculated and complex and his color more harmonious and subject to subtle modulations. *Miners' Wives* (Pl. 23, p. 413) is an excellent example of his postwar paintings. It is less spontaneous than *Scotts Run, West Virginia*, and its impact is less immediate. Yet one has only to observe the tragic faces of the women, their hands deformed by heavy work, and sense the grim bareness of setting, to know that his style has lost none of its bite. The acidulous yellow-greens of the floor, the hard red of brick, the cold blue of the out-of-doors, and the denim blue-gray of the women's clothes are, paradoxically enough, at the same time sensuously pleasing and evocative of the ugly realities of a world without grace or pleasure. Shahn did not lose his warm human sympathies in the face of esthetic sophistication; he is reputed to have said: "Is there nothing to weep about in this world any more? Is all our pity and anger to be reduced to a few tastefully arranged straight lines or petulant squirts?" Although Shahn made his most significant impact upon the contemporary world through his paintings, his writing, particularly his *The Shape of Content*, a published series of lectures he delivered at

Harvard, represents an important contribution to modern esthetic philosophy.

Jack Levine (1915—) is the youngest and perhaps last of the great social satirists born of the troubled mid-century. Levine was born in Boston. He attended a settlement-house art class, and his talent came to the attention of a Harvard art professor who introduced him to the old masters, including Daumier. Like Daumier, Levine is at his most brilliant when he is attacking the corrupt, hypocritical, and self-indulgent elements of society. *Welcome Home* (Fig. 567) reveals his distaste for success, authority, and the shrewd men and women who, he feels, dishonor power. Levine's devices for distorting and editorializing tend to be more traditional and painterly than those used by Ben Shahn. The heads are enlarged, as in a medieval Flemish painting. The faces, which almost caricature social types, remind one of Chaim Soutine's work in the way the distortions of features carry psychological implications. His application of paint recalls Rubens and the Baroque masters. Colored glazes which provide a beautiful translucent surface are contrasted with a heavy impasto of paint applied in direct, active strokes. Thus the canvases are both subtle in their tactile beauty and yet have a vigor and incisiveness of execution that sharpen his criticisms of the social scene.

Though Levine is very aware of the great masters of today and the past, there is nothing academic or derivative about his art. His intensity of feeling and splendid indigna-

tion are unique. Light glints from the writing surfaces of his forms, which seem to swell and shrink under the pressure of subterranean emotion. Somewhere Levine has stated that the artist's function is to bring "the great tradition and whatever is great about it up to date." His own work has contributed to this worthy ideal, for he has related twentieth-century American painting to Hogarth, Goya, Daumier, and other great social satirists of the past.

Still painting in the sixties, Jack Levine was the last of the socially conscious painters to focus on the ills of society. Such concern became subordinate to pure esthetic considerations until the advent of "Pop" art, but with "Pop," vehemence and anger gave way to a "cool" appraisal of social realities.

MURAL PAINTING

The years of the Depression and of social upheaval also witnessed a temporary stimulation of mural painting in America. Mexico had experienced a social revolution, and a large group of progressive painters, headed by Diego Rivera, José Clemente Orozco, and David Alfaro Siqueiros, initiated a program of mural painting as a means of furthering that revolution. Their wish was to create an art that was monumental, national, and heroic, one that would become part of the national consciousness. American artists watched the development of this Mexican school with intense interest, and many felt that the Mexican artists gained in stature as they dedicated themselves to communal goals. Rivera and Orozco came to the United States in the twenties and thirties to execute mural projects, and their presence stimulated a revival of the art.

Thomas Hart Benton (1889–) is the best-known of the American muralists, for during his heyday he was productive, vocal, and disputatious. As a youth he studied in New York and Paris, but abstraction did not appeal to his nature. The success of the Mexican muralists suggested an outlet to Benton for his essentially popular point of view. He commenced painting murals in which a sequence of related scenes overlap and interpenetrate one another to create a lively, almost journalistic style. *Mural No. 2, Arts of the West* (Fig. 568) has seven or eight vignettes of western life related by this effective compositional device. The restless movements and brilliant tonal and color patterns are counterbalanced to create a painting that is dynamic rather than architectonic.

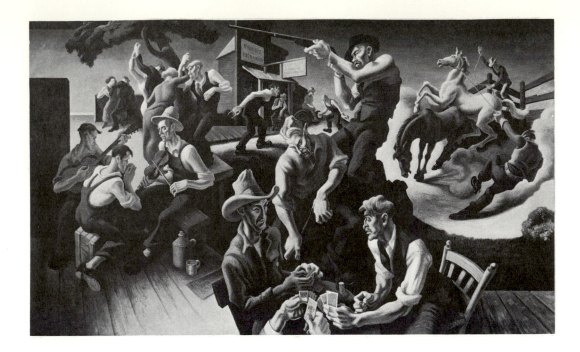

Among the relief programs set up to care for the unemployed during the Depression were various projects for artists. A number of fine murals were painted for public buildings as part of these projects, and in 1935 a section of fine arts was formed by the Federal government under the auspices of the Treasury Department. This bureau, which was continued until after World War II, was not designed primarily to provide economic assistance to artists but to enrich our public buildings with the talents of America's leading painters. Although many of the murals executed under this program hardly merited monumental proportions, it did offer a number of distinguished painters their first important commissions. It is conceivable that the taste for huge canvases in the fifties and sixties was stimulated by this revived mural tradition.

REGIONALISM

Another child of the Depression was a movement that developed during the thirties known as "regionalism." Regionalism represented a conscious attempt on the part of artists and critics to encourage a grass-roots culture in opposition to the sophistication and cosmopolitanism of the preceding two decades. The economic crisis forced many an artist to return home, to reevaluate what had appeared to be a provincial atmosphere, and to reconsider the meaning of the culture of democracy. The picturesque variety of American life and the significance of its traditions were rediscovered. Part of this rediscovery grew from the government-sponsored relief programs for

above : 568. THOMAS HART BENTON. *Mural No. 2, Arts of the West.* 1932. Tempera glazed with oil, 7′ 5″ × 13′ 3 1/8″. Art Museum of the New Britain Institute, New Britain, Conn.

below : 569. THOMAS HART BENTON. *July Hay.* 1943. Egg tempera, methyl cellulose, and oil on masonite, 38 × 26 3/4″. Metropolitan Museum of Art, New York (George A. Hearn Fund, 1943).

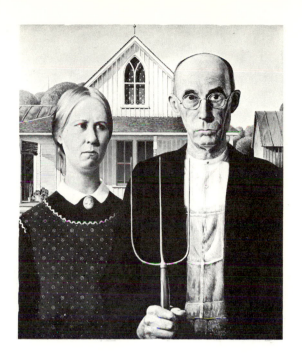

right : 570. GRANT WOOD. *American Gothic*. 1930. Oil on beaverboard, 29 ⁷/₈ × 24 ⁷/₈″. Art Institute of Chicago (gift of the Friends of American Art).

needy artists. Art centers and craft classes were set up throughout the land to encourage people to develop their abilities and continue local traditions. In addition, a great research project was initiated to record our native heritage of the visual arts. This resulted in the authoritative survey of American crafts known as *The Index of American Design*.

These projects and the general temper of the times combined to produce a lively "back-to-the-soil" movement and redirected the artists' attention to their native haunts. The message of the regionalist painters was strengthened by the work of such writers as William Faulkner, John Steinbeck, and James Farrell, who described the ways of life of different localities. Much folk music of the remote parts of America was also collected at this time.

Thomas Hart Benton, already mentioned as a muralist, was born in Missouri, and, since both his temperament and family traditions were conducive to a strong affection for the customs and landscape of the Middle West, he became one of the principal proponents of regionalism. *July Hay* (Fig. 569) presents his essentially picturesque view of rural life through its strong relationships of line and its tonal and color contrasts. His caricatured personalities and colorful versions of local customs were in accord with popular conceptions of the American way of life. In his aggressive polemics, written and oral, he became the champion of such concepts, particularly of the vigorous West as against the effete and inbred East.

One of the most effective painters of the Middle West was Grant Wood (1892–1942). Wood grew up in Cedar City, Iowa, where his ability received sufficient recognition and support to enable him to go abroad for a period of study. Paris introduced him to Impressionism, and though his work in this style was competent, it was neither distinguished nor highly personal. During a second trip abroad, Wood became interested in the meticulously wrought paintings of the Middle Ages, particularly the early Flemish school. He then realized that he was most moved by paintings of familiar and homely things seen and described with love and intensity. He returned home determined to paint his Iowa neighbors and environment with all the truthfulness and affection that had distinguished the medieval Flemish and German painters. *American Gothic* (Fig. 570) is a tribute to the success with which he realized this ambition. The sober faces of his sister and dentist are recorded with sobriety and concentration. The clothes, pitchfork, and Gothic Revival farmhouse in the background are unequivocally authentic.

Such a painting might appear to be an expression of unselective realism, but Wood did his own very subtle editorializing. He selected types of personalities that extoll the quiet, honest, hardworking life of the rural Middle West. The verticality of the main compositional masses and the pyramidal grouping of the figures in relation to the gable of the house establish a strong sense of stability. Also, the implication of spirituality in the Gothic window and the title bespeak a rejection of urbanism and bohemianism and of the sophistication of modern art.

The regionalism of the thirties was not only a rediscovery of America; it was also an attempt by artists to achieve a reintegration with the traditional pattern of American life and a reaffirmation of faith in that life. John Steuart Curry (1897–1946) applied his thick paint to such subjects as *Hogs Killing a Rattlesnake* and *Tornado Over Kansas* in a vigorous illustrational manner to create drama from Kansas farm life. Peter Hurd (1904–) of New Mexico, Aaron Bohrod (1907–) of Chicago, Paul Sample (1896–) of Vermont, and a host of others painted their familiar environment with affection and pungent realism and did much to popularize the American scene and create a new clientele of middle-class patrons.

Regionalism ceased to be a conscious artistic movement in the forties, but by then it had achieved certain ends. Though New York still remained the center of the art world, a number of local schools of painting had developed in the Middle West, the Far West, the South, and the Southwest. America had rediscovered itself and its rich diversity of customs, peoples, and resources.

21

Modern Painting: Fulfillment

In surveying the contemporary art scene, one is impressed by its vitality and almost overwhelmed by its variety. The range of current styles and the number of artists doing significant work is far too great to permit mention of them all. Only the perspective of time will determine which movements and which painters will remain most significant. A few typical and well-known representatives of each of the major recent trends have been selected for discussion in this chapter. The author's personal bias has inevitably played a role in the choice, and no attempt at prophecy is implied.

CONTEMPORARY REALISM

Because of the decisive departures from tradition that characterize much current painting, it is easy to underestimate the vigor of what is best termed "contemporary realism." Though many contemporary realists continue to use traditional representational disciplines and painting techniques, they achieve significance because of their integrity of vision, with its continued impact upon the American tradition. Even in its most orthodox forms contemporary realism is not the academic realism of the nineteenth century, for the dynamic character of the art

world of today has modified all meaningful expression. Abstraction has increased the concern of the realists with the role of formal structure, Expressionism has stimulated a more freely executed and emotional manner, and Surrealism, which sought archetypal truths in the irrational and the subconscious, has heightened sensibilities and opened new wellsprings of inspiration.

Two separate stylistic currents, both deriving from the earlier tradition of the American scene, became discernible after 1945. One, the more traditional, featured the painterly manner that was the hallmark of nonacademic art in Europe and America in the late nineteenth and early twentieth centuries. The other current, a part of our American heritage, continued the clean aseptic style initiated by Demuth and other Immaculates of the twenties. For purposes of discussion the first movement is identified in the following pages as "painterly realism," the latter as "precisionism."

Painterly Realism

The neoromantic mood of poetic reverie that appeared in France in the thirties, colored to some degree by the emotive potency of Surrealism, also softened the realism

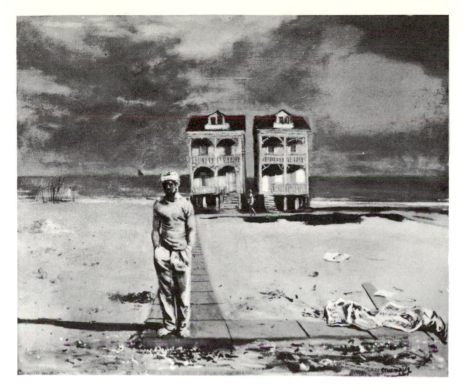

left : 571. WALTER STUEMPFIG. *Two Houses.* 1946. Oil on canvas, 25 × 30″. Corcoran Gallery of Art, Washington, D.C.

right : 572. WALTER MURCH. *Transformer.* 1965. Oil on canvas, 38 × 28 ½″. Collection Mr. and Mrs. Carl M. Silver, Providence, R.I.

of William Stuempfig (1914—). Essentially a romantic realist, Stuempfig projected a mood of magic into his paintings of shabby towns and old houses, largely through his sensitivity to the evocative power of space, light, and softly generalized brush work. *Two Houses* (Fig. 571) also reveals a debt to the Surrealists, for Stuempfig employs the emotive device of sharply converging perspective by which certain Surrealists intensified their dream images. Through an almost ambiguous sense of nearness and distance between the single figure and the pair of houses, with related verticals in a dominantly horizontal composition, Stuempfig communicates the lonely and nostalgic emptiness of the beach with the sweet intensity of a daydream. Ever since Raphaelle Peale painted *After the Bath* (Fig. 272) and Charles B. King immortalized the strangeness of familiar things in the *Poor Artist's Cupboard* (Fig. 307), American artists have celebrated the wonder of commonplace objects observed with sympathy.

An atmosphere of poetry, even mystery, also surrounds the stereotyped products of the machine age usually painted by Walter Murch (1907–67). Murch was essentially a still-life painter, but his still-life subjects were far removed from the usual studio props. Instead, as in *Transformer* (Fig. 572), he chose details from the great

world of industry and, through a rich manipulation of paint, created an aura of radiance and power whereby the simple form of the transformer projects the mysterious life force of electricity. Paint runs, brushed textures, transparent glazes, thick impasto, all the painterly devices of the Abstract Expressionist style developed in New York just after World War II (see pp. 439–42), contribute to the vibrant surfaces through which Murch achieved his effect of mystic radiance—the effect, however, controlled by a formal composition powerful in its very simplicity.

Despite the seemingly infinite explorations of new directions that characterized painting in the sixties, many conventions of studio painting remain deeply entrenched. Philip Pearlstein (1924—) of New York uses vigorous brush work and a limited warm palette to paint what are essentially traditional studio nudes. His unglamourized, strongly composed groups of figures posing in sparsely decorated settings under a harsh flow of bright light represent an old tradition brought up to date by a manner that achieves force through a strange air of almost clinical detachment and objectivity.

below: 573. RICHARD DIEBENKORN. *Landscape I, 1963.* 1963. Oil on canvas, 5′1¼″ × 4′2½″. San Francisco Museum of Art (memorial to Hector Escobosa, Brayton Wilbur, and J. Zellerbach).

The California Figurative School

The presence of Clyfford Still in San Francisco in the late forties, reinforced by the well-nigh universal impact of the New York action painters, stimulated a vigorous development of Abstract Expressionism in the San Francisco Bay area in the late forties and fifties. One of the many Abstract Expressionists in that area, Richard Diebenkorn (1922—), made a particularly forceful impression upon both California and the national scene. In the fifties a group of Berkeley painters, including Diebenkorn, David Park (1911–60), Elmer Bischoff (1916—), and later Nathan Olivera (1928—), established what came to be termed the "California Figurative School." These men, as well as others who shared their approach to painting, worked in a vehement, free style, usually employing a single figure or groups of figures in an interior or landscape setting.

Diebenkorn gradually became established as the most influential of the group. Though he employed richly orchestrated and high-keyed color applied in a freely brushed, heavy impasto, the general tenor of his paintings was contemplative and sober, often establishing a mood of loneliness or expectancy. In the sixties Diebenkorn added still-life and landscape subjects to his repertoire. *Landscape I* (Fig. 573) displays his strongly composed, broadly painted style. The vividly patterned arrangement of housetops, streets, terraced hillsides, and empty lots is projected in deep space. The flow of low light throws long shadows and emotionalizes the empty streets, reflecting that curious but characteristic urban residential phenomenon, the uninhabited city. In viewing this cityscape, one remembers the American-scene painters of the thirties, but the potency and evocative force of *Landscape I* reveals the added impact that both Abstract Expressionism and geometric abstraction have contributed to contemporary realism.

Wayne Thiebaud (1920—), another Californian, came into national prominence in the mid-fifties for his "Pop" subject matter, but both his attitude and style are much less impersonal than those of the typical Pop artist. Thiebaud was amused by many of the commonplaces of American commercial practice, whether in cafeteria, lunch counter, or department store. *Pie Rows* (Fig. 574) is typical in both subject matter and style. This rendering of the bright, synthetically colored slices of pie, arranged in the case to tempt the appetites of those hearty consumers of sweets who question neither mass production nor the artificial colors and flavors that accompany it, makes a lively commentary on our merchandising and eating habits. The rich impasto of paint, as heavy and gooey as the pie custards and frostings themselves, is

handled with consummate skill. In his most recent works Thiebaud has concentrated on figure painting, but not of the traditional studio-nude variety. Instead, familiar types dressed in mass-produced clothes, as quietly undistinguished as the slices of pie in *Pie Rows*, are presented with a genuine feeling for their modest character.

A very personal blend of expressionist vehemence, disciplined observation, and Oriental elegance pervades the handsome canvases of Bryan Wilson (1927—), a Californian who usually paints animals or birds (Fig. 575). In his subtly colored canvases large areas of gray predominate, accented by blacks, whites, and a few strong colors. Wilson has a distinctive capacity to summarize bird and animal forms with a remarkable combination of exactitude, vitality, and expressive force. His telling delineations of wild life are tensely composed in relation to richly brushed plant fragments and monotone backgrounds.

Precisionism

A tradition of sharply delineated, objective realism has been an important part of the American heritage since the days of Copley. Raphaelle Peale, Eakins, Harnett, and the Immaculates, to cite a few, achieved emotional intensification through detailed scrutiny of the world and meticulous rendering of it. Normal observation being not so analytical, sharp-focus seeing implies the special stimulus

of heightened interest. By inverse effect, detailed rendering can project this raised emotional tone.

The work of John Koch (1909—), of New York, may serve to introduce the group of artists discussed below, because his style is halfway between the more painterly manner described above and the more extreme precisionists. He paints the well-furnished and comfortable interiors of upper middle-class dwellers, subjects that would seem drained of emotive content both by familiarity and by the overpolished idealizations of advertising art.

above : 574. WAYNE THIEBAUD. *Pie Rows.* 1961. Oil on canvas, 24 × 30″. Collection Allan Stone, New York.

left : 575. BRYAN WILSON. *Deer Grazing.* 1967. Oil on canvas, 5′ 11 ½″ × 6′ 11 ½″. Private collection.

425

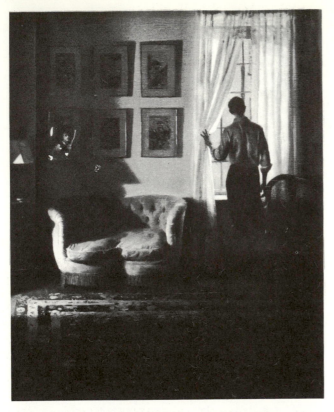

But Koch understands the evocative power of light, and in *Evening* (Fig. 576) the flow of late daylight through the darkening room and the expectancy of the waiting figure work together to project a mood of sweet-sad, sentimental reverie that is as familiar to us in the world of everyday activity as it is rare in the world of contemporary art.

Since the twenties Surrealists have projected a sense of reality into their fantasies by the virtuosity with which their images are rendered, and by the same technical methods the magic realists inject an illusion of fantasy into their treatment of fact. This vein of fantasy-reality continues to have its brilliant practitioners. Joe Raffaele (1933—), in New York, and Robert J. Baxter (1933—), in San Diego, Calif., permit a free-association flow of images to determine their subject matter. Then, by hyper-sharp focus in rendering, they create a convincing, even familiar, though strange, world. *Frigata Magnificens (Frigate-bird)* (Fig. 577), by Robert Baxter, is executed in tempera cross-hatching and stippling on a wash ground with brush strokes of such fine texture that they can be fully appreciated only through a magnifying glass. Yet the result is less one of technical skill than of emotive intensity produced both by the density of the forms and by the dreamlike juxtaposition of the images. The seated figure gazes quietly at the onlooker as though unaware of the enigma posed by the veiled nude woman and the symbolic frigatebird in the background. Trees and garden make a romantic setting for the actors, each seemingly isolated in a private, chill world. Though science and technology seem ever in the ascendancy, the dream still provides entry into the powerful world of the imagination.

As previously stated, contemporary realism has been strongly colored by the other movements current today. Thus geometric abstraction has influenced many representational painters to base their compositions on clearly defined planes of form and angular patterns. *The Subway* (Fig. 578), by George Tooker (1920—), provides a forceful, though depressing commentary on the deadly monotony of much modern urban living. The painting also illustrates the all-pervasive effect of abstract painting on contemporary traditional expression. In *The Subway* Tooker stresses the geometric framework within which so much of our lives is imprisoned today. The carefully composed repetitions of bars, railing, and girders and the almost endless perspectives of corridors, stairwells,

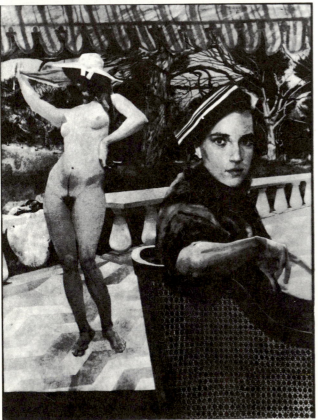

above: 576. JOHN KOCH. *Evening*. 1957. Oil on canvas, 20 × 16″. Collection Mrs. Russell W. McLean, Grosse Pointe Farms, Mich.

left: 577. ROBERT J. BAXTER. *Frigata Magnificens (Frigatebird)*. Tempera and wash, 38 ½ × 28 ½″. Collection Mr. and Mrs. Lewis P. Geyser, Sherman Oaks, Calif.

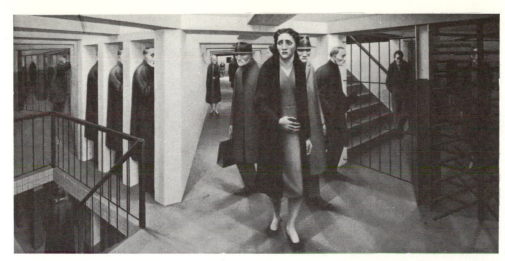

and subway exits seem like some geometric abstraction translated into a grim three-dimensional nightmare. Even the shadows of the automata who inhabit this mechanized world fall in geometric patterns. The use of deeply emotive perspectives and meticulously defined forms, as well as the obsessive effect achieved by the repetition of identical elements, particularly the figures in the phone booths, are all devices from the Surrealist vocabulary. *The Subway* illustrates the way in which all works of art are shaped by the interplay of three forces: the artist's personality, the physical world in which he lives, and the culture that molds his vision.

In California in the sixties there appeared a kind of hard-edge precisionism which combined some of the "cool" attitude of the Pop artists, the bold patterns of the hard-edge abstractionists, and the intense vision of the precisionists. Robert Bechtle (1932—), from the San Francisco Bay area, finds his subject matter in what might appear to be, for the artist, the most arid sector of American life, middle-class suburbia. The empty streets, parked cars, shrubbery, and clean houses, dulled by familiarity and too frequently idealized by Madison Avenue, evoke no nostalgic sentiments. But Bechtle's sharp eyes, seeing these forms with clairvoyant brilliance, make us freshly aware of their exact flavor and character. *'61 Pontiac* (Fig. 579) presents not only the image of the street and the automobile, with its slightly dented side, but also the interior from which the street is seen. The beveled window frame, with its fascinating dislocations of reflected forms, projects us back into the past, when beveled windows and mirrors contributed elegance to a household and at the same time entertained us with their surprising images. But the primary source of power in this work is not that it invokes the past; instead, its magic lies in the intensity with which the present is reproduced, an

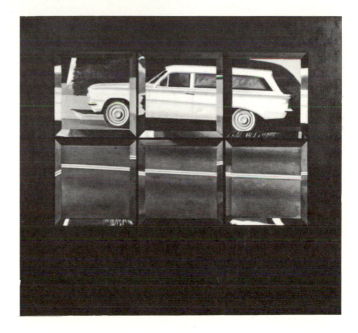

intensity that only occurs when artistic endeavor is carried to its ultimate potential.

Among the many other painters who produced exciting paintings in the controlled rigorous manner of the precisionists, two, at least, should be singled out for mention, though time and space forbid giving them the attention they deserve. In the forties, Honoré D. Sharrer (1920—) produced miracles of craftsmanship in a vein that reminds one of some clear-eyed medieval realist who sees the world with relish but is under no illusions as to its benign temper. Equally skilled, more openly satiric, and of irrepressible high spirits is Paul Cadmus (1904—), who for many years has observed the world about him with humor and absorbing interest.

Andrew Wyeth

American painting was born on the Atlantic seaboard, and it seems appropriate to return to that scene in concluding the discussion of this branch of contemporary realism. An artist who spends his summers in Maine and his winters in Pennsylvania, Andrew Wyeth (1917—) draws his subject matter from these strongholds of American tradition. Winslow Homer and Thomas Eakins were among the artists Wyeth admired most during his formative years, and their spirit helped shape his vision. His father, N. C. Wyeth, was one of America's most brilliant illustrators at the turn of the century, and the younger man had the advantage of a thorough training in drawing, as well as in the craft of painting. Like Homer and Eakins, Wyeth loves both nature and man with a gloomy intensity, and his sharp-focus, precise technique is admirably adapted to communicate both objectivity of vision and depth of feeling.

Brown Swiss (Fig. 580) shows these characteristics with singular strength, and, while close examination reveals an admirable control of the difficult tempera medium, one feels no display of technical virtuosity for its own sake. Instead, the artist's facility remains in the service of his intense, poetic vision. As usual, the compositional elements are minimal: a typical Pennsylvania farmhouse from the early nineteenth century, a few bare trees and sticks of fence, the long stretch of hill, and the cattle pond. One feels the passing of winter in the chill sunlight that lights up the front of the house and shines on the slope of the hill. The reflection provides the magic touch, mirroring the bright sky and a few sparkling details. An impeccable sense of composition contrasts the patterns of buildings, trees, and fence on the far left with the long stretch of earth on the right to project a sense of the relationship of man to nature that is the essence of rural existence.

A citizen of our troubled contemporary world, Wyeth recognizes that the drama of life contains hardship and suffering as well as serenity and beauty. An almost Surrealist mood of strangeness and oppression often hangs over his world, an element of our Puritan background, for our forefathers constantly reminded us that all was vanity in this vale of tears. A true colonial sparseness characterizes Wyeth's paintings. Each composition that he paints is reduced to its essence; he has said, "When you lose the simplicity, you lose the drama." These qualities distinguish *Christina's World* (Pl. 24, p. 414). The barren and harsh New England landscape and the indomitable human spirit provide the drama. The pitiless glare of light reveals the forms with a clarity that is equaled by the meticulous draftsmanship and the brilliant technical capacities of the artist. One senses the interaction of a lucid intelligence and a compassionate nature, overwhelmed by the strange beauty of life, as well as by the tragedy and hopefulness that appear to be the inevitable counterparts of man's existence.

CONTEMPORARY EXPRESSIONISM

Traditional Expressionism may sound like a contradiction in terms, but much contemporary expressionism is traditional as compared to the more recent developments in American painting, in that it is rooted in innovations initiated during the first decade of the century. Most of the painters discussed in this section continue the modes established by the central European Expressionists, the Fauves, and particularly the later style of Picasso, the influence of whose brilliant inventions, essentially expressionistic in character, cannot be overestimated. In each case the earlier European influence has been absorbed by the individual artist's temperament, adjusted to the native environment, and developed into a deeply personal style.

left : 580. ANDREW WYETH. *Brown Swiss.* 1957. Tempera, 2′ 6″ × 5′ ¹⁄₈″. Collection Mr. and Mrs. Alexander M. Laughlin, New York.

Many of the painters discussed in the preceding chapter intensified the expressionist elements of their output in the fifties and sixties, and the later work of a number of artists—Max Weber, Ben Shahn, Charles Burchfield, and Jack Levine, to name only a few—might with equal logic have been discussed here.

A curious vein of romantic expressionism appeared in the forties that was reminiscent of the French neoromantics of an earlier decade. Edwin Dickinson (1891—), Eugene Berman (1899—), Loren MacIver (1909—), and Morris Graves (1910—) became involved in a type of subjective painting which explored the world of dreams and drew upon a vast storehouse of psychological impressions to communicate their moods. Other expressionists tended to explore a more dynamic vein.

Rico Lebrun (1900–64) was born in Italy and spent his formative years there, developing great skill and strength as a draftsman, particularly in the rendering of the human figure in action. Coming to the United States in 1924, he spent some time in New York as a commercial artist, illustrator, and later as a mural painter. In the late thirties he moved to southern California, where he evolved his mature style and became a major influence through both his work and his activities as a teacher. During the last two decades of his life he employed a powerful

expressionist style characterized by somber color, bold contrasts of dark and light, and a formalized handling of the human figure, which in certain respects reveals the influence of Picasso, especially the Picasso of the *Guernica* period. Lebrun's great triptych, *The Crucifixion* (Fig 581), considered to be the first major work in his mature style, occupied his energies for three years. Though the essential iconography is traditional, he included many contemporary symbols to create a deeply disturbing and compelling modern version of the theme. Like Picasso's famous *Guernica*, Lebrun's *Crucifixion* is not a pictorial illustration, even though the various episodes and elements of the Crucifixion story can be identified. Instead, it is an epigrammatic distillation of the mood of tragedy, suffering, and sacrifice through the use of formalized, abstracted, and distorted naturalistic forms. Among his most powerful late works is the series of paintings based upon the monstrous tragedy of the Nazi extermination camps. In this series his early training in handling the human figure, used in conjunction with expressionistic devices of style and an almost Baroque chiaroscuro, contributed to the creation of some of the most passionate denunciations of man's inhumanity to man to appear in modern times.

The Crucifixion also provided the theme for *The Deposition* (Fig. 582) by Stephen Greene (1917—), who

employs a sensitive, personal kind of expressionistic distortion. The slight modulations of tone by which the forms are modeled, the angularities of patterns, and the emphasis on gesture and facial expressions to evoke an atmosphere of bereavement recall mannerisms of the medieval painters transcribed into a contemporary style.

Two expressionists from the Boston school, Hyman Bloom (1913—) and David Aronson (1923—), also treat religious themes, but their subject matter is derived from Jewish, rather than Christian, ritual and belief. A mystical quietude suggestive of unquestioning faith and unworldly piety radiates from *The Philosopher* (Fig. 583), by David Aronson. The almost El Greco-like triangulations of form, the muffled lines, and the softly brushed textures suggest a diffused and wavering ceremonial light. The minimizing of weight and volume and the withholding of incisive contrasts and emphatic lines project the mood of mystical detachment that dominates *The Philosopher*.

Balcomb Greene (1904—) painted geometric abstractions in the thirties and early forties. At that time he was deeply concerned with two aspects of abstract painting: the architectonic organization of the canvas and the effect of light upon planes tilted to absorb or reflect light or to cast shadows. Light still seems to remain a fundamental concern of Greene, though in the late fifties he shifted his attention to the landscape and later to the human figure in a landscape or city setting, and his concern with formal values was enriched by a more urgent and expressive style of execution. *Sunlight* (Fig. 584) shows his interest in the corrosive effect of sharp light upon color

top : 582. STEPHEN GREENE. *The Deposition.* 1947. Oil on canvas, 4′ 11″ × 2′ 10″. City Art Museum of St. Louis, Mo. (gift of Joseph Pulitzer).

far left : 583. DAVID ARONSON. *The Philosopher.* 1962. Encaustic, 40 × 27 ¾″. Collection Dr. Richard A. Schwalb, Dover, N.J.

left : 584. BALCOMB GREENE. *Sunlight.* 1962. Oil on canvas, 48 × 38″. National Collection of Fine Arts, Smithsonian Institution, Washington, D.C. (S. C. Johnson Collection).

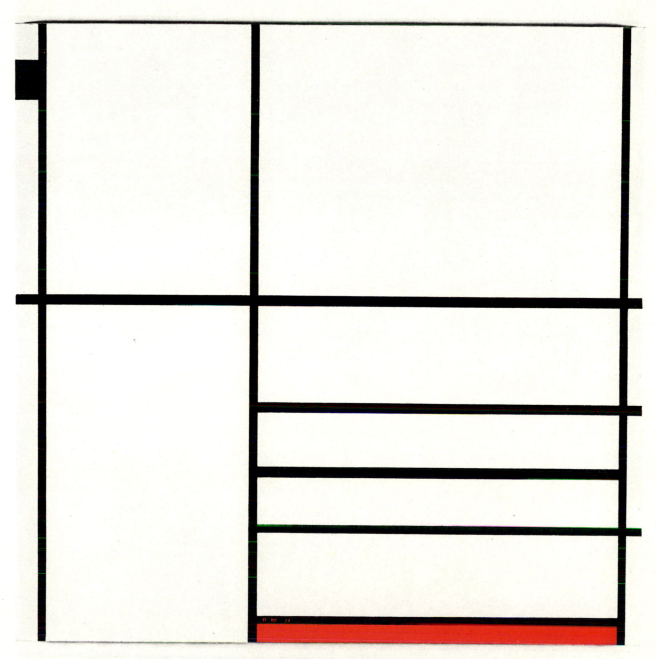

Plate 25. PIET MONDRIAN. *Composition in White, Black, and Red.* 1936. Oil on canvas, 40 ¼ × 41″. Museum of Modern Art, New York (gift of the Advisory Committee).

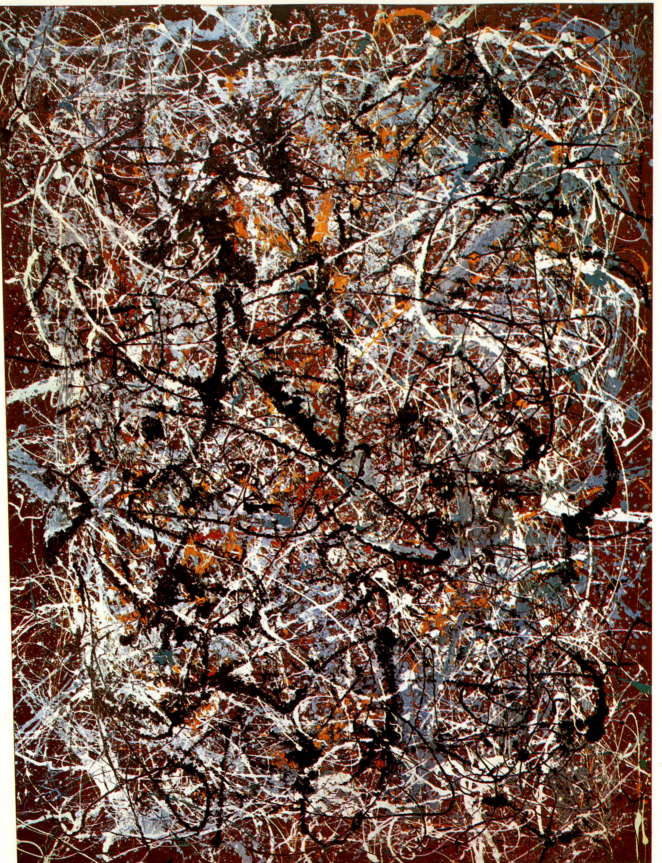

Plate 26. JACKSON POLLOCK. *Mural.* 1950. Oil, enamel, and aluminum paint on canvas, mounted on wood; 6 × 8′. Collection William S. Rubin, New York.

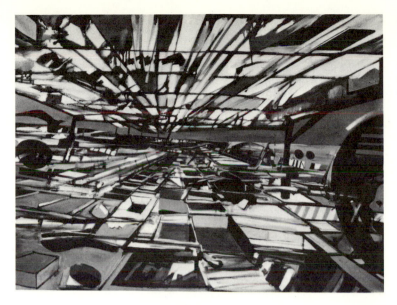

left: 585. JOHN HULTBERG. *The Great Glass Roof*. 1965. Oil on canvas, 36 × 48″. Courtesy Martha Jackson Gallery, New York.

below: 586. LARRY RIVERS. *The Sitter*. 1956. Oil on canvas, 4′ 3 1/8″ × 3′ 11″. Metropolitan Museum of Art, New York (gift of Hugo Kastor, 1956).

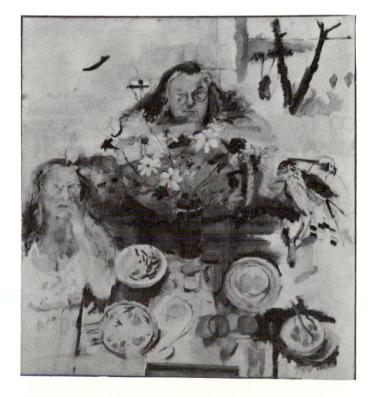

and form. The surface aspects of the figure, as well as the city street that forms the setting, appear annihilated by the brilliant illumination, leaving an almost Cubist sense of structure that reveals the basic facets of the form. The characteristic cool color creates an effect of splintered light shattered by some crystalline force and reflecting the omnipresent blue sky. The brush work is as energetic as that used by some of the Abstract Expressionists who were painting concurrently. Thus a sense of the dynamism and energy of radiating light is forcefully conveyed, but at the same time Greene's early concern with the formal organization of the canvas remains intact. *Sunlight* is almost bisymmetrical in the careful calculation of vertical movements in juxtaposition to the curve established by the arm, continued in the movement of the curb, and radiating around the circular form of the breast.

John Hultberg (1922—) produced a number of dynamic canvases, many of which reflect today's obsessive concern with speed and movement, as though an electrically illuminated world were being viewed from a speeding automobile. One is reminded of the canvases Joseph Stella painted of New York in the twenties, but, unlike Stella, Hultberg executes his paintings in a free, impetuous manner that seems half planned and half improvised. *The Great Glass Roof* (Fig. 585) shoots upward into deep space, suggesting not so much a sense of a fixed architectural structure of girders, metal frames, and glass panels as of a world in such violent movement that the eye cannot hold the forms in a static pattern. Abstract Expressionism, with its emphasis upon direct execution and improvisation, contributed much to the development of Hultberg's dynamic manner.

Larry Rivers (1923—) has been assigned by critics to both Abstract Expressionism and Pop Art, but the presence of sharply delineated figural elements in his paintings separates him from the orthodox Abstract Expressionists, and his free and impulsive application of paint distinguishes him from the typical Pop artist, even when, as is occasionally the case, his themes derive from Pop culture. *The Sitter* (Fig. 586) has intensively

developed areas, such as the figures and the still life of the table top, whereas other parts of the canvas remain relatively undetailed. The faces of the sitters reveal Rivers' uncanny talent for characterization, and this element of sharp realism provides a disturbing tension in contrast with the arbitrarily flattened perspective of the table top and the fragmented patterns of the flowered shirt, the bird, and the view from the window. It is this highly personal juxtaposition of contradictory elements, held together both by an almost formally symmetrical arrangement and by the regularly recurrent emphasis on details that gives the painting its special flavor. One senses the fragmentation of modern life and the artist's desire to synthesize the pieces into personal expression.

ABSTRACT PAINTING AND SURREALISM

The Fauve painters, the Cubists, the Dadaists, the German Expressionists, and the Italian Futurists had constituted the *avant-garde* of European painting in the first two decades of the century. In the Europe of the twenties these movements lost their initial impetus, giving way to two new dynamic developments. The first, originating with the Constructivists of Russia in the decade of the revolution, held as its ideal a pure abstract art. Russian Constructivism was short lived; in its place Moscow encouraged a school of social realism, but the Constructivist impulse toward pure abstraction was continued by certain of the Bauhaus painters in Germany, by the Dutch De Stijl group, and by the French proponents of Purism. All these groups conceived of a new science of painting based on completely abstract, essentially geometric forms related to the stylistic problems that grew from the mechanistic character of contemporary technology.

The second significant movement of the twenties, born in Paris, was Surrealism. The Surrealists also sought for a pure essence as the basis for their expression, but they sought it not in rational thought but rather in the unplumbed depths of the human subconscious.

During the thirties and early forties America had been receptive both to the ideas espoused by the geometric abstractionists and the Surrealists and to the practioners themselves, for a number of the important proponents of these movements visited or settled here. After 1945, in the years following World War II, the swing toward abstract and intuitive modes of painting in America was overwhelming, stimulated both by the presence of skilled and articulate spokesmen and by the social temper of the postwar period. The horror, waste, and tragedy of war made men cynical toward traditional humanism. The artist felt impelled to find eternal truths transcending

love, hate, patriotism, and nationalism—noble sentiments that had repeatedly led to slaughter and violence. Abstract art held out this promise, for it was based upon the pure, timeless, and eternal art elements of line, form, space, color, texture, and the compositional verities fundamental to the great art of all ages.

Intuition, the manifestation of the subconscious depths of the human psyche, provided the other key to timeless truths. Even though an artist spoke the timeless language of abstract plastic values, he spoke as an individual, a unique human being who neither thought nor felt identically with any other person. By following the dictates of his innermost impulses and feelings, each person could communicate his own particular essence. Thus two poles, pure abstraction and pure subjectivity, were established as the ultimates of expression, and these extremes even colored the practice of those schools of traditional painting that continued to flourish in the postwar years.

GEOMETRIC ABSTRACTION

Three European painters, Wassily Kandinsky, Piet Mondrian, and Josef Albers, played a primary role in introducing a concern with pure geometric abstraction into America—Kandinsky through the impact of his work; Mondrian and Albers through both their work and their presence in this country. Piet Mondrian (1872–1944) had already arrived at his geometric simplifications of form in the twenties. In the thirties his paintings were shown and admired in New York, along with works of other abstractionists and certain of the Surrealists, sponsored by Peggy Guggenheim, who during World War II played a role similar to that of Stieglitz three decades earlier. Mondrian's theories concerning pure plastic expression were also known here, having been published by the magazine *De Stijl* in Holland and France. Arriving in New York to live in 1940, his presence reinforced the influence projected through his paintings and his writings. Mondrian's early paintings had veered off from Cubism toward geometric abstraction but had retained the painterly handling of the Cubists. Those in his final style, such as *Composition in White, Black, and Red* (Pl. 25, p. 431) are as clean, sharp-edged, and pure in their geometric formality as if they had been produced by precision tools. Using only rectangular forms and vertical and horizontal lines of even width, Mondrian achieved a maximum of interest by his sensitive adjustment of size, shape, and the occasional introduction of primary colors into the basically black-and-white format. In the work illustrated one band of red placed at the bottom of the canvas and a black rectangle in the upper left animate the entire surface. The pleasure one derives from such a canvas is conveyed by the

sense of order and rightness in the relationship of parts. The result is a rarefied, impersonal kind of beauty in which all sentimental, humanistic, and associative aspects of painting have been removed, leaving only the formal and abstract elements.

Josef Albers (1888—) came to America in the thirties from Germany, where he had been associated with the Bauhaus group. In *Homage to the Square : "Ascending"* (Fig. 587), as in much of his painting, Albers restricted the forms to squares, going even farther than Mondrian in his search for simplicity and order by eliminating variety of form. In this way Albers was able to explore the possibilities of color more completely. Each of his compositions represents a color experiment. Albers often surrounds a neutral gray with two brilliant colors, which, upon prolonged observation, modify the gray and cause a sensation of continuously changing color relationships. He also works with color relationships to create illusions of spatial intervals and movement between the squares. Albers, like Mondrian, approaches the art of painting as would a scientist or engineer, albeit a scientist or engineer with exquisite taste. His students, continuing his explorations of modern esthetic premises, have been among the foremost painters of the mid-century.

A number of contemporary painters continued to explore the possibilities of precise, sharp-edged geometric abstraction, thus leading the way to the "hard-edge" school of the sixties. Others tended to enrich the geometry of their work with more complex surfaces, often reverting to a painterly handling. Irene Rice Pereira (1907–71) employed a variety of forms and surface textures and strong move-

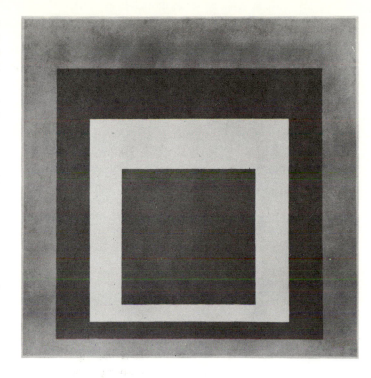

ments in space to increase the interest of her abstractions. *Green Depth* (Fig. 588) carries the eye back and forth in a series of regular but rhythmic movements suggesting a musical fugue in its involved and repetitious construction. In some of her compositions Pereira intensified the sense of movement in space without recourse to traditional devices by adding layers of transparent and translucent

above : 587. JOSEF ALBERS. *Homage to the Square : "Ascending."* 1953. Oil on composition board, 43 ½″ square. Whitney Museum of American Art, New York.

left : 588. IRENE RICE PEREIRA. *Green Depth.* 1944. Oil on canvas, 31 × 42″. Metropolitan Museum of Art, New York (George A. Hearn Fund, 1944).

435

materials to the canvas. By employing plastics and synthetics, she suggested new avenues of technical exploration in transparency, translucence, refraction, and color modulation.

Bradley Walker Tomlin (1899–1953) retained an essentially geometric pattern as the basis for his *No. 1* (Fig. 589), but the handling is painterly; that is, it candidly avows the character of oil paint and the brushing activity. In addition, an element of spontaneity in the free scattering of patterns, even an implication of cryptic symbolism in the motifs, suggests that the intellectual control that characterized Mondrian and Albers was giving way to Surrealist automatism. Though still structured and orderly, it reflects the powerful sweep toward Abstract Expressionism, the movement that dominated the late forties and fifties.

SURREALISM

In 1924 André Breton published his *Manifesto of Surrealism* in Paris. In it an absolute directive was given to make a clean sweep of rational systems of art and to substitute reliance upon spontaneous, intuitive, and undirected vision. Max Ernst, one of the early Surrealists, wrote, "Any conscious, mental control of reason, taste, will, is out of place in a work that deserves to be described as absolutely surrealist."

In the late thirties and early forties a number of major Surrealists came to New York, some temporarily, some to

above : 589. BRADLEY WALKER TOMLIN. *No. 1.* 1951. Oil on canvas, 3′ 6″ × 6′ 6″. Munson-Williams-Proctor Institute, Utica, N.Y. (gift of Edward Root).

right : 590. PAVEL TCHELITCHEW. *Hide and Seek.* 1940–42. Oil on canvas, 6′ 6 ½″ × 7′ ¾″. Museum of Modern Art, New York (Mrs. Simon Guggenheim Fund, 1942).

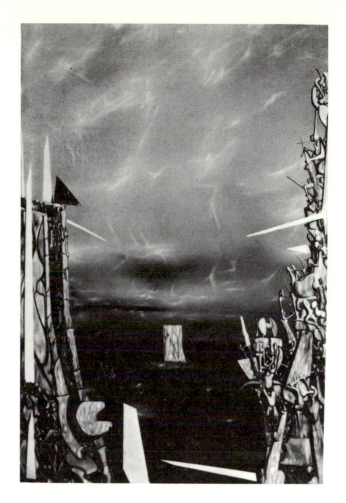

stay. André Breton himself spent some time in the United States, as did Matta (Echaurren), Max Ernst, Salvador Dali, André Masson, and others. Pavel Tchelitchew and Yves Tanguy were among those who became permanent residents. Two rather distinct groups developed from the Surrealist presence. One might be described as the "fantastic realists," who used traditional painting and drawing techniques to project fanciful, organic, fearsome, hallucinatory, and enigmatic visions in terms of realistic images. Tchelitchew, Tanguy, Dali, Ernst, and later certain American-born precisionists, often called "magic realists," were among the painters who worked in this vein.

By contrast, the other group employed less traditional forms and techniques inspired by the "psychic automatism" espoused by André Breton, Matta, and Masson, as well as by Klee, Miró, and Arp. These artists, exploiting the universality of the archetypal symbols derived from myths and from the personal subconscious, stimulated a body of symbolic, semiabstract painting. They decried all formalism and depended upon the direct outpouring of subconscious impulses, sometimes embodied in symbolic form, often of archaic or sexual derivation, and in other cases of a purely gestural nature. The gestural painting came closest to pure automatism, in that the act of placing color on canvas, the gesture of applying paint, served a more basic expressive function than did the symbolic content. Bradley Walker Tomlin, whose work has already been mentioned, Adolph Gottlieb, Arshile Gorky, Robert Motherwell, Jackson Pollock, Mark Rothko, and other major figures in the subsequent Abstract Expressionist movement all became involved in types of painting that were basically derived from Surrealist "psychic automatism," and from this impulse two currents evolved in the mid-forties. The first, gestural Abstract Expressionism, has been aptly described as "action painting"; the second, in which the symbolic content retains a fundamental expressive function, might best be termed "symbolic Abstract Expressionism."

Tchelitchew and Tanguy

Pavel Tchelitchew (1898–1957) was born in Russia but developed his highly personal style in Paris in the twenties. He came to America in the thirties. Here he contributed to the development of the fantastic and imaginative vein in American painting. *Hide and Seek* (Fig. 590) illustrates a curious amalgam of characteristic elements. The forms appear visceral and embryonic, bathed in body lymph and veined with blood vessels. These organic forms drift

in deep emotive spaces. The space effects are intensified by exaggerations of perspective and other expressionistic devices. Tchelitchew delighted in double images, forms that appear, disappear, and turn into other forms. All this Surrealist imagery is heightened by his incredibly skilled draftsmanship. His biologically oriented illusions remind us that a close relationship exists between the unknown recesses of the body and the mind.

Yves Tanguy (1900–55), born in France, also settled in America in the thirties and helped to popularize Surrealism here. *Fear* (Fig. 591) is typical of his style. A deep vista of space is peopled with enigmatic shapes and glimmering streaks of light. The foreground is filled with curious involved forms, which at first glance suggest undersea life but on closer examination appear to be fantastic, spreading growths of an organic, bonelike character. The color is gray and spectral. The painting is rendered in a detailed representational style, exact, precise, and controlled, so that, despite the threatening and nightmarish atmosphere, an emotional tone of hyperreality, as is implied by the term "Surrealism," is created. By

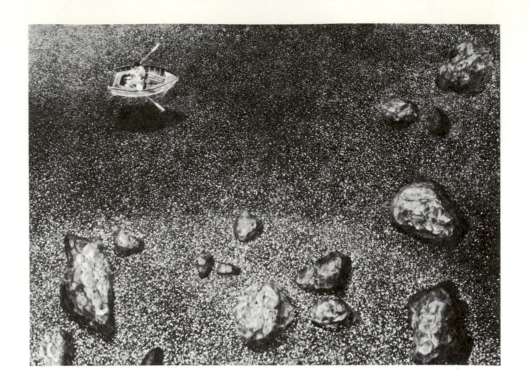

drawing on dreams, fears, and morbid fancies for forms and symbols and then rendering these symbols with hallucinatory clarity and specificity, the Surrealists frequently established an atmosphere of greater intensity than characterizes daily experience.

The use of fantastic imagery rendered in a manner that was, in essence, illustrational had few American followers, but the taste for a strange emotive image and a dreamlike intensity of mood continued in the work of the "magic realists." Kay Sage (1898—), Henry Koerner (1915—), and Bernard Perlin (1918—) often achieved such an atmosphere even when treating commonplace subjects. The chief instrument for accomplishing this was an almost hallucinatory clarity of detail which created a mood of hyperawareness. In *The Shore* (Fig. 592) Bernard Perlin employed this device to achieve an effect of magical strangeness. The boat and rowing figure float in jeweled radiance. The marvel of the painter's skill augments the

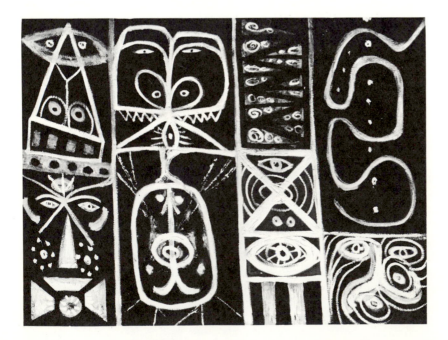

above : 592. BERNARD PERLIN. *The Shore*. 1953. Casein tempera, 47 × 34″. Collection Dr. and Mrs. Cranston W. Holman, New York.

left : 593. ADOLPH GOTTLIEB. *Vigil*. 1948. Oil on canvas, 36 × 48″. Whitney Museum of American Art, New York.

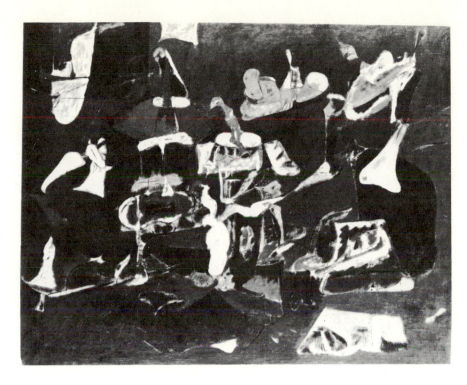

594. ARSHILE GORKY. *Dark Green Painting*. c. 1947. Oil on canvas, 3′ 8″ × 4′ 8″. Collection Mr. and Mrs. H. Gates Lloyd, Haverford, Pa.

wonder of light, transparency, and nature's myriad illusions. A similar element of Surrealist intensification remains, as we saw earlier, an important factor in the art of George Tooker (Fig. 578) and Andrew Wyeth (Fig. 580).

ABSTRACT EXPRESSIONISM

The most significant movement in the late forties and early fifties in America was Abstract Expressionism—abstract in that in its most extreme manifestations there was no representational content; expressionistic in its intense emotional tone. Three currents of modern painting fused to create the Abstract Expressionist movement: abstraction, which had turned painters from pictorial concerns to pure plastic values; Expressionism, with its emphasis on emotional intensification; and Surrealism, with its reliance upon automatism, improvisation, and the universality of certain symbols.

Adolph Gottlieb and Arshile Gorky were two of the many New York painters in the forties to pave the way for the fully developed Abstract Expressionist school by exploring various Surrealist premises. Adolph Gottlieb (1902—) began his study of painting with Robert Henri, but in the thirties he became involved in the *avant-garde* movements, particularly in Surrealist philosophy. Fascinated by the evocative power of primitive art and the universality of the symbols used in totemic and pictographic inscriptions, he began to create what appear to

be improvised compositions in which a freely painted grid of variously proportioned rectangles is filled with cryptic images, some abstract, some suggesting a figural origin (Fig. 593). In the fifties Gottlieb's style changed into one more consonant with fully developed Abstract Expressionism. He used larger canvases, simpler compositions, and more abstract symbols. His late works juxtapose two dissident forms of equal power to create an interrelationship that involves both equilibrium and tension.

Arshile Gorky (1904–48) was perhaps the most influential transitional figure of this period. Whereas Gottlieb, in the mid-forties, employed symbols related to primitive art, Gorky appears to have been more influenced by the amoebic, biologically oriented, swelling forms used by Miró and Arp, as well as by the organic, often visceral or sexual, symbols which float through the gelatinous spaces of Matta's canvases. *Dark Green Painting* (Fig. 594) is typical of Gorky's mature style, in that it displays sensitively brushed forms with strong organic overtones, existing on the borderline between the symbolic and the purely abstract. He made numerous drawings, which often served as preliminary studies for his paintings. The drawings appear to have been almost spontaneous improvisations using a flow of images from memory, dream states, and such orthodox Surrealist sources, as well as from nature, still life, and other works of art. Gorky's paintings retain the essential format of the preliminary drawings, enriched by painterly effects and

more complex relationships between the major forms and the background elements. The forms drifting in the undefined space of *Dark Green Painting* are both exquisite in their delicate sensibility and expressive of painful tension, with physiological and sexual implications that suggest great psychological stress, an aspect of his artistic personality confirmed by the fact that he committed suicide. It was the enrichment of essentially Surrealist motifs through painterly handling, the element of psychological tension, and the predominance of abstract over symbolic or representational forms that made Gorky significant.

Another major figure in the development of Abstract Expressionism was Hans Hofmann (1880–1966), who came to the United States from Munich in the early thirties. During the late thirties and forties he became one of the most influential teachers of modern theory in New York, emphasizing that creative expression grew from the translation of inner states of being into pure (nonrepresentational) form. Hofmann stressed in particular the dynamics of movement and countermovement, of positive and negative space, of advancing and receding color, and, above all, the importance of the direct expression of kinesthetic elements, of the tension and "push and pull"

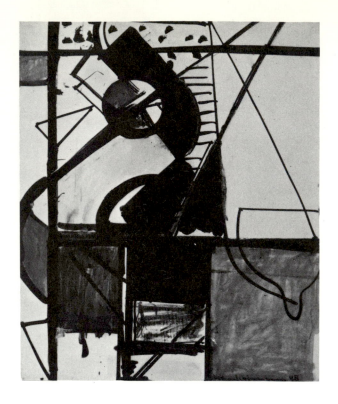

above: 595. HANS HOFMANN. *Construction*. 1948. Gouache, 16¾ × 14″. Whitney Museum of American Art, New York.

below: 596. JACKSON POLLOCK. *Number 17*. c. 1951. Duco on canvas, 4′ 9⅞″ × 4′ 10⅝″. Collection Mr. S. I. Newhouse, Jr., New York.

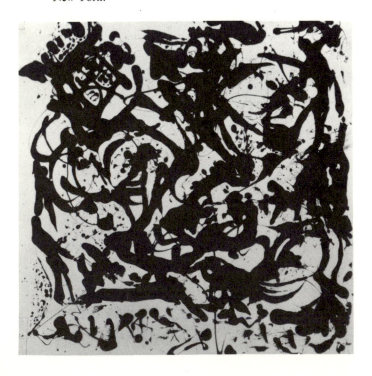

inherent in all action, as well as in all space and form relationships. In *Construction* (Fig. 595) the painting act is of primary importance. Freely executed lines, textures, and patterns are woven through a rectangular structure with the impact of an exclamation or a vehement gesture. This is painting as an elemental act, exhilarating in its spontaneous unfolding, exciting in its abandon.

Jackson Pollock and Franz Kline

The most manifest aspect of Abstract Expressionism appeared in the action painters of the late forties, particularly in the work of Jackson Pollock, Franz Kline, and Willem de Kooning. The "action painters" stressed direct execution so that the movements whereby the painting was created would elicit a kinesthetic response in the observer. Consequently one of their primary aims was to preserve the line movements and forms that reveal the process of painting. The medium and the tools were of primary importance, because they facilitated, inhibited, and to a degree controlled the painting activity. Frequently the action painters started out with no guide or plan beyond an initial impulse. The painting developed from the artist's continued power to invent, improvise, and expand. When completed, the painting stood as a pure expression of his gestures and creative impulses as poured forth in a frenzied interaction between the developing mass of

color, line, tone, and texture and his physical, intellectual, and esthetic make-up. Most action painters worked on enormous canvases that encouraged the use of the full arm and even body movements. The taste for very large canvases remained throughout the fifties and sixties.

The most celebrated virtuoso of action painting was Jackson Pollock (1912–56). During his formative years Pollock studied with Thomas Benton, absorbing some of his teacher's aggressively energetic manner. Later paintings reveal an admiration for the intuitive expressionism of Ryder, and in the early forties Pollock moved into the Surrealist orbit, employing both its symbolism and its transfer of physical energy into painterly expression through gestural automatism. In 1947 Pollock initiated his mature style, in which structured composition was replaced by an all-over field made up of a vortex of swirling lines, spatters, and drips, creating a dynamically energized surface. At this time Pollock began to paint his mural-sized canvases by laying them on the floor and pouring and splashing paint from buckets or dripping it from sticks with swinging arm movements. Rather than the usual heavy artists' oils, Pollock employed commercial enamels and metallic paints, because their texture was better suited to the pouring and dripping technique. Their viscous fluidity contributes to the fascinating labyrinth of tenuous, febrile, incredibly extended lines that seem to have been poured at high velocity to create a sense of endless flux and movement. In *Mural* (Pl. 26, p. 432) the web is gracefully interlaced, nowhere tangled, and the whole of it rests, visually, in a shallow, bas-relief space, close to the picture plane, and is composed, as in a classic Cubist painting, in relation to the picture frame, rather than to a point inside a system simulating deep perspective. *Mural* is both finely textured and large, so that much of the surging energy is lost in the diminished scale of a reproduction. *Number 17* (Fig. 596) is broad enough in execution to demonstrate, even as reproduced here, the qualities of line movement and texture created by Pollock's unique methods of applying paint.

Franz Kline (1910–62) also established an ultimate in action painting but, unlike Pollock, he retained certain traditional painterly values through his direct brushing of thick paint onto the canvas. *New York* (Fig. 597) is a fine example of his mature style. Heavily massed shapes and broad, vehemently brushed lines are projected across the length and width of the canvas in a grandiose gesture. In many of his most forceful works from the early fifties Kline confined himself to using only black and white; and the bold, unmodulated contrasts of value, in conjunction with the enormous size of his canvases, adds to the compelling and disturbing force of what appear to be pure projections of intense feeling into painted form. In his later works Kline reintroduced the use of color.

Symbolic Abstract Expressionism

Though the abstract aspect of Abstract Expressionism was a defining characteristic, figurative and ideational content continued to be present in the work of some of the most significant members of the movement, providing symbolic elements in the composition or a point of departure from which abstract forms and kinetic actions could be derived. Holland-born Willem de Kooning (1904—) was, paradoxically enough, one of the most vehement of the action painters, yet at the same time he retained figural images in his work. *Woman and Bicycle* (Pl. 27,

597. FRANZ KLINE. *New York*. 1953. Oil on canvas, 6′ 7″ × 4′ 2½″. Albright-Knox Art Gallery, Buffalo, N.Y. (gift of Seymour H. Knox).

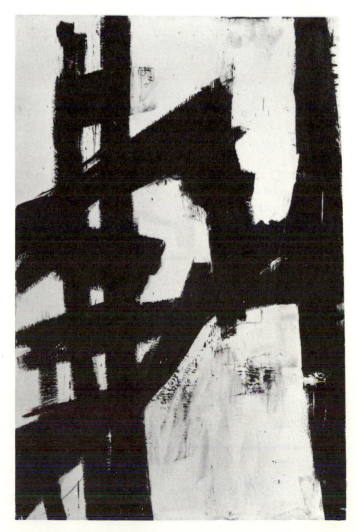

p. 449) was painted with a furious abandon, but from the tempest of slashing brush strokes, rich smears, and runs the forms of a woman and a suggestion of a bicycle appear. The great breasts swelling into three-dimensional space; the predatory, masklike face; and other crudely suggested, almost mutilated, anatomical forms add to the intensity of the work by providing a sardonic symbol that reinforces the violence of the color and execution.

Robert Motherwell (1915—), a philosophy major in college, provided much of the philosophic and literary rationale for Abstract Expressionism, particularly in its formative years. Motherwell's paintings are most frequently thematic, ideas providing a stimulus to invention and improvisation. Though his compositional arrangements seem thoughtfully constructed in relation to the format of the canvas, the execution appears spontaneous and free. In *The Voyage* (Fig. 598) the progression of forms suggests a sequence of experiences, and much of the effectiveness of the painting comes from the element of surprise and paradox: the almost tender awkwardness and curious dissonance of shape relationships, the enclosing and bursting through of large, somber masses. By inventing his own sober forms Motherwell achieves a grandeur suited to the nature of certain of his themes, as in his series of elegies to the Spanish Republic.

The sensitive and evocative art of William Baziotes (1912–63) remained rooted in the earlier Surrealist movement and reminds one of Paul Klee and his oft-repeated dictum, "Art does not render the visible: rather, it makes visible." Baziotes used curious and strange symbols that appear to have welled up from the subconscious. Though the shapes may have generated themselves, the execution was deliberate. Baziotes began his canvases with as much

spontaneity and as few preconceived ideas as possible. As the painting proceeded, the subject revealed itself. A tone of moonscape quietude pervades *The Beach* (Pl. 28, p.450), which seems at the opposite end of the spectrum from the tumult of much Abstract Expressionism. *The Beach* is logically organized, but logic does not explain the fascination of this mysterious, simply patterned canvas.

Theodoros Stamos (1922—) produced a number of beautiful canvases in the late forties and fifties, combining symbolic elements with subtle color and expressive brush work. Though these works are executed in a direct and unpremeditated manner, traditional compositional values appear to govern his highly refined relationships of lines, tones, and subtle, low-keyed colors. In *Greek Orison* (Fig. 599), from the early fifties, the vivid calligraphy of broadly brushed lines and thick accenting masses has an Oriental richness and elegance. In many later works this mood of quiet elegance gave way to an expressionistic intensity which Stamos achieved through turbulent brush work and stronger color.

COLOR-FIELD ABSTRACTION

At the end of the forties, while the various action painters and the symbolic Abstract Expressionists were evolving their particular individual styles, a third group of New York artists confined their attention to very simply composed paintings with an extremely limited number of forms which were closely related in shape to the format of the canvas. The prevailing emotional tone of these works was one of almost mystic quietude. A few basic divisions of the canvas, subtle relationships of color, and quietly diffused textures seem to represent an almost

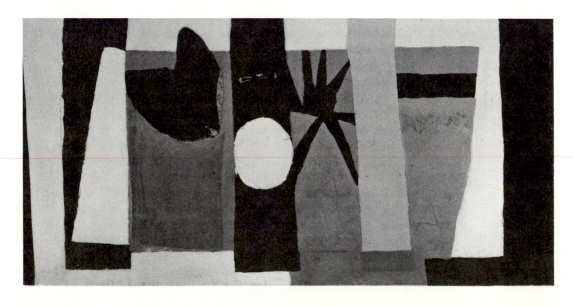

obsessive desire to reduce the art of painting to a simple essence at the opposite pole of expression from the turbulent action painting. Clyfford Still, Mark Rothko, and Barnett Newman, all of whom moved within the Surrealist orbit in the early forties, were among the first to confine their expression to these reductive explorations.

Clyfford Still (1904–) was an early contributor to the development of Abstract Expressionism. His huge canvases stand as aggressive statements of self-sufficiency, for Still believes that an artist paints for himself alone, that a painting represents a distillation, in abstract visual terms, of the essence of the artist as a person. His canvases do not exploit the linear dynamism and animated brush work of the action painters; neither do they depend on symbolic or representational content; instead, they tend to be made up of rather large, flat areas of a limited number of colors (Fig. 600). Sometimes the shapes appear like jagged or torn patches of color drifting across the canvas in rhythmically related movements; sometimes great vertical configurations stand as arresting, powerful uprights; in other canvases the shapes are rounded and floating. Since his canvases are more dynamic than those

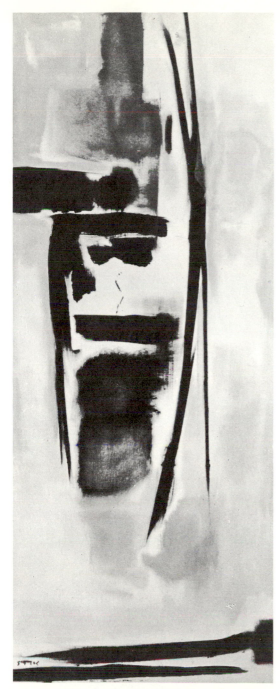

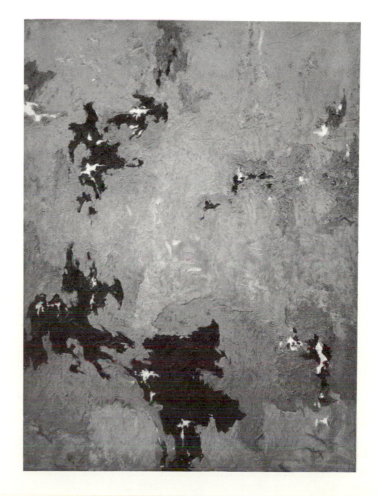

opposite : 598. ROBERT MOTHERWELL. *The Voyage.* 1949. Oil and tempera on paper, mounted on board; 4′ × 7′ 10″. Museum of Modern Art, New York (gift of Mrs. John D. Rockefeller III).

above : 599. THEODOROS STAMOS. *Greek Orison.* 1952. Oil on canvas, 5′ 7″ × 2′ 3″. Whitney Museum of American Art, New York.

right : 600. CLYFFORD STILL. *Number 2.* 1949. Oil on canvas. 7′ 7 ⁵⁄₈″ × 5′ 8 ⁷⁄₈″. Collection Mr. and Mrs. Ben Heller, New York.

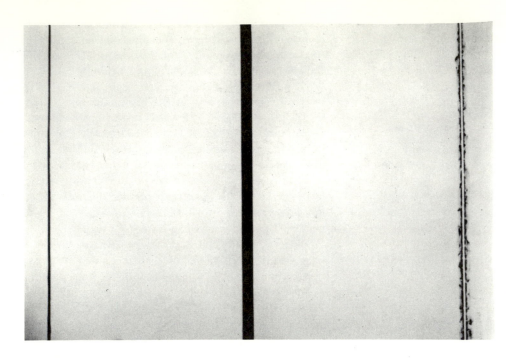

left: 601. BARNETT NEWMAN. *Shining Forth (to George).* 1961. Oil on canvas, 9' 6" × 14' 6". Collection the artist.

opposite: 602 JASPER JOHNS. *Target with Four Faces.* 1955. Encaustic on newspaper on canvas, 26" square; plaster faces in wood frame, 3¾ × 26". Museum of Modern Art, New York (gift of Mr. and Mrs. Robert C. Scull).

of Rothko or Newman, Still stands as a transitional figure between the action painters and the more contemplative color-field painters. Still painted in San Francisco in the forties and did much to stimulate the development of Abstract Expressionism on the West Coast. Sam Francis (1923—), a Californian, was one of his most original and forceful students.

Late in the forties and all through the fifties Mark Rothko (1903–70) organized his canvases around a few soft-edged, rectangular areas framed by small amounts of a uniformly colored background. *Number 10* (Pl. 29, p. 459) is typical. Sensitive color modulations create quiet vibrations, which, in conjunction with the calm, repetitive, floating forms, work together to create subtle, glowing statements that evoke a meditative mood in the viewer. In *Number 10* the rosy underpainting pervades the entire canvas, shining through the blues, the yellow, and the creamy whites like a warm flood of light. The recessive blue, also, is felt everywhere except in the yellow, thus making the yellow rectangle hover in the foremost plane. Rothko achieved a unique color quality by staining the canvas and then brushing heavier pigment over the stained area, thereby creating surfaces of vibrant luminosity.

The final and most fully realized phase of the work of Mark Tobey (1890—) relates closely to color-field painting, though it might more aptly be described as texture— or pattern—field painting. Tobey's works, moderate in size and executed with meticulous precision, featured finely textured all-over patterns, often with an Oriental calligraphic character. Because many of these figures are white on a dark background, they have frequently been called "white writing." Tobey's main concerns seemed to be to create lovely surfaces that invite contemplation.

Barnett Newman (1905–70) moved far away from expressionistic or symbolic concerns toward formal problems of pictorial structure; in many ways his work, though more painterly, appears related to the tradition of Mondrian and Albers. For over a decade Newman was primarily concerned with the use of one or more vertical stripes which consistently relate the shapes within the canvas to the framing edge, thus creating a composition of unified, uniformly articulated color areas. Typically, *Shining Forth (to George)* (Fig. 601) is made up of clearly defined vertical areas of color separated by stripes of varying widths. The relationships of hue, intensity, and value in each color are carefully adjusted to the quantity and proximity of the other colors in the canvas. Though the textured edges of the right-hand stripe suggest the gesture of brushing on paint, the texture is controlled, not impulsive, functioning as a formal element in relation to the other verticals. The large size of the canvases, the austere reserve of the vertical stripes, and the tensions and resolutions of color harmony communicate a sense of deep personal convictions about the nature of modern painting within the bounds of a severe inner discipline.

THE NEW REALISM

The genius of the originators, the "first generation" of post-World War II New York painters, was to assimilate

selected characteristics of the major styles in modern European art—the colorism and emotive power of Expressionism, the poetry, psychological intensity, and "automatic" methodology of the Surrealists, and the structure and organization developed by Cubism—and reorder all these elements into a new art so potent and authoritative it literally dominated American painting for well over a decade and made New York the world art center of our time. Given their struggles, their sustaining conviction, the remarkable quality of their achievement, and the universal recognition accorded them, the Abstract Expressionists have come to occupy an almost heroic position in the history of American art. Eventually, however, their enormous influence was challenged by the "second" and "third" generation painters whose new vision offered a variety of departures from that of their immediate and illustrious predecessors.

Three young men played an important role in turning the current of *avant-garde* painting in new directions in the mid-fifties: Larry Rivers (whose canvas *The Sitter* is reproduced as Fig. 586), Jasper Johns, and Robert Rauschenberg. All three renounced abstraction for specific imagery. Rivers acted as a momentary catalyzer to the nascent Pop movement, since some of his subject matter was derived from popular sources (mass media and patriotic motifs). Rauschenberg and Johns played a more important role. Reactors against the art of the "first generation,"

Rivers, Johns, and Rauschenberg all work in a "painterly" manner reminiscent of the very style that nurtured them —Abstract Expressionism.

Assemblage

Rauschenberg and Johns, who introduced "popular" (commonplace) materials into their art either by representing them or by actually incorporating real objects, did much to turn the tide back to an interest in the American scene, but with very different emotional overtones than had prevailed earlier. Both Johns and Rauschenberg produced "combine" paintings, or what is often termed "assemblage," in which objects of considerable three-dimensional bulk were integrated into the work, to bridge what Rauschenberg called "the gap between life and art." Much of the work of these two men has artistic validity both as visual statement and as philosophic exploration of esthetic premises. Assemblage, an extension of collage, which had been an accepted art form for fifty years, posed a fascinating challenge concerning the basic nature of art and the creative function of the artist. When an object was removed from its normal setting and incorporated into a work of art, it tended to become an abstraction, a visual entity rather than a physically functioning object, and to assume an emotive power that it did not have in real life. This had been seen in collage, in which strips of newspaper became abstract textures, and old photographs evocative symbols of earlier times.

The esthetic and emotional overtones that accompanied the dissociation of the real from its normal context had been anticipated by certain French nineteenth-century symbolists, both in literature and in painting, as well as by the later Dadaists and Surrealists. The revival of this interest received momentum from, among other impulses, the publication in 1951 of Robert Motherwell's anthology of primary and secondary sources entitled *The Dada Painters and Poets*, which was read avidly by the new generation of artists.

Jasper Johns (1930—) started to exhibit in the mid-fifties. Disturbed by the lack of formal structure and the spatial ambiguity of much Abstract Expressionist painting, Johns selected as his subject matter objects from the familiar environment which would present a surface that coincided with the surface of the picture plane, most notably flags and targets (Fig. 602). However, instead of seeking a *trompe l'œil* verisimilitude, he included an element of esthetic intensification through his richly brushed encaustic surfaces. Johns was also intrigued by the whole problem of illusion versus reality. In *Target*, by introducing the four three-dimensionally modeled heads at the edge of the painting, he added an element of spatial

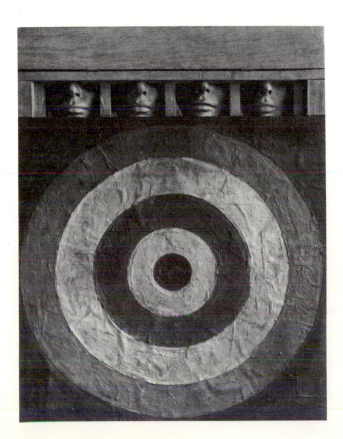

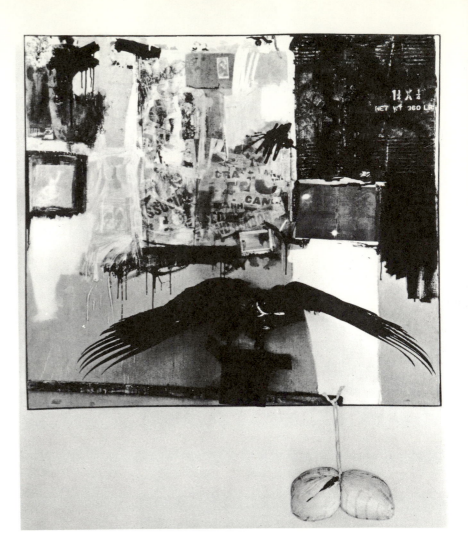

603. ROBERT RAUSCHENBERG. *Canyon*. 1959. Oil on canvas with assemblage, 7' 2 ½" × 5' 10" × 1' 11". Collection Mr. and Mrs. Michael Sonnabend, New York.

complexity; the heads intensify the flatness of the target, thereby reinforcing the awareness of the picture plane. Johns was also intrigued by the problem of the "art" object versus the "nonart" object. Thus the heads, "non-art" objects when seen in the shooting gallery, achieve an emotive strength in the pictorial context which they would have lacked in real life.

Robert Rauschenberg

Probably the most independent and adventurous of the experimental painters is Robert Rauschenberg (1925—). Wanting to work "in the gap between life and art," Rauschenberg has utilized a number of unprecedented devices to embody effectively his reactions to modern life. One of his "combines" features two radios, one tuned to jazz, the other to news broadcasts. Thus one hears two unrelated qualities of sound as one views the pictorial

elements, which include photographs of a horse race, rioters, and fragments of lettering seemingly both related and unrelated to the photographs, all incorporated into a freely painted matrix, which at times obscures and then reveals these ready-made materials. The effect is no more chaotic, meaningful, or meaningless than the welter of sights, sounds, debris, and movements that attack the senses as one moves through the streets of a large city.

Among the unorthodox materials incorporated into canvases Rauschenberg has included "objects of everyday experience (kitchen utensils, neckties, snapshots, coke bottles, radios, stuffed animals, magazine photos, mirrors, road signs, furniture)." These and other materials "are brought into contact with pictorial elements (paint as paste, as splash, as drip, as blob, pencil tracings, strips of canvas, bits of newspaper, cloth)." This conglomerate of objects projects from the canvas or merges into it, and probably one of the unique aspects of Rauschenberg's

art is that he can achieve a sense of unity despite this seemingly whimsical accumulation.

Nowhere else is this more apparent than in *Canyon* (Fig. 603). Here the materials on the top two-thirds of the painting are essentially flat, in the manner of traditional collage, and are unified by the impasto of paint as well as by the essentially rectangular format in which they are composed. In the bottom third is a great stuffed bird, which thrusts forward 23 inches, along with the projecting blocks of wood upon which the bird is mounted. Equally unorthodox is the bifurcated pillow suspended below the edge of the canvas. The bird is related to the upper half of the canvas by its color and by the fact that the rectangular shapes above are repeated below; the wings echo the general edges of the painted masses above. The pillow, too, continues the vertical of the light shape above it. Thus, despite the apparently arbitrary placement of disparate materials, a compositional unity is achieved. One sees *Canyon* as a related organization, and, though its symbolic meaning is open to conjecture (and many fascinating conjectures are stimulated by thoughtfully observing it), it exists primarily as a visual experience which is an end in itself, and its symbolic ambiguity provides a peripheral interest. Just as much Pop Art reveals the fact of the familiar, Rauschenberg reveals the power of dissociation to destroy the fact in the familiar.

Assemblage paintings such as this are only one facet of Rauschenberg's production. He has also been involved in sculpture, printmaking, and other creative activities. His lively mind knows no restraints, and his unorthodoxy is heroic; the whole art tradition has been challenged by his iconoclastic explorations. It may well be that the day of painting as a means of intellectual inquiry is past, and that the young artist, feeling the void, is desperately projecting that ancient and beloved art in new directions and on new quests, following the intuitive forces of his nature without question, knowing that the more rational approaches have been exhausted.

Pop Art

In the late fifties a number of painters in England and the United States initiated a very sophisticated reaction against both Abstract Expressionism and the more time-honored current forms of esthetic expression. In 1962 the movement was officially launched when one of New York's smartest galleries gave the Pop artists a show which, because of its attack on tradition, commanded the attention of both serious critics and seekers after novelty. In its evolutionary stages, before the typical aspects of Pop were sharply defined, the movement shared many similarities with European Dada of almost half a century

earlier. Like Dada, it was iconoclastic, skeptical of conventional esthetic attitudes and values, and tended to break down established art categories, producing works that spanned painting, sculpture, and objects of daily use. In this way the range of Pop Art covers paintings which are also sculptures (assemblage), sculptures which include painted elements, paintings and sculptures incorporating elements from the mass media of communications, and creations which are assemblages of standard, packaged, manufactured merchandise. In addition, "happenings," improvised semidramatic visual spectacles in which the audience participates, also contributed to the Pop culture of the sixties.

Pop Art is not truly popular art; its sophisticated attitudes assume a familiarity with artistic tradition far beyond that of a mass audience. Although it draws upon mass culture for its inspiration, it is neither critical of nor genuinely sympathetic to the mass point of view. Thus an art, which in many respects seems not to be art, has made use of such familiar elements as satire, idealization, abstraction, and intensification of feeling without assigning them an important role. All the activities associated with the movement have demonstrated high spirits, exhibited endless inventiveness and energy, and reflected a brash indifference to established standards of artistic values and conventional decorum. Much of it is pure fun and done with tongue in cheek; much of it represents a genuine attempt to reintegrate elements of popular or mass culture with the "fine arts"; and much of it reflects an attempt to take a "cool" attitude (an attitude of noninvolvement) toward the conflicted world of the sixties. The implication is that nothing can be done about a materialistic, worldly society plunged into situations without solutions, so that the only sensible attitude is one of unemotionalized acceptance of the realities, accompanied by a clear realization of their nature. In many ways Pop Art, like much current abstraction, displays a dispassionate concern with visual experience shorn of conventional social loyalties, hopes, and ideals; an enjoyment of sensation for its own sake; and a high level of unsentimental vitality. The Pop Art movement represents an *avant-garde* revolution against abstraction.

Richard Lindner (1901—) provides a good introduction to Pop Art, because, though his name has been associated with the movement, he remains a transitional figure. Many of his technical devices reflect his more traditional artistic orientation. Lindner was born in Hamburg, Germany, and spent his formative years first in Germany and then in Paris. He came to New York in 1941. Thus elements of both Expressionist exaggeration and geometric abstraction contribute to the strident force of his characterizations. *Rock-Rock* (Fig. 604)

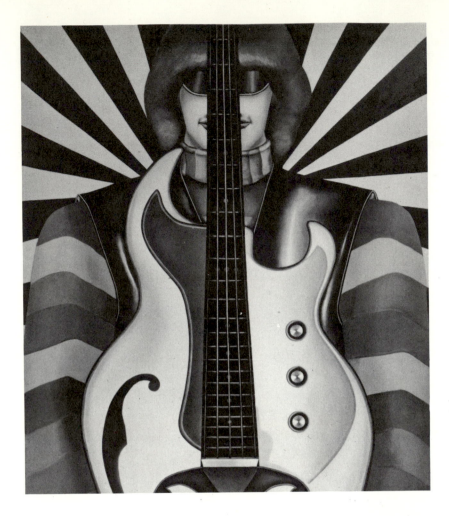

left : 604. RICHARD LINDNER. *Rock-Rock*. 1966–67. Oil on canvas, 5′ 10″ × 5′. Dallas Museum of Fine Arts, Dallas, Tex. (gift of Mr. and Mrs. James H. Clark).

below : 605. ROY LICHTENSTEIN. *Okay, Hot Shot*. 1963. Oil and magna on canvas, 6′ 8″ × 5′ 8″. Collection Remo Morone, Turin, Italy.

draws upon the world of rock and roll for its inspiration. The electric guitar that bisects the composition is no more hard and polished in its forms than the player, sexless and anonymous behind dark glasses, long hair, and leather. The bold stripes that radiate from the background, the chevron sleeve patterns, and the shiny surfaces of guitar and figure project an image of the youth of the sixties and their music—strident, contemptuous of sentiment or prettiness, and radiating physical vitality. The artist neither approves nor condemns his subject, and any possible elements of satire remain subordinate to pure fascination with the world of contemporary youth.

Roy Lichtenstein (1923—) in many ways departs farthest from accepted fine-arts standards and values in his typical canvases. Taking his inspiration from the world of comic books and newspaper comic strips, he employs from these mass-produced sources of entertainment for American youth the stock heroes and heroines with the standard situations and techniques. *Okay, Hot Shot* (Fig. 605) was derived from science fiction, with its

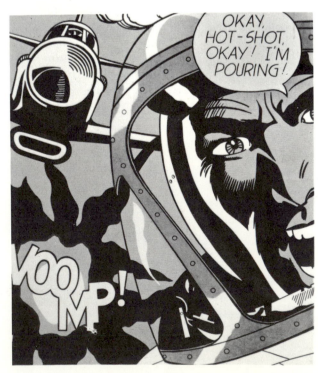

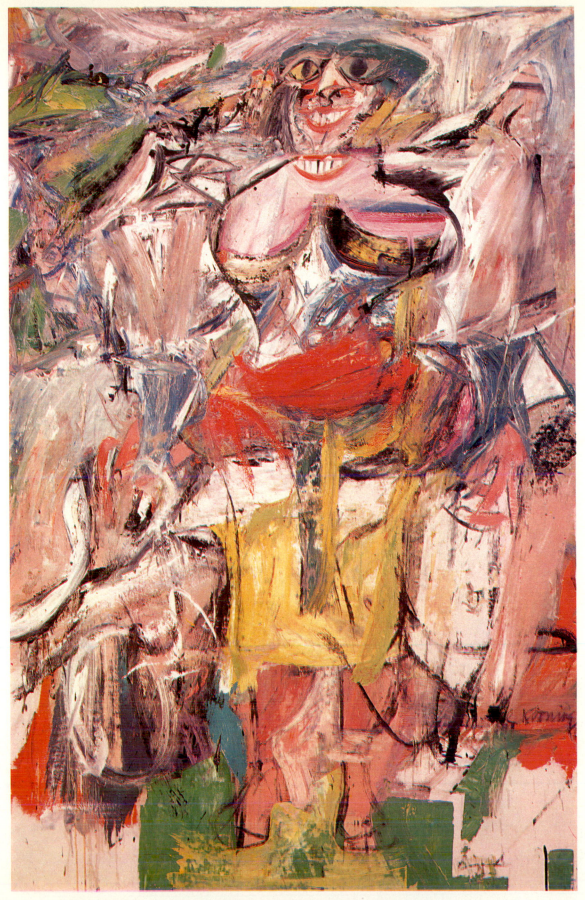

Plate 27. WILLEM DE KOONING. *Woman and Bicycle.* 1952–53. Oil on canvas, 6′ 4 ½″ × 4′ 1″.
Whitney Museum of American Art, New York.

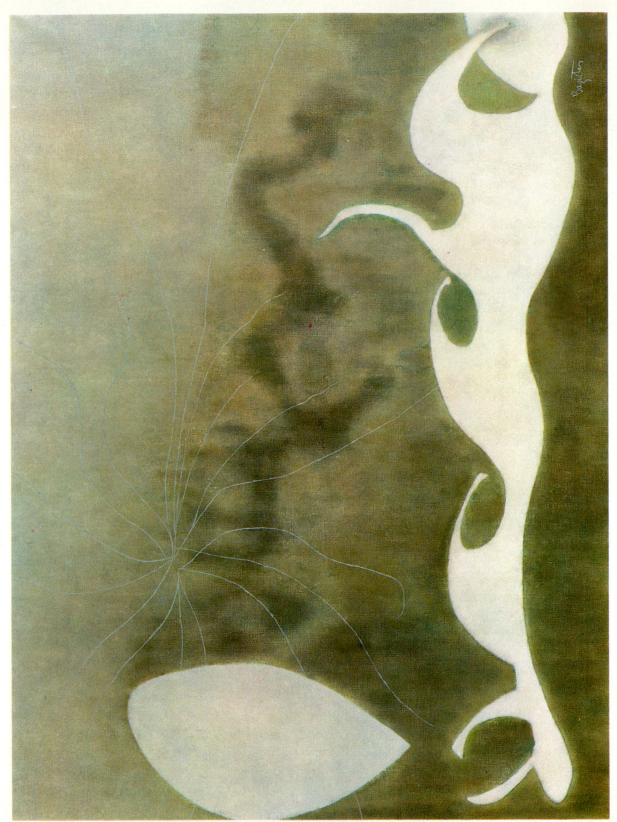

Plate 28. WILLIAM BAZIOTES. *The Beach*. 1955. Oil on canvas, 36 × 48″. Whitney Museum of American Art, New York.

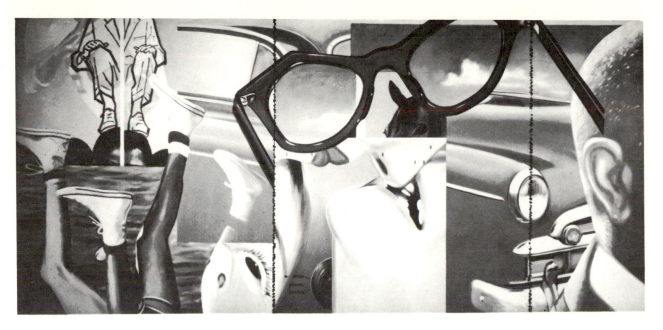

supermen, its prophetic inventions, and its ferocious encounters. The full range of comic-strip devices is employed, including the balloon containing dialogue, the expanding symbols for explosions, the mechanically regular Ben Day tonal textures that intensify the brilliance of the light-and-dark contrasts, the depersonalized line, and the enlarged forms that seem to extend beyond the boundaries of the canvas. Typical comic-book color has also been used—a strong yellow and a dark red, with the red reduced by Ben Day dots to produce a grayed pink. All these devices are handled with mechanical competence, so that no element of the artist's personality enters into the rendering. The effect is as though Lichtenstein viewed his subjects through a giant magnifying glass, which, by taking these symbols of mass culture from their familiar setting and enlarging them, makes us aware of their brutality, their fascination, and their slick fatuity. The result is a seemingly impersonal commentary on American mass entertainment. Unlike the familiar form of editorializing through expressionistic exaggerations, what we have here is a kind of editorializing through an absence of exaggeration, which has its own peculiar power. In the mid-sixties Lichtenstein expanded his repertoire of subjects. Using the familiar Ben Day dots, extended flat surfaces of color, and mechanically regular lines, he rendered landscapes (Fig. 642), objects from everyday life, and even traditional "art" subjects, such as a *Woman in a Flowered Hat* in the manner of Picasso.

James Rosenquist (1933—) draws upon another facet of mass culture for inspiration, the world of advertising, especially the outsize forms of the billboard. As in billboards, scale is an important element in the impact of his work. In *Painting for the American Negro* (Fig. 606) the enormous idealized forms, the smoothly rendered, slick surfaces, and the fragmented interlocking details glide across our consciousness like the flow of advertising images that assault the eye as one moves through the streets of any large city. A vacuous, meaningless dream—sweet, confusing, and soporific—*Painting for the American Negro* seems to reflect the world of salesmanship, where the fundamental values are acquisition and conspicuous consumption, and where even love becomes vapid and dehumanized. Like Lichtenstein, Rosenquist permits the uneditorialized image to reveal its own vacuity. The fetish for large canvases that characterized the fifties and sixties reached a climax in his work titled *F-111,* which, 10 feet high by 86 feet long, was composed of 51 interlocking panels.

Andy Warhol (1925—) probably has been the most publicized of this group of well-publicized artists. His best-known productions are silk-screened paintings done in Liquitex, in which a single image is repeated a number of times. Some of these stenciled paintings have presented famous personalities (for example, his Jacqueline Kennedy series). Others represent piles of boxes simulating shipping cartons with Brillo, Heinz Tomato Ketchup, and Campbell's Soup labels printed on their sides, done so accurately as to make the simulated boxes indistinguishable from the real thing. Warhol has even done a *Death and Disaster* series, one of which pictures an empty electric chair in

an execution cell. *Green Coca Cola Bottles* (Fig. 607) is typical. The rows of bottles are repeated with only slight variations. Some of the bottles appear empty or partially so, and the light reflections differ from container to container, but, despite this subtle variety, the bottles seem without meaning, stressing only the mechanical uniformity of mass-produced articles and neither condemning nor condoning this fact of modern life. In such works there is an absence of commitment to society at large, a delight in the surprise and shock of nonart, which leaves the viewer unmoved except to the degree that he is amused by the audacity of the artist. At the same time the art is deeply rooted in our mechanized, standardized, mass-production culture. That it breaks with established preconceptions of the realm of art is constructive; perhaps in a few decades this rupture will appear to be the real significance of Warhol and most of the other artists participating in the Pop movement.

Tom Wesselmann (1931—) is best known for his impudent, ingenious bathroom collages (or assemblages) and an amusingly vulgar group of *Great American Nudes*. In *Bathroom Collage 1* (Fig. 608) many objects (the towel, towel bar, tile, toilet paper, toilet seat) are real, but they are fused cleverly with the painted surfaces. Whether individual elements are real or simulated is less significant than the feeling of amusement elicited by the whole performance and the oblique but implicit ironic reflection on the American dream created by the world of industry and advertising. Clean, bright, and shiny, the effect is also cheap, thin, and unsubstantial, an effect achieved to a considerable degree by the weightless cutout figure, which, by contrasting the lack of volume in the human factor with the actual three-dimensional bulk of the manufactured objects, creates an ironic comment. It is as though Wesselmann is saying about modern life, "Everything is real except people!"

The number of artists associated with the Pop movement is too great to be encompassed here. Robert Indiana (1928—) has drawn upon the stenciled letters and numbers used for industrial labeling for inspiration, and a number of sculptors and experimentalists working in the assemblage realm between sculpture and painting have also contributed to the Pop movement, most notably Claes Oldenburg and George Segal (Figs. 690, 695). By the late sixties Pop had largely lost its novelty, but a number of the artists who had come to public notice in its heyday were still producing significant work. Two powerful influences of the Pop movement should be noted: First, it gave a forceful expression to the search for novelty and to the cool indifference to traditional values that typified the hypersophistication of much of America's youth in the early sixties. Second, the effect of the movement in turning a number of young painters away from abstraction toward subject matter and recognizable imagery was almost as great as the influence of Abstract Expressionism had been in the opposite direction a generation earlier. Man being the measure of his world, the human associations of Pop make it an irresistible style.

THE NEW ABSTRACTION

Optical ("Op") Painting

Op, like Pop, represented a revolt against what younger painters considered the long, almost tyrannical, reign of Abstract Expressionism. Unlike Pop, "optical" art maintained total abstraction and concerned itself, not with the painter's emotional and social commitments to his art and to his world, but primarily with the way the eye and mind respond to certain visual phenomena. Explicit as this

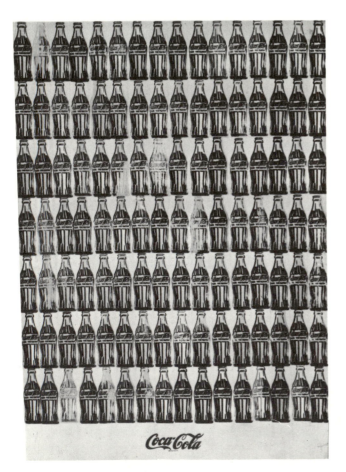

607. ANDY WARHOL. *Green Coca Cola Bottles*. 1962. Oil on canvas, 6′ 10 ¼″ × 4′ 9″. Whitney Museum of American Art, New York (gift of the Friends of the Whitney Museum).

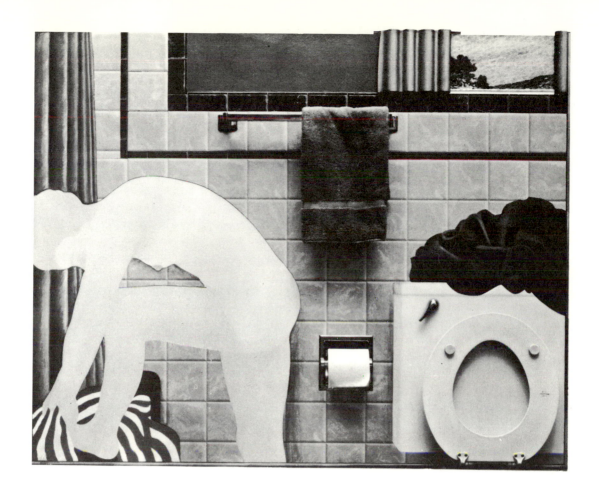

above: 608. TOM WESSELMANN. *Bathroom Collage, 1.* 1963. Assemblage, 4 × 5'. Courtesy Sidney Janis Gallery, New York.

interest may be in Op, it could be said that in virtually all modern painting—from nineteenth-century Impressionism on—there has been, to one degree or another, a conscious manipulation of the physical and psychological factors that condition optical perception, and these considerations are predominant in the work of such artists as Mondrian, Albers, and the color-field abstractionists. In 1965 the Museum of Modern Art in New York organized an exhibition conceived around the title "The Responsive Eye." William Seitz, who prepared the show and wrote its catalogue, used the term "perceptual abstraction" to describe what for a time was called Op Art. Seitz says, "Perceptual abstraction . . . exists primarily for its impact upon perception rather than for conceptual examination." Most of the works in the show were characterized by uniform, small-scale patterns repeated and without variation over a two- or three-dimensional surface to explore their effect upon the perceptions of the viewer. Color vibrations, illusory

distortions of form caused by alternating positive and negative patterns, and suggestion of movement were all primary concerns of the Op artists. These painters drew upon scientific materials from the fields of optics and psychology, as well as upon artistic knowledge, for the devices that make their work effective. The optical illusions fascinating them had interested artists, designers, and psychologists even prior to the nineteenth-century experiments in these areas, but never before had the devices of illusion alone provided the basis for pure painting. Op Art thus was an assimilation of knowledge from specialized disciplines, a significant fact in an age tending to isolate fields of inquiry from one another. Because of the tricks Op plays on the eye, it offers the wit and whimsy of Pop, but in the purity of its retinal appeal, the style has earned a place in the history of the "visual" arts.

Larry Poons (1937—) might with equal justification be classified as a field, hard-edge, or optical painter. He has, with an almost compulsive concentration, repeatedly explored the effect of regularly shaped, bright-colored, small ovals dotted at varying angles and intervals over a solid-colored ground. In *Away Out on the Mountain*

(Fig. 609) the typical dots move into and out of the field of vision like particles of energy transversing space; some dots advance, some recede, establishing vibrations that animate the entire space continuum of the painting. To be fully valued such works, far removed from the traditions of artistic humanism, must, like all works of art, be viewed with sympathetic interest.

Injured by Green (Pl. 30, p. 460) by Richard Anuszkiewicz (1930—) gives a more typical illustration of Op devices. It is made up entirely of circles of two sizes in three colors, placed with mechanical regularity over a background of uniform red. The blue, light blue-green, and darker green circles are grouped so that each of the three colors vibrates at a different intensity in relation to the background. Staring at the entire painting for a period of time is both hypnotic and dizzying, for the vibrations attack the eye with an almost painful intensity. A study of the interactions of the colors on one another provides a fascinating experience. The blue makes the red appear somewhat darker and less orange than it appears against the blue-green, while the dark green circles in the center make the red appear darkest, most orange, and most intense. Yet the final evaluation of the painting as a work of art depends not on an intellectual analysis of the effect of color upon color but, rather, upon the exhilaration it imparts. Its impact upon the optic nerves creates an emotional reaction that is analogous to the way in which an electric vibrator, by massaging the body muscles, creates a sense of well-being and pleasure. Unlike the electric vibrator, however, *Injured by Green* creates its stimulus on us as contemplative rather than as primarily physical beings.

Obsession (Fig. 610) by Julian Stanczak (1928—) is made up of lines of varying widths repeated in a sequence of positions so that they seem to move up and down and at the same time to create a surface that advances and recedes into convex and concave swells. *Obsession* is well named, for the effect is hypnotic, and the eye, unable to hold the lines in a static image, can at the same time hardly forgo attempting to do so. The Op prints discussed in Chapter 22 provide further explorations of the fascinating field of visual phenomena.

MINIMAL PAINTING

The purifying reductive tendencies inherent in the paintings of Rothko and Newman were carried even further in the work of one of their contemporaries, Ad Reinhardt (1913–67). An abstract painter since the thirties, Reinhardt was a mystic, inspired to a degree by the Oriental philosophies which were being espoused by certain groups of American intellectuals who questioned the humane potentialities of our technological and material progress.

Reinhardt sought an ultimate: to eliminate all the elements which create tension and to invoke a mood of hypnotic reverie. The typical canvases of his later years were painted a mat black, and within the all-consuming blackness barely perceptible rectangular configurations such as squares or crosses were defined only by shadowy changes of tone, too subtle to be seen in reproduction. Such figureless, featureless painting is both bold and courageous in its radical simplicity. Having eliminated the traditional burdens and embellishments of narrative, representation, perspective, etc., as illegitimate for two-dimensional art, the "minimal" artist attempts to make a monumental statement with the barest of means, with nothing but the essential, irreducible conditions of painting: pure color, flat surface, and the shape of the canvas at its edges.

In the late fifties and sixties minimal art assumed the dimensions of a movement, with both painters and sculptors pushing the search for fundamentals even beyond what had been *avant-garde* concepts. In painting, the relationship between a single image and the frame was frequently stressed, rather than the interrelationships between the internal parts of a composition. Even the validity of the picture plane was challenged by the adoption of staining and spraying techniques which produced colors that seemed to float in a spatial vacuum. These concerns characterize the stained and sprayed canvases of Jules Olitsky (1922—), where luminous colors float into one another across great open spaces. In *C+J&B* (Pl. 31, p. 461) the yellow at upper left fades imperceptibly into airy blues and greens. As is often the case in Olitsky's paintings from the mid-sixties, the edges of the canvas are accented by narrow bands of sharp-edged, crisply textured colors, in this case, reds, oranges, and yellows. These defining edges both frame and stabilize the floating color field, and by their narrow scale and crusty texture they intensify the extensive and ambiguous spaciousness of the main body of the canvas. The openness and grand scale of the works convey an awesome intimation of infinite space —or the converse, a spaceless infinity.

It should be pointed out that the use of staining and spraying paint on absorbent canvas, like the use of commercial enamels by Jackson Pollock a decade earlier, enlarged the painter's vocabulary of expressive effects by broadening the range of media. Thus in the sixties painters exploited the following elements: traditional painterly brush work; hard-edged, enamel-smooth surfaces; and stains or washes of transparent, almost bodyless paint, often spread on raw, unsealed duck and sometimes applied even before the support was stretched on a frame.

Morris Louis (1912–62), who worked in Washington, D.C., was a notable exponent of the use of transparent washes on an absorbent canvas. The pigment was applied

above : 609. LARRY POONS. *Away Out on the Mountain.* 1965. Acrylic on canvas, 6 × 12′. Allen Art Museum, Oberlin, Ohio.

right : 610. JULIAN STANCZAK. *Obsession.* 1965. Polymer tempera on canvas, 4′ 5 ½″ × 3′ 9″. Indianapolis Museum of Art, Indianapolis, Ind. (James E. Roberts Fund, 1965).

above : 611. MORRIS LOUIS. *Alpha-Iota*. 1961. Acrylic on canvas, 8′ 8″ × 12′. Collection Mr. and Mrs. Robert A. Rowan, Los Angeles.

below : 612. LORSER FEITELSON. *Untitled*. 1963. Oil and enamel on canvas, 6 × 5′. Los Angeles County Museum.

either in thin veils of pale color or, as in *Alpha-Iota* (Fig. 611) was allowed to spread across the canvas in rhythmic flows. The wavering lines, reminiscent of Art Nouveau in their lassitude, frame a great stretch of bare canvas. Here again, as in much minimal art, one feels a weariness of man's spirit, a desire to escape into an enfolding quietude from the pressures of a frenetic, discordant world.

While Rivers, Johns, and Rauschenberg redirected American painting away from the egocentric abstractions produced during the late forties and early fifties to the more public imagery and subject matter of Pop Art, they retained in their handling of the paint medium much of the rich facture practiced by, for instance, de Kooning and Kline. The post-1945 first generation, however, boasted not only Pollock but Rothko and Newman, whose totally abstract work—Pollock in linear skeins and webs and Rothko and Newman in pure stained or flat color—displayed an originality of form and technique and an equilibrium in style that served to launch and inspire a new generation of abstractionists, who, like the Op and Pop artists, were in reaction against the emotional vehemence and generalized symbolism that characterized the vanguard of painting in the previous decade. Jules Olitski, whose *C+J&B* we saw in Plate 31 (p. 461), developed an all-over articulation of the picture surface that recalls Pollock's delicate interlacings and Rothko's soft, luminous colors. A striking, sometimes strident contrast to such evocative, mood-filled paintings as these is provided by certain abstractions of the late fifties and

the sixties, described by various critics as "new," "post-painterly," or "hard-edge"—works by what might be called a "third generation" in post-World War II American painting. Emanating from Barnett Newman and continuing the analytical, precisely executed, formally structured vein initiated in America by Mondrian and Albers, the hard-edge abstractionists appear to reflect elements from our machine age, in which mass production and mass media of communication place a premium on the impersonal, the explicit, and the exact, while the ubiquitous space advertisements, billboards, and industrially produced merchandise present broad surfaces of brilliant, textureless color. The reductive tendencies explored by Barnett Newman and other color-field painters also influenced the hard-edge painters of the sixties, turning them toward minimal art concepts, so that their canvases are designed very simply, repeating without variation a few mechanically exact motifs to achieve a maximum of force with a minimum of means.

Untitled (Fig. 612) by Lorser Feitelson (1898—), a Los Angeles artist, explores the impact of great swinging blue lines of unvarying width against an intense red background. The elegant shapes which result have the cold beauty produced when an unflawed surface of brilliant color is combined with unfettered movement.

Ellsworth Kelly (1923—) is another hard-edge painter who explores a limited range of esthetic experiences. His dominant concern in his mature work is to establish a stable relationship between large, bold shapes placed in an extremely simple format. Frequently, as in *Red, White, and Blue* (Fig. 613), the forms which constitute the theme are identical in size and shape but different in color. The similarity of shape points up the dynamics of color interrelationship. The effect of the work is pure and impersonal, but one is involved emotionally rather than intellectually, because of the monumental and severe simplicity of the compositional elements. In the sixties Ellsworth Kelly experimented with cut-out shapes of an equal simplicity mounted in front of a pure white ground, thus adding an element of three-dimensional reality to what had been an illusion of three-dimensional space.

The paintings of Nicholas Krushenick (1929–) create fresh, spirited effects from combinations of elements that fascinated artists in the sixties. In *King Kong* (Fig. 614) rhythmic, overlapped curves moving into the

above : 613. ELLSWORTH KELLY. *Red, White, and Blue.* 1961. Oil on canvas, 7′ 4″ × 5′ 6″. Collection Mrs. Betty Parsons, New York.

right : 614. NICHOLAS KRUSHENICK. *King Kong.* 1966. Acrylic on canvas, 6′ 10″ × 5′ 10″. Private collection, New York, courtesy Pace Gallery.

615. Frank Stella. *Moultonville III*. 1966. Fluorescent alkyd and epoxy paint on canvas, 10′ 4″ × 7′ 2″. Nelson Gallery–Atkins Museum, Kansas City, Mo. (gift of the Friends of Art).

main area of the canvas from the sides and bottom contrast sharply with strong, horizontal stripes that complete the field. Composed of the heavy black lines of 1920s decorative conventions, Art Nouveau flourish in the scallop shapes, and hard, bright colors from advertising, the work interacts with the derisive title of a famous 1930s movie to conjure a playful mood in a hard-edge painting generally dominated by an austere esthetic.

A concern with the fundamental nature of the artistic experience, with the interrelationships between art, reality, and illusion; has motivated much exploration in all the fields of contemporary expression. The conception of a painting as a man-made object, flat and two dimensional,

which exploits color and pattern in its purest form without reference to the external world, has received a brilliant development in the great canvases of Kenneth Noland (1924—). Frequently employing a pictorial arena larger than the viewer's field of vision, so that the paintings seem to engulf the beholder, Noland composes his diamond-shaped, circular, or rectangular canvases in stripes that parallel the dominant direction of the canvas, concentrating his emphasis on the interaction of the vivid, flat colors upon one another. To minimize personal and painterly elements, mat acrylic paints often are applied with a roller to produce a nonreflective, textureless surface. Thus, the compositional variants are reduced to changing

Plate 29. MARK ROTHKO. *Number 10*. 1950. Oil on canvas, 7′ 6 ¾″ × 4′ 9 ⅛″.
Museum of Modern Art, New York (gift of Philip C. Johnson).

Plate 30. RICHARD ANUSZKIEWICZ.
Injured by Green. 1963.
Liquitex on board, 36″ square.
Collection Mrs. Janet S. Fleischer,
Elkins Park, Pa.

above: Plate 31. JULES OLITSKI. *C + J & B.* 1966. Acrylic on canvas, 5′ 9″ × 9′ 7 ½″. Collection André Emmerich, New York.

left: Plate 32. KENNETH NOLAND. *Blue Minor.* 1968. Acrylic on canvas, 3′ 1 ½″ × 7′ 9″. Collection Mr. and Mrs. Robert Kardon, Merion, Pa.

Plate 33. FRANK STELLA. *Sinjerli Variation IV*. 1968.
Fluorescent acrylic on canvas, diameter 10′.
Collection Mr. and Mrs. Burton Tremaine, Meriden, Conn.

amounts and intensities of color. *Blue Minor* (Pl. 32, pp. 460–61) displays Noland at the height of his powers—grand, spacious, and serene, playing the various amounts of cyan blue, the stripes of rose and white, and a narrow line of green against the two dominant bands, one blue, the other violet. The mood is poetic, the impact exhilarating, an impact that can be fully experienced only in front of the canvas, since size is a basic element of the work.

In the mid-sixties the work of Frank Stella (1936—) contained many departures from convention, even from the conventions of the hard-edge painters of the period. Initially Stella's works appeared in the usual rectangular format, but in the early sixties he began to employ hexagonal, chevron, X, and other unconventionally shaped canvases, and within these large outlines to compose regular stripes of subdued, often monochromatic color, sometimes separated by thin lines of black or metallic paint or even bare canvas. In his paintings of the mid-sixties, such as *Moultonville III* (Fig. 615), he abandoned the symmetry that characterized his earlier nonrectangular canvases and employed shapes which, in conjunction with painted stripes and large, flat areas, produce the illusion of three-dimensional form. Thus, one is not certain whether the border on the right-hand side of *Moultonville III* is a painted stripe or a folded form. In these illusionistic canvases fluorescent colors of astonishing intensity, used in proximity to grayer hues, vibrate and thereby increase the element of spatial ambiguity.

From a more recent series of paintings by Frank Stella comes *Sinjerli Variation IV* (Pl. 33, p. 462). Here, in a great 10-foot circular canvas, the bands of color are composed, alternately, to parallel the circular format, to oppose it, and to play against horizontals and verticals, thus reintroducing, through complex movements and countermovements, the dynamics so essential to traditional concepts of composition. The bands of lush, intense color overlap and enfold one another in an ambiguous space play curiously at odds with the flat, outline masses of color. A radically intellectual but decorative art, its problems have been decided with such austere protractor precision that color and composition seem locked into the implacable logic of the form the artist has imposed upon them.

The reductive tendencies, the search for essentials beyond the traditional fundamentals of composition, and the spatial illusionism of earlier schools of painting ended with the discovery that illusion itself remained a final reality of all art. No matter how flat, two colors in juxtaposition create a space relationship; and any two contiguous forms, even when identical, establish a relationship

involving elements of tension, movement, and spatiality. Hence, new vistas were opened for exploration by the contemporary artist.

For more than forty years the validity of the picture plane had been of prime concern to painters who felt that Renaissance perspective and the illusory space it created denied the actual flat character of the art of painting. In the sixties, as has been noted in relation to color-field painting, illusory space challenging the validity of the picture plane began again to intrigue painters.

In the late fifties Al Held (1928—) moved from Abstract Expressionism to a rather freely painted, hard-but-not-quite-hard-edge style which was unique in that his monumental canvases conveyed a sense of buoyant energy far removed from the impersonal, mechanical flavor that dominated most hard-edge painting. A more recent series of canvases reveals that Held has become intrigued both with illusion, particularly the illusions created by perspective, and with the dynamics and tensions caused by ambiguous relationships of space and form. His work has, at the same time, retained its characteristic energy. *Phoenicia X* (Fig. 616) projects a multitude of

blocks deep into the space within the canvas as well as into the space in front of the picture plane. Some blocks appear solid; others consist of a skeletal framework of lines that define the tantalizing tops, bottoms, and sides of the never-still rectangular blocks—tops, bottoms, and sides that shift their positions in space with each movement of the viewer's eyes, fronts suddenly transforming themselves into backs, tops and bottoms that shift their axes. Large circular forms at the upper and lower edges of the composition catalyze the movements and keep the unsteady forms flying in space.

Ronald Davis (1937—) goes farther than any of his contemporaries in his exploration of visual illusionism. *Red L* (Pl. 34, p. 471) presents what appears to be a broad, wedge-shaped area, topped and bottomed by diamond-shaped planes that recede rapidly from the frontal surfaces established by the apex of the wedge. The three-dimensional character of the interlocking forms that make up this visual complex is intensified by a suggestion of thickness on the front facet of each form. Thus Davis achieves a convincing illusion of a three-dimensional polyhedron projecting from the wall, when in actuality we are viewing an essentially two-dimensional surface hanging on a vertical plane.

Lest the painter appear to be taking his concern with illusionism too seriously, a variety of unorthodox elements are introduced to alleviate any tone of undue sobriety, perhaps a reflection of Pop attitudes. A zestful exploitation of visual paradoxes distinguishes *Red L*. The colors—sharp and acid in some areas, somber and heavy in others—violate every convention of color harmony. Yet, while they appear arbitrary and whimsical, they contribute to reinforcing the three-dimensional character of the whole. Freely painted, wavering lines play against geometrically precise edges and forms, while spatterings and drippings reminiscent of Abstract Expressionism disturb the otherwise flawless surfaces.

Davis, like many of his fellow painters, has abandoned such time-honored media as canvas and oil paint. *Red L* is painted on wood covered with polyester resin and fiberglass. This provides a high-gloss finish with the hard, clear, slightly translucent sheen of a freshly polished automobile. Irreverent in his exuberant explorations, Davis draws on many elements that have appeared in American painting since 1945. Geometric abstraction, boxed constructions, serial repetitions, Abstract-Expressionist splotchings, transparency, and simultaneity all have contributed to the imaginative way he plays with form and its problems.

Thus another dimension has been added to abstract painting; illusory space, created by conventional perspective, is again accepted as a valid element in abstraction. The validity of the picture plane, sacred to modern painters for fifty years, is sacrificed for the joy of illusion. Another aspect of illusionism appeared in the sixties; a number of painters, not content with creating the effect of three dimensions on a flat canvas, commenced to paint on canvases which were shaped in three-dimensions. Many of these works played with the perception of the viewer, fusing actual three-dimensional projections and recessions with painted spatial effects. This concern with spatial ambiguities seemed to be carrying the observer in full circle back to the Baroque delight in illusion and *trompe l'œil,* substituting the modern idiom of abstract, geometric forms for the humanistic vocabulary of the Baroque painters.

No one school of painting represents contemporary America. The artist of today inherits a tradition of infinite complexity and variety. Pop Art and sharp-focus realism, with its almost obsessive detail, represent one phase of the range of contemporary painting, and geometric abstraction and Abstract Expressionism represent others. Within one short decade Wyeth painted the people and places of rural America with exactitude, nostalgia, and compassion; Andy Warhol focused his sharp, cold eye on cans of soup, cartons of Brillo, executions, riots, and other assorted Americana; hard-edge painters dazzled audiences with their fluorescent stripes, concentric circles, and chevrons; Rauschenberg drew on the taxidermist's art, photography, the junk yard, and a wide range of painting media to form his enigmatic creations; Olitski subordinated all form to a luminous ambience of floating color. Such range of content and style means that there is room today for every form of expression.

Viewed in moments of depression much contemporary painting suggests only nihilism and chaos. In moments of optimism, one feels not only that the valid aspects of the old traditions are still with us but also that we are witnessing the birth of a new tradition. Form, space, color, line, and texture are being developed as elements in a new symphonic kind of art that is free from the role of naturalistic representation and has burst the forms and boundaries of all traditional expression. Such an art can attack the senses directly and vehemently to transmit profound intimations of both order and disorder. Moods of optimism and pessimism both have validity. Modern painting is as it is because of the multiplicity of our culture. We have a heritage of age-old conflicts which can lead the world to chaos, but we also have a heritage of knowledge, achievement, and change that holds a promise of orderly progress into the future.

22

Modern Graphic Arts
and Photography

GRAPHIC ARTS

Though printmakers, on the whole, tend to be slightly more conservative than painters, printmaking since the Armory Show has remained closely related to painting. This is not surprising, because a continuously increasing number of major painters have become seriously involved in the graphic arts, and even printmakers who are not painters work in the same social and cultural milieu. Thus an outline of developments in printmaking since 1913 repeats the patterns already observed in painting. In the twenties the vigorous vein of realism initiated by The Eight in the first decade of the century gradually gave way to America's initial explorations of Cubism, Expressionism, and abstraction. In the thirties American-scene realism and regionalism dominated printmaking. In the forties Surrealism, Expressionism, and abstraction, along with some experimental forays into new technical methods, infused new blood into the art of "multiples." In the late fifties and sixties Op, Pop, and extensive explorations of new media and materials provided startling departures from orthodox concepts. The fifties and sixties also saw prints of increasingly large dimensions replacing the more conservative format that had previously prevailed.

The later prints of George Bellows provide a transition from the journalistic vigor of Sloan and the early Bellows to the more thoughtful structuring that characterized much printmaking in the twenties. Bellows did much to popularize lithography as a major medium, probably being the most distinguished lithographer in the second and third decades of the century. In the twenties, under the influence of Cubist and Expressionist concerns with formal pictorial structure, Bellows modified the spontaneous manner of his earlier years for a more disciplined composition and for more fully developed and monumental three-dimensional forms. In his lithograph *Dempsey and Firpo* (Fig. 617) he employed the same composition as in his famous painting by the same name. Here great slashing diagonals that move all across the print and repeated pyramidal groupings of forms build an organization that is both dynamic and stable. Bellows' knowledge and control of the lithographic medium enabled him to produce a print in which the dramatic elements of the composition are enriched by bold contrasts of velvety blacks, sharp whites, and luminous grays.

The stimulus of the earlier Ash Can school, the more studied concern with formal values that characterized the later work of Bellows, and the new stylistic impulses

introduced from Europe activated a vigorous group of young printmakers in the twenties. These artists not only introduced more dynamic trends into printmaking and maintained the high technical level of lithography established by Bellows, but they also introduced wood engraving as a popular medium. Both lithography and wood engraving permitted richer and more dramatic tonal and textural effects than did the traditional types of etching practiced at the turn of the century.

The Twenties and Thirties

Abraham Walkowitz (1880–1965) forecast the changing temper of the times in his selection of subject matter, his choice of medium, and the new interest in stylized modes of expression when he made his lithograph *Abstraction : City* (Fig. 618). Reflecting the same interest in the energy

of the big city as the Italian Futurists, and drawing upon their dynamic stylistic devices, as well as upon the fresh and impulsive manner of John Marin, Walkowitz created a shimmering semiabstract pattern of lines and textures in this highly unconventional interpretation of New York. Traditionally, printmaking had tended to be an art in which disciplined craftsmanship played an important role. Walkowitz was among the first to abandon technical perfection in favor of the power of direct, untrammeled expression.

Wanda Gág (1893–1946), another of the youthful spirits, used an animated, personal manner to depict genre scenes of New York City and of her own apartment. In *Elevated Station* (Fig. 619) a rather lively expressionistic

distortion conveys the artist's amusement at the whimsical charm of these gangling structures, with their ugly utilitarian features disguised by bits of preposterous Victorian decoration. Here the medium of lithography facilitated the development of a rich tonal pattern. The light-hearted humor that characterized Wanda Gág continued the vein of amused sophistication which had been initiated earlier by Sloan and other members of The Eight, who felt no need to endow their artistic efforts with an attitude of unsmiling Victorian propriety.

This humorous point of view continued through the thirties in the prints of Peggy Bacon (1895—), Mabel Dwight, Adolph Dehn, and others. In *Queer Fish* (Fig. 620), by Mabel Dwight (1870–1955), the gentle humor is augmented by the carefully graduated tonalities of the lithographic medium. Here, as in the work of Wanda Gág, there is no biting social criticism; instead, the artist seems quietly entertained by the spectacle of life.

In the forties this light-heartedness disappeared. *The Great God Pan* (Fig. 621), by Adolph Dehn (1895—), hints at the changing temper of the times. The angular patterns, sharp textures, and bold contrasts of tone give a vehemence and bite to the Dehn lithograph that is absent from the humor of an earlier decade. Dehn's style in the thirties, with elements of caricature contributing expressive power, was strongly influenced by the German satirists, particularly George Grosz.

Three other major lithographers of the late twenties and early thirties whose work reflects the impact of the new movements in painting were George Biddle, Louis Lozowick, and Howard Cook. George Biddle (1885—),

who came from a prominent Philadelphia family, was educated at Groton and Harvard and later, when he knew he wanted to be an artist, in the academies of Philadelphia, Paris, and Munich. He found the academic world stifling, and it was from such nonacademic artists as Frederick Carl Frieseke, Mary Cassatt, and, later and most important, Jules Pascin, that Biddle learned to be independent of academic tradition and to have confidence in his own impulses, particularly the impulse to draw freely and distort to intensify character and compositional design. In

above : 620. MABEL DWIGHT. *Queer Fish*. 1936. Lithograph, 10 ⁵⁄₈ × 13″. International Business Machines Collection, New York.

left : 621. ADOLF DEHN. *The Great God Pan*. 1940. Lithograph, 10 ¼ × 14 ¼″. International Business Machines Collection, New York.

Cows and Sugar Cane (Fig. 622) one sees the intensification of character and the originality of design that he achieved through this independence. The expressive exaggeration of the awkward forms of the cows, particularly the rear view of the cow on the upper right, gives an incisive flavor to the print. The arbitrary patterning of the darks creates a vivid and unique design. Biddle experimented with the lithographic medium to enlarge its repertoire of effects. In *Cows and Sugar Cane* many of the lights have been scraped out of a black base with sandpaper or a razor blade, so that the print has a nervous liveliness of texture that provides more energy than the smooth gradations beloved by most lithographers.

Louis Lozowick (1892—), like Demuth, Sheeler, and a number of other artists of the late twenties, was strongly influenced by French Cubism in his taste for formal patterns and clean-cut forms, but he preferred to achieve these compositional qualities through a strict adherence to fact, even though the fact might be a prearranged one, as in *Still Life No. 2* (Fig. 623). Lozowick looked directly down on his still-life arrangement, thus creating the shallow and limited space preferred by most abstract painters. The shallow space stresses the sharply defined forms, precise edges, and controlled gradations of tone character-

istic of the lithographers who are by temperament master craftsmen. The clean rounded and squared shapes play against one another to create a brilliant pattern very much in the tradition of the Immaculates and, by being drawn from the immediate environment, conform to the preferences of the emerging American-scene painters.

Howard Cook (1901—) spent much of his life among hard-working people, and his choices in subject matter reflect his preferences for the daily verities of simple lives, rather than for the world of the sophisticates. Much of Cook's youthful preparation for life as an artist was spent doing commercial illustration, and the vigor and strength of his artistic expression indicate the positive discipline that comes from doing an assigned job well. Cook worked both as a painter and as a printmaker, and his printmaking activities involved both lithography and the more intractable medium of wood engraving. *Edison Plant* (Fig. 624) is a lithograph, but it reveals the same control and technical command that distinguish his engravings. Here again we see the impact of Cubism and abstract painting in the way powerful geometric patterns dominate this brilliant print, but, like so many Americans, Cook preferred to find his geometric forms in the vital world of American industry. Though basically a realist, Cook did more than put down what he saw before him; he simplified, edited, and composed to convey the truth he sensed beneath the surface. In *Edison Plant* this truth was the almost inhuman strength of the industrial world.

One of the strongest personalities, artistic and otherwise, to be active in the printmaking world of the twenties and thirties was Rockwell Kent (1882—). A romantic at heart, an adventurer both in the desolate stretches of nature and in the world of men, Kent chose wood engrav-ing as his favorite means of expression; his very masculine nature was challenged by the difficulties of the medium. *Northern Light* (Fig. 625) is one of his many great engravings in terms of technique and expressive power. Kent had traveled the cold seas and bare islands of the northlands and reveled in overcoming the hardships of this lonely and barren part of the world. In *Northern Light* the sleeping figure seems symbolic of man at peace with nature, sheltered and secure in the vast open spaces because of his calm assurance that nature, though cold, austere, and indifferent, is also benign for those with sufficient strength. This belief in man's potentialities is the basis for the figures with which Kent peoples his world, figures which symbolize moral strength through idealized physical forms.

Technically and compositionally *Northern Light* is magnificent. An encompassing cavelike shape constitutes the basic format within which a series of pyramidal forms build to the brilliant white mountain in the distance. Within this compact arrangement of forms Kent has achieved a tremendous richness of tone and texture. Values range from deepest blacks, through grays of varying textures, to shining white. The engraved textures span the gamut from parallel straight lines, through flowing sequences of curves, to stippled elongated dots that move in varying directions and rhythms to suggest form as well as surface quality. The print is a moving work of art. It is also a demonstration of brilliant technical virtuosity in one of the most difficult of artistic media.

The American Scene

Most of the American-scene painters discussed in Chapter 20 were also printmakers of distinction. Sheeler,

625. ROCKWELL KENT. *Northern Light*. c. 1928. Wood engraving, 5 1/2 × 8 1/8″. Philadelphia Museum of Art.

Hopper, Raphael Soyer, Marsh, and others created handsome lithographs and etchings, drawing their subject matter from the same milieu that inspired their paintings. Few of these men worked in wood engraving. Being essentially painters, they preferred the more painterly textural effects offered by lithography and etching. The regionalists of the thirties also produced some fine prints, as did the social critics. Thomas Hart Benton was the most productive printmaker of the former group and William Gropper one of the most effective of the latter.

Though hardly an ideological regionalist, Harry Wickey (1892—) produced some prints which reflect the flavor of that movement. Such a print is *Sultry August Afternoon* (Fig. 626). Wickey was born in a small town in Ohio. His grandparents on both sides of the family were farmers, and, like all small Midwestern boys, he lived in close proximity to farm life. A master of etching, Wickey did not confine his production to that medium. In the mid-thirties he produced a group of lithographs of farm life, of which *Sultry August Afternoon* is one of the most effective. The composition is purposefully symmetrical, creating an effect of somnolent quietude. The slow-moving arcs of the suckling piglets, the recumbent sow, and the round haystack are completely relaxed and without tension. Against this passive format the rich but free texture of the lithographic crayon evokes a sense of weighty forms, oppressive heat, and the heavy, earthy odor of the barn. Neither undue sentiment nor false idealization distorts the authenticity of the print. *Sultry August Afternoon,* like all Wickey's work, feeds into the mainstream of American realism.

above : 626. HARRY WICKEY. *Sultry August Afternoon.* 1936. Lithograph, 11 ³/₈ × 12 ¹/₈″. Philadelphia Museum of Art.

below : 627. STANLEY WILLIAM HAYTER. *Unstable Woman.* 1948. Etching, 14 ⁷/₈ × 19 ³/₈″. International Business Machines Collection, New York.

The Forties: Experimentation

The forties witnessed the reemergence of abstraction and Expressionism and the impact of Surrealism, movements that were to revolutionize and revitalize printmaking in the subsequent decades.

Stanley William Hayter (1901—) was born in England and made his first significant impact upon the art world in Paris, where in 1927 he established Atelier 17, a very influential workshop in printmaking. Hayter, more than any other single artist, encouraged experiments in combining traditional etching with related techniques, in exploring a wide variety of new methods of intaglio and relief printing, and in using new materials. His interests, however, were far from being limited to techniques, methods, and materials. His forms, which reflect Surrealist influences in their organic and biomorphic character, were organized according to abstract and expressionistic concepts to create prints of a highly dynamic character. About 1940 he came to the United States, where his presence and work encouraged freer combinations of the traditional intaglio processes (etching, engraving, and drypoint), as well as a working over of the etching plate through less orthodox methods to produce rich textural effects.

Unstable Woman (Fig. 627) illustrates the character of Hayter's work. The bold swirl of abstracted forms retains identifiable elements, a face, breasts, and other anatomical details, but the interest of the print is inherent in its dynamic composition and in its striking surface values, rather than in its symbolic or representational content. Unlike traditional etchers, Hayter achieved a tremendous linear and textural range by his unorthodox

Plate 34. RON DAVIS. *Red L.* 1969. Polyester, resin, and fiberglass; 4′ 10 ½″ × 11′ 10″. Courtesy Leo Castelli Gallery, New York.

Plate 35. Gabor Peterdi. *Eclipse IV*. 1966. Etching, soft-ground etching, relief etching, and segmented plates; 35 ¾ × 23 ¾". Courtesy Kovler Gallery, Chicago.

methods. Sharp and soft black and white lines; soft, blurred, and blotted textures of varying degrees of darkness; grained effects and others—all contribute to the visual excitement and expressive energy of the print. In addition to encouraging experimentation in techniques to achieve surface enrichment and abstract designs in printmaking, Hayter introduced a much larger format for prints than had been customary. The prints produced by Hayter and his followers were made large enough to compete with paintings on a wall rather than to be examined at close range in the cabinet or portfolio.

The concern with new media and abstract form stimulated by Atelier 17 is well exemplified in *Composition* (Fig. 628) by John Ferren (1905—), who was in Paris during much of the thirties. Instead of printing on paper, Ferren used plaster of Paris to receive the basic linear imprint from the etched plate. The plaster, poured on the inked metal plate, was allowed to harden, and then the plate and plaster imprint were separated, leaving the etched lines in dark and light and in relief. After the plaster hardened, the artist then proceeded to carve into the etched surface, thereby translating essentially linear relief into concave and convex surfaces. Later, color was added to intensify both the pattern and the sense of relief. Thus a marriage was performed between the colored print and bas-relief. The stimulus of such experiments toward broadening the range of printmaking was particularly fruitful in the late fifties and sixties.

Argentine-born Mauricio Lasansky (1914—) was another pupil at Atelier 17 who later came to the United States. Both his work and his teaching at the University of Iowa exerted a powerful influence on American printmaking. Lasansky, though his designs are highly abstracted, remains close to the Expressionist tradition. A concern with the human condition is an essential ingredient of his art, and his powerful *Dachau* (Fig. 629),

left: 628. JOHN FERREN. *Composition*. 1937. Etched and colored plaster with intaglio, 11 7/8 × 9 1/8″. Museum of Modern Art, New York (gift of the Advisory Committee).

below: 629. MAURICIO LASANSKY. *Dachau*. 1946. Burin, drypoint, and soft-ground etching, 15 3/4 × 23 3/4″. Collection the artist.

473

below : 630. PAUL LANDACRE. *Growing Corn.* 1940. Wood engraving, 8 ¾ × 4 ½". International Business Machines Collection, New York.

bottom : 631. ARMIN LANDECK. *Stair Hall.* 1951. Drypoint, 12 × 14 ³/₈". Philadelphia Museum of Art.

reminiscent in many ways of Picasso's *Guernica*, was born of a desire to protest in semiabstracted, semiorganic forms against the horror of the concentration camps. In this print Lasansky has achieved his ominous tonality and his harsh scratchiness of surface by combining drypoint and soft-ground etching with the direct use of the engraver's burin on the plate. Some of his most original work appeared in colored intaglio prints. A single plate was printed successively with different colors applied and then wiped away. Often the colored base print was overlaid with a black printing, in which case the color glows jewel-like from the interstices between the black lines.

Technical Prowess

One of the notable aspects of the forties is that, accompanying the interest in a free exploration of new media and materials, there arose a heightened sense of craftsmanship. A number of artists' work, characterized by an exquisite rendering of traditional techniques, provides a satisfying counterpoint to the experiments of the explorers.

Paul Landacre (1893—), one of California's most distinguished printmakers, has continued the practice of wood engraving revived by Rockwell Kent. Landacre has found his inspiration in his immediate surroundings and in the meticulous precision demanded by the technique of wood engraving. *Growing Corn* (Fig. 630), inspired by a young plant in his garden, is a brilliant achievement technically, and at the same time it reflects the growing interest in formal compositions and patterns. A small section of a corn plant is composed to provide an elegant arrangement of rhythmic line movements and bold tonalities. Landacre has taken full advantage of the orderly sequence of parallel and crosshatched lines by which the wood engraver achieves tonal variations, and the methodical and disciplined character of engraving is reflected in the controlled lucidity of the design.

The challenge of a difficult medium was mentioned in relation to wood engraving. Armin Landeck (1905—) selected the equally demanding medium of drypoint for his print *Stair Hall* (Fig. 631). In drypoint each line is engraved directly on the metal plate with a burin. The composition of *Stair Hall* is another application of Cubism in daily life, but it is done with drama, verve, and technical brilliance of an admirable nature. Each value in the print has been achieved by a series of clean lines, usually in parallel series but occasionally radiating from a central point. Each of these hundreds of lines has been made by carefully pressing the burin into the metal and pushing it with unwavering certainty to its destination. Yet the final effect is not labored. The craftsman's concern

with technique frequently precludes rich and expressive artistry. In Landeck's *Stair Hall* the rigor of the technique contributes to the mood of tension.

The early work of Federico Castellon (1914—) was distinguished by an almost obsessive perfection of technique. Inspired by memories of Spain, Castellon chose lithography as the medium in which to develop his first essays in printmaking. The technical finesse evident in *Of Land and Sea* (Fig. 632), remarkable for an artist in his mid-twenties, is indeed impressive. Much of Castellon's work of this period has a Surrealist flavor, though he employed none of the more obvious devices of Surrealism. Instead, the strange and haunting atmosphere of reverie is created by the immobile figures in the vast, empty landscape, reinforced by the dreamlike clarity of detail. After his early essays in lithography Castellon explored both etching and painting, using a freer and less introverted way of working.

Expressionism in the Fifties and Sixties

Although Abstract Expressionism dominated the world of painting in the early fifties, its immediate effect upon printmaking was not great. Most printmakers retained a bias in favor of subject matter, and, though the desire for a heightened emotional impact turned some of the most significant figures toward technical experimentation, many artists remained conservative in regard to their working methods but achieved emotional intensification through the language of Expressionism. Two artists who retained traditional techniques but developed as powerful printmakers within the expressionist tradition are Benton Spruance (1904–67) and Leonard Baskin (1922—).

Benton Spruance produced many beautiful prints over a number of years. In the late twenties and early thirties his work tended to be realistic and somewhat illustrational in character. These early works reveal an interest in formal compositional structure, as well as a high level of technical competence. His first lithographs were in black and white, but later, particularly in the fifties, he produced colored lithographs of great richness and subtlety. At the same time he developed a freer and more spontaneous way of working to intensify the emotional impact of his evolving expressionistic manner. His later prints often draw upon myth and legend for their themes. *Anabasis No. 1* (Fig. 633) is the first of a series of ten prints based

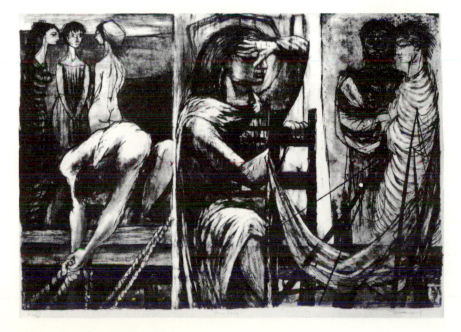

above : 632. FEDERICO CASTELLON. *Of Land and Sea*. 1939. Lithograph, 10 ⁹/₈ × 9 ⁷/₈″. International Business Machines Collection, New York.

left : 633. BENTON SPRUANCE. *Anabasis No. 1*. 1957. Lithograph, 14 ¹/₂ × 20 ⁷/₈″. Philadelphia Museum of Art.

475

left : 634. LEONARD BASKIN. *Mantegna at Eremitani*. 1922. Woodcut, 14 × 23 ⁵/₈″. Philadelphia Museum of Art.

below : 635. NATHAN OLIVERA. *Head, 1969.* 1969. Lithograph, 29 ¾ × 20 ¾″. Collection the artist.

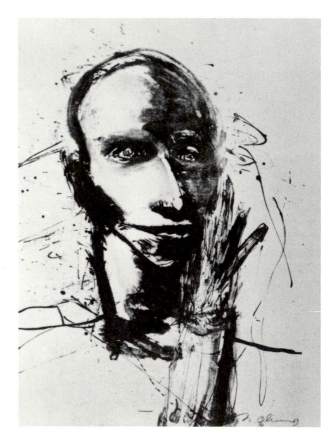

on incidents in Greek history. The theme is handled not primarily in terms of a clear narrative but rather with symbolic connotations which evoke an atmosphere of the legendary past. The figures, their gestures, and their relationships are difficult to relate to the retreat of the Greeks from Persia, but an air of deep solemnity and inexorable fate pervades the prints. The only one of the ten to be in color, *Anabasis 1* was printed from at least six plates to create its rich grays, browns, black, blood-red, and yellows. Its strange emotive force seems to be projected by the tripartite structure, the emotive distortions of form, and the rich tonalities. Like the prophetic statements of ancient oracles, its power derives from ambiguity rather than clarity.

Leonard Baskin also draws upon Expressionist tradition for his vigorous woodcuts, but it is the tradition of the freely cut, boldly textured prints of Munch, Gauguin, and the early twentieth-century Expressionist printmakers of central Europe. In *Mantegna at Eremitani* (Fig. 634) this forceful and direct manner is used with great effectiveness. The deep cutting creates a printed linear pattern of immense energy, against which the shadowy grain of the wood plays a quiet obbligato. The curious diagonal elongation of the head reinforces the dominant movement of the black lines to unify and heighten the movement of the entire composition. Baskin, like most Expressionists, is concerned with man and his moral state. He is also a sculptor of power, and his sculpture, like his printmaking, is within the Expressionist tradition.

Nathan Olivera is probably the most influential lithographer on the West Coast. His mature work, unlike that of Benton Spruance or Leonard Baskin, reveals the impact of Abstract Expressionism on his formative years. Though Olivera is deeply involved in painting, he has also, all through his career, been seriously committed to printmaking. Single figures and, most recently, single, isolated

heads usually provide the motifs for his frequently romantic, always highly emotionalized lithographs. His prints often display a vehemence and spontaneity that seem at variance with the craftsmanlike execution commonly associated with the print processes. Olivera reconciles this apparent contradiction by painting directly on the stones with tusche, a liquid lithographic medium. This encourages the free, painterly execution seen in *Head, 1969* (Fig. 635).

636. ANGELO SAVELLI. *Plato*. 1965. Relief print, 18 × 23″. Brooklyn Museum.

Here the tusche washes have been augmented by gum-acid burning, so that the nervous, frenetic, linear movements interplay with vigorously splotched—as well as with more subtly modulated—tonal gradations. By this direct manipulation of the lithographic medium an image of startling intensity has been created, which projects a mood of inner questioning and psychological tension. A number of Olivera's lithographs from the sixties use masses of a single color to augment the drama of stark black and white.

The Fifties and Sixties: Further Exploration

The interest in extending the technical resources of printmakers, which had been initiated by Stanley Hayter and his followers at an earlier date, was reinforced in the fifties and the sixties by printmakers, painters, and sculptors, who, impatient of traditional limitations, were expanding the boundaries of the arts by exploring both new materials and new concepts. Abstract Expressionism, Op, Pop, even assemblage, contributed to the vivacity of the printmaking scene.

Gabor Peterdi (1915—), born in Hungary, had worked with Hayter in Paris before coming to the United States. After his arrival here he continued his explorations, and over the decades he produced many rich and beautiful prints, at the same time continuing to investigate new ways of enlarging the printmaker's technical resources, particularly in the etching, engraving, and intaglio processes. His own statement best describes the methods he has employed in his recent work: "The printing is made from one,

or several metal plates. I roll through the large master plate with various textured materials on it (wrinkled paper, tin foil, textiles, etc.), then I do the same with smaller cut-out plates. Where I want to strengthen the color I re-roll it on the large plate, then I superimpose the smaller plates, and sometimes I use the inked textural materials as plates themselves. ... The whole process is printing, and offsetting the design from one plate to another. ... This method gives me a great depth and transparency that one can't achieve with direct printing." *Eclipse IV* (Pl. 35, p. 472) provides a brilliant demonstration of the surprising shapes, unorthodox textures, spatial complexities, and subtleties of color that he achieves through his highly original and inventive methods. A professor at Yale, Peterdi, like Lasansky, has had a widespread influence upon contemporary printmaking.

Plato (Fig. 636), by Angelo Savelli (1911—), is a pure relief print that, like *Composition* (Fig. 628) by John Ferren, seems to bridge the gap between printmaking and sculptural bas-relief. It is completely abstract and geometric in composition. The elegant pattern, like that in many of his earlier works, was projected into relief by building up a three-dimensional matrix which, under the pressure of the press, imposed an embossed form on the heavy wet paper. In *Plato* Savelli has augmented his earlier relief effects by actually cutting the inner areas of the triangular and rhomboidal shapes so that the apertures go through the paper. The beauty of the print results from the purity of its forms seen in varying levels of relief against the colorless paper.

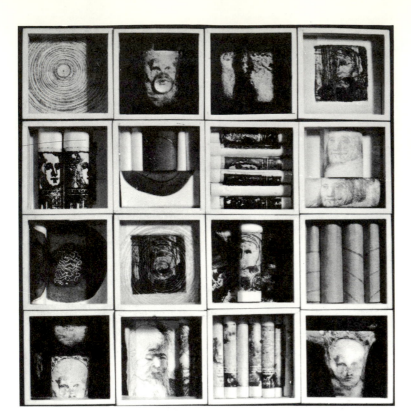

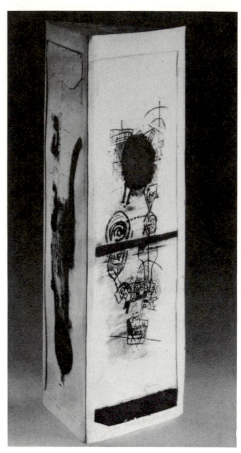

Two more prints that depart even farther from the traditional limits help to illustrate the unorthodox character of printmaking in the sixties. Sharon Arndt (1943—), in *Box Series I* (Fig. 637), has boxed sixteen separate prints done in varying styles and of different materials. These have been made into a single unit primarily by enclosing them in open, square containers of uniform size, which in turn are framed by a master box. Horizontal and vertical movements varied by circular shapes also help to relate the separate parts. Many of the prints are cylindrical, some on paper and others on plastics and related materials. This work had obviously been inspired by the boxed assemblages, which occupy an intermediary position between painting and sculpture.

Machine to Hunt Stars (Fig. 638) adds movement and a completely three-dimensional format to the repertoire of the printmakers of the mid-sixties. Juan Gomez-Quiroz (1939—), the artist responsible for this whimsical essay, is a Chilean by birth. He executed this intaglio color print on a single paper in three separate parts. The paper was then folded, and the triangular pillar thus created was mounted on a turntable, which revolves slowly. Again the realm of modern sculpture has been an inspiration; this is undoubtedly the first kinetic print. The last three prints and the one reproduced in Figure 644 were in the 15th National Print Exhibition at the Brooklyn Museum in 1966.

Op and Pop

Op and Pop styles, even assemblage, also stimulated new ventures in printmaking in the late fifties and sixties, though certainly not all optical-illusion art is of that late date. *Ascension* (Fig. 639), by Josef Albers, was done in the early forties in a conventional lithographic technique, but the print provides a brilliant example of Albers' early knowledge of, and fascination with, the effect of visual illusion. The straight lines move continuously before our eyes, ascending and descending, advancing and withdrawing. Of equal interest is the effect of various darknesses of gray suggested in the white background by the thickness of the black lines. Twenty years later Albers was still able to project new visual puzzles, such as that in Figure 640. Technically an engraving, yet hardly a print, *JHC II* is engraved in white on black plastic. The flat,

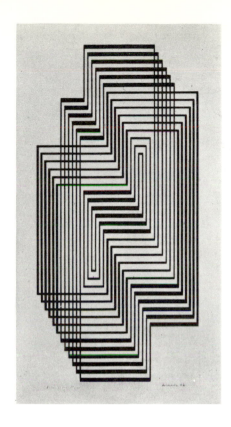

light and dark and the patterns of diagonal and plaid surfaces change, thereby creating a sense of movement within the print itself. Here again, new materials make possible new visual experiences.

Both Pop and Op elements characterize Roy Lichtenstein's *Moonscape* (Fig. 642), a work in which a silk-screened dark pattern on a metallic surfaced plastic suggests clouds and water while the Ben Day style pattern of dots provides a contrasting surface as well as a Pop effect. Essentially a stencil process involving a resist used on tightly stretched silk screens, silk screen had originally been developed for purposes of commercial reproduction, but in the thirties it became popular as a medium for fine-arts printmaking. Frequently used for multicolored prints, its particular advantage is that the light-weight silk screens facilitate the easy production of large-scale prints. Of

isometrically projected planes advance and recede simultaneously, thereby creating a dynamic spatial instability that defies understanding.

In *Eight of a Maze* (Fig. 641), Reginald Neal (1909—) printed a unique lithograph of lucite over canvas. One set of lines, on the top of the clear lucite, is separated by the thickness of the lucite from the line patterns on the surface below. As the viewer moves, the relationships of

top: 639. JOSEF ALBERS. *Ascension*. 1942. Lithograph, 17 ¼ × 8 ³/₁₆″. Museum of Modern Art, New York.

above: 640. JOSEF ALBERS. *Structural Constellation: JHC II*. 1963. Engraving on plastic, 19 ¼ × 25 ⅞″. Collection Mr. and Mrs. James H. Clark, Dallas.

left: 641. REGINALD NEAL. *Eight of a Maze*. 1965. Unique lithograph on lucite with canvas, 21 ½ × 29 ½″. Courtesy A. M. Sachs Gallery, New York.

late, silk screen has also been used in conjunction with the intaglio processes.

That virtuoso of the unexpected, Robert Rauschenberg, provides us with an index of the contemporary printmaker's ambitions and intolerance of conventional restraints. His colored lithograph *Booster* (Fig. 643) was executed on a 7-by-3-foot stone in a Los Angeles printmaking shop. In composing this imaginative print, Rauschenberg used life-size X-ray images of himself, combined with freely drawn materials, charts, and photographic prints. The juxtaposition of unorthodox materials gathered from a wide range of sources relates this print to assemblage and the "combine" paintings of the late sixties, and, like the enormous size of the print, indicates the desire of contemporary artists to surmount traditional limitations.

One last print illustrates the marriage of traditional techniques and Op effects. Beth Van Hoesen (1926—), a San Franciscan, has produced a number of delightful prints which, though conservative in technique and representational in style, often have a joyful whimsy about them. *Checks* (Fig. 644) is frankly entertaining, with the variously scaled checkerboard patterns building the forms and then, to our surprise, as in the upper right-hand corner, suddenly annihilating space by flattening out. Its playful tone, however, in no way detracts from the strength of the incisively portrayed head.

Gabor Peterdi claims that there have been more technical innovations in printmaking in the past thirty-five years than in the previous six hundred. At present there are a number of superbly equipped workshops in the United States preparing printmakers to work in all media, particularly intaglio, lithography, and serigraphy. These same studios are training master printers and issuing limited editions of fine prints by major artists. It is estimated that there are at present about three thousand artists seriously involved in printmaking. Which of these, if any, will emerge as the Rembrandts and Dürers of the future remains for time to tell. The contemporary scene is not characterized primarily by the intellectual and moral probity that, along with technical brilliance, constituted the grandeur of Rembrandt and Dürer, but it is neither lethargic nor lacking in artistic integrity. Many of its artists carry on their work in privation, with little reward or recognition. If our society provides the matrix from

top : 642. ROY LICHTENSTEIN. *Moonscape.* 1965. Silk screen on metallic plastic, 20 × 24″. Collection Philip Morris Incorporated, New York.

left : 643. ROBERT RAUSCHENBERG. *Booster.* 1967. Lithograph, c. 7 × 3′. Courtesy Leo Castelli Gallery, New York.

which great artists can emerge, there are thousands of skilled hands, courageous hearts, and disciplined minds to speak for it.

PHOTOGRAPHY

The camera, born of our mechanical and scientific technology, has continued to contribute to the creative ferment of our day. Lenses, camera mechanisms, films, filters, and printing processes have all undergone continuous refinements since World War I. Today camera images can be recorded at speeds up to 1/10,000 second. Telescopic lenses make it possible to photograph the surfaces of other planets, and microscopic lenses enable man to explore the smallest units of matter. Color film has opened up new vistas and greatly enlarged the esthetic potential of the photographic medium. Photography now plays a significant role in industry, scientific endeavor, communications, and the fine arts. In fact, the photographic image now ranks with the printed word as a basic means of communication among men.

As the capabilities of the camera have expanded, ideas about what constitutes the art of photography have become less rigid. The "pure" photograph, which records precise images with rich texture and exact detail, remains one of the primary forms of expression. Documentary photography—which captures moments of social significance, usually to provide information about people and social institutions under stress and thereby effect reforms—remains another field of valid endeavor. At the same time the worlds of painting, printmaking, and photography draw closer together. Abstract painting has stimulated in photographers an interest in pure patterns and in the surprising optical effects that can be achieved by exploiting and manipulating the photographic processes (Fig. 645). Bauhaus-inspired explorations of photo technology have revealed photo concepts that frequently have paralleled and reinforced Cubist, Dada, and even Surrealist experiments. In the sixties the lines of demarkation among photography, painting, and printmaking seemed at times to be meaningless. Photographs were incorporated into painted collages, printmakers drew on photographic negatives for silkscreen stencils and lithographic prints (Fig. 643), and projected film materials became an important element in "happenings." In the desire to explore the full range of visual experience, traditional boundaries were obliterated.

The signal achievement of the photographers in the twenties and thirties was to provide America with an incisive self-portrait. Edward Weston (1886–1958), Paul Strand (1890–), Berenice Abbott (1898–), Walker Evans (1903–), and Margaret Bourke-White (1906–) were among the many who contributed to this end. Edward

Weston and Paul Strand were probably the most distinguished exponents of "pure" photography; Berenice Abbott and Margaret Bourke-White, of the documentary photo. Both trends were fused with remarkable effectiveness in the work of Walker Evans.

One of the most versatile and productive masters active in the decades between the two world wars was Edward Weston. He spent most of his time on the beautiful Monterey peninsula of central California. His particular strength lay in his ability to perceive beauty of form and texture in unexpected subjects and places. His knowing eye encompassed landscapes, figures, architecture, and still life, and he approached them all with a fresh, poetic, and unconventional point of view. Weston discovered the beauty of the flotsam and jetsam of the sea, of driftwood, and of the incisive textures of the coastal landscape, but he was equally sensitive to the smooth magnificence of a

644. Beth Van Hoesen. *Checks*. c. 1963. Etching, 8 × 10 ½″. Brooklyn Museum.

645. Henry Holmes Smith. *Untitled*. 1946. Photograph. George Eastman House, Rochester, N.Y.

right : 646. EDWARD WESTON. *White Dunes, Oceano, California.* 1936. Photograph. Collection B. and N. Newhall, Rochester, N.Y.

below : 647. MARGARET BOURKE-WHITE. *At the Time of the Louisville Flood.* 1937. Photograph. George Eastman House, Rochester, N.Y.

White Dunes, Oceano, California (Fig. 646) illustrates the distinction and purity of his vision, as well as his technical prowess. The sharpness of focus throughout the depth of the composition creates an almost Surrealist atmosphere. Weston saw no conflict between reality and abstraction. Here the reality of the dunes was used to create a beautiful abstract complex of patterns. Weston revealed that the power of photography lay in the eye and mind of the photographer, rather than in the camera. In the service of a commonplace mind and conventional eye, the camera, no matter how fine an instrument, records commonplace and conventional images.

During the Great Depression of the thirties, the tragic years of World War II, and the subsequent social tensions, many photographers joined with other artists to use their talents to effect social change. Though the documentary photograph achieved its power through incisive reporting of facts, the purity of the print seemed less important to the documentary photographers than its capacity to influence the social climate. *At the Time of the Louisville Flood* (Fig. 647), by Margaret Bourke-White, focuses with irony on the discrepancies that exist between the facts of life and the glamorized images of the advertising world. The social effectiveness of photography received an added impetus when, in the thirties, the photographic essay became an inherent part of journalism. Bombarded as we are, day after day, by a barrage of photographic images, we almost cease to be aware of the impact this most recent art form has had upon our vision of the world.

bell pepper and to the detail of a figure focused at close range. His complete control and knowledge of the resources of the camera resulted in prints of unusual tonal brilliance and textural richness. Using an 8-by-10-view camera, Weston previsualized his prints in full detail before making an exposure. From these carefully composed plates he made his own contact prints, eschewing any cropping and rejecting enlargement because of the accompanying loss of the sharp precision that was essential to his art.

23

Modern Sculpture

Before 1945 American sculptors, with a few exceptions, were rather more conservative than the painters. Fortunately, exceptions did exist and their achievements are noteworthy. Since 1945 the sculptors have competed with, if not surpassed, the painters in their vigor, variety, and inventiveness.

The general developments that occurred between the Armory Show (1913) and the end of World War II (1945) might be summarized as follows: In the two decades after the Armory Show progressive American sculpture was characterized by a vigorous nonacademic realism inspired to a considerable extent by the powerful art of Rodin. Concurrently sculptors discovered the world of primitive sculpture, the strength of archaic Greek, Romanesque, and early Gothic carving, and the formal beauty of Oriental art. Thus in the twenties and thirties, contemporaneous with and gradually superseding the Rodin-derived realism, there appeared an interest in the formal qualities of sculptural design inspired by nonacademic historical sources. During the same time sculptors discarded the Beaux-Arts practice of preparing models in clay or plaster to be enlarged in stone or cast in bronze by assistants and began to carve directly in stone or wood in a search for an honest treatment of materials and monumental simplification of form.

It was also in the twenties and thirties that the impact of such *avant-garde* European sculptors as Brancusi, Arp, Picasso, and Gabo began to be felt here. In Paris Constantin Brancusi and Jean Arp had already conducted sculptural explorations in Expressionist, Surrealist, and purely abstract modes. Picasso and others had translated Cubist conceptions into sculptural form, and, most important, Naum Gabo had initiated his Constructivist experiments. The influence of Gabo, who had worked in Moscow, Berlin, Paris, and London before coming to the United States in 1939, was comparable to that of Rodin at the beginning of the century. Gabo invited sculptors into the foundry and the factory, introduced them to the use of synthetics such as plastics, and initiated the practice of composing in purely abstract form. Since 1945 these techniques have almost dominated the world of sculpture. Today the foundry and the factory constitute the sculptor's workshop.

In the fifties and sixties Abstract Expressionist, Pop, assemblage, and minimal sculpture (a reduction of form to its greatest possible simplification), as well as kinetic sculpture, all contributed to a scene of seemingly infinite variety. The most recent period is discussed later in this chapter; first, however, the earlier phases of modern sculpture must be examined.

right: 648. MAHONRI M. YOUNG. *Right to the Jaw*. 1926–27. Bronze, 14 × 23″. Brooklyn Museum (Robert B. Woodward Memorial Fund, 1928).

below: 649. JO DAVIDSON. *Gertrude Stein*. 1920. Bronze, height 31″. Whitney Museum of American Art, New York.

THE REALISTS

In the first two decades of the century it was largely the example of Rodin and his European followers that stimulated American sculptors to abandon outmoded academic formulas and to initiate a vigorous, though short-lived, school of nonacademic realism. These younger men followed Rodin's preference for roughly modeled

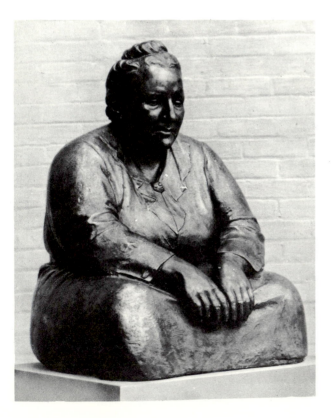

surfaces, as well as for projections and hollows that reflect the light with animation. One of the first of the young realists, Mahonri Young (1877–1957), left Salt Lake City to study at the Art Students League in New York. From New York he moved on to Paris, where he saw how Rodin gave expression to his belief that sculpture was the art of "the active line of the plane found, the hollows and projections rendered." Young returned to America to sketch and to practice a sculptural equivalent of the lively, almost journalistic painting of The Eight. His bronzes of ditchdiggers, prize fighters, and other genre subjects display engaging vitality. *Right to the Jaw* (Fig. 648) is a characteristic example, in which the freely modeled anatomical forms are composed in sweeping curves and large opposing diagonal movements. Mahonri Young revealed his feeling for metal by casting his bronze in lithe, twisting shapes rather than in the monumental patterns dictated by stone.

Jo Davidson (1883–1952) was a New Yorker who studied first at home and then in Paris. He, too, derived from Rodin a feeling for the expressive force of a directly modeled surface. Davidson did sculpture portrait heads of many great personalities of our age. Throughout his long professional career, he managed both to retain his integrity as a sculptor and to satisfy the demands of his clients for an incisive likeness. His famous portrait of Gertrude Stein (Fig. 649), through its contemplative pose and strongly structured head, combines a sensitive projection of the expatriate poet's character with monumentality of form.

Not all the younger sculptors were temperamentally sympathetic to the vigorous modeling and the intense romantic emotionalism of Rodin's style; a number were attracted to the formal qualities of design and the simpli-

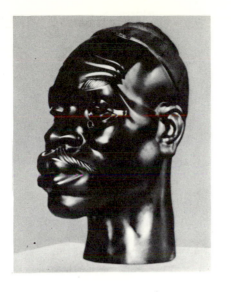

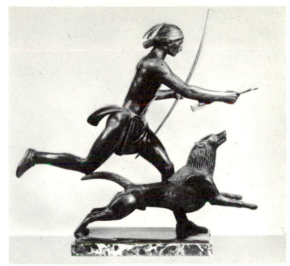

right : 650. MALVINA HOFF-MAN. *Senegalese Soldier.* 1928. Black marble, height 20 1/16″. Brooklyn Museum (in memory of Dick S. Ramsay, 1928).

far right : 651. PAUL MANSHIP. *Indian Hunter.* 1926. Bronze, height 23 ¼″. Metropolitan Museum of Art, New York (gift of Thomas Cochran, 1929).

below : 652. IVAN MEŠTROVIĆ. *Job.* 1945. Bronze, over life size. Syracuse University, Syracuse, N.Y.

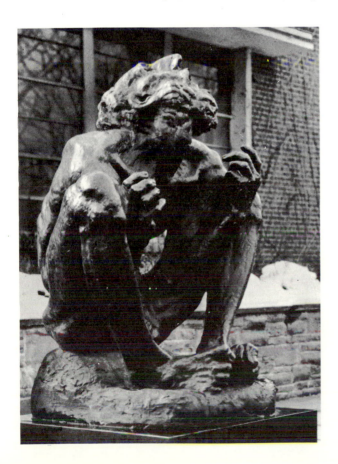

fications that distinguished the great sculptures of early civilizations and archaic cultures. Malvina Hoffman (1887–1966) was born in New York and, after a period of study, went to Paris and worked with Rodin. However, Rodin's vibrating surfaces and psychological subtleties had little influence on her style, which is characterized by large generalized forms and brilliantly polished surfaces, as in her black marble *Senegalese Soldier* (Fig. 650). Here Miss Hoffman's style creates a mask which repels any attempt to go below the surface. The form is clear, but the personality remains enigmatic. Her most impressive achievement was a series of bronzes representing the world's ethnic types, executed for the Field Museum of Natural History, Chicago.

Paul Manship (1885–1966) was born in Minnesota, studied briefly in the east, and then departed for the American Academy in Rome. Rome still dwelt in the shadow of eclecticism, but attention had turned to the earlier periods of Greek art and to the monumental styles of the ancient world. Manship found the formalizations of the archaic Greek sculptors and the rhythmic simplification of the Orient well suited to his own taste for disciplined elegance. His *Indian Hunter* (Fig. 651) reveals the thoughtfully balanced rhythms of his compositions, wherein curves are carefully juxtaposed and act as a foil to the straight lines. The stylized patterns of hair and drapery reveal familiarity with ancient and exotic practices, as do the careful formalizations of anatomy. Manship's obvious decorative appeal, his taste, and his high level of technical competence made him the recipient of many major commissions in the twenties and thirties, by which time his archaic and Oriental mannerisms had become acceptable in conventional and academic circles.

The urgent religious sculptures of the Middle Ages provided a protoexpressionistic influence far removed from the decorative formalism of Manship. Ivan Meštrović (1883–1961) and Alfeo Faggi (1885–1966) drew upon Romanesque and Gothic mannerisms for inspiration and frequently achieved an ardent strength of feeling. *Job* (Fig. 652), an over-life-size bronze by Meštrović, reveals

the strong emotional effect he achieved through elongations of form, the articulation of anatomical details, and the animated handling of the surface. Monumental and impressive though they are, Meštrović's stone carvings, perhaps because of their rather self-conscious Gothicizing, lose some of the direct force that distinguishes *Job*.

Gaston Lachaise (1882–1935) may well be the most significant sculptor to work in America before 1930. While his early work remains within the tradition of realism, his is a monumental realism based on a pure and very personal sense of sculptural values. Moreover, certain of his later works represent some of the first American essays into abstract volumetric form. Lachaise came to America from France in 1906. A master craftsman in wood, metal, and stone, he became an assistant to Paul Manship and other American sculptors. While working for others, he perfected his own very original and powerful style. Lachaise most frequently chose the nude female figure as his subject, and the essence of his style is exemplified in his great bronze *Standing Woman* (Fig. 653). The movement springs from the arched feet and carries up through the figure in a series of surging rhythms to culminate in the poised head and gracefully gesturing hands. The magnificently realized, swelling forms are based on a sympathetic observation of human anatomy, simplified and generalized to achieve a unique combination of monumentality and voluptuousness. In some of Lachaise' subsequent works the massive anatomical forms become semiabstract rhythmic elements in a composition employing voluminous ovoid masses. This tendency toward abstraction in his late work is further emphasized by a smooth perfection of surface. However, even during his mature years, when experiment and theory were directing the attention of many sculptors away from the human content of their work, Lachaise combined a personal and intense lyrical reaction to his living experiences with an intuitive feeling for formal esthetic values.

The Monumental Tradition

Anthropological and archeological discoveries, a growing respect for primitive culture, folk art, and other unorthodox sources, and, above all, the ferment of modern art all contributed to the demise of the Beaux-Arts tradition. The first vigorous reactions against the idealistic realism which was the particular province of that tradition have already been discussed. In the thirties and forties an increasing number of sculptors, while retaining the identity of their subject, focused primarily on formal aspects of their art. A feeling for the integrity of the materials, an awareness of the role that simplification played in achieving monumental design, and a basic involvement with volume, mass, and the other abstract elements of sculpture became of primary concern. These attitudes were intensified by an insistence on working directly in wood, stone, and even metal, cutting, chiseling, and polishing the most dense and obdurate materials. Thus were initiated the first definitive steps toward abstract sculpture.

One of the artists who early took a major interest in linear rhythms, abstract volumes, and the distinctive nature of his materials was Elie Nadelman (1885–1946). Nadelman was born in Poland; after a short period of

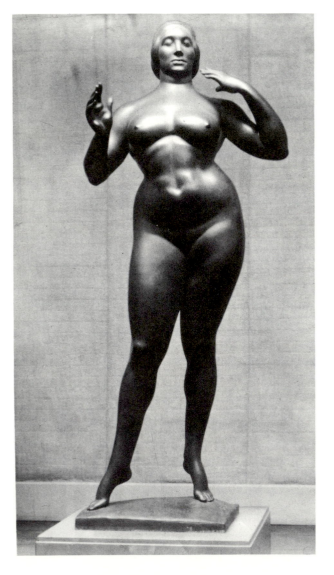

left: 653. GASTON LACHAISE. *Standing Woman.* 1912–17. Bronze, height 5' 10". Whitney Museum of American Art, New York.

right : 654. ELIE NADELMAN. *Sur la Plage*. 1917. Bronze and marble, length 26 ¼″. Whitney Museum of American Art, New York (Sarah Roby Foundation).

below : 655. HUGO ROBUS. *Song*. 1934. Brass, height 5′. Metropolitan Museum of Art, New York (Rogers Fund, 1947).

study in Germany he moved to Paris. Like many of the progressive young sculptors working after the turn of the century, Nadelman was at first influenced by Rodin's thinking, but he rapidly moved into the orbit of the Cubist and Fauve groups. In this stimulating atmosphere he began a most fruitful series of drawings and experimental sculptures, in which he constructed his forms by means of emphatic planes and curve-edged forms. Nadelman produced a number of heads, full figures, and genre and animal forms during the first two decades of the century; these vary in character from angular abstractions of naturalistic forms to rhythmic curvilinear studies of classic derivation.

In 1917 Nadelman settled in the United States, where he continued working in his unique manner, adding to his already very sophisticated interests a taste for folk art, which he collected and appreciated both for its droll humor and for its formal qualities. *Sur la Plage* (Fig. 654), executed in bronze and marble, reveals his preference for both elegance of form and a light, whimsical tone. The effective contrast of color immediately attracts the viewer's attention. At first the light-hearted, playful aspect of the piece obscures the serious intent of the artist. Further study, however, reveals his concern with the purification and abstraction of the form and its relation to the materials. Here the polished white marble has been the dominant factor in determining the degree of abstraction and generalization to be imposed on both the marble and the bronze in order to achieve the desired unification of the two materials. Equally important as an integrating element is the rhythmic flow of line that unites all parts of the work.

Few of the artists in the thirties and forties followed the vein of elegant sophistication that characterized Nadelman. Instead, the general movement was toward a sober monumentality. However, one later practitioner of high-spirited refinement should be mentioned. Hugo Robus (1885–1964) was born in Cleveland, Ohio, but, like most sculptors of his day, he gravitated to New York. Almost self-taught, he created sculptures characterized by an unusual combination of elegance, simplicity, and wit. His *Song* (Fig. 655) is unpretentious and charming, its fluid lines and simplified anatomical forms well suited to the gleaming brass in which it is cast.

The search for distinction of form and the integrity of dense and obstinate materials had no more dedicated advocate than William Zorach (1887–1966). Zorach came

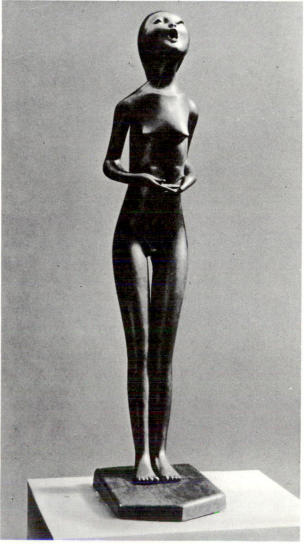

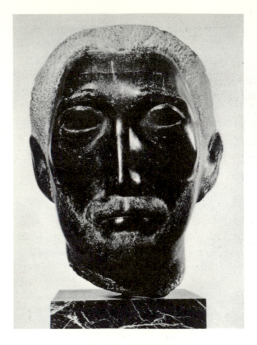

to New York from Lithuania. He began his career as a painter but soon turned his attention to sculpture. He found little interest in the directions taken by early Cubist sculpture, and, abandoning an initial essay in abstraction, he projected his warm and reverent feeling for people into monumental, simplified forms. He chose handsome and intractable materials; his *Head of Christ* (Fig. 656), in black granite, has the austere dignity of an ancient Egyptian portrait, and, as in Egyptian sculpture, the massive form was achieved by an endless struggle with the granite, one of the hardest of stones. The subtle contrast between the polished surfaces and the dull texture used for the hair keeps the form from appearing facile, thereby adding to the somber dignity of the head. Zorach's integrity extended far beyond a respect for materials and processes. His stylistic preferences were determined by his reverence for all life and for the great sculptural tradition which harks back to the beginnings of civilization.

Another artist who felt that a struggle with difficult material was essential to true sculptural honesty was John Flannagan (1895–1942), who went to New York from his North Dakota birthplace after studying at the Minneapolis Institute of Fine Arts. Flannagan first carved in wood. Later he turned to fieldstone, and he extended his preference for direct carving even to metal, occasionally working directly on unfinished bronze casts. The character of materials, particularly stone, might almost be considered the content of his work. Flannagan often chose stones of such a shape that the final sculptured form seems barely more than freed from its original matrix. An affectionate warmth of feeling, almost a tone of humor often characterizes his unpretentious and charming works (Fig. 657).

Among the other sculptors who produced distinguished work during the thirties and forties in the monumental tradition were José de Creeft (1884—), Robert Laurent (1890—), Heinz Warneke (1895—), Aaron Ben-Shmuel (1903—), and Chaim Gross (1904—).

CUBISM AND MODERN SCULPTURE

The impact of Cubism upon sculpture, initially in Europe and then in America, was twofold. First, there was an immediate and rather superficial adoption of the faceted forms of Cubist painting. The consequent influence has remained operative until today: a concern with formal structure; a tendency toward abstraction; an interest in open, modulated, and closed space relationships; and even a search for movement—all these are still dynamic factors in the world of sculpture. The related Constructivist movement proved to be an equally potent and permanent stimulus toward change.

In Paris, during the early years of Cubism and led by Picasso, the Spaniard Julio Gonzáles, Jacques Lipchitz, and even Nadelman had conducted experiments in dissecting the structure of the human form and breaking it down by a severe faceting of its important planes. Russian-born Alexander Archipenko (1887–1964) was in Paris during these early years and joined in the Cubist experimentation. Carrying these investigations further, he

Plate 36. CHRYSSA. *Fragment for the Gates of Times Square.* 1966.
Neon and plexiglass, 6′ 9″ × 2′ 10 ½″ × 2′ 3 ½″.
Whitney Museum of American Art, New York
(gift of Howard and Jean Lipman Foundation, Inc.).

Plate 37. Marisol. *Women and Dog.* 1964.
Wood, plaster, synthetic polymer paint, and miscellaneous items; 6′ × 6′ 10″ × 1′ 4″.
Whitney Museum of American Art, New York (gift of the Friends of the Whitney Museum).

right : 658. ALEXANDER AR-CHIPENKO. *Woman Combing Her Hair*. 1915. Bronze, height 13 ¾″. Museum of Modern Art, New York (Lillie P. Bliss Bequest).

far right : 659. JACQUES LIP-CHITZ. *Figure*. 1926-30. Bronze, height 7′ 1 ¼″. Museum of Modern Art, New York (Van Gogh Purchase Fund).

composed his *Woman Combing Her Hair* (Fig. 658) with juxtaposed concave and convex forms and open and closed spaces. By these means Archipenko not only created a vigorous abstract form but also suggested some of the dynamics of movement. The elegance of his polished surfaces also reflected the growing preoccupation of sculptors with the esthetics of industrial techniques and materials. Archipenko settled in the United States in the early twenties, and, although his later work did not live up to the promise of his early years, he had a decisive influence on a host of younger men.

An interesting example of the way the Cubist faceted planes could be used without departing very far from naturalistic appearances can be seen in the work of Hunt Diederich (1884–1953), who popularized Cubism to create lively objects of decorative charm.

Most of the artists who came into the Cubist orbit moved away from its surface aspects and decorative possibilities to probe more deeply into expressive and structural problems. This trend is well exemplified in the work of Jacques Lipchitz (1891–1973), one of the major figures in Paris in the exciting second decade of the century, when the principles of Cubism were being formulated. Born in Poland, Lipchitz went to Paris to learn stonecutting, modeling, and casting at the Academy Julien. About 1914, under the impact of Cubism, his style experienced a radical change. Much of his early Cubist work was along orthodox lines, simplifying the surfaces of forms to indicate structure and breaking the forms into interpenetrating planes. Toward the end of his Cubist period,

Lipchitz created some of his most original departures from the more obvious Cubist mannerisms. *Figure* (Fig. 659) reflects the Cubist enthusiasm for African sculpture in its abstractions, which create a monumental, yet evocative work of art. Working halfway between completely abstract forms and symbolic simplifications of anatomical forms, Lipchitz attacked the basic problems of formal composition in relation to expressive intent.

Lipchitz settled in the United States in 1941, and much of his sculpture since that time has been essentially expressionistic in character, employing rich, voluminous forms, and full, almost baroque, curvilinear rhythms. The themes are sometimes mythological, frequently liturgical. *Sacrifice*

right : 660. Jacques Lipchitz. *Sacrifice.* 1948–52. Bronze, height 4′ 1¼″. Whitney Museum of American Art, New York.

below : 661. Peter Grippe. *The City.* 1942. Terra cotta, height 9½″. Museum of Modern Art, New York.

far right : 662. Naum Gabo. *Linear Construction in Space Number 4.* 1957–58. Plastic and stainless steel, height 22½″. Whitney Museum of American Art, New York (gift of the Friends of the Whitney Museum).

(Fig. 660) exhibits the religious exaltation and the intensity that characterize much of his late work. The anthropomorphic, semiabstract forms, fearsome and ponderous, suggest myth in a way that is both mysterious and explicit. The priestly figure, with its enigmatic, concave face, pierces the breast of the sacrificial cock with solemnity. The heavy forms, brutal in their awkward strength, grew from the artist's desire to recapture the depths of fear and awe that gave primitive religious art its power.

Expressionism made its impact upon other sculptors of the forties. Peter Grippe (1912–) has suggested the continuous flow of life that takes place behind the walls of the metropolis in his imaginative terra cotta *The City*

(Fig. 661). Walls and faces intermingle with hands, feet, cryptic symbols, and scrawled notations to create a sculptural form as evocative of humanity as the murmur of voices. Digging deep within the unconscious recesses of his being, Grippe found symbols by which to communicate his subtle intuitions to his fellow man.

CONSTRUCTIVISM

The impulse away from realistically representational art, whether initiated or precipitated by Cubism, stimulated an interest in abstraction, particularly pure geometric abstraction, in a number of European intellectual centers. The most important of these centers were established first by the Constructivists in Russia and later by the De Stijl group in Holland and the Bauhaus in Germany. Accepting the premise of a technological and scientific society as the basis for both the revolutionary Communist state and its art, the Constructivists developed a concept of art which glorified mechanistic and technical forces. By utilizing the forms, techniques, and materials of industry, they created new esthetic values and art forms of particular significance to the industrial age. Antoine Pevsner (1886–1962) and his brother Naum Gabo were leading Constructivists who continued producing their brilliant abstractions in various European centers after they left Russia.

Naum Gabo (1890–) came to the United States in 1946, but his influence had preceded him. His early *Con-*

structions, precise, sharp-edged, and geometric, appear to have been shaped by the concepts of mathematicians and engineers with the beauty of their mechanical, pure forms, augmented by the lucid clarity of transparent and reflective materials. Gabo's initial work, like most early Constructivist sculpture, was predominantly geometric in its basic forms. The influence of Constructivist thought—as exemplified in the work of Gabo and his brother and in the teaching of Gabo's Bauhaus disciple, Lázló Moholy-Nagy (1895–1946)—was felt before World War II, but the full impact was not apparent until after 1945. Not until the post-World War II period did the seeds planted by Constructivist theories become dominant trends in America.

The character of Gabo's later work is well represented by *Linear Construction in Space Number 4* (Fig. 662). Abandoning the essentially geometric format of his earlier period, Gabo explored the potentialities of wire, glass, plastics, polished metal, and other unorthodox materials, which he composed in fluid and biomorphic forms. In these works he refined his experiments in the relationship of materials to form and in the interpenetration of space by transparent and "space-modulating" agencies.

One of Gabo's major achievements in the postwar period was to set a precedent for the use of monumental sculpture of colossal dimensions as part of an architectural ensemble. In 1957 his design for an 80-foot stainless and bronzed steel construction was completed in Rotterdam, Holland. Neither representational nor symbolic (two prime requisites for monumental sculpture in the past), Gabo's Rotterdam *Construction* remained a pure expression of our technological age presented in abstract forms which in many ways resemble those found in his *Linear Construction in Space Number 4*. An imposing steel tower (Fig. 663) by Aristides Demetrios (1932–), completed in 1967, reflects the impact of Gabo's monumental work in both its form and its size. Commissioned by a private real-estate developer, the 92-foot Cabot, Cabot & Forbes tower stands on a hilltop overlooking San Francisco Bay, where it functions as an identification, a focus, and a symbol for an imposing industrial park, an impressive example of collaboration between industry and the arts.

Alexander Calder

Another artist of the thirties whose work influenced the development of sculpture everywhere through subsequent decades was the originator of the mobile, Alexander Calder (1898–). The mobile was the first venture into the world of kinetic sculpture. Immobility had been the

distinguishing characteristic of sculpture in the past. Born in the most ancient civilizations, sculpture was created to eternalize the image in static and imperishable forms. Only in a period like the present one, when the conventions of the past are being discarded, a period of dynamic social, intellectual, and cultural change, could kinetic sculpture be conceived.

The son of a sculptor and trained first as an engineer, Calder is one of the most original and refreshing artists of the twentieth century. He was introduced to the world of Mondrian, Arp, and Miró in the Paris of the late twenties, a world in which light-hearted sophistication went hand in hand with serious effort. He began his career with rather playfully improvised forms, designed primarily to amuse by utilizing elements of space modulations in a witty manner (Fig. 664). In the early thirties he added movement, color, and a note of elegance to his unpretentious "mobiles," as he termed his suspended and carefully balanced constructions. Designed to move in response to the slightest current of air, their fragile and airy grace added a welcome note of lightness to the sculptural scene. At the same time their wit and whimsical

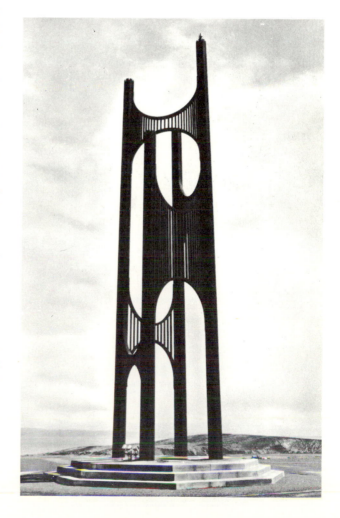

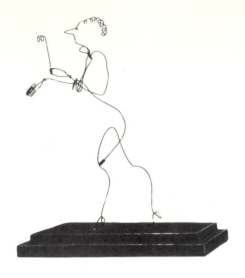

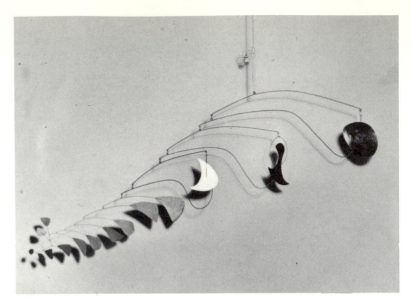

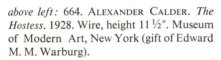

above left: 664. ALEXANDER CALDER. *The Hostess.* 1928. Wire, height 11½". Museum of Modern Art, New York (gift of Edward M. M. Warburg).

above right: 665. ALEXANDER CALDER. *Red Gongs.* c. 1950. Sheet aluminum, sheet brass, steel rod and wire, red paint; length c. 12'. Metropolitan Museum of Art, New York (Fletcher Fund, 1955).

charm provided an antidote to the generally sober and tendentious character of the art of the depression and war years. Though Calder's sculpture is essentially abstract, the shapes suggest the world of organic and "biomorphic," rather than geometric, forms.

Red Gongs (Fig. 665) is executed in painted sheet aluminum, brass, and steel. As in most of Calder's mobiles, the gaiety and grace of the forms and the fanciful arabesques they trace as they move through space can distract one from the sculpture's fundamental refinement and elegance. The flat, sharp shapes Calder employs, as well as the thin lines and wry bits of humor, are reminiscent of the works of Miró. The technical perfection with which the metal parts are shaped, the ingenuity with which they are combined, and the amusing and thoughtful involvements and counterbalancings of movement also recall the long tradition of Yankee tinkerers, particularly as embodied in the playful weather vanes that formerly accented the American skyline. The art of Calder also reflects Constructivist concerns: he utilizes shop practices to fabricate his metal structures, employs industrial finishes, and gives importance to transparency and space as basic elements in his mobiles.

More weighty and imposing, if only because of their monumental proportions, are his "stabiles," the static sculptures which Calder produced concurrently with his mobiles and which became his principal concern in the late fifties and sixties. *The Cock's Comb* (Fig. 666) is composed with the pointed flowing forms he most frequently uses for his stabiles. Even in his static sculptures Calder creates a sense of movement. *The Cock's Comb* rests gracefully upon its component parts, seemingly a symbol of arrested movement, without the usual pedestal or base. It is through his inventive departures from tradition that Calder has wielded his all-pervasive influence upon contemporary sculpture, an authoritative presence no less profound because his work radiates a blithe and gay attitude toward life.

AFTER 1945

The kaleidoscopic variety of American sculpture since 1945 equals that of painting: movements and counter-movements make generalizations difficult. Classification seems more than ever to distort the complexity of artistic expression, though it serves the practical purpose of grouping artists to provide a picture of over-all trends. In general, sculpture parallels the painting of the period.

There has been a strong swing toward abstraction, both geometric and biomorphic. In the sixties this tendency culminated in severely simplified, reductive forms, which, as in painting, are often described as "minimal." Much modern sculpture is of gigantic size; termed "environmental," such sculptures engulf the observer. In the fifties a sculptural equivalent of Abstract Expressionist painting frequently employed rough-surfaced, semiorganic abstract forms. These often seem

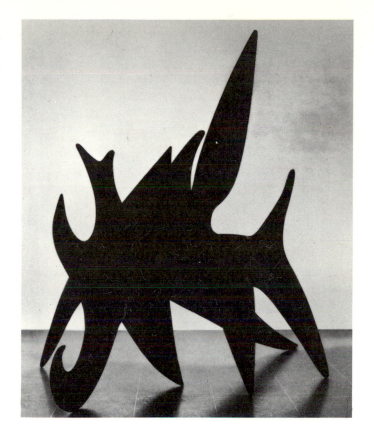

partially improvised. though spontaneity of execution is more difficult in sculpture than in painting because of the nature of the medium. The interest in sculpture that moves has expanded since Calder produced his first mobiles; much of the kinetic sculpture of the sixties was activated by motors or taped programming. Sound has frequently accompanied movement in kinetic sculpture.

Assemblage, initiated decades earlier by Marcel Duchamp and other Dada iconoclasts, added another dimension to the sculptural scene of the late fifties and sixties, sometimes with Surrealist, sometimes with Pop overtones. Pop contributed elements of satire, humor, and popular imagery to the sculptural scene of the sixties. Even Op claimed its sculptural counterpart in works utilizing brilliantly colored neon lights to create dazzling effects or many-faceted mirrors to multiply reflected images in a bewildering maze. And finally, some sculptors preferred to move against the current and remain within the time-honored fold of the realists.

Geometric Abstraction

Sidney Gordin (1918–), in the late forties and fifties, produced a number of sculptures which were related to Constructivism in many basic ways reflecting the influence of both Gabo and Piet Mondrian's paintings. Gordin's *Construction No. 5* of 1951 (Fig. 667) is an essay in tonality, geometric patterning, and space-modulating agencies. The play of white and black; of movement in, out, up, down, and across; of solid and transparent; and of line and mass is developed with vivacity and taste.

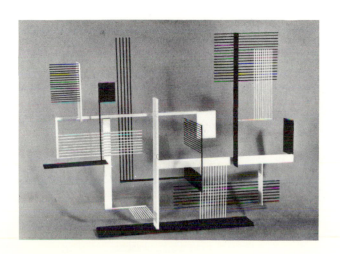

Like much contemporary sculpture, *Construction No. 5* is executed in steel, in this case painted.

Richard Lippold (1903–) conducted more complex essays in the interpenetrations of space, using intricate linear geometric patterns. A typical work, his 10-foot-high *Variation No. 7 : Full Moon* (Fig. 668) is executed in nickel-chromium wire, stainless steel wire, and brass rods. The exquisite delicacy of the thin lines intersecting space and the radiance and shimmer with which the light is reflected by the clusters of fine lines represent a most sensitive and poetic development of geometric abstraction. Since the effectiveness of Lippold's refined, room-size wire constructions depends upon carefully calculated illumination, these structures are as much essays in light as in metal. For the artist, these delicate structures are more than sources of visual delight; they are philosophic statements about modern life. Of one of his sculptures, Lippold has said:

Once installed, nothing can disturb it except the most delicate of matter; dust, a piece of paper, an enthusiastic finger. Again we must remember that a slip of paper in the wrong place—someone's desk or a portfolio—can now destroy mankind. It is not the main tensions we must fear, it is the little delicate relationships we must control.

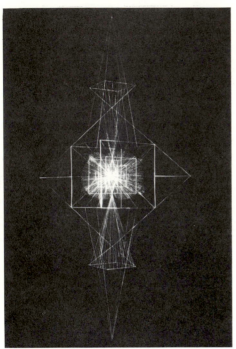

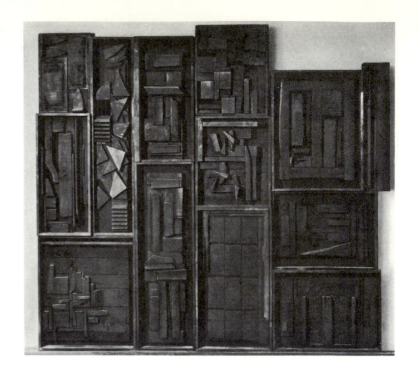

left : 668. RICHARD LIPPOLD. *Variation No. 7 : Full Moon.* 1949–50. Nickel-chromium wire, stainless-steel wire, brass rods; height 10′. Museum of Modern Art, New York (Mrs. Simon Guggenheim Fund).

above : 669. LOUISE NEVELSON. *Young Shadows.* 1959–60. Wood, height 9′ 7″. Whitney Museum of American Art, New York.

below left : 670. BERNARD ROSENTHAL. *Alamo.* 1967. Steel, height 15′. Cooper Square, New York.

The exploration of space-modulating agencies, of transparent materials, and of lightweight, thin elements lessened in the mid-fifties, to be followed by a concern with surface and bulk. Louise Nevelson (1900—) achieved her initial recognition with compositions built up of scraps of wood painted a uniform mat color, as in *Young Shadows* (Fig. 669), essentially a type of assemblage. (Some of her later compositions from the mid-sixties employ metal, plastics, and a variety of colors.) The many parts of *Young Shadows* have a dual interest. While one is ever conscious of wood-working power tools, such as the saw and the lathe, one is even more aware of the human beings who manipulate the machines and whose actions and demands created the omnipresent regularities and irregularities of shape. Ever present also is the mystery of the origin of the fragments that make up the composition and of their previous use, a mystery that is intensified by the uniform color which impersonalizes the parts without obliterating their variety and uniqueness. Over the entire assemblage one feels the hand of time. Each

basic unit or box has an individual character, and the interest of the entire piece is intensified by the inscrutable, quiet way the forms fade into more shallow relief and slighter movements as one's eyes move from upper left to lower right. Though the impersonal tool played its part in making possible such a work, the dominant mood is personal, a brooding concern with things. A somber, highly individualized taste provides the esthetic motivation in Nevelson's most characteristic work.

In the mid-sixties geometric abstractions tended to become increasingly simple and monumental in size, as the tendency toward simplification culminated in "minimal" sculptures, and the disposition toward monumental scale in the "environmental" sculptures. Bernard Rosenthal (1914—) showed a preference for weighty monumental form even in his early figural works. In the fifties and sixties, conforming to the dominant preference for abstraction, he divorced himself from representational elements, turning to generalized forms, frequently of a semiorganic character. In *Alamo* (Fig. 670) even the organic element has been eliminated in favor of pure geometric components. Basically, *Alamo* is a huge cube, its surfaces relieved by rectangular and circular variations. The massive bulk, the rigid modifications of what would otherwise be an unbroken cube, and the seeming impenetrability of the dense black surface all work together to create an almost frightening, yet deeply impressive sculptural entity. The drama implicit in the precarious footing on which the great cube rests adds to its ominous strength. Approaching minimal concepts in its cubic character, *Alamo* also conforms to what has been termed a "brutalist" trend, evident in some of the architecture of the mid-sixties, in which sheer bulk and massive weight contribute to an effect of almost barbaric magnificence.

Since it has neither the emotionalized overtones nor the surface complexities of *Alamo*, an untitled work by

Robert Morris (1931—) provides a more typical example of minimal sculpture (Fig. 671). Executed in a modern synthetic material, this large, symmetrical block, slightly tapered in form, is cleft by a narrow space which is illuminated by an inner light. Robert Morris has said: "Simplicity of shape does not necessarily equate with simplicity of experience. Unitary forms do not reduce relationships. They order them." Here order and relationships contribute to a form whose purity is intensified by the thin, luminous line that divides it into two equal parts. Such simplification neither invites nor repels; it exudes a kind of quietude that at one and the same time seems to represent an ultimate development and a dead end to the impulse toward abstraction.

Size as a fundamental esthetic factor has been utilized with great effectiveness in the creation of "environmental" sculptures. The observer no longer stands apart from the work but surrounds himself with it, walks through and around it, and experiences ever-changing relationships of form and space. Sculptors, in turn, find magnitude exhilarating. *Cigarette* (Fig. 672) by Anthony (Tony) Smith (1912—) is a plywood mock-up over 15 feet high and 26 feet wide, designed to be executed in plate steel. Such a sculpture is intended for an open plaza, where it can become an integral part of the urban atmosphere, open to the light of the sun and sky—an angular, serpentine, monumental form towering above the people and vehicles. In works on this scale the sculptor, like the contemporary architect, plans the project with models

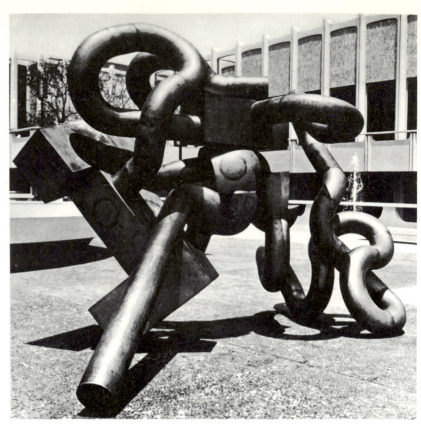

and blueprints, and the final product is executed in a factory by skilled workmen. The hand of the craftsman has been banished for the precise, impersonal techniques of today's machines, but the forms are no less the creation of the sculptor, for the mind and emotions remain master, whether the hand or the machine carries out the artist's dictates.

Biomorphic Abstraction

Not all of the post-World War II abstract sculpture is based on geometric forms. The "biomorphic" forms with organic and Surrealist overtones, originated by Brancusi and Arp and popularized by Calder, remain a vital part of the sculptor's vocabulary. One of the most distinguished sculptors to have worked continuously since the forties with a wide variety of forms is Isamu Noguchi (1904—). *Kouros* (Fig. 673) is a beautiful example of the biomorphic vein in which Noguchi worked extensively in the last half of the forties. *Kouros* employs interlocking planes which rest on one another in a manner reminiscent of his handsome table (Fig. 517), although in the sculpture, which is almost 10 feet high and is executed in pink marble, they are developed with more complexity and subtlety. The curiously flat, elegant forms are endowed with both

left : 673. ISAMU NOGUCHI. *Kouros.* 1945. Pink Georgia marble with slate base, height c. 9′ 9″. Metropolitan Museum of Art, New York (Fletcher Fund, 1953).

right : 674. PETER VOULKOS. *Pirelli.* 1967. Cast bronze and fabricated bronze tubing, 8 × 13 × 6′. Collection Mr. and Mrs. Stephen D. Paine, Boston.

strangeness and grace, and at the same time a monumental gravity characterizes the group. It is this ability to invent and combine forms containing so many diverse qualities that distinguishes Noguchi's art, which has been characterized by versatility throughout his career. Among his finest recent works are the handsome outdoor sculptured gardens, such as the one he created for the Beinecke Rare Book and Manuscript Library at Yale (Fig. 500). Unlike much of his previous work, the forms employed there are essentially geometric, but they are handled with the consummate skill and elegance typical of everything touched by his hand. The rapidity with which modern art has departed from traditional patterns is evident when one realizes that Noguchi studied with Gutzon Borglum.

About 1950 Leo Amino (1911—) created a number of handsome abstractions using finely modulated biomorphic forms of polished wood, plastics, and various synthetic stones with sensitivity and imagination.

Peter Voulkos (1924—), previously discussed as a ceramic potter-sculptor (Fig. 523), has now turned to bronze. A number of his works from the late sixties employ powerful, twisting forms composed in relation to massive rectangular blocks, as in *Pirelli* (Fig. 674). Conceived in a brutalist vein, its convolutions suggest some Herculean struggle projected into deep space by purely sculptural means. The forms inevitably remind one of the famous antique *Laocoön* group. In *Pirelli* the struggle is not between man and monster but between whatever conflicts exist within the viewer's feelings.

The works of Chryssa (1933—) might logically be placed under a number of classifications. *Fragment for the Gates of Times Square, II* (Pl. 36, p. 489) is basically a plexiglass cube, as minimal a form as one can conceive. Within the cube and controlled by electric circuits are multicolored neon lights shaped in rhythmic, biomorphic curves, partly, of course, because the neon tubing cannot be bent in sharp right angles. Since neon tubing, an advertising medium, contributes more than any other factor to the garish animation of city streets at night, neon-light sculpture might with equal logic be termed Pop, for neon is perhaps the symbol, par excellence, of popular culture.

When Chryssa arrived in New York from her native Greece, she found herself entranced by the visual vitality of Times Square. She wanted to become a sign maker, but, lacking a union card, she turned artist and began sculpturing with neon light. In *Fragment for the Gates to Times Square, II* Chryssa, finding inspiration in a technically magnificent but much abused advertising medium, created a work of art in which light, transparency, modulated space, and dazzling color provide a new esthetic experience of a high order.

Modern sculptors have ceased to be confined to traditional sculptural materials. Any substance that can be shaped, from vinyl fabrics, plastics, fiberglass, rubber, automotive junk, plumbing parts, and nylon stockings to such time-honored materials as stone, plaster, and bronze, has its particular visual potential, and the sculptor selects from this vast range of materials to suit his purposes.

Symbolic and Abstract Expressionism

Essays in geometric form failed to provide satisfying expression to certain temperaments. In the late forties and fifties a number of New York sculptors, responding to Expressionist and Surrealist influences, began to explore intuitive and emotive forms of expression. These men forged, bent, hammered, welded, and annealed their iron, steel, bronze, and silver images with the directness of the action painters, and, like the action painters, they achieved a powerful vehemence. Expressive twisted and bent forms and rough, hammered, corroded, and pitted surfaces lent tactile vigor to the products of forge and foundry.

The influence of David Smith (1906–65) on this phase of American sculpture cannot be overestimated. Smith started his career as a student of painting in the Cubist, Surrealist, and later Abstract Expressionist orbit. Outside the studio he labored as a metalworker in factories and, during the war, as a welder in a defense plant. This dual orientation, and a conviction that sculpture constituted a philosophic statement, turned him toward symbolic, quasi-abstract forms in his sculptures of the late forties and early fifties. *Family Decision* (Fig. 675), with its varied and seemingly improvised shapes that appear drawn in space, is typical of his production in the early fifties. In this period he worked in welded iron and steel, which was cut, twisted, bent, hammered, and otherwise shaped and then welded together. Metal rods, sheets, tubing, heavy wire, and even ready-made machine parts constituted his materials. Smith replaced the smooth elegance of Constructivist tradition with an almost harsh lack of surface refinement, as though he were referring back to the blacksmith, rather than adopting machine technology. His motifs remain enigmatic; numbers, letters, and organic and geometric elements intermingle in endless variety to create great, open, linear sculptures that seem to embrace the outdoor elements.

In the sixties Smith moved toward simpler, less linear sculptures that are larger and more monumental than

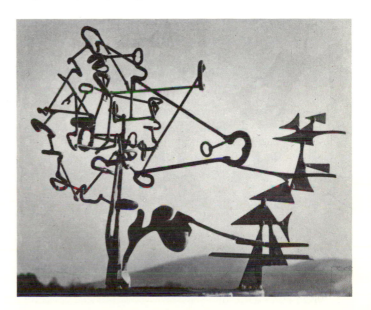

right : 675. DAVID SMITH. *Family Decision.* 1951. Bronze and steel, 26 × 38 × 18 ½″. Collection R. Alistair McAlpine, London, courtesy Marlborough-Gerson Galleries, New York.

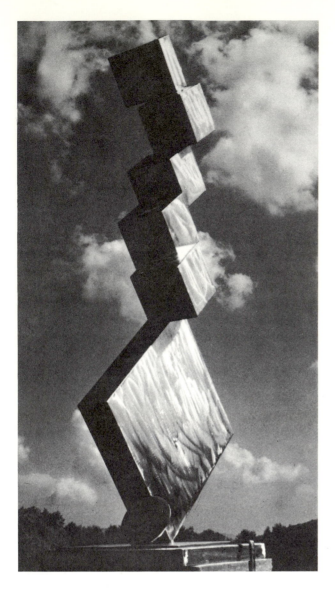

ings of small forms, and the occasional larger masses provide the eye with complex and fascinating changes of form. There is something of the enigma of ancient images corroded by time or by the action of the sea in these richly textured surfaces, which have much sensuous beauty and yet at the same time project strangely morbid and slightly ominous overtones of a Surrealist quality.

Seymour Lipton (1903—) retains a preference for the more traditional sculptural quality of weight. His forms may be built up of thin sheets or bars of metal, but they

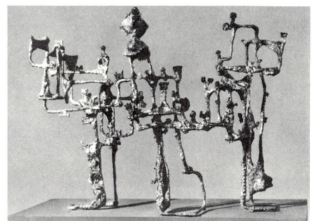

his earlier works. *Cubi I* (Fig. 676) is typical of his *Cubi* series, in that the massive rectangular blocks of steel thrust themselves majestically upward in great counterbalancing volumes. The polished surfaces which reflect the light provide an element of animation that complements the severe grandeur of these contemporary totems.

In many ways the work of David Smith predates and postdates Abstract Expressionism. The sculptures of Ibram Lassaw, Seymour Lipton, and Theodore Roszak come closer to being Abstract Expressionist sculpture.

Ibram Lassaw (1913—) works most frequently in brazed metal. His *Procession* (Fig. 677) combines bronzes and silver in intricately involved forms that move through space in measured, continuous rhythms. The swellings and shrinkings, the blisterings and drippings, the cluster-

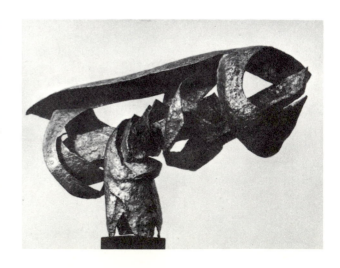

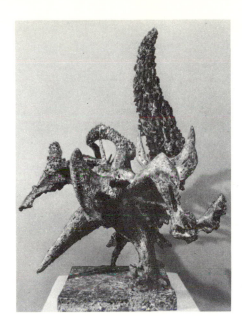
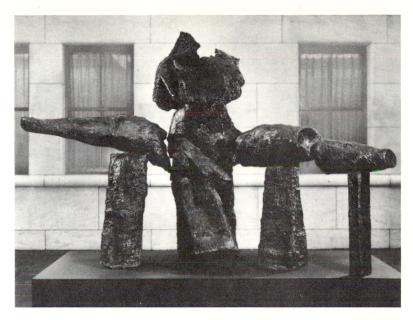

enfold one another to create a powerful sense of mass. *Storm Bird* (Fig. 678), in nickel silver, is composed with forceful movements. The angular forms penetrate one another and define voids by means of twisting rhythms, and the surface texture heightens the sense of drama.

The dynamic emotionalism that is the goal of Abstract Expressionism is brilliantly achieved in the sculpture of both Seymour Lipton and Theodore Roszak. Roszak (1907–) commenced his career with the severely geometric forms and cold, impersonal surface finish of the Constructivists. After World War II his style underwent a complete change, and he became engrossed in forms which are "meant to be blunt reminders of primordial strife and struggle, reminiscent of those brute forces that not only produced life, but in turn threatened to destroy it." At this time he abandoned the smooth surfaces of his early work for textures that are coarse, eroded, scarred, and pitted. *Spectre of Kitty Hawk* (Fig. 679) is made of welded and hammered steel, brazed with bronze and brass. Its spiked violence and anguished skeletal angularities eloquently express the terrors of the atomic age. Though Roszak is an abstract artist, his sculptures are attuned to modern existence, but on a cosmic, not a personal level, evoking universal fears that beset our times.

Among other sculptors of distinction who worked in metal in the late forties and fifties using the Abstract Expressionist idiom were David Hare (1917–) and Herbert Ferber (1906–). In the late fifties and early sixties Ferber created enormous cagelike metal sculptures that engulf the viewer in a dynamic, almost frightening environment of encompassing tortured forms.

left : 679. THEODORE ROSZAK. *Spectre of Kitty Hawk.* 1946–47. Welded and hammered steel brazed with bronze and brass, height 40 ¼". Museum of Modern Art, New York (purchase).

right : 680. REUBEN NAKIAN. *Goddess of the Golden Thighs.* 1964–5. Bronze, 8' 8 ½" × 12' 1". Detroit Institute of Arts (W. Hawkins Ferry Fund).

The recent sculptures of Reuben Nakian (1897–) combine figural and expressionistic elements and at the same time retain many of the surface characteristics of the Abstract Expressionists. His early work grew out of the tradition so well exemplified by William Zorach and John Flannagan, in which representational elements, treated in a monumental way, were carved from dense and weighty materials. Moving continuously away from direct representation during the fifties, Nakian developed a grand and strange manner, using barely identifiable figural elements, but he retained both the monumental aspects and the feeling for materials that characterized his early work. His manner in the sixties is well illustrated by *Goddess of the Golden Thighs* (Fig. 680). Like some ancient sculpture dredged from the bottom of the sea, eroded and corroded by time and the elements, the dislocated fragments that make up *Goddess of the Golden Thighs* have a morbid grandeur and solemnity. It is not an art that affirms our age by glorifying the machine and current technology, nor does it reflect the character of daily existence. Neither does it make a vain effort to revive the past by copying it. Instead, like a noble elegy, it speaks of the grandeur of human history in dying cadences that are both anguished and beautiful.

Kinetic Sculpture

A broad variety of experiments in kinetic sculpture, ranging from self-propelling mobiles to self-destroying assemblages, characterized the fifties and sixties. Most of these kinetic sculptures were activated by motors, although some were operated by the observer. A number emitted sounds ranging from Pop music to machinelike buzzings or shrill screeching noises. In some the sounds were synchronized with the movements of the sculpture; in others they appeared as uncoordinated surprises. Many kinetic sculptors think of their creations as machines and therefore wish no element of the sculptor's hand to mar the machined perfection of surfaces. Such is the preference of José de Rivera (1904—), whose sculptures, both static and kinetic, are masterpieces of curvilinear formalism. His *Yellow-Black* (Fig. 681), made of painted aluminum, appears to be a pure distillation of technological skills. Its flawless, thin shell, punctuated by perfect circles, almost hypnotizes the eye with the effortless flow of its rhythms. De Rivera has constructed a number of shining stainless steel parabolas which, propelled by silent motors, rotate slowly in space, thereby adding continuously changing relationships of line and form to their sinuous loveliness.

Fletcher Benton (1931—), who worked in San Francisco in the sixties, combined movement and color with handsome, formally composed geometric forms in such typical works as the *Synchronetic C-8800* series (Fig. 682). Beautifully crafted of plexiglass and metal, its parts have been organized with machinelike precision in a formal composition. In the center, slowly revolving disks of color overlap to reveal continuous changes of bold pattern and color. De Rivera and Benton still remain related to the Constructivist tradition in their technical and esthetic

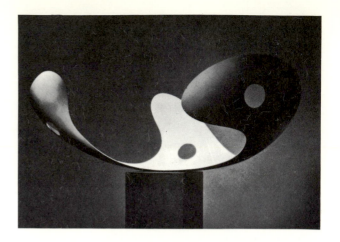

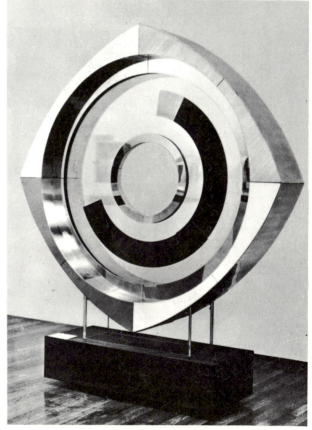

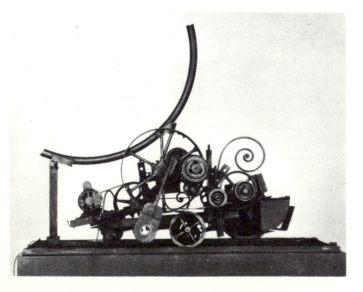

top : 681. JOSÉ DE RIVERA. *Yellow-Black.* 1946. Painted aluminum, 1′ 10″ × 5′. Collection Roy R. Neuberger, New York.

above : 682. FLETCHER BENTON. *Synchronetic C-8800.* 1966. Plexiglass and metal, 6′11″ × 5′ 10″ × 11″. Courtesy Esther Robles Gallery, Los Angeles.

left : 683. JEAN TINGUELY. *M.K. 111.* 1964. Motorized kinetic sculpture, iron; 3′ ½″ × 6′ 10 ½″. Museum of Fine Arts, Houston (purchased with funds donated by D. and J. de Menil).

right : 684. JOSEPH CORNELL. *Constellation of Autumn No. 2.*
c. 1960. Boxed assemblage, 8 5/16 × 13 × 3 1/2″. Collection
John Garafalos, Arlington, Va.

values, though color and movement add new levels of
visual complexity to their works.

The ultimate extremes in kinetic sculpture were the
self-consuming parodies on machines by the Swiss
sculptor, Jean Tinguely (1925—), who spent some time in
America. His *Homage to New York : A Self-constructing
and Self-destroying Work of Art* of 1960 was an assemblage
of piano, machine, and bicycle parts, fireworks, and pieces
of junk, which shuddered, shook, emitted sounds from a
pretuned radio, and at intervals went into a violent self-
destroying paroxysm. *M.K. 111* (Fig. 683) is a motorized
sculpture, which in operation is as much a "happening"
as a sculpture. The machine age has its lovers of machines.
In a work such as this the beauty of the pure and flawless
surface is cast aside for the fascination of working parts
moving in involved cycles. Perhaps as a wry commentary
on our mechanized society, *M.K. 111* moves, but the
movement is an end in itself; the machine neither produces
anything nor arrives at any final destination.

ASSEMBLAGE

No strict line of demarcation separates painterly and
sculptural assemblage: Whether one sees the image as an
essentially two- or three-dimensional experience probably
provides the most reasonable criterion for classification.
Precedent for sculptural assemblage can be found in
various arts of the past and of unsophisticated societies,
notably in the masks of Eskimo, African, and other
primitive peoples who attached feathers, bones, shells,
and fibers to their carvings. Early in the twentieth century
Man Ray, Marcel Duchamp, and other Dada and Sur-
realist innovators also discovered the emotional potency
that objects acquire when they are dislocated from their
normal context and incorporated into an artistic matrix.

The emotive potency of the used, the worn, the
abused, and the discarded has already been noted. Our
age of forced obsolescence and conspicuous consumption
produces a greater quantity of debris than any previous
period in history. In the fifties and sixties contemporary
sculptors, ever desirous of enlarging the expressive domain
of modern sculpture, took advantage of this largesse to
exploit both its visual and evocative powers.

The boxed assemblage, popular at the turn of the
decade and almost as close to painting as to sculpture,
provides a good introduction to the movement. One of
the best-known practitioners of this particular art form
was Joseph Cornell (1903–72). *Constellation of Autumn No. 2*

(Fig. 684) employs a number of his favorite motifs—the
ball, the sliding ring on a bar, astronomical charts, part
of a goblet, a fragment of sculpture—all placed in front
of a weathered and peeling bit of wall. The placement of
the parts is not absolute and permanent; if one tilts the
framed box, the ball and ring can change position, thus
changing many of the visual relationships. A grave,
poetic, and mysterious mood permeates this assemblage
of objects, which are related by the repetition of certain
forms (such as the circles and spheres), by compositional
arrangements, by repetition of similar textures, and by
the shadows. One is reminded of certain Surrealist painters,
Pierre Roy, for instance, who composed his meticulously
painted groupings of what appeared to be unrelated
objects in a similar way and evoked a poetry of common-
place objects seen in an unexpected relationship.

Whereas Cornell went to his attic and his collection
of memorabilia for the man-made objects in his boxed
arrangements, Richard Stankiewicz (1922—) goes to the
city dump or the wrecking yards for the discarded and
eroded machine parts with which he works. From these
middens of our culture come the parts used in such a
typical work as *Fish Lurking* (Fig. 685). Seen out of their
familiar environment, these parts of machinery, bits of
plumbing, and fragments of scrap iron take on a new
character. They are at once amusing and ingenious
fabrications, sad and brutal discards of our culture, and
rhythmic elements in a carefully constructed composition.

No light touch mitigates the ferocious strength of the
welded steel and canvas compositions of Lee Bontecou
(1931—). Her repertoire of effects is limited, but this in no
way detracts from their threatening power. *Untitled*, a
work of 1964, is typical (Fig. 686). Tightly composed in
vertical and horizontal masses, the movements carry one
inexorably to the gaping ovals that either reveal the fearful
steel teeth of zippers or appear like sightless, empty eyes

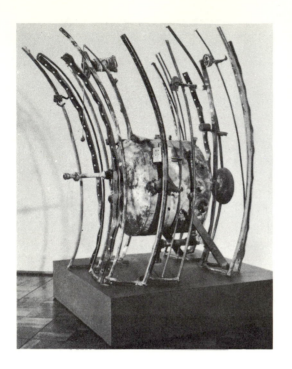

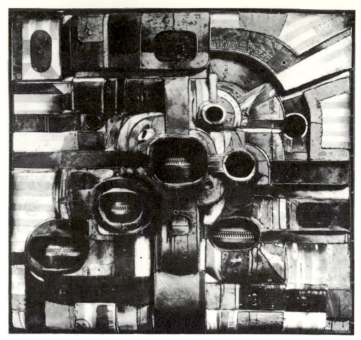

left : 685. RICHARD STANKIEWICZ. *Fish Lurking.* 1958. Metal, height 48 ¼". Collection Mrs. Albert H. Newman, Chicago.

right : 686. LEE BONTECOU. *Untitled.* 1964. Welded steel and canvas, 6' × 6' 8" × 1' 6". Honolulu Academy of Arts, Hawaii.

behind which exists a world of black nothingness. The concentrated density of the composition is reinforced by the cold and inhospitable surface of her materials. A kind of contemporary monster is created, a masklike image that carries a threat of terrifying realities lurking, behind the amenities of modern life.

One of the masters of the macabre whose frightening images involve no evasive abstractions or symbolism is Bruce Conner (1933—). *Baby* (Fig. 687) is rightfully one of his best-known works. Wood, wax, and nylon have been used to create this nightmare image of constriction, death, and ·disintegration. That man can be monster and that death and decay are inevitable are common knowledge, but seldom is this knowledge embodied in such concrete form as in *Baby.* The use of the highchair, a symbol of parental care, intensifies the horror of the image, which seems to say that from birth man is a prisoner, caught in the strangling web of circumstance, trapped in a nightmare existence. The profound pessimism and cultural conflict inherent in *Baby* characterized much of the arts of the sixties, particularly in fiction and the theater.

The mid-twentieth century has witnessed a continual fusion of the arts, some architecture approaching sculp-

ture, sculpture and painting losing their identities on the borderline between them, and assemblage appearing at times to bridge the gap between art and life. Sculpture, architecture, art, and life all seem fused in the great towers that Simon Rodilla, better known as Simon Rodia (1879–1965), constructed in Watts, a suburb of Los Angeles (Figs. 688, 689). This cluster of towers, the tallest of which approaches 100 feet in height, was built by the Italian immigrant tile setter for the following reason : "I wanted to do something for the United States because I was raised here, you understand ?" Working by himself over a stretch of more than thirty years, using steel rods, wire screening, concrete, broken dishes, stones, mirrors, shells, pieces of colored bottle glass, and other cast-off materials, Rodia created a grand assemblage that represents an impressive and sustained physical and artistic achievement. Intuitively rhythmic in their powerful structural forms, rich and complex in the orchestration of patterns, colors, and materials, the towers are a tribute to an untutored sensibility of a remarkably high order. Surrounded by a protecting wall is a maze of loggias, fountains, benches, and similar structures, from which the great towers rise majestically in related though not identical forms.

One of the striking characteristics of artistic movements is that they appear to be an expression of the subterranean awarenesses that constitute the inner life of a society. Caught by the artist's hypersensitive reactions and projected into concrete form, such intuitions summarize the

newborn currents of an age and, in so doing, help to shape the future. Thus, starting his work thirty years before the form of expression became popular, far from the sophisticated art world and its *avant-garde* movements, Simon Rodia created a monument which, more than any other single work, appears to give positive expression to the art of assemblage. There is none of the previously noted pessimism here; from the humblest discards of the society he loved, Rodia built one of the most powerful and poignant tributes to patriotic sentiment that America has produced.

POP ART AND REALISM

Though abstraction seemed to dominate the sculpture of the late forties and early fifties, the mid-fifties witnessed the rebirth of realism, but is was realism of an unorthodox character, far-removed from the academic or monumental figural tradition of earlier times. The influence of the Pop Art movement colored much of the emerging realism of the sixties, giving it a vivid, fresh character. The repre-

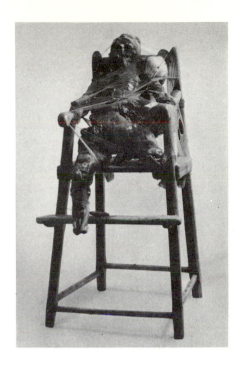

top : 687. BRUCE CONNER. *Baby.* 1958. Wood, wax, and nylon; height 35″. Collection Philip Johnson, New Canaan, Conn.

left : 688. SIMON RODIA (RODILLA). Watts Towers, Los Angeles. c. 1921–54.

below : 689. SIMON RODIA (RODILLA). Detail, Watts Towers, Los Angeles.

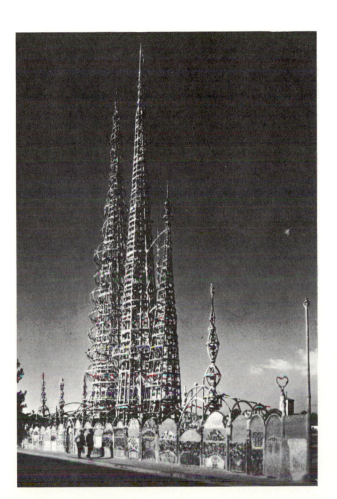

sentational sculpture of the sixties not produced in the Pop tradition usually carried thematic or symbolic overtones which distinguished it from the more purely visual realism of the pre-World War II years.

Swedish-born Claes Oldenberg (1929—) was a vigorous contributor to the Pop movement from its inception. He modeled his early pieces of "Americana" from plaster and painted them to resemble either the original objects or, in the case of food, the facsimiles which are used for display purposes. *Pastry Case* (Fig. 690) provides an amusing example of Oldenberg's expression in a moment of cheerful derision. Frequently his humor is more oblique, as in his giant-sized models of men's attire, food, and other familiar objects never previously immortalized in sculptural form. An ice cream cone of painted canvas and foam rubber enlarged to 12 feet in height becomes a frightening parody on everyday life. A page from a calendar or a "soft" toilet, a collapsed form made from vinyl stuffed with kapok, illustrates Oldenberg's statement: "I have combined my unworldly fantasy in a shock wedding to banal aspects of everyday existence." To extol the poetry of the familiar has become an artistic commonplace. Oldenberg joins the great satirists of the past in revealing the fantastic ugliness of much that has lost its visual identity to us through familiarity.

Another who delights in emphasizing the shock value of seamy realities is Edward Kienholz (1927—). *Back Seat Dodge-38* (Fig. 691), like all his "tableaux," is an assemblage of materials which, by their tawdry surfaces,

provide the vocabulary for his unequivocal confrontation with current life. The dilapidated vehicle, with its dents and worn paint, is no more shabby than the romance it houses. Few formal values are evident, but the work has its expressive distortions and inventions. The cut-down proportions of the car intensify its awkwardness, and the chicken-wire body of the lover lends a touch of sardonic humor. The impudence of a *Back Seat Dodge-38* is equalled by its factual truth, shocking only because it openly, and with no mock moralizing or sentiment, proclaims a fact. Again, comparison with the satirists of

top : 690. CLAES OLDENBERG. *Pastry Case*. 1962. Painted plaster and mixed media, 20 ½ × 30 × 14″. Museum of Modern Art, New York (Sidney and Harriet Janis Collection).

left : 691. EDWARD KIENHOLZ. *Back Seat Dodge-38*. 1964. Assemblage, 20′ × 12′ × 5′ 6″. Courtesy Dwan Gallery, Los Angeles.

other times is not out of line. Swift, Grosz, Goya, and a host of others have, with equal zest, proclaimed to previous generations that life is not beautiful.

Escobar Marisol (1930—), of Venezuelan parentage, was born in Paris. She has been associated with the Pop art movement in New York since its inception, drawing upon current mores for her witty sculptures. *Women and Dog* (Pl. 37, p. 490) is a typical work, with its figures developed in varying degrees of realism from the blocks of wood that form the unifying, formal factor in her work. Moving in and out of three dimensions by drawing, painting, and sculpturing, she adds actual fabrics and a real purse, so that multiple levels of reality and abstraction are in continuous interplay. These elements, combined with endless variations of her own handsome face in many degrees of simplification and stylization, work

together most effectively to create images of astonishing variety and vitality. In *Women and Dog* the sequential positions of the repeated faces, reinforced by the standing positions of the figures, suggest a movement oddly at variance with the blocked forms. Equally surprising is the small face of the central woman, which, emerging from a curious ovoid form, adds an enigmatic foil to the almost journalistic liveliness of the group. It is this play of abstraction and realism, of elaborately polychromed surfaces against natural wood, of fact and fancy, of topical chic with Surrealist strangeness that constitutes the fascination of these imaginative creations. Seldom has the culture of the streets and of the museum made a happier marriage.

Frank Gallo (1933—) has turned far from a concern with formal values. Working in epoxy resin, and most frequently using color to intensify the impact of his work, he approaches the human subject with a passionate desire to realize the uniqueness of each subject. His own words best describe his aim: "Postures of the human figure are potentially expressive . . . Perhaps it seems mundane to most artists, but to me, a celebration of the ordinary, a passion for the commonplace or subtleties of the incidental are of grave concern." This approach is brilliantly exemplified in *Male Image* (Fig. 692). Seldom are attitude and gesture caught with such strength. One is reminded of the drawings of Degas, particularly by the incisive line that delineates the folds of clothing which describe the bulk and weight of the body beneath. The lounging figure has a sad validity; it evokes compassionate concern as we realize how little of beauty, grace, and heroism makes up the tenor of daily existence. Using the most modern of media, Gallo joins with the old tradition of realism in his tender solicitude for the human condition. Cognizant of the unique identity of each being, he makes us conscious of individual significance.

In striking contrast to the highly personalized figures of Frank Gallo are the depersonalized automata that make up the world of Ernest Trova (1927—). Faceless and armless, each identical with the next, his world of men is without sex, identity, or destination. Figures similar to those in his *Study: Falling Man Series, Six Figures* (Fig. 693) were repeated, time after time, in a sequence of compositions in the mid-sixties. Though they vary in size and position, they appear to be robots moving without will as part of some great impersonal mechanism.

The highly individualized figures of Frank Gallo communicate belief in the separate identity of each living

left: 692. FRANK GALLO. *Male Image.* 1965. Epoxy resin, 5′ 3″ × 2′ 7″. Cleveland Museum of Art.

left : 693. ERNEST TROVA. *Study : Falling Man Series, Six Figures.* 1964. Chrome-plated bronze, 16 × 19 × 19″. Whitney Museum of American Art, New York (Larry Aldrich Foundation Fund).

George Segal (1924—) goes farther than Battenberg in his use of casts from real life. The molds from which his figures are cast are made from the live model, so that the plaster figures in his elaborate tableaux have the authenticity of photographs. The bus, the movie house, the gas station, and other such mundane settings provide the background for his compositions. The flat white or aluminum color of the figures isolates them from the realistic setting in which they are placed, emphasizing them and making the human factor the visual and emotional focus of the entire composition. Segal described his aim with unusual clarity when he said: "My biggest job is to select and freeze the gestures that are most telling. . . . I try to capture a subject's gravity and dignity. . . . I'm dependent on the sitter's human spirit to achieve total effectiveness." *Girl in Doorway* (Fig. 695) is one of his simplest compositions, yet it projects the attitude of its subject with astonishing force. The heavy body and wrinkled clothes only emphasize the distance between outward appearance and inner character, as conveyed by the thoughtful head and motionless hands. Lost in thought as she prepares herself for encounter with the world, the girl seems to embody the basic loneliness with which all individuals face life. Essentially a genre artist, Segal has projected a forceful image of the human spirit in its contemporary setting.

Though often associated with the Pop artists, Segal has avoided the cool Pop skepticism for an art of social commitment. The world of the meek and the humble has reappeared in the galleries and museums, testifying that a belief in the spiritual equality of all men is still a creative force in the twentieth century.

Only three and a half centuries have passed since the settlers from Europe constructed the first rude dwellings on the shores of Virginia. During that time the world has undergone greater changes than in any other comparable period in history. We now live in a world of almost inconceivable intellectual vigor, complexity, richness, and productivity. Periods of vigorous development are inevitably full of conflict and confusion, for if man is forging his way into new areas, there is no precedent or established pattern of behavior. The United States, more than any other country in the world, appears to be the heir of both the benefits and the conflicts inherent in this complex of progress and problems. America has always been the land of abundance; today this abundance extends itself to

being, despite the pressure toward conformity in our age. Ernest Trova's cold and shiny modular figures, by contrast, project a chill fear that man in the space age has lost his uniqueness to become part of a vast machine moved by some abstract, computerized destiny. The contrasts and conflicts of our age are mirrored in the endless variety of images and attitudes which summarize the contemporary art world.

Distance lends enchantment: the past, stripped to some degree of pain and conflict though the beneficent blurring of memory, inevitably assumes an aura of sentiment. In the sixties the clothes of the twenties provided a magic key to a recollected earlier age that seemed unconflicted and positive in outlook. Like the young who ransacked attics for clothes that recalled the past, John Battenberg employed clothing and airplane parts reminiscent of the early days of flight. In *Johnny's First Trip* (Fig. 694), using actual fliers' costumes dipped in wax as the basis for his molds, he cast his animated, fleshless figures in aluminum. The soft gray surface of the aluminum adds to the spectral fantasy of the disembodied figures moving into flight like characters in a dream. Though most of our realists face the world around them with laughter, pity, or fear, Battenberg has taken off into the realm of fancy. The realities of surface and detail in *Johnny's First Trip*, like pressed flowers in a book, evoke a nostalgic sentiment at the same time that they establish an uncanny sense of authenticity. Fact and fancy, dream and reality, technical ingenuity and imagination all come together in this work to create a fresh image of the past for today.

architecture, painting, sculpture, the crafts, and the allied arts. Institutions devoted to furthering the cause of the arts are well established in our national life and are flourishing. Architecture and the industrial arts reflect with particular clarity the technical accomplishment and the intricate social organization of our society, both in their scale and in the discipline and refinement of their visual qualities. Inherent in their finest achievements is the promise of an integration of our advanced technology and a scientific humanism. But such arts as painting and sculpture, which express the philosophical goals and questionings of our society, frequently reflect an atmosphere of pessimism, even anguish. Though we are energetic and productive, we are not certain where we are going, and though we may readily admit that life is an adventure and a quest, we frequently feel lost, anxious, and without direction.

Because our society is one in which creative individuals are searching to find new directions and forward-looking values with which to identify themselves, our age is beset with well-grounded fears and confusing crosscurrents. Exploration and certainty seldom go hand in hand, but the very desire to adventure into the realm of the unknown speaks of optimism and assurance, and nowhere is the spirit of adventure more evident than in the arts. Along with the scientists who set out to investigate the structure of the molecule or to explore outer space, the artist, too, steps forward, gravely or gallantly, into new forms of expression, intent on learning what is without and expressing what is within.

left : 694. JOHN BATTENBERG. *Johnny's First Trip.* 1966. Cast aluminum, height 7′ 11″. Krannert Art Museum, University of Illinois, Champaign, Ill.

above : 695. GEORGE SEGAL. *Girl in Doorway.* 1965. Plaster, wood, glass, aluminum paint; 9′ 5″ × 5′ 3 ½″ × 1′ 6″. Whitney Museum of American Art, New York.

Bibliography

This bibliography is divided into two sections. The first contains general references, which are pertinent to the entire text; the second lists references of particular interest for certain parts of this book. Each section is further subdivided into lists of surveys; works on architecture; books on painting, sculpture, prints, and—for the later periods—photography; and references for interiors, furniture, and crafts.

I. GENERAL REFERENCES

Surveys

Cahill, Holger, and Alfred H. Barr, Jr. *Art in America, A Complete Survey.* New York: Reynal & Hitchcock, 1939.

Dunlop, William. *History of the Rise and Progress of the Arts of Design in the United States,* 3 vols, rev. ed. New York: Benjamin Blom, 1965.

Green, Samuel. *American Art : A Historical Survey.* New York: Ronald, 1966.

Larkin, Olivier. *Art and Life in America,* rev. ed. New York: Holt, Rinehart and Winston, 1960.

Pierson, William H., Jr., and Martha Davidson. *Arts of the United States : A Pictorial Survey.* New York: McGraw-Hill, 1960.

Porter, James A. *Modern Negro Art.* New York: Dryden, 1943.

Architecture

Andrews, Wayne. *Architecture, Ambition and Americans.* New York: Free Press, 1964.

———. *Architecture in America.* New York: Atheneum, 1960.

Burchard, John, and Albert Bush-Brown. *The Architecture of America.* Boston: Little, Brown, 1961.

Coles, William A., and Henry Hope Reed, Jr. *Architecture in America : A Battle of Styles.* New York: Appleton, 1961.

Condit, Carl W. *American Building.* Chicago: University of Chicago, 1968.

Fitch, James M. *American Building.* Boston: Houghton-Mifflin, 1948.

Gifford, Don, ed. *The Literature of Architecture. The Evolution of Architectural Theory and Practice in Nineteenth-Century America.* New York: Dutton, 1966.

Gowans, Allan. *Images of American Living.* Philadelphia and New York: Lippincott, 1964.

Kimball, Fiske S. *American Architecture.* Indianapolis, Ind.: Bobbs-Merrill, 1928.

Mumford, Lewis. *Sticks and Stones,* 2nd rev. ed. New York: Dover, 1955.

Tallmadge, Thomas E. *The Story of Architecture in America.* New York: Norton, 1936.

Painting, Sculpture, and Prints

Barker, Virgil. *American Painting.* New York: Macmillan, 1950.

Black, Mary C., and Jean Lipman. *American Folk Painting.* New York: Potter, 1966.

Craven, Wayne. *Sculpture in America.* New York: Crowell, 1968.

Eliot, Alexander. *Three Hundred Years of American Painting.* New York: Time, 1957.

Gardner, Albert TenEyck, and Stuart Feld. *American Paintings : Painters Born by 1815.* Greenwich, Conn.: New York Graphic, 1965.

Goodrich, Lloyd. *Three Centuries of American Art.* New York: Praeger, 1967.

Isham, Samuel, and Royal Cortissoz. *The History of American Painting,* 3rd ed. New York: Macmillan, 1968.

McCoubrey, John W. *American Art, 1700–1960 : Sources and Documents.* Englewood Cliffs, N.J.: Prentice-Hall, 1965.

Prown, Jules D., and Barbara Rose. *American Painting.* Vol. I, *From its Beginnings to the Armory Show.* Vol. II, *The Twentieth Century.* Cleveland, Ohio: World, 1969.

Richardson, E. P. *Painting in America.* New York: Crowell, 1965.

Taft, Lorado. *History of American Sculpture.* New York: Macmillan, 1930.

Weitenkamp, F. *American Graphic Art.* New York: Macmillan, 1924.

Interiors, Furniture, and Crafts

Aronson, Joseph. *The Encyclopedia of Furniture.* New York: Crown, 1967.

Christensen, Erwin O. *The Index of American Design.* New York: Macmillan, 1950.

Comstock, Helen. *American Furniture.* New York: Viking, 1962.

Comstock, Helen, ed. *The Concise Encyclopedia of American Antiques.* New York: Hawthorne, 1958.

Lipman, Jean. *American Folk Art in Wood, Metal, Stone.* New York: Pantheon, 1948.

McKearin, George and Helen S. *200 Years of American Blown Glass.* New York: Crown, 1966.

Phillips, John Marshall. *American Silver.* New York: Chanticleer, 1949.

Ramsey, John. *American Potters and Pottery.* Clinton, Mass.: Colonial, 1939.

Winchester, Alice. *The Antiques Book.* New York: Wynn, 1950.

II. REFERENCES TO SPECIFIC PERIODS

Part I: The Arts of the Indians

Covarrubias, Miguel. *The Eagle, the Jaguar, and the Serpent.* New York: Knopf, 1954.

Davis, Robert Tyler. *Native Arts of the Pacific Northwest.* Stanford, Calif.: Stanford, 1949.

Dockstader, Frederick J. *Indian Art in America.* Greenwich, Conn.: New York Graphic, 1961.

Douglas, Frederick H., and René d'Harnoncourt. *Indian Arts of the United States.* New York: Museum of Modern Art, 1941.

Farb, Peter. *Man's Rise to Civilization as Shown by the Indians of North America from Primeval Times to the Coming of the Industrial State.* New York: Dutton, 1968.

Grant, Campbell. *Rock Art of the American Indian.* New York: Crowell, 1967.

———. *The Rock Paintings of the Chumash.* Berkeley, Calif.: University of California, 1965.

Haberland, Wolfgang. *The Art of North America.* New York: Greystone, 1968.

Inverarity, Robert Bruce. *Art of the Northwest Coast Indians.* Berkeley, Calif.: University of California, 1950.

Keleman, Pal. *Medieval American Art,* 2nd ed. New York: Macmillan, 1968.

LaFarge, Oliver. *A Pictorial History of the American Indian.* New York: Crown, 1956.

Pierson, William H., Jr., and Martha Davidson. *Arts of the United States : A Pictorial Survey.* New York: McGraw-Hill, 1960.

Vaillant, George C. *Indian Arts of North America.* New York: Harper, 1939.

Part II: The Arts of the Colonial Period

Surveys

Wright, Louis B., George B. Tatum, John W. McCoubrey, and Robert C. Smith. *The Arts in America : The Colonial Period.* New York: Scribner, 1966.

Architecture

Bridenbaugh, Carl. *Peter Harrison.* Chapel Hill, N.C.: University of North Carolina, 1949.

Eberlein, Harold, and Cortland Hubbard. *American Georgian Architecture.* Bloomington, Ind.: Indiana University, 1952.

Garvan, Anthony. *Architecture and Town Planning in Colonial Connecticut.* New Haven, Conn.: Yale, 1951.

Kimball, Sidney Fiske. *Mr. Samuel McIntire, The Architect of Salem.* Magnolia, Mass.: Peter Smith, 1966.

Kubler, George. *The Religious Architecture of New Mexico.* Colorado Springs, Colo.: Colorado Springs Fine Arts Center, 1940.

Morrison, Hugh. *Early American Architecture.* New York: Oxford, 1952.

Waterman, Thomas. *Domestic Colonial Architecture of Tidewater Virginia.* New York: Da Capo, 1968.

———. *The Dwellings of Colonial America.* Chapel Hill, N.C.: University of North Carolina, 1950.

———. *Mansions of Virginia, 1706–1776.* Chapel Hill, N.C.: University of North Carolina, 1951.

Painting, Sculpture, and Prints

Drepperd, Carl W. *American Pioneer Arts and Artists.* Springfield, Mass.: Pond Ekberg, 1942.

———. *Early American Prints.* New York: Century, 1930.

Flexner, James T. *America's Old Masters : First Artists of the New World.* New York: Dover, 1967.

———. *First Flowers of Our Wilderness (American Painting,* Vol. 1). New York: Harcourt, 1968.

Foote, Henry. *Robert Feke.* Cambridge, Mass.: Harvard, 1930.

Forbes, Harriette. *Gravestones of Early New England.* New York: Da Capo, 1967.

Hagen, Oscar F. L. *The Birth of the American Tradition in Art.* New York: Kennikat, 1965.

Ludwig, Allen. *Graven Images, New England Stone Carving and Its Symbols, 1650–1815.* Middletown, Conn.: Wesleyan, 1966.

Prown, Jules. *John Singleton Copley,* 2 vols. Cambridge, Mass.: Harvard, 1966.

Interiors, Furniture, and Crafts

Downs, Joseph. *American Furniture, Queen Anne and Chippendale Periods.* New York: Macmillan, 1952.

Part III: The Young Republic

Architecture

Bunting, Bainbridge. *Houses of Boston's Back Bay: An Architectural History, 1840–1917.* Cambridge, Mass.: Harvard, 1967.

Downing, Antoinette F., and Vincent J. Scully. *The Architectural Heritage of Newport, Rhode Island, 1640–1915,* 2nd ed. New York: Potter, 1965.

Early, James. *Romanticism and American Architecture.* New York: Barnes, 1965.

Fitch, James M. *American Building.* Boston: Houghton Mifflin, 1948.

Gilchrest, Agnes A. *William Strickland.* Philadelphia: University of Pennsylvania, 1950.

Hamlin, Talbot. *Benjamin Henry Latrobe.* New York: Oxford, 1955.

———. *Greek Revival Architecture in America.* New York: Oxford, 1944.

Hitchcock, Henry Russell. *Rhode Island Architecture,* 2nd ed. New York: Plenum, 1968.

Kimball, Fiske S. *Thomas Jefferson, Architect.* New York: Da Capo, 1968.

Sanford, Elwood T. *The Architecture of the Southwest.* New York: Norton, 1950.

Painting, Sculpture, and Prints

Baur, John H. *American Painting in the Nineteenth Century.* New York: Praeger, 1953.

Bloch, E. Maurice. *George Caleb Bingham.* Berkeley, Calif.: University of California, 1967.

Christ-Janer, Albert. *George Caleb Bingham of Missouri.* New York: Dodd, Mead, 1940.

Cowdrey, Bartlett, and Herman W. Williams. *William Sidney Mount, 1807–1868, An American Painter.* New York: Columbia, 1944.

Detroit Institute of Arts. *The Peale Family.* Detroit: Wayne State, 1967.

Drepperd, Carl W. *Early American Prints.* New York: Century, 1930.

Flexner, James T. *The Light of Distant Skies, 1760–1835.* (*American Painting,* Vol. 2.) New York: Harcourt, 1968.

Gardner, Albert TenEyck. *Yankee Stonecutters, The First American School of Sculptors.* New York: Columbia, 1945.

Goodrich, Lawrence B. *Ralph Earl.* Albany, N.Y.: State University of New York, 1967.

Lipman, Jean, and Alice Winchester. *Primitive Painting in America, 1750–1950.* New York: Dodd, Mead, 1950.

Ludwig, Allen. *Graven Images: New England Stone Carving and Its Symbols, 1615–1815.* Middletown, Conn.: Wesleyan, 1966.

Novak, Barbara. *American Painting of the Nineteenth Century.* New York: Praeger, 1969.

Richardson, E. P. *American Romantic Painting.* New York: Weyhe, 1944.

———. *Washington Allston: A Study of the Romantic Artist in America.* Chicago: University of Chicago, 1948.

Sellers, Charles Coleman. *Charles Willson Peale.* New York: Scriber, 1968.

Soby, James Thrall, and Dorothy C. Miller. *Romantic Painting in America.* New York: Museum of Modern Art, 1943.

Sizer, Theodore. *Colonel John Trumbull.* New Haven, Conn.: Yale, 1967.

Sweet, Frederick A. *The Hudson River School and the Early Landscape Tradition.* Chicago: Art Institute, 1945.

Thorp, Margaret Farrand. *The Literary Sculptors.* Durham, N.C.: Duke, 1965.

Interiors, Furniture, and Crafts

Andrews, Edward Deming and Faith. *Shaker Furniture.* New Haven, Conn.: Yale, 1937.

Bridenbaugh, Carl. *The Colonial Craftsman.* Chicago: University of Chicago, 1966.

Mongomery, Charles. *American Furniture of the Federal Period.* New York: Viking, 1966.

Ormsby, Thomas H. *Early American Furniture Makers.* New York: Archer, 1957.

Part IV: Between Two Wars: 1865–1913

Surveys

Mumford, Lewis. *The Brown Decades,* 2nd rev. ed. New York: Dover, 1955.

Architecture

Bunting, Bainbridge. *Houses of Boston's Back Bay: An Architectural History, 1840–1917.* Cambridge, Mass.: Harvard, 1967.

Bush-Brown, Albert. *Louis Sullivan.* New York: Braziller, 1960.

Condit, Carl W. *American Building Art: The Nineteenth Century.* New York: Oxford, 1960.

———. *The Chicago School of Architecture.* Chicago: University of Chicago, 1964.

Duncan, Hugh Dalziel. *Culture and Democracy: The Struggle for Form in Society and Architecture in Chicago and the Middle West During the Life and Times of Louis H. Sullivan.* Totowa, N.J.: Bedminster, 1965.

Hitchcock, Henry Russell. *The Architecture of H. H. Richardson and His Times.* Cambridge, Mass.: MIT, 1961.

Maass, John. *The Gingerbread Age.* New York: Bramhall, 1957.

McCoy, Esther. *Five California Architects.* New York: Reinhold, 1960.

Morrison, Hugh. *Louis Sullivan, Prophet of Modern Architecture.* Magnolia, Mass.: Peter Smith, 1958.

Olmsted, Roger, and T. H. Watkins. *Here Today. San Francisco's Architectural Heritage.* San Francisco: Chronicle, 1968.

Peisch, Mark L. *The Chicago School of Architecture.* New York: Random, 1964.

Schuyler, M. *American Architecture and Other Writings.* New York: Atheneum, 1964.

Scully, Vincent J., Jr. *The Shingle Style.* New Haven, Conn.: Yale, 1955.

Sullivan, Louis H. *Kindergarten Chats and Other Writings.* Ed. by Isabella Athey. New York: Wittenborn, 1947.

———. *The Testament of Stone: Themes of Idealism and Indignation.* Evanston, Ill.: Northwestern, 1963.

Painting, Sculpture, Prints, and Photography

Boswell, Peyton. *George Bellows.* New York: Crown, 1942.

Carson, Julia M. *Mary Cassatt.* New York: McKay, 1966.

Flexner, James T. *The World of Winslow Homer, 1836–1910.* New York: Time, 1966.

Frankenstein, Alfred. *After the Hunt: William Harnett and Other American Still Life Painters,* rev. ed. Berkeley, Calif.: University of California, 1969.

Gardner, Albert TenEyck. *Winslow Homer, American Artist: His World and His Work.* New York: Potter, 1961.

Goodrich, Lloyd. *Albert Pinkham Ryder.* New York: Whitney Museum, 1947.

———. *The Graphic Art of Winslow Homer.* Washington, D.C.: Smithsonian Institution, 1969.

———. *John Sloan.* New York: Whitney Museum, 1952.

———. *Thomas Eakins, His Life and Work.* New York: Whitney Museum, 1933.

———. *Winslow Homer.* New York: Braziller, 1959.

———. *Winslow Homer's America.* New York: Tudor, 1969.

Lipman, Jean, and Alice Winchester. *Primitive Painting in America, 1750–1950.* New York: Dodd, Mead, 1950.

McCausland, Elizabeth. *George Inness.* New York: American Artists Group, 1946.

Morgan, Charles H. *George Bellows, Painter of America.* New York: Reynal, 1965.

Mount, Charles Merrill. *John Singer Sargent, A Biography.* New York: Norton, 1955.

Novak, Barbara. *American Painting of the Nineteenth Century.* New York: Praeger, 1969.

Richardson, E. P. *Painting in America.* New York: Crowell, 1965.

Schendler, Sylvan. *Eakins.* Boston: Little, Brown, 1967.

Sloan, John. *John Sloan's New York Scene: From the Diaries, Notes, and Correspondence, 1906–1913.* New York: Harper, 1965.

Sutton, Denys. *Nocturne: The Art of James McNeil Whistler.* Philadelphia and New York: Lippincott, 1964.

Sweet, Frederick A. *Miss Mary Cassatt, Impressionist from Pennsylvania.* Norman, Okla.: University of Oklahoma, 1966.

———. *Sargent, Whistler and Mary Cassatt.* Chicago: Art Institute, 1954.

Wallace, David H. *John Rogers, The People's Sculptor.* Middletown, Conn.: Wesleyan, 1967.

Young, Dorothy Weir. *The Life and Letters of J. Olden Weir.* New Haven, Conn.: Yale, 1960.

Interiors, Furniture, and Crafts

Editors of *Life. America's Arts and Skills.* New York: Dutton, 1957.

Koch, Robert. *Louis C. Tiffany.* New York: Crown, 1964.

Kouwenhoven, John A. *Made in America.* Garden City, N.Y.: Doubleday, 1949.

Lynes, Russell. *The Tastemakers.* New York: Harper, 1954.

Rogers, Meyric R. *American Interior Design.* New York: Norton, 1947.

Stickley, Gustav. *Craftsman Homes.* New York: Craftsman, 1909.

Part V: The Modern Period

Surveys

Rose, Barbara. *American Art Since 1900 : A Critical History.* New York: Praeger, 1968.

—————. *Readings in American Art Since 1900 : A Documentary Survey.* New York: Praeger, 1968.

Architecture

American Institute of Architects. *Mid-Century Architecture in America : Honor Awards of the American Institute of Architects, 1949–1961.* Baltimore: Johns Hopkins, 1961.

Condit, Carl W. *American Building Art. The Twentieth Century.* New York: Oxford, 1961.

Fitch, James M. *Architecture and the Aesthetics of Plenty.* New York: Columbia, 1961.

Hitchcock, Henry Russell, and Arthur Drexler (eds). *Built in U.S.A. : Post War Architecture.* New York: Museum of Modern Art, 1952.

Jacobs, Jane. *The Death and Life of Great American Cities.* New York: Random, 1961.

Johnson, Philip. *Architecture, 1949–1964.* London: Thames & Hudson, 1966.

McHale, John. *R. Buckminster Fuller.* New York: Braziller, 1962.

Mumford, Lewis. *Roots of Contemporary Architecture.* New York: Grove, 1959.

Scully, Vincent J., Jr. *Frank Lloyd Wright.* New York: Braziller, 1960.

Stein, C. S. *Toward New Towns for America.* Cambridge, Mass.: MIT, 1966.

Wright, Frank Lloyd. *The Living City.* New York: Bramhall, 1958.

—————. *Writings and Buildings.* New York: Horizon, 1960.

Painting, Sculpture, Prints, and Photography

Agee, William C. *Synchronism and Color Principles in American Painting.* New York: Knoedler, 1965.

Alloway, Lawrence. *The Shaped Canvas.* New York: Guggenheim Museum, 1964.

Arnason, H. H. *Abstract Expressionists and Imagists.* New York: Guggenheim Museum, 1961.

—————. *Stuart Davis.* Washington, D.C.: National Collection of Fine Arts, 1965.

Arts Yearbook. Contemporary Sculpture. (Introd. by William C. Seitz.) *Arts Yearbook,* No. 8, 1965.

Ashton, Doré. *The Unknown Shore.* Boston, Little, Brown, 1962.

Baur, John H. *Charles Burchfield.* New York: Macmillan, 1956.

—————. *New Art in America : Fifty Painters of the Twentieth Century.* New York: Praeger, 1957.

Blesh, Rudy. *Modern Art U.S.A.* New York: Knopf, 1956.

Brown, Milton. *American Painting from the Armory Show to the Depression.* Princeton, N.J.: Princeton, 1955.

—————. *The Story of the Armory Show.* New York: Hirshhorn Foundation, 1963.

Calder, Alexander, and Jean Davidson. *Calder, An Autobiography with Pictures.* New York: Random, 1966.

Craven, Thomas. *A Treasury of American Prints.* New York: Simon & Schuster, 1939.

Dover, Cedric. *American Negro Art.* Greenwich, Conn.: New York Graphic, 1960.

Forsyth, Robert J. *John B. Flannagan.* South Bend, Ind.: Notre Dame, 1963.

Geldzahler, Henry. *American Painting in the Twentieth Century.* Greenwich, Conn.: New York Graphic, 1965.

Giedion-Welcker, Carola. *Contemporary Sculpture : An Evolution in Volume and Space.* New York: Wittenborn, 1955.

Goodrich, Lloyd. *Edward Hopper.* New York: Whitney Museum, 1950.

—————. *Pioneers of Modern Art in America : The Decade of the Armory Show, 1910–1920.* New York: Praeger, 1963.

—————. *Raphael Soyer.* New York: Praeger, 1967.

Gordon, John. *Geometric Abstraction in America.* New York: Praeger, 1962.

Gray, Cleve (ed.) *David Smith by David Smith.* New York: Holt, Rinehart and Winston, 1968.

Hess, Thomas B. *Willem de Kooning.* New York: Braziller, 1959.

Hope, Henry. *The Sculpture of Jacques Lipchitz.* New York: Simon & Schuster, 1954.

Hunter, Sam. *Larry Rivers.* New York: Jewish Museum, 1961.

—————. *Modern American Painting and Sculpture.* New York: Dell, 1959.

—————. *U.S.A. Art Since 1945.* New York: Abrams, 1958.

Jaffe, Irma B. *Joseph Stella.* Cambridge, Mass.: Harvard, 1970.

Kirby, Michael. *Happenings.* New York: Dutton, 1965.

Kuh, Katherine. *Break-Up : The Core of Modern Art.* Greenwich, Conn.: New York Graphic, 1965.

Lippard, Lucy R. *Pop Art.* New York: Praeger, 1966.

McShine, Kynaston. *Joseph Albers.* New York: Museum of Modern Art, 1965.

—————. *Primary Structures.* New York: Jewish Museum, 1966.

Melquist, Jerome. *The Emergence of an American Art.* New York: Scribner, 1942.

Nordness, L., and Allen S. Weller. *Art U.S.A. Now,* 2 vols. New York: Viking, 1963.

O'Hara, Frank. *Jackson Pollock.* New York: Braziller, 1959.

—————. *Nakian.* New York: Museum of Modern Art, 1966.

O'Hara, Frank. *Robert Motherwell.* New York: Museum of Modern Art, 1966.

—————. *The Peggy Guggenheim Collection.* London: British Arts Council, 1964.

Ritchie, Andrew. *Charles Demuth.* New York: Museum of Modern Art, 1950.

—————. *Sculpture of the Twentieth Century.* New York: Museum of Modern Art, 1952.

Rosenberg, Harold. *The Anxious Object.* New York: Horizon, 1964.

Seitz, William C. *The Art of Assemblage.* New York: Museum of Modern Art, 1964.

—————. *The Responsive Eye.* New York: Museum of Modern Art, 1964.

Solomon, Alan. *New York : The Art Scene.* New York: Holt, Rinehart and Winston, 1968.

—————. *Robert Rauschenberg.* New York: Jewish Museum, 1963.

Sweeney, James. *Alexander Calder.* New York: Guggenheim Museum, 1964.

Tomkins, Calvin. *The Bride and The Bachelors.* New York: Viking, 1965.

Williams, William Carlos. *Charles Sheeler : Paintings, Drawings, Photographs.* New York: Museum of Modern Art, 1939.

Williams, William Carlos, D. Phillips, and D. Norman. *John Marin Memorial Exhibition.* Los Angeles: University of California 1955.

Wyeth, Andrew. *Andrew Wyeth.* Boston: Houghton Mifflin, 1968.

Zigrosser, Carl. *The Artist in America.* New York: Knopf, 1942.

Interiors, Furniture, and Crafts

Alswang, Betty. *The Personal House: Homes of Architects and Writers.* New York: Whitney Library of Design, 1961.

Drexler, Arthur, and Greta Daniel. *Introduction to Twentieth Century Design.* New York: Doubleday, 1959.

Dreyfuss, Henry. *The Measure of Man : Human Factors in Design.* New York: Whitney Library of Design, 1961.

Faulkner, Ray and Sarah. *Inside Today's Home,* 3rd ed. New York: Holt, Rinehart and Winston, 1968.

Green, Lois Wagner (ed.) *Interiors Book of Offices.* New York: Whitney Library of Design, 1959.

Kaufmann, Edgar, Jr. *What is Modern Design ?* New York: Museum of Modern Art, 1950.

—————. *What is Modern Interior Design ?* New York, Museum of Modern Art, 1953.

Lynes, Russell. *The Taste Makers.* New York: Harper, 1954.

Nelson, George (ed.). *Chairs.* New York: Whitney Library of Design, 1953.

—————. *Living Spaces.* New York: Whitney Library of Design, 1952.

Niece, Robert Clemens. *Art in Commerce and Industry.* Dubuque, Iowa: Brown, 1968.

Panero, Julius. *Anatomy for Interior Designers.* New York: Whitney Library of Design, 1962.

Pahlmann, William. *The Pahlmann Book of Interior Design.* New York: Crowell-Collier-Macmillan, 1955.

Index

References are to page numbers, except for color plates and black-and-white illustrations, which are identified by plate and figure numbers.

Photographic Sources

References are to figure numbers unless indicated Pl. (plate).

Abbe, Dorothy, Hingham, Mass. (76–77); American Antiquarian Society, Worcester, Mass., Forbes Collection (191); American Crafts Council, New York (519); Andrews, Wayne, Grosse Pointe, Mich. (73, 80, 111–113, 119, 123, 125, 132, 201, 205, 207–208, 210, 218, 221, 224, 228, 232, 236, 351–352, 354–356, 358, 367–368, 370, 381, 469, 480–481, 486, 507); Armstrong Roberts, H., Philadelphia (348); Art Commission of the City of New York (457); Baer, Morley, Berkeley, Calif. (494); Baker, Olivier, New York (537, 576, 587, 591–593, 595, 599, 613, 677–678); Baptie, Charles, Annandale, Va. (Pl. 7); Bednarz, Adele, Galleries, Los Angeles (577); Blaisdell, Lee, Monterey, Calif. (234); Blaser, Werner, Basel (477); Bloch, Lore, Palo Alto, Calif. (39, 376); Blomstrann, E. Irving, New Britain, Conn. (100, 102, 143–144, 146, 149); British Columbia Government Travel Bureau, Victoria (57); Brown Brothers, New York (217, 219, 330, 453); Burckhardt, Rudolph, New York (572, 605, 608–609, 686); Buskett, Clarence, Sacramento, Calif. (404); California Department of Public Works, Division of Highways, Sacramento (504); Canadian National Railways, Chicago (51); Castelli, Leo, Gallery, New York (525, 611, 686, Pls. 30, 33); Chamberlain, Samuel, Marblehead, Mass. (72); Chicago Architectural Photographing Company (359–360, 364, 384); Christian, Wirt A., Richmond, Va. (117); Clements, Geoffrey, New York (432, 534–535, 548, 553, 555, 562, 564–565, 583, 604, 641, 649, 654, 666, 669, 671, 687, 690, 693, 695); Colonial Williamsburg, Inc., Williamsburg, Va. (118, 121); Crandall, Berton, Menlo Park, Calif. (344); Cushing, George M., Jr., Boston (154, 167, 186); Dementi Studio and Chamber of Commerce, Richmond, Va. (194); George Eastman House, Rochester, N.Y. (28); Elestel, John, New York (496); Essex Institute, Salem, Mass. (130–131); Farmer, Edward, Palo Alto, Calif. (345); Fisher, Elliot Lyman, Asheville, N.C. (353); Fletcher, Mike T., Black Star, New York (505); Flournoy, Virginia, Chamber of Commerce (206); Foster, Gene, Flagstaff, Ariz., and Museum of Northern Arizona, Flagstaff (43); Frick Art Reference Library, New York (181); Gemini G.E.L., Los Angeles (643); General Electric Company, Cleveland, Ohio, Office of the United States Commissioner General, and Canadian World Exhibition, Montreal (491); Gilman Gallery, Chicago (692); Gilpin, Laura, Santa Fe, N.M. (44); Golden Gateway Center, San Francisco (483); Grant, Campbell, Carpinteria, Calif. (50); Greenberg, Sherwin, McGranahan & May, Inc., Buffalo (533, 597); Guerrero, Pedro, New Canaan, Conn. (Pl. 17); Hassel, Paul, San Francisco (529); Hedrich-Blessing, Chicago (361–363, 475–476, 487, 506); Helga Photo Studio, New York (560, 627); Hickey & Robertson, Houston (683); Historical Society of Berks County, Reading, Pa. (66); Hopf, John, Newport, R.I. (128, 248, 378); Hubbard, Cortlandt V.D., Philadelphia (84); Jackson, Martha, Gallery, Inc., New York (585); Jackson, W.H., and Smithsonian Institution, Washington, D.C. (31); Jay-Bee Photographic Studio, Pittsburgh (484); Johnson, S.C., & Son, Racine, Wisc. (470); Jones, Pirkle, Mill Valley, Calif. (495); Juley, Peter A., & Son, New York (445, 568, 653); Kahn, Matt, Stanford, Calif. (52, 689); Kaufmann and Fabry Co., Chicago (464); Kerr, Coe, Gallery, New York (580); King, John, New Canaan, Conn. (Pls. 10, 12, 14, 21); Langley, J. Alex, New York (482); Leco Photo Service, Flushing, N.Y. (490); Lehmann, Matt, Menlo Park, Calif. (377); Library of Congress, Washington, D.C. (67, 74, 78, 82, 90, 107–110, 114, 120, 124, 127, 195, 197, 200, 203–204, 209, 215–216, 229, 231, 233, 235, 327); McCormack, Bob, Tulsa, Okla. (45); McKillop, William, New York (446); Manufacturers Hanover Trust Company, New York (502); Marcello, Joseph R., Providence, R.I. (182); © Maris, Ezra Stoller Associates [ESTO], Mamaroneck, N.Y. (249); Mendelowitz, Louis, Menlo Park, Calif. (249); Mesberg, B.G,. National Sales, New York (512); Morrow, E. E. (Skip), Savannah, Tenn. (11); Museum of the American Indian, New York (18, 25); Museum of the City of New York (342); Museum of Contemporary Crafts of the American Crafts Council, New York (390–391, 527); Museum of Modern Art, New York (68, 83, 122, 199, 357, 366, 466); Museum of New Mexico, Santa Fe (29, 35); National Archives and Records Service, Washington, D.C. (213); National Gallery of Art, Washington, D.C., Index of American Design (104–105, 153, 164, 192–193, 226–227, 243, 252, 263–265, 317, 319, 372, 387–388); National Park Service, U.S. Department of Interior, Washington, D.C. (27, 86, 98, 126, 211); Nelson, O.E., New York (596, 610); New Mexico State Tourist Bureau (30, 87–89, 313); New York City Parks, Recreation and Cultural Affairs Administration (452); New York Daily News (465); Norfolk Museum of Arts & Sciences, Norfolk, Va. (79); Ohio Historical Society, Columbus (1, 9, 22); Old Sag Harbor Committee, Sag Harbor, N.Y. (214); O'Neil, Mike, Waltham, Mass. (202); Parker, Maynard L., Los Angeles (516); Pennsylvania Academy of the Fine Arts, Philadelphia (349); City of Philadelphia (348); Philadelphia Museum of Art (Pl. 15); Phillips Studio, Philadelphia (270, 281, 284, 286, 322–323, 394, 426); Photo Art Commercial Studio, Portland, Ore. (532); Pollitzer, Eric, Garden City, N.Y. (601, 606, 615, 670); Preservation Society of Newport County, Newport, R.I. (129); Richards, Morgenthau Co., Inc., New York (520); Robinson Studio, Grand Rapids, Mich. (374); E. Robles Gallery, Los Angeles (694); St. John's University, Collegeville, Minn. (478); Sandak, Inc., New York (230, 456); Santa Fe Railway (32); Schiff, John D., New York (660); Schopplein, Joe, San Francisco (682); Serisawa, I., Los Angeles (558); Shulman, Julius, Los Angeles (369, 509, 688); Smithsonian Institution, Washington, D.C. (220); Stevens, Lt. Col. Albert W., © 1948 National Geographic Society, Washington, D.C. (7); © Robert Stohman, Darien, Conn. (501); © Ezra Stoller Associates [ESTO], Mamaroneck, N.Y. (474, 479, 488–489); © Ezra Stoller Associates [ESTO], Mamaroneck, N.Y., and Yale University News Bureau, New Haven (500); Sunami, Soichi, New York (413, 552, 623, 628, 639, 656, 679); Tennessee Department of Conservation, Nashville (212); Thomas Airviews, Long Island City, N.Y. (467); Thomas, Frank J., Los Angeles (684); Travelers Insurance Company, Hartford (503); United Nations, New York (485); University of Illinois Library, Urbana (347, 365); Untracht, Oppi, Brooklyn, N.Y. (523); Virginia Department of Conservation and Economic Development, Richmond (315); Weiss, Murray, Philadelphia (Pl. 32); Winant, Mark, and Staten Island Historical Society, Richmondtown, N.Y. (85); Wyatt, Alfred J., Philadelphia (336, 438, 594, 618, 622, 624–626, 633–634).